0074437

3 1702 00121 9454

20th Century American Folk, Self Taught, and Outsider Art

By
Betty-Carol Sellen
with
Cynthia J. Johanson

Neal-Schuman Publishers, Inc.
New York London

Published by Neal-Schuman Publishers, Inc.
100 Varick Street
New York, NY 10013

Cover: *Seven-Headed Dragon* by Herbert Singleton, 1991.
Enamel paint on carved wood, 110″ × 38″ × 2.5″.
Collection of Warren and Sylvia Lowe
Photo: Phillip Gould

Printed and bound in the United States of America

Library of Congress Cataloging-in-Publication Data

Sellen, Betty-Carol.
 20th century American folk, self-taught, and outsider art : a
resource guide / by Betty-Carol Sellen with Cynthia J. Johanson.
 p. cm.
 Includes bibliographical references and index.
 ISBN 1-55570-142-6
 1. Folk art—Information services—United States—Directories.
2. Outsider art—Information services—United States—Directories.
3. Folk artists—United States—Biography. I. Johanson, Cynthia J.
II. Title.
 NK 805.S46 1993
 745′.025′73—dc20 93-3146
 CIP

This book is dedicated to the memory of Jack Wing Seto who shared with me his talent for finding adventure in even the most familiar landscapes and to the memory of my sister Ginger Bennett— confidant, best friend, and enthusiastic supporter of all my endeavors.

BCS

CONTENTS

Black and White Illustrations

Color Illustrations

PREFACE

This book came about because as a person with a new interest in folk art (I didn't even know there was a problem with the label), I wanted to learn as much as I could about the field. I began taking every opportunity to collect and organize information. Soon I had learned enough to identify the components of the field which generate information, and used this knowledge to find more and to choose the categories that became the structure for *20th Century American Folk, Self-Taught, and Outsider Art: A Resource Guide.*

My interest in contemporary nontraditional folk art began in 1984 when I was living in the French Quarter of New Orleans, on sabbatical leave from my job as a college librarian in New York. Every day I would take a walk, and inevitably would end up in front of the Gasperi Folk Art Gallery; in smaller lettering the sign said "Contemporary Southern Folk Art." I wondered at what I was seeing through those windows, and one day I finally went in to ask. The art inside that gallery gave me a thrill; it filled me with excitement, "butterflies," the feeling that here was something new and wonderful.

Upon my return to New York, I went to see this art in galleries and exhibitions (surprising to me now, it was not easy to figure out which galleries to visit). Following Richard Gasperi's advice, I signed up for a lecture series at the Museum of American Folk Art Institute which, to my great good fortune, was being taught by two communicative experts—Didi Barrett, who was then the editor of *The Clarion,* and gallery owner Randall Morris. I took a trip with the Folk Art Explorer's Club, and attended symposia and an organization meeting or two. I learned about many artists, and I met a few. As a person educated in librarianship, I collected and organized information gathered at all these activities, in whatever form or format it came. This reference book is in part the result of this activity.

For those who have just discovered self-taught art and artists there are unexpected issues. Some of these have been discussed in the literature of the field. A few of these issues are: the problems inherent in a situation where people with income enough to buy art interact with people who have little or no income at all; the desire, common to many of us, to meet the artists versus the artists' need for time and privacy; the "pressure" by dealers and collectors on artists to repeat popular images; the "class strife," for want of a better phrase, between collectors, dealers, art historians, museum personnel, and others; and the racism and sexism that takes its own peculiar shape in this field. (In the matter of sexism, every critic, gallery owner, art historian, or other person who tries to diminish the life and experience of old women by calling them "grandma" or referring to them as "sweet," "naive," or "innocent" should be confined to that place populated by the devils portrayed in the art works of Jessie Cooper.)

Finally there is the conflict over terminology—the reason why the title of this book is so long. Each word that is used—*folk, self-taught, outsider, primitive, naive*—has its defenders and its detractors. Nearly every work listed in the

bibliography will have something to say about definitions and labels. I have my own strong opinions on the subject, but I will save them for another day. In this reference book I use the terms interchangeably or, in the case of the bibliography, I use the term used by the author of the work. As often as possible, I simply use the word *art*.

I hope that this resource guide, in addition to improving access to information, will help to increase the pleasure and insight people may gain from this art and the respect offered to those artists who create it.

ACKNOWLEDGMENTS

A book that is a guide to information about organizations, businesses, publications, museums, and artists is by definition dependent on the help and cooperation of many people. It follows that there are many to thank for their responsiveness to this project: the gallery owners and dealers who sent me information about their establishments and biographical information about their artists; the art center directors who described their programs and artists; the museum curators who answered my requests for information about permanent collections and exhibition plans; and the organization officials who described the focus of their particular group.

There are many people who went far beyond my initial requests, suggesting sources and artists not known to me. These include Bonnie Grossman of The Ames Gallery in Berkeley, Mia McEldowney of the Mia Gallery in Seattle, Richard Gasperi of the Gasperi Gallery in New Orleans, and Jo Tartt of the Tartt Gallery in Washington, DC, who let me spend hours with their files and personal libraries; Sherry Pardee who was most hospitable in Iowa City and spent a lot of time educating me about the artists in her part of the midwest; A.J. Boudreaux in New Orleans who shared stories and opinions and introduced me to some great artists and interesting collectors; and last, but definitely not least, Lynne Ingram of Lynne Ingram Southern Folk Art who kept the articles and information flowing to the very end.

Thanks too for the special efforts made by dealers and gallery owners Micki Beth Stiller of Montgomery, Alabama; Marcia Weber, also of Montgomery, who kept me informed all along the way about her eventually successful search for the family of Bill Traylor; Robert Cargo for rescuing me when I got lost in Tuscaloosa; and the people from the two galleries in Clayton, Georgia. Others owed special thanks are Sheldon Shapiro who drove way out of his way so I wouldn't get lost in Missouri, and Davis Mather who gave of his time and answered questions in Santa Fe. Leslie Muth, when she was in Houston and then later after her move to Santa Fe, answered many questions with patience every time I called, and supplied elusive publications. Joyce Porcelli was admirable and very helpful on a day when I was not, after too long a drive from Washington, DC to Cleveland. Ramona Lampell, Bruce Shelton, and Shelby Gilley also offered extra measures of help and information as did Linda Black from Southern Tangent Gallery in Sorrento, Louisiana.

Bonnie Haight of the Creative Growth Art Center in Oakland, California spent a large part of a very busy day showing me around the center, explaining its program, and introducing me to some of the artists. Suzanne Lacke of the National Institute of Art and Disabilities Gallery in Richmond, California took time out to come to where I was to describe their program and to tell me how to get in touch with other art centers. Suzanne Theis of the Orange Show Foundation gave directions to and information about folk art environments in Houston and other locations.

A number of collectors took the time to show me their collections and tell me about artists. I thank them for their kindness and hospitality. These were Warren and Sylvia Lowe of Lafayette, Louisiana; Bill Rose, Paul and Alvina Havercamp, and Kurt Gitter of New Orleans; and Butler and Lisa Hancock of Denver, Colorado. Richard and Maggie Wenstrup showed me their collection, introduced unknown artists and a gallery, supplied published materials, served as tour guides and offered wonderful hospitality in their Ohio home. Anne Miller of Louisville, Kentucky was a constant supporter of this project, introducing me to Kentucky artists and those from other areas too. She also sent quantities of information for the bibliography. Anne and her husband have shared their hospitality and their collection on two visits. Richard Edgeworth, Michael Blackwell, and Robert Stern, all of Chicago, supplied lots of information. Betsy Rupprecht and Jan Cunningham, not collectors but also from Chicago, supplied home, hospitality and friendship several times during this project. So did Atlanta, Georgia friends Liz Throop and Joy Wasson who, in addition, introduced me to Howard Finster. New York City colleagues and friends Susan Vaughn "downtown" and Charles Gilman "uptown" provided homes away from home.

Liza Kirwin of the Archives of American Art, Lynda Roscoe Hartigan of the National Museum of American Art, and Lee Kogan of the Museum of American Folk Art gave an extra measure of their time, as did Adrian Swain of Morehead State University, William Ferris of the Center for the Study of Southern Culture, Mary Bryon Hood of the Owensboro Museum of Fine Art, and Eason Eige of the Huntington Museum in West Virginia. Several busy curators took the time to supply advance information about exhibitions and catalogs so it could appear in this reference book. These people were Alice Yelen of the New Orleans Museum of Art, Trudy Thomas of the Museum of Northern Arizona, Carol S. Eliel of the Los Angeles County Museum of Art, and E. Jane Connell of the Columbus Museum of Art in Ohio. Chuck Rosenak supplied prepublication information about his book on Navajo folk art. Thank you too to longtime friend Roland Freeman for instruction in the technical aspects of book illustration.

Didi Barrett and Lynne Ingram read the bibliography over to look for errors and omissions and make suggestions. This can be a tedious task, and so is doubly appreciated. Marti Burt put much of the bibliography on the computer, and that task is even worse.

Librarians are essential to a project such as this one. There were many who helped whose names I do not know. Other librarians and library workers who offered many ideas and assistance were Marilyn Souders, of the *Newsweek* Library, Tom Ray of the Louisiana State University Library, Mary Wright and Donald Hardy of the Library of Congress, Carol Leita of the Berkeley, California Public Library, and Marie Maroscia and Bertha Bendelstein of the Brooklyn College Library in New York. Jeannie Kreamer of the University of Southwestern Louisiana provided useful guidance to video sources. The assistance of Cynthia Johanson of the Library of Congress was enormously helpful in collecting the data for the bibliography.

Many artists offered me information, and in some cases the pleasure of their company too. I thank them all very much. Minnie Adkins gets a special note of thanks for introducing me to so many people and for making bologna sandwiches just like my mother used to make and I never get to eat anymore.

I thank "my drivers" too—all my friends who give me a hard time for not having learned to drive, but who cart me around anyway: Dee Lehman who drove me all the way from east coast to west coast and back, and did not wreck the car when I screamed "Rolling Mountain Thunder" in response to sighting an

art environment, something she had never heard of (and for turning the car around at the not-very-close "next opportunity"); Elida Scola and Lisa Ratté for my first trip to Kentucky and Lynne Ingram for the second; and Linda Grishman in Vermont, Denny Wakkuri and Loyd Hopper in Tucson, Rita Scherrei in Los Angeles, Jane Botham in Milwaukee, and Mary Vela-Creixell in Houston.

Finally, and I know this is said all the time, but in this case it is true: I could not have done this project without the help and support of my very dear friend Marti Burt. Realizing about the time I did that I could not do this book and keep all my New York commitments, Marti offered me a free room of my own and unlimited cat care for my cats Neville and Mathilde while I traveled to meet artists, gallery owners, collectors, and museum people all over the country. She taught me how to use her computer, helped me out when panic set in, and ignored all anxiety attacks and my wonderful disposition that accompanied them. She is a gourmet cook and a lot of fun too and lives and works by an admirable set of human values. Thank you very much for all of it.

INTRODUCTION

The growth of interest over the past decade in twentieth century folk, self-taught, and outsider art, in all its manifestations and definitions, has been phenomenal. It has been at times a bit overwhelming to those who remember when it was "a small world" of interested parties; when those who sold the art, collected the art, exhibited it, and studied it at all, were known to each other. Explanations for this growth in interest are discussed occasionally: "more people have more money and can spend it on art," "there are more people," "it is a fad brought on by all this media attention and it will go away," "it is a reaction to bad mainstream art," "it is a reaction to mainstream 'bad' art," or, "it's Howard Finster's fault."[1]

The art itself provides more likely explanations. It is often the work of very talented artists. It is direct, honest, and communicates with the viewer. It is accessible. It is straight from the soul. It can be beautiful, or scary, or weird, but it is nearly always "real." Whatever the reasons, the growth in interest has resulted in a parallel growth in all the various elements in the field of twentieth century self-taught art.

Over two years ago, when this reference book was started, forty of the galleries listed did not exist or did not sell folk or outsider art. The numbers of art centers for the mentally ill, the developmentally disabled, and the elderly have increased and so has the marketing of their art.

Museums reporting a growth of interest in adding the art of self-taught artists to their permanent collections often noted that this was a new direction, and that they did not start "actively collecting" until some time in the 1980s. There have been many museum exhibitions of late, and it seems that there are more than in the past if you count all sizes of exhibitions and sponsoring institutions, but the resources necessary to do anything approaching an accurate count were not available.[2]

Several regions and states in the U.S.—Southern California, the Deep South, and the Southwest—have new organizations for those with an interest in the art. Intuit: The Center for Intuitive and Outsider Art, though Chicago-based, has a nationwide membership. The Folk Art Society of America reports a growth in membership.

Publications specific to the field have increased by two—*Raw Vision* and *In-'Tuit*. A few specialized newsletters have come into being, one of these being the newsletter of the Southern Folk Pottery Collectors Society. Mainstream art publishers are paying more attention to the subject of folk and outsider art; sometimes the results are such that one wishes they wouldn't.

The information in this reference guide is arranged to provide access to information about twentieth century folk, self-taught and outsider art and artists. It is organized around the many institutions in the field that create or provide this information: the galleries that sell it; the art centers that provide a place for elderly and mentally or emotionally disabled artists, and an opportunity to

display their work; the museums that have examples in their permanent collections and/or exhibit the art; the publications to read; the organizations to join; the educational opportunities to take advantage of; the books, periodicals and newspapers to read; and the films to see. The final section of the book, last but most important, is a list of contemporary self-taught artists—"self-taught" is the only criterion that links some of these artists together—with brief identifying information and references to where their work may be seen.

[1] Conversations overheard at the October 26, 1991, "Cult, Culture, and Consumer," sponsored by the Smithsonian Institution in conjunction with the *Mad With Passion* exhibition.

[2] *The Museum of American Folk Art Encyclopedia of Twentieth-Century American Folk Art* (Abbeville, 1990) by Chuck and Jan Rosenak has a list of major museum exhibitions from 1924 through 1989. This reference book has a list that starts in 1990.

GALLERIES

This chapter describes galleries, dealers, and other establishments that sell twentieth century folk, self-taught, and outsider art. Some of these specialize in the art of a geographical region, while others focus on art taking a particular direction. A few of the galleries included are associated with an Art Center program for the emotionally or developmentally disabled. Establishments that represent both academic and self-taught artists are included, as are three or four establishments that do not focus on art at all, but do regularly sell some art by self-taught artists. The artist lists provided here for each gallery or dealer include only the artists that fit the parameters of this book—twentieth century folk, self-taught, and outsider artists. Some establishments may handle additional artists or craftspeople who would not be considered folk, self-taught, or outsider artists.

The author visited all but forty of the galleries, dealers, and art centers described here. Cynthia Johanson visited and provided descriptions for most of the Florida galleries. Two other people scrutinized some Southern establishments that I missed. All people visited were most generous with their time and information.

Galleries are the best source to use to discover this art. Not only is the work of the artists available for viewing, but most reputable galleries have written documentation about the artists they represent. Many gallery owners are as enthusiastic about this art as any collectors or art historians. Some pursue scholarly endeavors related to the field. Becoming familiar with galleries, dealers, and the artists they represent is an important way to learn about the art. Buying

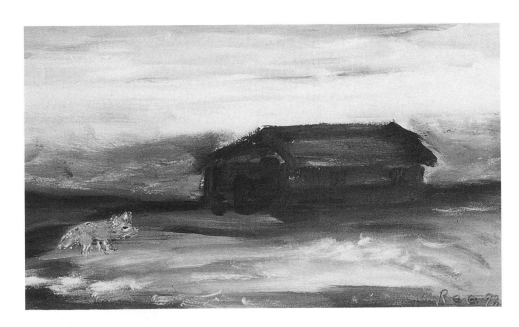

from a gallery may lessen the unfortunate impact of too many people approaching individual artists. The greatest service that respected galleries offer is quick access to art chosen by an experienced and educated eye.

Galleries are listed alphabetically, first by state, then by city within state, and finally by the gallery name.

Alabama

ANTON HAARDT GALLERY

1220 South Hull Street
Montgomery, AL 36104
(205) 263-5494

Anton Haardt

Payment Method:
Cash Check

DESCRIPTION

This gallery specializes in nationally known and some lesser known untrained Southern artists. Located at the epicenter of these folk art creations, the gallery offers reasonably priced quality art straight from the source. The small but well stocked studio/gallery is operated by Anton Haardt, an artist herself and a collector of folk art for twenty years. Ms. Haardt began collecting folk art in the late 1960s. Her studio/gallery houses her collections, as well as art for sale. The gallery has for sale a number of early Mose Tolliver works, some dated as early as 1970. She has on display her entire collection of Juanita Rogers' mud sculptures (which are not for sale); these are interesting to see because most people know Rogers for her drawings. In addition there are on display the only the remaining works of Montgomery artist Boosie Jackson who worked in the 1950s. Anton Haardt photographed Jackson's huge and fantastical environment before it was destroyed. She hand pulled the prints and made a silk screen in a limited edition. A few of these are left for sale. The gallery is open by appointment only.

ARTISTS

David Butler
Thornton Dial
Sam Doyle
Minnie Evans
Rev. Howard Finster
Sybil Gibson
Lonnie Holley
Clementine Hunter

Calvin Livingston
Charlie Lucas
R.A. Miller
Benjamin F. Perkins
Royal Robertson
Juanita Rogers
Mary T. Smith
Henry Speller

Jimmy Lee Sudduth
James "Son" Thomas
Annie Tolliver
Mose Tolliver
Inez Nathaniel Walker
Fred Webster
"Artist Chuckie" Williams
Ben Williams

COTTON BELT GALLERY

225 South Decatur Street
Montgomery, AL 36104
(205) 834-5544

Micki Beth Stiller

Payment Method:
Cash Check
Payment plan available

DESCRIPTION

The Cotton Belt Gallery focuses on the works of Alabama self-taught, folk, and outsider artists, including paintings, sculpture, and face jugs. The gallery is an extension of the private collecting interest of its owner, Micki Beth Stiller. "Alabama seems to have more talented folk artists than any other state," says Ms. Stiller, "perhaps a reflection of the heat combined with the great emphasis on religion, especially in the rural South." In addition to the art works of Alabama artists, several memory painters, Southern "wimmin" artists, and "whimsical" artists are also showcased. Cotton Belt is located in a circa-1870 Italianate cottage, which also houses Micki Beth Stiller's law practice.

ARTISTS

Sainte-James Boudrôt
Buzz Busby
Thornton Dial
Rev. Howard Finster

Sybil Gibson
Lonnie Holley
Clementine Hunter
James Harold Jennings

M.C. "5¢" Jones
Charlie Lucas
Ruth Mae McCrane
R.A. Miller

COTTON BELT GALLERY *Continued*

Reginald Mitchell
Benjamin F. Perkins
Virgil Perry
Juanita Rogers
Bernice Sims

Herbert Singleton
Mary T. Smith
Jimmy Lee Sudduth
Sarah Mary Taylor
Annie Tolliver

Mose Tolliver
Bill Traylor
Fred Webster

MARCIA WEBER/ ART OBJECTS, INC.
3218 Lexington Road
Montgomery, AL 36106
(205) 262-5349

Marcia Weber

Payment Method:
Cash Check
Payment plan available

ARTISTS
Chuck Crosby
Rev. Howard Finster
Sybil Gibson
Lonnie Holley
Clementine Hunter
James Harold Jennings
M.C. "5¢" Jones
Calvin Livingston

Woodie Long
Annie Lucas
Charlie Lucas
Benjamin F. Perkins
Sarah Rakes
Juanita Rogers
Bernice Sims
Jimmy Lee Sudduth

Annie Tolliver
Charles Tolliver
Mose Tolliver
Bill Traylor
Derek Webster
Myrtice West
"Artist Chuckie" Williams

DESCRIPTION
Marcia Weber is a private dealer who sells art by appointment or through photographs sent upon request. She also provides tours and curatorial assistance for private collectors and galleries. She has an exhibition space, open by appointment, with ongoing exhibitions. She says, "my business supports primary field research to preserve and document facts about outsider/folk artists, such as searching for the living family members and descendents of Bill Traylor."

ROBERT CARGO FOLK ART GALLERY
2314 Sixth Street (downtown)
Tuscaloosa, AL 35401
(205) 758-8884

Robert Cargo

Payment Method:
Cash Check
Payment plan available

ARTISTS
Garland Adkins
Minnie Adkins
Leroy Almon, Sr.
Z.B. Armstrong

Linvel Barker
Jerry Brown
Richard Burnside
Raymond Coins

Calvin Cooper
William Dawson
Roy Ferdinand, Jr.
Sybil Gibson

DESCRIPTION
At the time that it opened in December 1984, the Robert Cargo Folk Art Gallery was the only such gallery in Alabama. The gallery specializes in contemporary American folk art. In addition to the works of specific artists listed below, including some early work by Mose Tolliver and Jimmy Lee Sudduth, the gallery carries an extensive stock of antique quilts, including museum-quality pieces. The contemporary quilt designer Yvonne Wells is represented by this gallery. Mr. Cargo has a large collection of the works of Albert Freeman which, though not for sale, may be seen by visitors by appointment. The visitor will also find a large, carefully selected group of contemporary African-American quilts and Haitian voodoo flags. Plain-style nineteenth century Alabama furniture is also featured.

John Gilley	R.A. Miller	Herbert Singleton
Larry Gilley	Emma Lee Moss	Mary T. Smith
Ralph Griffin	Mark Anthony Mulligan	Robert E. Smith
Joseph Hardin	Benjamin F. Perkins	Georgia Speller
Rev. Herman Hayes	Virgil Perry	Henry Speller
Lonnie Holley	Tim Reed	Jimmy Lee Sudduth
Rev. John Hunter	Roger Rice	Sarah Mary Taylor
M.C. "5¢" Jones	Euple Riley	James "Son" Thomas
S.L. Jones	Titus Riley	Annie Tolliver
Junior Lewis	Royal Robertson	Mose Tolliver
Charlie Lucas	Juanita Rogers	Inez Nathaniel Walker
Sam Martin	Sulton Rogers	Derek Webster
Tim Martin	Jack Savitsky	Fred Webster
Willie Massey	Inez Shell	"Artist Chuckie" Williams
Thomas May	Bernice Sims	Jeff Williams

Arizona

JOHN C. HILL GALLERY
6990 East Main Street
Scottsdale, AZ 85251
(602) 946-2910

John C. Hill

Payment Method:
Cash Check
Payment plan available

DESCRIPTION
A well-lit gallery located upstairs on Main Street in Scottsdale, John C. Hill sells fine examples of antique Southwest Indian art including early kachinas, blankets and rugs, pueblo pottery, baskets, and old pawn jewelry. The gallery also carries American folk art such as fish decoys, quilts, and weathervanes, plus the folk art of the three twentieth century artists listed below. One of them, Morris Messenger, still creates his art work in Phoenix.

ARTISTS
Felipe Archuleta	Charlie Willeto
Morris Messenger	

IMPRESSIONS II GALLERY
2990 North Swan, Suite 147
Tucson, AZ 85712
(602) 323-3320

Cynthia Frush
Kurt Tallis

Payment Method:
Cash Check
MC Visa
Payment plan available

DESCRIPTION
Located in the Palomino Plaza, a Spanish colonial style small shopping area, this gallery has paintings, sculpture, original graphics, ceramics, and some contemporary American folk art.

ARTISTS
William Holzman	Juan Pond

California

THE AMES GALLERY
2661 Cedar Street
Berkeley, CA 94708
(510) 845-4949

Bonnie Grossman

Payment Method:
Cash Check
Payment plan available

ARTISTS
David Allen
Eddie Arning
Georgia Blizzard
Bob Carter
Raymond Coins
Jim Colclough
Abraham Lincoln Criss
William Dawson
Alberto (Abraham) Eidelman
Roy Ferdinand, Jr.
Robert Gilkerson
Homer Green
Esther Hamerman
Rev. Herman Hayes
Chester Hewell
Matthew Hewell
Sol Holzman
Rev. John Hunter

James Harold Jennings
M.C. "5¢" Jones
Tella Kitchen
Harold Kuettner
Harry Lieberman
Dwight Mackintosh
Alex A. Maldonado
David Marshall
Clyde Maurey
Meaders family
R.A. Miller
Ike Morgan
John Newmarker
Bennett Newsom
Howard Ortman
Warren Pierce
Dow Pugh
Achilles G. Rizzoli

Marie Rogers
Anthony Joseph Salvatore
Theodore Santoro
E.A. "Frog" Smith
Isaac Smith
Mary T. Smith
Georgia Speller
Henry Speller
Jimmy Lee Sudduth
Sarah Mary Taylor
Mose Tolliver
Donald Walker
Inez Nathaniel Walker
Tom Wilburn
"Chief" Willey
George Williams
Joseph Yoakum

and occasionally, Nellie Mae Rowe, Sister Gertrude Morgan, Russell Childers, and Elijah Pierce.

DESCRIPTION
This gallery specializes in nineteenth and twentieth century handmade objects and has an extensive selection of quilts, carved canes, tramp art, face jugs, and naive, visionary, and outsider paintings and sculpture. The gallery is in a big wonderful house in the Berkeley hills. Bonnie Grossman is most helpful and informative, and quite willing to talk about her artists and their art. A newsletter is published twice a year (see "Publications"). The gallery celebrated its twentieth anniversary in 1990. A visit to this gallery adds to the pleasure of collecting folk art.

FIRST STREET GALLERY/ ART CENTER
250 West First Street, Suite 100
Claremont, CA 91711
(714) 626-5455

Rebecca Hamm

Payment Method:
Cash Check

ARTISTS
Anthony Barnes
James Cadiz
Tom Carrion

James Collins
Laura De Cuir
Jose Del Rio

Frito Dominguez
Linda Ford
Pauline Fredrick

DESCRIPTION
The First Street Gallery and Art Center, a program operated by the Tierra del Sol Foundation, provides art instruction and exhibition opportunities for adults with developmental disabilities. At First Street, artists produce paintings, drawings, ceramic sculpture, and fine art prints in a studio environment. The gallery presents six exhibitions per year and promotes sales, and 70 percent of the proceeds go to the artists. Among the artists regularly available are those listed below.

Leon Fuller	Michael LeVell	Cindy Rodriguez
Marie Greenwell	Krista Mathews	Salvador Saspa
James Grisey	Steven Moore	David Seinfeld
Allison Hartfield	Beatrice Negrete	William Skipper
Cecilia Hernandez	Marilyn Neville	Mary Rose Tellez
Fay E. Johnson	Hector Oviedo	Elizabeth Tuck
Dan Keller	Helen Rae	Garry Williams

EVERETT DAVIS GALLERY

Neighborhood Center of
 the Arts
714 West Main Street, Suite A
Grass Valley, CA 95945
(916) 272-7287

Cheri Flanigan

Payment Method:
Cash Check
Payment plan available

DESCRIPTION

The Everett Davis Gallery is an inhouse gallery of the Neighborhood Center of the Arts (NCA), where the art works of people with developmental delays are exhibited and marketed. The gallery manager is on the Board of the Center; volunteers frame, prepare, and install exhibitions. Bimonthly exhibitions focus attention on the art work and generate sales. Commissions are an increasingly important source of student income. In 1989 a fifty-foot ceramic mural painted by NCA students was installed at a local swimming pool, and in 1990 Center artist Spencer McClay was awarded an Art-in-Public-Places commission. Students price their work, keeping 60 percent of the final price.

ARTISTS

Spencer McClay	Larry Mills

Other students of the Neighborhood Center of the Arts

DOUBLE K GALLERY

318 La Cienega Boulevard
Los Angeles, CA 90048
(310) 652-5990

Kim Kralj

Payment Method:
Cash Check
Payment plan available

DESCRIPTION

Kim Kralj is a graduate of the Claremont Colleges, receiving a degree in Film and Fine Art in 1984. She became interested in folk art while working for Larry Whiteley as his art assistant. Kralj took over the gallery from the late Mr. Whiteley in 1987. The Double K Gallery features one-of-a-kind objects often created anonymously, as "labors of love" for sweethearts and family members. The gallery also has artifacts from important American folk art environments, such as Calvin and Ruby Black's "Possum Trot" and Sanford Darling's "House of a Thousand Paintings." You will also find traditional works such as whirligigs, weathervanes, tramp art, and quilts at the Double K. The gallery represents several "outsider" artists who tend to be less well-known people. The focus of the collection, according to Kralj, is on the beauty of the work, and not so much on the artist's renown.

ARTISTS

Calvin and Ruby Black	"Bad" Ray Komer
Edward Patrick Byrne	Isaac Irwin Rabinov
Sanford Darling	Robert E. Smith
Ben Harris	

LA LUZ DE JESUS GALLERY
7400 Melrose Avenue
Los Angeles, CA 90046
(213) 651-4875

Robert Lopez

Payment Method:
Cash Check
MC Visa AE

DESCRIPTION
According to a self-description this shop has "curious Mexican art and ethnic artifacts from around the world." This is an "art environment" in and of itself, rather like Little Rickey's in New York City. When visited in the autumn of 1990, the gallery devoted a whole shelf to recent Finster works, mostly at reasonable prices, as well as some very expensive pieces. Also the bottle cap and wood constructions of Jon Bok were on display. There is a good selection of books on folk art for sale, plus advertising art from many countries.

ARTISTS
Jon Bok Rev. Howard Finster

NEW STONE AGE
8407 West Third Street
Los Angeles, CA 90048
(213) 658-5969

Susan Skinner
Fran Ayres

Payment Method:
Cash Check
MC Visa
Payment plan available

DESCRIPTION
This spacious and attractive shop for contemporary jewelry, ceramics, glass, furniture, and folk art was established in May 1984. There are more fine crafts than folk art, but the art that is there is carefully chosen and looks well in a contemporary setting.

ARTISTS
R.A. Miller Benjamin F. Perkins
Marie Nelson

CREATIVE GROWTH GALLERY
355 24th Street
Oakland, CA 94612
(510) 836-2340,
FAX (510) 836-2349

Irene Ward Brydon
Bonnie Haight

Payment Method:
Cash Check
MC Visa
Payment plan available

DESCRIPTION
This gallery, part of the Creative Growth Art Center, exhibits the work of disabled artists, most of whom participate in the Creative Growth art studio program. The works of these artists are imaginative, expressive, and quite distinctive. There are unforgettable art works to see and to buy. Some of the artists also create designs for the rug tapestries. The gallery has a regular schedule of ten exhibitions a year and also exhibits in corporate and community spaces. Sales and rentals provide earned income for these "outsider" artists. Quite reasonably priced, the art works are sought by many local collectors and others, who have happily discovered the place. Bonnie Haight, the gallery manager, is very helpful and will tell you about the artists and their work.

ARTISTS
Regina Broussard Donald Paterson
Camille Holvoet Larry Randolph
Dwight Mackintosh William Tyler

GALLERIA SCOLA

3646 Grand Avenue
Oakland, CA 94610
(510) 451-3525

Elida Scola

Payment Method:
Cash Check
MC Visa
Payment plan available

ARTISTS

John Abduljaami
Garland Adkins
Minnie Adkins
David Alvarez
Louise Alvarez
Leroy Archuleta
Ernest "Dude" Baker
Lillian Barker
Linvel Barker
Craig Black
Marion Connor
Calvin Cooper

Ronald Cooper
Lorraine Gendron
Larry Gilley
Denzil Goodpaster
Margaret Granatt
Mike Granatt
Joe Hernandez
James Harold Jennings
Joan Julene Jones
Charles Keeton
May Kugler
Sherman Lambdin

Jim Lewis
Junior Lewis
Miller & Bryant
R.A. Miller
Lonnie Money
Joe Ortega
Russell Rice
Mike Rodriguez
Ron Rodriguez
Earl Simmons
Jimmy Lee Sudduth
Mose Tolliver

DESCRIPTION

Galleria Scola is a large, well-arranged contemporary gallery space in a frame shop. Elida Scola carefully selects the work of self-taught artists during her travels around the United States, and from her home town of Oakland. The emphasis is on New Mexico, Louisiana, Kentucky, and other points South, with some California objects too. There are a few paintings, but the gallery owner prefers three-dimensional works.

NATIONAL INSTITUTE OF ART AND DISABILITIES GALLERY

551 23rd Street
Richmond, CA 94804
(510) 620-0290

Suzanne Lacke

Payment Method:
Cash Check
MC Visa

DESCRIPTION

This gallery is a 1,000-square-foot space adjacent to the art studio of the National Institute of Art and Disabilities. It hosts seven exhibits per year, which include both the artists of NIAD and prominent mainstream artists. The unique, intuitive art work created by the NIAD artists falls into the category of "outsider art." Some real gems may be found among their work, which is full of energy, immediacy, and vibrant color. The work is very reasonably priced and the money from its sale benefits the artists as well as the Institute. When visitors come to the gift shop or the gallery they are welcome to visit the studio as well. Suzanne Lacke, the curator of the NIAD Gallery, is happy to give tours and show the work of NIAD's artists. Slides of the work are also available upon request.

ARTISTS

Lois Barnett
James Boutell
Sandra Connor
Sylvia Fragoso
Samuel Gant
Juliet Holmes
Yvonne Hudson

Tony Laspina
Marlon Mullen
Rosita Pardo
Audrey Pickering
Kevin Randolph
Wendell Singleton
Helen Stewart

ONEIROS GALLERY
711 Eighth Avenue, Studio A
San Diego, CA 92101
(619) 696-0882

Bill Beck
Kathleen Benton

Payment Method:
Cash Check
Payment plan available

DESCRIPTION
The Oneiros Gallery carries contemporary, outsider, surrealist, and tribal art. It is open by appointment only.

ARTISTS
Louis Monza Jon Serl
Duane Schnabel

BRAUNSTEIN-QUAY
250 Sutter Street
San Francisco, CA 94108
(415) 392-5532

Ruth Braunstein

Payment Method:
Cash Check
Payment plan available

DESCRIPTION
Founded in 1961 by Ruth Braunstein in Tiburon, California, the Braunstein/Quay Gallery is now located very near the fashionable Union Square area of San Francisco in a large, light, state-of-the-art space. The focus of the gallery is on contemporary fine art. Shows change monthly and showcase the talent of the gallery's stable of about twenty-five artists, including several self-taught artists. In addition, the "Access Program," which runs concurrently with the main shows, features the work of emerging artistic talent.

ARTISTS
Calvin and Ruby Black Ted Gordon
Bruce Burris

CREATIVITY EXPLORED OF SAN FRANCISCO
3245 16th Street
San Francisco, CA 94103
(415) 863-2108

Ray Pattan

Payment Method:
Cash Check

DESCRIPTION
Creativity Explored is a fulltime art center for disabled adults. It has storefront windows that display some art, but no formal gallery. Exhibitions are held outside of the center at various locations throughout the San Francisco area, as well as in New York, Denver, and Mexico. The studio is open to the general public any time during usual working hours, so that people may observe the artists at work. If people are interested in viewing the work of specific artists, however, they should call ahead and make an appointment.

ARTISTS
"We have 81 students/artists enrolled in our program, covering a wide range of visual art including ceramics, paintings, monoprints, on-site installations, photography, fabric designs, and murals."

CREATIVITY UNLIMITED OF SAN JOSE
1403 Parkmoor Avenue
San Jose, CA 95126
(408) 288-8189

DESCRIPTION
The Creativity Unlimited Gallery is open weekdays, and is part of the parent organization art center of the same name. Curator Staci Gonzales presents new art work every seven weeks. Exhibits circulate through nine additional sites after showing in the Creativity Unlimited Gallery.

Staci Gonzales

Payment Method:
Cash Check

ARTISTS
Student artists of Creativity Unlimited

CASKEY-LEES
PO Box 1637
Topanga, CA 90290
(310) 455-2886

Bill Caskey
Liz Lees

Payment Method:
Cash Check

DESCRIPTION
Bill Caskey and Liz Lees manage the San Francisco Folk and Tribal Arts Show in the spring and the annual Los Angeles Tribal and Folk Art Show in Santa Monica in the fall. They also exhibit at these events and will sell items from their collection at home. At a recent visit works were on display by the artists listed below. There were also some good examples of tramp art and figures and signs from the Possum Trot site of Calvin and Ruby Black. Especially pleasing to look at was a tree full of wooden airplanes by Luis Moya, Jr., made to entertain the children in his Albuquerque neighborhood. Caskey and Lees are very helpful about their own collection and about other sources in the Los Angeles area. Open by appointment only.

ARTISTS

Felipe Archuleta	George Lopez
Leroy Archuleta	Carl McKenzie
Marie Romero Cash	Louis Monza
Rev. Howard Finster	Mose Tolliver
Eugenia Lopez	

MAIN STREET USA
1325 Albert Kinney Boulevard
Venice, CA 90291
(310) 392-6676

Tauni Brustin
Steve Johnson

Payment Method:
Cash Check AE
Payment plan available

DESCRIPTION
This gallery is packed with interesting things, so much so that one must take time to look around. There are carvings and sculpture, mostly unsigned. There is tramp art, prison art, bottle cap, and match stick art. The proprietors buy each item, one by one, because of some affinity or attraction to it. There are signed pieces of prison art and some other signed creations.

ARTISTS
Louis Emil (Slingshot) Hamm Ben Harris

THE CREATIVE CENTER
GALLERY
606 North Bridge
PO Box 943
Visalia, CA 93279
(209) 733-9329

DESCRIPTION
The Creative Center in Visalia, California is a visual and performing art center for developmentally disabled adults. The Creative Center Gallery, which is on the premises, has an ongoing show of work by Creative Center artists. Work is also on display in the showroom of the Creative Center office, where cards featuring reproduc-

THE CREATIVE CENTER GALLERY *Continued*

Katharine J. Nelson

Payment Method:
Cash Check
MC Visa

tions of art work are sold. Art work in the gallery includes acrylic painting, serigraph, watercolor, drawing, sculpture, ceramics, fabric art, weaving, papermaking, photography, and primitive art. Artists receive the major portion of proceeds from sales.

ARTISTS
Artists include all students enrolled in the visual arts program.

Colorado

ASTORIA BOOKS
1420 18th Street
Denver, CO 80202
(303) 292-4122

Michael Grano

Payment Method:
Cash Check MC
Visa AE Discover
Payment plan available

DESCRIPTION
This is a bookstore in lower downtown Denver, featuring works on art, architecture, and design. Michael Grano, the owner, met carver Bill Potts selling his art at flea markets. Grano liked the carvings and started displaying and selling them in the bookstore. On a recent visit there was a generous inventory available. Grano will send photos or slides of the art to those interested.

ARTISTS
William E. Potts

BRIGITTE SCHLUGER GALLERY
929 Broadway
Denver, CO 80203
(303) 825-8555

Brigitte Schluger

Payment Method:
Cash Check
MC Visa AE
Payment plan available

DESCRIPTION
This gallery has "primitive, folk, and Eskimo art" and also exhibits contemporary fine art. If and when she finds "a wonderful piece" of traditional folk art, the owner will exhibit it with the others. Established in 1975, this is one of four galleries, each with a different focus, that are referred to locally as "the Broadway Central Galleries." These galleries have openings together and have attracted a lot of interest from people in Denver. Brigitte Schluger presents eight exhibitions each year. She is enthusiastic about folk art and welcomes all to her gallery. It is hard to tear oneself away from this pleasant space and informative person.

ARTISTS

David Alvarez	Patrick Davis	Benjamin F. Perkins
Leroy Archuleta	Mamie Deschillie	Billy Rodriguez
Freddy Avila	"Uncle Pete" Drgac	Mike Rodriguez
Dewey Blocksma	Rev. John Hunter	Sulton Rogers
Loy "Rhinestone Cowboy" Bowlin	Woodie Long	Martin Saldaña
	Thomas May	Mary T. Smith
David Butler	Joe McAlister	Jimmy Lee Sudduth
Ned Cartledge	Columbus McGriff	Mose Tolliver
"Jimbo" Davila	Ike Morgan	

Connecticut

PRINCE ART CONSULTANTS
367 West Hill Road
Stamford, CT 06902
(203) 357-7723

Dan Prince

Payment Method:
Cash Check

DESCRIPTION
To an institutional, corporate and private clientele, Dan Prince offers services that include direct dealing and sales; collection evaluations and appraisals; writing for public relations, catalog, and curatorial works; and representation of artists.

ARTISTS
Larry Armistead
Aaron Birnbaum
George Cotrona
Karolina Danek
Virgil "Spot" Daniels
Homer Green
John Jordan

Andy Kane
Ray Librizzi
Jacob Nemoitin
Bernard Schatz (L-15)
Robert E. Smith
Lillian Webb

District of Columbia

ANTON GALLERY
2108 R Street, N.W.
Washington, DC 20008
(202) 328-0828

Gail Enns

Payment Method:
Cash Check Visa
Payment plan available

DESCRIPTION
This gallery uses two floors of a period-piece building in the Dupont Circle area of Washington, D.C. Basically a contemporary fine art gallery, the owner has an annual folk/outsider art exhibition that focuses on "the naive, undiscovered artist." Anton scheduled "the first show of Howard Finster's work in the DC area."

ARTISTS
Garland Adkins
Minnie Adkins
Linvel Barker
Minnie Black
Bruce Burris
Andrew Collett
Sam Doyle
Rev. Howard Finster
Denzil Goodpaster

T.A. Hay
Charley Kinney
Noah Kinney
Edd Lambdin
Tim Lewis
Willie Massey
Larry McKee
Carl McKenzie
Earnest Patton

SOUTHERN FOLK AND OUTSIDER ART
PO Box 15417
Washington, DC 20003
(202) 543-0273

Ginger Young

Payment Method:
Cash Check

DESCRIPTION
Ginger Young is a dealer and private collector who travels frequently to her home in Georgia and often picks up folk and outsider art along the way. The art she has for sale may be seen by appointment only. In addition to the artists listed below, Ms. Young has a selection of quilts and walking sticks from various artists.

SOUTHERN FOLK AND OUTSIDER ART *Continued*

ARTISTS

Leroy Almon, Sr.	Harold Garrison	R.A. Miller
Linda Anderson	W.J. Gordy	Valton Murray
Robyn Beverland	Chester Hewell	Grover Nix
Georgia Blizzard	Lonnie Holley	Mattie Lou O'Kelley
Tubby Brown	Charlie and Betty Hopkins	Benjamin F. Perkins
Richard Burnside	Harvey Hull	Virgil Perry
Ned Cartledge	James Harold Jennings	Frank Pickle
Raymond Coins	Jim Lewis	Marie Rogers
Jerry Coker	Calvin Livingston	Sulton Rogers
Melvin Crocker	Woodie Long	Bernice Sims
Michael Crocker	Jim Marbutt	Oscar Spencer
Rev. Howard Finster	A.G. Meaders	Jimmy Lee Sudduth
Buddy Fisher	John Meaders	Mose Tolliver
Jack Floyd		

TARTT GALLERY

2017 Q Street, N.W.
Washington, DC 20009
(202) 332-5652

Jo Tartt, Jr.

Payment Method:
Cash Check
Payment plan available

DESCRIPTION

The Tartt Gallery specializes in fine nineteenth and twentieth century photography, painting, and sculpture by regional artists and contemporary American outsider artists. The gallery maintains an inventory of outsider art that includes the work of over twenty artists and numbers about 300 pieces.

ARTISTS

Leroy Almon, Sr.	Ralph Griffin	"Butch" Quinn
Z.B. Armstrong	Joseph Hardin	Mary T. Smith
Baltimore Glassman	Lonnie Holley	Henry Speller
Gene Beecher	James Harold Jennings	John Stoss
Rick Blaisman	O.W. "Pappy" Kitchens	Jimmy Lee Sudduth
Georgia Blizzard	Justin McCarthy	James "Son" Thomas
Alexander Bogardy	Jake McCord	Mose Tolliver
Richard Burnside	Eric Calvin McDonald	Fred Webster
Raymond Coins	R.A. Miller	Frederick West
Rev. Howard Finster	Ronald Musgrove	
Caroline Goe	Benjamin F. Perkins	

VERY SPECIAL ARTS GALLERY

1331 F Street, N.W.
Washington, DC 20004
(202) 628-0800, (800) 933-8721

Denise Warner

DESCRIPTION

The Very Special Arts Gallery, as one of the first nonprofit, fully mainstreamed art galleries in the United States, represents emerging and recognized artists with an emphasis on works by artists with disabilities. The gallery carries both trained and self-taught artists. Services include custom picture framing. The gallery space is also available for private receptions and special occasions.

VERY SPECIAL ARTS GALLERY *Continued*

Payment Method:
Cash Check
MC Visa
Payment plan available

ARTISTS

David Alvarez
Robyn Beverland
Nancy Binns
Calvin Cooper
Jessie Cooper
Ronald Cooper
Gary Hargis
Dwayne Hewson
Junior Lewis

Leroy Lewis
Charlie Lucas
Valton Murray
Betty Cole Pinette
Tim Ratliff
Russell Rice
Mike Rodriguez
Mose Tolliver
Knox Wilkinson, Jr.

Florida

ART INSIDE
1320 South Atlantic Avenue
Cocoa Beach, FL 32931
(407) 783-0920

Brian Dowdall

Payment Method:
Cash Check

DESCRIPTION
Gallery owner and self-taught artist Brian Dowdall describes his space as "an old house, the kind of house that was built here for the Air Force. There are paintings covering the walls, and sticks leaning on the floor."

ARTISTS

Jesse Aaron
Robyn Beverland
David Butler
Rev. Howard Finster
Sybil Gibson
Woodie Long
Christian Martin
Ruth Mattie

R.A. Miller
Ike Morgan
Royal Robertson
Mary T. Smith
Jimmy Lee Sudduth
Annie Tolliver
Mose Tolliver

EAST MARTELLO ART GALLERY & MUSEUM
3501 South Roosevelt Boulevard
Key West, FL 33040
(305) 296-3913

Payment Method:
Cash Check

DESCRIPTION
The gallery is part of the museum (see reference under "Museums"), and both are housed in a historical Civil War fort. A collector friend has said that, all glorious scenery aside, Sanchez' work alone is worth a trip to Key West. Much of the work is part of the permanent collection; some of the pieces are for sale.

ARTISTS
Mario Sanchez

LUCKY STREET GALLERY
919 Duval Street
Key West, FL 33040
(305) 294-3973

Dianne Zolotow

DESCRIPTION
This gallery is in an old store front with big windows. It is very light and airy, making it easy to see the art on display. The gallery carries contemporary crafts as well as contemporary folk art. The staff is pleasant, and visitors are encouraged to ask for help if they want to know about contemporary folk and outsider art.

LUCKY STREET GALLERY *Continued*

Payment Method:
Cash Check
MC Visa AE

ARTISTS

Leroy Almon, Sr.
Priscilla Cassidy
Rev. Howard Finster
Homer Green
Bessie Harvey
James Harold Jennings
Woodie Long
Jake McCord
R.A. Miller

Helen LaFrance Orr
Benjamin F. Perkins
Mary T. Smith
Vannoy Streeter
Jimmy Lee Sudduth
James "Son" Thomas
Annie Tolliver
Mose Tolliver
Lena Zarate

VANITY NOVELTY GARDEN
918 Lincoln Road
Miami Beach, FL 33139
(305) 534-6115

Tamara Hendershot

Payment Method:
Cash Check
Payment plan available

ARTISTS

Joseph Abrams
Leroy Almon, Sr.
Z.B. Armstrong
Brian Dowdall
Rev. Howard Finster
Homer Green

Ralph Griffin
Alyne Harris
Eric Holmes
Johnnie Rae Jackson
Charlie Lucas
R.A. Miller

Benjamin F. Perkins
Jimmy Lee Sudduth
Annie Tolliver
Mose Tolliver
Fred Webster

DESCRIPTION
To quote from a Florida newspaper, "this folk art gallery is a mercurial menagerie of work by over two dozen artists, including some of folk art's best and most famous." Among other things you may find here are the oddly attired mermaid dolls made by Bec Poole of Maine, stuffed fish (both paper and real), wood and tin whirligigs, and the really wonderful-to-look-at braided rugs by Willie Eaglin. Eaglin is 83, blind, and works all day braiding his rugs and then wrapping them, without a frame, into his own shapes. The owner also collects old signage and "odd objects" from rural parts of Florida.

TYSON'S TRADING COMPANY
PO Box 369
Micanopy, FL 32667
(904) 466-3410

Jean Tyson
Ty Tyson

Payment Method:
Cash Check

DESCRIPTION
Tyson's Trading Company is "a source for knowledgeable dealers, collectors, and museums." The Tysons are available to help in the buying and selling of eighteenth, nineteenth, and twentieth century furniture and accessories, books, paintings, oriental rugs, folk art, Amish and African-American quilts, and American Indian and tribal arts. Open by appointment only.

ARTISTS

Jesse Aaron
Jerry Coker
Brian Dowdall
Rodney Hardee
Alyne Harris

Carolyn Mae Lassiter
Ed "Mr. Eddy" Mumma
Edward Ott
Mose Tolliver

BUD'S MENS SHOP

1866 North Tamiami Trail
North Fort Myers, FL 33903
(813) 997-4484

Payment Method:
Cash Check

DESCRIPTION

Located in a small Florida-style mall on "Old 41" —Weavers Corner Shopping Center—Bud's is a clothing store (!) with Frog Smith paintings on all the walls around the room. The proprietors are great supporters of this ninety-year-old Florida pioneer self-taught artist.

ARTISTS

E.A. "Frog" Smith

Georgia

BERMAN GALLERY

1131 Euclid Avenue, N.E.
Atlanta, GA 30307
(404) 525-2529

Rick Berman
Jennifer Berman

Payment Method:
Cash Check
Payment plan available

DESCRIPTION

The Berman Gallery was established in August 1981, and deals in "Southern untrained masters" and contemporary American ceramics. They have a large selection of early Howard Finster material available. Also, there is very fine quality and depth in the works of Mose Tolliver, Mary T. Smith, and Jimmy Lee Sudduth. The Bermans are very helpful and know many of the artists personally.

ARTISTS

Raymond Coins
Thornton Dial, Sr.
Minnie Evans
Rev. Howard Finster
William Hawkins
James Harold Jennings
Charley Kinney
Columbus McGriff
Lanier Meaders

R.A. Miller
J.B. Murry
Royal Robertson
Mary T. Smith
Henry Speller
Jimmy Lee Sudduth
James "Son" Thomas
Mose Tolliver
Inez Nathaniel Walker

CONNELL GALLERY/ GREAT AMERICAN GALLERY

333 Buckhead Avenue
Atlanta, GA 30305
(404) 261-1712

Martha Connell

Payment Method:
Cash Check

DESCRIPTION

This gallery features contemporary American crafts, not folk art. However, at this time the gallery is the agent for the Columbus (Georgia) Museum to sell selected art works from Pasaquan, the art environment created by the late St. EOM. The sale of this work is for the purpose of raising money to restore and preserve the Pasaquan art environment.

ARTISTS

St. EOM, Creator of the Land of Pasaquan

FAY GOLD GALLERY

247 Buckhead Avenue
Atlanta, GA 30305
(404) 233-3843

DESCRIPTION

The Fay Gold Gallery has a strong commitment to self-taught outsider artists, particularly of the Southeast. In addition, the gallery exhibits contemporary painting, photography, glass, and ceramics that have an indebtedness to the primitive self-taught visionary artists.

FAY GOLD GALLERY *Continued*

Payment Method:
Cash Check
MC Visa AE
Payment plan available

ARTISTS

Z.B. Armstrong Rev. Howard Finster
Thornton Dial R.A. Miller
Sam Doyle Mose Tolliver

JAMES ALLEN
2575 Peachtree Road, N.E. #26H
Atlanta, GA 30305
(404) 231-3417

James Allen

Payment Method:
Cash Check

DESCRIPTION

Mr. Allen describes himself as a "picker and dealer" in nineteenth and twentieth century regional African-American furniture and decorative art. He is listed here because he is a source for Ulysses Davis. Open by appointment only.

ARTISTS

Ulysses Davis

KNOKE GALLERIES OF ATLANTA
5325 Roswell Road, N.E.
Atlanta, GA 30342
(404) 252-0485

Dave Knoke

Payment Method:
Cash Check
Payment plan available

DESCRIPTION

This gallery was established in 1973, and specializes in nineteenth and twentieth century American art. Two years ago contemporary self-taught artists were added to the gallery, with a unique space for this part of the collection.

ARTISTS

Garland Adkins
Minnie Adkins
Leroy Almon, Sr.
Robyn Beverland
Tubby Brown
Richard Burnside
Archie Byron
Ned Cartledge
Raymond Coins
Jessie Cooper
Ronald Cooper
Rev. Howard Finster
Michael Finster
Jack Floyd
Sybil Gibson
Regine Gilbert
Russell Gillespie
Homer Green
Mary Greene

Ralph Griffin
Bessie Harvey
Lonnie Holley
Walter Tiree Hudson
Clementine Hunter
James Harold Jennings
Charley Kinney
Joe Light
Willie Long
Woodie Massey
Jake McCord
Carl McKenzie
Sam McMillan
Janet Munro
Mattie Lou O'Kelley
Benjamin F. Perkins
Daniel Pressley
Robert Roberg
Royal Robertson

Juanita Rogers
Nellie Mae Rowe
St. EOM
O.L. Samuels
Herbert Singleton
Mary T. Smith
Robert E. Smith
Q.J. Stephenson
Jimmy Lee Sudduth
Willie Tarver
James "Son" Thomas
Annie Tolliver
Mose Tolliver
Herbert Walters
Derek Webster
Fred Webster
Willie White
Allen Wilson

MODERN PRIMITIVE

1402 North Highland Avenue
Atlanta, GA 30306
(404) 892-0556

Mark Karelson
Kim Karelson
Clayton King

Payment Method:
Cash Check
MC Visa AE
Payment plan available

ARTISTS

Minnie Adkins
Leroy Almon, Sr.
Terry Braxton
Richard Burnside
Bruce Burris
Archie Byron
Rev. Howard Finster
Sybil Gibson
Alyne Harris
Constance Hawkins
Chester Hewell
Lonnie Holley

James Harold Jennings
S.L. Jones
Roland Knox
Carolyn Mae Lassiter
Charlie Lucas
Jake McCord
Columbus McGriff
Cleater Meaders
Edwin Meaders
R.A. Miller
Valton Murray
Grover Nix

Benjamin F. Perkins
O.L. Samuels
Lorenzo Scott
Jimmy Lee Sudduth
Mose Tolliver
Terry Turrell
Fred Webster
Knox Wilkinson, Jr.
Purvis Young
Malcah Zeldis

DESCRIPTION

The Modern Primitive gallery is one large room with 2,400 square feet for exhibits. The focus is on self-taught and visionary art, primarily from Southern states. The proprietors are very approachable and helpful and are enthusiasts about the art and artists. This gallery is a pleasure to visit.

ROBERT REEVES ART & ANTIQUES

1656 Executive Park Lane
Atlanta, GA 30329
(404) 634-9791

Robert Reeves

Payment Method:
Cash Check
Payment plan available
Other: Trade

ARTISTS

Jesse Aaron
Linvel Barker
Herman Bridgers
David Butler
Raymond Coins
Sam Doyle
Rev. Howard Finster
Joe Light

Gerd Lony
Columbus McGriff
J.B. Murry
Sulton Rogers
Nellie Mae Rowe
O.L. Samuels
Mary T. Smith
Henry Speller

Jimmy Lee Sudduth
Sarah Mary Taylor
Mose Tolliver
Derek Webster
Fred Webster
"Artist Chuckie" Williams

DESCRIPTION

Robert Reeves specializes in exceptional examples of antique and contemporary art by self-taught American artists. Both anonymous and well-known artists are represented. Mr. Reeves has a particular interest in African-American objects of aesthetic merit, including paintings, textiles, sculpture, and furniture. He has carefully selected material in all price ranges for beginning and advanced collectors, and is a resource for locating the hard to find. Additionally, the gallery carries Native American art and fine photography. Mr. Reeves' gallery takes up most of his home, and he is pleased to show and share his enthusiasm for this vital field of American art. Open by appointment only.

MAIN STREET GALLERY
641 Main Street
PO Box 641
Clayton, GA 30525
(706) 782-2440

Helen Meadors
Susan Belew
Jeanne Kronsnoble

Payment Method:
Cash Check
MC Visa
Payment plan available

ARTISTS
Minnie Adkins
Leroy Almon, Sr.
Betty Brown
Tubby Brown
Ned Cartledge
Jack Floyd
Russell Gillespie
Mary Greene

Ralph Griffin
Bessie Harvey
James Harold Jennings
Clyde Jones
Caroline Mae Lassiter
Junior Lewis
Woodie Long
Jake McCord

Valton Murray
Benjamin F. Perkins
Sarah Rakes
O.L. Samuels
Bernice Sims
Jimmy Lee Sudduth
Derek Webster

DESCRIPTION
Main Street Gallery is located in Clayton, Georgia, in an area of the southern Appalachian mountains noted for its scenic beauty. The town is in close proximity to Asheville and Atlanta. The primary focus of the gallery is folk art; it maintains an extensive selection from all around the United States. Main Street Gallery takes part in an annual show every August in conjunction with Timpson Creek Gallery and an artists' colony called Hambridge Center. The gallery also features contemporary crafts and a good selection of both contemporary and traditional twig furniture.

TIMPSON CREEK
Route 2, Box 2117
Clayton, GA 30525
(706) 782-5164

Cecile Thompson

Payment Method:
Cash Check
MC Visa
Payment plan available

ARTISTS
Linda Anderson
Brian Dowdall
Mary Greene
Alyne Harris
Columbus McGriff

R.A. Miller
Roy Minshew
Braxton Ponder
Barbara Pressley
Robert Roberg

David Vance
Annie Wellborn
"Indian Joe" Williams

DESCRIPTION
The rural northeast Georgia mountains provide the setting for Timpson Creek, a gallery that specializes in Southern folk art and antiques. Timpson Creek holds several shows every year, and people often will find the exhibiting artists visiting here. The "Southern Folk Expressions" show is held annually, from around the end of July into August. In the back of the building that houses the gallery is the workshop of Dwayne Thompson, a furniture maker of both skill and imagination. Cecile Thompson, the gallery's owner, says "My main focus is to introduce the work of my artist friends and sell it for them. Part of promoting them is having their work accessible to the public. That's the reason for the number of shows and artist receptions I put on."

CHARLES LOCKE

4137 Crape Myrtle Lane
Duluth, GA 30136
(404) 623-0042

Payment Method:
Cash Check

ARTISTS

Leroy Almon, Sr.
Alpha Andrews
Bill Bowers
Ned Cartledge
Rev. Howard Finster
Ralph Griffin
Lonnie Holley

James Harold Jennings
Charley Kinney
Columbus McGriff
R.A. Miller
Charles Munro
Janet Munro
Benjamin F. Perkins

Jes Snyder
Jimmy Lee Sudduth
James "Son" Thomas
Annie Tolliver
Mose Tolliver
Inez Nathaniel Walker
Annie Wellborn

DESCRIPTION

Charles Locke is a dealer specializing in twentieth century self-taught artists, with a special emphasis on Georgia artists.

JOHN DENTON

102 North Main Street
Hiawassee, GA 30546
(706) 896-4863

John Denton

Payment Method:
Cash Check

ARTISTS

Rev. Howard Finster
James Harold Jennings
Willie Massey

R.A. Miller
J.B. Murry
Royal Robertson

Nellie Mae Rowe
Mose Tolliver
Luster Willis

DESCRIPTION

Located in the majestic north Georgia mountains, the John Denton Gallery focuses on twentieth century outsider artists. It carries over 400 R.A. Miller works and over 200 individually numbered works of the Rev. Howard Finster. The Finster collection includes clock boxes from the 1960s, paintings from the late 1970s that have no number, examples from all of the numbered series, and Finster prints. For those who are not interested in folk art, the gallery also handles a wide variety of handmade knives, carries western art, and has a large print department.

C.S. SINGER/ AMERICAN FOLK AND OUTSIDER ART

3340 Harvest Way
Marietta, GA 30062
(404) 565-8263

Corey Singer

Payment Method:
UPS/COD

DESCRIPTION

"World's largest collection of early Howard Finster folk art," according to proprietor Corey Singer, including carvings, clocks, paintings with burnt wood frames. Mr. Singer is open by appointment, or he will send photographs.

ARTISTS

Rev. Howard Finster
R.A. Miller
Valton Murray
Mattie Lou O'Kelley

Benjamin F. Perkins
Jimmy Lee Sudduth
Mose Tolliver

CARROLL GREENE, JR.
16 West Oglethorpe Avenue
Savannah, GA 31401
(912) 234-3866

Carroll Greene, Jr.

Payment Method:
Cash Check
Payment plan available

DESCRIPTION
Mr. Greene is a collector of and dealer in African-American artifacts—objects made by African Americans and used by them in the traditional occupations connected with tobacco, sugar, lumber, and cotton. He has one contemporary self-taught African-American artist, listed below.

ARTISTS
Gerald Hawkes

WEATHERVANES ANTIQUE SHOPS
324 Watson Street
Thomson, GA 30824
(404) 595-1998

Tom Wells

Payment Method:
Cash Check Visa

DESCRIPTION
There are nine antique dealers at this location, open six days a week. Tom Wells specializes in nineteenth and twentieth century folk art and most particularly in Southern folk art.

ARTISTS
Z.B. Armstrong	R.A. Miller
Ralph Griffin	Jimmy Lee Sudduth
Sylvanus Hudson	Willie Tarver
Jake McCord	

Hawaii

JOHN FOWLER
Government Beach Road
Waawaa, Puna, HI 96778

Payment Method:
Cash Check
Payment plan available

DESCRIPTION
John Fowler is a dealer who handles tribal and ethnographic material of the Pacific islands, oceanic art, and primitive and naive art from around the world. American self-taught artists are listed below.

ARTISTS
Samuel Colwell Baker	Louis Monza
Charles Gibbons	Janet Munro
Herbert Kons	Judy Perry

Illinois

AMERICAN WEST
2110 N. Halsted Street
Chicago, IL 60614
(312) 871-0400

Geraldine Patla

Payment Method:
Cash Check MC
Visa AE Discover

DESCRIPTION
This gallery features fine contemporary Southwestern art including New Mexican folk art and Native-American-made jewelry.

ARTISTS
Max Alvarez	Frank Seckler
Leroy Archuleta	K.E. Smith
Ron Rodriguez	

ART MECCA

3352 North Halsted
Chicago, IL 60657
(312) 935-3255

Melanee Cooper
Julie Henderson

Payment Method:
Cash Check
MC Visa AE

DESCRIPTION

Art Mecca concentrates on contemporary American crafts, folk, and outsider art. Art Mecca is an eclectic gallery that prides itself on its extensive folk art collection. The gallery continually shows new works by nationally recognized folk and outsider artists.

ARTISTS

Dewey Blocksma	Edd Lambdin
Jon Bok	Sherman Lambdin
Ronald Cooper	Shirley Lambdin
William Dawson	Junior Lewis
Rev. Howard Finster	Carl McKenzie
T.A. Hay	R.A. Miller
James Harold Jennings	Mose Tolliver
Charley Kinney	Inez Nathaniel Walker

CARL HAMMER

200 West Superior
Chicago, IL 60610
(312) 266-8512

Carl Hammer
Jamie Kroul

Payment Method:
Cash Check
MC Visa AE

DESCRIPTION

The Carl Hammer Gallery features twentieth century American art of outstanding quality, both historical and contemporary, specializing in works by nontraditional artists. "The Carl Hammer Gallery puts unique emphasis on the factor of motivation in the creativity of art," says Mr. Hammer. "We focus on one-of-a-kind pieces which are unique statements of a particular individual, often daring expressions of their existence and individuality."

ARTISTS

Henry Darger	David Philpot
William Edmondson	Simon Sparrow
Rev. Howard Finster	Mose Tolliver
Lee Godie	Bill Traylor
S.L. Jones	Eugene Von Bruenchenhein
Mr. Imagination	Joseph Yoakum

OBJECTS GALLERY

230 West Huron Street
Chicago, IL 60610
(312) 664-6622

Ann Nathan
Mary Donaldson

Payment Method:
Cash Check
MC Visa AE
Payment plan available

DESCRIPTION

The Objects Gallery carries an inventory of "folk, outsider, intuitive, and visionary" art. Although the collection includes painters and paintings, the emphasis is on three-dimensional works. There are sculptural forms in clay, wood, and metal; contemporary, artist-made furniture; Americana and folk art; and African textiles and furniture.

ARTISTS

Sam Doyle	Sarah Rakes
Rev. Howard Finster	Bernice Sims
William Hawkins	Jimmy Lee Sudduth
Clementine Hunter	Bobby Washington
Levent Isik	"Artist Chuckie" Williams
Benjamin F. Perkins	Purvis Young

PHYLLIS KIND GALLERY
313 West Superior
Chicago, IL 60610
(312) 642-6302

William H. Bengston

Payment Method:
Cash Check
Payment plan available

DESCRIPTION
This gallery features contemporary American art, contemporary art from the former USSR, and American naive and outsider art.

ARTISTS
Stephen Anderson
"Peter Charlie" Besharo
Henry Darger
William Dawson
Rev. Howard Finster
Langston Moffett

J.B. Murry
Martin Ramirez
Inez Nathaniel Walker
P.M. Wentworth
Joseph Yoakum

Iowa

THE PARDEE COLLECTION: MIDWESTERN NON-TRADITIONAL FOLK ART
PO Box 2926
Iowa City, IA 52244
(319) 337-2500

Sherry Pardee

Payment Method:
Cash Check

DESCRIPTION
The Pardee Collection specializes in nontraditional Midwestern folk and outsider art from Iowa, Illinois, and Missouri. Sherry Pardee is a freelance folklorist and folk art dealer who has traveled extensively in the region finding new artists. Nearly all of the artists are previously undiscovered to the folk art world, and the collection represents a fresh body of work. There is a broad range of subject matter and media, ranging from the traditional to the obscure. Informal catalogs of photographs of the works are sent out upon request. Available by appointment only.

ARTISTS
Greg Dickensen
Allan Eberle
Paul Esparza
Paul Hein
Nick Jovan
Rollin Knapp

Randy Norberg
Virgil Norberg
Phil Saunders
Oliver Williams
Anthony Yoder

Kentucky

HEIKE PICKETT/ TRIANGLE GALLERY
522 West Short Street
Lexington, KY 40593
(606) 233-1263

Heike Pickett

Payment Method:
Cash AE
Payment plan available

DESCRIPTION
This gallery was founded in 1983 as the Triangle Gallery. The owner, Heike Pickett, reports that she gave Jessie and Ronald Cooper their first show. The gallery, with two floors and a sculpture garden, includes contemporary fine art and Kentucky folk art. There is a diverse range of works, with one room always devoted to a one-person show and the rest of the space used to display "something from everyone." The gallery is not open every day, so call in advance of a visit.

ARTISTS
Minnie Adkins
Garland Adkins
Lillian Barker

Calvin Cooper
Jessie Cooper
Ronald Cooper

Deborah Evans
Marvin Finn
Denzil Goodpaster
Unto Jarvi
Jim Lewis
Junior Lewis

Tim Lewis
Thomas May
Earnest Patton
Russell Rice
Margaret Hudson Ross
Edgar Tolson

KENTUCKY GALLERY OF FINE CRAFTS AND ART
139 West Short Street
Lexington, KY 40507
(606) 281-1166

Katie Baroni

Payment method:
Cash Check
MC VISA
Payment plan available

DESCRIPTION
This 2200-square-foot gallery space opened in September 1992 and "represents seventy-five artists in every medium including painting, sculpture, carving, fiber art, hand-made clothing, furniture and basketry." A few of the contemporary folk and other self-taught artists included in this gallery are listed below.

ARTISTS
Edward Chiasson
Diane Daniels
Debra Hille
Flo Jarvis
Harry Jennings
Louis Lamb
Edd Lambdin

Sherman Lambdin
Shirley Lambdin
Carl McKenzie
J. Olaf Nelson
Kathy Webb
Henry York

KENTUCKY ART & CRAFT GALLERY
609 West Main Street
Louisville, KY 40202
(502) 589-0102

Sue Rosen

Payment Method:
Cash Check
MC Visa

DESCRIPTION
The Kentucky Art and Craft Gallery opened in 1984 and is a wonderful showcase for fine crafts and folk art from all over the state. It is operated by the Kentucky Art and Craft Foundation, a nonprofit organization founded to provide educational and promotional opportunities for Kentucky's artists and craftspeople. The gallery showcases the work of over 400 Kentucky artists, with works in every medium, and covers every price range. There are twelve special exhibitions each year in two exhibition areas. The gallery also has a traveling exhibition program. Each work featured in the gallery is carefully chosen for its quality and craftsmanship.

ARTISTS
Garland Adkins
Minnie Adkins
Elisha Baker
Donnie Brown
Sam Brown
Sally Cammack
Calvin Cooper
Golmon Crabtree
Marvin Finn
Denzil Goodpaster

Mack Hodge
Scott Jackson
Unto Jarvi
Harry Jennings
Charles Keeton
Hazel Kinney
Edd Lambdin
Sherman Lambdin
Shirley Lambdin
Bonnie Lander

Jim Lewis
Junior Lewis
Tim Lewis
Carl McKenzie
Miller & Bryant
Lonnie Money
J. Olaf Nelson
Donny Tolson
Henry York

SWANSON/CRALLE GALLERY

1377 Bardstown Road
Louisville, KY 40204
(502) 452-2904

Chuck Swanson
Lynne Cralle

Payment Method:
Cash Check MC
Visa AE Discover
Payment plan available

DESCRIPTION

This gallery focuses on contemporary living artists, with mostly craft items. There are some folk and outsider artists represented too. In addition to the self-taught artists listed below, there are many others that, in the words of the owners, "come and go."

ARTISTS

Calvin Cooper
Jessie Cooper
Ronald Cooper
Melissa Cox and
Herb McAleese, Jr.

Marvin Finn
Rev. Howard Finster
Jesse Flowers
Edd Lambdin
Mark Anthony Mulligan

MOREHEAD STATE UNIVERSITY FOLK ART SALES GALLERY/ FOLK ART CENTER

119 West University Boulevard
Morehead, KY 40351
(606) 783-2204

Susan Scheiberg

Payment Method:
Cash Check
Payment plan available

DESCRIPTION

If you are old enough to remember the thrill of the penny candy store when you were a child, then you will know what it is like to walk into this sales gallery at Morehead. The riches of Kentucky folk art, wonderfully varied and reasonably priced, are arrayed floor to ceiling. The staff will also make sales arrangements over the telephone or by mail. The mailing address is: The Folk Art Center, UPO 1383, Morehead State University, Morehead, KY 40351

ARTISTS

Garland Adkins
Minnie Adkins
Lillian Barker
Linvel Barker
Marie Braden
Calvin Cooper
Jessie Cooper
Ronald Cooper
Ruth Cooper
Tim Cooper
Martin Cox
Robert Cox
John Gilley
Denzil Goodpaster
Larry Hamm

Hazel Kinney
Jim Lewis
Junior Lewis
Leroy Lewis
Thomas May
Carl McKenzie
Miller & Bryant
Eugene Peck
Tim Ratliff
Russell Rice
J.C. Rose
Joy Rose
Hugo Sperger
Genevieve Wilson

HACKLEY GALLERY/ BLUEGRASS ROOTS

PO Box 88
North Middletown, KY 40357
(606) 362-7084

Larry Hackley

Payment Method:
Cash Check

DESCRIPTION

Larry Hackley is a dealer in folk art from Kentucky and the South. He specializes in Kentucky wood carvings and is known for having curated a number of well-regarded exhibitions. Mr. Hackley has a very large inventory of folk art canes, and also handles face jugs and African-American quilts. He is hard to find at home, and you must call for an appointment.

ARTISTS

Garland Adkins
Minnie Adkins
Elisha Baker
Linvel Barker
Minnie Black
Golmon Crabtree
William Dawson
"Creative" G.C. DePrie
Michael Farmer
Rev. Howard Finster
Denzil Goodpaster

Gary Hargis
T.A. Hay
S.L. Jones
Charley Kinney
Noah Kinney
Edd Lambdin
Sherman Lambdin
Shirley Lambdin
Jim Lewis
Leroy Lewis

Tim Lewis
Willie Massey
Carl McKenzie
Earnest Patton
"Popeye" Reed
Mary T. Smith
Sarah Mary Taylor
Donny Tolson
Edgar Tolson
Henry York

Louisiana

GILLEY'S GALLERY
8750 Florida Avenue
Baton Rouge, LA 70815
(504) 922-9225

Shelby Gilley

Payment Method:
Cash Check MC
Visa AE Discover
Payment plan available

DESCRIPTION
Gilley's Gallery was founded in 1978, with art works of Clementine Hunter. Additional artists have been added over the years. The gallery had "one of the earliest shows of outsider art, based mostly on the collection of Sylvia and Warren Lowe," according to gallery owner Shelby Gilley. The gallery handles traditional to contemporary folk art, with an increasing emphasis during the last five years on folk art from the rural Southeast. The range of artists represented includes both widely known and newer discoveries; from the "classic" folk painting of Clementine Hunter to the small sculptured figures of the relatively unknown artist Craig Black. This is a very pleasant gallery to visit, with helpful staff to show you around and answer questions.

ARTISTS

Garland Adkins
Minnie Adkins
Leroy Almon, Sr.
Craig Black
Loy "Rhinestone Cowboy"
 Bowlin
Joan Bridges
Steele Burden
Richard Burnside
David Butler
Heleodoro Cantu
Jessie Coates
Raymond Coins
Marion Connor
Ronald Cooper
Chuck Cox
William Dawson
Sam Doyle

Rev. Howard Finster
Michael Finster
Homer Green
Bessie Harvey
Lonnie Holley
Clementine Hunter
Alvin Jarrett
James Harold Jennings
Joan Julene Jones
M.C. "5¢" Jones
Charley Kinney
Junior Lewis
Woodie Long
Charlie Lucas
Thomas May
Carl McKenzie
R.A. Miller
Ike Morgan

Sister Gertrude Morgan
J.B. Murry
Benjamin F. Perkins
Royal Robertson
Juanita Rogers
Marie Rogers
Herbert Singleton
Mary T. Smith
Henry Speller
Hugo Sperger
Jimmy Lee Sudduth
James "Son" Thomas
Mose Tolliver
Fred Webster
Willie White
"Chief" Willey
Luster Willis

BARRISTER'S GALLERY
526 Royal Street
New Orleans, LA 70130
(504) 525-2767

A.P. Antippas
A.J. Boudreaux

Payment Method:
Cash Check
MC Visa AE

ARTISTS
Murphy Antoine
Larry Bannock
Sainte-James Boudrôt
Willie Boyle
Roy Ferdinand, Jr.
Ralph Griffin
Ruth Mae McCrane
Reginald Mitchell

Ike Morgan
Royal Robertson
Sulton Rogers
Bernice Sims
Herbert Singleton
Johnny Ray Smith
Mary T. Smith
Henry Speller

Jimmy Lee Sudduth
James "Son" Thomas
Pat Thomas
Mose Tolliver
Willie White
"Artist Chuckie" Williams

DESCRIPTION
When you arrive at 526 Royal Street, ignore all the tribal art in the window and the main room when you walk through the front door (unless you like it of course). Continue on through to the French Quarter courtyard with its brick walls, fountain, and series of open rooms. This is the folk art section of the gallery, where you will find an excellent collection of contemporary Southern folk and outsider art, emphasizing, but not limited to, the work of black artists. There is a choice selection of especially high quality Jimmy Lee Sudduth and Mary T. Smith paintings. This gallery is also the source for an artist some consider the best living self-taught carver, New Orleans native, Herbert Singleton. Roy Ferdinand, Jr., a self-taught painter of the not-so-romantic side of contemporary New Orleans life, has his work here. Engage "A.J." in conversation and you will learn a lot from his strong feelings about the art and artists he represents in his gallery.

FRAMBOYAN
524 Dumaine
New Orleans, LA 70116
(504) 895-6091

Ron Dabney
Lynn Dabney

Payment Method:
Cash Check

DESCRIPTION
This French Quarter gallery is open by appointment only. Most of the work done here, by Lynn Dabney, has to do with fine art restoration, appraisals, and sale of selected pieces of "pre-Columbian, African, Oceanic, and Oriental art." In addition, though, Ron Dabney travels a lot through the South and finds some interesting regional folk art. This place is one to visit to find the unexpected. [Mailing Address: Lynn Dabney/Framboyan, 1521 Eighth Street, New Orleans, LA 70115.]

ARTIST
Joe McFall

GASPERI GALLERY
320 Julia Street
New Orleans, LA 70130
(504) 524-9373

Richard Gasperi

DESCRIPTION
This pioneer gallery in contemporary Southern folk art moved from its French Quarter location to the newly renovated warehouse district, New Orleans' contemporary art center, in 1989. At the same time as the move, Richard Gasperi broadened his venture to include contemporary trained artists as well as self-taught artists. The combination works well, especially in this soaring, white-walled gallery space. The folk art collection continues to be of the highest quality.

Payment Method:
Cash Check
MC Visa
Payment plan available

There is a magnificent collection of David Butler's painted tin sculpture and excellent examples of the works of Sister Gertrude Morgan and Clementine Hunter among the many artists represented in the gallery. Richard Gasperi is knowledgeable about the artists he represents and has an excellent library. The lucky purchaser leaves with printed information about the artist, in addition to the piece he or she has bought. The gallery offers appraisal services too.

ARTISTS

Bruce Brice	John Landry	Jon Serl
David Butler	Joe Light	Mary T. Smith
Henry Darger	Rev. McKendree Long	Jimmy Lee Sudduth
Patrick Davis	Sister Gertrude Morgan	James "Son" Thomas
Minnie Evans	J.B. Murry	Mose Tolliver
Rev. Howard Finster	Benjamin F. Perkins	Willie White
Mike Frolich	"Popeye" Reed	"Chief" Willey
Lee Godie	Royal Robertson	Luster Willis
William Hawkins	Nellie Mae Rowe	Jack Zwirz
Clementine Hunter	St. EOM	
O.W. "Pappy" Kitchens	J.P. Scott	

HAYES ANTIQUES
828 Chartres
New Orleans, LA 70116
(504) 529-5501

Jim Hayes
Judy Hayes

Payment Method:
Cash Check
Payment plan

DESCRIPTION
The Hayes Gallery carries "arts and crafts, folk art, and twentieth century decorative arts." These are unique pieces; one-of-a-kind objects of interest and superior quality. The owners prefer older works, but there are some good examples of work from contemporary Southern self-taught artists. Most of the folk art is from the South, as is much of the other work on display.

ARTISTS

Henry Bridgewater	Bob Shaffer
Steele Burden	Willie White

PELIGRO FOLK ART
900 Royal Street
New Orleans, LA 70116
(504) 581-1706

Michael Martin
Betsy Martin

Payment Method:
Cash MC
Visa AE Discover

DESCRIPTION
An "eclectic gallery"—which is an understatement—with an emphasis on folk art from many parts of the world, including the United States. They carry a few trained artists too.

ARTISTS

Loy "Rhinestone Cowboy" Bowlin	R.A. Miller
Buzz Busby	Benjamin F. Perkins
Lonnie Holley	Bernice Sims
Joan Julene Jones	Jimmy Lee Sudduth
Calvin Livingston	Mose Tolliver
Charlie Lucas	Fred Webster

SOUTHERN TANGENT

6482 Highway 22
Sorrento, LA 70778
(504) 675-6815

Linda Black

Payment Method:
Cash Check
MC Visa AE
Payment plan available

DESCRIPTION

Southern Tangent showcases the "wild talents" of south Louisiana's folk artists and craftspeople, and features Craig Black's fabulous fantasies on canvas and unique ceramic sculpture. The gallery is owned and operated by Linda Black, who makes it a point to get to know the artists she carries. She does not reject anyone who is self-taught and does original design or work because she wants people to have the opportunity to exhibit their work. The visitor will find works in many media, including works on paper, canvas, and wood; forged iron work and metal sculpture; ceramics; etched and stained glass; various wooden creations; fabric; and jewelry—all depicting the rich cultures found in south Louisiana. The gallery is located at the crossroads of Louisiana's plantation country. An Acadian village atmosphere surrounds the gallery with a coffee house and two antique shops. The gallery contains the works of many craftspeople and artists; over eighty people are represented. Some of the artists exhibited are listed below.

ARTISTS

Craig Black	Ralph Jones
Joan Bridges	May Kugler
Kelly Broussard	Lonnie Landry
Susan Conner	Dolores H. Legendre
Nelson Faucheaux	Jessie Mitchell
Marion Goodwyne	Mary Sue Richburg
Joan Julene Jones	Mary Thibodeaux

Maryland

COGNOSCENTI GALLERY

608 Reservoir Street
PO Box 4759
Baltimore, MD 21211
(410) 523-1507

Richard Edson

Payment Method:
Cash Check

DESCRIPTION

This is a private gallery specializing in contemporary folk and outsider art. In addition to contemporary folk art, the gallery features Haitian art, traditional American pottery, Southwest pottery, and Turkish textiles. Mr. Edson also offers consulting, collecting, and curating services, based on his ten years in the field. Open by appointment only.

ARTISTS

Andrea Badami	Rev. John Hunter
Baltimore Glassman	Charles Jay
Lillian Barker	Frank Jones
Linvel Barker	Junior Lewis
Raymond Coins	Elijah Pierce
Ronald Cooper	Dow Pugh
Michael Creese	Sulton Rogers
Ulysses Davis	R.P. Schroeder
Minnie Evans	Sarah Mary Taylor

Massachusetts

SAILOR'S VALENTINE GALLERY

38 & 40 Centre Street
Nantucket, MA 02554
(508) 228-2011

Carolyn Walsh
Pamela R. Michelsen

Payment Method:
Cash Check
MC Visa AE

DESCRIPTION
This gallery occupies one building that houses two collections. The gallery collection is devoted to fine art; the director's collection consists of the works of many folk artists. Represented are contemporary folk art, outsider art, American and European naive art, and Aboriginal art from Australia. The gallery is open year round; during the summer season, the exhibition calendar changes weekly, with concurrent shows from each collection.

ARTISTS

Linda Anderson
Elisha Baker
James Wallace Baker
E.A. Banks
Marion Conner
Calvin Cooper
Jessie Cooper
Ronald Cooper
Tim Cooper
Robert Cox
Michael Crocker
Karolina Danek
Rita Hicks Davis
Marvin Finn
Rev. Howard Finster

J.H. Floyd
Denzil Goodpaster
Lonnie Holley
Clementine Hunter
James Harold Jennings
Ricky Keeton
Jim Lewis
Junior Lewis
Tim Lewis
Charlie Lucas
Thomas May
Larry McKee
Anita Meaders
Lanier Meaders
R.A. Miller

Miller & Bryant
Lonnie Money
Mattie Lou O'Kelley
Benjamin F. Perkins
Tim Ratliff
Russell Rice
Marie Rogers
Hugo Sperger
Jimmy Lee Sudduth
James "Son" Thomas
Annie Tolliver
Mose Tolliver
Willie White
Henry York

Michigan

HILL GALLERY

163 Townsend Street
Birmingham, MI 48009
(313) 540-9288

Pamela Hill
Timothy Hill

Payment Method:
Cash Check
Payment plan available

DESCRIPTION
This gallery was established about 1970 and featured American folk art and high-style furniture. Then, in 1979, contemporary fine art was added. It was interesting to find, during an August 1991 visit to the gallery, that the featured artist was trained artist Michael D. Hall, who is himself a well-known collector and writer in the field of contemporary folk art. The Hills also do shows for the folk artists they represent and have worked hard to bring attention to the talented Detroit folk artist Willie Leroy Elliot.

ARTISTS

Eddie Arning
Willie Leroy Elliott
Edgar Tolson

Bill Traylor
Inez Nathaniel Walker

Minnesota

BOCKLEY GALLERY
400 First Avenue North
Minneapolis, MN 55401
(612) 339-3139

Todd Bockley

Payment Method:
Cash Check

DESCRIPTION
The Bockley Gallery exhibits work of American and European art brut, outsider art, and folk art.

ARTISTS
"Prophet" William J. Blackmon
Guy Church
Henry Darger
Clementine Hunter

Annie Lucas
Martin Ramirez
Mose Tolliver
Willie White

Mississippi

JUSTIN MASSINGALE
206 East Main Street
Clinton, MS 39056
(601) 355-7178

Justin Massingale

Payment Method:
Cash Check

DESCRIPTION
Specializing in contemporary folk art, including match stick, prison, twig, and bottle cap art, spool furniture, primitive painters, memory jugs, and the unusual and the bizarre.

ARTISTS
Richard Burnside
Raymond Coins
Ralph Griffin
Rev. John Hunter
Sulton Rogers
Mary T. Smith

Jimmy Lee Sudduth
Sarah Mary Taylor
James "Son" Thomas
"Artist Chuckie" Williams
Decell Williams

Missouri

AMERICAN FOLK ART GALLERY
14A North Meramec
St. Louis, MO 63105
(314) 725-4334

Sheldon Shapiro

Payment Method:
Cash Check
Payment plan available

DESCRIPTION
This gallery, opened by longtime art collector Sheldon Shapiro in September of 1991, features American folk art, self-taught and outsider art, and Americana. There is an ever-changing inventory with forty to fifty pieces on display at any one time.

ARTISTS
Leroy Almon, Sr.
Johnson Antonio
Felipe Archuleta
Rev. Howard Finster
Homer Green
S.L. Jones
Ike Morgan

Ron Rodriguez
Jon Serl
Robert E. Smith
Jimmy Lee Sudduth
Mose Tolliver
Inez Nathaniel Walker
"Artist Chuckie" Williams

GALERIE BONHEUR

9243 Clayton Road
St. Louis, MO 63124
(314) 993-9851

Laurie Carmody

Payment Method:
Cash Check
MC Visa
Payment plan available

DESCRIPTION

Laurie Carmody has been a dealer in international folk art for the past twelve years. She has specialized in Haitian art and also carries quite a few pieces from Brazil, Mexico, the Dominican Republic, and the Bahamas. Ms. Carmody recently moved from Connecticut to Missouri, and with this move she intends to change her focus to the self-taught Southern artists. She says she sells "any piece of folk art that I find interesting, appealing, worthy of putting in my own home."

ARTISTS

Felipe Archuleta
Milton Bond
Calvin Cooper
Ronald Cooper
Tim Cooper
Mamie Deschillie
Rev. Howard Finster
Milton Fletcher
S.L. Jones
Junior Lewis
Justin McCarthy

R.A. Miller
Benjamin F. Perkins
Judy Perry
Frank Pickle
Juanita Rogers
Jack Savitsky
Jimmy Lee Sudduth
Horacio Valdez
Elsie Van Savage
Fred Webster
Malcah Zeldis

RANDALL GALLERY

999 North 13th Street
St. Louis, MO 63106
(314) 231-4808

William Shearburn

Payment Method:
Cash Check
Payment plan available

DESCRIPTION

The Randall Gallery, located in the Warehouse District of St. Louis, is housed in a renovated sewing machine factory with 15,000 square feet of exhibition space, making it one of the largest in the Midwest. The Gallery represents both trained and untrained artists.

ARTISTS

Rev. Howard Finster
Bessie Harvey
James Harold Jennings
S.L. Jones
Justin McCarthy
R.A. Miller
Nellie Mae Rowe
Anthony Joseph Salvatore
Jon Serl

Michael I. Smith
Jimmy Lee Sudduth
Mose Tolliver
Bill Traylor
Gregory Van Maanen
Inez Nathaniel Walker
James Watkinson
Joseph Yoakum

New Jersey

LYNNE INGRAM SOUTHERN FOLK ART

174 Rick Road
Milford, NJ 08848
(908) 996-4786

Lynne Ingram

DESCRIPTION

Lynne Ingram is a folk art dealer who collects and sells "contemporary art by the self-taught Southern hand." She has a good eye for truly fine art, travels regularly, and personally knows most of the artists whose work she sells. Southern face jugs are a prominent part of the work available. Located in Milford, NJ about one hour outside of New York City, Ms. Ingram will make an appointment to see

LYNNE INGRAM SOUTHERN FOLK ART *Continued*

Payment Method:
Cash Check

you there, or will send photographs. She is a valuable resource for information about the artists and their work.

ARTISTS

Minnie Adkins
Leroy Almon, Sr.
Bob Armfield
Eddie Arning
Linvel Barker
Georgia Blizzard
Charles Brown
Jerry Brown
Louis Brown
Richard Burnside
Raymond Coins
Calvin Cooper
Ronald Cooper
Burlon Craig
Abraham Lincoln Criss
"Creative" G.C. DePrie
Rev. Howard Finster
Sybil Gibson
Bessie Harvey
Matthew Hewell
Albert Hodge
Clementine Hunter
Billy Ray Hussey

James Harold Jennings
M.C. "5¢" Jones
S.L. Jones
Hazel Kinney
Sammy Landers
Junior Lewis
Joe Light Family
Charlie Lisk
Charlie Lucas
Willie Massey
Thomas May
Jake McCord
Carl McKenzie
Anita Meaders
Cleater & Billie Meaders
Cleater Meaders, Jr.
Edwin Meaders
Lanier Meaders
Reggie Meaders
Mark Casey Milestone
R.A. Miller
Mark Anthony Mulligan
M.L. Owens

Benjamin F. Perkins
Melissa Polhamus
Royal Robertson
Marie Rogers
Sulton Rogers
Jack Savitsky
Bernice Sims
Mary T. Smith
Oscar Spencer
Q.J. Stephenson
Jimmy Lee Sudduth
Sarah Mary Taylor
Dwayne Thomas
James "Son" Thomas
Annie Tolliver
Charles Tolliver
Mose Tolliver
Inez Nathaniel Walker
Arliss Watford
Fred Webster
"Artist Chuckie" Williams
George Williams

New Mexico

ART OF THE AMERICAN DESERT
PO Box 1062
Santa Fe, NM 87504
(505) 983-1708

Murdock Finlayson

Payment Method:
Cash Check Barter
Payment plan available

DESCRIPTION
This dealer works from a large warehouse, where he handles New Mexican antiques, folk art, tin, American Indian art, quality Mexican antiques, and Southwestern naive art. Call for an appointment.

ARTISTS

Tobias Anaya
Felipe Archuleta
Leroy Archuleta
Mike Rodriguez
Ron Rodriguez

Anistacio "Tacho" Segura
Santiago "Tago" Trejo
Charlie Willeto
and many drawings by
 Felipe Archuleta.

CRISTOF'S

106 West San Francisco
Santa Fe, NM 87501
(505) 988-9881

Bill Bobb
Sande Bobb

Payment Method:
Cash Check
MC Visa AE
Payment plan available

DESCRIPTION

This gallery features fine contemporary Navajo weaving, Navajo sand paintings, Cochiti Pueblo storyteller dolls, select Native American jewelry, and other beautiful creations. Sometimes the temptation to expand the coverage of this book to fabric dolls is nearly overwhelming. The work of Fred Sandoval, carried by this gallery, is one of the sources of this temptation.

ARTISTS

Eugene "Baatsoslanii" Joe
Sylvia Johnson
Regina Naha
Vangie Suina
Herman Tyler

DAVIS MATHER FOLK ART GALLERY

141 Lincoln Avenue
Santa Fe, NM 87501
(505) 983-1660

Davis Mather
Christine Mather

Payment Method:
Cash Check
MC Visa AE

DESCRIPTION

This is a fine white-walled space that shows off the skilled carvings of contemporary New Mexico folk artists. The Mathers are well-informed and enjoy talking about the art of New Mexico. The colorful art and interesting, informative conversations make it a pleasure to visit this gallery. Included in the gallery in addition to the folk art are Paul Lutonsky's carved snakes painted in brilliant colors.

ARTISTS

David Alvarez
Felipe Archuleta
Leroy Archuleta
Mamie Deschillie
Ray Growler
Dan Hot
Alonzo Jimenez
Joe Ortega
Mike Rodriguez
Ron Rodriguez
Lula Herbert Yazzie
Wilfred Yazzie

LESLIE MUTH GALLERY

225 East De Vargas Street
Santa Fe, NM 87501
(505) 989-4620

Leslie Muth

Payment Method:
Cash Check
MC Visa AE
Payment plan available

DESCRIPTION

The Leslie Muth Gallery is in the historic section of Santa Fe in an 1859 adobe building, behind the oldest house in the United States and just off Old Santa Fe Trail. There are four exhibition rooms and a fenced courtyard for sculpture. The building is complete with vigas, arched doorways, and kiva fireplace in the old Santa Fe tradition (not to be confused with the current Santa Fe style).

ARTISTS

Tobias Anaya
Johnson Antonio
Eddie Arning
Freddy Avila
Johnny Banks
Sainte-James Boudrôt
Loy "Rhinestone Cowboy" Bowlin
Leon Box
Delbert Buck
Ned Cartledge
Henry Ray Clark
Mildred Foster Clark and Floyd Clark
Ronald Cooper
"Jimbo" Davila
Patrick Davis
Mamie Deschillie

LESLIE MUTH GALLERY *Continued*

Carl Dixon
"Uncle Pete" Drgac
Vanzant Driver
Roy Ferdinand, Jr.
Rev. Howard Finster
Ezekiel Gibbs
Ray Growler
Ruby Growler
Delores Hackenberger
Rev. Herman Hayes
Woody Herbert
William Holzman
Alva Hope
Dan Hot
Rev. John Hunter
Elizabeth Willeto Ignazio
Eddie Jackson

James Harold Jennings
Frank Jones
M.C. "5¢" Jones
Joel Lage
Price Larson
Woodie Long
Jesse Lott
Charlie Lucas
Nan McGarity
R.A. Miller
Deacon Eddie Moore
Manuel Morales
Ike Morgan
Benjamin F. Perkins
Naomi Polk
Mike Rodriguez
Isaac Smith

Mary T. Smith
David Strickland
Jimmy Lee Sudduth
Rev. Johnnie Swearingen
Luis Tapia
Dwayne Thomas
Annie Tolliver
Mose Tolliver
Herbert Walters
Willard "The Texas Kid" Watson
Derek Webster
George White
"Artist Chuckie" Williams
George Williams
Lula Herbert Yazzie
Wilfred Yazzie

THE RAINBOW MAN

107 East Palace Avenue
Santa Fe, NM 87501
(505) 982-8706

Bob Kapoun
Marianne Kapoun

Payment Method:
Cash Check
MC Visa AE
Payment plan available

DESCRIPTION

A gallery crammed full of art treasures, The Rainbow Man includes American Indian art, folk art from many regions, and historic photography—to name a few of the categories covered in depth. There is so much to see and admire, you can spend a long time here.

ARTISTS

Tobias Anaya
Johnson Antonio
Felipe Archuleta
Joe Archuleta
Leroy Archuleta
Mike Archuleta
Robert Archuleta
"Jimbo" Davila
Mamie Deschillie
S.L. Jones

Justin McCarthy
R.A. Miller
Angie Reano Owen
Ron Rodriguez
Jimmy Lee Sudduth
Mose Tolliver
Faye Tso
Inez Nathaniel Walker
Lula Herbert Yazzie
Wilfred Yazzie

GREGORY QUEVILLON

PO Box 113
Tesuque, NM 87574
(505) 989-7580

Gregory Quevillon

Payment Method:
Cash Check

DESCRIPTION

Mr. Quevillon owns over 100 paintings by self-taught artist Isador "Grandpa" Sommer. He is a dealer of North American Native American art and purchased this collection of naive paintings "eight years past as an investment and for my enjoyment." The collection, or individual paintings, mostly oils, is now for sale. A painting of Sommer's is in the collection of the New York State Historical Association in Cooperstown, New York.

ARTISTS

Isador "Grandpa" Sommer

New York

GALLERY 53 ARTWORKS

118 Main Street
Cooperstown, NY 13326
(607) 547-5655

Sidney Waller

Payment Method:
Cash Check
MC Visa AE
Payment plan available

ARTISTS

Bertha Halozan
Harold Hinckley
Lavern Kelley

James C. Litz
Charles Munro
Janet Munro

Gary Rathbone
Sulton Rogers

DESCRIPTION

"Gallery 53 Artworks is a nonprofit contemporary arts center located in upstate New York, in the picture-perfect village of Cooperstown, known as the village of museums. Situated on the shores of Lake Otsego, the Glimmerglass Lake in James Fenimore Cooper's novels, Cooperstown is home to the impressive folk art collection at Fenimore House, as well as to The Farmers' Museum and the National Baseball Hall of Fame and Museum. Gallery 53 Artworks shows a wide range of artworks but specializes in contemporary folk art by a half dozen New York State artists. The gallery organizes an annual folk art show in its main gallery, carries folk art year round in its annex gallery, and handles commissioned orders as well as curatorial projects. Inquiries are always welcome."

RENEE FOTOUHI FINE ART EAST

16R Newtown Lane
East Hampton, NY 11937
(516) 324-8939

Renee Fotouhi

Payment Method:
Cash Check
MC Visa AE
Payment plan available

DESCRIPTION

This gallery carries fine art and art by self-taught artists.

ARTISTS

James Bright Bailey
Richard Burnside
Minnie Evans
Rev. Howard Finster
Michael Finster
Ray Hamilton
Bessie Harvey
Ethel Jaret
"Lady Shalimar"
Joel Lage

Rose Liccardi
Jennie Maruki
Willie Massey
Justin McCarthy
R.A. Miller
Benjamin F. Perkins
Mary T. Smith
Mose Tolliver
Jeff Williams

AMERICAN PRIMITIVE GALLERY

596 Broadway #205
New York, NY 10012
(212) 966-1530

Aarne Anton

Payment Method:
Cash Check AE
Payment plan available

DESCRIPTION

"The American Primitive Gallery offers an outstanding selection of outsider art, as well as a changing inventory of folk art from fish decoys to weathervanes, whirligigs, and one-of-a-kind works of art of the nineteenth and twentieth century." Mr. Anton plans several exhibitions a year, which often are group shows around a theme.

ARTISTS

Richard Burnside
Buzz Busby
Charles Butler

Raymond Coins
Lonnie Holley
Rene Latour

AMERICAN PRIMITIVE GALLERY *Continued*

John Mason	Lee Steen
Willie Massey	Jimmy Lee Sudduth
Alipio Mello	James "Son" Thomas
R.A. Miller	Mose Tolliver
Mary T. Smith	Willie White

CAVIN-MORRIS

560 Broadway, 2nd Floor
New York, NY 10012
(212) 226-3768

Randall Morris
Shari Cavin Morris

Payment Method:
Cash Check AE
Payment plan available

DESCRIPTION

"The philosophy of the gallery is that great art from any epoch achieves a timelessness when its intent is pure, its execution is masterly and its concept is unique. We present art by artists both self-taught and academically trained, who have emigrated to this country, or were born here but also explore their cultures through their works. We also have a large collection of artists who are self-taught from the U.S.A. Many work without regard to the mainstream and have achieved dynamic and important styles that will affect art history for years to come. We believe in the positive dissemination of information and are pleased to collaborate with museums, students, and independent curators. We are just as happy to show the work of an unknown emerging artist as that by a 'known' artist. The key word to our interest is passion, and we have shaped the gallery to reflect that."

ARTISTS

Chelo Amezcua	Bessie Harvey	Jon Serl
Sam Doyle	John Harvey	Bill Traylor
Willie Leroy Elliott, Jr.	Justin McCarthy	Gregory Van Maanen
Rev. Howard Finster	Anthony Joseph Salvatore	James Watkinson

EPSTEIN/POWELL

22 Wooster Street
New York, NY 10013
(212) 226-7316

Gene Epstein

Payment Method:
Cash Check

DESCRIPTION

This gallery, housed in a Soho loft where most of the space is devoted to art, is open by appointment only. Started in 1978, it is a "low key operation" that specializes in the "older figures in the field such as S.L. Jones, Victor Joseph Gatto, Justin McCarthy, and Jack Savitsky."

ARTISTS

Jesse Aaron	Donovan Durham	James Harold Jennings
Rifka Angel	Antonio Esteves	S.L. Jones
Ned Cartledge	Minnie Evans	Lawrence Lebduska
Rex Clawson	Roy Ferdinand, Jr.	Emily Lunde
Jerry Coker	Rev. Howard Finster	Justin McCarthy
William Dawson	Victor Joseph Gatto	Ralph Middleton
Charlie Dieter	Joseph Hardin	R.A. Miller
Diane Duany	Rev. John Hunter	Peter Minchell

Emma Lee Moss
Ed "Mr. Eddy" Mumma
Mattie Lou O'Kelley
Benjamin F. Perkins
Joe Polinski
Daniel Pressley"
Old Ironsides" Pry
"Popeye" Reed
Max Romain

Nellie Mae Rowe
Jack Savitsky
Alvin Simpson
Isaac Smith
Clarence Stringfield
Jimmy Lee Sudduth
Ionel Talpazan
Mose Tolliver
Gueydan Verret

Inez Nathaniel Walker
Floretta Emma Warfel
"Chief" Willey
"Artist Chuckie" Williams
George Williams
Luster Willis
Malcah Zeldis

ESPIRITU

1070 Madison Avenue
New York, NY 10028
(212) 737-6440

Risha Meledandri

Payment Method:
Cash Check
MC Visa AE

DESCRIPTION

Espiritu is a small space with a mixture of twentieth century folk art from the United States, Africa, South America, and Mexico. There are a few paintings, and many carved and painted human figures.

ARTISTS

Patrick Davis
Rev. Howard Finster
Bertha Halozan

R.A. Miller
Fred Webster

FRANK J. MIELE GALLERY

1262 Madison Avenue
New York, NY 10128
(212) 876-5775

Frank J. Miele

Payment Method:
Cash Check
MC Visa AE

DESCRIPTION

Mr. Miele, a founder of Hirschl & Adler Folk, opened this gallery in September 1991. He says the new gallery will be devoted to "the work of contemporary artists who work in the folk tradition, artists who express their contemporary vision with a traditional aesthetic sensibility in the spirit of the self-taught artists of the nineteenth century." He says that although "the gallery will also handle a selection of works by 'outsiders,' this will not be the focus of the gallery." Since this latter art is the focus of this book, and not the people who paint "in the folk art tradition," many of Mr. Miele's artists are not listed here.

ARTISTS

J.R. Adkins
Ned Cartledge
"Uncle Jack" Dey
Charles Dieter
Alonzo Jimenez

Harry Lieberman
Mattie Lou O'Kelley
Paul Patton
Joseph Pickett
Jack Savitsky

Clarence Stringfield
Maurice Sullins
Inez Nathaniel Walker
Floretta Emma Warfel
"Chief" Willey

GALERIE ST. ETIENNE

24 West 57th Street
New York, NY 10019
(212) 245-6734

Hildegard Bachert
Jane Kallir

Payment Method:
Cash Check

DESCRIPTION

Galerie St. Etienne is the oldest gallery in the United States specializing in Austrian and German expressionists. Its subspecialty is American and international folk art. It represents the estate of Grandma Moses. "The gallery has an ongoing commitment to mounting museum-type loan exhibitions, often accompanied by scholarly, book-length catalogs."

ARTISTS

John Kane	Nan Phelps
Abraham Levin	Joseph Pickett
Israel Litwak	Horace Pippin
Anna Mary Robertson Moses	

HIRSCHL & ADLER MODERN

420 West Broadway
New York, NY 10012
(212) 966-6331

Payment Method:
Cash Check

DESCRIPTION

This spacious gallery which recently relocated from its uptown address on Madison Avenue features contemporary fine art. It is included here because of its inventory of the works of Bill Traylor. The gallery has published two catalogs about his art.

ARTIST

Bill Traylor

LESLIE HOWARD: ALTERNATIVE ART SOURCE

3 Charles Street
New York, NY 10014
(212) 989-3801

Leslie Palanker
Howard Sebold

Payment Method:
Cash Check
MC Visa
Payment plan available

DESCRIPTION

The Alternative Art Source is devoted to contemporary and antique folk art and crafts. The collection consists of objects from around the world. The gallery carries folk art from the United States and also from Haiti, India, Africa, Mexico, and Peru. The owners are particularly interested in promoting folk artists who have not yet gained recognition. They have a large collection of Appalachian folk art, tramp art, folk paintings, wood and tin cutouts, and furnishings. The owners also curate special exhibitions every month, as well as highlighting a particular contemporary craftsperson in their showcase window.

ARTISTS

Lillian Barker	Elliott Freeman	R.A. Miller
Calvin Cooper	Rev. Herman Hayes	Benjamin F. Perkins
Ronald Cooper	Hewell Family	Tim Ratliff
Melissa Cox & Herb McAleese	"Michigan" Jackson	J.C. Rose
Michael Crocker	Charley Kinney	John Sheldon
Bill Duffy	Junior Lewis	Hugo Sperger
Rev. Howard Finster	Carl McKenzie	Ionel Talpazan
Michael Finster	Meaders Family	Mose Tolliver

LINDERMAN FOLK AND OUTSIDER ART

530 West 46th Street, #3W
New York, NY 10036
(212) 307-0914

Jim Linderman

Payment Method:
Cash Check

DESCRIPTION

Jim Linderman is a private dealer in twentieth century folk art and works by outsiders. He is open by appointment only.

ARTISTS

Dwight Joe Bell
Victor Joseph Gatto
Dilmus Hall
James Harold Jennings
Anderson Johnson
S.L. Jones
Andy Kane
Lavern Kelley
Ivan Laycock

Justin McCarthy
Wesley Merritt
"Old Ironsides" Pry
Max Romain
Jack Savitsky
Simon Sparrow
Jimmy Lee Sudduth
Ionel Talpazan
Mose Tolliver

LITTLE RICKIE

49-1/2 First Avenue
New York, NY 10003
(212) 505-6467

Payment Method:
Cash MC
Visa AE

DESCRIPTION

This East Village establishment—a shop rather than a gallery—is included here because, amidst the curios and Elvis memorabilia, there is always some folk art by well-known self-taught artists. Many of the patrons are walking works of art themselves. A place not to be missed by those who appreciate colorful people and places.

ARTISTS

Jon Bok
Rev. Howard Finster
Michael Finster

Joel Lage
Jimmy Lee Sudduth
Mose Tolliver

LUISE ROSS GALLERY

50 West 57th Street
New York, NY 10019
(212) 307-0400

Luise Ross

Payment Method:
Cash Check
Payment plan available

ARTISTS

Jesse Aaron
Oscar Brown
Thornton Dial, Sr.
Minnie Evans
Ted Gordon
Carl Greenberg

DESCRIPTION

Since 1982, the Luise Ross Gallery has exhibited the work of self-taught artists. In addition to frequent gallery exhibitions, gallery staff also have organized exhibitions for public and university museums and have mounted exhibitions of the work of mentally handicapped artists. A scholarly compendium of Bill Traylor's exhibition history, bibliography, and public collections was published by the gallery in 1991 to help further knowledge of this twentieth century master. In addition to self-taught artists, the gallery exhibits work by contemporary artists.

Ray Hamilton
"Lady Shalimar"
Jennie Maruki
Justin McCarthy
Kenny McKay
Gaetana Menna

Ed "Mr. Eddy" Mumma
Irene Phillips
Henry Speller
Bill Traylor
Joseph Yoakum

PHYLLIS KIND GALLERY
136 Greene Street
New York, NY 10012
(212) 925-1200

Payment Method:
Cash Check
Payment plan available

DESCRIPTION
This gallery carries contemporary American art; European "outsiders" such as Aloise, Madge Gill, Gerard Lattier, Augustine Lesage, Albert Louden, Michel Nedjar, Perifimou, Shaffique Uddin, Scottie Wilson, and Adolf Wolfli; and American naive and outsider art.

ARTISTS

"Peter Charlie" Besharo	Martin Ramirez
Henry Darger	Drossos P. Skyllas
Rev. Howard Finster	Inez Nathaniel Walker
J.B. Murry	P.M. Wentworth
John Podhorsky	Joseph Yoakum

RICCO/MARESCA GALLERY
105 Hudson Street
New York, NY 10013
(212) 219-2756

Roger Ricco
Frank Maresca

Payment Method:
Cash Check

DESCRIPTION
This gallery focuses on masters of American self-taught, outsider art and emerging contemporary artists.

ARTISTS

Eddie Arning	William Edmondson
Hawkins Bolden	William Hawkins
David Butler	Mary T. Smith
Sanford Darling	Bill Traylor
Thornton Dial	Purvis Young
Sam Doyle	

SALE OF HATS
317 West 104th Street, #2F
New York, NY 10025
(212) 666-6628

Kerry Schuss

Payment Method:
Cash Checks

DESCRIPTION
Kerry Schuss is a private dealer who sells contemporary folk and outsider art from his home. He is available by appointment only.

ARTISTS

Madison Backus	"Lady Shalimar"
Aaron Birnbaum	Clyde Maurey
Freddie Brice	Lillian Smith
Rev. St. Patrick Clay	Philip Travers
Ray Hamilton	

North Carolina

BLUE SPIRAL 1
38 Biltmore Avenue
Asheville, NC 28801
(704) 251-0202

Payment Method:
Cash Check
MC Visa AE
Payment plan available

DESCRIPTION
"Asheville has a long-standing tradition of embracing arts and crafts that speak with eloquence and spirit. Blue Spiral 1, a three-level exhibition gallery on a par with the finest in the Southeast, is committed to expanding this heritage. With changing exhibits and a spontaneous installation and performance space, the gallery brings together art that is fresh, lively, often provocative, and sometimes controversial. The gallery also carries exceptional crafts from around the Southeast, and the works of many trained artists in addition to its folk art collection."

ARTISTS

Russell Gillespie	R.A. Miller
Bessie Harvey	Parks Townsend

COUNTRYSIDE ANTIQUES
Route 9 Box 383
Chapel Hill, NC 27514
(919) 968-8375

Kenneth B. Hoyle

Payment Method:
Cash Check
MC Visa
Payment plan available

DESCRIPTION
This is a wonderful and wonder-filled old house on a country road, Highway 15-501, six miles south of Chapel Hill. There are many beautiful antiques—furniture and decorative arts. Also, there is a sizeable collection of face jugs. (And the proprietor gives excellent directions to Haw River Animal Crossing, the creation of folk artist Clyde Jones.)

ARTISTS

Burlon B. Craig	Charles Lisk

AT HOME GALLERY
2304 Sherwood Street
Greensboro, NC 27403
(919) 294-2297

Mike Smith
Lisa Eller-Smith

Payment Method:
Cash Check

DESCRIPTION
This folk "cottage industry" gallery is modest but comprehensive, specializing in Southern artists with an emphasis on the better-known people in the Southeast. The gallery welcomes interested parties to look, chat, and comment. One area of specialty is photographs of many of the artists featured, including custom-designed frames by the artists. Open by appointment only.

ARTISTS

Leroy Almon, Sr.	Clyde Jones	Sarah Rakes
Chris Brown	M.C. "5¢" Jones	Royal Robertson
Richard Burnside	Calvin Livingston	Marie Rogers
Robert Clement	Charlie Lucas	Jack Savitsky
Raymond Coins	Brad Martin	Bernice Sims
Burlon Craig	Willie Massey	Q.J. Stephenson
Rev. Howard Finster	Mark Casey Milestone	Jimmy Lee Sudduth
Michael Finster	R.A. Miller	Annie Tolliver
Billy Ray Hussey	Benjamin F. Perkins	Mose Tolliver
James Harold Jennings	Melissa Polhamus	

CLINTON LINDLEY, LTD.
120 Antique Street,
Daniel Boone Village
Hillsborough, NC 27278
(919) 732-4300

Clinton Lindley

Payment Method:
Cash Check
MC Visa AE
Payment plan available

DESCRIPTION
"This gallery is full of art, including folk art, paintings, and early American and European artifacts. There is a large inventory of academic and folk art, particularly American, with two floors to explore."

ARTISTS
Robyn Beverland
R.A. Miller
Vollis Simpson

Marcus Staples, Jr.
Lillian Webb

SOUTHERN FOLK POTTERY COLLECTORS SOCIETY SHOP AND MUSEUM
1828 N. Howard Mill Road
Robbins, NC 27325
(919) 464-3961

Susan Hussey

Payment Method:
Cash Check
MC Visa

DESCRIPTION
This shop, opened in November 1991, carries folk pottery of North Carolina, Georgia, Alabama, and Virginia. The building, constructed according to regional traditions, houses a museum and special exhibitions. The exhibition in place for the opening was called "Kiln Disasters." The sales area features face vessels, some figures, and animals. There are forty potteries located in this part of North Carolina. The shop and museum are not open every day, so call ahead for hours or to make an appointment.

ARTISTS
John Brock
Charlie Brown
Jerry Brown
Burlon Craig
Billy Henson
Mark Hewitt
Billy Ray Hussey
Charles Lisk

Billie Meaders
Cleater Meaders
David & Anita Meaders
Edwin Meaders
Lanier Meaders
John R. Meaders
Reggie Meaders
Marie Rogers

URBAN ARTWARE GALLERY
207 West Sixth Street
PO Box 1133
Winston-Salem, NC 27101
(919) 722-2345

George Jacobs

Payment Method:
Cash Check MC
Visa AE Discover
Payment plan available

DESCRIPTION
Since 1986, Urban Artware has featured the work of Southeastern outsider and other regional self-taught artists. Recent exhibitions have included early paintings by the Rev. Howard Finster, a James Harold Jennings retrospective, and group shows. Also featured are emerging artists such as Mark Casey Milestone, Woodie Long, Ted Lyons, and Mark Clark, all of whom have had solo shows. Located in a newly renovated turn-of-the-century building, the gallery also features contemporary American craft jewelry, pottery, wood, and glass. The gallery and shop are operated by George Jacobs, who in most cases works directly with the artists. Mr. Jacobs says, "I try to be sure that the artist receives a fair share of the sale of current work."

ARTISTS

Mark Clark	Ted Lyons	Jack Savitsky
Rev. Howard Finster	Mark Casey Milestone	Mary T. Smith
James Harold Jennings	William Henry Overman	Jimmy Lee Sudduth
Woodie Long	Benjamin F. Perkins	Mose Tolliver
Charlie Lucas	Royal Robertson	Inez Nathaniel Walker

Ohio

J.E. PORCELLI/ AMERICAN FOLK ART
12708 Larchmere Boulevard
Cleveland, OH 44120
(216) 932-9087

J.E. Porcelli

Payment Method:
Cash Check
Payment plan available

DESCRIPTION

The gallery is on the street level of a shop where period furniture from Europe and America is restored and sold. The furniture is displayed in the Porcelli Gallery, too, and makes a nice setting for Ms. Porcelli's American folk art and Americana—including tramp art, quilts, bottle cap art, carved canes, architectural items, numerous unsigned pieces, and contemporary self-taught Ohio carver Silvio Peter Zoratti. Joyce Porcelli, with an MFA from Pratt Institute, started with a gallery featuring contemporary "fine art." Customers often looked and said, "I could do that." With her shift to folk art, they still say it, but, in each case, as she says, "they don't." Ms. Porcelli is very enthusiastic about the art, and shares the pleasure of it with her customers, including the wonderful works of Mr. Zoratti. Open by appointment only, or "by chance."

ARTISTS

Rev. Albert Wagner	Silvio Peter Zoratti

and other artists as they come to the owner's attention

Oregon

JAMISON/THOMAS
1313 N.W. Glisan
Portland, OR 97209
(503) 222-0063

William Jamison

Payment Method:
Cash Check
MC Visa AE
Payment plan available

DESCRIPTION

The Jamison/Thomas Gallery was founded in 1980 as the "Folk Craft Gallery," with a primary focus on ethnic and self-taught artists and craftspeople. Over the years the gallery's focus has changed so that contemporary painters, sculptors, and printmakers are its main area of representation. But the gallery has continued to champion the work of a half dozen self-taught and outsider artists. It has made an effort to introduce and then to provide a platform for an artist to bring his or her work to the public, regardless of formal educational background. Mr. Jamison says that "each artist represented, whether self-taught or formally educated, brings a strength and a vision to the gallery which is a strand of the same thread." Mr. Jamison is very interested in both and shares his enthusiasm with those who visit the gallery.

ARTISTS

Russell Childers	Louis Monza
Burlon Craig	Georgiana Orr
Ruza Erceg	Jon Serl
Robert Gilkerson	

PULLIAM-DEFFENBAUGH-NUGENT
522 N.W. 12th Street
Portland, OR 97209
(503) 228-6665

Rod Pulliam
Mary Ann Deffenbaugh
Tim Nugent

Payment Method:
Cash Check
MC Visa AE
Payment plan available

DESCRIPTION
This very accessible gallery features painting and sculpture by contemporary Northwest artists, from recent graduates of the Pacific Northwest College of Art to Guy Anderson and Mark Tobey. Two self-taught artists are represented.

ARTISTS
Ree Brown James Martin

Pennsylvania

JACK SAVITT GALLERY AT CAMELOT
2015 Route 100
Macungie, PA 18062
(215) 398-0075

Payment Method:
Cash Check
Payment plan available

DESCRIPTION
Jack Savitt and his wife Mary-Lou represent Jack's late father, Jack Savitsky, one of America's foremost twentieth century folk artists. The gallery is in a restored 1730 Pennsylvania farmhouse that is also the Savitts' home. It is located on Route 100, formerly known as the Kings Highway, one of the oldest roads in Pennsylvania. The gallery has a wide range of Savitsky's works, from major paintings to his most recent drawings.

ARTIST
Jack Savitsky

JANET FLEISHER GALLERY
211 South 17th Street
Philadelphia, PA 19103
(215) 545-7562

John Ollman

Payment Method:
Cash Check

DESCRIPTION
"The Janet Fleisher Gallery is a prestigious gallery of contemporary mainstream and self-taught art."

ARTISTS
Felipe Archuleta	Sister Gertrude Morgan
Eddie Arning	Philadelphia Wireman
David Butler	Elijah Pierce
Henry Darger	Horace Pippin
Sam Doyle	John Podhorsky
William Edmondson	Martin Ramirez
Minnie Evans	Jon Serl
Rev. Howard Finster	Edgar Tolson
William Hawkins	Bill Traylor
Frank Jones	P.M. Wentworth
Alex A. Maldonado	Joseph Yoakum
Justin McCarthy	Purvis Young

South Carolina

MARY PRAYTOR GALLERY

26 South Main Street
Greenville, SC 29601
(803) 235-1800

Mary Praytor

Payment Method:
Cash Check
MC Visa

DESCRIPTION

This large, 3,000 square foot gallery specializes in contemporary art and folk art, in all media, with a concentration in Southern artists.

ARTISTS

Norman Bowens
Herron Briggs
H.A. Brown
Rev. Howard Finster
Michael Finster
James Harold Jennings
Clyde Jones
Woodie Long

Charlie Lyons
R.A. Miller
Benjamin F. Perkins
Sarah Rakes
Oscar Spencer
Jimmy Lee Sudduth
Allen Wilson

RED PIANO ART GALLERY

220 Cordillo Parkway
Hilton Head, SC 29928
(803) 785-2318

Louanne La Roche

Payment Method:
Cash Check
MC Visa

DESCRIPTION

The Red Piano is a very comfortable gallery that feels more like a home than a commercial establishment. Rooms have been added from time to time, to give a good feeling of space; the walls are glass, opening on a woods with palm trees and an occasional deer wandering by. If you can look away from the wonderful view, you will find lots of contemporary fine art, plus a few self-taught artists.

ARTISTS

Z.B. Armstrong
Sam Doyle
Jake McCord

Jimmy Lee Sudduth
Wesley Stewart

RED PIANO TOO

PO Box 993,
751 Sea Island Parkway
St. Helena's Island, SC 29920
(803) 838-2241

Elayne Scott

Payment Method:
Cash Check
MC Visa

DESCRIPTION

Housed in a building from the last century, this large gallery space contains an eclectic collection of items for sale: art from Africa, Indonesia, the Carribbean; African-American art; handcrafted toys, some of them very old; antiques; and the works of contemporary self-taught artists. The proprieter says the gallery also has "the largest bead collection in the Southeast," and a large collection of Native American art and jewelry. This is a very colorful space.

ARTISTS

Z.B. Armstrong
Sam Doyle
Rev. Howard Finster
Lonnie Holley
Carolyn Mae Lassiter

Jake McCord
R.A. Miller
Roy Minshew
Benjamin F. Perkins
Jimmy Lee Sudduth

Tennessee

BELL BUCKLE CRAFTS
Railroad Square
Bell Buckle, TN 37020
(615) 389-9371

Anne White-Scruggs

Payment Method:
Cash Check
MC Visa Discover

DESCRIPTION
Bell Buckle was an old railroad town that nearly died during the Depression. Then some people started a restoration project. Anne White-Scruggs' shop was the first to open, about twelve years ago, in the old bank building. She carries a variety of works, including hand-made furniture, crafts, and art.

ARTISTS
Homer Green
J.L. Nipper

Michael Rossman
Vannoy Streeter

MAGGIE VAUGHN
PO Box 486
Bell Buckle, TN 37020
(615) 389-6878

Maggie Vaughn

Payment Method:
Cash Check

DESCRIPTION
Maggie Vaughn sells some folk art from her home, by appointment only. She will also take you to meet local carver Homer Green.

ARTISTS
Homer Green

Willie White

RISING FAWN FOLK ART
202 High Street #7
Chattanooga, TN 37403
(615) 265-2760

Jim Hedges
Sally Brooks
Angele Usery

Payment Method:
Cash Check
Payment plan available

DESCRIPTION
This gallery-dealer specializes in Southern folk art, with paintings, sculpture, story quilts, and face jugs. Open by appointment only.

ARTISTS
Leroy Almon, Sr.
Georgia Blizzard
Jerry Brown
Richard Burnside
William Edmondson
Rev. Howard Finster
Sybil Gibson
Homer Green
Bessie Harvey
Lonnie Holley
Clementine Hunter
Joe Light
Woodie Long
Annie Lucas

Charlie Lucas
R.A. Miller
Benjamin F. Perkins
Frank Pickle
Sarah Rakes
Bernice Sims
Vannoy Streeter
Jimmy Lee Sudduth
Sarah Mary Taylor
James "Son" Thomas
Annie Tolliver
Charles Tolliver
Mose Tolliver
Fred Webster

G.H. VANDER ELST

5163 Waddell Hollow Road
Franklin, TN 37064
(615) 794-9631

Ghislain Vander Elst

Payment Method:
Cash Check
Payment plan available

DESCRIPTION

G. H. Vander Elst specializes in twentieth century nontraditional folk art. Entering into the marketplace only since 1989, he is becoming known both for his introduction of new artists and for his background with the "art brut" movement of Europe and the "outsider" grouping here in the United States. G. H. Vander Elst solicits all who have an interest in either of these often parallel movements.

ARTISTS

Georgia Blizzard
Rev. Howard Finster
Homer Green
Joseph Hardin
Lonnie Holley
Walter Tiree Hudson
James Harold Jennings
Joe Light
Benjamin F. Perkins

Robert Roberg
Robert E. Smith
Hugo Sperger
Vannoy Streeter
Jimmy Lee Sudduth
Mose Tolliver
Lillian Webb
Fred Webster

EDELSTEIN/DATTEL ART INVESTMENTS

4134 Hedge Hills Avenue
Memphis, TN 38117
(901) 767-0425

Paul Edelstein
Lisa A. Dattel

Payment Method:
Cash Check
Payment plan available

DESCRIPTION

This gallery concentrates mainly on Southern regional folk art from 1940 to the present.

ARTISTS

Hawkins Bolden
David Butler
Kacey Carneal
William Edmondson
Rev. Howard Finster
Omah Fitzgerald
Theora Hamblett
Clementine Hunter
O.W. "Pappy" Kitchens
Joe Light
Harry C. Marsh

Sister Gertrude Morgan
Benjamin F. Perkins
Braxton Ponder
Royal Robertson
Mary T. Smith
Henry Speller
Jimmy Lee Sudduth
James "Son" Thomas
Fred Webster
Luster Willis
Jack Zwirz

BRUCE SHELTON/ FOLK ART

212 Leake Avenue
Nashville, TN 37205
(615) 352-1970

Bruce Shelton

Payment Method:
Cash Check

DESCRIPTION

Bruce Shelton spends most of his time on the road picking up folk art for dealers and collectors. He has tentative plans to start a gallery one day soon. In the meantime Bruce visits regularly the New England states, Washington, D.C., Chicago, Atlanta, Louisiana, Texas, Virginia, North Carolina, and Florida. He will gladly make "house calls" and "gallery calls" to show you what he has to sell. He does business by mail or telephone, too.

BRUCE SHELTON/FOLK ART *Continued*

ARTISTS

Jesse Aaron
Minnie Adkins
Linvel Barker
Robyn Beverland
Priscilla Cassidy
Ronald Cooper
Denzil Goodpaster
Homer Green

Alvin Jarrett
Lloyd "Hog" Mattingly
Carl McKenzie
Ed "Mr. Eddy" Mumma
Helen LaFrance Orr
Frank Pickle
Braxton Ponder
Dow Pugh

Royal Robertson
Sulton Rogers
James "Son" Thomas
Mose Tolliver
Fred Webster
Wesley Willis

Texas

VALLEY HOUSE GALLERY

6616 Spring Valley Road
Dallas, TX 75240
(214) 239-2441

Donald Vogel
Cheryl Vogel
Kevin Vogel

Payment Method:
Cash Check

DESCRIPTION

Valley House Gallery was founded in 1953 by Donald and Margaret Vogel. It is situated on five acres of sculpture gardens in far north Dallas. The gallery represents many contemporary artists and also carries nineteenth and early twentieth century paintings, drawings, and sculpture. Only the outsider and naive artists are listed below.

ARTISTS

Hub Miller
Valton Tyler

Velox Ward
Clara McDonald Williamson

BRAZOS BOOKSTORE AT MENIL COLLECTION

1520 Sul Ross Street
Houston, TX 77006
(713) 521-9148

Sheila Rosenstein

Payment Method:
Cash Check
MC Visa

DESCRIPTION

It is a bookstore—a very good one in fact. Also, because of the interest of the manager Sheila Rosenstein, folk art pieces are placed about the store and are for sale at very reasonable prices.

ARTISTS

Vanzant Driver

Ike Morgan

CONTACT: OUTSIDER ART SOURCE

4241 South Judson
Houston, TX 77005
(713) 665-3776

Andy Klasel
Cherry Jochum

Payment Method:
Cash Check

DESCRIPTION

Andy Klasel is a dealer and picker who specializes in looking for specific pieces or work from artists at the request of a gallery or a collector. A few of the artists he has contact with are listed below. Available by appointment only.

ARTISTS

Brian Dowdall
James Harold Jennings
Ruth Mattie
Ike Morgan

Royal Robertson
Jimmy Lee Sudduth
George Williams

RM GALLERY

2707 Colquitt
Houston, TX 77098
(713) 526-6450

Rena Minar

Payment method:
Cash Check

DESCRIPTION

RM Gallery was established in 1992 on a street where there are twelve other galleries. RM Gallery "is the first on the street to exclusively represent and exhibit folk and outsider art." They feature artists from all parts of the United States but the focus is on those living in and around Texas.

ARTISTS

Leroy Almon, Sr.
Cyril Billiot
Carl Block
David Butler
Henry Ray Clark
Patrick Davis
Ezekiel Gibbs
Rev. John Hunter
Frank Jones
Price Larson
Oscar McKay
Carl Nash

Benjamin F. Perkins
Royal Robertson
Cherry ShaEla'reEl
Xmeah ShaEla'reEl
Isaac Smith
Robert E. Smith
Roberta Stokes
David Strickland
Jimmy Lee Sudduth
Rev. Johnnie Swearingen
Mose Tolliver
William Warmack

ROBINSON GALLERIES

3514 Lake Street
Houston, TX 77098
(713) 526-0761

Thomas V. Robinson

Payment Method:
Cash Check
MC Visa AE
Payment plan available

DESCRIPTION

This gallery deals in late nineteenth century and early twentieth century American art, and contemporary international art with an emphasis on artists now living in the United States. Mr. Robinson has an interest in "popular art"–a term he prefers to "folk art"–because of its influence on contemporary trained artists.

ARTISTS

Roy Bowen

William Rhule

APPALACHIAN FOLK ART

PO Box 567
Little Elm, TX 75068
(214) 292-2224

Ramona Lampell

Payment Method:
Cash Check
Payment plan available

DESCRIPTION

The Lampells are dealers in the folk art of all Appalachian artists found in their book, *O, Appalachia* and other Appalachian artists they have found since the book was published.

ARTISTS

Minnie Adkins
Carleton Garrett
Dilmus Hall
Rev. Herman Hayes
James Harold Jennings
S.L. Jones
Charley Kinney

Noah Kinney
Charlie Lucas
Benjamin F. Perkins
Cher Shaffer
Oscar Spencer
Hugo Sperger
Clyde Whiteside

SOL DEL RIO ART GALLERY
1020 Townsend
San Antonio, TX 78209
(512) 828-5555

Dorothy L. Katz

Payment Method:
Cash Check
MC Visa

DESCRIPTION
The gallery is one of a complex of small buildings, each one with a different emphasis: antiques; fine contemporary crafts; and international folk art, mostly from Mexico. Sol Del Rio features art and sculpture and the works of several self-taught artists as listed below.

ARTISTS
Michael Creese
John Lawson Felder
M.C. "5¢" Jones
Price Larson

WEBB FOLK ART GALLERY
107 North Rogers
Waxahachie, TX 75165
(214) 938-8085

Bruce Webb
Julie Webb

Payment Method:
Cash Check

DESCRIPTION
The Webbs buy and sell both old and contemporary folk art, gathered from their travels throughout the South, from a building in downtown Waxahachie. In another building nearby they sell from a collection of old lodge memorabilia, tramp art, and memory jugs.

ARTISTS
Cyril Billiot
Carl Block
Bessie Harvey
Rev. John Hunter
M.C. "5¢" Jones
Deacon Eddie Moore
Carl Nash
Royal Robertson
Xmeah ShaEla'ReEl
David Strickland
Jimmy Lee Sudduth
Rev. Johnnie Swearingen
James "Son" Thomas
"Artist Chuckie" Williams

Vermont

WEBB & PARSONS
545 South Prospect Street
Burlington, VT 05401
(802) 658-5123

Pat Parsons

Payment Method:
Cash Check
MC Visa

DESCRIPTION
This gallery, in business for more than 20 years, focuses on contemporary American fine, folk, and outsider art. The gallery also has work of Nova Scotia folk carvers Eddie Mandaggio, Brad Naugler, and Leo Naugler. Open by appointment only.

ARTISTS
Gayleen Aiken
Aaron Birnbaum
Larry Bissonette
Jessie Cooper
Ronald Cooper
Rev. Howard Finster
Justin McCarthy
Dwight Mackintosh
"Old Ironsides" Pry
Roland Rochette
Walt Scheffley
Fannie Lou Spelce
Bill Traylor
Inez Nathaniel Walker
Floretta Warfel

PASSEPARTOUT GALLERY
13 East Allen
Winooska, VT 05404
(802) 655-3710

Elizabeth Bunsen

Payment Method:
Cash Check
MC Visa

DESCRIPTION
This gallery has been exhibiting self-taught and outsider artists since 1987. The focus is primarily but not exclusively on Vermont artists, both self-taught and trained.

ARTISTS
Gayleen Aiken
Larry Bissonette

and the artists from GRACE (Grass Roots Art and Community Effort, see p. 65)

Washington

McVAY'S WOODCARVING FARM
6178 South Maxwelton
Clinton, WA 98236
(206) 321-4973

Judy McVay
Boaz Backus

Payment Method:
Cash Check
MC Visa AE

DESCRIPTION
The art gallery displays a large collection of woodcarvings from the Pacific Northwest, including some of the area's leading chainsaw woodcarvers. The "woodcarving farm" is in a park-like setting and represents over forty-seven regional artists. There is an especially wonderful carved mural of the animals of the Pacific Northwest created by Judy McVay.

ARTISTS
Steve Backus
Lynn Chalk
Rob Chalk
Don Etu
Jack Livingston
Judy McVay
Mike McVay

Pat McVay
Susan Miller
Charlie Mitchell
Dave Sipes
Daniel Smith
Terry Tessler

MIA GALLERY
536 First Avenue South
Seattle, WA 98104
(206) 467-8283

Mia McEldowney

Payment Method:
Cash Check
MC Visa
Payment plan available

DESCRIPTION
The MIA Gallery features both contemporary fine art and folk and outsider art, from West Coast artists and artists throughout the United States. Mia McEldowney emphasizes works in both categories that have a narrative theme. The gallery, founded in 1983, moved from its Occidental Square location to a large space in the Florentine Building, two blocks south, where visitors enjoy sixteen-foot ceilings, large columns, and a second-floor mezzanine for offices. This is one of those galleries where it is safe not to know everything before you enter. Gallery staff are knowledgeable, helpful, and friendly and will answer all questions about the art and the artists. The MIA Gallery is a good place to learn about some of the lesser-known self-taught artists of the Pacific Northwest.

ARTISTS
John Abduljaami
Leroy Almon, Sr.
Walter Barkas

Jon Bok
Ree Brown
David Butler

Ruza Erceg
Rev. Howard Finster
Tim Fowler

MIA GALLERY *Continued*

Dilmus Hall
Bessie Harvey
Daniel Minter
Rosemary Pittman

William E. "Bill" Potts
Stephen Powers
Jon Serl
Simon Sparrow

Rivkah Swedler
Mose Tolliver
Terry Turrell

Wisconsin

**JOHN BALSLEY/
DIANE BALSLEY**
8325 North Cedarburg
Brown Deer, WI 53209
(414) 355-9779

**John Balsley
Diane Balsley**

*Payment Method:
Cash Check
Payment plan available*

DESCRIPTION
The Balsleys handle a wide range of artworks by contemporary self-taught artists as well as one-of-a-kind and/or anonymous pieces, including tramp art and carved canes. "They operate a small exclusive business dealing in high-quality examples of artworks." Open by appointment only.

ARTISTS

Leroy Almon, Sr.
Z.B. Armstrong
Richard Burnside
Jessie Cooper
Ronald Cooper
Rev. Howard Finster
Reginald K. Gee
T.A. Hay
S.L. Jones
Charley Kinney
James Lamb
Carl McKenzie

R.A. Miller
Earnest Patton
Benjamin F. Perkins
Frank Pickle
Mary T. Smith
Jimmy Lee Sudduth
Sarah Mary Taylor
James "Son" Thomas
Mose Tolliver
Fred Webster
and environmental pieces by
 Ronald Beard.

GLAEVE GALLERY
125 State Street
Madison, WI 53703
(608) 255-3997

Jerry Glaeve

*Payment Method:
Cash Check
MC Visa*

DESCRIPTION
Located one block from the Wisconsin state capitol building, the present location of Glaeve Gallery was originally the city's first fire station. Remodeled in 1929 for the Castle Doyle Coal & Oil Company, the building features a unique ceramic facade that is a city landmark. The gallery's collection includes ethnic art with a strong emphasis on African, Native American, and South and North American folk art. The gallery is filled to the brim with objects of "native, folk, and ethnic art." In addition to the art, there are books, music tapes, and jewelry. Many of the books are about folk art. The emphasis in the gallery appears to be on sculpture and forms other than paintings. Mr. Glaeve travels and meets the artists himself and has interesting stories to tell.

ARTISTS

Ray Carpenter
Calvin Cooper
Ronald Cooper
Rev. Howard Finster
Michael Finster

John Gilley
Anna King
Jim Lewis
Junior Lewis
Meaders family

Frank Pickle
Tim Ratliff
Marie Rogers

DEAN JENSEN GALLERY

217 North Broadway
Milwaukee, WI 53202
(414) 278-7100

Dean Jensen

Payment Method:
Cash Check
Payment plan available

DESCRIPTION

While this gallery focuses primarily on contemporary art by artists with national and international reputations, it also regularly mounts exhibitions of twentieth century folk and outsider art. The gallery is located in a large, converted warehouse space in Milwaukee's historic Third Ward, suggestive of many of the galleries in New York's Soho. Besides its large inventory of folk/outsider art, the gallery has a selection of antique Mexican masks.

ARTISTS

Edward Cooper
Josephus Farmer
Rev. Howard Finster
Denzil Goodpaster
Ted Gordon
S.L. Jones
Wesley Merritt
Albert "Kid" Mertz

John Poppin
Mary T. Smith
Henry Speller
Jimmy Lee Sudduth
James "Son" Thomas
Carter Todd
Mose Tolliver
Inez Nathaniel Walker

and now and then, Hawkins Bolden, Sister Gertrude Morgan, Bill Traylor, and Joseph Yoakum.

ECCOLA

237 North Broadway
Milwaukee, WI 53202
(414) 273-3727

Leon Bonifaci

Payment Method:
Cash
MC Visa AE

DESCRIPTION

A very eclectic shop with "objects, furniture, art." The staff says "unpredictable" may be the best word to use to describe the place. Folk art is included in this very colorful and spacious shop.

ARTISTS

Donnie Brown
Calvin Cooper
Robert Cumpston

Thomas May
Russell Rice

METROPOLITAN GALLERY

1018 West Scott Street
Milwaukee, WI 53204
(414) 672-4007

Kent Meuller
Jim Pattison

Payment Method:
Cash Check
Payment plan available

DESCRIPTION

In the Walker's Point area, this is "the happening gallery" in Milwaukee. It carries conceptual, outsider, and figurative art by emerging and established artists. The owners say "eclectic" is the word that fits best. Open by appointment only.

ARTISTS

"Prophet" William J. Blackmon
Eugene Von Bruenchenhein

William Warmack

OTHER SOURCES
OF FOLK AND OUTSIDER ART

There are many small shops, usually displaying and selling contemporary crafts, that have folk artists from time to time. Also there are festivals throughout the country that feature local artists. A few of these are the Omnicraft festival sponsored by the Owensboro Museum in Owensboro, Kentucky in June; the Morgan County Sorghum Festival in West Liberty, Kentucky the third weekend in September; the annual Red River Revel in Shreveport, Louisiana in the fall; the Festivals Acadian in Lafayette, Louisiana the third weekend in September; the Ohio State Fair; and the Kentucky State Fair. State visitors and convention bureaus supply information.

The annual Jazz and Heritage Festival in New Orleans, the last weekend in April and the first weekend in May, has a folk art section. Folk artists who frequently exhibit their work are Bruce Brice, Lorraine Gendron, Joan Julene Jones, David Allen, O.L. Samuels, A.B. Owen, Charles Brock, and Jessie Coates. Write to the New Orleans Jazz and Heritage Foundation, PO Box 53407, New Orleans, LA 70116 for information. The director of the folk art division is Johnda Wilson.

The Kentuck Festival in Northport, Alabama is an annual event scheduled for the third weekend of October. The festival "celebrates the Deep South with presentations of its visionary folk art, traditional and contemporary crafts, legendary music, and regional food." Artists regularly in attendance are Mose Tolliver, Annie Tolliver, Charles Tolliver, Benjamin F. Perkins, Jimmy Lee Sudduth, Bernice Sims, Woodie Long, Miller & Bryant, Lorraine Gendron, Lonnie Holley, Charlie Lucas, Annie Lucas, and Fred Webster. Write for information to the Kentuck Festival of Arts, Kentuck Museum, PO Box 127, Northport, AL 35476. The director is Georgine Clarke.

The "Outsider Art Fair" scheduled for January 30 and 31, 1992. The producers, Sanford L. Smith and Associates (responsible for the Fall Antiques Show at the Pier in New York and other such events) "assembled leading galleries of outsider, naive, self-taught, visionary, and intuitive art for the first time anywhere." A few of the U.S. galleries scheduled to exhibit were: Lynne Ingram/Southern Folk Art, Milford, New Jersey; The Ames Gallery, Berkeley, CA; Leslie Muth Gallery, Santa Fe; Gasperi Gallery, New Orleans; Ricco/Maresca, New York; Carl Hammer, Chicago; Cavin-Morris, New York; Hill Gallery, Birmingham, MI; Judith Alexander, New York; Frank J. Miele Gallery, New York; American Primitive, New York; Luise Ross, New York; Gilley's Gallery, Baton Rouge; Sailor's Valentine, Nantucket; Epstein/Powell, New York; Jamison/Thomas, Portland, OR; Red Piano, Hilton Head; Objects Gallery, Chicago; Galerie Bonheur, St. Louis; Webb and Parsons, Burlington, VT; and the Phyllis Kind Gallery, New York. The Museum of American Folk Art was to provide a book store and organize a symposium. The location for the event was the Puck Building, Lafayette and Houston Streets, in New York City. Plans call for this to be an annual event. [Information provided by the organizers in advance of the event.]

ART CENTERS

Art Centers, as the term is used here, are programs that use opportunities for artistic expression to help people with disabilities or the elderly to develop creatively, to enhance their self-esteem through their accomplishments, and often to increase occasions for interaction with the larger community. These centers provide structure, materials, and a safe place to work. They often have a gallery which exhibits the artists' work and lets clients of the center earn income through the sale of their art (see "Galleries"). Some centers may market their artists' work through arrangements with commercial galleries. Most of the programs identified and contacted for this book are in California, but not all of them. For instance, Very Special Arts has an international program. The people involved in these Art Centers are part of a wonderful undertaking. It is a pleasure to visit these centers and become aware of the art being made there.

Centers are arranged alphabetically by state, then by city within state.

California

**FIRST STREET GALLERY/
ART CENTER**
250 West First Street, Suite 100
Claremont, CA 91711
(714) 626-5455

Catherine Perillo,
Program Director

The First Street Gallery and Art Center was opened in Claremont in 1989 by Tierra del Sol, a private nonprofit foundation. The foundation has provided services to adults with developmental disabilities since 1971. The Art Center provides a studio/classroom where students may learn about drawing, painting, ceramics, and printmaking from professional artists. The First Street Gallery exhibits art work of the Center students. People are encouraged to become Friends of First Street; write for membership to the address above. Friends help the Center to continue and receive a discount on artwork at the First Street Gallery.

**THE NEIGHBORHOOD
CENTER OF THE ARTS**
714 West Main Street,
Suites A and B
Grass Valley, CA 95945
(916) 272-7287

Gillian Hodge,
Director

The Neighborhood Center of the Arts was founded to provide opportunities for people with developmental delays to increase their independence, to earn income, and to achieve integration into the community through their talents as artists.

The students work in studio situations in a variety of arts disciplines: painting, printmaking, clay working, and the fiber arts. As they gain technical skills, they move toward specialization in their main field of interest, exhibiting and selling their artwork, applying for and completing commissions, and generating individual exhibitions. The advisors who guide them are professional artists with degrees and exhibition records in their fields.

The inhouse Everett Davis Gallery holds bimonthly exhibitions featuring specific aspects of the students' art works (see Galleries section). Headed by a gallery manager who is a member of the Center's Board of Directors, volunteers of the gallery Committee prepare, design, and coordinate exhibitions in- or out-of-house. Well-attended artists' receptions are popular community events, generating significant sales. Students are involved with all aspects of marketing their work, including pricing.

**CREATIVE GROWTH ART
CENTER**
355 24th Street
Oakland, CA 94612
(510) 836-2340

Irene Ward Brydon,
Executive Director

The Creative Growth Art Center provides art programs, opportunities to learn about independent living, and vocational opportunities for adults who are physically, mentally, or emotionally disabled. There is an art studio program for the very gifted, where people with potential may become partially or fully self-supporting through their art. Drawing, painting, printmaking, graphic arts, fabric arts, ceramics, and sculpture are included. "Artists in Residence" and other staff provide guidance. As one of these artists said, "for the exceptionally talented we provide quality materials and a safe place to work, and do not otherwise try to influence the art of these people." The Creative Growth Art Center has a gallery (see Galleries section) that professionally exhibits the art of Creative Growth clients. Exhibition at the gallery helps to enhance the clients' self-image and provides an opportunity for the clients to earn income. It is possible

CREATIVE GROWTH ART CENTER *Continued*

to help Creative Growth by becoming a member. Write for a membership form to the address above. Members receive newsletters, a discount on art works by Creative Growth artists, and admission to special events at the Center. [There is a description of the Creative Growth Art Center in the Summer 1991 issue of *Folk Art Messenger,* 6-7.]

NATIONAL INSTITUTE OF ART AND DISABILITIES
551 23rd Street
Richmond, CA 94804
(510) 620-0290

Ronald E. Wray,
Executive Director

"The Institute is founded on the belief that creativity is the highest level of human functioning," and that everyone should have an opportunity to develop his or her own creativity. To put this belief into action, the National Institute of Art and Disabilities provides a stimulating environment, with a large art studio. Here the artists work independently and are encouraged to express in visual terms their thoughts and feelings. A professional art gallery on the premises (see Galleries section) exhibits the work of Institute artists alongside that of outstanding non-disabled artists. The Institute's program includes workshops, lectures, conferences, consultations, publications, and videotapes. Florence Ludins-Katz, the painter, and her husband, a retired clinical psychologist, started the Institute in 1984. Memberships are available, and contributions help support the programs. Write for information about the various categories for joining NIAD.

CREATIVITY EXPLORED OF SAN FRANCISCO
3245 16th Street
San Francisco, CA 94103
(415) 863-2108

Raymond M. Patten,
Director

This is a full-time visual art center for disabled adults. The purpose of the program is to provide a stimulating studio environment in which the students/artists may develop their skills for personal expression and consequently "further develop independent living skills, and a new sense of self-esteem and self-reliance." The open studio of Creativity Explored is accessible to the public at large for viewing works in progress or the artworks displayed in their studio gallery. Creativity Explored has mounted over forty public exhibitions, including shows in the Museum of Modern Art, Bank of America, Cavin-Morris Gallery in New York, and the Vorpal Gallery. By July 1991, for instance, Creativity Explored had arranged for thirty installations of their artists' work in California, Colorado, and Mexico City. Although they do not have a formal gallery at their 16th Street address, this book includes an entry for Creativity Explored in the Galleries section that explains how the art works may be seen and purchased.

CREATIVITY UNLIMITED OF SAN JOSE

1403 Parkmoor Avenue
San Jose, CA 95126
(408) 288-8189

Joy Larane Wilson,
Executive Director

"Creativity Unlimited" of Santa Clara County in San Jose was formed to provide a fine art program for mentally, physically, and developmentally challenged adults who live in the south Bay Area. It has five studios and a staff of ten serving about sixty challenged student artists. There is an on-site "Creativity Unlimited Gallery" where curator Staci Gonzales presents new art works every seven weeks. There are off-site studio exhibits at nine additional locations. Creativity Unlimited's stated mission is to provide a center "where valuable and talented people can come to express their creativity while learning the life skills most people take for granted."

THE CREATIVE CENTER

606 North Bridge
PO Box 943
Visalia, CA 93279
(209) 733-9329

Katharine J. Nelson,
Executive Director

The Creative Center in Visalia, California was established in 1977 as a nonprofit fine arts program for developmentally disabled adults. The Creative Center offers a program of visual and performing arts and life skills. Students are encouraged to explore their identities, develop their talents, and see themselves in positive relationship with their peers and the broader community. Instructors are all professional artists who share their talents with eighty students enrolled in the program. The visual arts department offers classes in acrylic painting, watercolor, sculpture, ceramics, fabric art, weaving, drawing, serigraph, papermaking, primitive art, photography, and a mural class, which has completed five murals in the community during the past two years. Creative Center artists have competed with professional artists and have consistently received top honors for their work. In addition to its own gallery (see Galleries section), work is shown in four other galleries in the Visalia area and is displayed by invitation during special events in the community.

District of Columbia

VERY SPECIAL ARTS

Education Office
John F. Kennedy Center for the Performing Arts
Washington, DC 20566
(202) 628-2800

Very Special Arts, founded in 1974 by Jean Kennedy Smith as an educational affiliate of the Kennedy Center, is an international organization "dedicated to enriching the lives of children and adults with disabilities, through programs in the arts," including visual arts. More than one million people in the United States alone participate in Very Special Arts activities. The international program, established in 1984, exists in more than fifty countries around the world. Festivals are organized in many communities, most of which offer an exhibition of art works. The program also runs the Very Special Arts Gallery in Washington, D.C., which represents artists with disabilities (see Galleries).

Florida

**NATIONAL ART
EXHIBITION BY THE
MENTALLY ILL, INC.**
PO Box 350891
Miami, FL 33135
(305) 448-3879

Juan Martin,
President

The National Art Exhibition by the Mentally Ill, Inc., is a "nonprofit Florida-based organization dedicated to reducing the stigma associated with mental illness by discovering, studying, promoting, exhibiting, and preserving the art of the mentally ill throughout the nation." The organization has an annual art exhibition in Miami. The Third National Art Exhibition by the Mentally Ill took place in Miami in February 1991. The Fourth National Art Exhibition by the Mentally Ill was in Miami, at One Herald Plaza, March 6 to April 30, 1992. Thirty art works from fourteen states were exhibited. The organization has memberships available in several categories, and welcomes support for its programs. A quarterly newspaper is published.

New York

**HAI-HOSPITAL
AUDIENCES, INC./
ARTS WORKSHOP
PROGRAM**
220 West 42nd Street
New York, NY 10036
(212) 575-7695

Elizabeth Marks,
Director

The HAI mission is to provide cultural access for the disabled and disadvantaged. The Arts Workshop Program is for visual arts, and has the goal of providing structure and quality materials to participants who are mentally ill or developmentally disabled. Many of these workshop participants live in group settings and may not be able to keep their own work. HAI acts as guardian of the collection, and has worked out agreements with several commercial galleries to sell the work of HAI artists, for the benefit of the artists. In 1990 a book by Elizabeth Marks and Thomas Kloche about the HAI collections of outsider art was published (see Bibliography); a film has been made (see Filmography); and several public exhibitions have been organized. These have included "Six Artists from the HAI Collection" at the Parsons School of Design in New York City (December 5, 1990-January 11, 1991), and another exhibition at the City Gallery, 2 Columbus Circle, New York City (September 1-November 1, 1991). Memberships in HAI are available, to help support their programs. There is a "periodic publication" called the HAI News.

Vermont

OUT AND ABOUT
R.D. 3, Box 800
Morrisville, VT 05661
(802) 888-7040

Nola Denslow,
Executive Director

Out and About is a nonprofit organization, headquartered in Morrisville, Vermont, where elders of the area come to spend the day. The program is aimed at promoting the highest possible level of independent living. It relies heavily upon the arts because, in the words of Ms. Denslow, "the making of art depends upon imagination, emotional vulnerability, intuitive cognition, a need to communicate clearly, and an accumulated life experience—qualities present in the aged." Participants are encouraged to express themselves in a variety of creative programs, including visual arts. Workshops guided by

professional artists are provided. In 1991 these artists in residence included professionals in writing and dance as well as in painting and sculpture. The work of Out and About artists has been exhibited and well-received in the area. Orison Shedd creates intricate line drawings that he has sold to art patrons. Nina Hooper won a spot on the "Very Special Arts" 1990 calendar for one of her watercolors. In between shows the art work is available for sale, with 85 percent of the proceeds going to the artists. In 1991 Out and About published the second edition of *Solstice Review* (see Bibliography) about its program and its clients. Write to the director for further information.

GRACE/GRASS ROOTS ART AND COMMUNITY EFFORT

RFD Box 49
West Glover, VT 05875
(802) 525-3620

Don Sunseri,
Executive Director

The mission of GRACE is to discover, develop, and promote "native talent" in northern Vermont. GRACE workshops promote self-teaching. There is no systematic instruction in technique or style. A variety of materials and a comfortable work space are provided. Four professional artists "facilitate" workshops in local spaces—nursing homes, town halls, old store fronts, day centers for disabled people. Mr. Sunseri says, "Most GRACE participants are in their 70s, 80s, and 90s, but it is not uncommon to have an octogenarian working alongside a young mother, away from her kids for a few hours, or a middle-aged woman with Downs Syndrome sharing her colored markers with an English teacher." GRACE art is consistently shown in local schools and public places such as laundromats, store windows, and restaurants. It also appears in more formal exhibitions: "Original GRACE" (1979), "Images of Experience" (1983), "Real Romantics" (1985), "The World of Gayleen Aiken" (1987), and "Ten Years of GRACE" (1987). There is also a GRACE art exhibition at the local "Bread and Puppet" Circus in August, and the works are now sought by collectors and museum curators in the U.S. and Europe. There have been several touring exhibitions. The art of people in the GRACE program is sometimes for sale, usually locally. A few of the artists have been seen in Vermont galleries, including Webb & Parsons in Burlington and Passepartout Gallery in Winooski.

MUSEUMS

Descriptive material and information about artists represented in permanent museum collections was provided by the museums, nearly always by members of the curatorial staff. Information about the Albuquerque Museum of Art, History, and Science and about the Museum of African-American Life and Culture in Dallas, Texas was obtained from written sources. Before visiting any museum with the intention of seeing the work of specific artists, it is best to call ahead to see if the work is currently on view or if it may be seen by special arrangement. The hours and days of opening are not included here because they are subject to change, especially in the case of some of the smaller institutions. It is a pleasure to know that when visiting the nation's capital, one can now always go to the first floor of the National Museum of American Art and see five galleries hung with folk art from the permanent collection.

Museums are arranged alphabetically by state, then by city within state, and then by the name of the museum if a city has more than one museum.

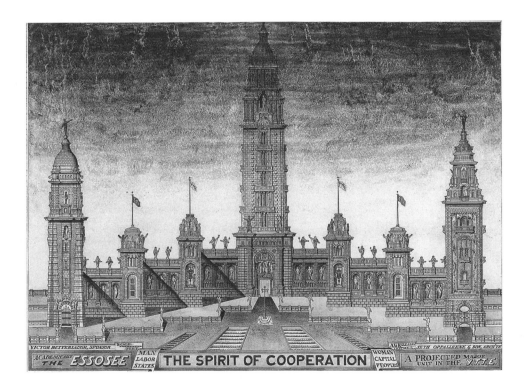

Alabama

BIRMINGHAM MUSEUM OF ART

2000 8th Avenue North
Birmingham, AL 35203
(205) 254-2565

The museum has a number of folk artists, particularly artists from the Southeast, but from other areas too. This collection includes works by:

Z.B. Armstrong
Ronald Cooper
William Dawson
Thornton Dial
Charlie Dieter
William Edmondson
Rev. Howard Finster
Lorraine Gendron
Ted Gordon
Ralph Griffin
Joseph Hardin
Lonnie Holley
Clementine Hunter
Rev. Jeff Hunter
James Harold Jennings
Charley Kinney
Joe Light
Rebecca Light
Charlie Lucas
Willie Massey

Justin McCarthy
R.A. Miller
Sister Gertrude Morgan
Ike Morgan
J.B. Murry
Benjamin F. Perkins
"Old Ironsides" Pry
Royal Robertson
Sulton Rogers
Jack Savitsky
Bernice Sims
Mary T. Smith
Robert E. Smith
Jimmy Lee Sudduth
Sarah Mary Taylor
Mose Tolliver
Herbert Walters
Fred Webster
Willie White
George Williams

FAYETTE ART MUSEUM

530 North Temple Avenue
Fayette, AL 35555
(205) 932-8727

The museum collection houses works of three Fayette County folk artists, plus one adopted from a neighboring county. In addition the museum has approximately 1,500 pieces—much of it art on found objects—by former resident Lois Wilson (1905-1980), an artist with formal training whose last years were spent trying to "rid my brain of all the dreary things I had been taught." Director/curator Jack Black says this woman's work is reason enough to visit the museum. The Fayette County folk artists are Benjamin F. Perkins, Jimmy Lee Sudduth, and Fred Webster. The neighbor is Sybil Gibson. The museum is open Monday, Tuesday, Thursday, and Friday, and at other times by reservation.

FINE ARTS MUSEUM OF THE SOUTH

4850 Museum Drive
PO Box 8426
Mobile, AL 36689
(205) 343-2667

"FAMOS" has thirteen sculpture pieces by African-American artist Robert Marino(1893-1973), pottery from Cheever Meaders, and a snake jug and a face jug made by Lanier Meaders. There is also one piece of wire sculpture by a local self—taught artist, David "Sir" Chesley Harris. Over the last six years the museum has had two exhibitions of "outsider" art, but at present has no others scheduled.

MONTGOMERY MUSEUM OF FINE ARTS
One Museum Drive
PO Box 230819
Montgomery, AL 36123
(205) 244-5700

Works by folk artists are included in various permanent collection exhibitions throughout the year. The acquisition of works by Southern folk artists for the permanent collection is a collecting priority of the museum. In recent years the museum has had exhibitions titled "The Hemphill Collection of American Folk Art," "Amish Quilts," "Southern Folk Images," and "Charlie Lucas" and will continue to book exhibitions of folk art. Artists in the collection are Clementine Hunter, Elijah Pierce, Mose Tolliver, and there are a significant number of works by Bill Traylor.

Arizona

MUSEUM OF NORTHERN ARIZONA
Route 4, Box 720
Fort Valley Road
Flagstaff, AZ 86001
(602) 774-5211

The Museum of Northern Arizona features galleries in archaeology, ethnology, geology, and fine arts. Approximately eight changing exhibits are held each year, including annual Hopi, Navajo, and Zuni artists' exhibitions. The museum offers many educational programs for children and adults, including trips to places of interest on the Plateau. It also publishes a quarterly magazine, *Plateau.* For more than sixty years the museum has been committed to supporting, encouraging, collecting, studying, and exhibiting new expressions, as well as traditional art forms, by Native American artists from the Colorado Plateau. Some of the artists represented at MNA whose works represent a departure from traditional Native American styles are:

Alice Cling
Evelyn Fredericks
John Fredericks
Ron Malone
Nora Naranjo-Morse

Al Qoyawayma
Brenda Spencer
Baje Whitethorne
Harold Willeto

ARIZONA STATE UNIVERSITY/ ART MUSEUM
Nelson Fine Art Center
Tempe, AZ 85287
(602) 965-2787

The museum has many eighteenth and nineteenth century folk art pieces, and a quilt by Helen Stice. The only twentieth century pieces are two face jugs by Lanier Meaders.

Arkansas

ARKANSAS ARTS CENTER
Macarthur Park
Ninth and Commerce Streets
PO Box 2137
Little Rock, AR 72203
(501) 372-4000

The Arkansas Arts Center's permanent collection includes drawings and sculpture by folk/outsider artists. The works are not always on exhibit, but may be viewed by appointment. Artists included are:

Ulysses Davis
William Edmondson
Minnie Evans
Lee Godie
Ted Gordon
William Hawkins

Clementine Hunter
S.L. Jones
Sister Gertrude Morgan
O.L. Samuels
Bill Traylor

California

CRAFT AND FOLK ART MUSEUM
6067 Wilshire Boulevard,
4th Floor
Los Angeles, CA 90036
(213) 937-5544

Founded in 1973, the museum is dedicated to the documentation, conservation, and collection of folk art, contemporary craft, design, and architecture. The museum sponsors many educational programs. The present collection "numbers around 1800 objects" and includes works by:

Minnie Adkins	Howard Sheare
Calvin Cooper	Buster Simpson
Sam Doyle	Luis Tapia
Eluid Levi Martinez	Mose Tolliver
Lanier Meaders	Fred Webster
Dan Sansone	Luster Willis

The Library/Media Resource Center was opened in 1979 and supports the research pertinent to all of the museum programs. There is an extensive collection of books, journals and audiovisual materials, plus thousands of original files on artists and organizations. The library, which also serves as an archive documenting all of CAFAM's exhibitions and programs, is used by the public as well as museum staff and others. Plans have been drawn for a greatly expanded research library, which will include a Center for the Advanced Study of Art, Design, and Material Culture. The Center will be a fellowship program and "think tank." The purpose is "to expand knowledge of the meaning of objects to individuals and in culture, through research, publication, and dialogue."

OAKLAND MUSEUM
1000 Oak Street
Oakland, CA 94607
(510) 273-3401/3005

The Oakland Museum is an internationally acclaimed regional museum of California, offering visitors an opportunity to view the state in microcosm. Permanent and changing exhibitions, collections, and programs deal exclusively with the California theme, presenting the ecology, history, artistic expression, and cultural diversity of the state. There are permanent and special exhibits of the work of the state's most highly regarded painters, sculptors, photographers, and craftspeople. The collection includes works by:

John Abduljaami	Felix Angel Mathews
Peter Allegaert	John Newmarker
Ursula Barnes	Ruth Renick
John Ehn	John Roeder
Louis J. Henrich	Peter Thompson
George F. Knapp	Carrie Van Wie
Alex A. Maldonado	

SAN FRANCISCO CRAFT AND FOLK ART MUSEUM
Landmark Building A,
Fort Mason Center
Laguna and Marina Boulevard
San Francisco, CA 94123
(415) 775-0990

The museum, established in 1983, has changing exhibitions and presents films, lecture series, and special events. There is no permanent collection. A newsletter is published, as is a quarterly publication, *A Report*. These publications and free use of the reference library are available to museum members. The exhibition "Primal Portraits: Adam and Eve Imagery as Seen by Twentieth Century American Self-Taught Artists" was presented in the summer of 1990. In 1991 the museum presented an exhibition, "Looking Pretty, Sitting Fine" which included the Baltimore screen painters.

District of Columbia

ARCHIVES OF AMERICAN ART
Smithsonian Institution
Eighth and F Streets, N.W.
Washington, DC 20560
(202) 357-2781

The Archives of American Art has the largest collection of primary source material documenting visual arts in the United States. The Archives makes available to researchers the original records of American painters, sculptors, craftspeople, collectors, dealers, and also those of critics, historians, curators, museums, societies, and art publications. Millions of items are available for study at the Archives and at the regional centers in New York City, Detroit, Boston, and San Marino, California. The collection is available to all interested people. Some collections, often those of living persons, may have restrictions, and the use of unfilmed collections of papers require advance appointments, so it is recommended that anyone wishing to use the Archives call in advance.

Two early collections are the records of Edith Halpert's American Folk Art Gallery and the papers of Holger Cahill. Herbert Waide Hemphill, Jr. donated his papers to the archive and these include, among other items and documents, letters from artists Miles B. Carpenter, Rev. Howard Finster, S.L. Jones, Gustav Klumpp, George Lopez, Alex A. Maldonado, Eddie Owens Martin (St. EOM), Sister Gertrude Morgan, and Luis Tapia. Among the papers of self-taught artists are materials from Eddie Arning, Henry Darger, Rev. Howard Finster, James Hampton, Grandma Moses, and Horace Pippin.

Taped interviews made by Willem Volkersz include those with:

Minnie Black	Jesse Howard
Ned Cartledge	Eddie Owens Martin (St. EOM)
Chief Rolling Mountain Thunder	Columbus McGriff
	R.A. Miller
Jim Colclough	Dow Pugh
"Cedar Creek Charlie" Fields	Herman Rusch
Rev. Howard Finster	Fred Smith
Ed Galloway	Mary T. Smith
Carlton Garrett	Robert E. Smith
Emil Gehrke	Jimmy Lee Sudduth
Robert Gilkerson	Mose Tolliver
Dilmus Hall	Willard Watson
Irene Hall	

There are also other interviews with artists William Dawson, Miles B. Carpenter, Rev. Howard Finster, Marshall B. Fleming, and Edgar Tolson, and interviews with a number of collectors.

Liza Kirwin, Southeast Regional Collector of the archive, notes the special problems of collecting primary materials from artists who are either illiterate or not interested in documentation. She says, "we seek artists' spoken words and observations, slides, photographs, and videotapes." Among these types of materials, in addition to the tapes noted, are the collection of David Butler photographs made by John Geldersma and papers of people closely associated with an artist.

NATIONAL MUSEUM OF AMERICAN ART
Smithsonian Institution
Eighth and G Streets, N.W.
Washington, DC 20560

The National Museum of American Art represents "outstanding visual accomplishments" from the eighteenth century to the present. Included are more than 600 examples of folk art. In 1986 the museum acquired the Hemphill Collection. Prior to that time about 150 pieces of folk art had been collected, and additional pieces have been acquired since the Hemphill Collection. In 1990 the museum presented a major exhibition and publication, "Made With Passion: The Hemphill Folk Art Collection." In early 1992 the exhibit "Folk Art Across America" opened and is on view indefinitely in the five newly designed galleries on the museum's first floor. Lynda Roscoe Hartigan, curator, Museum of American Art, says the museum has a serious commitment to the study and acquisition of this art. The museum is responsible for several publications with relevance to folk art, which are listed in the bibliography: *Made With Passion: The Hemphill Folk Art Collection; Afro-American Art: 20th Century Selections* (includes White, Edmondson, Hampton); *Hispanic American Art* (includes Ramirez, Barela, Ortega); and *Free Within Ourselves: African-American Artists in the Collection of the National Museum of American Art* by Regenia Perry. In addition to earlier works and anonymous works, artists in the collection include:

Felipe Archuleta	Irving Dominick
Eddie Arning	William Edmondson
Steve Ashby	Minnie Evans
Patrocino Barela	Albina Felski
"Peter Charlie" Besharo	"Cedar Creek Charlie" Fields
Calvin and Ruby Black	Rev. Howard Finster
Nounoufar Boghosian	Walter Flax
Robert Brown	Marshall B. Fleming
Vincent Canade	J.O.J. Frost
Miles B. Carpenter	Harold Garrison
Jennie Cell	Victor Joseph Gatto
Clark Coe	Theodore H. Gordon
Jim Colclough	James Hampton
Hinson C. Cole	Perkins Harnly
David Courlander	Bonnie Harris
Earl Cunningham	William Hawkins
Frances Currey	Thorvald Arnst Hoyer
Henry Darger	Frank Jones
William Dawson	Joe Jones

NATIONAL MUSEUM OF AMERICAN ART *Continued*

S.L. Jones
Josephine Joy
Edward A. Kay
Gustav Klumpp
Benniah C. Layden
Doris Emrick Lee
James Leonard
George Lopez
Howard Taft Lorenz
Justin McCarthy
Eric Calvin McDonald
Fred McLain
Lanier Meaders
Ben Miller
Peter Minchell
Ethel Wright Mohamed
Louis Monza
Sister Gertrude Morgan
Jose Benito Ortega
Leslie Payne

John Perates
"Old Ironsides" Pry
"Butch" Quinn
Martin Ramirez
Max Reyher
Jack Savitsky
Clarence Schmidt
Jon Serl
Q.J. Stephenson
Patrick J. Sullivan
Mose Tolliver
Edgar Tolson
Bill Traylor
Inez Nathaniel Walker
P.M. Wentworth
George W. White, Jr.
Charlie Willeto
Robert Windham
Malcah Zeldis

The Library of the National Museum of American Art and the National Portrait Gallery is in the Old Patent Office Building and may be entered at Eighth and F Streets, N.W. or Eighth and G Streets, N.W. Directions to the library are given at the Guard Office. The telephone number is (202) 357-1886. The library is a research collection and is open to the public. The collection includes 45,000 catalogued volumes, principally on American art, history, and biography. Auction catalogs, periodicals and serials, scrapbooks, microforms, and uncatalogued art ephemera in 300 file drawers make up the remainder of the collection. Emphasis is on painting, graphic art, and sculpture, with a growing concern for photography and decorative arts.

PHILLIPS COLLECTION
1600 21st Street, N.W.
Washington, DC 20009
(202) 387-2151

The Phillips has a collection of nineteenth and twentieth century American and European painting and sculpture. Included are works by Grandma Moses, John Kane, and Horace Pippin.

Florida

EAST MARTELLO MUSEUM
3501 South Roosevelt Boulevard
Key West, FL 33040
(305) 296-3913

The museum is a private, nonprofit institution of the Key West Art and Historical Society, housed in a building constructed as a Civil War fortress. Two collections of interest to folk art people are: The Papio Collection, which consists of the sculpted scrap metal "creatures" made by Stanley Papio and situated outside his home until his death in 1982; and a large collection of wood carvings and drawings of Mario Sanchez.

Georgia

HIGH MUSEUM OF ART
1280 Peachtree Street, N.E.
Atlanta, GA 30309
(404) 892-3600

The High Museum features "19th and 20th-century American painting, decorative arts, photography, African art and prints." Folk and outsider artists in the collection include:

Eddie Arning
Georgia Blizzard
David Butler
Ned Cartledge
Ulysses Davis
William Edmondson
Minnie Evans
Rev. Howard Finster
Carlton Garrett

Dilmus Hall
Clementine Hunter
Lanier Meaders
Mattie Lou O'Kelley
Nellie Mae Rowe
Mose Tolliver
Bill Traylor
Lizzie Wilkerson
Knox Wilkinson

COLUMBUS MUSEUM
1251 Wynnton Road
Columbus, GA 31906
(404) 649-0713

This museum houses a collection that concentrates on objects from the deep South, particularly Georgia, Alabama, and northern Florida. St. EOM's collection of artistic and written work (about 2,000 objects), and films and tapes of the artist, which belong to the Marion County Historical Society, are in storage at the museum. The Columbus Museum has actively engaged in collecting and exhibiting the work of self-taught artists since the 1980s. Included in the collection are:

Carl Brown
Burlon Craig
Minnie Evans
Thomas Jefferson Flanagan
D.X. Gordy
Rev. Hayes
S.L. Jones

Lanier Meaders
Jessie DuBose Rhoads
St. EOM
Mose Tolliver
Edgar Tolson
Herman Wadsworth
Fred Webster

plus anonymous works—over 300 pieces in all.

MUSEUM OF ARTS AND SCIENCES
4182 Forsyth Road
Macon, GA 31210
(9112) 477-3232

Folk art objects in the permanent collection are almost exclusively the works of potters. There are pieces from Bill Meaders, Edwin Meaders, Cleater Meaders, Marie Rogers, Mike Merritt, and Chester Hewell. A number of these are face jugs. In 1989 the museum had an exhibition, "Georgia Clay: Pottery of the Folk Tradition." An illustrated catalog was published (see "Bibliography").

KING-TISDELL COTTAGE FOUNDATION
503 East Harris Street
Savannah, GA 31401
(912) 234-8000

The foundation administers the King-Tisdell Cottage, a museum dedicated to preserving the black history and culture of Savannah and the Sea Islands. The museum is at 514 E. Huntingdon Street in Savannah. In 1988 the museum presented "Wooden Souls," a documentary of the work of master sculptor Ulysses Davis, with

KING-TISDELL COTTAGE FOUNDATION *Continued*

photodocumentation by Roland L. Freeman. On February 23, 1992 a year-long exhibition of the Ulysses Davis Collection, sponsored by the foundation, opened at the Savannah History Museum. It was the desire of Ulysses Davis that his work be kept together and be sold as a collection to the King-Tisdell Cottage Foundation. His wish remains the desire of his family, according to foundation president W.W. Law. Before his death, Davis approved the movement of his barber shop to the King-Tisdell Cottage. With his shop preserved as a museum, his work will be exhibited in its original setting. The organization is actively soliciting funds to purchase the art collection, and tax deductible gifts to support this purchase may be made to the foundation at the Harris Street address listed above.

Illinois

TARBLE ARTS CENTER
Eastern Illinois University
9th Street at Cleveland Avenue
Charleston, IL 61920
(217) 581-2787

The collections at the Tarble Arts Center include "Academic, contemporary, historical and international exhibitions; contemporary Illinois folk art, American Scene prints, and contemporary regional art collections." Eastern Illinois University started to collect Illinois folk arts in 1976, through the College of Fine Arts. "The impetus for the Folk Arts Collection came from three surveys of contemporary folk artists living in east central and southeastern Illinois, conducted in 1976 and 1985." The Folk Arts Collection, survey data, and archival materials were passed from the College of Fine Arts and the Paul T. Sargent Gallery to the Tarble Arts Center when it opened in 1982. "Outsider and naive artists of particular note featured in the permanent collection are painter Jennie Cell (1905-1988), carver and assemblage-maker Ferd Metten (1893-1977), textile artist Cora Meek (age 102 in 1992), and Arthur Walker (1912-)."

THE ART INSTITUTE OF CHICAGO
Michigan Avenue and
Adams Street
Chicago, IL 60603
(312) 443-3600

There are numerous drawings by Joseph Yoakum, a few drawings by Henry Darger, and two works by Minnie Evans in the Department of Prints and Drawings. The Department of American Arts has a carved and painted wood turkey by Leroy Ortega, two miniature Mardi Gras floats made of beads by John Landry, a whirligig by Frank Memkus, and a small sculpture by Albert Zahn—all of these on exhibition in the Folk Art Galleries. The 20th Century Painting and Sculpture Department has in its collection a Grandma Moses, "Making Apple Butter," 1958, and a Horace Pippin, "Cabin in the Cotton," before 1937.

MUSEUM OF ONTEMPORARY ART
237 E. Ontario Street
Chicago, IL 60611
(312) 280-2660

The Museum of Contemporary Art has shown outsider or folk art a number of times in its history, particularly as it relates to the Chicago art movement known as "Imagism." The museum owns several works by Henry Darger, Lee Godie, and Joseph Yoakum.

Kansas

MUSEUM OF GRASSROOTS ART
Highways 460 and 1055
Vineland, KS 66044
(913) 842-8242 or
(913) 594-3801

Founded in 1981 by the Kansas Grassroots Art Association (KGAA), this museum in a grange building is used to display examples of environmental art by artists whose works could not be preserved "on site" (which is the preferred goal of KGAA). Examples of works and artists in the collection are: Dave Woods of Humboldt, Kansas, who "strung together junk into fantastic arrangements in his house and yard;" hundreds of concrete yard pieces made by Ed Root and saved by his sons when the family farm was covered over by a reservoir; Inez Marshall who created "the Continental Sculpture Hall" in Portis, Kansas; John Hollenbeck of Cottonwood Falls and Hans Jorgenson of Lincoln; Harry Ponder (carver); Fred Smith; eight pieces of driftwood sculpture from the environment of "Cap" Harvey, Coos Bay, Oregon; a boat by Walter Flax; a bird by Romano Gabriel; a gate and tools by Ed Galloway; and a windmill by Edd Hoch.

KGAA has an extensive library on grassroots artists and environments. One of the major collections is a slide library of over 4,000 slides, black and white, and color negatives of sites worldwide, as well as film, video, and audio tapes related to environmental art. There are clipping files from newspapers and magazines about artists, and a collection of books, exhibition catalogs, and magazine articles.

The museum is open in the afternoons of the first Sunday of the warmer months (April through November)—since the museum building has no heat—and by appointment. The library is open by appointment. For appointments or further information write KGAA, PO Box 221, Lawrence, KS 66044. [A museum profile by Barbara Brackman appears in *Folk Art Messenger,* Winter 1991.]

Kentucky

APPALACHIAN MUSEUM/ BEREA COLLEGE
Jackson Street
Berea, KY 40404
(606) 986-9341

The museum is located on Jackson Street, just behind Boone Tavern. It was created when several collections of Appalachian related objects were donated to Berea College. Permanent exhibits focus on the culture of preindustrial Appalachia. There is one gallery devoted to temporary exhibits. The museum does have a few pieces of twentieth century folk art, but has no systematic plan to acquire it. They do schedule exhibitions though, usually one per year. In 1986 there was an exhibit of southwest Virginia artist Fred Carter. In 1987 they exhibited "Remembrances: Recent Memory Art by Kentucky Folk Artists." They had a Howard Finster exhibition in 1988. A slide/tape program accompanied this exhibition and will be shown to any visitor asking to see it. In 1991 there was an exhibit of the works of Evan Decker, a self-taught artist from Wayne County, Kentucky, and in 1992 the museum hosted an exhibit of mostly twentieth century carved canes from the earlier "Sticks" exhibition at the Kentucky Arts and Crafts Foundation in Louisville. The permanent collection includes works by Fred Carter, Carlos Cortez Coyle, and Rev. Howard Finster.

KENTUCKY MUSEUM/ WESTERN KENTUCKY UNIVERSITY
Bowling Green, KY 42101
(502) 745-2592

The Kentucky Museum has a collection titled "Handmade Harvest: Traditional Crafts of Tobacco Farmers." It was assembled in 1987 by the museum staff for an exhibition with the same name. There are a few works that qualify as art, including puppets and paintings by Helen LaFrance Orr, carved figures and canes by Homer Bowlin, carved figures and a snake cane by Ed and Pansy Cress, a figure and tobacco truck by Noah Kinney, stone figures by William McClure, carvings by Charlie Lewis, and a painted gourd by Sally Cammack. There is also a fox figure by Hal McClure.

FOLK ART MUSEUM
The Folk Art Center/
Morehead State University
119 West University Boulevard
Morehead, KY 40351
(606) 783-2760

The Folk Art Museum, curated by Adrian Swain, came into being as the Folk Art Collection in the spring of 1985 "to provide a museum environment in which to preserve, document, exhibit and study the creative work of the region's self-taught, grassroots artists." The mailing address is: The Folk Art Center, UPO 1383, Morehead State University, Morehead, KY 40251. The collection includes works by:

Garland Adkins
Minnie Adkins
Mabel Alfrey
Elisha Baker
Lillian Barker
Linvel Barker
Minnie Black
Marie Braden
Donnie Brown
Bob Cassady
Benny Catron
Calvin Cooper
Harry Cooper
Jessie Cooper
Ronald Cooper
Ruthie Cooper
Tim Cooper
Martin Cox
Paul Cox
Johnnie Eldridge
Debbie Evans
John Fairchild
Michael Farmer
Marvin Finn
John Gilley
Larry Gilley
Denzil Goodpaster
Larry Hamm
Gary Hargis
T.A. Hay
Mack Hodge
Harry Jennings
Arlie Johnson
Charley Kinney

Hazel Kinney
Noah Kinney
Roddie Leath
Jimmy Lewis
Junior Lewis
Leroy Lewis
Tim Lewis
Willie Massey
Thomas May
Carl McKenzie
William Miller and
 Rick Bryant
Earl Moore, Sr.
Nolan Parsons
Jody Partin
Earnest Patton
Eugene Peck
Jack Pennington
Gilbert Perrin
Darwood Potts
Bobby Quinlan
Tim Ratliff
Russell Rice
J.C. Rose
Joy Rose
Hugo Sperger
Donny Tolson
Edgar Tolson
Benny Wells
Linda Williams
Russell Williams
Genevieve Wilson
Don Young
Tom Young

OWENSBORO MUSEUM OF FINE ART

901 Frederica Street
Owensboro, KY 42301
(502) 685-3181

The museum has many traditional collections. Of special interest here is the collection of Kentucky art which documents the work of artists connected to Kentucky by birth, education, or residence. In 1991 the museum presented "the premier exhibition" of its collection of works by Kentucky's self-taught artists and crafts people: "Kentucky Spirit: The Naive Tradition." This art will be included in the museum's new Kentucky Wing that is scheduled to open in 1993. Other permanent exhibitions have been: "The Naive Approach" in 1983 and "Unschooled Talent" in 1979. Self-taught artists in the collection include:

Garland Adkins
Minnie Adkins
Lillian Barker
Edgar Bell
Minnie Black
Roger Blair
Pat Brothers
Sally Cammack
Connie Carlton
Mary Anderson Cayce
Elmer Cecil
Maurice Clayton
Calvin Cooper
L.D. Cooper
Ronald and Jessie Cooper
Kenneth Cross
Sam Drake
Everett Druien
John Eldridge
Michael Farmer
Don Farrell
Marvin Finn
John Gilley
Denzil Goodpaster
Jim Harris
Renee Hicklin
Unto Jarvi
Charley Kinney

Noah Kinney
Don Lacy
Edd Lambdin
Shirley Lambdin
Bonnie Lander
Connie Lewis
Jim Lewis
Junior Lewis
Tim Lewis
William E. Low
Lloyd "Hog" Mattingly
Thomas May
Carl McKenzie
Thomas O. Miller
William Miller and
 Rick Bryant
Lonnie Money
Helen LaFrance Orr
Earnest Patton
Russell Rice
Margaret Hudson Ross
Erwin Lex Shipley
Judge Robert M. Short
Rev. Oda Shouse, Jr.
Tim Sizemore
Hugo Sperger
Judge George Triplett, III

The museum has an extensive library with reference materials, photographs of artists, and documentary material for all exhibitions including artists in attendance.

Louisiana

ALEXANDRIA MUSEUM OF ART
933 Main Street
PO Box 1028
Alexandria, LA 71309
(318) 443-3458

The museum has the North Louisiana Folk Art Collection that was featured at the 1984 World's Fair in New Orleans. Most of the arts and crafts included represent traditional works. Other artists represented are David Allen and Clementine Hunter.

RIVERSIDE MUSEUM/ LOUISIANA ARTS AND SCIENCE CENTER
100 South River Road
PO Box 3373
Baton Rouge, LA 79821
(504) 344-9463

The Museum has in its permanent collection a number of paintings by artist Clementine Hunter. In the summer of 1991, the museum hosted an exhibition, "Outsider Art," which included Louisiana artists Heleodoro Cantu, Jessie Coates, and Marion Conner.

RURAL LIFE MUSEUM
Louisiana State University
6200 Burden Lane
Baton Rouge, LA 70808
(504) 765-2437

The Rural Life Museum of Louisiana's collection of artifacts and antiques has developed around the plantation home of Steele Burden and his family, which was given to LSU. Many of the objects were gathered from around the countryside by Burden; the beautiful landscaping is also the result of his long years of work. At the time of this writing, Burden was still at the Museum, seated in a corner making ceramic sculpture. This self-taught artist's works are found in the homes of many collectors. They are sold, when available, at the Museum and at Gilley's Gallery in Baton Rouge (see "Galleries").

UNIVERSITY ART MUSEUM
University of Southwestern Louisiana
Drawer 42571
Lafayette, LA 70504
(318) 231-5326

The museum's permanent collection is located at 101 Girard Park Drive. Founded July 1, 1983, the museum has among its objects the Louisiana Art Collection of nineteenth and twentieth century artists, "both academic and outsider." The outsider artists include Clementine Hunter (three works), David Butler (one work), Milton Fletcher (one work), and Royal Robertson (four works). The exhibition "Baking in the Sun" circulated from USL to other museums. The catalog prepared for the exhibition won a prize in 1988 for excellence in art publishing.

NEW ORLEANS MUSEUM OF ART
One Lelong Avenue, City Park
PO Box 19123
New Orleans, LA 70124
(504) 488-2631

The museum collection contains arts of the Americas, pre-Columbian to the present; photography; African and Asian art; thirteenth through nineteenth century European painting; and decorative arts. It is actively developing a folk art collection. Twentieth century folk artists represented are:

Eddie Arning
Robyn Beverland
Ivy Billiot
Sainte-James Boudrôt
Bruce Brice
David Butler
Miles B. Carpenter
Earl Cunningham
William Dawson
"Uncle Jack" Dey
Antonio Esteves
Rev. Howard Finster
Victor Joseph Gatto
Sybil Gibson
Ralph Griffin
William Hawkins
Clementine Hunter
Charles W. Hutson
James Harold Jennings
Clyde Jones
Frank Jones
Charley Kinney
Gustav Klumpp
O.W. "Pappy" Kitchens
Joe Light

Willie Massey
Justin McCarthy
Sister Gertrude Morgan
Benjamin F. Perkins
Elijah Pierce
"Old Ironsides" Pry
"Butch" Quinn
"Popeye" Reed
Royal Robertson
Sulton Rogers
St. EOM
J.P. Scott
Jon Serl
Bernice Sims
Mary T. Smith
Marion Souchon
Jimmy Lee Sudduth
Rev. Johnnie Swearingen
Willie Tarver
Charles Tolliver
Mose Tolliver
Gregory Van Maanen
Willie White
"Chief" Willey

The museum has sponsored a number of exhibitions including one of David Butler works and another featuring Clementine Hunter. A major exhibition, "Passionate Visions of the American South: Self-Taught Artists from 1940 to the Present," is scheduled for 1993-1994 at the museum and then will travel.

MEADOWS MUSEUM OF ART

Centenary College
2911 Centenary Boulevard
Shreveport, LA 71104
(318) 869-5169

The museum has a collection of paintings and drawings. Artists in the permanent collection include:

David Butler
Rev. Howard Finster
J.B. Murry
Juanita Rogers

Mose Tolliver
Mary T. Smith
James "Son" Thomas

Note: Magale Library Gallery at Centenary has Milton Fletcher in its collection.

Maryland

**AMERICAN VISIONARY
ART MUSEUM**
Development Office
PO Box 287
Stevenson, MD 21153
(410) 653-5202

Incorporated in 1989, this museum is "in process," but with the determination and success rate of Rebecca Hoffberger, it is certain to be realized. "The American Visionary Art Museum, to be located in Baltimore's Inner Harbor area, will be the first museum in North America to be wholly dedicated to assembling a comprehensive national collection of the finest and most original examples of American visionary art," says Hoffberger. The museum has its founding roots in the People Encouraging People program, Maryland's largest training program of job and independent living skills for people who have a chronic mental illness. While employed as director of development at PEP, AVAM's board president, Rebecca Hoffberger, conceived of a museum/education center as a "national showcase for the remarkable talents and accomplishments of the disabled, the elderly, and other self-taught artists, and a place for quality training and employment of high-functioning handicapped people." The museum will be housed in the renovated space of a large former whiskey warehouse. There will be a sculpture garden, a library, a theater, a gift shop, and five or six exhibition galleries in the facility.

Just a few examples of the collections and artists' work already acquired by the American Visionary Art Museum include: the entire archive of Dr. Otto Billig, consisting of his large private library, research papers, and over 1200 pieces of art; the Adamson Travelling Collection of Great Britain; art works by the Baltimore Glassman, Gerald Hawkes, Eddie Arning, Abraham Lincoln Criss, Martin Ramirez, Frank Jones, and Rev. Howard Finster; the Light-Saraf Film Archive; BBC Films on Outsider Artists archive; a Joseph Abrams hat, an Eric R. Holmes painting, and other works from Tamara Hendershott's collection; and many others. In addition, the National Institute of Mental Health and U.S. Public Health officials have designated the AVAM as "the national depository for the best of the self-taught art created within their walls over the last 100 years."

Mississippi

DELTA BLUES MUSEUM
114 Delta Avenue
PO Box 280
Clarksdale, MS 38614
(601) 624-4461

The Delta Blues Museum is a division of the Carnegie Public Library in Clarksdale, and was founded by librarian Sid F. Graves. The museum is dedicated to blues artists, with hundreds of related photographs, recordings, and memorabilia. In addition to two Othar Turner fifes, and a life-sized figure of Muddy Waters (wearing clothes donated by Waters' widow Marva Morganfield), there are in the collection six James "Son" Thomas pieces—five animals and one skull. The Delta Blues Museum Gift Shop sells postcards featuring the photographs by Tom Rankin of grassroots environments.

COTTONLANDIA MUSEUM
Highway 49-82 Bypass
Greenwood, MS 38930
(601) 453-0925

Cottonlandia is a small regional history museum with an active arts department. "Carroll County, Mississippi," a collection of watercolors by self-taught artist James McAdams, is "one of the most cherished units in that operation." Mr. McAdams picked up a set of water colors the day after his retirement as an architect, and began to paint. His work "without being bland or boring, shows his contentment and joy in living." The museum has a large body of his work.

MISSISSIPPI MUSEUM OF ART
201 Pascagoula Street
Jackson, MS 39201
(601) 960-1515

The Mississippi Museum of Art has one piece that fits the parameters of this book. It is an oil painting by Theora Hamblett, "Walking, Meditating in the Woods."

MISSISSIPPI STATE HISTORICAL MUSEUM
PO Box 571
Jackson, MS 39205
(601) 359-6929

The museum is a division of the Mississippi Department of Archives and History. The collection began around 1902, and now numbers approximately 30,000 catalogued items. There is a large collection of swamp cane and white oak baskets woven by Choctaw crafts people. Artists in the collection are:

Willie Barton	A.J. Mohammed
Loy "Rhinestone Cowboy" Bowlin	Matthew Renna
	Sulton Rogers
Eula Crabtree	Earl Simmons
Burgess Dulaney	Mary T. Smith
James Howard	Henry Speller
O.W. "Pappy" Kitchens	James "Son" Thomas
Paul Lebetard	Decell Williams
Ethel Wright Mohamed	George Williams
Alice Mosely	Luster Willis

SMITH ROBERTSON MUSEUM
528 Bloom Street
PO Box 3259
Jackson, MS 39207
(601) 960-1457

The Smith Robertson Museum is named in honor of a community leader who served Jackson as an alderman from 1893-1899. He was born an enslaved person in Alabama and in Jackson devoted himself to the education of black youth. The Smith Robertson Museum interprets the life, history, and culture of black Mississippians. The museum houses examples of traditional and non-traditional folk art including "quilting, basket weaving, cane carving, recycled tire art, pottery, architecture, and bottle art. In addition, there are a number of paintings by various self-taught individuals."

LAUREN ROGERS MUSEUM OF ART
Fifth Avenue at Seventh Street
PO Box 1108
Laurel, MS 39441

The Lauren Rogers Museum has one Theora Hamblett painting. It has a religious theme, was painted in 1969 in oil on canvas, and is called "Transfiguration."

UNIVERSITY OF MISSISSIPPI

University Museums
University, MS 38677
(601) 232-7073

"The University Museum [in Oxford] has an extensive collection concentrating on Mississippi folk artists both black and white. These include the following: Theora Hamblett, over 400 paintings portraying children's games, home memories, dreams, and visions; Sulton Rogers, wood carvings including figures, animals, canes, etc.; Clementine Hunter, painting; James "Son" Thomas, ceramics; and Jimmy Lee Sudduth, paintings."

New Jersey

NEWARK MUSEUM

49 Washington Street
PO Box 540
Newark, NJ 07107
(201) 596-6550

The Newark Museum has "one of the premier folk art collections in America, which it makes a point of displaying continuously. The museum was the first in America to mount an exhibition of folk art, in 1930 and again in 1931. Both were organized by Holgar Cahill." Many twentieth century pieces have been added during the last ten years, including "a very important John Scholl sculpture." The collection now emphasizes work by black artists and includes two drawings by Bill Traylor, fifteen sculptures by William Edmondson, eighteen pieces by David Butler, and pieces by Minnie Evans, the Philadelphia Wireman, Hawkins Bolden, and Purvis Young. The Museum also owns a painting by Joseph Pickett.

New Mexico

ALBUQUERQUE MUSEUM OF ART, HISTORY AND SCIENCE

2000 Mountain Road, N.W.
PO Box 1293
Albuquerque, NM 87103
(505) 243-7255

The Albuquerque Museum has in its permanent art collection numerous examples of naive art, which have been the basis for a number of exhibitions. The following carvers were listed in the catalog *Santos, Statues, and Sculpture: Contemporary Woodcarving from New Mexico,* as belonging to the Albuquerque Museum (the museum would not confirm this list):

Leroy Archuleta	Felix A. Lopez
Frank Brito	Lusito Lujan
Alonzo Jimenez	Zoraida and Eulogio Ortega
Eurgencio and Orlinda Lopez	Marco A. Oviedo
Jose Benjamin Lopez	Horacio Valdez

MUSEUM OF NEW MEXICO/MUSEUM OF INTERNATIONAL FOLK ART

PO Box 2087
Santa Fe, NM 87504
(505) 827-6350

The Museum of International Folk Art, located at 706 Camino Lejo, two miles southeast of the Santa Fe Plaza, contains a visual feast. Most often noted for the Gerard Collection of over 100,000 objects from one hundred countries, the museum also has extensive collections of Southwestern art and artists. The museum now has a broad development policy for the American collection. Judy Chiba Smith, Curator of the European and American Collections, provided the following list of artists found in the collections of the Museum of International Folk Art:

Lionel Adams
Felipe Archuleta
Leroy Archuleta
Charles Balth
Harold Bayer
Camille Blair
David Butler
Miles B. Carpenter
Ned Cartledge
Russell Childers
Jim Colclough
"Uncle Jack" Dey
Frank Demaray
J. Evans
Amos Ferguson
Marvin Finn
Rev. Howard Finster
Robert Gallegos
Carlton Garrett
Clementine Hunter
Alonzo Jimenez

S.L. Jones
Gustav Klumpp
Harry Lieberman
Sister Gertrude Morgan
Mattie Lou O'Kelley
Elijah Pierce
Jose M. Rivera
Nellie Mae Rowe
Martin Saldaña
Dan Sansone
Antoinette Schwob
"Pop" Shaffer
Miles Smith
Barbara Strawser
Clarence Stringfield
Edgar Tolson
Inez Nathaniel Walker
Willard Watson
"Chief" Willey
Joseph Yoakum
Larry Zingale

New York

FENIMORE HOUSE MUSEUM
Lake Road
PO Box 800
Cooperstown, NY 123326
(607) 547-2533

Fenimore House is the museum of the New York State Historical Association. The folk art collection is nationally known, though more for its nineteenth than its twentieth century pieces. In recent years, however, an aggressive effort has been made to increase the twentieth century folk art holdings. The collection is national in scope, and includes works by the following artists:

Eddie Arning
David Butler
William Edmondson
Ralph Fasanella
Rev. Howard Finster
Bessie Harvey
William Hawkins
Lavern Kelley
Emily Lunde
Gregorio Marzan
Frank Moran
Grandma Moses
Janet Munro

Sulton Rogers
John Scholl
Jon Serl
Frank Severt
Mary Shelley
Queena Stovall
Jimmy Lee Sudduth
Mose Tolliver
Edgar Tolson
Annie Wellborn
Isidor "Pop" Wiener
Malcah Zeldis

MUSEUM OF AMERICAN FOLK ART/EVA AND MORRIS FELD GALLERY

Columbus Avenue at 66th Street
New York, NY 10023
(212) 595-9585

Established in 1961 as the Museum of Early American Folk Art, "Early" was dropped from its title in 1966. The permanent collection consists of over 4,000 objects representative of all ages and aspects of American folk art. The museum sponsors many activities including exhibitions, publications, lectures, film programs, and the Folk Art Explorers' Club. The museum created the Folk Art Institute to foster and increase knowledge of the American folk arts. The Institute offers an accredited postgraduate certificate in Folk Art Studies as well as courses in conjunction with New York University's Graduate Program. Goals are reached through classroom study, independent guided research, museum internships, access to the museum collection, museum exhibitions, and hands-on experiences. The museum also publishes *Folk Art* (formerly *The Clarion*), a quarterly magazine. The museum's administrative offices are at 61 West 62nd Street, New York, NY 10023 (212) 977-7170. Two museum shops adjacent to the Feld Gallery and at 62 West 50th Street sell many folk art publications. The permanent collection includes twentieth-century folk art by:

J.R. Adkins
Fred Alten
David Alvarez
Max Alvarez
Johnson Antonio
Felipe Archuleta
Leroy Archuleta
Eddie Arning
Steve Ashby
Joseph P. Aulisio
Andrea Badami
Calvin and Ruby Black
Nounoufar Boghosian
Rev. Maceptaw Bogun
Mary Borkowski
Frank Brito, Sr.
David Butler
Charles Butler
Ned Cartledge
Clark W. Coe
Chester Cornett
Burlon Craig
Earl Cunningham
"Jimbo" Davila
"Uncle Jack" Dey
Richard Dial
Thornton Dial, Sr.
Thornton Dial, Jr.
Sam Doyle
Antonio Esteves
Minnie Evans
Rev. Howard Finster
Lee Godie
Denzil Goodpaster

Ted Gordon
Theora Hamblett
William Hawkins
Jesse Howard
Clementine Hunter
Alonzo Jimenez
S.L. Jones
Andy Kane
Tella Kitchen
Gustav Klumpp
Karol Kozlowski
Rene Latour
Harry Lieberman
Ronald Lockett
Emily Lunde
Gregorio Marzan
Lanier Meaders
Sister Gertrude Morgan
Grandma Moses
J.B. Murry
Pucho Odio
Mattie Lou O'Kelley
Ben Ortega
John Perates
Matteo Radoslovich
"Popeye" Reed
Simon Rodia
Mike Rodriguez
Ron Rodriguez
John Roeder
Nellie Mae Rowe
St. EOM
Anthony Joseph Salvatore
Alex Sandoval

Jack Savitsky
John Scholl
Antoinette Schwob
Lorenzo Scott
Jon Serl
Mary Shelley
Jimmy Lee Sudduth

Luis Tapia
Mose Tolliver
Edgar Tolson
Bill Traylor
Inez Nathaniel Walker
"Chief" Willey
Malcah Zeldis

The museum's library contains close to 10,000 volumes, 200 periodicals, and 100 video tapes and films. There is an extensive collection of exhibition catalogs and auction catalogs. The museum has established a resource center for the study of twentieth century folk art. Subject files and artist files include articles, photographs from books, newspaper clippings, and photographs. Chuck and Jan Rosenak have donated their collection of documents, photographs, and audio and video tapes to the center. The Photographic Archives contain more than 5,000 slides from the museum, library and private collections. The library is open to members and the public, by appointment only. [For historical and other details see the articles by Alice Hoffman in *The Clarion,* Winter 1989, and *Folk Art Messenger,* Spring 1989.]

North Carolina

ASHEVILLE ART MUSEUM
Civic Center
Asheville, NC 28801
(704) 253-3227

The Asheville Art Museum owns five paintings by artist McKendree Robbins Long, a North Carolina native, and has the loan of one painting by the artist W.A. Cooper, who also lived in this state." In the spring of 1992 the museum held an exhibition, "Inside Visions," in which McKendree Long is featured.

ACKLAND ART MUSEUM/ UNIVERSITY OF NORTH CAROLINA
Campus Box 3400
Chapel Hill, NC 27599
(919) 966-5736

The Ackland Museum has a collection of North Carolina art, including a large collection of ceramic pieces. There are approximately sixty-two jars, plates, and pitchers, and two grave markers. Represented are Burlon Craig, Charles B. and Enoch S. Craven, David Donkel, Nicholas Fox, Henry H. and Royal P. Heavner, the Jugtown ware potters, Ben Owens, Samuel Propst, Luther Richie, Daniel and James Seagle, and the Webster School potters. There are two face jugs and a snake jug by Craig, a sculpture, "Hare," by Claude Richardson, Jr., and three wood sculptures by Edgar Alexander McKillop. There is also a sculpture by Raymond Coins, and one drawing and one painting by Minnie Evans.

MINT MUSEUM OF ART
2730 Randolph Road
Charlotte, NC 28207

The Mint Museum has an extensive collection of American ceramics. The Daisy Wade Bridges Collection numbers over 3,000 pieces and includes works by native American potters, particularly those of the southwestern United States; folk potters east of the Mississippi, with an emphasis on those from North Carolina and the southeastern United States; and decorative pottery and porcelain, including Art Pottery, from the Colonial period to the present. In about 1984 the museum received as a gift/purchase the collection of Dorothy and Walter Auman of Seagrove. Well-known potters and descendants of potters, the Aumans spent over thirty years searching out early pieces of North Carolina pottery. Eventually they amassed a collection of some 1,900 pieces, covering all periods and types of North Carolina pottery, from eighteenth century shards to contemporary, traditional pieces. This collection now belongs to the Mint Museum.

The Delhom-Gambrell Library of the Mint Museum of Art has extensive literature on the subject of American pottery and porcelain. In addition to the many objects she brought to the museum, Daisy Bridges also donated books, catalogs, journals and slides, which make research and understanding of the collection possible. The library is open to all by appointment.

NORTH CAROLINA MUSEUM OF ART
2110 Blue Ridge Boulevard
Raleigh, NC 27607
(919) 833-1935

The museum occasionally exhibits "outsider" artists. Art in the permanent collection consists of seven works on paper by Minnie Evans, and "a wonderful painting by a North Carolina self-taught artist, Lena Bulluck Davis."

NORTH CAROLINA STATE UNIVERSITY
Visual Arts Center, Box 7306
Raleigh, NC 27695
(919) 515-3503

The Visual Arts Center is in fact a museum. Among self-taught artists in the permanent collection are Vernon Burwell, James Harold Jennings, Georgia Blizzard, and Annie Hooper. There are plans to add other self-taught artists. The most significant part of the collection is the Annie Hooper bequest—2,500 objects made of a variety of materials such as putty, cement, driftwood, and seashells; nearly all are painted and decorated. The individual pieces range in size from 6 to 48 inches. An exhibition of the works of Annie Hooper accompanied by a major catalog publication is planned for 1994.

SOUTHERN FOLK POTTERY COLLECTORS SOCIETY/SHOP AND MUSEUM
Route 2, Box 592
1828 North Howard Mill Road
Robbins, NC 27325
(919) 464-3961

The shop and museum opened in 1991 in an area where there are sixty active potteries. The museum has a permanent display of Southern folk art pottery from the nineteenth century to the present. There are also special temporary exhibitions, the first of which was "Kiln Disasters." The shop carries a select offering of "folk pottery by all the major Southern folk potters." There is also a reference library at the museum, including several video productions on the subject of Southern folk pottery. Call ahead because hours of opening vary.

THE LYNCH COLLECTION
North Carolina
Wesleyan College
3400 North Wesleyan Boulevard
Rocky Mount, NC 27804
(919) 977-7171

The college does not yet have a gallery for it, but it owns the Robert Lynch Collection of Outsider Art, and many of the pieces in it may be seen in *Signs and Wonders: Outsider Art Inside North Carolina*. Twenty to 25 percent of the collection is on view in various places around the campus. The collection includes some four hundred pieces by eighteen artists, all from the eastern North Carolina region. "The principal artists are Leroy Person (an especially large collection of some 250 pieces), Vernon Burwell, Herman Bridgers, Jeff Williams, William Owens, Arliss Watford, and Q.J. Stephenson."

ST. JOHN'S MUSEUM OF ART
114 Orange Street
Wilmington, NC 28401
(919) 763-0281

The museum collection includes American paintings, works on paper, and sculpture. The focus is on North Carolina art, including Jugtown pottery. Recently renovated, the museum is a complex of three architecturally distinct buildings with a common-walled sculpture garden. In addition to the permanent installations, the museum schedules ten to twelve temporary exhibitions each year, and there is a commitment to educational programs. The museum has a significant collection of the work of Minnie Evans, who lived in Wilmington and was a friend to the museum. The film "The Angel That Stands By Me" was filmed in great part at the museum. In December 1992 the family of Minnie Evans will join with the museum to celebrate the hundredth anniversary of the artist's birth. There are eleven works by Minnie Evans on permanent display. In addition the museum has two pieces of sculpture, a giraffe and a horse, by Clyde Jones.

Ohio

AKRON ART MUSEUM
70 East Market Street
Akron, OH 44308
(216) 376-9185

The permanent collection contains regional, national, and international paintings, sculpture, photographs, and prints from 1850 to the present. In 1987 the museum began actively collecting contemporary folk art, and now has thirty-eight objects in its collection. Artists include:

Miles B. Carpenter	Anthony Joseph Salvatore
Earl Cunningham	Jon Serl
William Hawkins	Simon Sparrow
Wayne D. McCaffrey	Mose Tolliver
Justin McCarthy	Eugene Von Bruenchenhein
Sister Gertrude Morgan	Joseph Yoakum
"Popeye" Reed	Malcah Zeldis

CINCINNATI ART MUSEUM
Eden Park
Cincinnati, OH 45202
(513) 721-5204

The museum has a folk art gallery, with almost all of the pieces dated prior to the twentieth century. There are two paintings by Nan Phelphs and two large landscapes that are dated to the early twentieth century and signed "L.A. Roberts." One of these paintings usually hangs in the folk art gallery, "though we know nothing about the

CINCINNATI ART MUSEUM *Continued*

artist." The Department of Prints, Drawings, and Photographs has two oil pastels by Eddie Arning—"Girl in Blue with White Birds," ca. 1972, and "Crusading for a Great Love of Life," ca. 1971—both gifts of Mr. and Mrs. Alexander Sackton.

COLUMBUS MUSEUM OF ART
480 East Broad Street
Columbus, OH 43215
(614) 221-6801

The first art museum in Ohio, the Columbus Museum of Art was established in 1878. Along with mainstream art reflecting the history of western culture, the museum has now added to its collection the works of self-taught artists of the region. This includes a large collection of "Popeye" Reed, William Hawkins, and Elijah Pierce. In recent years the museum has presented such exhibitions as a show of many pieces from the Elijah Pierce collection in 1986; "New Traditions/Non-Traditions: Contemporary Art in Ohio," December 1989-January 1990, which included works by thirteen self-taught Ohio artists; a major show of William Hawkins' work in 1990; "Popular Images/Personal Visions"; and "Elijah Pierce, Woodcarver," January-May 1993. [A profile of the museum, by Gary Schwindler, is in the *Folk Art Messenger* Spring 1991.]

MIAMI UNIVERSITY ART MUSEUM
Patterson Avenue
Oxford, OH 45056
(513) 529-2232

The Miami University Art Museum is a public institution dedicated to the exhibition, interpretation, and preservation of works of art. The museum serves both the university community and the general public. The Art Museum houses five galleries of changing exhibitions and a growing permanent collection of more than 30,000 pieces. The museum had an exhibition of Clementine Hunter and Nellie Mae Rowe in 1987. In 1990 the Curator of Collections, Edna Carter Southard, presented a major exhibition, "Contemporary American Folk, Naive, and Outsider Art: Into the Mainstream?" There is a catalog for each of these exhibitions. Included in the permanent collection are works by:

Charlie Dieter	Judith Neville
William Hawkins	Elijah Pierce
Clementine Hunter	"Old Ironsides" Pry
S.L. Jones	Sophy Regensburg
Mary Merrill	Anthony Joseph Salvatore

SOUTHERN OHIO MUSEUM
825 Gallia
Portsmouth, OH 45662
(614) 354-5629

This museum has a commitment to showing outsider art rather than having a permanent collection of it. Recent temporary exhibitions have included "Mountain Harmonies" which featured the works of Charley Kinney, Noah Kinney, and Hazel Kinney; and "Local Visions," curated by Adrian Swain, featuring outsider artists from northeastern Kentucky. The permanent collection has one piece of "outsider art" in it: "Parting the Red Sea" by Hazel Kinney.

Pennsylvania

LEHIGH UNIVERSITY ART GALLERIES
Chandler Hall, Number 17
Lehigh University
Bethlehem, PA 18015
(215) 758-3615

The museum focuses on contemporary art, with an eclectic permanent collection. It has sponsored exhibitions of folk and outsider art. It is assembling a major collection, including videos and other documentary materials, of Rev. Howard Finster and members of his family including Beverly Finster, Michael Finster, K. Allen Wilson, and Chuck Cox. Minnie Adkins is also represented in the museum's collection.

Tennessee

AUSTIN PEAY STATE UNIVERSITY
Margaret Fost Trahern Gallery
Box 4677
Clarksville, TN 37044

The museum collection contains one stone carving, "Critter," by William Edmondson, and several painted cement sculptures by Tanner Wickham—"Sargeant York" and two "Sleeping Dogs."

KNOXVILLE MUSEUM OF ART
410 10th Street
Knoxville, TN 37916
(615) 525-6101

The Knoxville Museum of Art opened in March, 1990, and since then has had three exhibitions of folk/self-taught/outsider art. They include "O, Appalachia," April 2-June 7, 1991; "Fond Recollections of William Russell Briscoe," May 10-June 7, 1991; and a 1992 exhibition of Mexican folk art from the Nelson A. Rockefeller Collection. The permanent collection includes paintings by local artist William Russell Briscoe, and a mixed media sculpture by another local artist, Bessie Harvey. The museum also has a pre-twentieth century folk painting collection from the Edgar William and Bernice Chrysler Garbisch Collection.

CARL VAN VECHTEN GALLERY OF FINE ARTS
Fisk University
Nashville, TN 37203
(615) 329-8543

The Carl Van Vechten Gallery of Fine Arts has a collection of non-traditional folk art and outsider art. The collection, based upon a gift from A. Everette James, is titled "The James Collection at Fisk." It includes the following artists:

Z.B. Armstrong
W.A. Cooper
Sam Doyle
Alvin Jarrett
Anderson Johnson
Eric Calvin McDonald

Sister Gertrude Morgan
Wesley Stewart
Vannoy Streeter
Sarah Mary Taylor
Mose Tolliver

**CHEEKWOOD FINE
ARTS CENTER**
1200 Forrest Park Drive
Nashville, TN 37205

Cheekwood has a collection of limestone sculpture by Nashville artist William Edmondson. The museum has six pieces in the permanent collection with an additional four on extended loan to the collection. "As far as we know, we have the only gallery devoted entirely to his work."

**MUSEUM OF
APPALACHIA**
PO Box 359
Norris, TN 37828
(615) 494-7680

Mr. John Rice Irwin, native of Tennessee, gathers Appalachian artifacts and installs them at the seventy five-acre Museum of Appalachia, located fifteen miles north of Knoxville on Highway 1-75, exit 22. There is a schoolhouse and a church, several homes, a barn, a blacksmith shop—and many furnishings from the past. He not only collects the pieces, he collects the people's stories as well. There are crafts people and artisans on hand at the annual Tennessee Fall Homecoming in October.

The Museum of Appalachia also has a folk art collection. Some of the artists represented are: Troy Webb and his extended family of carvers; Minnie Black, creator of gourd creatures; "Cedar Creek Charlie" Fields, who painted his house and almost everything in it with polka dots; Dow Pugh, whose carvings are on display; and "many more too numerous to mention." There are special collections on display, one of handmade walking canes and another of carved figures. The Museum of Appalachia is "open during daylight hours the year 'round."

Texas

**ART MUSEUM OF
SOUTHEAST TEXAS**
500 Main Street
Beaumont, TX 77701
(409) 832-3432

The museum has the collection of the environmental works of Felix "Fox"Harris. Some of the pieces are always on display in the museum courtyard.

**MUSEUM OF AFRICAN-
AMERICAN LIFE
AND CULTURE**
PO Box 26153
Dallas, TX 75226
(214) 565-9026

This museum has the Billy R. Allen Folk Art Collection. Some of the artists included in it are Calvin J. Berry, David Butler, Milton A. Fletcher, Clementine Hunter, Frank Jones, Sister Gertrude Morgan, J.P. Scott, Rev. Johnnie Swearingen, Willard "Texas Kid" Watson, and George White.

THE MENIL COLLECTION
1515 Sul Ross
Houston, TX 77006
(713) 525-9400

The Menil Collection includes some examples of twentieth century folk/outsider art. There are: two paintings by Rev. Johnnie Swearingen, one drawing by Henry R. Clark, one painting by Ernest C. Hewitt, three drawings by Frank Jones, two drawings by Bill Traylor, five paintings by Forrest Bess, and one bird piece by Jeff McKissack.

SAN ANGELO MUSEUM OF FINE ARTS

704 Burgess Street
PO Box 3092
San Angelo, TX 76902
(915) 658-4084

This west Texas museum is interested in contemporary folk art, and tries to make it a regular part of exhibition schedules. In the fall of 1991 the museum presented "Like Nobody Else: Three West Texas Folk Artists." The artists included Emma Lee Moss, a "naive painter;" Jethro Jackson, maker of small tableaux; and Donald C. Keeny, a wood sculptor who could be said to be influenced by folk art, rather than being a self-taught artist himself. Mrs. Moss is no longer working. Her archives and the majority of her remaining paintings are on deposit with the museum. Also in 1991 the museum hosted the exhibition "Hecho Tejano: Four Texas Mexican Folk Artists," organized by Texas Folklife Resources. "Narrated Images" was an exhibition presented in 1988.

Virginia

CUMBERLAND MUSEUM

McClure Avenue
PO Box 1278
Clintwood, VA 24228
(703) 926-6632 or 926-8433

Fred Carter was a self-taught carver and collector of Appalachian artifacts who established this museum to house his collection. He started carving at age fifty to express his feelings about the people and the land where he lived. The museum is open seven days a week, but the hours vary so call ahead.

MARSH GALLERY

Modlin Fine Arts Center
University of Richmond
Richmond, VA 23173
(804) 289-8276

The gallery has changing exhibitions of contemporary art by both established and emerging artists, national and international. The director, Richard Waller, says there is no folk art in the permanent collection. "However, we have periodically had exhibitions of this type of art in the past, and we plan to continue to do so." The most recent folk art exhibit, January 11-February 7, 1991, was "Anderson Johnson: Folk Artist with a Mission."

MEADOW FARM MUSEUM

County of Henrico/Division of Recreation and Parks
8600 Dixon Powers Drive
PO Box 27032
Richmond, VA 23273
(804) 672-5124

The museum is located in a 150-acre park in Glen Allen, Virginia, and includes a nineteenth century farmhouse and outbuildings. Staff demonstrate traditional folk life skills throughout the year. Folk art exhibitions occur on an annual basis in the exhibition gallery. In addition to examples of nineteenth century folk art, the permanent collection of twentieth century folk art includes paintings, drawings, and sculpture by:

Edward Ambrose	Anderson Johnson
Patsy Billups	Selma Keith
Georgia Blizzard	Marion Line
Abe Criss	Oscar Spencer
Alpha Frise	Jimmy Lee Sudduth
Lonnie Holley	Mose Tolliver

The museum includes a library and an archival collection containing books, catalogs, periodicals, research files, and slides on many contemporary folk artists, with an emphasis on the work of Virginia

MEADOW FARM MUSEUM *Continued*

folk artists. There is a collection of video tapes (VHS) on the following artists:

Ann Murfee Allen Anderson Johnson
Edward Ambrose Selma Keith
Eldridge Bagley Marion Line
Abe Criss Oscar Spencer

The collection and archives are open to the public by appointment—call (804) 672-5125. Call ahead for information on exhibitions, museum hours, and access to the farmhouse—(804) 672-5106.

ROANOKE MUSEUM OF FINE ARTS
One Market Square
Roanoke, VA 24011
(703) 342-5760

The Roanoke Museum of Fine Arts was established in 1951 and has, among other things, "a small collection" of folk/outsider art including: seventeen pieces by the Rev. Howard Finster, two pieces by Leroy Almon, Sr., and three pieces each by Mose Tolliver, Fred Webster, and Benjamin F. Perkins. There are also works by Clovis Boyd, James Harold Jennings, and a face jug by Burlon Craig. The museum has a commitment to "expanding this collection, exhibiting works of this nature regularly (at this point we have a folk art area in our permanent gallery space), and also sharing the works in our collection with other institutions." [*Folk Art Messenger,* Summer 1990, has a museum profile by Tara Tappert and Brian Sieveking.]

MILES B. CARPENTER FOLK ART MUSEUM
Route 460, Box 137
Waverly, VA 23890
(804) 834-2897

The museum, Miles Carpenter's white frame house, is located on Route 460 in Waverly, Virginia, between Petersburg and Suffolk. The museum collects artifacts, photographs, slides, and newspaper clippings about the woodcarver's life and art. There are two video tapes and a slide program available at the museum for visitors to see. Some of Carpenter's art works are also on display.

ABBY ALDRICH ROCKEFELLER FOLK ART CENTER
307 South England Street
Williamsburg, VA 23187
(804) 220-7255

The Folk Art Center opened its new facilities on May 1, 1992. The 19,000 square foot space includes nine exhibition galleries, administrative offices, a library, research facilities and a gift shop. Started in 1957 to house the collection of Abby Aldrich Rockefeller, there are now 3,000 objects from the eighteenth, nineteenth, and twentieth centuries. Objects in the twentieth century collection include works by:

Eddie Arning Lawrence Lebduska
Miles Carpenter Edgar A. McKillop
Steve W. Harley Martin Ramirez
Karol Kozlowski Irwin Weil
Benniah G. Layden

[Museum profiles by Charlotte Morgan in the Fall 1990 Folk *Art Messenger* and by Ellin Gordon in the Spring 1992 *Folk Art Messenger.*]

Washington

WASHINGTON STATE HISTORICAL SOCIETY
315 North Stadium Way
Tacoma, WA 98403
(206) 593-2830

The collection of the Historical Society consists of paintings, several of which date to the late nineteenth century. One exception is the Ronald Debs Ginther collection of watercolors painted 1929-1935, which depict Depression scenes in the Pacific Northwest. Self-taught painter Ginther was once a member of the IWW.

West Virginia

HUNTINGTON MUSEUM OF ART
2033 McCoy Road
Huntington, WV 015701
(304) 529-2701

The museum has many important collections including its famous glass collection; American, French and English paintings and graphics; decorative arts; and several other categories, including regional art. There is a first-rate collection of decorated powder horns and over 350 folk canes. The museum also houses a collection of early folk art. The collection of contemporary folk art, with a focus on works from Appalachia, is a museum emphasis. There are plans for a folk art gallery in building plans. Some especially powerful pieces are a boat with six people fishing by Willie Massey; a concrete sculpture, "The Death of Dr. Crawford," by Dilmus Hall; a "Tower of Babel" under construction with workers carrying bricks up the sides of the tower, by the Rev. Herman Hayes. A large collection of the art of Evan Decker has been a recent acquisition. In the collection are:

Minnie Adkins	Charley Kinney
Jessie Cooper	Noah Kinney
Evan Decker	Willie Massey
Dilmus Hall	Bobby Quinlan
Rev. Herman Hayes	Donny Tolson
S.L. Jones	Edgar Tolson

MANSION MUSEUM/ OGLEBAY INSTITUTE
Route 88
Wheeling, WV 26003
(304) 242-7272

The museum has a permanent collection that includes paintings by various artists important to the heritage of the area. Included in this collection are two paintings by Patrick J. Sullivan. Another self-taught artist in the collection is Jeanie Caldwell-Daugherty.

Wisconsin

MILWAUKEE ART MUSEUM
750 N. Lincoln Memorial Drive
Milwaukee, WI 53202
(414) 224-3200

The Milwaukee Art Museum, in its magnificent lakeside setting, has a substantial folk art collection. The twentieth century holdings increased significantly with the 1989 acquisition of the Michael and Julie Hall Collection of American Folk Art. In the future the collection will be permanently installed in a separate space dedicated to American folk art. Twentieth century artists in the Milwaukee Art Museum, some from the Hall Collection and some not, are:

MILWAUKEE ART MUSEUM *Continued*

Fred Alten
Felipe Archuleta
Eddie Arning
Steve Ashby
"Prophet" William J. Blackmon
David Butler
Alax Butz
Miles B. Carpenter
Anna Celletti
James Crane
Henry Darger
William Dawson
William Edmondson
Josephus Farmer
Ralph Fasanella
Rev. Howard Finster
Lee Godie
Theodore H. Gordon
Bessie Harvey
Jesse Howard
Clementine Hunter
J. Huntington
Luther Jones
S.L. Jones
L.M. Kalas
John Kalie

Charley Kinney
Lawrence Lebduska
Jim Lewis
Justin McCarthy
E.A. McKillop
Anna Louisa Miller
Peter Minchell
Sister Gertrude Morgan
Earnest Patton
John Perates
Elijah Pierce
Daniel Pressley
"Old Ironsides" Pry
Martin Ramirez
W.S. Rosenbaum
Anthony Joseph Salvatore
Jack Savitsky
Drosses P. Skyllas
Fred Smith
Simon Sparrow
Mose Tolliver
Bill Traylor
Eugene Von Bruenchenhein
Inez Nathaniel Walker
Joseph Yoakum
Albert Zahn

There are numerous pieces from the Possum Trot environment of Calvin and Ruby Black and an extensive collection of works by Edgar Tolson. There are face jugs by E.J. Brown, Bob Brown, and Burlon Craig, and walking sticks by Ben Miller and Denzil Goodpaster; also many anonymous pieces in each category above. [Articles on the museum appear in Folk *Art Messenger,* Spring 1990, and *Folk Art Finder,* April-June 1990.]

UNIVERSITY OF WISCONSIN-MILWAUKEE ART MUSEUM

3253 North Downer Avenue
Milwaukee, WI 53211
(414) 229-5070

The UWM Art Museum, according to director Michael Flanagan, has six to eight curated exhibitions per year, six from outside and two from the over 4,000 objects in the permanent collection. The museum is committed to doing exhibits of outsider art. Exhibitions at the university have included one for the works of Josephus Farmer, curated by Joanne Cubbs in 1982; "Folk Art Carvings of Northern New Mexico" in 1989; two solo exhibitions of the works of Prophet Blackmon and William Hawkins, and the "Local Visions" exhibition from Kentucky in 1990. The most recent exhibition took place November 8-December 20, 1991, titled "Personal Intensity: Artists in Spite of the Mainstream," organized with the assistance of Chicago artist Roger Brown. [Museum profile by Michael Flanagan, *Folk Art Messenger,* Fall 1990.]

WISCONSIN FOLK ART MUSEUM

100 South Second Street
Mount Horeb, WI 53572
(608) 437-4742

The Wisconsin Folk Art Museum is devoted to preserving a rich regional diversity of folk expressions. The museum engages in ongoing efforts to document and support traditional artists. In addition the museum exhibits works by farmer and memory painter Lavern Kammerude, works by Joe Hvovat, John Bambio whirligigs, and Jerry Holter carvings. This museum is open May 1 through Labor Day seven days a week, 10 a.m. to 5 p.m.; weekends only from Labor Day to December 23, and closed December 24-April 30.

JOHN MICHAEL KOHLER ARTS CENTER

608 New York Ave
PO Box 489
Sheboygan, WI 53082
(414) 4458-6144

The John Michael Kohler Arts Center was established in 1967. Its mission is to encourage and support innovative exploration in the arts. A primary program focus is exhibitions in contemporary art, with emphasis on new genres, installation art, unconventional photography, the crafts, ongoing folk traditions, and the work of self-taught artists and visionaries. At present Director of Special Projects Joanne Cubbs is near completing a ten-year project to document grassroots art environments. (The Kohler Foundation, a separate organization, has been involved in many site preservation projects in the state.) Artists in the permanent collection include Eugene Von Bruenchenhein, Fred Smith, Mary Le Ravin, and Nick Englebert.

MUSEUM OF WOODCARVING

PO Box 371
Shell Lake, WI 54871
(715) 468-7100

This museum houses the work of one man, Joseph Thomas Barta, who carved one hundred life-sized figures and over four hundred miniatures. The museum houses most of these pieces and attracts many visitors. It is open May 1 through October 31, daily from 9 a.m. to 6 p.m.

MUSEUM EXHIBITIONS

This chapter includes a selected list of exhibitions (mostly of groups of artists) that have occurred since 1989. Exhibitions are arranged from the most to the least recent, by date of opening. A few of the exhibitions included are scheduled in the future; information about them was supplied by curators in advance of the exhibition openings. If a catalog was published or is planned, that fact is noted in these exhibition descriptions; detailed annotations of the catalogs themselves may be found in the bibliography, in the section on "Books and Exhibition Catalogs." For a list of exhibitions from 1924 through 1989, see pp. 343-354 of Chuck and Jan Rosenak's *Museum of American Folk Art Encyclopedia of Twentieth-Century American Folk Art and Artists* (Abbeville Press, 1990).

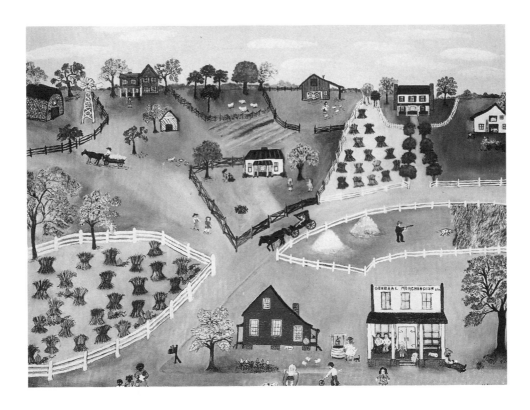

PASSIONATE VISIONS OF THE AMERICAN SOUTH:
Self-Taught Artists, 1940-Present

NEW ORLEANS
MUSEUM OF ART
New Orleans, Louisiana

Organizer
Alice Rae Yelen

October 1993-January 1994
The exhibition will feature self-taught artists raised or working in the South, selected for the aesthetic qualities of their work. Works will be organized by common themes which emerge from the work. Catalog. (Selection of artists in process.)

FEARFUL SYMMETRY:
The Tiger Cat in the Art of Thornton Dial

MUSEUM OF AMERICAN
FOLK ART/STUDIO
MUSEUM IN HARLEM
New York, New York

Guest Curator
Thomas McEvilley

September 18, 1993-January 9, 1994
Presents the works of this major contemporary African-American self-taught artist from Bessemer, Alabama. Catalog.

COMMON GROUND/UNCOMMON VISION:
The Michael and Julie Hall Collection of American Folk Art

MILWAUKEE ART
MUSEUM
Milwaukee, Wisconsin

Curator
Russell Bowman

April 16-June 20, 1993
Presentation of this premier collection of American folk art which will attempt to blend the aesthetic and the material culture points of view. Catalog. Artists in the Hall collection are listed in the Milwaukee Art Museum entry, "Museum" section.

THE CUTTING EDGE OF CREATIVITY
(Note: At presstime notice has been received that this exhibit was cancelled.)

MUSEUM OF NORTHERN
ARIZONA
Flagstaff, Arizona

Curator
Trudy Thomas

January 30-May 5, 1993
The exhibition focuses on "non-traditional artworks from four American native art producing regions: the Southwest, the Northwest Coast, the Plains, and Hawaii. The art for the exhibition has been assembled from museums, artists, and private collections in the United States and Canada. Though often tradition-based, the art departs in some way. The nature of the departure varies, from artist to artist and region to region. Close to one hundred artists will be represented in the exhibition." —Trudy Thomas. Educational programs and artists' demonstrations will take place during the exhibition. Catalog.

ELIJAH PIERCE:
Woodcarver

COLUMBUS MUSEUM
OF ART
Columbus, Ohio

Curators
E. Jane Connell,
Nannette V. Maciejuner

January 24-May 16, 1993
"The first definitive retrospective on Pierce (1892-1984), organized in honor of the centennial of his birth. The exhibition is also one of the first interdisciplinary studies to consider a major African American folk artist in both aesthetic and social contexts." —E. Jane Connell. Catalog.

PARALLEL VISIONS:
Modern Artists and Outsider Art

LOS ANGELES COUNTY
MUSEUM OF ART
Los Angeles, California

Curators
Maurice Tuchman,
Carol S. Eliel

October 18, 1992-January 3, 1993
"The exhibition investigates the art of compulsive visionaries in the twentieth century and its relation to five generations of modernism." —Carol S. Eliel. Catalog.

ARTISTS INCLUDE

Henry Darger
Rev. Howard Finster
J.B. Murry
Martin Ramirez

Simon Rodia
Clarence Schmidt
P.M. Wentworth
Joseph Yoakum

GIVE ME A LOUDER WORD UP:
African-American Art

METROPOLITAN
STATE COLLEGE OF
DENVER/CENTER FOR
VISUAL ARTS
Denver, Colorado

Curator
Sally L. Perisho

July 10-August 22, 1992
An exhibition of sixty two-dimensional and three-dimensional works by African-American artists who are "self-taught, independent, imaginative, and up until recently, isolated from the contemporary art world." —Sally L. Perisho.

ARTISTS INCLUDE

Hawkins Bolden
David Butler
Thornton Dial, Sr.
Thornton Dial, Jr.
Sam Doyle
William Hawkins
Lonnie Holley
Clementine Hunter

Ike Morgan
J.B. Murry
Philadelphia Wireman
Naomi Polk
Royal Robertson
Mary T. Smith
Jimmy Lee Sudduth

STEP LIVELY:
The Art of the Folk Cane

MUSEUM OF AMERICAN FOLK ART/EVA AND MORRIS FELD GALLERY
New York, New York

June 4-September 14, 1992
Exhibition of about 150 American folk canes from the early nineteenth century to the present, from the collection of George H. Meyer. The emphasis of the exhibition was on the sculptural quality of the objects. A book, *American Folk Art Canes: Personal Sculpture*, by George H. Meyer, was published in conjunction with the exhibition.

WORKS OF ART . . . WORLDS APART

FENIMORE HOUSE/ NEW YORK STATE HISTORICAL ASSOCIATION
Cooperstown, New York

Curator
Paul D'Ambrosio

May 1-December 31, 1992
"The exhibition of over 150 artworks contrasts nineteenth and twentieth century pieces from the collection of Fenimore House—nineteenth century folk art being mass produced, to provide commercial products . . . twentieth century folk art working out of a need for personal expression." —Exhibition Announcement. In conjunction with this exhibition, the museum scheduled a three-day symposium on twentieth century folk art, chaired by Paul D'Ambrosio with speeches by Lee Kogan, Sal Scalora, Varick Chittenden, and Linda Morley.

ARTISTS INCLUDE
David Butler
Ralph Fasanella
Rev. Howard Finster
Bessie Harvey
William Hawkins
Clementine Hunter

Sister Gertrude Morgan
Grandma Moses
Jon Serl
Jimmy Lee Sudduth
Mose Tolliver
Malcah Zeldis

FOLK ART ACROSS AMERICA

NATIONAL MUSEUM OF AMERICAN ART
Washington, DC

Curator
Lynda Roscoe Hartigan

Opened Spring 1992; on view indefinitely
A new permanent installation of sixty artworks drawn from the museum's collection and exhibited in five galleries on the redesigned first floor. "Embracing folk art as an equal partner in American art, the display, which will be revised from time to time, is intended to redefine the ways in which visitors are encouraged to think about the history of American art." —Elizabeth Broun.

ARTISTS INCLUDE
Miles B. Carpenter
William Edmondson
Rev. Howard Finster
James Hampton

Jose Benito Ortega
Martin Ramirez
Edgar Tolson
Bill Traylor

CONTEMPORARY AMERICAN FOLK ART:
The Balsey Collection

HAGGERTY MUSEUM
OF ART/MARQUETTE
UNIVERSITY
Milwaukee, Wisconsin

Curator
Curtis L. Carter

April 15-August 2, 1992
"The Balsley Collection, consisting of several hundred sculptures, paintings, drawings, canes, whirligigs, furniture, and miscellaneous objects, is driven by an intense passion for the unusual artistic expression found in the work of individual visionaries rather than in the typical decorative craft of a traditional folk art community." Catalog.

ARTISTS INCLUDE

Jesse Aaron
Stephen Anderson
Leroy Archuleta
Eddie Arning
Ronald Beard
"Prophet" William J. Blackmon
William Alvin Blayney
Richard Burnside
David Butler
Raymond Coins
Ronald Cooper
Lonzo Coulter, Sr.
Ulysses Davis
William Dawson
"Creative" Gerald DePrie
Helen Dobbins
Josephus Farmer
E.J. Favell
Rev. Howard Finster
Reg. H. Gee
Lee Godie
Dilmus Hall
Bessie Harvey
William Hawkins
H. Hayden
Jesse Howard
August Jackson
Peter Jodocy
S.L. Jones
Charley Kinney
Paul Lauterbach

Lawrence Lebduska
Michael Lenk
Harvey Lowe
Charlie Lucas
Carl McKenzie
Wesley Merritt
R.A. Miller
J.B. Murry
Earnest Patton
Benjamin F. Perkins
"Popeye" Reed
Emma Rennhard
Royal Robertson
Nellie Mae Rowe
Paul K. Schimmack
Mary T. Smith
Simon Sparrow
Henry Speller
Jimmy Lee Sudduth
James "Son" Thomas
Carter Todd
Mose Tolliver
Edgar Tolson
Eugene Von Bruenchenhein
Schenk Von Stauffenberg
Inez Nathaniel Walker
Derek Webster
"Chief" Willey
George Williams
Joseph Yoakum

IT'LL COME TRUE:
Eleven Artists First and Last

ARTISTS' ALLIANCE
Lafayette, Louisiana

Project Director
Mark Marcin

April 11-May 16, 1992
The exhibition presents eleven self-taught artists from Mississippi, Louisiana, and Texas. The majority of the works exhibited came from the collection of Sylvia and Warren Lowe. Catalog.

ARTISTS INCLUDE

David Butler

Henry Ray Clark

Roy Ferdinand, Jr.

Royal Robertson

Sulton Rogers

James "J.P." Scott

Xmeah ShaEla'ReEl

Herbert Singleton

Mary T. Smith

James "Son" Thomas

"Artist Chuckie" Williams

VERNACULAR ART

UNIVERSITY ART
GALLERY/CALIFORNIA
STATE UNIVERSITY
Hayward, California

Curator
Lew Carson

April 9-May 2, 1992

"Most of the artists in 'Vernacular Art' are self-taught. Few of them employ shading or perspective. They tend to be low tech, using unpretentious materials such as felt pens and oil pastels. In some cases these artists are from a low socio-economic background; in other instances they are developmentally delayed or have spent time in prison. Despite these circumstances, they have made personal and meaningful visual statements." —Lew Carson. Brochure published.

ARTISTS INCLUDE

Eddie Arning

Georgia Blizzard

Rev. Howard Finster

Ted Gordon

Camille Holvoet

Leon Kennedy

Alex A. Maldonado

Ed Newell Murphy

B.J. Newton

Donald Paterson

Robert Stansbury

Inez Nathaniel Walker

THREE WESTERN PENNSYLVANIA FOLK ARTISTS:
Jory Christian Albright, Rev. Richard Cooper, Norman "Butch" Quinn

SOUTHERN
ALLEGHENIES
MUSEUM OF ART
Loretto, Pennsylvania

Curator
Paul Binai

December 6, 1991-March 15, 1992

This exhibition "is a continuance of the ongoing series exploring significant art of the last years of the twentieth century at the Southern Alleghenies Museum of Art. This event is part of our celebration of the fifteenth anniversary of the founding of our institution and focuses especially on the work of three artists who represent largely self-taught talents." —Paul Binai. Brochure published.

OUTSIDER ARTISTS IN ALABAMA

ALABAMA ARTISTS
GALLERY/ALABAMA
STATE COUNCIL ON
THE ARTS
Montgomery, Alabama

Curator
Miriam Fowler

November 17, 1991-January 10, 1992
"I have chosen both living and deceased [Alabama] artists. These are artists who, in my opinion, have done unique and eccentric work, defining their world without concern for academic opinions."
—Miriam Fowler. Catalog.

ARTISTS INCLUDE

Buzz Busby
L.W. Crawford
Thornton Dial
Sybil Gibson
Joseph Hardin
Lonnie Holley
Boosie Jackson
Calvin Livingston
Woodie Long
Annie Lucas
Charlie Lucas

Robert Marino
Benjamin F. Perkins
Virgil Perry
Juanita Rogers
Bernice Sims
Jimmy Lee Sudduth
Annie Tolliver
Mose Tolliver
Bill Traylor
Fred Webster
Myrtice West

PERSONAL INTENSITY:
Artists in Spite of the Mainstream

UNIVERSITY OF
WISCONSIN-MILWAUKEE
ART MUSEUM
Milwaukee, Wisconsin

Guest Curator
Roger Brown

November 8-December 22, 1991
"Organized with the assistance of Chicago painter Roger Brown, this exhibit allows outsider, naive, or folk artists to be seen in the same realm as other artists who are sophisticated but not considered mainstream." —E. Michael Flanagan. Catalog.

ARTISTS INCLUDE

Steven Anderson
Ronald Beard
"Peter Charlie" Besharo
William Dawson
Minnie Evans
Lee Godie
William Hawkins
Jesse Howard
Clementine Hunter
John Kane

Guillermo McDonald
Edgar Alexander McKillop
Sister Gertrude Morgan
Elijah Pierce
Horace Pippin
Martin Ramirez
Drossos P. Skyllas
Edgar Tolson
Bill Traylor
Malcah Zeldis

AFRICAN-AMERICAN FOLK ART:
From the Collection of Dr. A. Everett James

VAN VECHTEN GALLERY AT FISK UNIVERSITY
Nashville, Tennessee

Curator
Liane Egan

October 18-December 31, 1991
An exhibition of folk art from the personal collection of Dr. James, "an avid collector and enthusiast of African-American folk art."

ARTISTS INCLUDE

Leroy Almon, Sr.
Z.B. Armstrong
Richard Burnside
Vernon Burwell
Charles Butler
David Butler
W.A. Cooper
L.C. Crawford
Ulysses Davis
William Dawson
Mattie Dial
Sam Doyle
Minnie Evans
Marvin Finn
William O. Golding
Mary Gordon
Ralph Griffin
Dilmus Hall
Ann Harris
Bessie Harvey
Ezekial Holley
Kubia Holley
Lonnie Holley
Sylvanus Hudson
Clementine Hunter
Alvin Jarrett
Anderson Johnson
Joe Light
Hosea Light
Mosea Light
Rachele Light
Rebekah Light
Rosie Lee Light

Annie Lucas
Charlie Lucas
John W. Mason
Willie Massey
Jake McCord
Eric Calvin McDonald
Columbus McGriff
Sister Gertrude Morgan
J.B. Murry
Ronald Musgrove
Royal Robertson
Juanita Rogers
Sulton Rogers
Nellie Mae Rowe
Edward Smith
Mary T. Smith
Henry Speller
Wesley Stewart
Vannoy Streeter
Jimmy Lee Sudduth
Sarah Mary Taylor
James "Son" Thomas
Annie Tolliver
Charlie Tolliver
Mose Tolliver
Willie Mae Tolliver
Felix Virgous
Inez Nathaniel Walker
Willie White
"Artist Chuckie" Williams
Jeff Williams
Luster Willis

THE OUTSIDERS:
Folk Artists with a Mission

YORKTOWN ARTS FOUNDATION/ON THE HILL
Yorktown, Virginia

October 16-December 20, 1991
Exhibition featuring the work of three self-taught Virginia Artists: Geneva Beavers, Anderson Johnson, and "Spike" Splichal.

PERSONAL VOICE:
Outsider Art and Signature Style

AMERICAN CENTER
FOR DESIGN
Chicago, Illinois

Curators
E. Michael Flanagan,
Frank C. Lewis

Septemper 10-November 1, 1991
This exhibit presented works that "arguably still display the 'signature style' of their creators." Brochure published.

ARTISTS INCLUDE

Leroy Almon, Sr.
Felipe Archuleta
Eddie Arning
Dwight Joe Bell
"Prophet" William J. Blackmon
E.J. Brown
Richard Burnside
Miles B. Carpenter
Jessie Cooper
Ronald Cooper
Vestie Davis
William Dawson
Sam Doyle
Rev. Howard Finster
Lee Godie
Denzil Goodpaster
Ted Gordon
Bessie Harvey
William Hawkins
Jesse Howard
Clementine Hunter
James Harold Jennings
S.L. Jones
Charley Kinney

Noah Kinney
Junior Lewis
Carl McKenzie
Lanier Meaders
Mr. Imagination
Earnest Patton
Benjamin F. Perkins
David Philpot
Frank Pickle
William Potts
"Butch" Quinn
J.P. Scott
Mary T. Smith
Simon Sparrow
Henry Speller
Jimmy Lee Sudduth
Sarah Mary Taylor
James "Son" Thomas
Mose Tolliver
Inez Nathaniel Walker
William Warmack
Derek Webster
Charlie Willeto
"Chief" Willey

KENTUCKY SPIRIT:
The Naive Tradition

OWENSBORO MUSEUM
OF FINE ART
Owensboro, Kentucky

Curators
Mary Bryon Hood,
Jane K. Wilson

August 18-September 22, 1991
This is the premiere exhibition of the Owensboro Museum's collection of works of art by Kentucky's self-taught artists and craftspeople. A companion photo-documentary exhibition, "Spirited Kentuckians," was also produced and focused on portraits of the artists. Catalog.

ARTISTS INCLUDE

Garland and Minnie Adkins
Lillian Barker
Edgar Bell
Minnie Black
Roger Blair
Sally Cammack

Connie Carlton
Mary Anderson Cayce
Elmer Cecil
Maurice Clayton
Calvin Cooper
L.D. Cooper

Ronald and Jessie Cooper
Kenneth N. Cross
Sam Drake
Everett Druien
John Eldridge
Michael Farmer
Don Ferrell
Marvin Finn
Denzil Goodpaster
Jim Harris
Renee Hicklin
Unto Jarvi
Charley Kinney
Noah Kinney
Don Lacy
Edd Lambdin
Sherman Lambdin
Bonnie Lewis
Jim Lewis
Junior Lewis

William E. Low
Lloyd "Hog" Mattingly
Thomas May
Carl McKenzie
Thomas O. Miller
William Miller and
 Rick Bryant
Lonnie Money
Helen LaFrance Orr
Earnest Patton
Russell Rice
Margaret Hudson Ross
Erwin Lex Shipley
Robert M. Short
Rev. Oda Shouse, Jr.
Tom Sizemore
Hugo Sperger
George V. Triplett
Otis Earl Walker
Melvin Wathen

LIVING TRADITIONS:
Southern Black Folk Art

THE MUSEUM OF
YORK COUNTY
Rock Hill, South Carolina

Curator
Phyllis Rollins

August 17-October 27, 1991
"[This] exhibition grew from a desire to feature an under-recognized facet of our Southern art heritage . . . As these regional artists gain national recognition, it seems only fitting that we should grant them the attention they so deserve here at home." —Phyllis Rollins. Catalog.

ARTISTS INCLUDE

Leroy Almon, Sr.
Richard Burnside
Archie Byron
Arthur Dial
Thornton Dial, Sr.
Thornton Dial, Jr.
Ralph Griffin
Bessie Harvey
Lonnie Holley

Joe Light
Ronald Lockett
Charlie Lucas
Mary T. Smith
Henry Speller
Jimmy Lee Sudduth
James "Son" Thomas
Mose Tolliver
Felix Virgous

YARD ART

BOISE ART MUSEUM
Boise, Idaho

Curator
Sandy Harthorn

May 18-July 7, 1991
" 'Yard Art' is an exhibition of unique objects gathered together to explore the diverse attitudes and forms found in and about personal outdoor spaces. The show attempts to present as broad a range of personal expressions as it could . . . It includes work from artists who have been trained in an academic setting as well as by those who received no formal art education." —Dennis O'Leary. Catalog published. Artists include Tim Fowler, Emil and Veva Gehrke, and Lee and Dee Steen.

LOOKING PRETTY, SITTING FINE:
The Baltimore Screens and Folk Art Chairs

SAN FRANCISCO CRAFT AND FOLK ART MUSEUM
San Francisco, California

Curator
John Turner

May 4-June 23, 1991
An exhibition that featured, in part, the Baltimore, Maryland screen painters. A description of the exhibition appears in the museum's newsletter dated May/June 1991.

ARTISTS INCLUDE

Frank Cipolloni	Tom Lipka
Frank De Oms	Alonzo Parks
Johnny Eck	Ben Richardson
Dee Herget	Ted Richardson

RELIGIOUS VISIONARIES

JOHN MICHAEL KOHLER ARTS CENTER
Sheboygan, Wisconsin

Curator
Joanne Cubbs

March 3-May 12, 1991
"This exhibition was presented as part of an ongoing effort to support the work of self-taught artists and to investigate themes in contemporary American art that otherwise receive limited attention. In 1985, the Arts Center presented a precursor to this exhibition, also titled 'Religious Visionaries,' which began our critical exploration of this special genre of expression by self-taught painters and sculptors." —Ruth DeYoung Kohler. Catalog. Artists include Norbert Kox, Mary LeRavin, and Simon Sparrow.

SPIRITS:
Selections from the Collection of Geoffrey Holder and Carmen De Lavallade

KATONAH MUSEUM OF ART
Katonah, New York

Guest Curator
John Beardsley

February 24-May 5, 1991
"With the same passion and originality that inform his other work, Holder over the years has gathered artworks from Africa, the Caribbean, Mexico, and North America, often the powerful creations of lonely, untutored visionaries. This collection, drawn primarily from sources outside the Western mainstream, demonstrates how art transcends cultural barriers and speaks to us with an unusual directness however unfamiliar the form." —Sponsor's Statement. Catalog.

ARTISTS INCLUDE

Felipe Archuleta
Vernon Burwell
Ulysses Davis
Minnie Evans
Rev. Howard Finster
William Hawkins
Stephen Huneck

Sister Gertrude Morgan
Elijah Pierce
Steven Polaha
Nellie Mae Rowe
Jon Serl
Mose Tolliver

THE CUTTING EDGE:
Contemporary American Folk Art

MUSEUM OF AMERICAN
FOLK ART/EVA AND
MORRIS FELD GALLERY
New York, New York

Curator
Barbara Cate

December 6, 1990-March 10, 1991
Assembled from the collection of Chuck and Jan Rosenak, "This exhibition is as diverse as America, a melting pot of twentieth century folk art, created by rural and urban artists from widely different backgrounds. For the first time in an exhibition of contemporary folk art, the works of self-trained Native Americans who break with tradition are included." —*The Clarion,* Fall 1990.

ARTISTS INCLUDE

Johnson Antonio
Felipe Archuleta
Leroy Archuleta
Eddie Arning
Steven Ashby
Andrea Badami
"Peter Charlie" Besharo
William Blayney
Rev. Maceptaw Bogun
Mary Borkowski
David Butler
Miles B. Carpenter
Henry Ray Clark
Raymond Coins
Helen Cordero
Henry Darger
William Dawson
Mamie Deschillie
"Uncle Jack" Dey
Sam Doyle
Minnie Evans
Josephus Farmer
Rev. Howard Finster
Victor Joseph Gatto
Lee Godie
Ted Gordon
William Hawkins

Jesse Howard
Clementine Hunter
Frank Jones
S.L. Jones
Gustav Klumpp
George Lopez
Alex A. Maldonado
Betty Manygoats
Gregorio Marzan
Justin McCarthy
Christine McHorse
Sister Gertrude Morgan
Ike Morgan
Ed "Mr. Eddy" Mumma
Louis Naranjo
Leslie Payne
Elijah Pierce
Naomi Polk
"Old Ironsides" Pry
Dow Pugh
Martin Ramirez
Enrique Rendon
John Roeder
Juanita Rogers
Nellie Mae Rowe
Jack Savitsky
Jon Serl

MUSEUM OF AMERICAN FOLK ART/EVA AND MORRIS FELD GALLERY *Continued*

Robert E. Smith
Henry Speller
Clarence Stringfield
Jimmy Lee Sudduth
Mose Tolliver
Edgar Tolson
Bill Traylor
Emmet Tso
Faye Tso

Horacio Valdez
John Vivolo
Inez Nathaniel Walker
"Chief" Willey
George Williams
Luster Willis
Joseph Yoakum
Malcah Zeldis

NATURAL SCRIPTURES:
Visions of Nature and the Bible

LEHIGH UNIVERSITY/
RALPH WILSON
GALLERY
Bethlehem, Pennsylvania

Curators
Elaine Garfinkel,
Adrian Swain,
Ricardo Viera

November 1-December 28, 1990
"Common to the work of these artists is a kind of backwoods natural theology of God's Kingdom where stories of innocence, suffering, and redemption are 'twice told' in Nature, cultural debris, and Scripture. Each of these artists is a visionary master or homespun shaman, of a new kind of American 'sacred art' " —Ricardo Viera. Catalog.

ARTISTS INCLUDE
Minnie and Garland Adkins
Jessie and Ronald Cooper

Rev. Howard Finster
Hugo Sperger

LOCAL VISIONS:
Folk Art from Northeast Kentucky

UNIVERSITY OF
WISCONSIN-MILWAUKEE
ART MUSEUM
Milwaukee, Wisconsin

Sponsors
Folk Art Collection/
Morehead State University

October 19-December 16, 1990
"Kentucky boasts the existence of some powerful, indigenous, idiosyncratic art. We refer to it loosely as 'folk art,' a term which seems superficially to satisfy our need for a label . . . This exhibition was developed, in part, to place this art and its creators in some sort of cultural context." Catalog.

ARTISTS INCLUDE
Garland Adkins
Minnie Adkins
Lillian Barker
Linvel Barker
Calvin Cooper
Jessie Cooper
Ronald Cooper
Charley Kinney

Noah Kinney
Junior Lewis
Leroy Lewis
Tim Lewis
Carl McKenzie
Earnest Patton
Hugo Sperger

UNCOMMONLY NAIVE

WRIGHT MUSEUM OF ART/BELOIT COLLEGE
Beloit, Wisconsin

Curator
Yolanda Saul

September 23-October 28, 1990
" 'Uncommonly Naive' is a collection of paintings, drawings, and art objects that focuses on the art of the self-taught and often unknown artists." —Yolanda Saul. Catalog.

ARTISTS INCLUDE

Josephus Farmer	"Butch" Quinn
Rev. Howard Finster	Nellie Mae Rowe
Milton Fletcher	Henry Speller
Carl McKenzie	Mose Tolliver
Irving Mendes	Bill Traylor

MADE WITH PASSION:
The Hemphill Folk Art Collection

NATIONAL MUSEUM OF AMERICAN ART
Washington, DC

Curator
Lynda Roscoe Hartigan

September 22, 1990-January 21, 1991
Exhibition includes "tin men" trade signs, visionary and political paintings, whirligigs, tattoo designs, fraternal objects, bottle-cap animals, carvings, canes, and face jugs. "This collection is in the National Museum of American Art because it represents an essential part of the American visual heritage . . ." —Elizabeth Broun. Book, by Lynda Roscoe Hartigan, published in conjunction with this exhibition.

ARTISTS INCLUDE

Felipe Archuleta	Benniah G. Layden
Eddie Arning	James Leonard
Andrea Badami	George Lopez
"Peter Charlie" Besharo	Alex A. Maldonado
Calvin and Ruby Black	Justin McCarthy
Robert Brown	Lanier Meaders
Miles B. Carpenter	Ben Miller
Clark Coe	Peter J. Minchell
Jim Colclough	Louis Monza
Henry Darger	Sister Gertrude Morgan
"Uncle Jack" Dey	Leslie J. Payne
Irving Dominick	John Perates
Josephus Farmer	Martin Ramirez
Albina Felski	Rod Rosebrook
"Cedar Creek Charlie" Fields	Jack Savitsky
Rev. Howard Finster	Jon Serl
Marshall B. Fleming	Q.J. Stephenson
Harold Garrison	Edgar Tolson
Victor Joseph Gatto	Bill Traylor
William Hawkins	Inez Nathaniel Walker
Frank Jones	Charlie Willeto
S.L. Jones	Joseph Yoakum
Edward A. Kay	Malcah Zeldis
Gustav Klumpp	

OUTSIDERS:
Artists Outside the Mainstream

OCTAGON CENTER
FOR THE ARTS
Ames, Iowa

Guest Curator
Ivan Hanthorn

September 9-October 21, 1990
"It has been our goal in our exhibit program to introduce our audience to opportunities they may not otherwise have had and to help them learn about artists and about how and why they do what they do. We have also tried to help people know that the ability to create exists in everyone and that each individual has a unique way of expressing that creativity. I believe this exhibit achieves our goals." —Martha Benson. Catalog.

ARTISTS INCLUDE

Leroy Almon, Sr.
Milo Benda
David Butler
Rev. Howard Finster
Sybil Gibson
Lee Godie
S.L. Jones
Hugo Kalke
Albert "Kid" Mertz
R.A. Miller

Mr. Imagination
"Butch" Quinn
Simon Sparrow
Mose Tolliver
Bill Traylor
Eugene Von Breunchenhein
Inez Nathaniel Walker
Willie White
Paul Williams
Joseph Yoakum

EVEN THE DEEP THINGS OF GOD:
A Quality of Mind in Afro-Atlantic Traditional Art

PITTSBURGH CENTER
FOR THE ARTS
Pittsburgh, Pennsylvania

Curator
Judith McWillie

August 18-September 30, 1990
"This exhibition explores the work of seven individuals whose lives affirm strong continuities in American cultural history." —Judith McWillie. Catalog.

ARTISTS INCLUDE

Z.B. Armstrong
Willie Leroy Elliott, Jr.
Ralph Griffin
Bessie Harvey

J.B. Murry
Philadelphia Wireman
Jimmy Lee Sudduth

CONTEMPORARY AMERICAN FOLK, NAIVE AND OUTSIDER ART:
Into the Mainstream?

MIAMI UNIVERSITY
ART MUSEUM
Oxford, Ohio

Curator
Edna Carter Southard

February 6-August 5, 1990
The curator's statement lists the many questions posed by the kind of art described in the title—classifications, labels, the possibility of naivety in mass media culture, the possibility of isolation in mass media culture, who are these artists, what is the mainstream, what aesthetic criteria can be applied. She continues: "The collection as it was conceived was intended to be inclusive and show the broad

range of this type of art. If we are a university art museum devoted to intellectual inquiry, then let us show the range of a problem."
—Edna Carter Southard. Catalog.

ARTISTS INCLUDE

Charles Dieter
Rev. Howard Finster
Ben Harris
William Hawkins
Clementine Hunter
S.L. Jones
Birdie Lusch
Mary Merrill
Morris B. Newman
Elijah Pierce

"Old Ironsides" Pry
Martin Ramirez
"Popeye" Reed
Sophy Regensburg
Nellie Mae Rowe
Anthony Joseph Salvatore
Mary T. Smith
Mose Tolliver
Bill Traylor

ORGANIZATIONS

Organizations supply opportunities for camaraderie with those who share an interest in folk art, programs for learning about and seeing folk art and artists, and in some cases the chance to work on projects of interest that enhance the appreciation of this field and its creative work.

The organizations described here have a variety of purposes and memberships. The first two organizations listed, the Folk Art Society of America and Intuit: The Center for Intuitive and Outsider Art, are membership groups with a national base. The next few organizations are membership-based with local or regional interests—for instance, the Southern Folk Pottery Collectors Society is for people seeking information about a specific art form (usually face jugs). Next on the list are organizations devoted to the education, development, and/or protection of folk art environments. The last set of organizations is mostly cultural in focus or sponsors publications or other activities of interest to those who enjoy contemporary folk, self-taught, and outsider art.

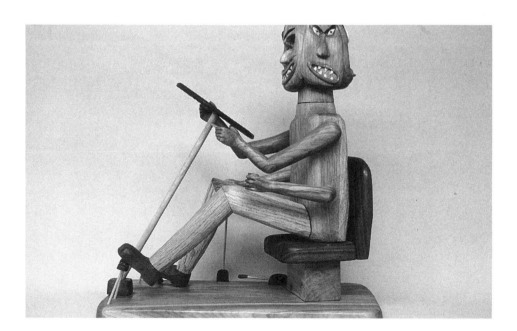

National

THE FOLK ART SOCIETY OF AMERICA
PO Box 17041
Richmond, VA 23226

The Folk Art Society of America was founded in 1987 by fourteen Richmond-based people who shared an interest in folk art and artists. The Society now has members from all over the United States and several foreign countries. The goals of the organization are to discover, promote, study, document, and preserve folk art, folk artists, and folk art environments. This is done through annual conferences, the sponsorship of exhibitions, and a publication called the *Folk Art Messenger*. Annual memberships are: $20.00 general; $50.00 patron; $10.00 student; $30.00 foreign.

INTUIT: THE CENTER FOR INTUITIVE AND OUTSIDER ART
PO Box 10040
Chicago, IL 60610
(312) 759-1406

Ellen Glassmeyer

This organization was founded in 1991 and is "devoted to celebrating artists who, for one reason or another, seem to be motivated by a unique personal vision and demonstrate remarkably little influence from the mainstream art world." The organization sponsors exhibitions, lecture series, and other educational opportunities, and publishes a newsletter, *In'tuit*. Plans for the future include a museum. Membership dues are $25.00 for students, $35.00 for regular membership and $100 or more for patron membership.

Regional/Local

AMERICAN FOLK ART SOCIETY
597 Chippendale Avenue
Simi Valley, CA 93065

Attn: Mel Penner

The American Folk Art Society was founded in Los Angeles in 1990. Its purpose is to provide an opportunity for people with similar interests to gather together for talks, lectures, and social events. Interests of members include carousel art, quilts, weathervanes, and historical and contemporary folk art. The group meets every other month, usually in the home of a collector. Written announcements of programs are mailed to members. For membership write to the address listed. Membership dues, payable to the American Folk Art Society, are: $35.00 single; $50.00 double.

NORTH CAROLINA FOLK ART SOCIETY
141 Norwood Avenue
Asheville, NC 28804

The North Carolina Folk Art Society was established in 1988 to study and promote the understanding and appreciation of folk art, and to disseminate information on folk artisans and folk art material. It meets four times a year, in conjunction with exhibits and other events when possible. Southern traditional (decorative material culture) and contemporary (outsider, visionary, naive) folk art are treated equally. Education and social interaction are the goals of the Society. The organization publishes an annual newsletter once per year which is available as part of the membership or by separate order (see "Publications"). Memberships are: $20.00 individual; $30.00 couples.

THE DEEP SOUTH SOCIETY, ART AND PLEASURE CLUB
c/o Bill Rose,
Corresponding Secretary
3500 St. Charles Avenue, #204
New Orleans, LA 70115

This organization was founded in 1992, to study and promote the understanding and appreciation of self-taught artists and their art, and to disseminate relevant information. The Society's objectives are "very limited," according to the founders. "No commercial interests will be promoted, networking among interested collectors will be encouraged and facilitated, and there will be social get-togethers."

FOLK ART ASSOCIATION OF THE SOUTHWEST
c/o Richard Trump, President
3993 Old Santa Fe Trail
Santa Fe, NM 87501
(505) 984-8680

The goal of this association is to promote, preserve, and encourage interest in folk art. It was founded in mid-1992, and has plans for future projects. The group wishes to work with and support the activities of the Folk Art Society of America. Membership is open to all who wish to join; dues were not set as of this writing. Meetings are held at members' homes.

SOUTHERN FOLK POTTERY COLLECTORS SOCIETY
1224 Main Street
Glastonbury, CT 06033

This is an organization for the collector of Southern folk pottery, with the following benefits: "To acquire unique pieces made exclusively for Society members; a first chance to acquire pieces from the Society's own collection; a periodic newsletter with informative articles on the potters and their wares; opportunities to contact other collectors; and opportunities to visit potters and witness the creation of folk pottery." In November 1991 the Society opened a shop/museum in Rollins, North Carolina. Annual membership in the Society is $25.00.

Educational/Preservational

SPACES: SAVING AND PRESERVING ARTS AND CULTURAL ENVIRONMENTS
1804 North Van Ness
Los Angeles, CA 90028
(213) 463-1629

Seymour Rosen,
President

SPACES is an organization founded in 1978, with members from all over the country. Its purpose is to support all efforts to preserve contemporary large scale folk art environments. This support takes many forms: educating the public about the existence and value of the art and architectural works; providing positive information and interpretation to government agencies and to the media; providing suggestions and encouragement to those trying to save sites; and publishing a high-quality newsletter. The newsletter also keeps the membership informed about books and other publications; conferences and symposia; situations at various sites; and anything else that will serve to enhance and conserve contemporary folk art environments. Membership: $15 individual; $25 individual sponsor; $25 institutional; $50 individual patron; $100 individual benefactor; $250 corporate.

KANSAS GRASSROOTS ART ASSOCIATION

PO Box 221
Lawrence, KS 66044

Barbara Brackman,
Executive Secretary

KGAA, as it is usually called, was founded in 1974 as a nonprofit organization. It is dedicated to preserving and documenting folk art environments. The objectives are "to preserve grassroots art on its original site, if possible; to document art environments and artists; and to increase public awareness and appreciation of grassroots art." KGAA maintains a library of photographs and information about sites, an art site index, and a museum. KGAA offers technical assistance to those wanting to preserve sites. Members receive a quarterly newsletter, *KGAA News.* Membership: $10.00 student; $15.00 general; $25.00 contributing; $50 or more, patron.

ART BEAL FOUNDATION

881 Hillcrest
Cambria, CA 93428

Elizabeth Appel,
President

This foundation, formed in 1984, works to restore and maintain the folk art environment created by Art Beal and called "Nitt Witt Ridge." In the summer of 1991 some major restoration work was accomplished. The foundation was revitalized in the Spring of 1992, and may be considered "essentially a new organization," according to president Elizabeth Appel. A fundraiser was scheduled for August 8, 1992 to raise money for a new roof. An archive for Art Beal's papers and memorabilia is being developed. The senior class at California Polytechnic has been assigned to do an inventory and write a report on the structures at Nitt Witt Ridge. Donations and offers of help are much appreciated and should be sent to the Foundation address listed (and not to the formerly publicized post office box).

BOTTLE VILLAGE/ PRESERVE BOTTLE VILLAGE COMMITTEE

PO Box 1412
Simi Valley, CA 93062
(805) 583-1627

Janice Wilson,
President/Site Director

The Preserve Bottle Village Committee is a nonprofit tax exempt organization dedicated to restoring and preserving Grandma Prisbrey's Bottle Village. This organization has fought a hard fight to preserve this truly wonderful folk art environment from developers. Funds are needed to continue preservation efforts, pay property taxes, meet government demands for engineering studies, and care for the grounds. In addition to supplying money, donations are a visible sign of support for the project—for the overworked committee and for local authorities. Those who donate $20.00 or more receive a newsletter that is published two or three times a year. The site is open to "always needed" volunteers and to those doing research. Once the site is renovated to meet earthquake codes, at least three of the fifteen buildings will also be open to the public.

FRED SMITH'S WISCONSIN CONCRETE PARK

Price County Forestry Dept./
Concrete Park
Normal Building
Phillips, WI 54555

The Concrete Park, administered by the Price County Forestry Department, is always in need of funds to restore and preserve the sculpture garden created by Fred Smith. Tax deductible donations may be sent to the address listed. Donors will be put on a mailing list to receive notices of interesting events at the park.

FRIENDS OF IDA KINGSBURY

6718 Beryl Street
Houston, TX 77074
(713) 777-1083

Tom La Faver,
Chair

The goal of this organization is to build a permanent display space for the art work of Ida Kingsbury—rescued from her garden and from certain destruction after her death. Mrs. Kingsbury's whimsical (and sometimes not so whimsical) characters, animals, and signs are painted on wood, metal, and found objects. They are currently in storage at The Orange Show—A Folk Art Foundation. The Foundation has purchased land where the display space will be constructed; now the task of the "Friends" is to raise money for a building. Donations payable to the "Friends of Ida Kingsbury" are tax deductible. Construction fund pledge forms are available. A membership costs $100 and members receive reports about projects, activities, and finances.

FRIENDS OF THE WALKER ROCK GARDEN

5407 37TH Avenue, S.W.
Seattle, WA 98126
(206) 935-3036; (206) 725-2338

The Walker Rock Garden, built during the years between 1959 and 1980, was made by Milton Walker. The garden consists of a series of arches, structures, and walkways made of rocks, crystals, chunks of glass, and other objects. After Mr. Walker's death, his son and widow worked to keep up the garden. Now there is a "friends group," formed to raise money and to maintain the premises. Donations are needed and appreciated. Tours of the garden, at the address listed, take place from Easter through Labor Day. Please call one of the telephone numbers listed to schedule a tour.

THE ORANGE SHOW: A FOLK ART FOUNDATION

2402 Munger
Houston, TX 77023
(713) 926-6368

Suzanne Demchak Theis,
Director

Founded in 1980 to preserve the Orange Show site created by Houston grassroots artist Jeff McKissack, the Foundation has added to its mission the identification and preservation of other sites in Texas and the education of the public to appreciate this form of art. A wide variety of performing and artistic events are presented, including "Eyeopeners," which include tours to folk art sites such as the Beer Can House, the Fan Man and the Flower Man—all Houston sites. The Orange Show Foundation has also been instrumental in saving the yard art of Ida Mae Kingsbury. The Orange Show: A Folk Art Foundation welcomes members and there are a number of dues categories. Write or call for information.

The Orange Show Folk Art Library has a collection of books, periodicals, articles, photographs, and original pieces of information concerning folk art in and around Houston, and in other locations. There is a state-by-state site directory. The library is open to the public during the Foundation's regular business hours. It is helpful if one calls ahead for an appointment.

THE PASAQUAN PRESERVATION SOCIETY

Marion County
Historical Society
Buena Vista, GA 31815
(404) 568-2263

The Pasaquan Preservation Society "is essentially a subsidiary of the Marion County Historical Society," says Fred Fussell, "and is charged with responsibilities for maintaining, preserving, and interpreting St. EOM's Pasaquan—a magnificent colorful art site in Buena Vista, Georgia." The membership of the Pasaquan Preservation Society is composed of those from the Marion County Historical Society, as

Mulkey McMichel,
Chair

well as other people whose interests are focused on Pasaquan only. Annual membership dues are $25.00, renewable on July 4 (St. EOM's birthday). A selection of St. EOM's artwork is available for purchase; sales are handled by Connell/Great American Gallery in Atlanta (see "Galleries" section). Funds from memberships, contributions, and sales from the gallery are much needed and are used to save the Pasaquan site.

PAINTED SCREEN SOCIETY OF BALTIMORE
PO Box 12122
Baltimore, MD 21281

Elaine Eff,
Director

The Painted Screen Society was founded in 1985 to preserve and promote screen painting and related rowhouse arts in Baltimore's neighborhoods. The Society sponsors workshops, lectures, films, and more. Membership supports the goal of creating a permanent facility for teaching and exhibiting Baltimore's unique community tradition. In addition to receiving information, members may volunteer for all sorts of projects. Membership is $10.00.

ROLLING THUNDER MONUMENT
c/o Mr. and Mrs. Mike Flansaas
PO Box 332
Imlay, NV 89418
(708) 538-7402; (708) 538-7414

Those interested in helping to preserve the folk art environment of the late Chief Rolling Mountain Thunder are asked to send money. The need for care and maintenance is great and requires generous donations. Call the people listed above, or drop in to take a self-guided tour on weekdays or a guided tour on Sundays. Thunder Mountain Monument is located on Highway 170, just southwest of Winnemucca, Nevada.

Educational/Cultural

APPALSHOP
306 Madison Street
Whitesburg, KY 41858
(606) 633-0108

Appalshop is a cooperative organization of media artists who produce films, television programs, theater, radio, audio recordings, and photography. They have their own radio station, production, and office space. The people of Appalshop, which began in a downtown Whitesburg storefront, "are still trying to get the words, songs, and visions out about what goes on in these mountains, and give the people of Appalachia a chance to speak for themselves." Their focus is on "material culture," but a few projects are of interest to folk art people, such as a video of Minnie Black and her gourd band, another on Jerry Brown's pottery, and a film, "Handcarved," about Chester Cornett.

CENTER FOR SOUTHERN FOLKLORE
152 Beale Street
Memphis, TN 38103
(901) 525-3655

The Center for Southern Folklore is a private nonprofit organization dedicated to recording and presenting the people and traditions of the South. The Center presents many programs to schools and to visitors. Many of their well-regarded films and videotapes are of interest to folk art people. The Center sponsors an annual heritage

CENTER FOR SOUTHERN FOLKLORE *Continued*

Judy Peiser,
Executive Director

festival in the summer and publishes a list of films, videos, and books available through the Center. Members receive invitations to special events, the Center newsletter, and discounts on all items in the Center catalog. Memberships: $25.00 member; $100 subscriber; $500 patron; $1000 benefactor.

FRIENDS OF THE CENTER/CENTER FOR THE STUDY OF SOUTHERN CULTURE
University of Mississippi
University, MS 38677
(601) 232-5993

William Ferris,
Director

A Friends organization was founded in 1984 to provide support for the Center's teaching, research, and outreach programs on the American South. Members receive the quarterly newsletter *Southern Register;* information about special programs and activities; and lists of books, recordings, and other items offered by the Center. Special discounts on programs and purchases are offered to Friends. Subjects of publications and items sold are frequently of interest to folk art people. Memberships: $25 regular; $50 contributing; $100 associate; $500 sustaining; $1000 patron. Contributions are tax deductible.

FOLK ART CENTER AND SOUTHERN HIGHLAND HANDICRAFT GUILD
PO Box 9545
Asheville, NC 28815
(704) 298-7928

Andrew Glasgow,
Director

The Folk Art Center, located on the Blueridge Parkway at Milepost 382, opened its beautiful 30,500 square foot building in 1980. It is operated by the Southern Highland Handicraft Guild (the Guild was founded in 1930 to preserve and encourage crafts culture in the Southern Appalachians). The Center schedules many special exhibitions, programs, workshops, and demonstrations. It houses the Allanstand Craft Shop, museum space, and an excellent library. Although the stated focus is on traditional mountain crafts as well as contemporary American crafts, some works displayed fit the contemporary folk art category—especially those of wood carvers and sculptors. So do many of the books and other materials in the library. To keep abreast of exhibition schedules and other programs, people are encouraged to become a Folk Art Center member. Please contact the Center for information.

THE FOLK ART SOCIETY OF KENTUCKY
Box 22564, Henry Clay Station
Lexington, KY 40522

"The purpose of the Folk Art Society of Kentucky, Inc. is to increase and disseminate knowledge and appreciation for the arts outside the generally recognized tradition of the fine arts. These include communal arts and crafts of all cultures, past and present; the popular arts; and the idiosyncratic work of eccentric individuals. The Society does this through primary research and documentation in various media, lectures, seminars, workshops, publications, and exhibitions. The ultimate goal of the Society is to establish a physical center or centers in Kentucky where documentation and original objects of art and craft may be preserved and exhibited and otherwise made available for research and for the education of the public at large. Officers and members of the Society serve without remuneration." A number of excellent publications are available from

the Society, among them *Folk Art of Kentucky, God, Man and the Devil: Religion in Recent Kentucky Folk Art,* and *Sticks: Historical and Contemporary Kentucky Canes.* For membership information, write to the organization.

THE JARGON SOCIETY
1000 Fifth Street
Winston-Salem, NC 27101
(919) 724-7619

Tom Patterson,
Executive Director

A nonprofit public corporation devoted to charitable, educational, and literary purposes, the Jargon Society sponsors the Southern Visionary Folk Art Preservation Project. Among its aims are the discovery and documentation of work by visionary folk artists over a none-state region; publication of a series of books on these artists; educational programming to promote greater public awareness of their work; preservation of folk art environments; and eventual establishment of a museum to house these works. Financial contributions from foundations, grant agencies, corporations, and interested individuals are the source of support. Contributions to the Society are tax deductible.

KENTUCKY ART AND CRAFT FOUNDATION
609 West Main Street
Louisville, KY 40202
(502) 589-0102

Rita H. Steinberg,
Executive Director

The Kentucky Art and Craft Foundation has as its mission to advance and perpetuate the art and craft heritage of Kentucky. It does so by providing educational and promotional opportunities for Kentucky artists and through educational efforts about the work produced in the state. The Foundation has, as one of its projects, the Kentucky Art and Craft Gallery (see "Galleries" section).

PUBLICATIONS

This chapter contains a list of publications that may interest those who collect, sell, or study contemporary folk and outsider art. The reader may obtain these publications by subscription, by joining the publishing organization, or by making a contribution to the sponsoring group. A few publications are free for the asking. This list is in two sections, each arranged alphabetically by title. The first section describes publications with a folk/outsider art focus or consistent inclusion of information. The second section lists art magazines that mention contemporary folk and outsider art with enough frequency to encourage the interested reader to check them on a regular basis. The concluding paragraphs mention other art publications and popular magazines that occasionally have articles on contemporary folk and outsider art.

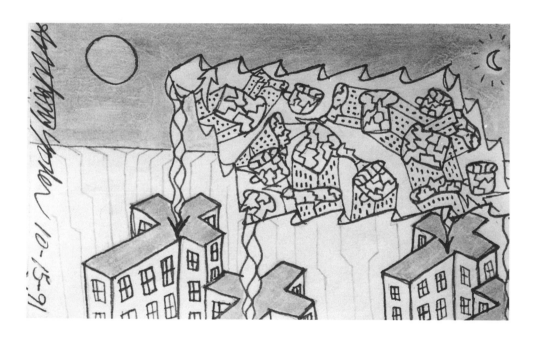

Specialized Publications

Ames News

The Ames Gallery
2661 Cedar Street
Berkeley, CA 94708
(510) 845-4949

This newsletter is published twice a year by Bonnie Grossman, director of The Ames Gallery. The newsletter announces gallery exhibitions, additions to the inventory, and books, catalogs, and other materials available for sale at the gallery. There are also notes of projects and activities throughout the country and a "Calendar of Events" with a California focus. Profiles of gallery artists David Marshall, Theodore Santoro, Alex Maldonado, Achilles Rizzoli, and Eddie Arning have been included in the newsletter. The publication includes illustrations. Write to the gallery to be placed on the mailing list.

The Cane Collector's Chronicle

15 Second Street, N.E.
Washington, DC 20002

The Cane Collector's Chronicle features articles about categories of canes; collections of importance or on exhibit; and auctions and shows. The July 1992 issue included such articles as: "Political Parade Canes," by Jim Gifford, and "Capital Canes," by Linda L. Beeman, about cane collections in the Washington D.C. area. The "events" section included notices of the exhibition "Step Lively" at the Museum of American Folk Art and of the publication of George Meyer's book on folk canes. *The Cane Collector's Chronicle* does not deal exclusively with the folk art cane. Those who are interested, however, may subscribe for an annual price of $30.00 by writing to publisher Linda Beeman at the above address.

Folk Art

The Museum of American Folk Art
61 West 62nd Street
New York, NY 10023
(212) 977-7170

Membership in the Museum of American Folk Art includes a subscription to *Folk Art* (the magazine's name was changed from *The Clarion* beginning with the fall 1992 issue). The magazine is published four times a year; single issues may be ordered for $5.00. Each issue includes several feature articles, news notes about what is going on around the country, book reviews, and museum news and information. Last but not least are the many colorful gallery advertisements that the reader may use to locate art and artists and to see handsome color illustrations of art work.

Folk Art Finder

117 North Main Street
Essex, CT 06426
(203) 767-0313

The *Folk Art Finder,* which began in March 1980, is described by its producers as "an informal newsletter of contemporary folk art." Among its contents are brief essays on current topics within the field, lists of exhibitions and publications, and "sketches" to introduce newly discovered artists. Annual subscription prices are $12.00 in the U.S. and $18.00 for subscribers in Europe.

Folk Art Messenger

The Folk Art Society of America
PO Box 17041
Richmond, VA 23226

The *Folk Art Messenger* is a quarterly publication of the Folk Art Society of America, and a subscription is included with a membership in that organization. It has been published since the fall of 1987 and includes feature articles, news reports, book reviews, book lists, an exhibition calendar, and much more. There are reports about the organization's activities, including details about annual meeting programs. Illustrations are included.

Folk Art Notes

Southern Arts Federation
1293 Peachtree Street, N.E.
Suite 500
Atlanta, GA 30309

Folk Art Notes is published twice a year by the Southern Arts Federation to inform the public of activities and news in the fields of Southern folk arts and folklife. Issues examined had notices of nontraditional folk art exhibitions as well as information about traditional folk arts. Free of charge.

Folklife Center News

The Library of Congress
American Folklife Center
Washington, DC 20540

This quarterly newsletter reports on the programs and activities of the American Folklife Center. Most of the contents are from a folklore point of view. Once in a while there is something of interest related to nontraditional folk art. Available free upon request.

Hai News

Hospital Audiences, Inc.
220 West 42nd Street
New York, NY 10036
(212) 575-7676

The *HAI News* is an illustrated "periodic publication" of HAI. It describes current programs of the organization, including information about their "mentally ill artists who participate in HAI's Arts Workshop Program." The Spring 1992 issue contained an article on "Outsider Art in New York City."

In'Tuit

Intuit: The Center for Intuitive
 and Outsider Art
PO Box 10040
Chicago, IL 60610

In'tuit is published twice each year (the first issue was published in Spring 1992) and is available to members of the sponsoring organization. Contents of the introductory issue included a brief biography of Jesse Howard, information about the organization's first lecture series, "Fantastic Spaces," and news about other projects and exhibitions. There is a calendar of upcoming events. Illustrations are included.

KGAA News

Kansas Grassroots Art Association
PO Box 221
Lawrence, KS 66044

KGAA News is a quarterly newsletter that began publication in the Fall of 1980 as the *Kansas Grassroots Art Association Newsletter,* and comes with membership in KGAA. The newsletter provides information about preservation activities and on sites that are open to visitors, reviews topical books and films, and includes information about exhibits and about projects of the organization. An issue will often highlight one state, and provide local site information, other places of interest to visit, and recommendations for restaurants and places to stay. *KGAA News* has included many articles on individual grassroots artists. Back issues are available for a reasonable charge.

The Orange Press

The Orange Show: A Folk Art Foundation
2402 Munger
Houston, TX 77023
(713) 926-6368

This newsletter, published by "The Orange Show," is available to those who join the Foundation membership group. It reports on the many projects sponsored to investigate and document folk art sites in Texas and on the lectures, publications, tours, and the library collection developed to encourage people to learn about this folk art form. The March/April 1991 issue inaugurated a "planned series of essays that investigates the art forms on which all our activities are based." There have been several descriptive articles on sites in Houston. The publication is illustrated.

Raw Vision

Raw Vision Ltd.
Dept. 193
1202 Lexington Avenue
New York, NY 10028
(212) 714-8381

Raw Vision is an international journal of intuitive and visionary art. It is "devoted to the many forms of intuitive artistic expression that exist outside normal cultural confines . . . whatever the label." Each issue contains in-depth articles and extensive visual materials about artists and art environments. Global in its coverage, among the Americans considered to date have been Howard Finster, Henry Darger, Miles B. Carpenter, Joe Gatto, Tressa Prisbrey, William Hawkins, The Philadelphia Wireman, Martin Ramirez, and Achilles Rizzoli. There is a "Raw News" section that provides information country by country, and a section devoted to book reviews. Two issues are published each year, and the annual subscription price is $19.00.

A Report
The San Francisco Craft and Folk Art Museum
Landmark Building A-Fort Mason Center
San Francisco, CA 94123
(415) 775-0990

This quarterly publication is free to museum members. It is also distributed throughout the United States to universities and to other mu.seums. Individual issues may be purchased for $2.50. Each issue features articles related to the museum's current exhibition. Occasionally non-traditional folk art is the subject.

Southern Folk Pottery Collectors Society
1224 Main Street
Glastonbury, CT 06033

This quarterly newsletter is a benefit of membership in the Society and is aimed at collectors. It is included in the membership dues of $25.00 per year. Articles focus on "definitions," potters and their wares, activities at the Society Shop and Museum in Robbins, North Carolina, and collecting matters in general. Illustrations are included.

The Southern Register
Center for the Study of Southern Culture
University of Mississippi
University, MS 38677

The Southern Register is the quarterly newsletter of the Center for the Study of Southern Culture and is available to those who join the organization, Friends of the Center. The newsletter reports on projects, conferences, and other activities sponsored by the Center. It notes relevant conferences at other institutions and reviews books. It includes brief articles, of which contemporary folk art has sometimes been the topic. The newsletter provides ordering information for books, video cassettes, and other items carried by the Center which always has titles related to folk art.

Spaces
Saving and Preserving Arts
 and Cultural Environments
1804 North Van Ness
Los Angeles, Ca 90028
(213) 463-1629

This newsletter is published once or twice each year and comes with a membership in the organization of the same name. It includes news about environmental art sites in the United States and abroad, announcements of exhibits, book reviews, and editorial commentary. Illustrations are included.

Voices
North Carolina Folk Art Society
141 Norwood Avenue
Asheville, NC 28804

This newsletter is published once per year and is part of the membership privileges of the Society, or it may be purchased separately for $7.00 per annual issue. Members write the articles, which are about collecting experiences, visits to artists, artists' biographies, and other relevent matters. The initial issue, published in the fall of 1992, contained twenty two pages of information about the organization and articles about artists Royal Robertson; Joe McFall and his wife in Mason Hall, Tennessee; Marshall Fleming; Albert Hodge, "the renegade potter"; and little-known Pennsylvania artist James Popso.

General Interest Magazines

Art and Antiques
89 Fifth Avenue
New York, NY 10003
(212) 206-7050

Published monthly except in July and August, *Art and Antiques* includes information about collecting, exhibitions, and openings. Sometimes, as in the Summer 1990 issue, it considers art outside the mainstream. The March issue each year features the "top 100 collections," which in 1992 included folk art collectors with references to the artists collected.

Art and Auction
250 West 57th Street
New York, NY 10107
(212) 582-5633

Art and Auction refers to itself as "the magazine of the international art markets." It is mostly about the market value of art. The majority of the articles focus on prices, predictions, and re-

ART AND AUCTION Continued

cent sales. A "couple of issues a year" are said to have articles on folk art, according to the publisher. The July/August issue each year is an "International Directory" of antiques dealers, auction houses, art galleries, antiques shows, art services, associations, and art fairs. The magazine is published monthly except for the July/August combined issue.

Art in America
575 Broadway
New York, NY 10012
(212) 941-2800

Art in America is published eleven times each year; the August issue is an annual guide to museums, galleries, and artists. It includes artist, gallery, and catalog indices, and an index to the year's editorials. There is also a section called "Museum Previews." This publication is indexed in *The Reader's Guide to Periodical Literature* and the *Art Index*.

New Art Examiner
1255 South Wabash, 4th Floor
Chicago, IL 60605
(312) 786-0200

Published by the New Art Association, this journal has some "outsider art" coverage that more often than not is quite negative. Indexed in *Art Index*.

Public Art Review
2955 Bloomington Avenue South
Minneapolis, MN 55407

This periodical is published twice each year with an annual subscription rate of $10.00. The editors are interested in receiving and publishing articles about environmental art, to which they have already given some attention.

Other Sources

Art Papers, published in Atlanta, comes out six times a year and reports on exhibitions, museums, reviews, and articles related to what is going on in Alabama, Arkansas, Florida, Georgia, Louisiana, Mississippi, North Carolina, Tennessee, Texas, and Virginia. *Art Muscle* from Milwaukee publishes information about outsider art. *Dialogue: An Art Journal* provides information about the visual arts in Illinois, Indiana, Kentucky, Michigan, Ohio, Pennsylvania, and West Virginia. *Antiques West,* published in San Francisco "for people who buy and sell art and antiques in the west" often has news or articles about nontraditional folk and outsider art. Addresses for all of these publications may be found in a public library.

Popular newsstand magazines that pay attention to folk art with some frequency are *Country Living, Elle Decor, Metropolitan Home,* and *Southern Home.*

EDUCATIONAL OPPORTUNITIES

The most fruitful approach to learning about contemporary nontraditional folk and outsider art is reading and looking at the art itself. It also helps to listen to collectors, gallery owners, and artists, and to read the writing of critics, commentators, and theorists.

There are a few additional opportunities for folk art study. Some are highly structured and require a block of time, such as a study trip; others may be one-time events. The more formal approaches range from course work at New York

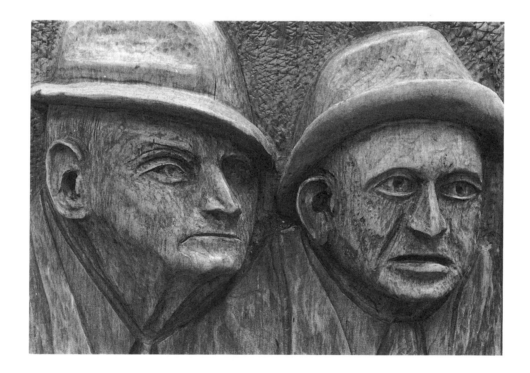

University leading to a degree, to one-day, two-day, and three-day symposia scheduled by a variety of institutions.

The list that follows consists of a sample of events that suggest opportunities the interested person may watch for to learn about twentieth century folk, self-taught, and outsider art. They are organized from the most formal or most time-consuming to the least formal or shortest. Some of these are ongoing, while some have already happened but are similar to opportunities that will probably arise in the future. A few of these may not resemble "educational" programs, but all provide the opportunity to learn if you look and listen.

FOLK ART STUDIES/NEW YORK UNIVERSITY

Folk Art Studies/AFA
New York University
Department of Art and
 Art Professions
School of Education, Health,
 Nursing, and Arts Professions
Barney Building
34 Stuyvesant Street
New York, NY 10003
(212) 998-5700

A Master of Arts in Folk Art Studies/AFA is offered by the NYU Department of Art and Art Professions, in collaboration with the Museum of American Folk Art. The emphasis of the curriculum is on the history and aesthetics of the folk art object. A wide range of courses is offered, many of which are open to non-matriculated students.

The program has three major components: history, aesthetics, and research techniques of folk art; internships/apprenticeships in the arts; and a final project consisting of a written paper. Applicants are required to possess an undergraduate degree in art or a related field and demonstrate an active interest in the field of American folk art. In addition there are school-wide requirements for graduate study.

Dr. Marilyn Karp is the program's director. The program coordinator is Dr. Judith Weissman. Write for a detailed prospectus on the program and a NYU bulletin.

FOLK ART INSTITUTE/MUSEUM OF AMERICAN FOLK ART

The Folk Art Institute
Museum of American Folk Art
61 West 62nd Street
New York, NY 10023
(212) 977-7170

The Folk Art Institute is a museum-based program of the Museum of American Folk Art and is accredited by the National Association of Schools of Arts and Design. There is a "Folk Art Studies" component and a "Hands-on Craft and Heritage Courses" component. Recent courses in Folk Art Studies have included "American Furniture: Folk and Fine," "Understanding Folk Art," "Folk Art in American Life," "American Folk Pottery," "Outsider Folk Art of the 19th and 20th Centuries," and "Folk Painting."

Fees and materials required for the "hands-on" courses and for the Folk Art Studies courses may be found in a brochure published each semester by the Folk Art Institute. Fees vary according to the classification of the student: matriculation in the 36-credit Museum Certificate program; auditors (students attending course on a non-credit basis); or students in the NYU graduate school program. All courses meet for fourteen weeks unless otherwise noted.

The director of the Folk Art Institute is Barbara Cate. Lee Kogan is the assistant director and the registrar is Phyllis Tepper.

CENTER FOR ADVANCED STUDY OF ART, DESIGN, AND MATERIAL CULTURE

Center for Advanced Study
 of Art, Design, and Material
 Culture
Craft and Folk Art Museum
6067 Wilshire Boulevard
Los Angeles, CA 90036
(213) 934-7239

The Center is "a program of the Craft and Folk Art Museum of Los Angeles. The Center's mission is to expand knowledge of the meaning of objects in contemporary society through multicultural and multidisciplinary research, dialogue, and publication. Conceived primarily as a fellowship program and think tank, it will include a public component, providing a forum for scholars and artists to exchange ideas with interpreters (museum and cultural workers, teachers, journalists, librarians, and others who influence visual perception) in small focal groups and public symposia."

The Center's director is Joan M. Benedetti.

SCHOOL OF THE ART INSTITUTE OF CHICAGO

Every summer since 1985 this school at the Art Institute of Chicago has offered a travel/art-history course that explores the cultural landscape. This study tour is taught by Lisa Stone and Jim Zanzi, both well-known for their research and documentation of art environments. The class explores the wide variety of expressions by artists in the midwestern landscape.

The 1992 study tour was scheduled to visit the Dickeyville Grotto of Father Mathias Wernerus ("Holy Ghost Park"); the Paul and Matilda Wegner "Peace Monument and Little Glass Church" in Cataract, Wisconsin; the grotto in Rudolph, Wisconsin built by Philip Wagner and continued by Edmund Rybicki; and Fred Smith's Wisconsin Concrete Park. For information call Lisa Stone, (414) 566-4292.

FOLK ART EXPLORER'S CLUB/MUSEUM OF AMERICAN FOLK ART

Beth Bergin
Membership Director
Museum of American Folk Art
61 West 62nd Street
New York, NY 10023
(212) 977-7170

The Folk Art Explorer's Club trips, ranging in length from one to several days, may seem too much fun to be educational. The longer expeditions provide opportunities to visit the homes of private collectors who discuss their collections, to meet with artists, to hear lectures by an expert or two, to have an insider's tour of galleries and museums, and to learn informally from other tour participants. These longer trips have gone to New Mexico, Louisiana, Georgia, North Carolina, Kentucky, and the San Francisco Bay Area.

Recent tours have been guided expertly by Beth Bergin and Chris Cappiello from the Museum of American Folk Art staff. Write or call to find out about the future availability of these pleasurable learning experiences.

THE FOLK ART SOCIETY OF AMERICA

The Folk Art Society of America is a membership organization described under "Organizations." Its educational activities include the program presented at the Society's annual meeting. The fifth annual meeting, for instance, took place in Los Angeles and focused on folk art environments and their makers. The 1991 annual meeting, in Chicago, included a panel discussion featuring four folk artists who talked about influences on their work. At the same meeting Russell Bowman, director of the Milwaukee Art Museum, lectured on "Parallel Visions: The Relationship of Folk Art to Contemporary Art." Elaine Eff, the Director of Maryland's Cultural Conservation program and producer of the award-winning film on Baltimore's painted screens, was the keynote speaker at the annual meeting in Alexandria, Virginia in 1990. Future annual meetings are planned for Santa Fe and New Orleans.

INTUIT: THE CENTER FOR INTUITIVE AND OUTSIDER ART

Intuit is a membership organization located in Chicago (see "Organizations"). This new organization has an educational component and has sponsored several programs with educational content. In the spring of 1992 Intuit presented a series of lectures on environments. Speakers included John Maizels on environments throughout the world, Susanne Theis on environments in the United States, and Don Howlett on Wisconsin environments. The organization sponsored a study tour October 1-4, 1992 called "The Artist in the Landscape."

EDUCATIONAL OPPORTUNITIES OFFERED BY OTHER ORGANIZATIONS

The Folk Art Society of America and Intuit are just two of the membership organizations that sponsor lectures and educational programs. Many of the others listed under "Organizations" also offer educational opportunities. The Orange Show: A Folk Art Foundation provides many opportunities for those who live in Houston, including slide shows, lecture series, trips to folk art environments, art celebrations, and more.

SYMPOSIA

Another learning source is the museum, art center, or gallery-sponsored event. A sample of these that have taken place in the recent past are listed below:

1. In 1992, the New York State Historical Association sponsored its 45th annual "Seminars on American Culture" in Cooperstown. To celebrate a new dedication to collect examples of twentieth century art for the permanent collection of Fenimore House Museum, the second session, July 8-11, 1992, consisted of a "Symposium on 20th Century Folk Art." It was held in conjunction with the exhibition "Worlds of Art . . . Worlds Apart." Speakers included Lee Kogan, Museum of American Folk Art; Sal Scalora, University of Connecticut; Linda Morley, Harvard University; and others. Paul D'Ambrosio was the symposium chair.
2. On April 11, 1992, the Oakland Museum hosted a major symposium on outsider art called "Altered States—Alternate Worlds." The symposium was held in conjunction with the retrospective exhibition of the drawings of Dwight Mackintosh; both were sponsored by the Creative Growth Art Center. Speakers included Didi Barrett, Roger Cardinal, John MacGregor, Gladys Nilsson, Seymour Rosen, and Allen Weiss.
3. The February 13-15, 1992 College Art Association annual conference, held in Chicago, featured a special session entitled "The Myth of the Artist Outsiders." Joanne Cubbs of the John Michael Kohler Arts Center organized the session, which included several speakers.

SYMPOSIA *Continued*

4. In February 1992, the High Museum in Atlanta sponsored a program and lecture by Marcia Weber: "Bill Traylor—Reflections of His Life and Work." The lecture occurred in conjunction with the museum's exhibition of Bill Traylor's art.

5. "The Collections of Artists: Their Influence" was the name of a panel discussion that included, among others, Roger Brown. The discussion was held at the University of Wisconsin-Milwaukee on November 16, 1991. This program was scheduled as part of the exhibition, "Personal Intensity: Artists in Spite of the Mainstream."

6. "The Legacy of Africa in the New World" was the title of a symposium held January 11-12, 1991 at the Waterloo Museum of Art in Waterloo, Iowa. The session called "Artists' Roundtable Dialogue" included self-taught artists David Philpot and Derek Webster.

7. On December 7-8, 1990, the Museum of American Folk Art sponsored "A Symposium: The Cutting Edge." The subject was twentieth century American folk art and the speakers were Trudy Thomas, Museum of Northern Arizona; Chuck Rosenak, co-author of the *Museum of American Folk Art Encyclopedia of Twentieth Century Folk Art and Artists;* Jack Beasley, Indian trader from Farmington, New Mexico; and Robert Bishop, Museum of American Folk Art director. Other speakers were Florence Laffal, Ann Oppenhimer, Sterling Strauser, and Herbert Waide Hemphill, Jr.

8. On October 26, 1990, the National Museum of American Art and the Archives of American Art organized a symposium held at the Hirshhorn Museum in Washington, D.C., in conjunction with the exhibition "Made with Passion: The Hemphill Folk Art Collection" at the National Museum of American Art. A few of the speakers were Avis Berman, Susan L.F. Isaacs, Kinshasha Holman Conwill, Kenneth Ames, Richard Ronas, Donald Kuspit, and Judith McWillie. The symposium was called "Cult, Culture and Consumers: Collecting the Work of Self-taught Artists in Twentieth-Century America."

9. A four-day seminar scheduled to complement the exhibition "Made with Passion: The Hemphill Folk Art Collection" took place on October 9-12, 1990 at the National Museum of American Art in Washington, D.C. The seminar, "American Folk Art," included such topics as approaches to folk art, cultural contexts, and the marketplace. Also included were two special visits to folk art environments.

10. Sailor's Valentine Gallery in Nantucket presented a Saturday symposium series during the summer of 1990. One session, on African-American folk art, featured Judith McWillie, Paul Arnett, and others. Another session, "20th Century American Folk Art," featured speakers Didi Barrett, Lynda Roscoe Hartigan, Russell Bowman, and Adrian Swain.

11. In April 1990, three lectures and a symposium at the Miami University Art Museum in Oxford, Ohio, complemented the exhibition of contemporary folk art at the museum— "Contemporary American Folk, Naive, and Outsider Art: Into the Mainstream?" Speakers included Eugene Metcalf, Gary Schwindler, Michael Hall, and Rayna Green.

BOOKS AND EXHIBITION CATALOGS

All books and exhibition catalogs in this bibliography have been examined. The annotations are descriptive rather than evaluative. This section tries to be as comprehensive as possible, at least in terms of available titles. In some cases, where the bibliography for a given artist—Moses, Kane, Pippin, Traylor, Hunter, or Finster, for example—is very long and can be found in one of the books devoted entirely to that artist, only a few of the titles were included here because of space limitations. Every item is either in print or available in a library. All titles examined were in the Library of Congress and/or the library of the Museum of American Folk Art. Museum shops are also a good source for books about self-

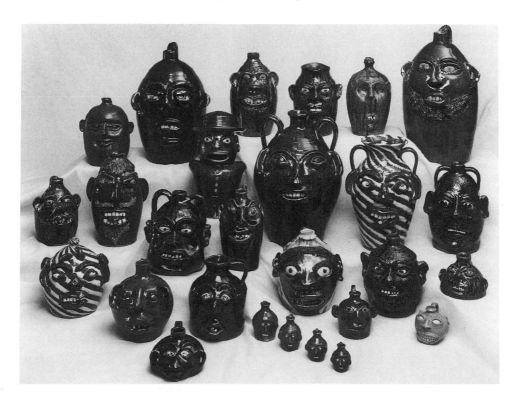

taught art and artists, as are many art galleries. Museums keep exhibition catalogs longer than one might expect, so it pays to ask about availability. If out-of-print books are not available in your local library, you might pursue an interlibrary loan request.

Note that as a general rule, exhibition catalogs are listed by title (not by author). The author is used, however, for books published "in conjunction with" an exhibition, even when the book also serves as the catalog for the exhibition. The practice here tries to follow the practice of the Library of Congress. Since there seem to be some inconsistencies, the reader searching for a particular book or catalog is advised to check both title and author.

The annotations for catalogs (and for other relevant books) often include a list of the artists in the show, in keeping with the theme of this book to emphasize access to the art and the artists. There are a few books where the list of artists included is far to long to be included in the annotation. In these cases, the information will be available through the index, accessed by artist. Since this book is devoted to twentieth century folk art and is predicated on its interest and value as art, little space has been given to those who deny its existence or validity—Bronner, Vlach, and others. Otherwise, books on every theme and point of view are listed here, including reference books, biographies, exhibition publications of all sizes, picture books, and books meant for children.

1. *10 Southern Black Folk Artists.* New Orleans: Barrister's Gallery, 1990.
[exhibition catalog]
Exhibition in Houston, March 1990. Catalog by A.P. Antippas of Barrister's Gallery in New Orleans. Biographical notes and information from interviews. Artists: Larry "Big Chief" Bannock, Roy Ferdinand, Jr., Ralph Griffin, Ruth Mae McCrane, Herbert Singleton, Mary T. Smith, Jimmy Lee Sudduth, James "Son" Thomas, Mose Tolliver, Willie White.

2. *10 Years of GRACE: An Exhibition of Vermont Grass Roots Art.* St. Johnsbury, VT: GRACE/Catamount Arts, 1987.
[exhibition catalog]
Don Sunseri, the project founder, describes the development of the Grass Roots Art and Community Effort (GRACE), which this show celebrates. Ninety-four works; thirty-two artists presented. Artists: Gayleen Aiken, Theda Baker, Margaret Bergen, Jeanette Bessette, Larry Bissonnette, Glen Buck, Dorothy Bupp, Myrtie Button, Ritchie Delisle, Berta Diller, Peg Fife, Grace Gould, Mabel Graham, Ezra Hill, Bernice Johnston, Dot Kibbee, Arlene Lane, Ruth Linberg, Della MacArthur, Stanley Marcile, Phyllis Nourse. Biographies. Checklist. Illus.; color, black & white.

3. *1975 Artists Biennial Winners: C. Kenneth Havis, James Hill, O.W. "Pappy" Kitchens, Michael Kostiuk, Russ Warren, Edward Whiteman.* New Orleans: New Orleans Museum of Art, 1976.
[exhibition catalog]
July 24-September 5, 1976. New Orleans Museum of Art. List of works in the exhibition and a reproduction of "The World's Most Famous Dance" (oil on canvas, 1974), by O.W. "Pappy" Kitchens.

4. *20th Century American Folk Art from the Arient Family Collection.* Chicago: Northern Illinois University Art Gallery, 1987.
[exhibition catalog]
October 16-November 14, 1987. Essay by Didi Barrett about the development of interest in twentieth century folk art. Notes by the Arients on the collecting experience. Artists: William Dawson, Sam Doyle, Howard Finster, Derek Webster, Luster Willis. Biographies. Photographs of the artists. Illus.; color.

5. *The 35th Biennial Exhibition of Contemporary American Painting.* Washington, D.C.: Corcoran Gallery of Art, 1977.
[exhibition catalog]
February 26-April 3, 1977. Twenty-four artists including O.W. "Pappy" Kitchens. The curator, William Fagaly, says "this choice is not whimsical; it is my contention that both the formal and narrative influences of folk art idioms manifestly pervade much American painting." Biographical data. Illus.

6. *The 41st Biennial Exhibition of Contemporary American Painting.* Washington, D.C.: The Corcoran Gallery of Art, 1989.
[exhibition catalog]
Organized by William Fagaly. Corcoran Gallery April 5-June 4, 1989 and traveled. Focused on painting in the South. Includes work of J.B. Murry, with commentary on the art and the artist. Says Murry "comes close to pure abstraction without completely abandoning the figure."

7. Abernathy, Francis Edward, ed. *Folk Art in Texas.* Dallas: Southern Methodist University Press, 1985.
Information on Texas folk art and artists. Essays on art in Texas cemeteries, automobile decorations, mural art, and others. Some essay titles are "Folk Art in General, Yard Art in Particular"; "Some People Call This Art" (John and Mary Milkovisch at the Beer Can House in Houston); "The Orange Show" of Jeff McKissack; "Johnny Banks, Black Man, Texan, Artist"; and "Eddie Arning: Texas Folk Artist," by Alexander Sackton. Publication no. 17 of the Texas Folklore Society. Illus.

8. *African-American Artists 1880-1987, Selections from the Evans-Tibbs Collection.* Seattle: University of Washington Press and the Smithsonian Institution Press, 1989.
[exhibition catalog]
Essays; checklist; artist biographies; bibliography. Essay by Richard Powell "From Renaissance to Realization 1920-1950" mentions Bill Traylor and Clementine Hunter, with color plates for each. The essay "The Search for Identity 1950-1987" by Sharon F. Patton includes Joseph Yoakum and Sister Gertrude Morgan, also with color plates.

9. *The Afro-American Tradition in Decorative Arts.* Cleveland: Cleveland Museum of Art, 1978. [exhibition catalog]
Curated by John Michael Vlach. Information on African-American folk arts in a cultural context. Focuses on basketry, musical instruments, wood carving, quilting, and other crafts. Clay skull by James "Son" Thomas.

10. Alexander, Wade, ed. *God's Greatest Hits.* New York: Random House, 1970.
Verses from the Bible illustrtated with color photographs of the art of Sister Gertrude Morgan. From the cololection of Rod McKuen.

11. *Always in Season: Folk Art and Traditional Culture in Vermont.* Montpelier, VT: Vermont Council on the Arts, 1982. [exhibition catalog]
May 8-November 1, 1982. Vermont Historical Society Museum. Jane C. Beck says her "folklorist approach is reflected in the focus." In addition to gravestones and butter prints there are some artists: Gayleen Aiken (the description next to her painting is an example of an attempt to make an artist "fit" a folklorist definition); Burleigh Woodward, carver; Herbert "Cap" Wilcox, carver; Lee Hull, memory painter; Charles Chaffee, cane carver; Frank Patoine, carver; Roland Rochette, collages; Bessie Drennan and Marion Hastings, painters. Illus.; color, black & white.

12. *Amazing Grace: The Life and Work of Elijah Pierce.* Columbus, OH: Martin Luther King, Jr. Center for Performing and Cultural Art, 1990. [exhibition catalog]
John Moe, curator. Information on the hardships of Pierce's life in Mississippi, his place in his community in Columbus, and his religious beliefs. Says Pierce started carving to remember his birth place and early associations. Quotes from Pierce about his art. Illus.

13. *America Expresses Herself: 18th, 19th and 20th Century Folk Art from the Herbert W. Hemphill, Jr. Collection.* Indianapolis: Children's Museum, 1976. [exhibition catalog]
October 2, 1976-March 13, 1977, to mark the opening of the museum. They wanted something "to appeal to children and adults, to contribute to the Bicentennial celebration and to give a special feeling about America—and we found Bert Hemphill and his collection." Essay by Hemphill, "Confessions of a Collector." Artists include: Edgar Tolson, Justin McCarthy, Peter Charlie Besharo, Martin Ramirez, Harold Garrison, W.G. Williams, Rev. Maceptaw Bogan, Mary Borkowski, Edward Kay, Malcah Zeldis, Jack Savitsky, Minnie Evans, J.C. Huntington, Victor Joseph Gatto, Joseph Yoakum, Jessie DuBose Rhoades, Lamont "Old Ironsides" Pry, Albina Felski, Clark Coe, William Edmondson, Eddie Arning, Miles B. Carpenter, Russell Gillespie, Clarence Stringfield, Mattie Lou O'Kelley, Felipe Archuleta, S.L. Jones, John L. Fancher, P.M. Wentworth, Sister Gertrude Morgan, Harry Lieberman, Jose Mondragon, Elijah Pierce, Peter Marshall, George Lopez, and Lanier Meaders. Illus.

14. *American Cat-alogue: The Cat in American Folk Art.* New York: Avon Books/Museum of American Folk Art, 1976. [exhibition catalog]
Bruce Johnson, curator. The portrayal of the cat in a variety of media. Says "sometimes the cat is a symbol of the home and its comforts, sometimes it is the symbol of the sinister." Artists include John Kane, Malcah Zeldis, Victor Joseph Gatto, Andrea Badami, Jack Savitsky, and Morris Hirshfield. Illus.

15. *American Folk Art and Craft Show.* Washington, D.C.: Very Special Arts Gallery, 1991. [exhibition catalog]
April 3-May 31, 1991. Information on the gallery, the parent organization (Very Special Arts), and on HAI/Hospital Audiences Inc. Biographies. Artists: David Alvarez, Kenneth Alvey, Calvin Cooper, Ronald Cooper, Jessie Cooper, Marcia Finks, Denzil Goodpaster, Junior Lewis, Leroy Lewis, Charlie Lucas, William Miller and Rick Bryant, Valton Murray, Tim Ratliff, Russell Rice, Mike Rodriguez, Mose Tolliver, and Kathi Ince; and, from HAI: Carl Greenberg, Rosemary Hurkamp, Helen Kossoff, Jennie Muraki, Ken McKay, Gaetana Menna, Frances Montague, Wally Nicholson, Irene Phillips, and Ana Rodriguez.

16. American Folk Art and Craft Show. Washington, D.C.: Very Special Arts Gallery, 1992. [exhibition catalog]
Annual exhibition of artists and craftspeople, many but not all of whom have disabilities. In-

formation on the sponsoring organization and biographies of the artists. Some of those exhibited are: Robyn "The Beaver" Beverland, Valton Murray, Annie Tolliver, Mose Tolliver, Knox Wilkinson, and a number of Kentucky artists including Calvin Cooper, Jessie and Ronald Cooper, Denzil Goodpaster, Junior Lewis, Leroy Lewis, Tim Ratliff, Russell Rice, William Miller, and Rick Bryant.

17. *American Folk Art from the Ozarks to the Rockies.* Tulsa: Philbrook Art Center, 1975.
[exhibition catalog]
Includes six states: Arkansas, Missouri, Kansas, Oklahoma, New Mexico, Colorado. Primary focus on living artists. Three hundred works in following categories: paintings, carvings, toys and dolls, fabric arts, farm and household objects, and environmental works. Painters: Helen Bitteck, Streeter Blair, Camille Blair, W.L. Collier, Daisy Cook, Dorris Curtis, Margie Dillon, Virgie Fiveash, Jimmie E. Martin, Emma Morgan, Florence Shank, Jo Sickbert, Lena Sitz, Robbie Berry Trone, Flora C. Washington, Joseph Yoakum. Carvers: Felipe Archuleta, Patrocino Barela, Wayne Bergman, Calvin J. Berry, Frank Brito, Joe Chalakee, Gloria Lopez, Peter Engles, Earl Eyman, George Lopez, Ben Ortega, Robert Troutman. Environmental works: Zelia Branstetter, Wishing Well, Tulsa, OK; S.P. Dinsmoor, Garden of Eden, Lucas, KS; Dinosaur Park in Eureka Springs, AK; and also Dave Woods of Humboldt, KS; Cecil Porter, Nowata, OK; and Roscoe Mattison, Collinsville, OK.

18. *American Folk Art: From the Traditional to the Naive.* Cleveland: The Cleveland Museum of Art, 1978.
[exhibition catalog]
Lynette I. Rhoades considers the need to study and define folk art; the development and variety of American folk art; contemporary interest in it; and the difficulties involved in evaluating the art and aesthetic qualities. The folk art is divided into "utilitarian," "visions of the unseen," and "naive representation of reality." Contemporary artists included are Edgar Tolson, Fred Alten, Nobil Stuart, Edward A. McKay, Mattie Lou O'Kelley, Steve Ashby, Felipe Archuleta, Benjamin Ortega, and James Hampton. Biographical information. Illus.; color, black & white.

19. *American Folk Art from the Collection of Herbert Waide Hemphill, Jr.* Oceanville, NJ: The Noyes Museum, 1988.
[exhibition catalog]
June 5-September 11, 1988. Sid Sachs, curator. An essay, "Preserving the Lone and Forgotten: The Herbert Waide Hemphill, Jr. Collection," discusses Hemphill's emphasis on folk art, and twentieth century folk art in particular, as a direct outgrowth of modernist thought, and suggests eight categories of approach to the study of the collection: Patterns of Decoration; Beyond Function; Political Commentary and History Painting; Visionaries and Outsiders; Religious Imagery and Mythology; Popular Culture, Traditional Functions of Art, and the Sculptural Imperative. Forty-four artists and anonymous pieces. Bibliography, Checklist. Illus.

20. *American Folk Art from the Milwaukee Art Museum.* Milwaukee, WI: Milwaukee Art Museum, 1989.
[exhibition catalog]
January 5-April 16, 1989 and then traveled in Wisconsin as part of the Shared Arts Resources program. Curator Jayne E. Stokes wrote the essay about the Museum folk art collection and about some of the artists included in it. Twentieth century artists include William J. "Prophet" Blackmon, Ralph Fasanella, John Kane, Lawrence W. Lebduska, Anna Louisa Miller, Eddie Arning, Joseph Yoakum, Felipe Archuleta, Josephus Farmer, and Simon Sparrow. Checklist. Illus.

21. *American Folk Art: The Herbert Waide Hemphill, Jr. Collection.* Milwaukee: Milwaukee Art Museum, 1981.
[exhibition catalog]
Said to be the first major publication on the Hemphill collection. Includes frequently quoted essays by Russell Bowman, "Varieties of Folk Art Expression"; Donald B. Kuspit, " 'Suffer the Little Children to Come Unto Me' Twentieth Century Folk Art"; and "The Hemphill Perspective: A View from a Bridge"—a dialogue between Hemphill and Michael D. Hall. Illus.; color, black & white. [Review: *Folk Art Finder 3* (3) September/October 1982, 17, by Florence Laffal]

22. *American Folk Sculpture: The Personal and the Eccentric.* Bloomfield Hills, MI: Cranbrook Academy of Art Gallery, 1971.
[exhibition catalog]
November 9, 1971-January 2, 1972. Essay by Michael Hall. Focus is on nineteenth and twentieth century sculpture by untrained artists "working to express a private view." Most of the work included is anonymous. Twentieth century artists: Edgar Tolson, E.A. McKillop, Clark Coe, Elijah Pierce, William Edmondson. Illus.; color (2), black & white.

23. *American Folk Sculpture from the Hall Collection.* Lexington, KY: University of Kentucky Art Gallery, 1974.
[exhibition catalog]
February 17-March 10, 1974. Forward by Michael Hall and Julie Hall, with an introduction by Robert Bishop that says "The Hall Collection represents a synthesis of the traditional and the modern. With unfailing vision, they have gathered the best of both." Artists include Elijah Pierce, William Edmondson, John W. Perates, Miles B. Carpenter, Edgar Tolson. Many illus.; mostly black & white.

24. *American Mysteries: The Rediscovery of Outsider Art.* San Francisco: Art Commission Gallery, 1987.
[exhibition announcement]
One leaf, illus. with a Jon Serl painting. Exhibition curated by John Ollman, Randall Morris, Shari Cavin Morris and Donald Fontowitz, September 29-November 7, 1987. Listed here, to show which artists were included by these highly regarded curators: Peter Charlie Besharo, Archie Byron, Henry Darger, Howard Finster, Tony Fitzpatrick, Bessie Harvey, Frank Jones, S.L. Jones, Alex A. Maldonado, Justin McCarthy, Louis Monza, J.B. Murry, Philadelphia Wireman, John Podhorsky, Martin Ramirez, Anthony Joseph Salvatore, Jon Serl, Matthew I. Smith, Bill Traylor, P.M. Wentworth, Joseph Yoakum, Julio Miraglia.

25. Ames, Kenneth. *Beyond Necessity: Art in the Folk Tradition.* New York: W. W. Norton/Winterthur Museum, 1977.
Ames "shocked and challenged" the folk art world with his opinions at the Winterthur folk art conference in 1977. Background for looking into the development of interest in contemporary folk art.

26. *Anii Anaadaalyaa'Igii (Recent Ones That Are Made): Continuity and Innovation in Recent Navajo Art.* Santa Fe: Wheelwright Museum of the American Indian, 1988.
[exhibition catalog]
July 10-October 3, 1988. Curated by Bruce D. Bernstein and Susan Brown McGreevy who wrote essays, as did Chuck Rosenak, Shonto W. Begay, and Luci Tapahonso. Photographs of art work and biographies. Categories of art: wood figures, cardboards, carvers. Among the artists presented: Woody Herbert, Johnson Antonio, Dan Hot, and Mamie Deschillie. [Review: *Folk Art Messenger* 2 (1) Fall 1988 4, by Susan Heroy]

27. *Animistic Landscapes: Joseph Yoakum Drawings.* Philadelphia: Janet Fleisher Gallery, 1989.
[exhibition catalog]
Forward by John Ollman. Brief essay by Randall Morris. Each emphasizes the storytelling qualities of Yoakum's work and the awareness of the spirituality of natural surroundings expressed in his art. Checklist. Chronology of Yoakum's life, exhibits. Twenty color illus.

28. *Another Face of the Diamond: Pathways through the Black Atlantic South.* New York: Intar Latin American Gallery, 1988.
[exhibition catalog]
January 23-March 3, 1989 and traveled. Project director Inverna Lockpez says "In this exhibition we intend to address that Black African Folk Art from the American South is one aspect of a widespread international tradition, from both sides of the Atlantic, where southern artists and their Latin American counterparts share the same idiom and iconography." Essays by Judith McWillie, Robert Farris Thompson, and John Mason. Biographies and quotes from artists: Hawkins Bolden, Archie Byron, Thornton Dial, Sr., Minnie Evans, Ralph Griffin, Dilmus Hall, Lonnie Holley, Joe Light, Charlie Lucas, J.B. Murry, Mary T. Smith. Illus.; color, black & white. [Review: *Folk Art Messenger* 2 (4) Summer 1989, 6, by Jay Tobler]

29. *Ape to Zebra: A Menagerie of New Mexican Woodcarvings, The Animal Carnival Collection of the Museum of American Folk Art.* New York: Museum of American Folk Art, 1986.
[exhibition catalog]
December 10, 1985-February 16, 1986. Introduction by Elizabeth Wecter. Art of twelve New Mexico carvers "most of whom have been

influenced by Felipe Archuleta." Artists: David Alvarez, Max Alvarez, Felipe Archuleta, Leroy Archuleta, Frank Brito, Sr., Richard "Jimbo" Davila, Alonzo Jimenez, Ben Ortega, Mike Rodriguez, Ron Rodriguez, Alejandro Sandoval, Luis Tapia. Notes. Checklist. Black & white photographs by Davis Mather.

30. Arbus, Amy. *No Place Like Home.* Garden City, NY: Dolphin/Doubleday, 1986.
Visits to five cities: New York, Los Angeles, Houston, San Francisco, and Albuquerque. Portraits of people who "have homes unlike anyone elses." Included is the Houston Beer Can House with a full-page photograph of Mary and John Milkovisch in front of their home, and information on how Mr. Milkovisch would string beer cans and fit them onto his house.

31. Arkus, Leon Anthony. *John Kane, Painter.* Pittsburgh: University of Pittsburgh Press, 1971.
Includes "Sky Hooks: The Autobiography of John Kane as told to Marie McSwigan" and "A Catalogue Raisonne" of Kane's paintings by Arkus. Lots of detail on the life, the art, the documentation of his work. Numerous illus., color, black & white.

32. Arnow, Jan. *By Southern Hands: A Celebration of Craft Traditions in the South.* Birmingham, AL: Oxmoor House, 1987.
Mostly crafts but also embroidery pictures by Ethel Wright Mohamed; carved canes by Parks Townsend and Luster Willis; carvings by Marvin Finn and Cyril Billiot; and face jugs by Burlon Craig and Charles Lisk. There is a resource section in the back that lists, among other useful information, state folklife programs. Index. Illus.; color, black & white.

33. *Art Across America.* Washington, D.C.: Very Special Arts Gallery, 1990.
[exhibition catalog]
December 3, 1990-January 31, 1991. Works of fifty-one artists from each state plus the District of Columbia. Biographies on self-taught artists Gary Oliver, Washington, D.C.; Elizabeth Layton, Kansas; Kathi Ince, Maine; Gerald Hawkes, Maryland; Gila Gelford, Michigan; William Britt, New York; and Ken Alvey, Mississippi. Not illus.

34. *Artists of the Black Experience.* Chicago: University of Illinois at Chicago Circle, 1984.
[exhibition catalog]
Presented February 2-24, 1984 by the Black Studies Program and others. The exhibition "celebrates the continuing legacy of African traditions." Artists: Clementine Hunter, Frank Jones, Mr. Imagination, Inez Nathaniel Walker, Simon Sparrow, Bill Traylor, Joseph Yoakum, Sister Gertrude Morgan. Traylor drawing on the cover.

35. *The Artworks of William Dawson.* Chicago: Chicago Public Library Cultural Center, 1990.
[exhibition catalog]
January 27-April 7, 1990. Curators: Kenneth Burkhart and others. Foreward by Roger Brown. Essay, by Ruth Ann Stewart, about Dawson's life and art. Bibliography. Checklist. Illus.; color, black & white.

36. *At the Heart of Change: Cross Cultural Currents in Southern Contemporary Art.* Kennesaw, GA: Kennesaw State College, 1992.
[exhibition brochure]
January 30-March 14, 1992. Examines how eight Southern artists have responded to forces at work in the region. Self-taught artists included are Bessie Harvey, Howard Finster, Thornton Dial, Sr., Ronald Lockett. All are illustrated, Dial and Harvey in color.

37. Babcock, Barbara A. "Modeled Selves: Helen Cordero's 'Little People'." In *The Anthropology of Experience,* 316-343. Victor W. Turner, and Edward M. Bruner. Chicago: University of Illinois Press, 1986.
Essay about Helen Cordero, the Cochiti Pueblo potter "who invented the Storyteller doll." The author is chiefly concerned with how to understand the relationships between Cordero's art and her life and "what her structured self-images mean to her." Author details Cordero's life, culture, and people. Illus.; black & white.

38. *Baking in the Sun: Visionary Images from the South—Selections from the Collection of Sylvia and Warren Lowe.* Lafayette, LA: University Art Museum, University of Southwestern Louisiana, 1987.
[exhibition catalog]
June 13-July 31, 1987 and traveled. Essays by Andy Nasisse, "Aspects of Visionary Art," and Maude Southwell Wahlman, "Africanisms in Afro-American Visionary Arts." Biography, photographs, and art works of sixteen Southern artists: Juanita Rogers, Mose Tolliver,

Howard Finster, David Butler, James Harold Jennings, Raymond Coins, Henry Speller, Royal Robertson, Burgess Dulaney, Bessie Harvey, Sam Doyle, Mary T. Smith, James "Son" Thomas, J.B. Murry, George Williams, and Luster Willis. Checklist. References. Illus.; color, black & white.

39. Baldwin, Karen, Anne Kimzey, and Keith Stallings. *Folk Arts and Folklife In and Around Pitt County: A Handbook and Resource Guide.* Greenville, NC: East Carolina University Folklore Archive, 1990.
Traditional folk arts and life, with resources for the educator. There are two people who are artists too: Henry Cowan, a cement sculptor, and Lester Gay, a windmill and whirligig maker. Sections include "Material Arts," "Musical Arts," "Occupational Folklife," "Regional Cookery," "Home Medicine & Midwifery," and "Narrative Arts." Bibliography. Illus.

40. Barnard, Nicholas. *Living With Folk Art: Ethnic Styles From Around the World.* Boston: Bulfinch Press/Little, Brown, 1991.
Folk art at home. Although some may scorn art used as decoration, it is helpful to see how it may be placed to be safe and seen. Essays on the art, including contemporary American folk art. Suggesting a lack of respect, intentional or not, the author does not identify the artists, even when their names are known. Index. Color photographs.

41. Barth, Jack, Doug Kirby, Ken Smith, and Mike Wilkins. Roadside America. New York: Simon and Schuster, 1986.
Guide to roadside "tourist attractions," which wouldn't be there, the authors point out, if people did not like to look at them. In addition to Cypress-Knee museums, roller skating parrots, and wild west museums there are entries for Coral Castle in Florida; Nitt Witt Ridge, Grandma Prisbrey's Bottle Village, and Watts Towers in California; Peterson's Rock Gardens in Oregon; the Orange Show in Texas; and the Garden of Eden in Kansas. Brief text and photos., mostly black & white.

42. Bearden, Romare, and Harry Henderson. *Six Black Masters of American Art.* Garden City, NY: Doubleday/Zenith Books, 1972.
Horace Pippin is one of the artists included, with commentary and information on his life and work. Illus.

43. Beardsley, John, and Jane Livingston. *Hispanic Art in the United States: Thirty Contemporary Painters and Sculptors.* New York: Abbeville Press, 1987.
Issued in conjunction with an exhibition at the Museum of Fine Arts, Houston, May-September 1987, and traveled. In addition to the trained artists are Felipe Archuleta, Gregorio Marzan, Martin Ramirez, Luis Tapia, and Felix A. Lopez. Essays by Beardsley, Livingston, and Octavio Paz. Artist biographies. Artist bibliographies. General bibliography. Index. Illus.; color. [Review: *The Clarion* 13 (2), Spring 1988, 71-72, by Georgianna Lagoria]

44. Beck, Jane. *Memories Touched by Fancy: Bessie Drennan, Vermont Artist.* Middlebury, VT: Vermont Folklife Center, 1990.
Life and works of Bessie Drennan, 1882-1961, who grew up in the small rural community of Woodbury, Vermont and painted memories of her childhood. She was "known as a village eccentric" until she picked up a paint brush late in life. Detailed essay about the artist. List of paintings. Illus.; color, black & white.

45. Becker, Howard S. *Art Worlds.* Berkeley: University of California Press, 1982.
The author treats art as the work some people do. He uses "art world" to describe people "whose cooperative activity, organized by their joint knowledge of conventional means of doing things, produces the kind of art work that the art world is noted for. This network includes all art workers, not just the creator of a given piece." After several chapters devoted to this "art world," Becker has a chapter on Folk Artists, Naive Artists, and Arts and Crafts. He explains his belief that naive artists have no connection with the art world and says naive painters are assimilated easily because their art resembles the known, and other folk art works just "are" and can be described only by enumerating their features. "Arts and Crafts" are "defined." James Hampton, Clarence Schmidt, Tressa Prisbrey, Jesse Howard, Herman Rusch, S.P. Dinsmoor and Watts Towers are mentioned.

46. *Beyond Tradition.* New York: The Katonah Gallery, 1984.
[exhibition catalog]
Curator Ute Stebich says American folk art reflects, in its diversity, the cultural pluralism of the United States and "Unlike trained artists

these men and women have little interest in formal values or an art historical point of view . . . they are concerned with communicating their message through specific subject matter drawn from their immediate worlds and their unique perceptions of the larger world." Artists: Felipe Archuleta, Ralph Fasanella; Howard Finster, William Hawkins, and Felix A. Lopez.

47. *Bibliography of American Folk Art for the Year 1987.* New York: Museum of American Folk Art, n.d.
Subject arrangement: general works; folk art of ethnic groups; folk art of religious sects; categories of folk art, with subdivisions; plus auction catalogs. Index. Not annotated. "Only imprints of the year 1987 are included." Compiled by Eugene Sheehy, Rita Keckeissen, and Edith Wise.

48. *Bibliography of American Folk Art for the Year 1988.* New York: Museum of American Folk Art, 1990.
Same format as 1987 edition. 1988 imprints plus some 1987 received too late for the previous edition. Section added: "Museum of American Folk Art Exhibitions and Events." Compiled by Sheehy, Keckeissen, Wise.

49. Bihalji-Merin, Oto. *Masters of Naive Art: A History and Worldwide Survey.* New York: McGraw-Hill, 1971.
Naive paintings from the late seventeenth century to "the present," from many countries. There is also a London edition, published the same year. American artists: Morris Hirshfield, John Kane, Joseph Pickett, Horace Pippin. There are 389 illus.; including 204 color plates.

50. Bihalji-Merin, Oto. *Modern Primitives: Masters of Naive Painting.* New York: Harry N. Abrams, 1959.
Contains a chapter called "American Primitives from the Colonial Time to the Present." Illus.

51. Bihalji-Merin, Oto, and Nebjosa Bato Tomasevic. *World Encyclopedia of Naive Art.* Secaucus, NJ: Chartwell Books, 1984.
Naive artists from many countries, including the USA. Introductory essay includes discussion on definitions and history; children's art; the artistic expressions of the mentally ill; and spare-time painters and amateurs. There is an alphabetical list of naive artists with illustrations and biographical data; a survey by country (written by Julia Weissman for the USA);

and a list of artists by country, with 89 Americans from Aragon to Zeldis. Numerous color illustrations and black & white photographs of the artists. Other back-of-the-book matter, including a bibliography.

52. *Bill Traylor.* Little Rock, AR: Arkansas Art Center, 1982.
[exhibition catalog]
October 14-November 28, 1982 and traveled. Introduction to themes in Traylor's art by Maude Southwell Wahlman. Chronology. List of exhibitions 1940-1983. Illus.(8); black & white.

53. *Bill Traylor.* Montgomery, AL: Montgomery Museum of Fine Arts, 1982.
[exhibition catalog]
November 6-December 30, 1982. Biographical information by the assistant curator Margaret Lynne Ausfeld. Checklist (30 works). Bibliography. Illus. (5); black & white.

54. *Bill Traylor.* New York: Hirschl & Adler Modern, 1985.
[exhibition catalog]
December 2, 1985-January 11, 1986. Introduction by Charles Shannon. List of one-person shows, brief bibliography, and a checklist of the fifty-one works in the exhibition. Illus.; color, black & white.

55. *Bill Traylor 1854-1947.* New York: Hirschl and Adler Modern, 1988.
[exhibition catalog]
December 15, 1988-January 14, 1989. Photograph of Traylor, with notes by John Yau. List of exhibitions, biographical notes. Illus.

56. *Bill Traylor Drawings.* Chicago: Chicago Public Library Cultural Center, 1988.
[exhibition catalog]
February 6-April 16, 1988. The essay by Michael Bonesteel is a detailed consideration of the art of Bill Traylor. Illus.; color, black & white.

57. *Bill Traylor: People's Artist.* Montgomery, AL: New South, 1940.
[exhibition brochure]
Pamphlet announcing that "New South is proud to have on its walls the first exhibition of works of Bill Traylor." There are a few details about his background, his art and the statement that "Bill Traylor's works are completely uninfluenced by our Western culture."

58. Bishop, Robert. *The All-American Dog: Man's Best Friend in Folk Art.* New York: Avon Books/Museum of American Folk Art, 1977. Overview of folk artists' use of the image of the dog that includes work by naive painters, carvers, sculptors, and others. Twentieth century artists (and their dogs): Morris Hirshfield, J.R. Adkins, Malcah Zeldis, Alex A. Maldonado, Mattie Lou O'Kelley, Howard Finster, Larry Zingale, Justin McCarthy, Bernard Langlais, Nobil Stuart, Carl Wesenberg, Fred Alten, Earl Eyman, Steven Polaha, S.L. Jones, Miles B. Carpenter. Illus.

59. Bishop, Robert. *American Folk Sculpture.* New York: E.P. Dutton, 1974.
Picture-book of folk sculpture arranged by type such as gravestones, religious objects, whirligigs, and so on. Bibliography; index. A few contemporary artists are included: Simon Rodia, Rodney Rosebrook, S.P. Dinsmoor and their environments; Albert Zahn, William Edmondson, Edgar Tolson, Elijah Pierce, Joseph Thomas Barta, James Hampton, John Perates, Joe Lee, Clark Coe, Miles B. Carpenter, Archie Gilbert, George T. Lopez, and E.A. McKillop. Index. Illus.; color, black & white.

60. Bishop, Robert. *Folk Painters of America.* New York: E.P. Dutton, 1979.
Types of folk painting are illustrated by geographical origin: New England, New York and New Jersey, Pennsylvania, the South, and others. Paintings from the seventeenth century to the twentieth century are represented. Approximately forty-five contemporary artists are included. Bibliography. Index. Illus.; color (70), black & white. [Review: *Folk Art Finder* 1 (2) May/June 1980, 7, by Jules Laffal]

61. Bishop, Robert, Judith R. Weissman, Michael McManus, and Henry Niemann. *The Knopf Collector's Guide to American Antiques: Folk Art: Paintings, Sculpture, and Country Objects.* New York: Alfred A. Knopf, 1983.
A buyer's guide to folk art, this publication covers nearly every type of folk art from the 1700s to the 1980s. Pieces illustrated are arranged by subject or function. Each entry describes a representative work and indicates name of artist when known. Informative introductory essay. Index.

62. *Black Art Ancestral Legacy: The African Impulse in African-American Art.* New York: Harry N. Abrams/Dallas Museum of Art, 1989. [exhibition catalog]
December 3, 1989-February 25, 1990, then traveled. Alvia J. Wardlaw, Regenia A. Perry, Edmund B. Gaither; curators. Several essays, including "African Art and African-American Folk Art: A Stylistic and Spiritual Kinship" by Perry. The yards of David Butler and Derek Webster, and art of Mr. Imagination, Bruce Brice, and John Landry illustrate Perry's essay. Essays by William Ferris and Robert Farris Thompson have references to and illustrations of folk art. Self-taught artists in the exhibition: William Edmondson, Minnie Evans, Bessie Harvey, Mr. Imagination, John Landry, David Philpot, Daniel Pressley, Sulton Rogers, Bill Traylor, Willard Watson, Derek Webster. Artist photographs, biography. Bibliography. Index. Illus.; color, black & white. [Reviews: *The Clarion* 16 (2) Summer 1991, 53-54, 56, by Judith McWillie; *Folk Art Messenger* 4 (1) Fall 1990, 6-7, by Jay Tobler; *Folk Art Finder* 12 (1) January-March 1991, 14-15, by Sal Scalora]

63. *Black Folk Art in Cleveland.* Cleveland, OH: Mather Gallery, Case Western Reserve University, 1984. [exhibition catalog]
Guest curator Gladys-Marie Fry. [dates not included] Essay by Fry on black urban folk art, its historical background and religious influences. Artists: Peggy Davenport, art from found objects; The Rev. Albert Wagner, painter; Helen Dobb, painter; Jim Moss, woodcarver; Benjamin Collins, metalsmith; Jonathan Rollins, woodcarver; Nick Beggins, metalsmith; and a few others, including a needleworker and a quilter. Photographs of the artists. Illus.; color, black & white.

64. *Black History/Black Visions: The Visionary Image in Texas.* Austin, TX: University of Texas Press, 1989. [exhibition catalog]
Huntington Gallery, University of Texas, Austin. January 27-March 19, 1989, and traveled. Lynne Adele says "the exhibit focus is on self-taught African-American artists who are visionary artists whose work deals with the unseen or seen only by the artist." She believes visionary art is distinctly African-American. Es-

says and photographs of artists. References. Artists: John W. Banks, Ezekiel Gibbs, Frank Jones, Naomi Polk, Johnnie Swearingen, Willard Watson. Illus.

65. Black, Mary, and Jean Lipman. *American Folk Painting*. New York: Clarkson N. Potter, 1966. Focus is on historical paintings, with some twentieth century works at the end including Horace Pippin, Joseph Pickett, Morris Hirshfield, Steve Harley, Harriet French Turner, Clara Williamson, John Kane, J.O.J. Frost, and Grandma Moses. Bibliography. Illus.; color, black & white.

66. Blasdel, Gregg N. *Symbols and Images: Contemporary Primitive Artists*. New York: American Federation of the Arts, 1970.
The title is "An attempt to suggest the true nature of the aesthetic relationship and the common sensitivity that these paintings share rather than to emphasize their identity with a particular kind of art. "Self-taught" would most easily embrace each of the individuals. Artists: J.R. Adkins; Andrea Badami; Catherine Banks; Margaret Batson; Nounoufar Boghosian; Henry Berger; Peter Contis; Minnie Evans; Sarah Frantz; Flora Fryer; Theora Hamblett; Fay Jones; Frank Jones; Anna Katz; Sadie Kurtz; Harry Marsh; Sister Gertrude Morgan; Shigeo Okumara; Gertrude Rogers; Anna Fell Rothstein; Saint EOM; Mary Borkowski, James Castle, France Folse, Milton Hepler, Clementine Hunter, Jennie Novick, Helen Rumbold, Virginia Tarnoski. Biography, artist statements. Illus.

67. *A Blessing from the Source: The Annie Hooper Bequest*. Raleigh, NC: North Carolina State University/The Jargon Society, 1988.
[exhibition catalog]
April 23-June 30, 1988. Small selection of the thousands of cement, putty, and driftwood sculptures that illustrate Bible stories that were important to Annie Hooper, an artist from the Outer Banks of North Carolina. Notes by Jonathan Williams of the Jargon Society; introduction by Charlotte Brown, director of the Visual Arts Program at North Carolina State University; biographical essay by Roger Manley, and an essay by Manley on religious art in the South. Illus.

68. Bock, Joanne. *Pop Wiener, Naive Painter*. Amherst, MA: University of Massachusetts Press, 1974.

Isidor "Pop" Wiener began working late in life, tapping into his East European Jewish heritage and his own talents, with no formal training. Text from taped interviews. Bibliography. Illus.; color, black & white.

69. Boyd, Elizabeth. *Popular Arts of Spanish New Mexico*. Santa Fe: Museum of New Mexico Press, 1974,
Information about architecture, textiles, wood and metal work, and some painting. Biographies of *santeros,* material on Penitentes. Bibliography.

70. Briggs, Charles L. *The Wood Carvers of Cordova New Mexico: Social Dimensions of an Artistic Revival*. Knoxville: University of Tennessee Press, 1980.
Examines the "revival" of Hispanic arts following the Anglo discovery of Jose Dolores Lopez, and a view of the impact of the marketplace. Photographs of artists. Included are Luis Tapia, Jose Dolores Lopez, Jose Rafael Aragon, Patrocino Barela, George Lopez, and others.

71. Bronner, Simon J., ed. *American Folk Art: A Guide to Sources*. New York: Garland, 1984.
Bibliographical essays arranged by topic. Emphasis is heavily on "material culture," though books about art seem to have slipped in, in spite of the stated desire to avoid consideration of "objects." Author and subject indices.

72. Burrison, John A. *Brothers in Clay: The Story of Georgia Folk Pottery*. Athens, GA: University of Georgia Press, 1983.
Historical background on Georgia folk pottery. Information on the potters themselves and the pottery; including Lanier Meaders and family and others. Many face jugs. Illus.; color, black & white. [Review: *Folk Art Finder* 5 (4) November/December 1984, 15, by Stuart C. Schwartz]

73. Burrison, John A. *Southern Folk Pottery, An Appreciation: Foxfire 8*. Garden City, NY: Anchor Press/Doubleday, 1984.
A collection of articles, introduced by Burrison, on the pottery tradition, the pottery families, and the work of various individuals. Many details on home life, family histories. Tells about Lanier Meaders, Edwin Meaders, Charlie Brown, Burlon Craig, and others. Differing opinions presented on the origins of face jugs. Illus.

74. *By Good Hands: New Hampshire Folk Art.* Durham, NH: University of New Hampshire, 1989.
[exhibition catalog]
Of the 103 works in this exhibition, four are contemporary art: Stuart Williams, "Squirrels and Birds," 1986 (ink on paper); Dorothy Graham, "The Doomed Ship," 1985 (ink on paper); Joseph C. Carreau, "The Switch House," (ink on paper); Ellie Gagnon, "Ice Fishing," (oil on board).

75. Cahill, Holger, Maximilien Gauthier, Jean Cassou, et al. *Masters of Popular Painting: Modern Primitives of Europe and America.* New York: Arno Press for the Museum of Modern Art, 1932.
One section describes Europeans; the other, Americans. Holger Cahill says "folk and popular art is very close to the sources of American expression." He sees a continuum from the work of the "earliest anonymous limners of seventeenth century New England to the contemporary work displayed in the exhibition . . . the discovery of the art of the people has been the work of our generation." Artists section includes, among others: John Kane, Lawrence Lebduska, Joseph Pickett, Horace Pippin, Patrick J. Sullivan.

76. Cannon, Hal. *Utah Folk Art: A Catalog of Material Culture.* Provo, UT: Brigham Young University Press, 1980.
Included, as are other state surveys elsewhere, because along with "material culture" some idiosyncratic art does appear. Divisions in the book are: Indians, Frontier, Ranch, House, Craft, Carving, and, finally, Painting. Color photographs of self-taught artist Francis Leroy Horspool "a self-declared Utah primitive"; Joseph Bolander of Orderville; Julious Twohy; and Thelma Peterson. Illus.

77. Cardinal, Roger. *Outsider Art.* New York: Praeger, 1972.
About cultural conditioning and how it affects and establishes the definition of art. Cardinal says "Rather than come to terms with the demands of the cultural norm, there do exist artists who have turned away and drawn the essence of their art from the situation of disequilibrium." Wants readers to consider alternatives to established art. Among his detailed examples is Simon Rodia. A scholarly work that is considered influential in establishing the concept of "outsider" art.

78. Carpenter, Miles B. *Cutting the Mustard.* Tappahannock, VA: American Folk Art Company, 1982.
Autobiography by Carpenter with introductory material by Hemphill, Lester Van Winkle and Jeffrey Camp. Memories of childhood, work, home, family, and friends. He tells about how he carves and what he thinks about it: "There is an old story about wood, and it's true. There is something in there, under the surface of every piece of wood. You don't need no design 'cause it is right there; you just take the bark off and if you do a good job you can find something." Illus.

79. Carraher, Ronald G. *Artists In Spite of Art.* New York: Van Nostrand Reinhold, 1970.
In the author's words, "A compendium of naive, primitive, vernacular, anonymous, spontaneous, popular, grassroots, folk, serv-ur-self art." Lots of outdoors art: signs, environments, whirligigs—mostly from the West, especially Washington State, for a change. Illus.; black & white.

80. Carroll, Patty, and James Yood. *Spirited Visions: Portraits of Chicago Artists.* Urbana: University of Illinois Press, 1991.
Photographs that "convey the artist within his or her own imagination and work." Mr. Imagination is photographed and described as a "great redeemer, an artist who reclaims what has been tossed away, a salvager who finds meaning and design in his ability to perform his powerful acts of transubstantiation."

81. *Cat and Ball On a Waterfall: 200 Years of California Folk Painting and Sculpture.* Oakland, CA: The Oakland Museum, 1986.
[exhibition catalog]
March 22-August 3, 1986. Harvey Jones, curator. An historical survey of California folk art. Essays: Donna Reid, "We Are the Folk"; Susan C. Larson, "The Strange and Wonderful World of California Folk Art"; and, Seymour Rosen and Louise Jackson, "Folk Art Environments in California: An Overview." Bibliography, biographies, checklist. Artists: John Abduljaami, Peter Allegaert, Arshag N. Amerkhanian, Ursula Barnes, Calvin and Ruby Black, Andrew Block, Peter Mason Bond, Bob Carter, Dalbert

Castro, Marcel Cavalla, Jim Colclough, Carlos Cortez Coyle, Urania Cummings, Frank L. Day, Jack Forbes, Robert Gilkerson, Esther Hamerman, Louis J. Henrich, Josephine Joy, George F. Knapp, Harold Kuettner, Harry Lieberman, Alex A. Maldonado, Louis Monza, John H. Newmarker, Bennett Newsom, Jane Porter, Irwin Rabinov, Martin Ramirez, Morton Riddle, John Roeder, James Clyde Scott, Jon Serl, Carrie Van Wie, Mark Walker, P.M. Wentworth, Marlene Zimmerman, and the environments of Duke Cahill, Joseph Cholagian, "Litto" Damonte, Sanford Darling, John Ehn, Romano Gabriel, Tressa Prisbrey, Simon Rodia, and the now destroyed Emeryville flats. Illus.; color, black & white. [Review: *The Clarion* 12(1) Winter 1987, 26, by Randall Morris]

82. *A Centennial Salute to Clementine Hunter.* New Orleans: New Orleans Museum of Art, 1985.
[biographical essay accompanying exhibition]
Eva Lamothe describes a visit with Clementine Hunter: Hunter's appearance at age 100 and her painting techniques at the time. Lamothe asked about any possible African influences on her work. "Her answer was a negative 'un unh': She was not interested in discussing African influences on her work."

83. Chambers, Bruce W. *Art and the Arts of the South: The Robert R. Coggins Collection.* Columbia, SC: Columbia Museum of Art, 1984.
Exploration of the "uniquely Southern artistic vision." One chapter, "Three Self-Taught Artists," considers the work of Bill Traylor, William O. Golding, and Eugene A. Thompson. Short biographical notes. Illus.

84. *Charles W. Hutson 1840-1936: A Retrospective Exhibition.* New Orleans: Isaac Delgado Museum of Art, 1965.
[exhibition catalog]
June 6-27, 1965. There are copious illustrations of this self-taught artist's work, with descriptions of the work and biographical information. [note: Delgado Museum now the New Orleans Museum of Art]

85. Chase, Judith W. *Afro-American Art and Craft.* New York: Van Nostrand Reinhold, 1971.
Cultural history of African Americans. Author starts from prehistoric times and continues to the present day to demonstrate that the cultural heritage is one continuous stream. Self-taught artists briefly mentioned are Horace Pippin, William Edmondson, and Minnie Evans. Also references to Hugh Moore, "formerly a porter at the Cleveland Art Museum," and Teddy Gunn, as self-taught Afro-American artists.

86. *Circles of Tradition: Folk Art in Minnesota.* Minneapolis: University of Minnesota Art Museum, 1989.
Essay by Willard B. Moore called "Circles of Tradition" considers two views of the meaning of tradition that may apply to folk artists: artists whose work mirrors the culture and is part of everyday life, the model of the folk artist in the Middle Ages; and artists who are set apart, often alienated, and responsible for introducing new ideas and symbols, and who create works of little appeal to their neighbors. Says the latter is prevalent in Minnesota. He defines three circles of tradition: the innermost circle, "Integrated Tradition," which is interwoven into community life; the second circle, "Perceived Tradition," which is not totally integrated into the community but perceived by some individuals as "tradition"; and the outermost circle of "celebrated traditions," that is, creations that are traditional to another time and place. Includes other essays and illustrations, mostly of carvers.

87. *City Folk: Ethnic Traditions in the Metropolitan Area.* New York: Museum of American Folk Art, 1988.
[exhibition brochure]
PaineWebber Art Gallery June 13-September 9, 1988. Gerard C. Wertkin, curator. The seven-page brochure unfolds into a color poster of Ralph Fasanella's "Subway Riders." The exhibition was organized around the themes of "faith/ritual, celebration/performance, work/craft, people/memories. Some of the artists in the exhibition were Harry Lieberman, Ralph Fasanella, Gregorio Marzan, Miguel "Mikie" Perez, Jean Fritz Chery, M. Jankasutas, Onnie Miller, Vincenzo Ancona, Yaroslava Mills.

88. Coe, Ralph T. *Lost and Found Traditions: Native American Art, 1965-1985.* New York: American Federation of Arts, 1986.
Published in conjunction with an exhibition that traveled throughout the United States. Issues included: collecting; timeless works of

art; tradition—speaking to the present, respecting the past; and the "non-vanishing Indian." Organized by region. There are illustrations with commentary.

89. Collins, George R. *Fantastic Architecture: Personal and Eccentric Visions*. New York: Harry N. Abrams, 1980.
"Evidence of the unofficial world of architecture. Work of folk artists and others who have been unrestrained by zoning laws . . . forms they arrived at with complete freedom of fantasy." Author covers the world. United States examples include: Ed Galloway, Simon Rodia, Grandma Prisbrey, Baldasare Forestiere, Father Wernerus, Clarence Schmidt, Chief Rolling Thunder, Herman Rusch, Howard Finster, Fred Smith, S.P. Dinsmoor; and also Leedskalnin's Coral Castle, Driftwood Charley's site in Yuma and Gabriel's Flower Garden in Eureka, California.

90. *Collision*. Houston: Lawndale Alternative, University of Houston, 1985.
[exhibition catalog]
September 22-November 4, 1984. Eight artists "involved in a related aesthetic—unusual combinations of objects from everyday life, transformed by deft juxtaposition into pictorial/sculptural compositions." Information on the artists, including self-taught artist Jesse Lott and his statement about his "urban folk art." Photograph of the artist.

91. *Common Ground/Uncommon Vision: The Michael and Julie Hall Collection of American Folk Art*. Milwaukee, WI: Milwaukee Art Museum, 1993.
[exhibition catalog]
Exhibition scheduled for the Milwaukee Art Museum and then travel. Includes an interview by curator Russell Bowman of Michael Hall and Julie Hall who assembled the collection. Essays by Kenneth L. Ames, "Folk Art and Cultural Values"; Lucy L. Lippard, "Crossing Into Uncommon Grounds"; and Jeffrey R. Hayes, "De/Fining Art History: The Hall Collection of American Folk Art." Each object in the collection receives an entry in the catalog and is illustrated. Those that appear in the exhibition are indicated. [Information pre-publication from Mary Garity Lacharite]

92. *Contemporary American Folk, Naive, and Outsider Art: Into the Mainstream?* Oxford, OH:
Miami University Art Museum, 1990.
[exhibition catalog]
February 6-August 5, 1990. Curator: Edna Carter Southard. Eugene Metcalf discusses "Folk Art, Museums, and Collecting the Modern American Self." Gary Schwindler discusses the separation between mainstream and outsider art and issues around terminology. Trained artists include Rick Borg, Smoky Brown, and Aminah Robinson. For a list of self-taught artists in the exhibition, see the "Museum Exhibitions" section. Bibliography. Illus.

93. *Contemporary American Folk Art: The Balsley Collection*. Milwaukee, WI: Haggerty Museum of Art, Marquette University, 1992.
[exhibition catalog]
April 15-August 2, 1992. Curator: Curtis L. Carter. Essays by Roger Manley, "Outsider Art and Narrative Form," and Didi Barrett, "Finding Rousseau in Your Own Backyard." Other writings by John and Diane Balsley, on collecting, and by Carter. Checklist. Profiles of the artists. References. For a list of the artists see the "Museum Exhibitions" section. Illus.; color, black & white.

94. *Contemporary Art from Alaska*. Washington, D.C.: National Collection of Fine Arts, Smithsonian Institution Press, 1978.
[exhibition catalog]
National Collection of Fine Arts June 23-September 17, 1978. Most of the artists were trained, with the exception of James Kivetoruk Moses and Fred J. Anderson.

95. *Continuity and Change: American Folk Art from the Collection of Robert Bishop*. Osaka: Hankyu Department Stores, 1984.
[exhibition catalog]
May 6-June 15, 1984 and traveled in Japan. Curators: Didi Barrett, Henry Niemann. Introduction Japanese and English. Text Japanese, except for artist's name, title of work. Objects from the eighteenth, nineteenth, twentieth centuries. Contemporary artists: Janet Munro, Tella Kitchen, "Uncle Jack" Dey, "Chief" Willey, Howard Finster, Mattie Lou O'Kelley, Jack Savitsky, Malcah Zeldis, Clementine Hunter, Sister Gertrude Morgan, Mose Tolliver, Earl Cunningham, Ruth Perkins, Eddie Arning, Gustav Klumpp, Peter Charlie Besharo, John Perates, Antonio Esteves, W.L. Barton, David Butler, David George Marshall, Felipe Archuleta, Pucho Odio, Andy Kane, Bill Traylor, S.L.

Jones, Inez Nathaniel Walker, Vestie Davis, Lawrence Lebduska, and a few others. Illus.

96. *Coral Castle*. Homestead, FL: Coral Castle, 1988.
Publication distributed to visitors to this grassroots art environment. Background on the "lost romance" said to have inspired Ed Leedskalnin to build his castle and its surrounds. Description of the site, technical information on its construction, and biographical details on the artist/architect. Photographs, color and black & white, of the artist and art.

97. *The Creative Spirit*. Richmond, CA: National Institute of Art and Disabilities, 1990.
[exhibition catalog]
Introduction by Florence Ludins-Katz and Elias Katz. Exhibition of Institute artists: Sylvia Fragoso, Marlon Mullen, Samuel Gant, Audrey Pickering, Beverly Trieber, Robert James, James Boutell, Wendell Singleton, Rosita Pardo, Tony Laspina, Helen Stewart, Leslie Sylvester, Juliet Holmes, Sandra Connor, and Kevin Randolph. For each there is a photograph of the artist and several illustrations, one in color, of the art.

98. Cubbs, Joanne. *Eugene Von Bruenchenhein: Obsessive Visionary*. Sheboygan, WI: John Michael Kohler Arts Center, 1988.
The text by Joanne Cubbs includes biography, the paintings, "Visionary Worlds of the Outside Artist," the artist's romanticism, and sculpture, photography, poetry. Artist's own writings on pages 25-41. Many color plates of art (ceramics, bone sculpture, paintings). Color photographs of the artist, his home. [Review: *Folk Art Finder* 10 (3) July-September 1989, 15, 18-19, by Roger Cardinal]

99. *The Cutting Edge of Creativity*. Flagstaff, AZ: Museum of Northern Arizona Press, 1993.
NOTE: Notice was received at presstime that this exhibit has been cancelled.
Museum of Northern Arizona January 30-May 5, 1993. Trudy Thomas, Curator of Fine Arts, is responsible for the exhibition and the catalog. The focus is on art from native cultures that have been exposed to other cultures—Hawaii, the Pacific Northwest Coast, the Plains, and the Southwest—and is inspired by tradition but also departs from that tradition. The nature and amount of departure varies from artist to artist and region to region. The approach is to cut across the categories derived from European art history—folk, experimental, tradi-

tional, craft, fine art. Curator Thomas states that this exhibition does not attempt to be "the definitive statement" because art is always changing. Essays are included by Thomas, on the state of artistic endeavor in the Southwest; by Lynn J. Martin of the Hawaii State Foundation of the Arts, on contemporary Hawaiian art; by Dr. Emma Hansen, curator of the Plains Indian Museum, Buffalo Bill Historical Center in Cody, Wyoming, on art from Plains cultures; and by Charlotte Townsend-Gault, curator and author from the National Gallery of Canada, on the art of the Northwest Coast. Quotations from interviews with the artists, photographs of the art, and a bibliography. [Information pre-publication from Trudy Thomas]

100. *David Butler*. New Orleans: New Orleans Museum of Art, 1976.
[exhibition catalog]
First public showing of Butler's work. Introduction by curator William A. Fagaly who says "Louisiana has a rich tradition of folk art, and while it can still boast of numerous talented naive painters . . . environmental folk artists such as David Butler are rare in the state." Biographical details, information on how Butler started creating sculptures. Butler was age seventy-seven, lived alone in Patterson, Louisiana, and his yard art was intact at the time of this exhibition. Black & white photographs.

101. De Mejo, Oscar. *My America*. New York: Harry N. Abrams, 1983.
Introductory text by Selden Rodman about this self-taught artist who was born in Italy and came to the United States in 1947. Bibliography. Illus.; color.

102. *Deliberate Lives: A Celebration of Three Missouri Masters*. St. Louis: First Street Forum, 1984
[exhibition brochure]
May 29-July 8, 1984. Artists: L.L. Broadfoot, Alva Gene Dexhimer, Jesse Howard. Curator Alex "Sandy" Primm, provides information on the lives of all three and says "they shared an outlook still common in rural Missouri—the belief an individual can and must be self-sufficient."

103. *A Density of Passions*. Trenton: New Jersey State Museum, 1989.

[exhibition catalog]
July 29-September 24, 1989 of self-taught and mainstream artists. Background information and comment on the qualities of the work. Self-taught artists: Henry Darger, Howard Finster, Frank Jones, Ted Gordon, Gerald Hawkes, J.B. Murry, Philadelphia Wireman, Gregory Van Maanen, Joseph Yoakum. Illus.; color, black & white.

104. Dewhurst, C. Kurt, and Marsha MacDowell. *Rainbows in the Sky: The Folk Art of Michigan in the Twentieth Century.* East Lansing, MI: Michigan State University, 1983.
Traditional folk art and "art influenced by popular culture." Includes fish decoys, paintings, carvings, and the work environment of Clarence Hewes. Biographies and illustrations of art.

105. Dewhurst, C. Kurt, Betty MacDowell, and Marsha MacDowell. *Artists in Aprons: Folk Art by American Women.* New York: E.P. Dutton/Museum of American Folk Art, 1979.
"The story of American art as practiced by women in their homes." Includes what authors refer to as the full range of women's known folk art: embroideries, drawings, water colors, oils. Twentieth century women include: Inez Nathaniel Walker, Grandma Moses, Clara McDonald Williamson, Sister Gertrude Morgan, Clementine Hunter, Theora Hamblett, Queena Stovall, Gertrude Rogers, Tella Kitchen, Mattie Lou O'Kelley, Malcah Zeldis, Albina Felski. Book contains biography, photographs, and art illustrations of more than one hundred named women artists

106. Dewhurst, C. Kurt, Betty MacDowell, and Marsha MacDowell. *Religious Folk Art in America; Reflections of Faith.* New York: E.P. Dutton/Museum of American Folk Art, 1983.
Explores the link between religion and American folk art. Says spiritual emphasis has declined in fine art but not folk art. Artists include Howard Finster, Patrick J. Sullivan, Fannie Lou Spelce, Minnie Evans, Sister Gertrude Morgan, James Hampton, Malcah Zeldis, John Wasilewski, Harry Lieberman, Horace Pippin, Carlton Elonzo Garrett, Emily Lunde, Harriet French Turner, Ethel Mohamed, Elijah Pierce, William Edmondson, Joseph Thomas Barta, John W. Perates, Morris Hirshfield, Father Wernerus, the "Lund's Scenic Garden," S.P. Dins-

moor, Ned Cartledge, "Uncle Jack" Dey, Andrea Badami, Lanier Meaders, Jose Dolores Lopez. Essays, bibliography. Illus.; black & white.

107. *Different Drummer: Works by American Self-Taught Artists.* New York: Metlife Gallery, 1991.
[exhibition brochure]
Gallery exhibit December 16, 1991-February 1, 1992 curated by Linda Marhisotto. Introduction on the focus of the exhibition with color illustrations of the works of four of the artists: Willie Massey, Sam Doyle, David Butler, Jimmy Lee Sudduth, and William Hawkins. Other artists exhibited were Jesse Aaron, Raymond Coins, Minnie Evans, Bessie Harvey, Lonnie Holley, Alipio Mello, Mary T. Smith, Mose Tolliver, Bill Traylor, and Joseph Yoakum.

108. *Earl Cunningham (1893-1977): The Marilyn L. and Michael A. Mennello Collection.* Monterey, CA: Monterey Peninsula Museum of Art, 1989.
[exhibition catalog]
Essay, "The Cunningham Collection: Its Story," by Marilyn Menello tells of her discovery of the artist in St. Augustine in 1969, provides details on the artist and his life, and his development and experience as an artist. Comments by Robert Bishop and by William C. Ketchum, Jr. Chronology. Checklist. Seven full pages of color illustrations. [This was a traveling exhibition organized by Exhibits USA: A Division of Mid-America Arts Alliance]

109. Earnest, Adele. *Folk Art in America: A Personal View.* Exton, PA: Schiffer, 1984.
History of the author's interest in folk art, the growth of the importance of American folk art in the art world, and the development of the Museum of American Folk Art. A few illustrations of twentieth century art including William Edmondson, Clark Coe, and John Scholl. Earnest was a dealer and founding member of the Museum of Early American Folk Art.

110. *An Easter Anthology.* Owensboro, KY: Owensboro Museum of Fine Art, 1989.
[exhibition catalog]
Subtitled "An Anthology on Spiritual Inspirations in Contemporary Art," there are three chapters that reflect the arrangement of the exhibit: two on the life and work of Thomas Merton; and one including works by Ronald Cooper, Unto Jarvi, Junior Lewis, and others. Essays, checklist, a few black & white illustrations.

111. Eaton, Allen H. *Handicrafts of the Southern Highlands*. New York: Dover, 1973.
First published in 1937, the author of new preface says this is too romantic a look at a dangerously impoverished people. Sections on "folk art as carving" and another on "folk pottery." Mentions the Meaders and the Browns under folk potters. Carvers include Joe Burkett of Boone, North Carolina who carved "articles and animals, some painted, some look like African carvings"; Nicodemus Adams of Banner, VA who carved "small animals, birds, miniature coffins, and tombstones"; Sam Smith, Sevierville, Tennessee, who made birds of wood and wire and was said to have a "very original perspective"; Allen Kilgore of Dante, Virginia; Willy Smith and D.L. Millsap.

112. Eaton, Linda B. *A Separate Vision: Case Studies of Four Contemporary Indian Artists*. Flagstaff: Museum of Northern Arizona Press, 1990.
Essays by Linda Eaton about problems that beset Indians who are contemporary artists. She notes that market demand is for the idea of Indian art established in the early twentieth century. Eaton says lumping all Indian artists together "denies the existence of each artist's unique vision." There is a description of the Museum of Northern Arizona support for efforts by Indian artists "to move away from the expected forms and techniques" and to find "creative artistic synthesis" out of their own experiences. Notes on the lives and work of Nora Naranjo-Morse, Santa Clara Pueblo, clay sculptor; Baje Whitethorne, Navajo, landscape painter; John Fredericks, Hopi, wood sculptor; and nontraditional weaver Brenda Spencer. Illus.; black & white.

113. *Eddie Arning*. New York: Hirschl & Adler Folk, 1988.
[exhibition catalog]
November 18, 1988-January 7, 1989. Preface by Frank Miele who describes Arning's work as "bold and beautiful." Some works are compared, with illustrations, to mainstream artists. Illus.; color.

114. *Eddie Arning: Selected Drawings 1964-1973*. Williamsburg, VA: Colonial Williamsburg Foundation, 1985.
[exhibition catalog]
Organized by the Abby Aldrich Rockefeller Folk Art Center for an exhibition in 1985. Essay, "Eddie Arning: The Man," by collector Alexander Sackton, and another by curator Barbara Luck on "Eddie Arning: The Drawings." Many illus.; color, black & white. In some cases the print source of the work is included.

115. *Edgar Tolson: Kentucky Gothic*. Lexington, KY: University of Kentucky Art Museum, 1981.
[exhibition catalog]
University art museum September 13-October 18, 1981 and traveled. Notes on the art, chronology, bibliography, catalog of works listed in chronological order. Priscilla Colt prepared the exhibition, and she does much more than list the pieces: she provides detailed commentary on the art. Photograph of Tolson. Cover illustration in color; all others black & white.

116. Eff, Elaine. "To Keep Tradition Going: Conserving Baltimore Screen Painting." In *Folk Life Annual 90*, 132-143. Washington, D.C.: Library of Congress, 1991.
Information on the East Baltimore community where screen painting may be found, when it started and why, and current efforts to revitalize the art. William Oktavec and other artists are described, and there is information on the creation of the Painted Screen Society and the making of a documentary film on the subject. Chronology. Illus.; color.

117. *Elijah Pierce, Wood Carver*. Columbus: Columbus Museum of Fine Arts, 1973.
[exhibition catalog]
November 3-December 30, 1973. A look at Pierce's art covering more than fifty years, "carved between haircuts." Described as a preacher who loves to tell about his carvings, a true believer. "In an age when spirituality has become fashionable—as long as it has nothing to do with the religion you were raised with—he knows the Bible word for word, believes in miracles, and the power of prayer." Quotes from the artist. Checklist. Illus.; black & white.

118. *Elijah Pierce, Woodcarver*. Columbus, OH: Columbus Museum of Art, 1993.
[exhibition catalog]
January 24-May 16, 1993 and traveled. Curators: E. Jane Connell, Nannette V. Maciejunes. The "first definitive retrospective exhibition on Pierce (1892-1984) in honor of the centennial of his birth." Considers the artist in aesthetic and social contexts and addresses

technique, stylistic development, and the effects of patronage on his art. Includes 173 carvings, with both religious and secular themes. Preface by Merribel Parsons, a statement by the curators, introduction by Robert Bishop. Essays: Gerald L. Davis, "Elijah Pierce, Woodcarver: Doves and Pain in Life Fulfilled"; Michael D. Hall, "Hands-On Work: Style as Meaning in the Carvings of Elijah Pierce"; John F. Moe, "Your Life is a Book: The Artistic Legacy of Elijah Pierce"; Regenia A. Perry, "Elijah Pierce and the African American Tradition of Woodcarving"; and Aminah Robinson, "A Holy Place: A Tribute to Elijah Pierce." Catalog of exhibition: Autobiographical Works; Free Standing Sculpture Carvings: Animals and Figures; Secular Reliefs; Tableaus; Religious Reliefs; Message Signs; Morality Subjects; Pierce: The Universal Man. Annotated checklist, chronology, bibliography. Illus. [Information pre-publication from E. Jane Connell]

119. Emmerling, Mary E. *American Country.* New York: Clarkson N. Potter, 1980.
A picture book that includes the 1850's townhouse of Robert Bishop, showing some of his art collection; a turkey carved by Felipe Archuleta; carvings by Miles B. Carpenter and paintings by Howard Finster in the home of early collectors Jeffrey and Jane Camp; and one or two other illustrations of Carpenter and Archuleta art. Index.

120. Emmerling, Mary E. *Collecting American Country.* New York: Clarkson N. Potter, 1983.
Color photographs of Burlon Craig and his face jugs; the face jugs of Lanier Meaders and others; and Felipe Archuleta and some of his animals. Index.

121. *Enisled Visions: The Southern Non-Traditional Folk Artist.* Mobile, AL: Fine Arts Museum of the South, 1987.
[exhibition catalog]
Curated by Stephen Faircloth and Suzan Courtney; opened February 4, 1987. Written contributions by Didi Barrett and by Richard Gasperi. Eleven artists "whose inspiration developed from the experience of their personal lives." Artists: Howard Finster, David Butler, Bill Traylor, "Pappy" Kitchens, James "Son" Thomas, Robert Marino, Jack Zwirz, Luster Willis, Theora Hamblett, Clementine Hunter, and Sister Gertrude Morgan.

122. Esterman, M. M. *A Fish That's a Box: Folk Art from the National Museum of American Art.* Arlington, VA: Great Ocean Publishers, 1990.
A book written for children, so the photographs and accompanying text generally make sense. Thirty-five objects from the Hemphill Collection at the National Museum of American Art are pictured, including a cane with a snake and lizard carving by Ben Miller; an oil painting of a train by Jack Savitsky; a "Root Monster" by Miles B. Carpenter; a carving of an accordion player by Benniah Layden; a Felipe Archuleta baboon; a whirligig by Charlie Burnham; a face jug by Robert Brown; carvings by Edgar Tolson, Edward Kay, Michael Fleming; paintings by Peter Charlie Besharo and Alex A. Maldonado; and a set of musicians and dancers by Charlie Fields. Also, a number of anonymous works.

123. *Eugene Von Bruenchenhein 1910-1983.* Chicago: Carl Hammer Gallery, 1990.
[exhibition brochure]
May 4-June 1, 1990. Essay by Lisa Stone says he was an outsider who worked in virtual isolation. Chronology, exhibitions, collections. Illus.; color, black & white.

124. *Evan Decker: Kentucky Folk Carver.* Lexington, KY: University of Kentucky, 1982.
[exhibition brochure]
October 22-November 14, 1982. Center for Contemporary Art, University of Kentucky. Essay by James Smith Pierce. Catalog list introduced by Arthur F. Jones: "the purpose of the following catalogue is to provide a preliminary record listing the majority of Evan Decker's known works." Illus.; black & white.

125. *Even the Deep Things of God: A Quality of Mind in Afro-Atlantic Traditional Art.* Pittsburgh: Pittsburgh Center for the Arts, 1990.
[exhibition catalog]
August 18-September 30, 1990 curated by Judith McWillie who talks of continuities in cultural history. Grey Gundaker writes about the multicultural dimensions of the artists' works. Artists: Z.B. Armstrong, Willie Leroy Elliott, Jr., Ralph Griffin, Bessie Harvey, J.B. Murry, Jimmy Lee Sudduth, The Philadelphia Wireman. Illus.; color, black & white.

126. *Expressions of a New Spirit: Highlights from the Permanent Collection of the Museum of American Folk Art.* New York: Museum of American

Folk Art, 1989.

[exhibition catalog]

Curators: Elizabeth Warren, Stacy Hollander. After European and national travels, the exhibition inaugurated the new gallery space of the museum, near Lincoln Center. The catalog introduction touches on definitions, early collectors, early exhibitions, museum development. Twentieth century artists: John Scholl, Fred Alten, Chester Cornett, Harry Lieberman, Howard Finster, Joseph Aulisio, Bill Traylor, Eddie Arning, Sister Gertrude Morgan, William Hawkins, John Perates, Felipe Archuleta, and two figures from Possum Trot. Bibliography. Illus.; color.

127. *Expressions of the Soul: Three Perspectives on Baltimore's African-American Community.* Baltimore: Eubie Blake National Museum and Cultural Center, 1992.

[exhibition catalog]

January 25-March 31, 1992. Curator: Roland L. Freeman. Introduction about growing up in the Baltimore African-American folk culture. Freeman writes about the three examples of this culture that were presented in the exhibition: the work of eight quilters; selections from his own photodocumentary work in Baltimore; and "the first comprehensive showing of the work of Joy Alston, a self-taught, emerging Baltimore folk artist." Photographs of the artists by Roland Freeman. Illus.

128. *The Extension of Tradition: Contemporary Northern California Native American Art in Cultural Perspective.* Sacramento: Crocker Art Museum, 1985.

[exhibition catalog]

July 13-October 6, 1985. Essays on changes in Indian art including "Contemporary Indian Art: A Critic's View," "Tradition: A Contemporary Perspective," and "Made by Choice." Biographies. Book includes one self-taught artist, Dalbert Castro. Illus.; color, black & white.

129. *Eyes of Texas: An Exhibition of Living Texas Folk Artists.* Houston, TX: University of Houston/Lawndale Annex, 1980.

[exhibition catalog]

Exhibit October 3-26, 1980. Co-curators: Gaye Hall and David Hickman. The artists included the Rev. Johnnie Swearingen, Eddie Arning, Ezekiel Gibbs, Nan McGarity, Ernest "Spider"

Hewitt, Earl Cabaniss, Willard "Texas Kid" Watson, Timoteo Martinez, Mildred Foster Clark, Floyd O. Clark, Bill Tabor, Ann Montalbano, Eddie Jackson, and Inez Unger. Introduction by Cecilia Steinfeldt, senior curator at the San Antonio Museum Association, who says this exhibition is "vital proof that naive art still flourishes in the Lone Star State." The catalog includes biographical information on the artists, photographs of the artists, and black and white illustrations of their work.

130. *Fearful Symmetry: The Tiger Cat in the Art of Thornton Dial.* New York: Harry N. Abrams, 1993.

[exhibition catalog]

Published in conjunction with the exhibition of the same name as the title; September 18, 1993-January 9, 1994 in New York City and traveled. Sponsored by the Museum of American Folk Art and the Studio Museum in Harlem. Essays by curator Thomas McEvilley and by Amiri Baraka. There are to be "100+" color plates. [Information pre-publication from Lee Kogan]

131. Fels, Catherine. *Graphic Work of Louis Monza.* Los Angeles: Plantin Press, 1973.

Contents include an essay "Sources of Symbolism in Monza's Prints" by Fels and a biography by Victoria Feldon. There is a chronological list of graphic works from 1954-1971. Illus.; black & white.

132. Ferris, William. *Local Color: A Sense of Place in Folk Art.* New York: McGraw-Hill, 1982.

Introduction by Ferris. Interviews with nine Mississippi folk artists including Luster Willis, Theora Hamblett, Ethel Wright Mohamed, James "Son" Thomas, Victor Bobb, and several craftspeople: their art, their lives, their inspiration. Index. Photos. [Revised paper edition published 1992 by Anchor Books, New York]

133. Ferris, William, ed. *Afro-American Folk Art and Crafts.* Jackson, MS: University Press of Mississippi, 1989.

Articles on contemporary people and the traditions within which they work: quilt makers, sculptors, instrument makers, basket makers, builders, blacksmiths, and potters. Articles include "Visions in Afro-American Folk Art; The Sculpture of James Thomas" by Wil-

liam Ferris; "James 'Son Ford' Thomas, Sculptor" also by Ferris; and an article by David Evans on prison-made art. Bibliography. Filmography. Index. Illus. (Originally published: Boston, MA: G.K. Hall, 1983).

134. *The Fine Art of Folk Art.* Cincinnati: Cincinnati Art Museum, 1990.
[exhibition catalog]
May 11-September 2, 1990, curated by Anita J. Ellis, who says "The purpose of this publication is to offer a sense of the depth and quality of folk art collections in Ohio." Twentieth century artists included Nellie Mae Rowe, Sol Landau, Robert McWilliams, Edward Hageman, Elijah Pierce, Nan Phelps, Ralph Fasanella, and L.A. Roberts. Many color illus., with commentary.

135. *Fine Folk: Art 'n' Facts from the Rural South.* Martinsville, VA: Piedmont Arts Association, n.d.
[exhibition catalog]
Curator's statement by Howard Smith. Biographies by Anne Smith. Artists from the collection of Anne and Howard Smith: Richard Burnside, James Harold Jennings, Willie Massey, R.A. Miller, Benjamin F. Perkins, Oscar Spencer, Jeffrey Williams. Illustrations of the artists and their work.

136. Finster, Howard. *Howard Finster, Man of Visions.* Atlanta: Peachtree, 1989.
Written and illustrated by Howard Finster, with an interview and afterword by Susie Mee. Ms. Mee grew up in Pennville, Georgia near Finster's House and Garden. She met him in 1975. A Howard Finster family and friends scrapbook is included. Many color photographs of people and art by Linda Schaefer.

137. Finster, Howard. *Howard Finster's Vision of 1982. Visions of 200 Light Years Away.* Summerville, GA: Privately printed, 1982.
Photographs of Finster, his friends, his art, his family. Includes messages to the reader, an autobiography. Black & white drawings and decorations.

138. Finster, Howard. *Howard's Road from 3 to 71 Years: The Scrapbook of All Time.* Summerville, GA: Privately printed, 1988.
A Howard Finster scrapbook of his life experiences, his family and his friends. Eight pages of color illustrations. Black and white illustrations abound.

139. Finster, Howard, and as told to Tom Patterson. *Howard Finster: Stranger from Another World, Man of Visions New on This Earth.* New York: Abbeville Press, 1989.
An "oral autobiography" related by the Rev. Finster to Patterson. After an introduction, Patterson organizes Finster's sermons/memories in a clear and chronological manner. Many illus. of the artist's work and photographs by Roger Manley and Victor Faccinito. [Review: *The Clarion* 15 (2) Spring 1990, 65-66, 68, by Lanford Wilson]

140. *Folk Art and the Street of Shops.* Dearborn, MI: Henry Ford Museum, 1971.
About Henry Ford's many collections, including mostly nineteenth century folk art. On page 17 there is a "sculptural group" by E.A. McKillop, presented to Ford in 1929 to commemorate the opening of the Henry Ford Museum.

141. *Folk Art in Oklahoma.* Oklahoma City: Oklahoma Museums Association, 1981.
[exhibition catalog]
May 3-June 19, 1981; Oklahoma Art Center's Art Annex. The first Oklahoma effort to search for and document "the visual folk arts." Introduction provides information on methodology and definitions. Essays on Oklahoma art and artists including Morris Tenenbaum; the environments of John Muhlbacher, Ed Galloway, Irene Hall, and Ted Townsend; and painters Jack Harrold, Gwyn Davis, E.L. Spybuck, L.S. Sloane, Louis Shipshee, and Red Shelite. There are also several carvers included: Earl Eyman, Tom Baker, John Balzer, and others. There are some biographies and some illustrations.

142. *Folk Art of Kentucky: A Survey of Kentucky's Self-Taught Artists.* Lexington, KY: University of Kentucky Fine Arts Gallery, 1976.
[exhibition catalog]
November 23, 1975-December 19, 1075 and traveled. Essays "Folk Art of Kentucky: Explanation and Analysis," by James Smith Pierce, and another by Ellsworth Taylor on what is Kentucky folk art. Photographs and biographies of artists: Noah Kinney, Charley Kinney, Edgar Tolson, Chester Cornett, Marvin Finn, Evan Decker, Unto Jarvi, John Hurst, Mack Hodge, Eldon Irvine, Leonard Fields, Lonnie Spencer, Willie Ousley, Clarence Ellis, Earnest Patton, and several others. Illus.

143. *Folk Art of the People: Navajo Works*. St. Louis: Craft Alliance Gallery and Education Center, 1987.
[exhibition catalog]
Curated by Chuck Rosenak, September 4-26, 1987. Talks about Navajo nontraditional art and his experiences in finding it. Essay by Ralph Coe. Artists: Johnson Antonio, Dan Hot, Faye Tso, Mamie Deschillie, Roger Hataalii family, Leonard Willeto, Alfred Walleto (Charlie Willeto). Biographies. Black & white illus.

144. *Folk Art USA Since 1900 from the Collection of Herbert Waide Hemphill, Jr.* Williamsburg, VA: The Abby Aldrich Rockefeller Folk Art Center, 1980.
[exhibition catalog]
Introduction by Beatrix Rumford, who credits Hemphill with "popularizing the notion that contemporary folk art has artistic validity." Quotes Hemphill's advice to the collector: "Don't buy solely as an investment; learn your subject and know those who create the art; whenever possible, handle objects in collections and shops; when you buy, go to a reputable and knowledgeable dealer, unless you are sure of yourself; and, above all, love and want to live with your find." There are fifty-nine examples of painting, drawing, and sculpture. Black & white illus.

145. *Folk Arts of Washington State: A Survey of Contemporary Folk Arts and Artists in the State of Washington.* Tumwater: Washington State Folklife Council, 1989.
Focus is on traditional crafts and decorative art from ethnic communities. Several essays. Self-taught artists include Don Olson, painter; Richard Carl Peterson, woodcarver; welder/sculptor Jacob Stappler; Cy Williams, woodcarver; Pete Merrill and Emil Gehrke whirligigs; and the "grotto-like yard art of John O. McMeekin."

146. *Folk Carvings of Northern New Mexico*. Chicago: The Design Foundation, 1989.
[exhibition catalog]
Northern Illinois University/Chicago Gallery, May 19-June 17, 1989, and traveled. Introductory essay by Lynda K. Martin: "Contemporary Folk Art Based in Tradition." Notes by Robert Vogele on his collecting experiences. Artists are Felipe Archuleta and son Leroy Archuleta, Enrique Rendon, and Marco Oviedo. For each artist there is information about their lives and work, with color photographs.

147. *Folk Memories: T.A. Hay (1892-1988)*. Cincinnati, OH: Art Jones/Art On the Other Side of the Street, 1989.
[exhibition catalog]
A small catalog prepared for the Art Jones Gallery exhibition April 14-May 20, 1989. There is an essay about the art and the artist by James Smith Pierce and seven illustrations of Hay's work.

148. *Folk-The Art of Benny and George Andrews.* Memphis, TN: Memphis Brooks Museum of Art, 1990.
[exhibition catalog]
September 22-November 18, 1990 and traveled. Self-taught George Andrews and his "mainstream artist" son Benny Andrews. Introduction by Patricia Bladon. Essay by Judd Tully. Illus.; color, black & white.

149. "*Folkwaves.*" San Francisco: San Francisco State University, 1988.
[exhibition catalog]
March 21-April 7, 1988 curated by Holly Tegard, with the cooperation of Bonnie Grossman of The Ames Gallery, Berkeley. Artists: Alex A. Maldonado, Robert Gilkerson, Bob Carter, Herbert Lyons, Judy Perry, William Dawson, Harold E. Bayer, Mildred Eads, Jerry Farrell, Sol Holzman, Janet Munro, Theodore Santoro. Brief essay and biographical notes. Checklist. Illus.; black & white.

150. *Forever Free: Art by African-American Women 1862-1980*. College Park, MD: University of Maryland, 1981.
[exhibition catalog]
October 29-December 3, 1981 at the University of Maryland Art Gallery Based on a traveling exhibition organized at the Illinois State University, Normal. Essay, "Art by African-American Women: A Brief History" by Susan W. Wortech. Two self-taught artists are included in this exhibition: Clementine Hunter and Minnie Evans. Checklist. Illus.

151. Found in New York's North Country: The Folk Art of a Region. Utica, NY: Museum of Art, Munson-Williams-Proctor Institute, 1982.
[exhibition catalog]
February 27-May 2, 1982 and traveled. Di-

vided into: Expressions of Traditional Life; Popular Taste; and Personal Invention. A few twentieth century examples including Veronica Terrillion, William J. Queor, Richard Merchand, William B. Massey, Helen Ashworth. Essays by Herbert Waide Hemphill, Jr. and Varick A. Chittenden. Bibliography. Illus.; black & white.

152. *Four American Primitives: Edward Hicks, John Kane, Anna Mary Robertson Moses, Horace Pippin.* New York: ACA Galleries, 1972.
[exhibition catalog]
Organized by Andrew J. Crispo, February 22-March 11, 1972. Says "the exhibit affords the opportunity of experiencing again the beauty and poetry of these enormously gifted painters." Attempts to define the naive artist and the schooled artist. Introduction to each artist includes commentary on life and artistic work. Illus.; black & white.

153. *Frank Jones, Devil Houses: Drawings from the Collections of The Sam Houston State University Art Faculty.* Huntsville, TX: Sam Houston State University, 1989.
[exhibition catalog]
Exhibition April 3-17, 1989 at the University's Gallery 100. Includes a long and very detailed essay by William Steen about the artist's personal history and about Jones' art. There is information on the prison art show where his work was first exhibited and the early interest shown by Murray Smither. There are photographs of Jones in the prison. References. Checklist. Illus.

154. *Freedom of Expression: Different Drummer.* Menasha, WI: Gilbert Paper/A Mead Company, 1990.
"Design Potpourri," sponsored annually by the Gilbert Paper Company, had as its 1990 theme "freedom of expression." One of the four projects presented was one by Jackson Design, a small artfully designed book called "Different Drummer" that features the art of Benjamin F. Perkins, Jimmy Lee Sudduth, Howard Finster, Bessie Harvey, and religious sign painter W.C. Rice. Text by Michael Dolan. Color illustrations of the art. Portraits of the artists.

155. Fried, Frederick, and Mary Fried. *America's Forgotten Folk Artists.* New York: Pantheon Books, 1978.

Authors say that "this book contains text and photographs of people's art, " that there is no clear dividing line "where what has begun simply as a craft becomes art," and that the coming of the machine age has by no means stilled the urge to create individual works of art. Chapter called "The Passing Scene" has several pages on the painted window screens of East Baltimore and mentions William Oktavec, Johnny Eck, Richard Oktavec, Benjamin B. Richardson, and others. Location information on outdoor murals and roadside sculpture. Bibliography. Index. Illus.

156. Fritz, Ronald J. *Michigan's Master Carver Oscar W. Peterson.* Boulder Junction, WI: Aardvark Publications, 1987.
Peterson is famous for his fish decoys. He also made other objects. Author concentrates his attention on the non-decoy art and provides much information about the artist and the quality of his work. Illus.; color, black & white.

157. *From Hardanger to Harleys: A Survey of Wisconsin Folk Art.* Sheboygan: John Michael Kohler Arts Center, 1987.
[exhibition catalog]
May 8-17, 1987 and traveled. Focus is on traditional forms still actively produced. Biographical information. Illus.; color, black & white. [Review: *The Clarion* 13(2), Spring 1988, 72-73 by Steve Siporin].

158. *From the Woods: Washington Wood Artists.* Bellingham, WA: Whatcom Museum of History and Art, 1991.
[exhibition brochure]
May 25-August 18, 1991 and traveled. Essay by curator Lloyd E. Herman. Self-taught artist Tim Fowler recollects in his art jobs he has held including "Manic Roofer," "Apple Picking God," "Dishwasher God," —each depicting a frenzied workman.

159. Fuller, Edmond L. *Visions in Stone: The Sculpture of William Edmondson.* Pittsburgh: University of Pittsburgh Press, 1973.
Introductory essay tells about Edmondson's life, his discovery as an artist, his vision. Also information on materials used and his methods. Photographs by Edward Weston. His stone carvings shown in his yard.

160. Fussell, Fred C., ed. *Memory Paintings of an Alabama Farm: The Art and Remembrances of Jes-*

sie DuBose Rhoads, Alabama Folk Artist. Columbus, GA: Columbus Museum, 1983.
Paintings and written memories of early years of the twentieth century. Fussell says Jessie DuBose Rhoads was a conscientious observer who recorded a lifestyle typical of Alabama of her time. Illus.; color.

161. Garisto, Leslie. *From Bauhaus to Birdhouse*. New York: HarperCollins, 1992.
Colorful illustrations of birdhouses, most shown in the landscape, including a few examples of those "increasingly prized as folk art." Bird houses by Lee Steen, Mose Tolliver, Willie Massey, and Benjamin F. Perkins are commented upon, with an illustration of a gourd house made by Perkins.

162. George, Phyllis. *Kentucky Crafts: Handmade and Heartfelt*. New York: Crown, 1989.
One chapter, "Folk Art and More," features the art of Marvin Finn, Sally Cammack, Denzil Goodpaster, Kurt Ludwig, Unto Jarvi, and Bonnie Lander. Large and numerous color photographs of the artists and their work, with commentary by the author and the artists.

163. *Georgia Clay: Pottery of Tradition*. Macon, GA: Museum of Arts and Sciences, 1989.
[exhibition catalog]
July 29-November 26, 1989. Suzanne Harper, curator. Essay, "The Story of Georgia Folk Pottery, by John A. Burrison, tells about many aspects both technical and commercial. Brief descriptions of different areas in the state and what the potteries produced. Checklist. Illus.; color, black & white.

164. *Georgia Folk Art*. Gainesville, GA: Quinlin Art Center and Gainesville College, 1991.
[exhibition catalog]
Curators: Kathleen Jackson, Robert Westervelt. Essay by Tom Patterson, "The Folks Are As Good As the People, The Outside Is In, And Art Is Art," mentions the controversy over labels and suggests that one should just enjoy the art. Checklist. Artists: Leroy Almon, Linda Anderson, Alpha Andrews, E.M. Bailey, Bill Bowers, Archie Byron, Ned Cartledge, Ulysses Davis, Howard Finster, Jack Floyd, Carlton Garrett, Mary Greene, Ralph Griffin, Dilmus Hall, Bessie Harvey, Theodore Hill, Danny Hotchkinson, Columbus McGriff, Kenneth McIntosh, R.A. Miller, Roy Minshew, J.B. Murry, Valton Mur-

ray, Willene Nix, Mattie Lou O'Kelley, Sarah Rakes, Tommy Richards, Nellie Mae Rowe, Lorenzo Scott, Cher Shaffer, St. EOM, Kenneth Allen Wilson. No exhibition dates given. A few Illustrations.

165. *The Gift of Josephus Farmer*. Milwaukee: University of Wisconsin/ Milwaukee Art History Gallery, 1982.
[exhibition catalog]
November 1-December 17, 1982 curated by Joanne Cubbs. Includes commentary on the artist and his art and various influences such as popular culture, religion, memories of the South, and Africa. Illus.; color, black & white.

166. *"Gifted Visions:" Contemporary Black American Folk Art*. Storrs, CT: Atrium Gallery/University of Connecticut, 1988.
[exhibition brochure]
September 1-23, 1988. Curator: Sal Scalora. Photographs, biographies, and brief notes on the artists: Leroy Almon, David Butler, Steve Ashby, William Dawson, Juanita Rogers, Simon Sparrow, Royal Robertson, Nellie Mae Rowe, J.B. Murry, Patsy Billups, Luster Willis, Inez Nathaniel Walker, Mose Tolliver, Bill Traylor, Minnie Evans, Mary T. Smith, Bessie Harvey, Elijah Pierce, Henry Speller, and Walter Flax.

167. Glassie, Henry. *Pattern in the Material Folk Culture of the Eastern United States*. Philadelphia: University of Pennsylvania Press, 1968.
Regional cultures in four areas along the eastern seaboard, with "artifactual evidence" to prove his points. Material culture point of view as to the "correct" definition of folk art. Included here because he is quoted so often.

168. Glassie, Henry. *The Spirit of Folk Art: The Girard Collection at the Museum of International Folk Art*. New York: Harry N. Abrams/The Museum of New Mexico, 1989.
Glassie has selected 300 objects from the many thousands in the Girard collection and has written around them a philosophical essay on folk, art, folk art, folk art and fine art, and other singular concepts. Notes. Bibliography. Index. 345 illus.; 285 in color. [Review: *The Clarion* 15 (3) Summer 1990, 30-31, by Randall Morris].

169. *God, Man and the Devil: Religion in Recent Kentucky Folk Art*. Lexington, KY: Folk Art Society of Kentucky, 1984.
[exhibition catalog]
Mint Museum, Charlotte, North Carolina, June/July, 1984, and traveled. Essays by Larry Hackley, James Smith Pierce. Art selected with certain categories in mind: objects to decorate the home of the devout; objects to evangelize; objects to sell—categories "not mutually exclusive." Artists: Minnie Black, J. Frank Byrley, Chester Cornett, Homer Creech, Jim Feltner, Richard Fodor, Mack Hodge, John Hurst, Unto Jarvi, Charley Kinney, David Lucas, Carl McKenzie, Anna G. Miller, Earnest Patton, Lonnie Spencer, Donny Tolson, and others. Illus.

170. *Good and Evil: Visions by Eastern Kentucky Artists*. Urbana-Champaign: University of Illinois/School of Art and Design, 1988.
[exhibition catalog]
December 2, 1988-January 29, 1989 and traveled. Based on the Eastern Kentucky folk art collection at Morehead State University. Introduction by Morehead curator Adrian Swain. Essay by Lisa Wainwright on the contribution of Eastern Kentucky folk artists to the history of spiritual expression. Artists with illustrations, in black & white, are Noah Kinney, Charley Kinney, Junior Lewis, Jessie Cooper, Carl McKenzie, Hugo Sperger, Earl Moore, Sr., Ronald Cooper, Calvin Cooper, and Linvel Barker. Included in the exhibition but not illustrated are two women, Hazel Kinney and Minnie Adkins.

171. Grabhorn, Edwin. *The Wonderful City of Carrie Van Wie*. San Francisco: Grabhorn Press, 1963.
Carrie Van Wie painted, for the most part, San Francisco architectural landmarks. In this book, printed in a limited edition by the Grabhorn Press, twenty-one of her works are reproduced in color. This book is not easy to find but there is a copy in the rare book collection at the Library of Congress.

172. Graburn, Nelson, ed. *Ethnic and Tourist Arts: Cultural Expressions of the Fourth World*. Berkeley, CA: University of California Press, 1979. Though not specifically about the "folk art" covered in this bibliography, the authors cover a subject that should be of concern to collectors: the impact of consumers on the artist. It is noted that Western society in general rewards and promotes change in its own art, while bemoaning the same thing in others.

173. *The Grand Generation: Memory, Mastery, Legacy*. Seattle: University of Washington Press/Smithsonian Institution Press, 1987.
[exhibition catalog]
Published in conjunction with a traveling exhibition, organized by the Office of Folklife Programs at the Smithsonian. Contributions from Mary Hufford, Marjorie Hunt, and Steven Zeitlin. Photographs by Roland Freeman and others. Exhibition "to evoke the culture and creativity of older Americans and advance our understanding of these elders who are society's tradition bearers." Writings about motivations, including the "life review" process. Among those represented in print and illustration are Elijah Pierce, Ethel Mohamed, Bluma Purmell (memory painter), Norman Rankin (carver), George Winkler ("whimsical" wooden figures), Helen Cordero, Burleigh Woodard, John Hartter, William Drain, Rodney Richard, Sr. (Maine carver), Robert Burghardt, Vincenzo Ancona, and Ray Faust. Checklist of the exhibition. Illus.; color, black & white.

174. *Grand Pa Wiener*. Cooperstown, NY: New York State Historical Association, 1970.
[exhibition catalog]
July-November 1970. Introduction by Louis C. Jones. Brief biography by Joanne Bock. Photograph of the artist. Illustrations, black & white, divided as follows: birds and animals, Biblical scenes, still lifes, imagery of the old country, new country impressions.

175. *Grandma Moses 1860-1961*. New York: Hammer Galleries, 1980.
[exhibition catalog]
May 23-June 27, 1980, in association with Galerie St. Etienne. The preface by Robert Bishop includes information about the life, the art, and the success of the painter. Notes. Color illustrations.

176. *Grandma Moses (1860-1961): An American Treasure*. New York: Hammer Galleries, 1990.
[exhibition catalog]
September 17-October 27, 1990 to celebrate the fiftieth anniversary of the discovery of the artist. Introductory material and color illustrations.

177. *Grandma Moses: Anna Mary Robertson Moses.* Washington, D.C.: National Gallery of Art, 1979.
[exhibition catalog]
February 11-April 1, 1979. Essays including one by Archibald MacLeish and another by Moses, "How Do I Paint?" Biographical sketch. Checklist. Illus.; color, black & white—some with notes on the sources of the work.

178. *The Grandma Moses Night Before Christmas Poem by Clement Moore.* New York: Random House, 1991.
Paintings by Grandma Moses used to illustrate this well-known poem by Clement C. Moore. Most of the paintings were done in 1960.

179. *Grass Roots Art: Wisconsin.* Sheboygan, WI: John Michael Kohler Arts Center, 1978.
[exhibition catalog]
November 12-December 30, 1978 and traveled. Essay by Wanda Cole on definitions of the untrained artist, folk traditions, sources of inspiration. Cole quotes Austrian Alois Reigel as the first to lend dignity to the idea of a folk art and tradition in his critical writings. Works chosen "have an innovative aspect, exhibit a sense of integrity, and involvement of an artist with his subject more often than with his craft." A few of the 56 artists are: Howard Angermeyer, sculpture made with plumbing parts; Gladys Bartol, memory painter; Aaron Beechy, pencil drawings and painted wood; Henry Boogaard, carver; Daniel Craig, oil on wood (only black artist in the exhibition); Lucy Dahlin, painter; Nick Engelbert, concrete sculptor; Dan Erlstroesser, painter; Charles Foote, carver; Walter Kufahl, painted carvings; Lynn Miller, painter; and Fred Smith, folk environment.

180. Greenfield, Verni. *Making Do or Making Art: A Study of American Recycling.* Ann Arbor, MI: UMI Research Press, 1986.
Studies "recycling" as it is motivated by aesthetic ends. She says this activity is embraced by fine artists, folk artists, and others as well. The author studies a number of "practitioners," especially Grandma Prisbrey. There is a detailed discussion of the role of personal loss in Tressa Prisbrey's construction of Bottle Village.

181. Haardt, Anton. *Juanita.* Montgomery, AL: Anton Haardt Gallery, 1982.
A pamphlet with information by Ms. Haardt on the life and work of self-taught Alabama artist Juanita Rogers. Six black & white illus.

182. Hall, Michael D. *Stereoscopic Perspective: Reflections on American Fine and Folk Art.* Ann Arbor, MI: UMI Research Press, 1988.
Essays that present Hall's views from various perspectives as artist, collector and critic. Gathered from lectures, articles, publications in exhibition catalogs, including: essay from Folk Sculpture U.S.A.,1976; interview with Hemphill in 1981 from the Milwaukee exhibition of the latter's collection; an essay on face jugs; and others. [Review: The Clarion 14 (1) Winter 1989, 64, 66, by Russell Bowman]

183. Hall, Michael D., and Eugene W. Metcalf. *The Artist Outsider: Creativity and the Boundaries of Culture.* Washington, D.C.: Smithsonian Press, 1993.
"Outsider art from the perspectives of the European, with its emphasis on the psychological, and the American, with its emphasis on the social." The book has two sections: the first deals with outsider art as art, the second with the art from a social perspective. Within each of these two sections there are two subdivisions: articles that deal with general, theoretical and historical issues; and articles that focus on a particular artist. The essayists look at the idea of the outsider from as many perspectives as possible. Included are the viewpoints of art historians, curators, philosophers, anthropologists, psychologists, psychiatrists, social historians, folklorists, a sculptor, and a religion scholar. There is no single viewpoint. Contributors include Joanne Cubbs, Constance Perin, Lucy Lippard, Maureen Sherlock, Kenneth Ames, Michel Thevoz, Laurent Danchen, David Maclagan, Michael Hall, Eugene Metcalf, Richard Nonas, Daniel Robbins, Mark Gisborne, Leo Navratil, Michael Owen Jones, Charles Zug, Gerald L. Davis, and Sally Harrison-Pepper. Illus. [Information prepublication from Eugene Metcalf]

184. Hamblett, Theora with Ed Meek, and William S. Haynie. Theora Hamblett Paintings. Jackson, MI: University of Mississippi Press, 1975.
Hamblett's paintings in her home are called "dreams hanging up to dry." Detailed biography and commentary on where her paintings

come from, with many color illustrations and background notes.

185. *Hand to Hand, Heart to Heart: Folk Art in Rhode Island.* Providence, RI: Rhode Island Heritage Commission,
State survey of traditional, "community-related" folk art. Michael Bell, project director. In addition there are notes and illustrations on the drawings and paintings of two individuals: Cornelius O'Neil who was born in 1899 in Ireland and made it to the United States in 1931—a memory painter "who imagines himself driving down a country road and paints what he would see"; and James Perry, Sr., a Rhode Island native, retired carpenter and store owner, who "always liked to draw." Photographs of the artists and illustrations of the art.

186. Hartigan, Lynda. *James Hampton: The Throne of the Third Heaven of the Nations Millennium General Assembly.* Montgomery, AL: Montgomery Museum of Fine Arts, 1977.
[exhibition catalog]
Traveling exhibition of a foil-decorated assemblage that was constructed, for religious purposes, over a period of fourteen years. In her essay Hartigan says "it may not be mere coincidence that James Hampton decided to build his 'throne' in Washington, D.C., the city of monuments—James Hampton was a serious monument maker." Information on his life and his artistic creation. Illus.

187. Hartigan, Lynda. *Made with Passion: The Hemphill Folk Art Collection in the National Museum of American Art.* Washington, D.C.: Smithsonian Institution Press, 1990.
Hartigan begins with a seventy-page narrative about Hemphill and his experiences as a collector, curator, and author in "his chosen territory of folk art." She says that for over four decades he assembled a collection that altered the perception of American art. There are numerous photographs of artists, dealers, collectors, art works, and Hemphill himself. This essay provides a history of the field. The catalog of the exhibition at the National Museum of American Art follows—199 works, including some from more than fifty-four contemporary artists, from the 427 works acquired by the National Museum in 1986. Notes on the artist accompany each work pictured. Extensive bibliography. Index. [Review: *Folk Art Finder* 12

(3) July-September 1991, 22-23, 1991, by N.K. Thoman]

188. *The Heart of Creation: The Art of Martin Ramirez.* Philadelphia: Goldie Paley Gallery/Moore College of Art, 1985.
[exhibition catalog]
September 6-October 18, 1985 and traveled. Essays by Roberta Smith, Russel Bowman, Stephen Master about what is known of the artist's life, how his work was discovered, efforts to conserve it, and discussion of the art. Checklist. List of exhibitions. Bibliography. Illus.

189. *Heavenly Visions: The Art of Minnie Evans.* Raleigh, NC: North Carolina Museum of Art, 1986.
[exhibition catalog]
January 18-April 13, 1986, based upon the collection of Nina Howell Starr, "who collected and championed the artist for more than twenty years." Includes 1960s interview with Minnie Evans about her visions. Lengthy essay on the art itself. Chronology. Bibliography. Exhibition history. List of works in this exhibit. Illus.; color, black & white.

190. *Hecho Tejano: Four Texas Mexican Folk Artists.* Austin: Texas Folklife Resources, 1990.
[exhibition catalog]
This exhibition, put together by Texas Folklife Resources, traveled to seven galleries and museums in the state from September 1990 through January 1992. One of these was the San Angelo Museum of Fine Arts—which mails the ten-page catalog upon request. It contains a three-page introduction to this kind of folk art that "reflects the bicultural status of its makers." Artists and their works are Jose Varela, ceramist; Beatrice Ximenez, cement sculptor; Benito Morales, woodcarver; and Manuel Castaneda, whirligigs.

191. Hemphill, Herbert Waide, Jr., ed. *Folk Sculpture USA.* Brooklyn, NY: The Brooklyn Museum, 1976.
[exhibition catalog]
Written to accompany the exhibition March 6-May 31, 1976. At the Brooklyn Museum and then traveled to the Los Angeles County Museum of Art. Examples of eighteenth, nineteenth, and twentieth century folk sculpture including sculptured animals, signs, toys, whirligigs, walking sticks, face jugs, and human figures. Artists of the twentieth century include Edgar

Tolson, Clark Coe, Joe Lee, Fred Blair, Ed Davis, William Edmondson, Jose Dolores Lopez, Elijah Pierce, Miles B. Carpenter, Daniel Pressley, Felipe Archuleta, Clarence Stringfield, and Frank Mazur. Essays by Daniel Robbins, Michael Hall, and Michael Kan. The Robbins essay, "Folk Art Without Folk," is frequently quoted: he discusses early interest in American folk art, says contemporary scholarship hasn't added a thing, and doubts that there is any longer any "folk tradition" or "folk." The essay by Kan, "American Folk Sculpture: Some Considerations of Its Ethnic Heritage," discusses African-American and Spanish-American traditions. The "conversation" between Sarah Faunce, Brooklyn Museum, and Michael D. Hall, sculptor and collector, discusses his interest in folk sculpture, artists he has found. Illus.; color, black & white.

192. Hemphill, Herbert, and Michael D. Hall. "The Hemphill Perspective: A View from the Bridge." In *American Folk Art: The Herbert Waide Hemphill, Jr. Collection*, 7-17. Milwaukee: Milwaukee Art Museum, 1981.
[exhibition catalog]
Interview with Hemphill, one of the first, where he responds to questions about his collecting experience, his motivations, and the significance of his collection.

193. Hemphill, Herbert W., Jr., and Julia Weissman. *Twentieth-Century American Folk Art and Artists*. New York: E.P. Dutton, 1974.
Includes the work of 145 identified and fifty-nine anonymous artists. The contents are arranged chronologically as a "broad survey of the wealth and variety of American folk art produced since 1900." There are paintings, drawings, sculpture, constructions, collages, ceramics, and environments. This book has been called the "major pictorial anthology of twentieth century folk art." Index of illustrations of artists.

194. Hoberman, Mary Ann. *A Fine Fat Pig*. New York: Harper/Collins, 1991.
Children's book with colorful illustrations by Malcah Zeldis. Each illustration fills a page, with a poem by Hoberman opposite. For "children three to seven"—and everyone else who likes the art.

195. Hollander, Stacey C. *Harry Lieberman: A Journey of Remembrance*. New York: Dutton

Books/Museum of American Folk Art, 1991. Contains an introduction about Harry Lieberman's paintings, his place in the tradition of Jewish art, his work as ethnic and religious folk art, and his role as a memory painter. There are chapters organized around various parts of his life: his immigration; his Hasidism; symbols and sources and developments in his work. The many color reproductions of his work are accompanied by explanations of their symbolism.

196. *Home and Yard: Black Folk Life Expressions in Los Angeles*. Los Angeles: California Afro-American Museum, 1987.
[exhibition catalog]
November 7, 1987-April 3, 1988. Lizzetta LeFalle-Collins, curator, says the importance of this exhibition lies in its assertion that a continuance of Southern folk and outsider art expressions exists in the West. Essays: Dr. Beverly Robinson, UCLA, "gives the reader an overview of folk life expressions"; LeFalle-Collins addresses the actual folk life/art expressions and suggests reasons for their presence in Los Angeles as a decorative art form. Bibliography. Illus.; black & white and color—especially the steel sculpture garden of Lew Harris.

197. *Honest to Goodness Art*. Buffalo, NY: Burchfield Art Center, State University of New York, 1988.
[exhibition catalog]
December 4, 1988-January 15, 1989. Presents a "grass-roots tradition of picture making." Self-taught artists in the exhibition are Juan Cavarzos (paintings of farm workers and city mission dwellers from his own experience), Tanya Ganson ("childlike paintings of ghastly scenes of violence remembered from Russia"), James Litz (an innocent view of life, less complicated than his experiences), Rosario Provenja (paintings using found objects, "delights in color," with "a house full of paintings" and "no regard for domestic order"), Bridgette Robinson (pastels on paper, with "close attention to detail, inspiration from immediate surroundings"), Eleanor Rudolph (memory painter of country life), and Stanley Szeluga (Poland is his subject). Photographs of the artists. Biographical notes. Checklist. Illus.; color, black & white.

198. *Horace Pippin.* Washington, D.C.: The Phillips Collection, 1976.
[exhibition catalog]
February 25-March 27, 1977 and traveled. A retrospective exhibition which included one-third of Pippin's life work which is "hard to put together because of the wide dispersal of work among collectors." All catalog illustrations in color "because Pippin was a master colorist." Statement by Romare Bearden about meeting Pippin.

199. *Horace Pippin: A Chester County Artist.* West Chester, PA: Chester County Historical Society, 1988.
[exhibition catalog]
Exhibition January 30-June 12, 1988 to honor the centennial of Horace Pippin (1988-1946). Essay of his childhood, war experiences, place where he lived—with no mention of the racism that affected his life. "Pippin painted on the street corners of West Chester, and enjoyed the company of little children . . . his renderings an intimate and historically accurate record of the daily lives of blacks living in West Chester in the mid-1930s."

200. Horne, Catherine Wilson, ed. Crossroads of Clay: The Southern Alkaline-Glazed Stoneware Tradition. Columbia, SC: McKissick Museum/ University of South Carolina, 1990.
Published in conjunction with an exhibition. Essays included are: "The Cultural Hearth of the Southern Pottery Tradition: The Historical Geographic Framework," by John Winberry; "International Encounters at the Crossroads of Clay: European, Asian, and African Influences on Edgefield Pottery," by John Michael Vlach; "The Scene at the Crossroads: The Alkaline-Glazed Stoneware Tradition of South Carolina," by Cinda K. Baldwin; and "Out of Edgefield: The Migration of Alkaline-Glazed Stoneware Potters in the Lower South," by Georgeanna H. Greer. There is also a catalog of objects, a bibliography, and pictures of many face jugs. Illus.; color, black & white.

201. Horne, Field. *Mountaintop and Valley: Greene County Folk Arts Today.* Hensonville, NY: Black Dome Press, 1991.
This book is about traditional folk arts. It was originally published to accompany an exhibition at the Catskill Gallery in Catskill, New York. People included were "traditional, excellent, and community based." Nearly everything in the book is a craft rather than art. One artist is included and that is chainsaw carver Hal McIntosh. There is brief background information on his life and work. Illus.

202. Horwitz, Elinor Lander. *Contemporary American Folk Artists.* Philadelphia: J.B. Lippincott, 1975.
The introductory chapter is a consideration of "definitions." Folk painters: Sister Gertrude Morgan, "Uncle Jack" Dey, Charles Gleason, Gideon Cohen, Clementine Hunter, James Rexrode, Hattie Brunner, Inez Nathaniel Walker, Ralph Fasanella, Bruce Brice. Folk carvers: Edward Ambrose, Miles B. Carpenter, Elijah Pierce, Mario Sanchez, Jim Colclough, George Lopez. Environments: Joseph Bell (yard filled with windmills); Dow Pugh; Walter Flax with his field of battleships (photographs of art and artist—only way to see the ships now); "Cedar Creek Charlie" Fields; James Hampton; and Simon Rodia. Photographs of the artists. Biography. Sources of inspiration. Illus.; black & white.

203. Horwitz, Elinor Lander. *The Bird, the Banner, and Uncle Sam: Images of America in Folk and Popular Arts.* Philadelphia: J.B. Lippincott, 1976.
Brief sketches of the use of patriotic symbols; found presidents images especially popular. Interviews of artists asked about their motives. Includes Malcah Zeldis, Charlie Fields, Elijah Pierce, Edgar Tolson, Justin McCarthy, and the yard art of E.M. Bailey. Illus.

204. *How the Eagle Flies: Patriotism in Twentieth Century Folk Art.* Richmond, VA: Meaglow Farm Museum, 1989.
[exhibition catalog]
Curator Chris Gregson provides information on each of the artists. Those illustrated are Edward Ambrose, Earnest Patton, Benjamin F. Perkins, Leslie Payne, Howard Finster. Charlie Fields, Raymond Coins, L.G. Wright, and Ann Murfee Allen. Other artists in the exhibit are Eldredge Bagley, painter; James Cook, painted wood; George Hardy, painted wood; and well-known artists William Hawkins, Mose Tolliver, James Harold Jennings, Joe McFall, Carl McKenzie, Dow Pugh, Jack Savitsky, Jimmy Lee Sudduth, Fred Webster. Also John Vaughn and Arliss A. Watford, Sr.

205. *Howard Finster: American Flag Paintings.* Washington, D.C.: Govinda Gallery, 1992. [exhibition catalog]
May 8-July 4, 1992. Uses the many American flags with messages by Howard Finster as the focus of this gallery exhibit. Introduction by the Rev. Finster, "What the Flag Is" and also a poem, "The Beautiful Flag." All the paintings are enamel on wood. There are twenty-four full-page color plates, a catalog of the exhibit, and one black & white illustration.

206. *Howard Finster Man of Visions: The Garden and Other Creations.* Philadelphia: Philadelphia Art Alliance, 1984. [exhibition catalog]
May 25-June 30, 1984. Forward by John Ollman. Essay and biography by Victor Faccinto. Checklist, bibliography, message from Finster. Numerous black & white photographs

207. *Howard Finster, Painter of Sermons.* Lexington, KY: Folk Art Society of Kentucky, 1988. [exhibition catalog]
January 21-September 8, 1988. Berea College Appalachian Museum, presented by the Folk Art Society of Kentucky. Essay by James Smith Pierce. Catalog of the works in the exhibition. Black and white illustrations. A slide-tape show of Howard Finster's Paradise Garden accompanied this exhibit and is available for viewing, upon request, at the Berea College Appalachian Museum.

208. "Howard Finster, Summerville, Folk Artist Minister." In *Southwind: Many Worshippers, One God,* 46-63. Calhoun, GA: Calhoun High School, 1985.
Finster states his religious beliefs, that he built his garden in response to these feelings. He gives his views on building his church and says that God told him to do it. Finster says he believes in all churches and says "I have Buddhist friends, I have infidel friends." Photos.

209. *Images of Experience: Untutored Older Artists.* Brooklyn, NY: Pratt Institute, 1982. [exhibition catalog]
Curators: Ellen Schwartz, Amy Snider, and Don Sunseri. Essays that discuss the interest in older artists who begin their artwork late in life. Considers the influence of the "life review" process. Says that the crudeness of technique and the childlike elements are not the significant components of the art of the elderly, but rather a quality and imagery related to long life experience. Of the nineteen artists included, eleven were from New York City and eight were from Vermont. A few of these were Roland Rochette, a Vermont painter of memories of early farming days; Glenn Buck, also a Vermont memory painter; Desider Lustig, Hungarian-born New Yorker who painted "imaginary, baroque" rooms; and Stanley Marcile of Vermont who painted "fantasy buildings."

210. *In Another World: Outsider Art from Europe and America.* London: South Bank Centre, 1987. [exhibition catalog]
Exhibition traveled to eight galleries and museums in England and Wales. Began June 13, 1987 and ended May 22, 1988. The eighteen artists exhibited included Americans Henry Darger, Martin Ramirez and Joseph Yoakum. Introduction by Monika Kinley, who selected the art. Includes several essays, a catalog of works and black & white illustrations.

211. *In/Outsiders: From the American South.* Montgomery, AL: Montgomery Museum of Fine Arts, 1992. [exhibition catalog]
Exhibition, September 13-November 8, 1992, curated by Bruce Lineker, for the 1992 Montgomery biennial. Includes academic and self-taught Southern artists including Jimmy Lee Sudduth, Lonnie Holley, Charlie Lucas, and Benjamin F. Perkins. There is a one-page story from each artist and illustrations of their art, including the environments of Perkins, Holly, and Lucas. Checklist of exhibition.

212. *Inside Visions.* Asheville, NC: Asheville Museum of Art, 1992. [exhibition brochure]
April 3-May 31, 1992. Curator Frank Thomson in an essay outlines the history of the training of artists in Western society, and notes the current fascination with "outsiders." Roger Manley writes in an essay "Beyond the Outside" about definitions and says "Interestingly the definition has little, if anything, to do with the art at all." Of the five artists in the exhibition, McKendree Long most fits the parameters of this book on self-taught outsider artists. Each of the essays has discussion

about the five artists, where they belong in the definition of things, and descriptions of their work. The other four artists are Andy Nasisse, Mary Nash, Juan Logan and Pauline Willis. Illus.; color.

213. *Insider Art.* Hyde Park, VT: Grace Roots Art and Community Efforts, 1990.
[exhibition catalog]
Curated by Peter Gallo. An exhibit of art by artists of different backgrounds: work by formally trained artists; artworks found at lawn sales, craft shops, flea markets; and paintings and drawings by those who have participated in GRACE workshops and Out & About. Text for the catalog is a selection of grocery lists made by Mrs. Grace Arnold of Cady's Falls, Vermont and collected for fifteen years by her son Carl.

214. *Interface: Outsiders and Insiders:* Lancaster, OH: The Artist's Organization, Ohio State University/Trisolini Gallery, 1986.
[exhibition catalog]
Exhibition at the Lancaster Gallery for the Visual Arts, Ohio University and traveled. Curator: Gary Schwindler. Essay says the exhibit brings together academic and non-academic artists; develops comparisons. Self-taught artists include William Hawkins, Lola Isroff, Birdie Lusch, Lloyd Moore (a photographer), Anthony Joseph Salvatore, and one or two others.

215. *It'll Come True: Eleven Artists First and Last.* Lafayette, LA: Artists Alliance, 1992.
[exhibition catalog]
April 11-May 16, 1992. Mark Marcin, project director. Art from the collection of Warren Lowe and Sylvia Lowe. Essay by Stephen Flinn Young on the problems with labels and the usual comments about the artist versus the collector. Brief notes on the artists, with quotations attributed to them. List of references. Illus.; color, black & white. For a list of the artists included, see the "Museum Exhibitions" section.

216. Jacka, Lois Essary, and Jerry Jacka. *Beyond Tradition : Contemporary Indian Art and Its Evolutions.* Flafstaff, AZ: Northland, 1991.
Crafts and art of contemporary Native Americans of the Southwest. Only brief information about the artists, so one cannot identify those who are self-taught just by reading this book. Includes Michael Naranjo (who may not be

classified as self-taught since he was blinded in Vietnam and had to give up painting for the bronze sculpture he does now), John Fredericks, and Baje Whitethorne. Index. Numerous illustrations in color.

217. Janis, Sidney. *They Taught Themselves: American Primitive Painters of the 20th Century.* New York: Dial Press, 1942.
A pioneer book on the lives and artistic works of thirty self-taught artists. Janis says the purpose is to bring attention to these "noteworthy self-taught talents in contemporary American painting, to discuss their work, to record salient experiences on the part of the artists in creating these works. Alfred H. Barr says some of the painters are vastly more significant than others and believes that Janis was too generous in his inclusiveness. All the paintings reproduced are discussed in detail. Artists: Morris Hirshfield, William Doriani, Patrick J. Sullivan, John Kane, Henry Church, Joseph Pickett, Gregorio Valdes, Anna Mary Robertson Moses, Israel Litwak, Patsy Santo, Max Reyher, Bernard Frouchtben, Charles Hutson, William Samet, Lawrence Lebduska, Ella Southworth, Hazel Knapp, Renault Tourneur, Horace Pippin, George Aulont, Emile Branchard, Josephine Joy, Samuel Koch, Flora Lewis, Jessie Predmore, George Lothrop, Charles M. Johnson, P. Hurst, William Mulholland, Cleo Crawford.

218. *Jesse J. Aaron.* Palatka, FL: Florida School of the Arts, 1980.
[exhibition catalog]
February 15-March 15, 1980 at the Florida School of the Arts. Introduction by Stuart Purser, including biographical data, information on how Aaron got started making his art, his subjects, materials used, and what he thought about other artists (after a 1975 trip to New York). Some pieces are described. Checklist. Fourteen illustrations. Photograph of the artist.

219. *John Kane (1860-1934).* New York: ACA Galleries, 1969.
[exhibition catalog]
October 14-November 1, 1969. Biographical introduction with some commentary on the art, excerpted from "Three Self-Taught Pennsylvania Artists" by Leon Arkus. Checklist. Illus.; black & white.

220. *John Kane: Modern America's First Folk Painter.* New York: Galerie St. Etienne, 1984. [exhibition catalog]
At the Galerie St. Etienne April 17-May 25, 1984, then to the Carnegie Institute in 1985. Essay on the life and artistic achievements of Kane by Jane Kallir. Mentions "petty jealousy of local painters who tried to get him dismissed as a fraud." Many illustrations, color and black & white, of his work and a photo of the artist and his wife.

221. Johnson, Jay, and William Ketchum, Jr. *American Folk Art of the Twentieth Century.* New York: Rizzoli, 1983.
A picture book of color illustrations and artist biographies, with a strong preference for naive and memory painting. Seventy-three artists are included. Attention is required to separate the genuine from those who paint in self-conscious "folk art style." An introduction by Robert Bishop on the opinions, traditions, and definitions of folk art.

222. *Jon Serl.* Portland, OR: Jamison-Thomas Gallery, 1988. [exhibition catalog]
Curated by William Jamison, with an essay by Susan C. Larson. Three color illustrations and a photograph of the artist.

223. *Jon Serl: Painter.* Mahwah, NJ: Art Galleries of Ramapo College, 1986. [exhibition catalog]
Serl's "First one-person exhibition in the East" (no dates in the catalog). Introductory essay by Selden Rodman on the artist and his works. Biographical details. Interview with Serl—about his life, beliefs, memories. Illus.; black & white.

224. Jones, Suzi, ed. *Webfoots and Bunchgrassers: Folk Art of the Oregon Country.* Eugene: Oregon Arts Commission, 1980.
Results of a state survey done by folklorists. Illustrated sections on pioneers, Indians, ethnic art.

225. *Justin McCarthy.* Allentown, PA: Allentown Art Museum, 1984. [exhibition catalog]
March 10-April 21, 1985. Essays by Ute Stebich, Red Grooms, Dorothy Strauser, Sterling Strauser, Tom Armstrong, Mimi Gross, William Fagaly, George Montgomery, and Herbert Hemphill and Randall Morris. Covers definitions, art, discovery, biography. Illus.; some color.

226. Kallir, Jane. *The Folk Art Tradition: Naive Painting in Europe and the United States.* New York: Viking Press, 1981.
Author provides background on arts and crafts in Europe and America and discusses folk art in modern times, which includes "American nonacademic painting" as well as Rousseau and the French naives. Artists illustrated are Kane, Pippin, Moses, Pickett, Hirshfield, Fred E. Robertson, Clara McDonald Williamson, and Nan Phelps. Color plates.

227. Kallir, Jane. *Grandma Moses: The Artist Behind the Myth.* New York: Clarkson N. Potter, 1982.
Detailed consideration of Grandma Moses and her artistic life and development. Biographical data. Illus.; color, black & white.

228. Kallir, Otto. *Art and Life of Grandma Moses.* New York: The Gallery of Modern Art/A.S. Barnes, 1969.
Positive appraisals of Moses' art by Louis Bromfield, who believes that in its design and composition it resembles Persian and Moslem Indian painting and often has a "literary appeal"; by Jean Cassou, who says it "upholds the rights of nature"; and by John Canady, who tells why he believes she was a good painter. Essay by Kallir on her art and life. Quotations from Moses herself. Biographical data. Documentary material at Bennington Museum. Black & white illustrations with commentary.

229. Kallir, Otto. *Grandma Moses.* New York: Harry N. Abrams, 1973.
A huge illustrated book of the works of Grandma Moses, including her "beginning," her "growing recognition" and "fame," the range of her art, and a "documentary section." This book, according to the author, is an attempt to present and examine the personality of Anna Mary Robertson Moses. He says her art and personality are inseparable. Illus.; color, black & white.

230. Kallir, Otto, ed. *Grandma Moses: American Primitive.* New York: Dryden Press, 1946.
Forty paintings with notes by Moses. A chapter called "My Life's History." Other text by Louis Bromfield, Otto Kallir. Illus.

231. Kammerude, Lavern, and Chester Garthwaite. *Threshing Days: The Farm Paintings of Lavern Kammerude.* Mount Horeb, WI: Wisconsin Folk Museum, 1990.
Memory paintings of farmer/artist Lavern Kammerude that document "the seasons of work on a family farm." The text is by Chester Garthwaite, also a farmer, who supplied the information on old practices portrayed in Kammerude's art (the artist died before the book of his paintings was completed). "Together, Kammerude's paintings and Garthwaite's stories, present life on the southern Wisconsin family farm of the 1920s and 1930s." Illus.; color.

232. Kane, John. *Sky Hooks: The Autobiography of John Kane.* Philadelphia: J.B. Lippincott, 1938. See entry under "Arkus, Leon Anthony" for the annotation.

233. Kaprow, Allen. *Assemblage, Environments and Happenings.* New York: Harry N. Abrams, 1966. Book includes a discussion of the work of Clarence Schmidt in the context of assemblage and environment. Illustrated.

234. Katz, Elaine S. *Folklore for the Time of Your Life.* Birmingham: Oxmoor House, 1978.
About the techniques of collecting folklore with a section on folk artist Jimmy Lee Sudduth (pp.157-172). Includes information on his life, paintings, and what it is like to visit him in his Fayette, Alabama home. There is an interview and photographs. There is also information on Lida Holley, a "primitive" (pp.172-178).

235. Keister, Douglas, and Karen Pfeifer. *Driftwood Whimsy: The Sculptures of the Emeryville Mudflats.* Emeryville, CA: California Photo Service, 1985.
Although the art is "anonymous," this book is included because it is one of the few sources for viewing this now destroyed site. (People are no longer allowed to walk here or build driftwood sculptures, because it is harmful to the nesting ground for birds).

236. *Kentucky Spirit: The Naive Tradition.* Owensboro, KY: Owensboro Museum of Fine Art, 1991.
[exhibition catalog]
August 18-September 22, 1991. Based on the museum's collection, which will be housed in a new wing in 1993. Included an exhibition, "Spirited Kentuckians," of photographs of artists by Charles W. Manion. Catalog includes the photographs, illustrations of the art, biographical notes, a catalog of the collection, and a profile of the museum. For a list of artists in the exhibition, see the "Museum Exhibitions" section.

237. Ketchum, William C., Jr. *All-American Folk Arts and Crafts.* New York: Rizzoli, 1986.
Opinions on what is "American" about American folk art, with numerous illustrations of nineteenth and twentieth century objects. Some commentary but no information on the artists—some of whom are only imitators of the "folk art style." A few of the folk artists illustrated are Milton Bond, Virgil Norberg, Mary Shelley, Inez Nathaniel Walker, Elijah Pierce, Ben Ortega, Malcah Zeldis, John Perates, Ned Cartledge, Mattie Lou O'Kelley, and Peter Charlie Besharo. Index. [Reviews: *The Clarion* 12(2/3) Spring/Summer 1987, 66, by Didi Barrett; *Folk Art Finder* 8 (3) July-September 1987, 18, by Dan Prince]

238. Klamkin, Marian, and Charles Klamkin. *Wood Carvings/North American Folk Sculpture.* New York: Hawthorne Books, 1974.
There is one chapter only that deals with contemporary work. Two artists cited as showing "craftsmanship and originality" are Edgar Tolson and James McCallister Edgington. Illus.; black & white.

239. Kleeblatt, Norman L., and Gerard C. Wertkin. *The Jewish Heritage in American Folk Art.* New York: Universe Books, 1984.
[exhibition catalog]
In the introduction and an essay, "Jewish Folk Art in America: Traditional Form and Cultural Adaptation," Kleeblatt and Wertkin present a systematic examination of American Jewish life as preserved in the work of folk artists and the traditional arts. Additional text by Mary Black, "Aspects of American Jewish History: A Folk Art Perspective." Contemporary artists include Morris Hirshfield, Malcah Zeldis, Mae Shafter Rockland, Israel Litwak, Paul O. Kremer, Samuel Rothbort, and Meichel Pressman. Bibliography. Illus.

240. Kuspit, Donald. " 'Suffer the Little Children to Come Unto Me': Twentieth Century Folk Art." In *American Folk Art: The Herbert Waide*

Hemphill, Jr. Collection, 37-47. Milwaukee: Milwaukee Art Museum, 1981.
[exhibition catalog]
Discourse on the nature of folk art. Develops the theory that "the folk object is a species of toy." Says "from the romantic point of view folk art is innate art, originating independently from a cultural environment, while the view of modern sociology, 'unequivocally empirical,' holds that folk art is a manipulation of common forms and meanings." Kuspit presents much more discussion and concludes that "conceiving of the folk artist as a primitive dialectician, the inadequacy of the modern empirical conception of folk art's dependence on the larger cultural environment becomes self-evident."

241. Laffal, Ken. *Vivolo and His Wooden Children.* Essex, CT: Gallery Press, 1976.
Description of contemporary folk artist John Vivolo based upon many hours spent with Vivolo and his family. Many details about his early life in Italy and his experiences after coming to the United States. Inventory and chronology of Vivolo's work. Illus.; some color.

242. Lampell, Ramona, Millard Lampell, with David Larkin. *O, Appalachia: Artists of the Southern Mountains.* New York: Stewart, Tabori and Chang, 1989.
Twenty self-taught artists and craftspeople from the Appalachians, Virginia to Alabama. There are 150 color photographs of the art, the artists, and the countryside. The text tells of the art and the artist. Artists included are S.L. Jones, Cher Shaffer, Dilmus Hall, Carleton Garrett, Hugo Sperger, Herman Hayes, Benjamin F. Perkins, James Harold Jennings, Minnie Adkins, Oscar Spencer, Charlie Lucas, Noah and Charley Kinney, and Clyde Whiteside. [Review: *Folk Art Messenger 3* (1) Fall 1989, 4, by William M. Oppenhimer]

243. La Roche, Louanne, ed. *Sam Doyle.* Kyoto: Shashin Kaguku, 1989.
Essay by Louanne La Roche tells about St. Helena Island, Sam Doyle's connection to this special place rooted in African tradition, and his depiction of the people he knew. Sixty-two color illustrations; one of the artist, and one of his space. Four black & white photos.

244. Lavitt, Wendy. *Animals in American Folk Art.* New York: Alfred A. Knopf, 1990.
Self-taught artists from the 1700s to the present, with 350 photographs, most in color, of the representation of animals in American folk art. Brief text. Some of the artists are Minnie and Garland Adkins, Minnie Black, Nellie Mae Rowe, Clyde Jones, Lawrence Lebduska, Victor Joseph Gatto, Albert Freeman, Gregorio Marzan, Emma Lee Moss, Simon Sparrow, Clyde Jones, "Butch" Quinn, Sam Martin, Michael Finster, Thornton Dial, Oscar Peterson, Matteo Radoslovich, Pucho Odio, Fred Alten, Linvel Barker, Marvin Finn, Ed Lambdin, Jesse Aaron, David Alvarez, and Alonzo Jimenez—and many more, such as Finster, Tolson, and Tolliver—whose works are illustrated frequently and so are not listed here. (The painting on page 153 is by Annie Tolliver, not Mose).

245. *Lee Steen.* Missoula, MT: Yellowstone Art Center, 1974.
[exhibition catalog]
January-February 1974. Art Center director John A. Armstrong says "collecting what remained of Lee and Dee Steen's fantasy world will be the most significant act of any museum or gallery in this state." He describes the process of saving the sculptures and wooden constructions made by the twin brothers. James Todd writes with great feeling about discovering this environment in Roundup, Montana—about the place, the Steens, and their art. Dee Stein died some years before his brother; Lee was tricked into a nursing home by a social worker. One photograph, taken at the exhibition, is a recreation of a corner of the original environment. Illus.

246. *Library of Curious and Unusual Facts: Odd and Eccentric People.* Alexandria, VA: Time-Life Books, n.d. [1992?]
A compilation of facts and photographs about unusual people. Included are Baldasare Forestiere and his underground garden in Fresno, California; Kea's Ark, in Newark, New Jersey before its destruction; Edward Leedskalnin's Coral Castle in Florida; the Orange Show, the beer can house built by John Milkovisch, the Flower Man, Cleveland Turner, and the Fan Man, Robert Harper, all in Houston, Texas; Sanford Darling, Grandma Prisbrey and Romano Gabriel in California; and the newspaper house of Elis Stenman in Pigeon Cove,

Massachusetts. Also included are many such creators from other countries. Bibliography and index.

247. *Like Nobody Else: Three West Texas Folk Artists.* San Angelo, TX: San Angelo Museum of Fine Arts, 1991.
[exhibition brochure]
September 12-October 20, 1991. The three artists are memory painter Emma Lee Moss; Jethro Jackson, a model maker; and trained artist Donald C. Keeney, a wood sculptor. Biographical notes. Illus.

248. *Lions and Tigers and Bears, Oh My! New Mexican Folk Carvings from the Collection of Christine and Davis Mather.* Corpus Christi, TX: Art Museum of South Texas, 1986.
[exhibition catalog]
October 17-December 21, 1986. Mathers tell of their meeting Felipe Archuleta. Biographical notes on the artists Felipe Benito Archuleta, Alonzo Silverio Jimenez, David Alvarez, Leroy Archuleta, Mike Rodriguez, Paul Lutonsky (trained artist who carves brightly colored snakes), Alex Sandoval, and Joe Ortega. Bibliography. Illus.; some color.

249. Lipman, Jean, and Tom Armstrong, eds. *American Folk Painters of Three Centuries.* New York: Hudson Hills Press, 1980.
Includes eighteenth, nineteenth, and twentieth century works. Biographical information and commentary on paintings is as follows: Sam Rosenberg on Henry Church; Nina Little Fletcher on J.O.J. Frost; the editors on Steve Harley; Sidney Janis on Morris Hirshfield and Joseph Pickett; Leon Anthony Arkus on John Kane; Esther Sparks on Olaf Krans, and Selden Rodman on Horace Pippin. Photographs of artists. Color plates of art. Index. [Review: *Folk Art Finder* 1 (7) July/August 1980, 17, by Florence Laffal]

250. Lipman, Jean, Robert Bishop, Elizabeth Warren, and Sharon Eisenstat. *Five-star Folk Art: One Hundred American Masterpieces.* New York: Harry N. Abrams, 1990.
Authors say the book is about "quality." Twentieth century painters who passed "the test" are John Kane, Horace Pippin, Morris Hirshfield, Bill Traylor, Harry Lieberman, Joseph Pickett, and Martin Ramirez. The "wood, metal, stone workers" are Jose Dolores Lopez, David Gold-smith, William Edmondson, Clark Coe, and Simon Rodia. Robert Bishop wrote an "afterword," and Sharon L. Eisenstadt wrote an appreciation of Holger Cahill. Notes. Bibliography. Illus.; color.

251. Lippard, Lucy. "Elizabeth Layton." In *Women and Aging: An Anthology by Women*, 148-157. Editors: Jo Alexander, Debi Berrow, Lisa Domitrovich, Margarita Donnelly, and Cheryl McLean. Corvallis, OR: Calyx Books, 1986.
Lippard tells of Layton's first drawings, which "saved her own life and added immeasurably to ours." Layton is described as one of the "most original and the most feminist artists in the U.S. today." Details of the anguish in her life and her triumphs are described along with an analysis of some of her artworks. Lippard calls the political Elizabeth Layton "Everywoman," resisting the evils of the modern world. Says she is able to tackle the difficult content in her paintings—aging, racism, sexism, the general pollution of the world—because "she doesn't give a damn about the art world." There are eight black and white illustrations of Layton's work plus a color illustration on the cover of the book.

252. Lippard, Lucy R. *Mixed Blessing: New Art in a Multicultural America.* New York: Pantheon Books, 1990.
Cross-cultural activity as reflected in the visual arts. She identifies the ethnic backgrounds of artists "to demonstrate the tremendous range possible in an intercultural art that combines a pride in roots with an explorer's view of the world as it is shared with others." Self-taught artists in this book are James "Son" Thomas, Thornton Dial, Bessie Harvey, Lonnie Holley, Mary T. Smith, and Nellie Mae Rowe. Says why she dislikes the term "outsider art," prefers the term "vernacular art."

253. *Living Traditions: Southern Folk Art.* Rock Hill, SC: Museum of York County, 1991.
[exhibition catalog]
August 17-October 27, 1991. Essays by Douglas DeNatale, Paul Arnett. Eighteen artists. Illustrations. For a list of artists in the exhibition, see the "Museum Exhibitions" section.

254. Livingston, Jane, and John Beardsley. *Black Folk Art in America: 1930-1980.* Jackson, MS: University Press of Mississippi/Center for the

Study of Southern Culture for the Corcoran Gallery of Art, 1982.

Published in conjunction with the exhibition at the Corcoran that featured the art of twenty artists. Essays by Jane Livingston, John Beardsley, and Regenia Perry. Essay by Perry is on the origins of twentieth century black American folk art and its evolution over past centuries. Biographies, art works, and photographs of the artists: Jesse Aaron, Steve Ashby, David Butler, Ulysses Davis, William Dawson, Sam Doyle, William Edmondson, James Hampton, Sister Gertrude Morgan, Inez Nathaniel Walker, Leslie Payne, Elijah Pierce, Nellie Mae Rowe, James "Son" Thomas, Mose Tolliver, Bill Traylor, George White, George Williams, Luster Willis, and Joseph Yoakum. Catalog of the exhibition. Bibliography. Illus. [Review: *Folk Art Finder* 3 (2) May-August 1982, 16, by Jules Laffal]

255. *Local Visions: Folk Art from Northeast Kentucky.* Morehead, KY: Morehead State University, 1990.
[exhibition catalog]
At the University of Wisconsin-Milwaukee October 19, 1990-December 16, 1990 and traveled. Catalog by Adrian Swain. Biographies. Photographs of artists. Checklist. Illus.; color, black & white. For a list of artists in the exhibition, see the "Museum Exhibition" section.

256. Long, Worth, and Roland Freeman. "Leon Rucker: Woodcarver." In *Black People and Their Culture,* 33-34. Editor: Linn Shapiro. Washington, D.C.: Smithsonian Institution Press, 1976. Discussion about a walking stick carved with faces of people and with animals. The artist is Leon Rucker of Lorman, Mississippi.

257. *Louisiana Folk Painting.* New York: Museum of American Folk Art, 1973.
[exhibition catalog]
September 17-November 4, 1973. Guest curator, William A. Fagaly. Biographical information on the artists—Clementine Hunter, Bruce Brice, and Sister Gertrude Morgan. Artists' photographs. Checklist.

258. MacGregor, John. *The Discovery of the Art of the Insane.* Princeton, NJ: Princeton University Press, 1989.
A comprehensive study of the relations between the art of the insane and both the psychiatric profession and the art world. Begin-
ning with the first recorded interest in the art of a mentally ill patient, it follows the history of such interest to the present day. MacGregor makes connections between the art of the insane and mainstream artists. He also shows how the insane themselves were bound to the culture in which they lived and did in fact have the desire to communicate with the outside world. Allen Weiss calls this book "the only worthy supplement to Prinzhorn's 'Artistry of the Mentally Ill,' and to Dr. Morgenthaler's collection and study of Adolf Wolfli." [Reviews: *Raw Vision* (3) Summer 1990, 53, by Allen S. Weiss; *Folk Art Messenger* 3 (3) Spring 1990, 6-7, by Roger Cardinal]

259. MacGregor, John. *Dwight Mackintosh: The Boy Who Time Forgot.* Oakland, CA: Creative Growth Art Center, 1992.
Introduction by Irene Ward Brydon, executive director of the Center, who describes early encounters with Dwight Mackintosh, and provides detailed information on the philosophy and programs of the Creative Growth Art Center. An essay by MacGregor presents much information and commentary on the art, on the life, and on the artistic development of Mackintosh. He says the artist "belongs firmly within the category of Outsider Art." Extensive notes. Illus.; color, black & white. (Published in conjunction with the retrospective exhibition of the art of Dwight Mackintosh at the Creative Growth Art Center gallery and the symposium "Altered States—Alternate Worlds" sponsored by the Center at the Oakland Museum on April 11, 1991).

260. *Made by Hand: Mississippi Folk Art.* Jackson, MS: Mississippi Department of Archives and History, 1980.
[exhibition catalog]
January 22-May 25, 1980. State survey and exhibition of Mississippi folk art of the nineteenth and twentieth centuries. Edited by Patti Black, the catalog contains essays by William Ferris, Roland Freeman, Georgeanna Greer, and others. In addition to crafts there are artists "Son" Thomas, Jerome Seu, Willie Barton, Luster Willis, "Pappy" Kitchens, Theora Hamblett, M.B. Mayfield, Herman Hayes, Abe Murry, Jim McCandless, George Williams, Helen Pickle, Harry Warren.

261. Madian, Jon. *Beautiful Junk*. New York: Little, Brown, 1986.
Children's book that incorporates a fictionalized account of a young boy from the neighborhood watching Simon Rodia collect salvage for the construction of his towers. Charlie, the boy, learns some lessons from his encounters with the old man. There is a postscript about the true story of Rodia and the fight to save the real Watts Towers. Illustrated.

262. *The Magic of Naive*. DeKalb, IL: Swen Parson Gallery/Northern Illinois University, n.d. [exhibition catalog]
Yolanda Saul, curator. Purpose of the exhibition was "to document the variety of artistic experience found in Naive Art." American artists include Josephus Farmer, Milton Fletcher, Sister Gertrude Morgan, Marcia Muth, Judith Neville, Mattie Lou O'Kelley, Nellie Mae Rowe, Henry Speller, Malcah Zeldis, and others. Illus.; color, black & white.

263. *Malcah Zeldis: American Self-taught Artist*. New York: Museum of American Folk Art, 1988. [exhibition brochure]
Four-page brochure of an exhibition, July 21-September 9, 1988 at the Washington Square East Galleries/New York University. One page statement on the work by guest curator Henry Niemann. Checklist. Color reproduction of the painting "Roseland" on the cover.

264. Manley, Roger. *Signs and Wonders: Outsider Art Inside North Carolina*. Raleigh, NC: North Carolina Museum of Art, 1989.
Book published in conjunction with an exhibition July-October 1989 at the above-named museum, and traveled. Essay by Manley: "Seed and Shadow: The Function of Outsider Art." It is interspersed with many photographs of art and the artists in their own environments. Artists: Herman Bridgers, Almetta Brooks, Vernon Burwell, Raymond Coins, Minnie Evans, Hermon Finney, Harold Garrison, Russell Gillespie, Annie Hooper, James Harold Jennings, Clyde Jones, Rev. McKendree Long, William Owens, Leroy Person, Vollis Simpson, Arthur Spain, Q.J. Stephenson, Arliss Watford, and Jeff Williams. Notes. Biographies, bibliography, checklist.

265. Maresca, Frank, and Roger Ricco. *American Self-Taught*. New York: Knopf, 1993.
Book of twentieth century American self-taught artists. Works include paintings and drawings. The book will include approximately seventy-five artists with full-color multiple reproductions of their work. Biographies, "based upon extensive research to present new information," will be included. The introduction is by Lanford Wilson. This book is intended to complement the earlier title by Ricco and Maresca, *American Primitive: Discoveries in Folk Sculpture,* published by Knopf in 1988. [Information pre-publication from Frank Maresca]

266. Maresca, Frank, and Roger Ricco. *Bill Traylor: His Art-His Life*. New York: Alfred A. Knopf, 1991.
This a richly illustrated book of Bill Traylor's work. It includes is a brief chronology of Traylor's life; a list of exhibitions; and a brief bibliography. There is also an interview with Charles Shannon, the Alabama artist who is credited with discovering Bill Traylor on the streets of Montgomery. Mention of any controversy over biographical or other facts is not included. [Reviews: *Folk Art Finder* 13 (1) January-March 1992, 16-17, by Florence Laffal; *The Clarion* 17 (1) Spring 1992, 33, 78, by Diane Finore; *Folk Art Messenger* 5 (3) Spring 1992 has a lengthy review essay by Norman Girardot]

267. Marks, Elizabeth, and Thomas Klocke. *The HAI Collection of Outsider Art: 1980-1990*. New York: Hospital Audiences, Inc., 1990.
Information about the HAI program, description of the collection, notes on historical context. The catalog is of a "core group" of mentally ill artists who are major contributors to the HAI collection. Commentary on artists, their art. Artists: Gaetana Menna, Kenny McKay, Carl Greenberg, Ray Hamilton, Donna Caesar, Jennie Maruki, Irene Phillips, Mercedes Jamison, James Prendergast, Patirna Daddea, Wally C. Nicholson, Oscar Brown, George Knerr, Helen Kossoff, Frances Montague, Ana Rodriguez, Ethel Jaret, and Lena Scalisi. Illus.

268. Marshall, Howard W., ed. *Missouri Artist Jesse Howard, With a Contemplation on Idiosyncratic Art*. Columbia, MO: Missouri Cultural Heritage Center, 1983.
Biography of Jesse Howard and an essay about the two major divisions in folk art scholarship: those who approach the art as idiosyncratic and personal and those who favor the folklorist approach. Author favors the "community is everything" view.

269. *Mary Nohl: An Exhibit of Sculpture, Painting, and Jewelry.* Milwaukee, WI: Cardinal Stritch College, 1991.
[exhibition catalog]
Exhibit at the Layton Honor Gallery at the college, January 27-February 28. Mary Nohl is not a self-taught artist. She had early training at the Art Institute of Chicago. She is included here because this reclusive artist who has nothing to do with the art world has created a most incredible, magical, and mysterious environment in the yard of her home on the shores of Lake Michigan. The catalog introduction by Joanne Cubbs describes the art, the person, and, sadly, the hostility her work has inspired. "As has been the fate of so many creative women throughout history," says Cubbs, "Nohl is also commonly referred to as 'the witch'. " An essay by the curator Barbara Munger tells about the artist's life, her art, and her constant struggle with vandals.

270. *Masters of Naive Art.* Kyoto: Daimaru Museum, 1989.
[exhibition catalog]
Exhibition supported by the Ministry of Foreign Affairs, Japan/Agency for Cultural Embassy of the United States in collaboration with Galerie St. Etienne. It opened at the Daimaru Museum in Kyoto and traveled to two other museums in Japan, all in 1989. Text by Jane Kallir. In English and Japanese. Artists: French, American, Haitian, Yugoslav. American artists are Morris Hirshfield, John Kane, Lawrence Lebduska, Israel Litwak, Anna Mary Robertson (Grandma) Moses, Abraham Levin, Nan Phelps, Horace Pippin. Jane Kallir's introduction focuses on an brief accounting of the Western art world's interest in naive painting. Kallir presents a definition: she maintains that "the naive lacks training but creates easel paintings; folk concentrate on craft objects." Kallir describes various periods of interest in naive art. Illus.

271. Mather, Christine, and Sharon Woods. *Santa Fe Style.* New York: Rizzoli, 1986.
For folk art enthusiasts there is, mixed among the beautiful home and landscape settings, the art of Ben Ortega, Frank Brito, David Alvarez, Felipe Archuleta, Leroy Archuleta, and Alonzo Jimenez. There are also photographs of Pop Shaffer's Hotel and Rancho Bonito, a folk art environment. Index. Illus.; color, black & white.

272. Mendes, Guy. *Light at Hand: Photographs 1970-1985.* Frankfurt, KY: Gnomon Press, 1986.
A collection of the photographs of Guy Mendes, who was born in New Orleans in 1948 and moved to Kentucky to teach and work in 1966. Included here because among the photographs one finds portraits of Edgar Tolson, Howard Finster, St. EOM, and Sister Gertrude Morgan.

273. Meyer, George H., ed. *Folk Artists Biographical Index.* Detroit: Gale Research, 1987.
Information on 9,000 American folk artists from the seventeenth century to the present: alphabetical list by artist with where and when "flourished," type of work, and usually one or two information sources. Indexes by ethnicity, geography, media, museum collections.

274. Meyer, George H., with Kay White Meyer. *American Folk Canes: Personal Sculpture.* Bloomfield, MI: Sandringham Press/Museum of American Folk Art, 1992.
More than 300 canes, from the early nineteenth century to contemporary, with an emphasis on earlier objects, are presented in full color. The book is introduced with an overview of cane making including motivations, materials chosen, documentation and the place in (men's) society. A few of the many chapters are "Tapping at Art's Door," by Lynda Roscoe Hartigan; "Themes in Contemporary Folk Canes," by Larry Hackley; "Documentation," by George Meyer and Kay Meyer; and "Dating American Canes," by Kurt Stein. There are chapters on African-American canes and also Native-American cane making. Some of the contemporary cane makers whose works are shown are Denzil Goodpaster, Tim Lewis, Henry York, Preston Cathart, Luster Willis, Parks Townsend, Hugh "Big Daddy" Williams, Ben Miller, Larry McKee, Duane Sparrow, Walter S. Peavley, Ralph Buckwalter, Anton Jeleznik, Carl McKenzie, Elisha Baker, the Reverend St. Patrick Clay, and Willie Massey. Photographs by Charles B. Nairn. Biblio.

275. *Michigan Folk Art: Its Beginnings to 1941.* East Lansing: Michigan State University, 1976.
[exhibition catalog]
August 29-October 10, 1976 and traveled. Introduction by Marsha MacDowell and C. Kurt

Dewhurst. Artists: carver Fred Alten; Ray Poole who made animal constructions from drain tiles; Paul N. Domke who created Dinosaur Park; and Ed Kay, creator of "political" totems. Illus.

276. *Miles B. Carpenter.* Richmond, VA: Hand Workshop, 1989.
[exhibition catalog]
Biography by Jeff Camp. Checklist. List of group and individual exhibitions. Bibliography. Illus.

277. *Miles Carpenter: A Second Century.* Radford, VA: Radford University, 1990.
[exhibition catalog]
Curator's statement by Anna Fariello. Essay by Lynda Roscoe Hartigan: "Miles Carpenter: Carving the Old Fashioned Way?" Bibliography, checklist, chronology, ten black & white illustrations.

278. *Miles Carpenter: The Woodcarver from Waverly.* Richmond, VA: Anderson Gallery, Virginia Commonwealth University, 1985.
[exhibition catalog]
May 26-June 30, 1985 and traveled to Meadow Farm Museum. Interview with Carpenter, by Chris Gregson. Essay by Marilyn A. Zeitlin. An interview discusses Carpenter's art—how he started, materials, his "audience." Zeitlin writes about folk art and where Carpenter fits. Illus.

279. *Missing Pieces: Georgia Folk Art 1770-1976.* Atlanta: Georgia Council for the Arts and Humanities, 1976.
Edited by Anna Wadsworth. State survey and exhibition. Notes and essays. Includes Ulysses Davis, Thomas Jefferson Flanagan, William Rogers, Nellie Mae Rowe, and quiltmaker Harriet Powers. Color illustration of the entrance hall of Rowe's house decorated with a variety of her art. Illus.

280. Mohamed, Ethel Wright. *My Life in Pictures.* Jackson, MS: Mississippi Department of Archives and History, 1976.
A book of the stitchery "paintings" of Ethel Wright Mohamed. Charlotte Capers, Oliver P. Collins, editors.

281. Monthan, Guy, and Doris Monthan. *Arts and Indian Individualists: The Art of Seventeen Contemporary Southwestern Artists and Craftsmen.* Flagstaff, AZ: Northland Press, 1975.

Introductory essay about the emergence of Native American artists who demonstrate in their work both individualism and their Indian heritage. Two artists who are used as examples and are described as self-taught are Helen Cordero, who used her experience with traditional Pueblo pottery to create her famous storyteller dolls, and Michael Naranjo of Santa Clara Pueblo who learned to make sculpture after being blinded in Vietnam. The book includes biographical information and photographs. The authors note that the history of the recognition of individualist artists is very short. Illus.

282. *Morris Hirshfield 1872-1946.* New York: Sidney Janis Gallery, 1965.
[exhibition catalog]
From 1937 until the time of his death in 1946, Morris Hirshfield completed a total of 74 paintings, according to the information in this catalog. For this exhibition (March 2-April 3, 1965), "the catalog lists forty-seven canvases, forty-four of which make up the present exhibit." Illus.; black & white.

283. *Mose T.* Montgomery, AL: Montgomery Museum of Fine Arts, 1981.
[exhibition catalog]
December 12, 1981-February 7, 1982. Seventy works in the exhibition. Includes a chronology of his life, work, painting; a bibliography; a photograph of the artist; and illustrations of the art.

284. *Mountain Harmonies: An Exhibition of Paintings and Carved Constructions by Charley, Noah, and Hazel Kinney of Lewis County, Kentucky.* Portsmouth, OH: Southern Ohio Museum, 1990.
[exhibition brochure]
Exhibit April 8-May 27, 1990. Catalog essay by Adrian Swain about the Kinneys and their lives in Toller Hollow, Kentucky. Small black and white illustrations.

285. *Muffled Voices: Folk Artists in Contemporary America.* New York: Museum of American Folk Art, 1986.
[exhibition catalog]
Didi Barrett, curator, writes about the lack of acceptance of these artists by the folk art establishment, the modernist critics, and the folklorists. Artists: Eddie Arning, Miles B. Car-

penter, Raymond Coins, Henry Darger, Sam Doyle, Howard Finster, William Hawkins, Alex A. Maldonado, Justin McCarthy, Louis Monza, Sister Gertrude Morgan, Peter Charlie Besharo, David Butler, Minnie Evans, Ted Gordon, "Popeye" Reed, Nellie Mae Rowe, Mose Tolliver, Inez Nathaniel Walker, John Podhorsky, Martin Ramirez, Anthony Joseph Salvatore, Jon Serl, Robert E. Smith, Simon Sparrow, P.M. Wentworth, Joseph Yoakum, and Malcah Zeldis. Biographies. Illus.; color, black & white.

286. *The Naive Approach.* Owensboro, KY: Owensboro Museum of Fine Art, 1983.
[exhibition catalog]
February 13-March 20, 1983. Arthur F. Jones curated the show and wrote the catalog essay. There is a checklist of artists, all residents of Kentucky: Rosa Brooks Beason, Carl Cook, Carlos Cortez Coyle, Evan Decker, Leonard Fields, Mrs. Tom Gibson, Oliver Hays, Charley Kinney, David Lucas, Harrison Mayes, Anna C. Miller, Margaret Hudson Ross, E. Lex Shipley, Tom Sizemore, Helen Whittemore, and Raymond Lebrun (a Haitian artist and refugee detained at the Lexington federal prison).

287. *Naives and Visionaries.* New York: E.P. Dutton/Walker Art Center, 1974.
[exhibition catalog]
One of the first exhibitions of environmental art. Works of James Hampton, Simon Rodia, S.P. Dinsmoor, Clarence Schmidt, Fred Smith, Jesse Howard, Herman Rusch, Grandma Prisbrey, and Louis Wippich. Biographies of each and commentary on the works. Illus.; color, black & white.

288. *Naivety in Art.* Tokyo: Setagaya Art Museum, 1986.
[exhibition catalog]
Essay by Herbert Hemphill on American "Naive Art." Biographies, illustrations of art, photographs of artists. American artists (catalog also includes Europeans and Japanese): Olaf Krans, Joseph Pickett, John Kane, Patrick Sullivan, "Grandma" Moses, Horace Pippin, Morris Hirshfield, Steve Ashby, Elijah Pierce, Mose Tolliver, Bill Traylor, Howard Finster, William Edmondson, Edgar Tolson, Martin Ramirez, and Joseph Yoakum. [Review: *Folk Art Finder* 9 (2) April-June 1988, 15-16, by Florence Laffal]

289. *Narrative Images: Folk Art and Related Contemporary Art.* Dallas: The Crescent Gallery, 1987 .
[exhibition catalog]
Curator Luanne McKinnon says the intention of this exhibition is "to present a large group of artworks by both self-taught and trained artists, illustrating by comparison the relationships and influences between the two groups." A few of the self-taught artists are Bill Potts, Johnny Banks, Carl Dixon, Vanzant Driver, Milton Fletcher, Ezekiel Gibbs, Jesse Lott, Ike Morgan, Emma Lou Moss, Anthony Joseph Salvatore, Steve Shepard, John Swearingen—and many of the frequently exhibited such as Tolliver, Traylor, Butler and Hawkins. Philadelphia Wireman is included too. Illus.

290. *Natural Scriptures: Visions of Nature and the Bible.* Bethlehem, PA: Lehigh University Art Galleries, 1990.
[exhibition catalog]
November 1-December 28, 1990. Curators: Elaine Garfinkel, Adrian Swain, Ricardo Viera. Essay by Norman Girardot, "Four Meditations on the 'Art With No Name'. " Artists Minnie and Garland Adkins, Jessie and Ronald Cooper, Howard Finster, and Hugo Sperger. Color photographs of the artists and art.

291. *Ned Cartledge.* Atlanta: Nexus Press, 1986. Publication concurrent with exhibition at Georgia Museum of Art (no dates given). Plates, many in color, with artist's commentary on his work. Also an autobiographical essay about his background and the sources for his social commentary. Exhibitions list; collections list; index of plates.

292. *Nellie Mae Rowe: Visionary Artist.* Atlanta, GA: Judith Alexander, 1983.
[exhibition catalog]
First pages are "Nellie Mae Rowe In Her Own Words." Then follows "Memories Shared," by Judith Alexander, the organizer of this exhibition. Chronology, exhibitions, awards, public collections. Bibliography. Catalog of exhibition. Illus.; color, black & white.

293. *New South, New Deal and Beyond: An Exhibition of New Deal Era Art, 1933-1943.* Montgomery, AL: Pioneer Press, 1990.
[exhibition catalog]

September 14-October 27, 1989. At the Alabama Artists Gallery, Montgomery, and traveled. Essay by Miriam Rogers Fowler on the aims and purposes of the "New South School and Gallery," which were to broaden the cultural life of all Southerners of all classes; encourage native talent; and encourage interest in a more contemporary view of art. "The group is also important because of their discovery of Bill Traylor, and for organizing the first exhibition of his art." Notes, biographies, illus., including Bill Traylor.

294. *New Traditions/Non-Traditions: Contemporary Folk Art in Ohio.* Columbus: Columbus Museum of Art, 1989.
[exhibition brochure]
December 2, 1989-January 26, 1990. Organized by the Ohio Arts Council and the Columbus Museum. Curator: E. Jane Connell. Guest curators: Roger McLane and Eugene Metcalf. Eighty pieces exhibited include paintings, drawings, and sculpture. The thirteen contemporary Ohio folk artists in the exhibition are Mary Borkowski, Okey Canfield, the Rev. St. Patrick Clay, William Hawkins, Tella Kitchen, the Rev. "Mad Mac" McCaffrey, Paul Patton, Elijah Pierce, Janis Price, "Popeye" Reed, tatoo artist Stoney St. Clair, and Anthony Joseph Salvatore. Also an anonymous tin piece. Brief essays, checklist, color illustrations.

295. *New World Folk Art: Old World Survivals and Cross-Cultural Inspirations, 1492-1992.* Cleveland, OH: Cleveland State University Art Gallery, 1992.
[exhibition catalog]
Exhibition September 25-October 23, 1992 curated by John Hunter and Gene Kangas. List of articles and artists. Focus: "to pay homage to both native born and immigrant people of the New World" with an emphasis upon the "importance of interactions between cultures and their effects on folk imagery." Artists include John Perates, William Edmondson, Silvio Zoratti, Felipe Archuleta, Leroy Archuleta, Edward Kay, decoy carvers, and others. Bibliography. Illus.

296. *Next Generation: Southern Black Aesthetic.* Winston-Salem: Southeastern Center for Contemporary Art, 1990.
[exhibition catalog]
May 5-July 15, 1990. In Winston-Salem, then

traveled. Essays on African-Americans in the art world, by Lowery S. Sims; on "The Triple Negation of Colored Women Artists," by Adrian Piper. Included notes on a panel discussion. Folk artists include Lonnie Holley, Jesse Lott, Hawkins Bolden. Illus. of art in color. Lonnie Holley shown at home.

297. Niemann, Henry Paul. *Malcah Zeldis: Her Life and Evolution of Her Work, 1959-1984.* New York: New York University, School of Education, Health, Nursing and Arts Professions, 1990.
[Ph.D dissertation; unpublished. Copy available at the library of the Museum of American Folk Art]
Contents: "A Framework for Analyzing the American Folk Painting of Malcah Zeldis"; "Zeldis on Zeldis"; "The Paintings: An Artistic Evolution" including "The World of Fantasy," "I Remember," "The Religious Experience," "Historical Figures," and "Zeldis in Search of Herself." Notes. Bibliography. Slides included.

298. Nosanow, Barbara Shissler. *More than Land or Sky: Art from Appalachia.* Washington, D.C.: Smithsonian Institution Press, 1981.
Published on the occasion of an exhibition organized by the National Museum of American Art, October 30, 1981-January 3, 1982, and traveled. Essay by Nosanow about the region. Biographies of artists and color illustrations of their work. Includes trained and self-taught artists. The latter are Howard Finster, Lonnie Holley, David "Blue" Lamm, David A. Lucas, Edward Rogge, Mary Shelley, and Joe W. Thrasher.

299. Ohrn, Steven, ed. *Passing Time and Traditions: Contemporary Iowa Folk Artists.* Ames, IA: Iowa State University Press, 1984.
Survey of traditional folk art in Iowa by the folklorists. Nearly everything refers to a community heritage. Written to accompany a state survey of folk arts, by the Iowa state folklorist.

300. O'Kelley, Mattie Lou. *Circus.* New York: Atlantic Monthly Press, 1986.
Children's book about an old fashioned circus arriving in town, featuring the paintings of O'Kelley as illustration for the story.

301. O'Kelley, Mattie Lou. *From the Hills of Georgia: An Autobiography in Paintings.* Boston: Atlantic Monthly/Little, Brown, 1983.

Introduction by Robert Bishop. In brief written narratives with accompanying paintings, this self-taught artist from Maysville, Georgia presents a chronicle of her life as a farm child. There are color reproductions of the farm in many seasons, interiors of the home with the eight O'Kelley children, and scenes of work on the farm.

302. O'Kelley, Mattie Lou. *Mattie Lou O'Kelley, Folk Artist.* Boston: Bulfinch Press/Little, Brown, 1989.
Introduction by Robert Bishop. Full-page color reproductions of the artist's memory paintings organized by the seasons. Includes family photographs and a list of paintings.

303. *One Hundred Miles: The 100th Anniversary of Miles Carpenter.* Waverly, VA: The Miles B. Carpenter Museum, 1989.
Booklet prepared for an "exhibition of folk art and an outdoor festival" organized by the Miles B. Carpenter Museum, with the help of the Folk Art Society of America, May 6 and 7, 1989.

304. *One Space/Three Visions.* Albuquerque: Albuquerque Museum, 1979.
[exhibition catalog]
August 5-November 4, 1979. Three visions are "Native American, Hispanic, and Contemporary." In the Native American section, Ramona Sakiestewa says "The artists voiced a unified opinion that Indian art patrons, serious collectors, museum exhibitions, craft fairs, and Indian markets were most responsible for the development of their careers." The introduction to Hispanic arts describes two types of contemporary *santeros*: "Men like Horacio Valdez and George Lopez who inherited their craft through family and ties to the Penitente brotherhood; and others such as Luis Tapia and Felix Lopez who took it up as a means of ethnic self-discovery, and shrink from the religious exclusivity implied by the word *santero.*" Comments on Felipe Archuleta. Indian artists: Helen Cordero, Linda Maestas, Serefina Ortiz, Manuel Vigil and others. Hispanic artists: Felipe Archuleta, Frank Brito, Felix Lopez, Luis Tapia, and more. The "contemporary section" was for trained artists from each group above, plus "Anglos." Checklist. Illus., black & white.

305. Oneal, Zibby. *Grandma Moses, Painter of Rural America.* New York: Puffin Books, 1986.

The information on Anna Mary Robertson Moses background, the character (or lack of) of her husband, and the part she played in supporting her family and guiding her own destiny is not usually given the emphasis that it receives here. Although the book is designed for the 7-11 age group, all might find the information enlightening. It is part of a series called "Women of Our Time."

306. Oppenhimer, Ann F., and Susan Hankla, eds. *Sermons In Paint: A Howard Finster Folk Art Festival.* Richmond, VA: University of Richmond, 1984.
Ann Oppenhimer describes Finster, his family, and his work. Hankla writes of his art and vision and compares him to William Blake. Peter Morrin places him within the framework of Southern religious fundamentalism. Others write about his religion, his painting, and his music. Examples of Finster quotation and art are sprinkled throughout the book. List of the works shown as part of the festival, a chronology of exhibitions from 1976-1984 and a three-page bibliography. Illus.

307. *Orphans In The Storm.* Birmingham, Al: 10 2 4 Gallery, 1991.
[exhibition brochure]
Exhibit November 1-December 30, 1991 at the above-named gallery and presented in collaboration with the Anton Haardt Gallery in Montgomery. The brochure includes photographs and several paragraphs of biographical information for each of the artists. Includes David Butler, William Dawson, Thornton Dial, Sam Doyle, Minnie Evans, Howard Finster, Sybil Gibson, Bessie Harvey, Clementine Hunter, Lonnie Holley, Boosie Jackson, James Harold Jennings, Calvin Livingston, Charlie Lucas, Benjamin F. Perkins, Royal Robertson, Juanita Rogers, Mary T. Smith, Henry Speller, Jimmy Lee Sudduth, James "Son" Thomas, Mose Tolliver, and Inez Nathaniel Walker.

308. *Out of the Boot: Self-Taught Louisiana Afro-American Artists.* Los Angeles: California Afro-American Museum, 1989.
[exhibition catalog]
May 23-June 18, 1989. Curated by Lizzetta LeFalle-Collins and Richard Gasperi. The artists are "noted for their rich, vibrant colors and uniqueness of expression. Lacking con-

ventional instruction, these artists have forged artistic expression from found objects and have produced visionary themes and images from the roots of Louisiana's rich tradition." Artists: Bruce Brice, Sister Gertrude Morgan, Milton Fletcher, Clementine Hunter, John Landry, J.P. Scott, James "Son" Thomas, Willie White.

309. *Out of the Mainstream: Independent and Visionary Art of the Northwest.* Missoula, MT: Missoula Museum of the Arts, 1987.
[exhibition catalog]
Essay by Willem Volkersz, "Cultural Imprint and Private Vision—Folk Art in America Today." Artists: Russell Childers, Marjorie McDonald, Lee and Dee Steen, Georgiana Orr, James Miller, James Castle, Ruza Erceg, Ernest King. Gilberta Manker, Winnie Lloyd. Detailed biographies for each. Illus.

310. *Outside the Main Stream: Folk Art in Our Time.* Atlanta, GA: High Museum, 1988.
[exhibition brochure]
May 19-August 12, 1988. High Museum of Art at Georgia-Pacific Center. Statement by curator, Barbara Archer. More than 130 works by sixty-six artists. Color illus.: whirligig by R.A. Miller, a Nellie Mae Rowe painting, David Butler's "Wiseman on a Camel," stick by Denzil Goodpaster.

311. *Outsider Art.* Baton Rouge, LA: Louisiana Arts and Science Center, 1991.
[exhibition brochure]
August 13-September 8, 1991. Contemporary folk art drawn from the collections of Shelby R. Gilley of Baton Rouge, and Warren and Sylvia Lowe of Lafayette, Louisiana. The artists are "self-taught and working outside the mainstream of the contemporary art world." Artists: David Butler, Heleodoro Cantu, Jessie Coates, Raymond Coins, Marion Conner, William Dawson, Sam Doyle, Howard Finster, James Harold Jennings, Junior Lewis, Woodie Long, Charlie Lucas, Thomas May, R.A. Miller, J.B. Murry, Benjamin F. Perkins, Royal Robertson, Juanita Rogers, Marie Rogers, Herbert Singleton, Mary T. Smith, Jimmy Lee Sudduth, James "Son" Thomas, Mose Tolliver, Willie White, and Luster Willis.

312. *Outsider Artists in Alabama.* Montgomery: Alabama State Council on the Arts, 1991.
[exhibition catalog]
Based on an exhibition at the Alabama Artists Gallery in Montgomery which opened November 1991. Essays by Tom Patterson, "Look at That! A Personal View of 'Outsider' Art in the American South" and an essay called "Who are the Outsiders?" by Joey Brackner. Biographies of artists are sometimes from interviews, and sometimes by others. Artists: Lloyd Busby, L.W. Crawford, Thornton Dial, Sybil Gibson, Joseph Hardin, Lonnie Holley, Boosie Jackson, Calvin Livingston, Woodie Long, Annie Lucas, Charlie Lucas, Robert Marino, Benjamin F. Perkins, Virgil Perry, Juanita Rogers, Bernice Sims, Jimmy Lee Sudduth, Annie Tolliver, Mose Tolliver, Bill Traylor, Fred Webster, and Myrtice West. Illus.; color, black & white, and photographs of the artists.

313. *Outsiders: Art Beyond the Norms.* New York: Rosa Esman Gallery, 1986.
[exhibition catalog]
January 11-February 12, 1986. Lengthy introduction on definitions and descriptions of outsider art says these artists "are often, though not always, eccentric persons who operate outside the norms of the art world. They are primarily untrained and minimally, if at all, aware of the canons of 'official art.' At some time in their lives, often at times of intense psychic crisis, they begin to create art." "Certain art historians and anthropologists assert that the 'outsider' cannot produce significant art. But this position raises the crucial and thorny question of just what is 'significant art." American artists: Henry Darger, Howard Finster, Ted Gordon, Frank Jones, Justin McCarthy, Martin Ramirez, Joseph Yoakum, J.B. Murry, and Anthony Joseph Salvatore. Illus.

314. *Outsiders: Artists Outside the Mainstream.* Ames, IA: Octagon Center for the Arts, 1990.
[exhibition catalog]
September 9-October 21, 1990. Introductory material on the significance of visiting these artists which resulted in an interest in outsider art. Artists in the exhibition are Leroy Almon, Milo Benda, David Butler, Howard Finster, Sybil Gibson, Lee Godie, Mr. Imagination, S.L. Jones, Simon Sparrow, Willie White, Eugene Von Bruenchenhein, "Butch" Quinn, Hugo Kalke, Kid Mertz, R.A. Miller, Guido Polo, Mose Tolliver, Bill Traylor, Inez Nathaniel Walker, Paul Williams, and Joseph Yoakum. Biography and notes on each. Illus.; color, black & white.

315. *Outsiders: Sarah Keene Meltzoff, Alan St. James Boudreaux, Francois Lucet, James La Lande.* New Orleans: Barrister's Gallery, 1992.
[exhibition catalog]
Exhibit which opened February 1, 1992. Essays by A.P. Antippas on each of the artists. Boudreaux is self-taught; the others are not.

316. Panyella, August. *Folk Art of the Americas.* New York: Harry N. Abrams, 1981.
Source for a colorful illustration of an octopus (painted root) sculpture by Miles B. Carpenter; an illustration of a Howard Finster artwork; and a "naive" painting by Mimi Vang Olsen of New York City.

317. *Parallel Visions: Modern Artists and Outsider Art.* Los Angeles: Los Angeles County Museum of Art, 1992.
[exhibition catalog]
October 18, 1992-January 3, 1993. Curators: Maurice Tuchman and Carol S. Eliel. Examines the relationships between the work of modern and contemporary artists and that of compulsive visionaries. Introductory text includes Tuchman on the intent of this exhibition and the definition of the term "outsider" as used here; "Eyes Outside and Eyes Inside" by Jonathan Williams, a personal reflection on outsiders; and an essay by Carol S. Eliel, " 'Moral Influence' and Expressive Intent: A Model of the Relationship between Insider and Outsider." The next six essays look at mainstream twentieth century artists generationally and consider their awareness of outsider art. Authors are Reinhold Heller, Roger Cardinal, Sarah Wilson, Russell Bowman, Mark Gisbourne, and Carol S. Eliel and Barbara Freeman. Three essays on outsiders follow: "On the Meaning of Creativity and Madness" by Sander Gilman; "I See a World Within a World: I Dream But Am Awake" by John MacGregor; and "Nostalgia for the Absolute: Obsession and Art Brut" by Allen Weiss. The final essay, which considers the role of the museum in all this, is by Donald Preziosi and is called "Art History, Museology, and the Staging of Modernity." Approximately 225 works: modern and contemporary art, 115 works; art of compulsive visionaries, 110 works. "Visionaries" from the United States are: Henry Darger, Howard Finster, J.B. Murry, Martin Ramirez, P.M. Wentworth, and Joseph Yoakum; and environmental artists Simon Rodia and Clarence Schmidt. Outsider artist biographies, with one or two references. Checklist. "Fully illustrated." [Information pre-publication from Carol S. Eliel]

318. *The Pardee Collection: A Catalog of Non-Traditional Midwestern Folk Artists.* Iowa City, IA: Privately printed, 1982.
A catalog from a dealer in midwestern folk art which includes biographical statements and color reproductions of the work of the following artists: Paul Hein, painter; Oliver Williams, paintings and sculpture; Paul Saunders, painter; Virgil Norberg, wind toys and weathervanes; Randy Norberg, wooden models; Allen Eberle, inventor of his own art movement which he calls "Splintalism"; Greg Dickenson who "embraces and celebrates" pop culture; Anthony Yoder, a Mennonite "whose visionary art work is inspired by his meditations upon Bible Scripture"; Rollin Knapp who paints portraits of imaginary women friends and contemporary presidents; and Nick Jovan, who paints his visions. [May be ordered from Sherry Pardee, PO Box 2926, Iowa City, IA 52244. Inquire as to price]

319. *Passionate Visions of the American South: Self-Taught Artists, 1940-Present.* New Orleans, LA: New Orleans Museum of Art, 1993.
[exhibition catalog]
Catalog for the exhibition scheduled mid-October 1993 to early January 1994 and scheduled to travel. Exhibition and catalog organized by Alice Rae Yelen. Objects selected by Yelen and Kurt Gitter. Essays: "Aesthetics and the Southern Self-Taught Artist," by Jane Livingston; The Cultural South: A Fertile Environment for Self-Taught Artists," by William Ferris; "American Folk Art Within the Context of American Art," by Susan Larsen; "The Influence of African-American Self-Taught Artists on Mainstream Artists," by Lowery Sims. The catalog will also include an overview, "Southern Self-Taught Artists," as well as brief essays on the objects in the context of the exhibition's thematic divisions: "daily life," "religion," "nature," and "patriotism." [Information obtained pre-publication from Alice Rae Yelen]

320. Patterson, Tom. *St. EOM in the Land of Pasaquan: The Life and Times and Art of Eddie Owens Martin.* Winston-Salem, NC: The Jargon Society, 1987.
A book described "as told to and recorded by"

Tom Patterson. Introductory material about St. EOM, an opinion about the place by a neighbor, and text that is based upon three years of conversation. Photographs by Jonathan Williams, Roger Manley, and Guy Mendes. [Review: *The Clarion* 13(4) Fall 1988, 67, by Daniel C. Prince]

321. Perry, Regenia. *Free Within Ourselves: African-American Artists in the Collection of the National Museum of American Art.* Washington, D.C. and Petaluma, CA: National Museum of American Art, Smithsonian Institution and Pomegranate Press, 1992.
Essays about thirty-one mainstream and self-taught African-American artists in the National Museum of American Art collection. Includes artists of the nineteenth and twentieth centuries. Self-taught artists are Minnie Evans, Sister Gertrude Morgan, William Edmondson, James Hampton, Bill Traylor, Frank Jones, and Joseph Yoakum. There are biographies, quotations from the artists, a color illustration of a primary work by each artist, and illustrations in black and white. There are photographs of the artists. Introduction by Kinshasha Holman Conwill. A bibliography focused on African-American art and culture, by Lynda Roscoe Hartigan, emphasizes works that are useful to educators. This publication written to accompany a national tour of the art. [Information prepublication from Perry and from Hartigan]

322. *Personal Intensity: Artists In Spite of the Mainstream.* Milwaukee: University of Wisconsin-Milwaukee, 1991.
[exhibition catalog]
November 8-December 21, 1991. Curated by Roger Brown. Pieces owned by Mr. Brown, with "a small selection of historically familiar works" chosen by him from public and private collections. For a list of artists, see the "Museum Exhibitions" section. Illus.

323. *Personal Voice: Outsider Art and Signature Style.* Chicago: American Center for Design, 1991.
[exhibition catalog]
September 10-November 1, 1991. Curators: E. Michael Flanagan and Frank C. Lewis. Catalog commentary by Frank C. Lewis. Color illustrations of work of Jessie Cooper, James "Son" Thomas, Derek Webster, S.L. Jones, Bessie Harvey, Prophet William Blackmon, and Jimmy Lee Sudduth. For a list of artists in the exhibition, see the "Museum Exhibitions" section.

324. *Pioneers in Paradise: Folk and Outsider Artists of the West Coast.* Long Beach, CA: Long Beach Museum of Art, 1984.
[exhibition catalog]
November 25, 1984-January 20, 1985 and traveled. A survey of art made in California, Washington, and Oregon from 1844-1984. Curators: Susan Larsen-Martin, Lauri Robert Martin. Essays: Larsen-Martin on West Coast folk and outsider artists and Herbert Hemphill and Randall Morris with "Remarks." Biographies. Catalog. Bibliography. The twentieth century artists: Carrie Van Wie, R.D. Ginther, John A. Sowell, P.M. Wentworth, Louis Monza, Romano Gabriel, John Roeder, John Hoff, Calvin and Ruby Black, Martin Ramirez, Irwin Rabinov, Marcel Cavalla, Alan Van Hoecke, Peter Mason Bond, Sanford Darling, Andrew Block, Harry Lieberman, Rose Erceg, Hugo Wallin, Richard Cole, Jon Serl, John Podhorsky, Jim Colclough, Frank Day, Morton Riddle, James Miller, Russell Childers, David Rust, Alex A. Maldonado, Theodore Gordon, Robert Gilkerson, and Georgianna Orr. Illus.; color, black & white.

325. *Popular Images, Personal Visions: The Art of William Hawkins, 1895-1990.* Columbus, OH: Columbus Museum of Art, 1990.
[exhibition catalog]
Curator: Gary Schwindler, with an essay on the art and the artist. Checklist of paintings and drawings. List of exhibitions and awards. Illus.; color, black & white.

326. *Portraits from the Outside: Figurative Expression in Outsider Art.* New York: Groegfaex Publishing, 1990.
[exhibition catalog]
Parsons School of Design Gallery, November 7-November 30, 1990. Essays by John MacGregor, Roger Cardinal, Allen Weiss, and others. Includes, among the artists, Americans Bessie Harvey, "Trees Is Soul People to Me," an interview; and an essay about J.B. Murry, "This Well is Deep and Never Go Dry." Illus.

327. Posen, Sheldon, and Daniel Franklin Ward. "Watts Towers and the Giglio Tradition." In *Folklife Annual 1985*, 143-157. Washington, D.C.: Library of Congress, 1985.
Authors attempt to link a southern Italian folk celebration of a Catholic saint to the construction of Watts Towers by Simon Rodia. Authors

express dismay that Rodia is called a folk artist. Illus.

328. Price, Sally. *Primitive Art in Civilized Places.* Chicago: University of Chicago Press, 1989. This book is not about contemporary American self-taught/folk art, but it is about ethical and other such matters that ought to be of interest to collectors, dealers, museum people, and others who should care about the artists.

329. Prisbrey, Tressa. *Grandma's Bottle Village.* Santa Susana, CA: Privately printed, 1959. Booklet written by Tressa Prisbrey to provide background information on her life and on the construction of Bottle Village; made available to people who visited her. Her sense of humor and her wit are evident. Illus.

330. Proby, Kathryn H. *Mario Sanchez: Painter of Key West Memories.* Key West, FL: Southernmost Press, 1981. Information on the artist and the Cuban-American community where he grew up. Commentary on the art and a bibliography specific to Sanchez. Color plates of the art and two family photographs.

331. Proctor, Bernardine B. *Black Art in Louisiana.* Lafayette, LA: Center for Louisiana Studies, University of Southwestern Louisiana, 1989. The stated objective of the book is to present a view of the range of work of African-American artists in Louisiana. The works and lives of eighty-four artists are presented including self-taught painters Bruce Brice and Milton Fletcher and New Orleans wood carvers Charles, Eric and Randolph Hutchison, who are famous for their bird sculptures. All artists in the book were asked is there "black art"? There were strong opinions on each side of the question, with all the above named artists thinking it "irrelevant."

332. *Psychological Paintings: The Personal Vision of Jon Serl.* Newport Beach, CA: Newport Harbor Art Museum, 1981. [exhibition catalog] December 12, 1981- February 7, 1982. Essay by Jessica Jacobs, "Jon Serl: A Psychological Vision," tells of his roots "in poverty and vaudeville," and that memories of this laid the foundation for his art. Says his life shaped a personality that "thrived on perception and nurtured a directness and vividness in appli-

cation." Details on how and where he lived, his popularity with "art types" in Laguna Beach who spent a lot of time at his studio, and his move to the desert to be alone. Commentary on his images, his attitudes, his paintings. Says the concept that women are predatory is evident in Serl's art. Checklist. Illus.

333. Purser, Stuart R. *Jesse J. Aaron, Sculptor.* Gainesville, FL: Purser Publications, 1975. Introduction provides biographical information on wood sculptor Jesse Aaron. Author tells of meeting Aaron and shares stories and anecdotes. Fourteen drawings by Purser of Aaron's artwork.

334. *Queena Stovall: Artist of the Blue Ridge Piedmont.* Cooperstown, NY: New York State Historical Association, 1974. [exhibition catalog] October 6-25, 1977 at Lynchburg College in Virginia, then traveled. Forward by Louis Jones and Agnes H. Jones. Includes biographical information about Queena Stovall and notice of her recognition as an artist. Paintings with comments. Says her work is in Randolph-Macon Woman's College, Oglebay Institute-Mansion Museum, and the Virginia Museum of Fine Arts in Richmond.

335. Quimby, Ian M. G., and Scott T. Swank, eds. *Perspectives on American Folk Art.* New York: W.W. Norton/Winterthur Museum, 1980. Papers from a conference at Winterthur Museum, 1977. Discussion and dispute about the nature and significance of American folk art. Essays on regional and ethnic considerations, definitions, and theory. Beatrix Rumford's essay has been referred to as "the accepted history of interest in American folk art." A few of the others are: "Expanding Frontiers: The Michigan Folk Art Project," by Marsha MacDowell and C. Kurt Dewhurst; "Arrival and Survival: The Maintenance of an Afro-American Tradition in Folk Art and Craft," by John Michael Vlach; "Beating a Live Horse: Yet Another Note on Definitions and Defining," by Roger L. Welsch; "The Arts: Fine and Plain," by George A. Kubler; "Folk Art: The Challenge and the Promise," by Kenneth Ames; and "L.A. Add-ons and Re-dos: Renovation in Folk Art and Architectural Design." Index. [Review: *Folk Art Finder* 4 (1) March/April 1983, 16, by Jules Laffal]

336. Radin, Ruth Yaffee. *A Winter Place.* Boston: Little, Brown, 1982.
Summary from the book: "A family carrying ice skates passes villages, farms, and forests on the way to a frozen lake up in the hills." Fifteen color paintings by Mattie Lou O'Kelley illustrate this children's book.

337. *Rambling on My Mind: Black Folk Art of the Southwest.* Dallas: Museum of African-American Life and Culture, 1987.
[exhibition catalog]
September 1, 1987. Essays on traditional black folk art, Louisiana folk craft tradition, and black folk art in Texas. Extensive notes and bibliography. Artists: David Allen, John W. Banks, Calvin Berry, Josephine Burns, David Butler, Carl Dixon, Milton Fletcher, Ezekiel Gibbs, Alma Guenter, Clementine Hunter, Frank Jones, Sister Gertrude Morgan, Ike Morgan, Emma Lee Moss, J.P. Scott, Rev. Johnnie Swearingen, Donald Washington, Willard "Texas Kid" Watson, George White. Illus.

338. Ray, Dorothy Jean. *Aleut and Eskimo Art: Tradition and Innovation in South Alaska.* Seattle: University of Washington Press, 1981.
The subject matter of this book is the decorative and sculptural arts of the Eskimos living south of Saint Michael, Alaska, from the time of the first European contact to 1979. Discussion and interpretation of traditional and market art. Two chapters of special relevance, "The New Arts," and "What is Past is Prologue." She says "souvenir making is so subtle here, unlike the north, it is hardly noticed."

339. Ray, Dorothy Jean. *Eskimo Art: Tradition and Innovation in North Alaska.* Seattle: University of Washington Press, 1977.
Deals with the arts of the people living north of Saint Michael, Alaska—the Inupeat—on Saint Lawrence Island. Art of the historical and contemporary period. Discussion and interpretation of traditional and market arts. Illustrated. "Production of market art in the north is not so subtle as in the south."

340. *Religious Visionaries.* Sheboygan, WI: John Michael Kohler Arts Center, 1985.
[exhibition brochure]
January 20-March 24, 1985. Joanne Cubbs, curator, writes of a still vital religious tradition among a number of self-taught artists and painters. Biographical information is supplied for the artists: Howard Finster, Josephus Farmer, Simon Sparrow, Alan Berg, Jose Dolores Lopez, and George Lopez. Checklist. Illus.; black & white.

341. *Religious Visionaries.* Sheboygan, WI: John Michael Kohler Arts Center, 1991.
[exhibition catalog]
March 3-May 12, 1991. Curated by Joanne Cubbs, who wrote the introductory essay and biographies. Artists: Simon Sparrow, Mary LeRavin, and Norbert Kox. Commentary on the art as well as the artists is included. Checklist and numerous color illustrations.

342. *Remembrances: Recent Memory Art by Kentucky Folk Artists.* Louisville: Kentucky Art and Craft Foundation Gallery, 1986.
[exhibition catalog]
September 29-November 30, 1986. The artworks "depict community and family life as seen through the eyes and minds of the artists." Essay by Larry Hackley. Artists: Rosa Brooks Beason, Minnie Black, Evan Decker, Denzil Goodpaster, Mack Hodge, Unto Jarvi, Charley Kinney, Noah Kinney, David Lucas, W.R. Mays, Carl McKenzie, William I. Nelson, Earnest Patton, R.W. Rawlings, Josephine Richardson, Margaret Ross, Lillie Short, Tim Sizemore, Hugo Sperger, Donny Tolson, and Betty Wallen. Illus.; color, black & white.

343. Ricco, Roger and Frank Maresca, with Julia Weissman. *American Primitive: Discoveries in Folk Sculpture.* New York: Alfred A. Knopf, 1988.
A picture book of more than 400 pieces by "artists with no formal training," arranged by what "appears to be the intention of the artist." Includes sculpture from past centuries, anonymous pieces, and twentieth century works. Illustrated contemporary artists are: Dilmus Hall, Popeye Reed, Vernon Burwell, Hawkins Bolden, William Edmondson, Rodney Rosebrook, Jesse Aaron, Philadelphia Wireman (not labeled as such), Elijah Pierce, Howard Finster, Josephus Farmer, Bessie Harvey, Raymond Coins, Oscar Peterson, Clark Coe, Denzil Goodpaster, Charlie Fields, Calvin Black, Edgar Tolson, David Butler, Stanley Papio, and Jim Colclough. Notes, bibliography.

344. Rinzler, Ralph, and Robert Sayers. *The Meaders Family: North Georgia Potters.* Washington,

D.C.: Smithsonian Institution Press, 1980. Biography, artistic history, methodology, and materials of this famous family of traditional potters. Photographs of their face jugs.

345. *The Road to Heaven is Paved With Good Works: The Art of Reverend Howard Finster.* New York: Museum of American Folk Art, 1989.
[exhibition brochure]
September 21, 1989-January 5, 1990. At the PaineWebber Group Gallery. The brochure includes a bibliography, and when it is unfolded it reveals a Finster "poster." Guest curator, John Turner.

346. *Robert E. Smith: Story Painter.* Bozeman: Montana State University, 1989.
[exhibition catalog]
Haynes Fine Art Gallery, at the University, and traveled. Twenty-eight works in the exhibition (acrylic, india ink, and crayon on paperboard). Willem Volkersz tells about the artist, his art, and why Volkersz is attracted to it. Three color illustration of Smith's work.

347. Rodman, Selden. *Artists in Tune With Their World: Masters of Popular Art in the Americas and Their Relation to the Folk Tradition.* New York: Simon & Schuster, 1982.
Book documents the popular arts of the Western hemisphere—from the Eskimo printmakers of Alaska to the painters of Mexico, Brazil, and Haiti. Art critic Rodman maintains that the values once ascribed to Western high art are today found exclusively in the works of self-taught creators "who remain closely linked to the folk tradition and whose motivation is to document or explore the simple pleasures or dislocations of the working people around them." U.S. artists who fit his perceptions are: William Edmondson, Horace Pippin, Minnie Evans, Minnie Deschamps, Simon Rodia, James Hampton, Morris Hirshfield, Ralph Fasanella. Biblio. Indices. Illus.; color, black & white.

348. Rodman, Selden. *Horace Pippin: A Negro Painter in America.* New York: Quadrangle Books, 1947.
About Horace Pippin and his life; the town of West Chester where he lived, his years of fame and success, and his later sorrowful years. There are comparisons to other black artists, sketches of his war diary. List of reproductions of his work. Life chronology. List of works and their location.

349. Rodman, Selden, and Carol Cleaver. *Horace Pippin: The Artist as a Black Man.* New York: Doubleday, 1972.
Authors say that long before the concepts that "black is beautiful" and that African-Americans had a special culture gained wide recognition, Horace Pippin had "unselfconsciously celebrated those self-evident truths in his paintings. Pippin's pride is manifested in all his work." They say he was also proud of being an American and thought the American dream would come true—eventually. Many details about his life history. Illus.

350. Rose, Howard. *Unexpected Eloquence: The Art in American Folk Art.* Annandale-on-Hudson, NY: Raymond Saroff/Edith C. Blum Art Institute, Bard College, 1990.
Editors say "An art collector and dealer by profession, Howard Rose developed a passionate interest in folk art. Concerned by the lack of serious art criticism about the subject and disturbed by the condescension with which folk art is generally treated by the critics, he wrote this book in the 1970s. He narrows his field to exclude "mere Americana" and focuses on a body of art work with the same set of evaluative criteria applied to mainstream art. Among other topics, Rose describes "a revision of conventional preconceptions about the multifaceted American heritage and in doing so challenges the art establishment and opens up the field to the large audience of art lovers." In the concluding pages Rose details the various conceptual problems in folk art criticism, with snobbish art reviewers, and people such as Kenneth Ames and Daniel Robbins.

351. Rosen, Michael. *Elijah's Angel: A Story for Chanukah and Christmas.* Orlando, Fl: Harcourt Brace Jovanovich, 1992.
Elijah's Angel is based on the life of woodcarver Elijah Pierce (1892-1984). Aminah Brenda Lynn Robinson is the illustrator. She spent many hours in Pierce's barbershop, and "her pictures of his carvings, her renderings of the barbershop, her colors and details . . . are a part of her own story of Elijah, her teacher and friend." This book for children tells of "Michael," who visits the barber/carver every Monday after Hebrew school and

never thinks about "being seventy-five years younger than or a different color from the woodcarver." When Elijah gives Michael a special carved angel, "Michael worries. How can he possibly bring home a Christmas angel, a forbidden graven image—especially on Chanukah?" [Information pre-publication from Michael Rosen]

352. Rosen, Seymour. *In Celebration of Ourselves.* San Francisco: California Living Books, 1979. Photographs and brief text on California folk environments and celebrations. Some people and places are Simon Rodia and Watts Towers; Desert View Tower; Possum Trot; Emeryville; Grandma Prisbrey's Bottle Village; Nitt Witt Ridge; and the projects of Baldessare Forestiere, Duke Cahill, John Guidici, Sanford Darling, Driftwood Charlie, "Litto" Damonte, Romano Gabriel, and John Ehn. There are entries for such celebrations as costumes, murals and county fairs. An additional section mentions "other environments," and warns of potential loss.

353. Rosenak, Chuck, and Jan Rosenak. *Museum of American Folk Art Encyclopedia of Twentieth-Century American Folk Art and Artists.* New York: Abbeville Press, 1990.
Includes 255 painters, sculptors, potters, and creators of environments from the twentieth century "classics" such as Pippin, Picket, Kane, and Grandma Moses to recent discoveries. Detailed information on each artist includes: biographical data, general background, artistic background, subjects and sources, materials and techniques, artistic recognition. Other sections of the book include "major and mostly group" exhibitions from 1924 to the beginning of 1990; selected public collections, photographs of the artists, and a bibliography. There is a color illustration of each artist's work. Index. [Reviews: *Raw Vision* 5 Winter 1991/92, 59, by John Maizels; *Folk Art Messenger* 4 (2) Winter 1991, 4, by Lisa Howorth; *Folk Art Finder* 12 (2) April-June 1991, 20-22, by Willem Volkersz]. Note: A paperback edition with additional artists is in preparation at the time of this writing.

354. Rosenak, Chuck, and Jan Rosenak. *The People Speak: Navajo Folk Art.* Flagstaff, AZ: Northland Press, 1994.
Essays about Navajo folk art and culture by Chuck and Jan Rosenak with a lengthy intro-

duction by Chuck Rosenak. Includes portraits and biographies of forty contemporary Navajo folk artists and pages of photographs of Navajo lands. Full color plates, eighty pages, illustrate the art works. A few the forty artists to be included are Johnson Antonio, Charlie Willeto, Mamie Deschillie, Dan Hot, Woody Herbert, Lawrence Jacquarz, the Pete sisters, Alice Cling, Betty Manygoats, Silas Claw, and Myra Tso. Among the appendices are a chronology of Navajo history and a bibliography. [Information pre-publication from Chuck Rosenak]

355. Rubin, Cynthia Elyce, ed. *Southern Folk Art.* Birmingham, AL: Oxmoor House, 1985.
Chapters on pottery, painting, sculpture, decorative furniture, and textiles; historical and twentieth century, but little of the latter. Face jugs are illustrated.

356. Rumford, Beatrix, and Carolyn J. Weekley. *Treasures of American Folk Art: From the Abby Aldrich Rockefeller Folk Art Center.* Boston: Little, Brown/Colonial Williamsburg Foundation, 1989.
Published to celebrate the fiftieth anniversary of the Abby Aldrich Rockefeller Collection, there is information on its beginnings and on the artists collected. Twentieth century artists included are Eddie Arning, Steve Harley, Miles B. Carpenter, William Edmondson, Irvin Weil, and Edgar McKillop. Index. There are numerous color illustrations.

357. *A Rural Life: The Art of Lavern Kelley.* Clinton, NY: Hamilton College, 1989.
[exhibition catalog]
February 12-March 26, 1989. Emerson Gallery/Hamilton College. Commentary by William Salzello, the organizer of the exhibition; remarks on Kelley's work by Sydney Waller and Leslie Keno; Lavern Kelley's feelings about being in an exhibition; a chronology of Kelley's life and art work; and, an essay—with photographs—about Kelley and the context of his work. Gilbert T. Vincent writes about "patronage" and its effects on the artist. Checklist. Bibliography. Illus.; many in color.

358. *Ruth Mae McCrane and Bernice Sims: Memory Painters.* New Orleans: Barrister's Gallery, 1991.
[exhibition brochure]
April 1991 exhibition at the Icons Gallery in

Houston, arranged by Barrister's Gallery in New Orleans. Essay about the differences and parallels in the lives of these two very different artists, written by A.P. Antippas. Commentary about their lives and their work.

359. *Santos, Statues, Sculpture: Contemporary Woodcarving from New Mexico.* Los Angeles: Craft and Folk Art Museum, 1988.
[exhibition catalog]
Written by Laurie Beth Kalb, this catalog is arranged by concepts that categorize the work according to its inspiration and purpose. Artists are listed by concept and include George Lopez, Jose Mondragon, Frank Brito, Leroy Archuleta, Alonzo Jimenez, Luis Tapia, Enrique Rendon, Horacio Valdez, and Marco Oviedo.
[Review: *The Clarion* 14(3) Summer 1989, 26, by Andrew Conner]

360. Sarno, Martha Taylor. *Karol Kozlowski (1885-1969): Polish-American Folk Painter.* New York: Summertime Press, 1984.
This Polish-American folk painter lived in Brooklyn, New York and was a blue-color worker whose "hobbies were limited to his art and to maintaining a small collection of exotic birds." The author describes how Kozlowski's art and aspects of his life were interwoven. Detailed biography; the discovery of his art by Abril Lamarque; information about his methods of work; a catalog of paintings and drawings from an exhibition at the Abby Aldrich Rockefeller Folk Art Center. A "Table of Subject Matter" and a chronology of the artist's life end the book. Illus.; color, black & white.

361. *Schmidt.* Burlington, VT: Robert Hull Fleming Museum, 1975.
[exhibition catalog]
December 1, 1974-January 26, 1975. Walker Art Center in Minneapolis, and traveled. Photodocumentary exhibitions of the environment created by Clarence Schmidt in Woodstock, New York. Taped interview of the artist with authors William Lipke and Gregg Blasdel. Maps, photographs of the interiors and the exteriors of the buildings. Final pages of the catalog about Schmidt and his art.

362. Schoonmaker, David, and Bruce Woods. *Whirligigs and Weathervanes.* New York: Sterling Books, 1991.
Information on how to make these wooden objects—with color illustrations of art works by Ed Larson, James Harold Jennings, Vollis Simpson, and others. Some historical information too.

363. Schuyt, Michael, Joost Elffers, and George R. Collins. *Fantastic Architecture: Personal and Eccentric Visions.* New York: Harry N. Abrams, 1980.
Depicts the work of "architects, artist philosophers, eccentrics, and folk artists and the forms they arrived at with complete freedom of fantasy and without any restrictions of zoning laws and building codes." Examples from all over the world. American's works illustrated: Ed Galloway, Simon Rodia, Grandma Prisbrey (color illus.), St. EOM, Father Wernerus, Clarence Schmidt (photo of the artist in a self-made hat worth seeing), Chief Rolling Thunder, Romano Gabriel, Driftwood Charlie (color illus.), S.P. Dinsmoor, Fred Smith. Also color photographs of Finster's garden, Edward Leedskalnin's Coral Castle, and the Prairie Moon Garden of Herman Rusch. An essay by George Collins and many black & white photos.

364. *The Sculpture of Fred Alten.* Lansing, MI: Michigan Artrain, 1978.
[exhibition catalog]
A traveling exhibition; no dates or places given. Catalog edited by Julie Hall whose essay addresses such topics as Alten's life and his art sources, images, and materials. Many black and white illustrations.

365. Seitz, William C. *The Art of Assemblage.* Garden City, NY: Doubleday, 1962.
[exhibition catalog]
At the Museum of Modern Art and traveled. One section about Simon Rodia in which Rodia's work is set in "the context of the history of the collage, the primarily urban work of trained artists." Illus.

366. *Selections from the American Folk Art Collection of Mr. and Mrs. Robert P. Marcus.* New York: Sotheby's, 1989.
[auction catalog]
On Saturday, October 14, 1989. Illustrations of art works of Mattie Lou O'Kelley, Janet Munro, Edgar Tolson, Earl Cunningham, Pucho Odio, and Marie Keegan.

367. *A Separate Reality: Florida Eccentrics.* Fort Lauderdale, FL: Museum of Art, 1987.

[exhibition catalog]
April 23-July 5, 1987 and traveled. Essay by Arthur F. Jones about the art and the artists. Karen Valdes, curator, says she chose individuals who create objects or environments for themselves. Biographies and photographs of the artists. Artists: Jesse Aaron, H.L. Archer, Buddy Boone, Earl Cunningham, Mr. Eddy, John Gerdes, Jacob Kass, Edward Leedskalnin, Paul Marco, Langston Moffett, Stanley Papio, Mario Sanchez, Haydee and Sahara Scull, George Voronovsky, Joe Wiser, and Purvis Young.

368. *Shared Visions: Native American Painters and Sculptors.* Phoenix, AZ: Heard Museum, 1991. Publication prepared to accompany an exhibition of the same name at the Heard Museum April 13, 1991-July 28, 1991 and traveled. Organized by curator Margaret Archuleta of the museum staff and Rennard Strickland of the Indian Law Center in Oklahoma. Although a number of the artists had no formal training, all of them were or are consciously professional fine artists. This catalog is included, therefore, only because the textual material provides insights into the problems that surface when people in one cultural context define the art of people in another.

369. *Shared Visions/Separate Realities.* Orlando, FL: Valencia Community College, 1985.
[exhibition catalog]
March 22-May 2, 1985. Exhibition of the work of John Geldersma, a university professor, and David Butler, a retired sawmill worker. Notes about each, and Geldersma tells of meeting Butler. Brief essay about the two artists by Calvin Harlan; essay by Maude Southwell Wahlman on Butler, "Symbolic Dimensions in the Art of David Butler." Checklist: 12 works by Geldersma; 15 works by Butler; 2 by collaboration. Biblio. Illus.

370. Siporan, Steve, ed. *Folk Art of Idaho: "We Came to Where We Were Supposed to Be."* Boise: Idaho Commission on the Arts, 1984.
A state survey of traditional works. Some individualistic works that slipped in are the painted animals and figures of Joseph Pierce Stock, who was active in the 1940s; whirligigs of Walter Jones and of Joe Briton from the 1980s; wood carvings of Richard Waits and the "Pumpkin Holler" figures made by Gladys Bickelhaupt and her friends.

371. *Six Naives: An Exhibition of Living Contemporary Naive Artists.* Akron, OH: Akron Art Institute, 1974.
[exhibition catalog]
December 2, 1973-January 13, 1974. Curated by Michael Hall who also wrote the catalog essay. Introduction by Herbert W. Hemphill, Jr. Artists: Steve Ashby, Mary Borkowski, Ralph Fasanella, Inez Nathaniel Walker, Edgar Tolson, and Palladino. Illus.; color, black & white.

372. Smith, Howard A. *Index of Southern Potters, v.1.* Mayodan, NC: Old America Company, 1986.
An alphabetical index of eighteenth, nineteenth, and twentieth century potters in the states of North Carolina, South Carolina, Georgia, Alabama, and Mississippi. Includes potters' names, one or two sentences of background information including dates, location, and type of ware. Also a bibliography and a glossary. Amount of information varies from artist to artist, depending on what information could be found.

373. Smith, Robert E. *Book of Cartoons and Moody Artist Story.* Springfield, MO.: Privately published, 1987.
Stories and black-and-white illustrations by this self-taught Missouri artist. The stories are "The Moody Artist" and "The Terrible Number of Drunken Drivers."

374. Smith, Robert E. *Book of Poems, Autobiography, Some Art Illustrations and Articles.* Springfield, MO: Privately published, 1987.
Book includes sixteen poems, an essay about his life as an artist, and notes about his army life, his childhood, how he lives now, and his appearance. Essay by Paul Flemming and Robert Smith, "Painter Robert E. Smith is Hanging In There," and one by Smith alone called "After Thirty Years of Experimenting."

375. *Solstice Review 1991.* Barre, VT: Northlight Studio Press, 1991.
Published by the project Out and About (see Art Centers section), this second edition explores the kinship between the natural world and the community elders who contributed their art and their writing and biographies to this publication.

376. *Sotheby's Fine Americana.* New York: Sotheby's, 1992.

[auction catalog]

Some of the artists illustrated: Mattie Lou O'Kelley, Fannie Lou Spelce, Inez Nathaniel Walker, Russell Gillespie, William Hawkins, Eddie Arning, Floretta Emma Warfel.

377. *Sotheby's Important Americana.* New York: Sotheby's, 1990.
[auction catalog]
Photographs of the art of Bill Traylor, Gustav Klumpp, Minnie Evans, Peter Charlie Besharo, Sam Doyle, Howard Finster, Harry Lieberman, Antonio Esteves, Victor Joseph Gatto, William Hawkins, Justin McCarthy, Peter Minchell, Ike Morgan, Pucho Odio, Mattie Lou O'Kelley, "Old Ironsides" Pry, Jack Savitsky, Mose Tolliver, Knox Wilkinson, Luster Willis, Malcah Zeldis, and "Chief" Willey.

378. *Sotheby's Important Americana.* New York: Sotheby's, 1991.
[auction catalog]
Includes illustrations of works by Streeter Blair, Howard Finster, Bill Traylor, J.O.J. Frost, William Hawkins, Elijah Pierce, Mattie Lou O'Kelley, Theodore Jeremenko, John Perates, Floretta Emma Warfel, Mose Tolliver, Inez Nathaniel Walker.

379. *Southern Folk Images: David Butler, Henry Speller, Bill Traylor.* New Orleans: University of New Orleans, 1984.
[exhibition catalog]
April 1-20, 1984 and traveled. Curator William Fagaly says folklorists, anthropologists, and social scientists focus on environment and community in which the creative process occurs; art historians, dealers, and collectors are more interested in the creation itself. Information on the artists and their art—each by a different writer. Illus.

380. *Southern Folk Pottery Collectors Society Catalog.* Glastonbury, CT: Southern Pottery Collectors Society, 1991.
Items for sale, arranged by potter, with photographs of the works available, biographies of the potters, and information about the Society's museum and sales shop. A few of the potters listed who make face jugs are John Brock, Billy Ray Hussey, Charles Lisk, Burlon Craig, Jerry Brown, Billy Henson, Lanier Meaders, Cleater and Billie Meaders, David and Anita Meaders, Reggie Meaders, and Marie Rogers.

381. *Southern Visionary Folk Artists.* Winston-Salem: The Jargon Society, 1985.
[exhibition brochure]
January 11-February 10, 1985. Curated by Roger Manley and Tom Patterson, who also provide commentary on the art. Works by Annie Hooper, Bernard Schatz, St. EOM, Georgia Blizzard, Leroy Person, Howard Finster, Sam Doyle, William Owens, Dilmus Hall, James Harold Jennings, and others. Illus.

382. *Southern Works on Paper, 1900-1950.* Atlanta: Southern Arts Federation, 1981.
[exhibition catalog]
Montgomery Museum of Fine Arts, September 13-November 1, 1981, and traveled. Exhibition arose out of the belief that compared to musicians and writers, Southern artists had been ignored. Several essays. Self-taught artists included, along with trained artists, were Bill Traylor, Sister Gertrude Morgan, Minnie Evans, Mattie Lou O'Kelley, and Clementine Hunter. Illus.

383. *Spirits: Selections from the Collection of Geoffrey Holder and Carmen de Lavallade.* Katonah, NY: Katonah Museum of Art, 1991.
[exhibition catalog]
February 24-May 5, 1991. Guest curator, John Beardsley. Catalog essays, with photographs, about Holder, and about what he collects. Biographies of the collectors included, in addition to a checklist and numerous full-page color plates. The art in the catalog is from Africa, Haiti, Mexico, and the United States. For a list of self-taught American artists in the exhibition, see the "Museums Section."

384. *Spiritual Expressions: Painting and Sculpture of the Thornton Dial Family.* Atlanta: North Avenue Presbyterian Church, n.d.
[exhibition brochure]
Very brief biographical notes. Includes Ronald Lockett, Richard Dial, Sr., Dan Dial, and Thornton Dial, Jr. Illus.; black & white.

385. *St. EOM in the Land of Pasaquan: The Visionary Art and Architecture of Eddie Owens Martin.* Winston-Salem, NC: The Jargon Society/ The Columbus Museum, 1987.
[exhibition brochure]
Curated by Fred C. Fussell and Tom Patterson. Brief biography of the artist, and descriptive information about the work. Checklist of forty-two items.

386. *Stamford's Healer and Humanitarian: Dr. Jacob Nemoitin (1880-1963)*. Stamford, CT: Stamford Historical Society, 1989.
[exhibition catalog].
Exhibition of art and artifacts from the life of an important contributor to the Stamford community when it was a mill town of immigrant workers. Biographical information and illustrations. Nemoitin was a self-taught painter.

387. Steinfeldt, Cecelia. *Texas Folk Art: One Hundred Fifty Years of the Southwestern Tradition.* Austin, TX: Texas Monthly Press, 1981.
Texas folk art includes "subtle distinguishing characteristics—a partiality for subjects that made Texas famous, and the interpretation of rugged lifestyles and the rural character of the land, even into the twentieth century." A few of the artists noted in this book with biographical information and information on the art are: Eddie Arning, George W. White, Consuelo (Chelo) Amezcua, Ezekiel Gibbs, Frank Jones, Fannie Lou Spelce, Clara McDonald Williamson, and Velox Ward. Illus.

388. Stern, Jane, and Michael Stern. *Amazing America.* New York: Random House, 1978.
A variety of "roadside attractions" for the traveler, arranged geographically. Information on the now-leveled Holyland USA (the authors didn't know who had built it); the vividly colorful Fred Burn's House in Belfast, Maine; and the Paper House in Pigeon Cove, Massachusetts. In the mid-Atlantic region they note Mahalchik's Fabulous Fifty Acres and Clarence Schmidt's environment in New York. In the South there is the Ave Maria Grotto, Leedskalnin's Coral Castle in Florida, "Bailey's Sculpture Garden" in Atlanta, Eddie Martin's home in Buena Vista, and "Plant Farm Museum" in Summerville, "also known as Finster's Paradise Garden." The entry for Louisiana includes a description of Bruce Brice's "Treme Wall Mural," painted to protest the destruction of a historical black neighborhood (the mural too has been destroyed; Brice does have photographs of it, though).

389. *Sticks: Historical and Contemporary Kentucky Canes.* Louisville, KY: Kentucky Art and Craft Gallery, 1988.
[exhibition catalog]
Text by Larry Hackley and others who talk about a study of "this very common object" and the people who make them. Checklist. A few of the carvers presented are Robert Bosco, Homer Bowlin, Andrew Collett, Denzil Goodpaster, Mack Hodge, Edd Lambdin, Tim Lewis, Carl McKenzie, Earnest Patton, and Helen LaFrance Orr. Thirty-seven illustrations in color.

390. Stigliano, Phyllis, and Janice Parente. *Bill Traylor.* New York: Luise Ross Gallery, 1990.
An exhibition history, list of public collections, and a bibliography. Essay on Bill Traylor and his art by Peter Morrin. Photograph of Traylor on the cover.

391. Stone, Lisa, and Jim Zanzi. *The Art of Fred Smith: The Wisconsin Concrete Park.* Phillips, WI: Price County Forestry Department, 1991.
Forty pages about folk artist Fred Smith and the place he built. The book also serves as a self-guided tour to the site, which is open to the public, located on Highway 13 on the south edge of Phillips. Most of the fifty-one illustrations are photographs taken during Smith's lifetime; the site has changed dramatically since then, say the authors. There are many quotes and stories, collected by Zanzi, who visited with Smith during the last ten years of his life. Included is a site map and walking tour.

392. *Stories to Tell: The Narrative Impulse in Contemporary New England Folk Art.* Lincoln, MA: DeCordova and Dana Museum and Park, 1988.
[exhibition catalog]
August 13-October 30, 1988 and traveled. Four essays. Focus of the exhibition is on "material culture," with a defense of definitions. Includes artists Rose Labrie, Lee Hull, Willard Richardson, Philip Barter, Marion E. Hastings, John Egle, Justo Susana, and maybe a few others. Illus.

393. *Straight from the Heart: A Folk Art Sampler of Western Illinois.* Quincy, Il: Gardner Museum of Architecture and Design, 1990.
Information about traditional crafts, prepared by Sherry Pardee. There is one folk artist that fits the definitions of this book, and that person is George Parsons, a wood carver. He "scouts the neighborhood for fallen limbs, scrounging wood wherever he can get it." He says "You see a figure or something in a piece of wood and then you try and dig it out of there."

394. *Sullivan's Universe: The Art of Patrick J. Sullivan, Self-Taught West Virginia Painter.* Wheeling, WV: Oglebay Institute, Mansion Museum, 1979.
[exhibition catalog]
April 1-June 30, 1979. Gary E. Baker, curator. Contents include an introduction, Early Works, Master Works, Late Works, and notes. Introduction mentions "nine known or presumed surviving paintings." There is information about his life and his struggle to be an artist. He was encouraged by Sidney Janis, but his failure to make a living at art turned Sullivan bitter and he seldom painted after he had to return to hard labor. Includes quotes from Sullivan plus the fact that his paintings are in the Museum of Modern Art, the Sacred Heart Church in Wheeling, and the Mansion Museum. Illus.; color, black & white.

395. Sweezy, Nancy. *Raised in Clay: The Southern Pottery Tradition.* Washington, D.C.: Smithsonian Institution Press, 1984.
Although its subject is traditional potters and the cultural traditions of which these crafts are a part," this book is included here because of the face jug illustrations of Burlon Craig and Lanier Meaders—and detailed information about the potteries—many of which make face jugs and animals now. Other potters included are Jerry Brown, Cleater Meaders, and Marie Rogers, who all make face jugs. Extensive bibliography.

396. *Symbols and Images: Contemporary Primitive Artists.* New York: American Federation of Arts, 1970.
[exhibition catalog]
Curator Gregg Blasdel. Reproduction of one art work for each artist and a statement by the artist, or a friend or relative of the artist. Includes Andrea Badami, J.R. Adkins, Catherine Banks, Margaret Batson, Nounoufar Boghosian, Mary Borkowski, Henry S. Burger, James Castle, Peter Contis, Minnie Evans, France M. Folse, Sarah Franz, Flora Fryer, Theora Hamblett, Milton Hepler, Clementine Hunter, Fay Jones, Frank Jones, Anna Katz, Sadie Kurtz, Harry C. Marsh, Sister Gertrude Morgan, Jennie Novik, Shigeo Okumara, Gertrude Rogers, Anna Fell Rothstein, Helen Rumbold, St. EOM, and Virginia Tarnoski.

397. *Third National Art Exhibit by the Mentally Ill.* Miami: National Exhibition by the Mentally Ill, 1991.
[exhibition brochure]
Essay on the art by Rick Fisher from the Southern Arts Federation. Curators: Wendy Blazier, Jose Martinez Canas. Five color photographs and checklist. Art is listed by institution, not the artist's name. (The Second National Exhibit by the Mentally Ill in 1990—publication not seen—was curated by Martinez Canas, and the brochure had an essay by Jules Laffel.)

398. Thoman, Nancy Green Karlins. *Justin McCarthy (1891-1977): The Making of a Twentieth Century Self-Taught Painter.* Ann Arbor, MI: University Microfilms International, 1986.
[Ph.D dissertation, New York University, 1986]
Tells about the artist's early life with his family, his first works of art, and the years of his discovery as an artist (1960-1977). Says he was different from his self-taught peers in that he painted many different subjects and did not turn to art because of either trauma in old age or religious vision. Bibliography. Illus.

399. Thompson, Robert Farris. "African Influence on the Art of the United States." In *Black Studies in the University,* 122-170. Armstead L. Robinson, Craig C. Foster, and Donald H. Ogilvie (Eds.). New Haven: Yale University Press, 1969.
Describes evidence of continuity of African influences on the art of African Americans. Identifies seven traits common to African-American sculpture that suggests an African influence.

400. Thompson, Robert Farris. *Flash of the Spirit: African and Afro American Art and Philosophy.* New York: Vintage Books, 1983.
Examines "visual and philosophic streams of creativity and imagination, running parallel to the massive musical and choreographic modalities that connect black persons of the western hemisphere, as well as millions of European and Asian people attracted to and performing their styles, to Mother Africa." Thompson's view of the relationship between African art and the art of African Americans.

401. Thompson, Roy. *Face Jugs, Chickens, and Other Whimseys; Vernacular Southern Folk*

Pottery. Glastonbury, CT: Southern Folk Pottery Collectors Society, 1990.

Definition of vernacular pottery as "produced under exacting circumstances and according to traditional designs, methods, and ways of working and thinking." Some of the potters noted are Jerry Brown, Charles Lisk, John Brock, Vernon Owens, Lanier Meaders, Burlon Craig, Marie Rogers, and Billy Ray Hussey. Says that face jugs, popular with collectors, did not originate in the South, as many believe. Bibliography. Checklist of potters. Illus.

402. *Thornton Dial: Strategy of the World.* Jamaica, NY: Southern Queens Park Association, 1990.

[exhibition catalog]

Exhibition September 27-October 27, 1990. Essay by Paul Arnett and an introduction by Robert Bishop. Of special interest is the section "Thornton Dial Talks About His Work." There is a checklist and sixty-seven color illustrations.

403. *Three Centuries of Connecticut Folk Art.* Hartford, CT: Wadsworth Athenaeum, 1979.

[exhibition catalog]

September 25-November 18, 1979 and traveled. Included 239 pieces from early colonial times to 1979. The later pieces include a carving by Charles Ormsby, a photograph of a Clark Coe whirligig "on site," a memory painting by George Fournier, a polychromed carving by John Vivolo, and photographs of Holyland USA. The catalog includes brief biographies, two essays, a bibliography, a checklist, and illustrations.

404. *Three Self-Taught Pennsylvania Artists: Hicks, Kane, Pippin.* Pittsburgh, PA: Museum of Art/ Carnegie Institute, 1966.

[exhibition catalog]

Essays about the lives, work history, and art of the three artists. Illus.; color, black & white.

405. *Three Western Pennsylvania Folk Artists: Jory Christian Albright, Rev. Richard Cooper, and Norman "Butch" Quinn.* Loretto, PA: Southern Alleghenies Museum of Art, 1992.

[exhibition catalog]

Forward by Paul Binai, curator. Albright and Cooper write the notes on their lives. Charles Martin writes about Quinn. Checklist of the exhibit. One black & white illustration for each.

406. *Through a Woman's Eye: Female Folk Artists of 20th Century America.* Tokyo: Asahi Shimbun, 1988.

[exhibition catalog]

September 15-October 4, 1988 at the Isetan Museum of Art in Tokyo. Forward by Robert Bishop. Introduction by William C. Ketchum, Jr. English and Japanese. Biographical information. Grandma Moses and Mattie Lou O'Kelley included with a lot of fake folk. Illus.; color, black & white.

407. *Through the Looking Glass: Drawings by Elizabeth Layton.* Kansas City, MO: Mid-America Arts Alliance, 1984.

[exhibition catalog]

Catalog issued in conjunction with a traveling exhibition sponsored by Exhibits USA, a division of the Mid-America Arts Alliance. The exhibition was on view at the National Museum of American Art, April 3-June 28, 1992, in Washington, D.C. and was called "Elizabeth Layton: Drawing on Life." The catalog includes an introduction by Don Lambert, who discovered the work of Layton and a lengthy and detailed biographical essay by Lynn Bretz about the life and work of this mostly self-taught artist, who is classified by some as an "outsider." There is an introduction to the exhibit, an index of drawings, and color and black & white plates accompanied by commentary from the artist.

408. *The Ties that Bind: Folk Art in Contemporary American Culture.* Cincinnati, OH: The Contemporary Art Center, 1986.

[exhibition catalog]

Information about the art; less about the artists. Curators: Eugene Metcalf and Michael Hall. Essay by Metcalf, "Confronting Contemporary Folk Art" and one by Hall, "The Bridesmaid Bride Stripped Bare." Extensive annotated bibliography and a checklist "organized according to the artist's response to the 20th century." Artists: Edgar Tolson, Jesse Howard, Calvin and Ruby Black, Julius and Hermina Dorcsak, Chester Cornett, Anna D. Celletti, Ned Cartledge, Eddie Arning, Josephus Farmer, Elijah Pierce, Miles B. Carpenter, William Hawkins, J.B. Woodson, Philadelphia Wireman, Roy Kothenbeutal, Howard Finster, Valton Tyler, John Perates, Felipe Archuleta, Anthony Joseph Salvatore, Drossos Skyllas, Charley Kinney.

Exhibition included a photo mural of Rosetta Burke's Detroit environment, now destroyed. [Review: *The Clarion* 12 (2/3) Spring/Summer 1987, 64, by Timothy Lloyd]

409. *A Time to Reap: Late-Blooming Folk Artists.* South Orange, NJ: Seaton Hall University/Museum of American Folk Art, 1985.
[exhibition catalog]
November 9-December 7, 1985. Essay by curator Barbara Kaufman about "old age" in the twentieth century, and how this could affect the phenomena of so many "late blooming" artists. Curator Didi Barrett writes about those who paint their own memories as opposed to those who paint second-hand memories. She notes the process of "life review" in elderly people and suggests examples. Artists: Jesse Aaron, Pat Annunziato, Felipe Archuleta, Eddie Arning, Steve Ashby, J.P. Aulisio, Andrea Badami, Minnie Black, Andrew Block, David Butler, Miles B. Carpenter, Jim Colclough, Sanford Darling, William Dawson, "Uncle Jack" Dey, William Edmondson, Antonio Esteves, Josephus Farmer, Emanuele Giacobbe, Denzil Goodpaster, Henry Gulick, Esther Hamerman, William Hawkins, Clementine Hunter, S.L. Jones, Gustav Klumpp, Leon Kuperszmid, Sadie Kurtz, Harry Lieberman, Alex A. Maldonado, Gertrude Morgan, Grandma Moses, Tressa Prisbrey, Matteo Radoslovich, Martin Ramirez, Enrique Rendon, Rodney Rosebrook, Alex Sandoval, Jon Serl, Benjamin Simpson, Fred Smith, Queena Stovall, Veronica Terrillion, Isadore Tolep, Mose Tolliver, Bill Traylor, Alfred Walleto, "Pop" Wiener, Lizzie Wilkerson, "Chief" Willey, Joseph Yoakum. Biography, bibliography, and illustrations.

410. *Transmitters: The Isolate Artist in America.* Philadelphia: Philadelphia College of Art, 1981.
[exhibition catalog]
Exhibit March 6-April 8, 1981. Catalog-length essay in which the Halls discuss the nature and significance of the "isolate" artist, most particularly the ones in this show. Several other essays. In this catalog there is more said about the art than is usual. The exhibit included ninety-eight paintings by twenty-one American artists: Morris Hirshfield, John Perates, Felipe Archuleta, Fred Alten, Martin Ramirez, Joseph Yoakum, P.M. Wentworth, Peter Charlie Besharo, Henry Darger, Abraham Levin, Edgar Tolson, Inez Nathaniel Walker, Mose Tolliver, S.L. Jones, Miles B. Carpenter, Elijah Pierce, Howard Finster, Jesse Howard, William Blayney, William Edmondson, Drossos Skyllas.

411. Turner, J. F. *Howard Finster, Man of Visions: The Life and Work of a Self-Taught Artist.* New York: Alfred A. Knopf, 1989.
A biography about Howard Finster and his family. Includes his religious and creative life. Starts with his childhood and covers his years as a preacher, the creation of Paradise Garden, and much more. There are 203 illustrations, most in color, an extensive bibliography, and a "biographical summary" by Victor Faccinto and Turner. [Review: *The Clarion* 15 (2) Spring 1990, 65-66, 68, by Lanford Wilson]

412. Turner, John F., and Judith Dunham. "Howard Finster Man of Visions." In *Folklife Annual 1985,* 158-173. Washington, D.C.: Library of Congress, 1985.
About the development of Finster's garden, his vision in 1976 when he was told to paint "sacred art." Finster, it is said, views his life in statistical terms—number of sermons, words, weddings, funerals, and so on. He is "motivated by a spiritual, if not economic, drive to work hard." Color illustrations of the garden and paintings.

413. *Twentieth Century American Folk Art and Outsider Art at Auction.* Litchfield, CT: Litchfield Auction Gallery, 1992.
[auction catalog].
Sales date November 21, 1992 with items on exhibit November 17-21. Objects include face jugs, paintings, carvings, and sculpture. Works of artists from all parts of the country are included. There are 118 artists represented with biographical information provided via bibliographical references. Nine artists have information included in the catalog: Bernice Sims, John Frank Vivolo, Sarah Rakes, Melissa Polhamus, Jacob Knight, Albert Hoffman, Rita Hicks Davis, John Bula, and Binford "Benny" Taylor Carter, Jr. A partial list of other artists includes Leroy Almon, Sr., John Brock, Richard Burnside, Burlon Craig, William Dawson, Josephus Farmer, Lonnie Holley, Clementine Hunter, Billy Ray Hussey, James Harold Jennings, Clyde Jones, Charley Kinney, Charles Lisk, Willie Massey, The Meaders Family, Howard Finster, R.A. Miller,

Ike Morgan, Benjamin F. Perkins, Royal Robertson, Jack Savitsky, Hugo Sperger, Q.J. Stephenson, Jimmy Lee Sudduth, Mose Tolliver, Edgar Tolson, and John Vivolo. Illus.; color and black & white.

414. *Twentieth Century American Icons: John Perates.* Cincinnati, OH: Cincinnati Art Museum, 1974.
[exhibition catalog]
December 8, 1974-January 5, 1975. Michael Hall calls the work "modern masterpieces" and says "the dominant quality in the Perates work is the stark, almost physical power that radiates from each icon." Illus.

415. *Two Arks, A Palace, Some Robots, and Mr. Freedom's Fabulous Fifty Acres: Grassroots Art in Twelve New Jersey Communities.* Hoboken, NJ: Privately printed, 1989.
Published in conjunction with a traveling exhibit that started at the City Without Walls Gallery in Newark, New Jersey on May 17, 1989. Essay by Holly Metz on documenting New Jersey environments, with reports of loss. Sites include Kea Tawana's Ark; Noah's Ark House; Clam Shell House; Frank Cambria's Roma Garden; George Daynor's Palace Depression; Matteo Radoslovich and his garden of whirligigs; the junkyard robots built in Newtonville and Hammonton by William Clark; Angelo Nardon's Villa Capri in Nutley; Joseph Laux's Fairy Garden in Deptford; and others. Detailed information on the builders and their creations. Notes. Numerous photographs. [May be ordered from R. Foster, 300 Observer Hwy., 5th floor, Hoboken, NJ 07030]

416. *Two Black Folk Artists: Clementine Hunter, Nellie Mae Rowe.* Oxford, OH: Miami University Art Museum, 1987.
[exhibition catalog]
January 10-March 15, 1987. Shown together because "what each has in common is an innate ability to create in an idiom that defines the true meaning of folk art: the honest, heartfelt expression of an inventive spirit, untrained in any academic sense—what makes a good folk artist is no different from what makes any art good—a visual aesthetic sensibility that has quality." Biography and illustrations.

417. *Two Black Mississippi Folk Artists: Mary Tillman Smith and Sarah Mary Taylor.* Lexington: Folk Art Society of Kentucky, 1986.
[exhibition catalog]
Curators: Larry Hackley and James Smith Pierce. The essay by Pierce draws parallels between the two artists. There is information on each artist, including a catalog of works exhibited. Illus.; black & white.

418. *"Uncommonly" Naive.* Beloit, WI: Wright Museum of Art, Beloit College, 1990.
[exhibition catalog]
Curated by Yolanda Saul. Essay on outsider art that includes notes on the Prinzhorn Collection. Exhibition of "Naive Artists" (Josephus Farmer, Howard Finster, Milton Fletcher, Nancy McGuire, Carl McKenzie, Irving Mendes, and Pat Neely); and "Outsider Artists" (Jeffrey Hirsch, Jamie Nathenson, "Butch" Quinn, Nellie Mae Rowe, Mose Tolliver, Henry Speller, Bill Traylor, and Louis Walker, Jr.). Illus.

419. *Unschooled Talent: Art of the Home-Taught and the Self-Taught from the Private Collections in Kentucky.* Owensboro, KY: Owensboro Museum of Fine Art, 1979.
[exhibition catalog]
July 8-August 5, 1979. Curator, Art Jones. Essays by Larry Hackley, on face jugs; by James Smith Pierce, on Howard Finster; by Don Snyder, on decoys; and on Edgar Tolson by Ellsworth Taylor. Artists: Dow Pugh, E.J. Brown, Burlon Craig, Lanier Meaders, Steve Ashby, Edgar Tolson, Howard Finster, Felipe Archuleta, Jesse Howard, Elijah Pierce, Howard Angermeyer, Minnie Black, Frank Brito, Mike Brumley, J.F. Byrley, Miles B. Carpenter, Theodore Clayton, William Dawson, Evan Decker, Marvin Finn, Denzil Goodpaster, I.W. Hurst, Eldon Irvine, Unto Jarvi, Noah Kinney, George Lopez, Gloria Lopez, William Low, Sister Gertrude Morgan, Ray Prosper, Margaret Ross, Albert Steller, and Inez Nathaniel Walker.

420. *Urban Visions: The Paintings of Ralph Fasanella.* Ithaca, NY: Herbert F. Johnson Museum of Art, Cornell University, 1985.
[exhibition catalog]
September 11-November 10, 1985 and traveled. Organized by Suzette Lane McAvoy. Comments on the work and art by Professor Nick Salvatore, New York State School of Industrial and Labor Relations. Essays by McAvoy and Paul D'Ambrosio. Checklist. Illus.; color, black & white.

421. Van Horn, Donald. *Carved in Wood: Folk Culture in the Arkansas Ozarks*. Batesville, AR: Arkansas College Folklore Archive Publications, 1979.
The author says this book is "An attempt to document folk sculpture created by contemporary folk sculptors who live and work in the Arkansas Ozarks." Says woodcarving is the medium of choice because that is the material at hand and that it was introduced into the Ozark region as part of a larger collective effort to upgrade economy of the region. "From the many who produced simple carvings—from the ranks of woodcarvers—have come true folk sculptors. The carver who provides for himself and the viewer an aesthetic experience is creating folk sculpture." The book is in two parts: Part I—Introductory material about folk sculpture, the area, and regional traditions; Part II—the folk sculptors. Some of the artists are: Jim Nelson, Eppes Mabry, D.T. Towsend, Junior Cobb, Jim Warren, Marvin Warren, and Nona Warren Hastings. Illustrations of art; artists.

422. *Vernacular Art*. Haywood, CA: University Art Gallery, California State University, 1992.
[exhibition brochure]
April 9-May 2, 1992. Includes a list of the artists exhibited, sources of the works, and a sentence or two about each artist. There is an illustration of a painting by Camille Holveot and another of an Eddie Arning drawing. The twelve artists in the exhibition are listed in the entry in the "Museum Exhibitions" section.

423. *Vernacular Pottery of North Carolina: 1982-1986*. Raleigh: North Carolina State University, 1987.
[exhibition catalog]
April 5-July 31, 1987 at the university gallery. Approximately 150 pieces from the pottery collection of Leonidas Betts. Objects are from a number of potteries. Betts prepared the information on the potters. Illustrations include face jugs of Owens Pottery, Burlon Craig, Charles Lisk, and Brown Pottery.

424. *Visions: Expressions Beyond the Mainstream from Chicago Collections*. Chicago: The Arts Club, 1990.
[exhibition catalog]
Curator: Don Baum. Introduction by Lisa Stone. [Dates of exhibition missing from copy examined.] Stone talks about "vision" and the various artists in the exhibition and the "vision" of Chicago artists, dealers, and collectors who have "embraced works beyond the mainstream, insuring them a vital and dignified place in the life of the arts in this city." Artists included Stephen Anderson, Robert Bannister, Adam Berg, Peter Charlie Besharo, Henry Darger, Frank Day, William Edmondson, Minnie Evans, Rev. Howard Finster, Mr. Imagination, "Guiyermo" McDonald, Sister Gertrude Morgan, B.J. Newton, John Podhorsky, Drossos P. Skyllas, Simon Sparrow, Bill Traylor, Eugene Von Bruenchenhein, P.M. Wentworth, and Joseph E. Yoakum. The catalog includes biographical information, a checklist, and illustrations.

425. *Vital Signs: An Exhibition of Art In and About Atlanta*. Atlanta: Nexus Contemporary Art Center, 1991.
[exhibition catalog]
May 4-June 8, 1991. Exhibition to inaugurate the new Nexus Gallery. Curatorial statements by Annette Cone-Skelton, Louise E. Shaw, and Edward Spriggs; mostly about the Atlanta art scene. In addition to the mainstream artists are "outsiders" Ned Cartledge, Ulysses Davis, Howard Finster, and Nellie Mae Rowe. Illustrations of "insiders" only.

426. Vlach, John Michael. *Plain Painters: Making Sense of American Folk Art*. Washington, D.C.: Smithsonian Institution Press, 1988.
Vlach states that there is a need to find a new label for "so-called folk painting." Chapter by chapter he presents his case, using examples of such as the Freake limner, Ammi Phillips, and Benjamin West. He says the people called "folk" painted the way they did because of lack of skill or talent. There is a chapter about Grandma Moses, and one called "Contemporary Plain Painting: New Forms, New Criteria." Index. [Review: *Folk Art Messenger* 2 (3) Spring 1989, 8-9, by Randall Morris in which he calls the chapter on contemporary "plain painting" "ridiculous."]

427. Vlach, John Michael, and Simon J. Bronner. *Folk Art and Art Worlds*. Ann Arbor, MI: UMI Research Press, 1986.
Essays from the 1983 meeting on folk art organized by the American Folklife Center at

the Library of Congress. Eleven essays examine folk art as activities and things that exist in social context. Most of the essayists object to collectors, of the private or the museum variety. Contributors: John Michael Vlach, Eugene Metcalf, David Jaffee, Charles Bergengren, Simon J. Bronner, Jack Santino, Sheldon Posen, Charles L. Briggs, Rosemary O. Joyce, Suzi Jones, Henry Glasse. Index. [Review: *The Clarion* 12 (2/3), Spring/Summer 1987, 63-64 by Michael Hall]

428. Vogel, Donald, and Margaret Vogel. *Aunt Clara: The Paintings of Clara McDonald Williamson.* Austin, TX: University of Texas Press, 1966. Written on the occasion of a retrospective exhibit of Williamson's art at the Amon Carter Museum when she was age ninety-two. Paints "memories and dreams of the world she knew over fourscore years ago." The authors describe her as a master of primitive painting. She started painting in her sixties, when her husband died. Story of her life and her work, interwoven with illustrations of the art. Chronological list of paintings 1943-1966.

429. Vogel, Donald, and Margaret Vogel. *Velox Ward.* Austin, TX: University of Texas, 1982. Much of the text in the artist's own words. Details about his life, including that his first name came from the lettering on his family's sewing machine. Tells about how he started painting. Memory paintings, mostly, about rural Texas life. Illus.; color.

430. Volkersz, Willem. "Word and Image in American Folk Art." In *The Folk Identity, Landscapes and Lores: University of Kansas Publications in Anthropology, 17,* 91-120. Eds. Robert J. Stannard, Jerry Smith. Lawrence, KS: University of Kansas, 1989. Essay on disputes and definitions in American folk art. Information on important early exhibitions and writings. Tells of the recent state surveys and exhibitions that reveal a great deal about the bias of the curator; that the only survey to deal with art, as art, was the one in California. The second section of the paper talks of his interests, especially in the uses of written language in folk art, and the final section deals with culture and folk art. Specific artworks are used to illustrate his points. Notes. Illus.

431. Wade, E. L., ed. *The Arts of the North American Indian: Native Traditions in Evolution.* New York: Hudson Hills Press/Philbrook Art Center, 1986. Starts with the prediction that all traditional culture will soon be lost regardless of the "much publicized resurgence of powwows and politics—recovering a few shards does not restore the pot." Essays consider the controversies in Native-American art, the impact of the marketplace, the role of the contemporary artistic creator, effect of white patronage on individual artists, and the role of the Santa Fe Studio on the development of Native-American art.

432. Wade, Edwin L., and Rennard Strickland. *Magic Images: Contemporary Native American Art.* Norman, OK: Philbrook Art Center/University of Oklahoma Press, 1981. Discussions of the traditional versus the innovative in contemporary Native American art. Labels critics and collectors who say that authentic native art is dying as patronizing. Considers scholarly failures, the persistent "Anglo" domination of Indian aesthetics, and the role of federal art programs in destroying creativity. There is a section on artists and their styles, with examples of their work. Illus.; color, black & white.

433. Wahlman, Maude Southwell. *Mojo Working: An Introduction to African Religious Symbols in African-American Folk Art.* Gainesville, FL: University Press of Florida, 1993. Developing ideas presented in her essay in the catalog Baking in the Sun , Wahlman develops "two important African religious concepts: religious writing and healing charms." The first three chapters discuss writing systems as they appeared in the New World, and the writing systems in African-American folk art. This section is followed by chapters about charmmaking traditions. There are approximately sixty to sixty-five color illustrations and one hundred black & white ones. [Information prepublication from Maude Wahlman]

434. Wampler, Jan. *All Their Own: People and the Places They Build.* Cambridge, MA: Schenkman Publishing, 1977. Information on twenty-two environments. Many photographs that, in some cases, are the only access to destroyed grassroots art environ-

ments. Includes: Boyce Luther Gulley's castle, Phoenix; E. Quigley's homemade house, from a rock collection started at the age of nine; Everett Knowlton's Stonington, Massachusetts miniature village with all interiors furnished; Henry Dorsey of Brownsboro, Kentucky; Fred Burns of Belfast, Maine; Maude Meagher and Carolyn Smiley of Los Gatos, California; Harry Andrews of Loveland, Ohio; Cabot Yerxa, Desert Hot Springs, California; the "Gingerbread House" by William Preston in Virginia; and many of the more well-known such as S.P. Dinsmoor, Art Beal, Romano Gabriel, and others.

435. Ward, Daniel Franklin. *Personal Places: Perspectives on Informal Art Environments.* Bowling Green, OH: Bowling Green State University Popular Press, 1984.
A collection of essays on grassroots art environments. Elaine Eff writes about East Baltimore painted screens; Steven Ohrn details the work of Paul Friedlein on "Jolly Ridge," in Iowa; Varick A. Chittenden writes about Veronica Terrillion in Lewis County, New York. Tom Stanley, an artist, writes about two South Carolina folk environments: Joshua Samuels and his "Can City" in Waterboro, Colleton County; and L.C. Carson's "City" in Orangeburg, the latter said to be influenced by Carson's visit to the Ave Maria Grotto in Cullman, Alabama. There are essays on Watts Towers, S.P. Dinsmoor, Harry Andrews, and Ed Galloway. Lisa Stone writes about "The Painted Forest" in Valton, Wisconsin; Verni Green on recycling and aesthetics. These are two essays on "theoretical approaches" and two on preservation, one by Barbara Brackman and one by Dan Prince. Extensive references and photographs.

436. Watson, Patrick. *Fasanella's City.* New York: Alfred A. Knopf, 1973.
A biography of Fasanella's life and art. The paintings are related to his politics, religion, ethnic background, and class. Many color illus.

437. *The Watts Towers.* Los Angeles, CA: Committee for Simon Rodia's Towers and Walls, n.d. Information about the towers and their maker, about the demolition threat, and the efforts to save the site. Illustrations.

438. Weatherford, Claudine. *The Art of Queena Stovall: Images of Country Life.* Ann Arbor, MI: UMI Research Press, 1986.

A biography of the artist with information about her community. Personal letters and interviews of people portrayed in her art. Details on the form and meaning of many paintings.

439. Westlund, Darren. *Cambria Treasures.* Cambria, CA: Small Town Surrealist Productions, 1990.
Book of interviews with "noteworthy Cambrians," not the least of whom is Art Beal, the creator of Nitt Witt Ridge. Included are descriptions of Beal's life, his creations, and many of his opinions about people—especially those he refers to as the "Madame Rich Bitches" and "Doctors Stoopntakits" of the world. The interviews took place during Beal's ninety-second year, and there are also photographs taken during the celebrations of his two birthdays after that one. The author talks about the difficulties encountered with preservation efforts and the hostility of some neighbors. In one of the other interviews of a "Cambrian noteworthy," there is more shared about Beal by someone who knew the artist. [This small press book may be ordered from Cambria Book Company, 784-C Main Street, Cambria, CA 93428 (805) 927-3995.]

440. *What It Is: Black American Folk Art from the Collection of Regenia Perry.* Richmond, VA: Virginia Commonwealth University, 1982. [exhibition catalog]
October 6-27, 1982. Perry tells of her initial interest in folk art, inspired by meeting Sister Gertrude Morgan in New Orleans, and the following years spent collecting and documenting the works of African-American self-taught artists. There is information about the artists, with photographs and illustrations of the art. Included are Bruce Brice, David Butler, William Dawson, Sam Doyle, Minnie Evans, Clementine Hunter, John Landry, Sister Gertrude Morgan, Inez Nathaniel Walker, Juanita Rogers, Nellie Mae Rowe, Mose Tolliver, and Luster Willis.

441. *When, The, Skies, Not, Cloudy, All, Day: The Art of Evan Decker.* Lexington, KY: Folk Art Society of Kentucky/Berea College Appalachian Museum, 1992.
[exhibition catalog]
Catalog, published after the event, for the exhibition at the Appalachian Museum,

February 17-May 26, 1991, and traveled. Introduction by curator Larry Hackley. Essays by sociologist Julie Ardery, "Past and Presence: The Art of Evan Decker"; historian John Lewis, "Cowboys in Appalachia: Western Images in the Art of Evan Decker"; and art historian Arthur Jones, "Decoding Evan Decker's Art: Duality of the Sacred and Profane." Illustrations of the art and the artist. [Information obtained pre-publication]

442. Whiteson, Leon. *The Watts Towers of Los Angeles.* Oakville, Ontario, Canada: The Mosan Press, 1989.
Information, photographs, and a bibliography about Simon Rodia. It is suggested that one read the reviews before considering this book. [Review: *Spaces* 11, Summer 1991, 9, by Seymour Rosen. Also printed in *Raw Vision* 5, Winter 1991/92, 59]

443. *William Edmondson: A Retrospective.* Nashville, TN: Tennessee State Museum, 1981. [exhibition catalog]
Essays by John Michael Vlach, William H. Wiggins, and others. Wiggins discusses the impact of religion on Edmondson's sculpture. Other material: catalog of the exhibition, family interviews, chronology, and some collections where his work may be seen. Illus.; black & white.

444. *William Edmondson/David Butler: The William L. Fuller, Jr. Bequest to the Newark Museum.* Newark, NJ: Newark Museum, 1989. [exhibition brochure]
Exhibition in place from November 1989 through December 1992. Essay by curator Gary A. Reynolds on the lives and the art of the artists. Says "although the work is very different, Edmondson and Butler share in a long and vital tradition of African-American folk art." Illus.

445. *William L. Hawkins, 1895-1990.* New York: Ricco/Maresca Gallery, 1990. [exhibition catalog]
October 11-November 10, 1990. Essay by Gary Schwindler, and about thirty color plates of Hawkins' art. There is a list of exhibitions from 1982-1990 and a brief list of public collections.

446. *William L. Hawkins: Transformations.* Charleston, IL: Tarble Arts Center, College of Fine Arts, Eastern Illinois University, 1989. [exhibition catalog]

Essay by Gary Schwindler. Information about his lifelong interest in drawing and painting, beginning with Hawkins' childhood, and how in Columbus, as an adult, he would sell his works "to those unable to afford original art or expensive reproductions." Tells of his prominence in the contemporary American art scene. Many illustrations.

447. Williams, Jonathan. *Le Garage Ravi De Rocky Mount.* Rocky Mount, NC: North Carolina Wesleyan College Press, 1988.
Four pages of dialogue with the sculptor Vernon Burwell about his work and the figures he chose to portray. Biographical information. Photographs of Burwell and some of his sculpture.

448. Wilson, Charles R., and William Ferris. *Encyclopedia of Southern Culture.* Chapel Hill, NC: University of North Carolina Press, 1989.
"Art and Architecture—Painting and Painters, 1960–1980" provides Nellie Mae Rowe, Sam Doyle, Sister Gertrude Morgan, and Howard Finster as examples of regionalism in art. "Art and Architecture—Sculpture" has relevant information for those interested in folk art. Notes abundance of carved objects—canes ("snakes and politicians common"), and animals. Mentions William Edmondson; the Appalachians. Artists in the section on folk painting are Minnie Reinhardt, Queena Stovall, Jesse DuBose Rhoads, Theora Hamblett, Sam Doyle, Clementine Hunter, Fannie Lou Spelce, Bill Traylor, Luster Willis, Minnie Evans, Velox Ward, Howard Finster and others; all set in the context of Southern culture. [Review: *The Clarion* 15 (3) Summer 1990, 26-28, by J. Garrison Stradling]

449. Wilson, Christine, ed. *Ethel Wright Mohamed.* Jackson, MS: Mississippi Department of Archives and History, 1984.
Story of the family farm in pictures: scenes from the family farm in Belzoni and trips abroad, and "pictures straight from the imagination of Mrs. Mohamed."

450. Wilson, Emily Herring, and Susan Mullally. *Hope and Dignity: Older Black Women of the South.* Philadelphia: Temple University Press, 1983.
Chapter devoted to Minnie Evans, "Green Animals Around the Moon," describes how she

started to draw and her artistic successes. Says she learned the Bible "by heart" and the books of Ezekiel, Samuel, and Revelations in particular influenced her visions, translated into figures of angels, prophets, and emperors. Details from Evans herself about what inspired her art, her experiences, and, most of all, her dreams.

451. Wilson, James L. *Clementine Hunter: American Folk Artist.* Gretna, LA: Pelican, 1988.
Biography of the artist including information on her family, Melrose Plantation, beginnings and discovery as an artist, and her later years. Her works are listed by category, and there is information on dating the paintings. There is a large section of color plates with the artist's commentary and "The Letters of Francois Mignon." Another section includes critical commentary on Hunter's art. Appendixes: Permanent Collections; Shows and Exhibitions; and, Bibliography. Index.

452. *Word and Image in American Folk Art.* Kansas City, MO: Mid-America Arts Alliance, 1986.
[exhibition catalog]
Exhibition traveled to various Mid-Western sites from 1986-1988; of art that adds written words to the images. Essay by Willem Volkersz, curator. Artists include Howard Finster, Mary T. Smith, Jesse Howard, Alva Gene Dexhimer, Dilmus Hall, Robert Gilkerson, L.W. Crawford, Charles C. Eckert, Minnie Black, Sarah Mary Taylor, M.L. Owens, and Robert E. Smith. The catalog, designed by John Muller and with lettering by Robert E. Smith, won an award from the Art Museum Association of America. Illus.

453. *The World of George W. White, Jr.,* Waco, TX: Waco Creative Art Center, 1975.
[exhibition catalog]
Introduction by Murray Smither. This was the "first exhibition of his art" and includes elaborate carved canes, paintings, and carved three-dimensional scenes. Says George White "has spent the last nine years of his life documenting black America, demonstrating pride in his heritage." Biographical information. Illus.; black & white.

454. *The World of Grandma Moses.* Washington, D.C.: International Exhibition Foundation/ Galerie St. Etienne, 1984.
[exhibition catalog]
Exhibition organized and circulated to the Museum of American Folk Art, the Baltimore Museum of Art, Cheekwood, and others during 1984-1985. The text by Jane Kallir includes information on Moses' life, classifications attached to her work, artistic development, and successes. This was the first major exhibition after Grandma Moses' death. Checklist. Illus.; color, black & white.

455. *The Worlds Folk Art Church: Reverend Howard Finster & Family.* Bethlehem, PA: Lehigh University Art Galleries, 1986.
[exhibition catalog]
Exhibition September 5-October 26, 1986 curated by Ricardo Viera and Norman Girardot. Book records activities of the 31st Annual Contemporary American Art Exhibit. Features work of Finster and his family. More than usual commentary on work of Michael Finster, Allen Wilson, Chuck Cox, and other family members. Essays and illustrations.

456. *Worth Keeping: Found Artists of the Carolinas.* Columbia, SC: Columbia Museum of Art and Science, 1981.
[exhibition catalog]
September 6-November 8, 1981 and traveled. Organized by Tom Stanley. Assistance from John Kelley, Roger Manley. "Organized by art historians; guided by a concept of folk art as the product of visionary, naive, and grassroots artists." Brief statements from artists on the work and its meaning. Environmental artists include L.D. Cooper, Walter Streetmyer, Dan Robert Miller, Marion Hamilton, Perry Jennings, James Bright Bailey, D. Land, Joshua Samuel, Woodrow Gantt, and Mike Aun. Photographs.

457. *Yard Art.* Boise, ID: Boise Art Museum, 1991.
[exhibition catalog]
May 18-July 7, 1991. Curated by Sandy Harthorn, this exhibit of work by twenty-eight artists in the Western states included academic and non-academic artists. Among them are Tim Fowler, Emil Gehrke, and Lee and Dee Steen. Biographies, bibliography, and many photographs.

458. Zug, Charles G. III. *Turners and Burners: The Folk Potters of North Carolina.* Chapel Hill, NC: University of North Carolina Press, 1986.
Historical and technical information includ-

ing the Southern stoneware tradition and about clays, turning, glazes, and burning. In the "culture" section, there is a chapter that includes face jugs. Notes, bibliography, index of North Carolina potters. General index. Illus. [Reviews: The Clarion 12 (4) Fall 1987, 71, by Steven B. Leder; Folk Art Finder 2 (4) September/October 1981, 17, by Stuart C. Schwartz]

459. Zug, Charles G. III. "New Pots for Old: Burlon Craig's Strategy for Success." In *Folklife Annual 88-89*, 126-137. Washington, D.C.: Library of Congress, 1989.
Tells of the adaptability of this North Carolina potter, who is known for his face jugs. Zug tells of meeting Craig and of the potter's new prosperity. Description of a kiln opening. Biographical details and information on the pottery tradition. Illus.

PERIODICAL ARTICLES

The majority of the references here are to publications that specialize in folk, self-taught, and outsider art. These are *The Clarion* (title changed to *Folk Art* as of fall 1992), *Folk Art Finder, Folk Art Messenger, KGAA News* (formerly *Kansas Grassroots Art Association Newsletter*), *Raw Vision,* and *In'tuit.* A few specialized newsletters and publications are included. In addition, this section includes articles found during a search of art and other periodical indexes, and articles recommended by collectors and gallery staff. These come from art journals, the popular press, and miscellaneous other sources. The annotations are descriptive. When an article discusses the work or lives of particular artists, the annotation identifies the artist(s) covered.

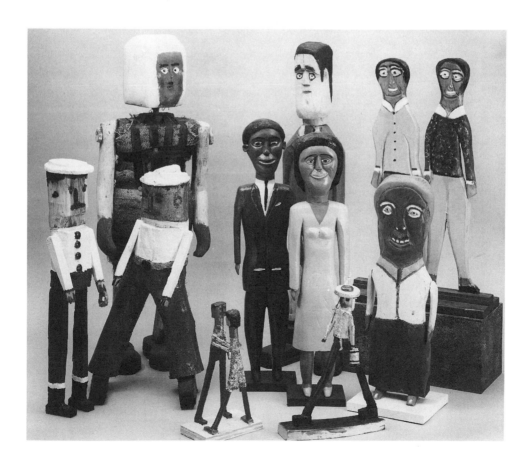

1. "Adam and Eve in Folk Art." *Folk Art Finder* 2, no. 5 (November 1981): 4-6, 8-9.
Notes that the story of Adam and Eve is very popular with folk artists no matter what their usual style and subject. Presentation of four artists "who have interpreted the Adam and Eve story: Edgar Tolson of Kentucky; Eurgencio Lopez of New Mexico; Jack Savitsky of Pennsylvania; and Marcia Muth of New Mexico." Descriptions of their work with brief biographies. Illus.

2. Adams, Joe. "Wesley Stewart 'The Toothpick King'." *Folk Art Finder* 13, no. 4 (October (1992): 20.
Biographical information with description of the art. He makes sculptures with toothpicks and glue. A former employee of a Florida television station, he encountered many celebrities who acquired his work. Illus.

3. Adele, Lynne. "African-American Visionary Traditions and the Art of Frank Jones." *The Clarion* 15, no. 5 (Winter 1990-1991): 42-48.
Describes recent attention to the "visionary impulse in African-American folk art." She says the drawings of Frank Jones are evidence of the significance of this impulse. Includes information about the artist's early life. Notes. Illus.

4. Adler, Elizabeth Mosby. "Directions in the Study of American Folk Art." *New York Folklore* 1 (1975): 31-44.
Article examines the definitions of folk art by artists, curators, collectors, art historians, and folklorists. Says "all but folklorists tend to define folk art in terms of art and aesthetics. The folklorist adds the element of tradition, creating a more rigid definition based on the standards of the creator. This dichotomy evolved because of 'art historical' exhibits which popularized and polarized, American folk art."

5. "Albert (Kid) Mertz." *Folk Art Finder* 11, no. 1 (January 1990): 14.
The writer compares Mertz to "Cedar Creek Charlie" Fields because Mertz decorated his Michigan house inside and out with dabs and swirls of color. "He painted on cans, bottles, everything else in sight that he could lay hands on." Says "he died about a year ago."

6. Alexander, James. "Mose T." *Art Papers* (March 1982): n.a.
Review of an exhibition of Mose Tolliver's work. Opinions on why the work is of interest, information on his subject matter, and worries about fame ruining the artist.

7. Almon, Leroy Sr. "Speakeasy." *New Art Examiner* (September 1991): 13-14.
Artist Leroy Almon gives his opinions about folk art. Does not care about the negative attitudes of "critics, scholars, and experts." He likes collectors. He says "we know we are not accepted in the mainstream. But we also know we are the mainstream." Describes importance of religion in what he does. Says Elijah Pierce was his spiritual leader. "My talent is a gift from God."

8. "Annie Hooper (1897-1986)." *Folk Art Finder* 7, no. 3 (July 1986): 13.
Notice of the death of Annie Hooper, who filled her house and outbuildings in Buxton, North Carolina with 5,000 figures related to Bible stories. Says that a folklorist spent two months with Hooper documenting the work and her comments about it. Work was left to the Jargon Society.

9. Apfelbaum, Ben. "Dorothy and Sterling Strauser: Friends of Folk Art." *The Clarion* 12, no. 2-3 (Spring/Summer 1987): 56-57.
About the couple meeting in art school, early acquaintance with Victor Joseph Gatto, discovery of Justin McCarthy at a county fair, and artists "Old Ironsides" Pry, Jack Savitsky, and Charlie Dieter whom they met and helped and promoted.

10. Archer, Barbara. "Carolyn Mae Lassiter." *Folk Art Finder* 11, no. 4 (October 1990): 14.
Sketch about the background and art of Carolyn Mae Lassiter who creates with brush and ink "mythical animals and forms." Says she is Baltimore born but grew up near Ahoskie, North Carolina. "As an adult she and her husband moved to Cuernavaca, Mexico, where they lived among the Nahuatl Indians. Several of the Indian artists were experimenting in century-old themes brushed on bark." In 1979 Lassiter began experimenting with line drawings on bark.

11. Archer, Barbara. "Valton Murray." *Folk Art Finder* 11, no. 4 (October 1990): 13.
Sketch about the background and art of Valton Murray, who paints primarily landscapes. "Murray uses Liquitex oils on canvas to

achieve his vibrant colors." He is the son of two Georgia cotton pickers.

12. Ardery, Julie. "Art Press Review: The Designation of Difference." *New Art Examiner* (September 1991): 29-32.
Ardery has nothing much good to say about any of the three folk/outsider art publications she reviews: *The Clarion, Folk Art Finder,* and *Raw Vision.*

13. Arient, Jim. "Lee Godie, 'French Impressionist'. " *Folk Art Finder* 4, no. 5 (January 1984): 7-8.
About the strategy and techniques necessary to find and purchase art from Lee Godie when she was living on the streets of Chicago.

14. Arient, Jim. "William Dawson." *Folk Art Finder* 4, no. 2 (May 1983): 13-14.
Sketch about carver and painter William Dawson, born October 20, 1901 on a farm near Huntsville, Alabama. Description of his later life in Chicago and his discovery as an artist.

15. Arient, Jim. "William Dawson: Chicago Carver." *Folk Art Messenger* 3, no. 2 (Winter 1990).
About the background, life, and artistic works of carver Dawson, who grew up on a farm in Alabama, moved to Chicago after his marriage, and started making his art after he retired in 1965. Descriptions of some of the figures he makes and his later interest in painting. Notes some of the exhibitions of Dawson's work. Illus.

16. Aronson, Steven M. L. "Naive Melody in Manhattan." *Architectural Digest* (October 1990): 244-249, 290.
Illustrations of a folk art collection in a New York apartment that was started after the owner's visit to the Museum of American Folk Art.

17. "Art in New York Subways." *Folk Art* 17, no. 3 (September 1992): 70.
Notice of the participation of the Museum of American Folk Art in fundraising efforts to purchase a painting, "Subway Riders," by Ralph Fasanella. The painting is to be installed in a subway station. Information included on how to contribute.

18. "The Art of Martin Ramirez." *Folk Art Finder* 6, no. 4 (November 1985): 4-5.
Review of the first in-depth exhibition of the work of Ramirez. Article tells about what is known of his life, his incarceration in a mental hospital, the materials he used for his drawings, and his discovery by the art world when psychologist Tarmo Pasto brought Ramirez to the attention of Chicago artist Jim Nutt. Illus.

19. "Art with an Attitude." *Inside Art* (July 1991): 4.
A New Mexico publication which discusses definitions, including "real" folk artists. Says Felipe Archuleta was possibly the "last of the old breed of folk artist" and Joel Lage, who lives in the tiny village of Llano, New Mexico, is an example of the new. Description of his sculpture, all made with materials from a dump; the tools he uses; and his feelings about what he does. Illus.

20. "Artist Creates Work Based on Play." *Articles* [*New Orleans Contemporary Arts Center*] 3, no. 2 (December 1990): n.p.
Describes mixed media drawing by New Orleans artist Roy Ferdinand, Jr. "Life During Wartime, 1990." The drawing represents the artist's response to hearing the reading of a play with the same name. Subject of the painting is drug-related violence.

21. "The Artworks of William Dawson." *Events. Calendar of the Chicago Public Library Cultural Center* (February 1990): 1, 3.
Says "the imaginative and playful art of Chicagoan William Dawson is presented in this first-time overview of his work." Tells about themes, forms, references in his art. Lists the materials he has used over the years. Compares "the improvisational qualities" of Dawson's work to those of a jazz musician.

22. Atkins, Jacqueline M. "Joseph E. Yoakum, Visionary Traveler." *The Clarion* 15, no. 1 (Winter 1990): 50-57.
An article with information about the artist's life, what he said inspired him to paint, influences on his art, and his influence on others.

23. Bailey, Mildred Hart. "Painted Memories of a Slave's Daughter." *Modern Maturity* (October 1981): 42-44.
Stories of life at Melrose Plantation in Louisiana; about Clementine Hunter's place there, and about Francois Mignon and his influence on Hunter. Several photographs, including one of the artist.

24. Bailey, Robbie, Scott Cannon, Sharon William, and Leigh Ann Smith. "The Wizard of

Windmills: An Interview with R.A. Miller." *Fox-fire* (September 1989): 146-151, 154.
Description of the artwork, space and materials. R.A. Miller tells about his family—his father was shot by an angry neighbor before Miller was born. He worked in a cotton mill, as a farmer, and hauling wood. His religious salvation led him to be a preacher. He tells about starting to make windmills and feeling blessed in being able to make his artwork. Describes the pieces he makes and tells why he chooses the forms he does.

25. Baker, Gary E. "Patrick J. Sullivan: Allegorical Painter." *The Clarion* (Winter 1980): 34-42.
Background on the artist's life and artistic recognition—although he was never able to earn enough to live on. Discusses his paintings of landscapes and religious subjects. Illus.

26. Baldwin, Karen. "Folk Art in our Backyard(s)." *Newsletter of the North Carolina Folklore Society* 13, no. 3-4 (November 1991): 3-5.
Tells of her discomfort with the word "outsider" and also with the way folklorists deal with this art. Describes a "recent encounter" with yard artist Rosalie Daniels, seventy-five, near Stantonsburg, North Carolina. Detailed description of her "extensive garden decorative assemblage of salvaged materials."

27. Balsley, Diane. "Prophet Blackmon: Painter of Predictions." *Folk Art Messenger* 3, no. 4 (Summer 1990): 1, 3.
Information on William "Prophet" Blackmon, his preaching, his painting, his commitment to helping the people in his inner-city neighborhood. Illus.

28. Balsley, Diane. "Wesley Merrit, Michigan Carver." *Folk Art Finder* 13, no. 3 (July 1992): 13.
A sketch of a self-taught carver, Wesley Merrit, who makes carvings of many different animals, especially dogs and bears. "Each animal seems to have a distinct personality." Illus.

29. Barrett, Didi. "American Primitive." *The Clarion* 13, no. 4 (Fall 1988): 49-53.
Introduction to several pages of illustrations reprinted from the new book, *American Primitives: Discoveries in Folk Sculpture,* by Roger Ricco and Frank Maresca.

30. Barrett, Didi. "Folk Art of the Twentieth Century." *The Clarion* 12, no. 2-3 (Spring/Summer 1987): 32-35.
Tells of the acquisition of a core of the Hemphill collection by the National Museum of American Art. Sketches the history of formal interest in twentieth century American folk art. Illus.

31. Barrett, Didi. "A Time to Reap: Late Blooming Folk Artists." *The Clarion* (Fall 1985): 39-47.
Information on some of the more than fifty artists included in an exhibition at Seton Hall of artists who began to paint and sculpt late in life. "It is a phenomenon of the twentieth century," says Barrett, "that artists can and do bloom in their older years—after lifetimes in the fields, factories, or homes—and that appreciation of their work goes beyond the patient humoring of family and friends to reach the open and receptive market place." Works of eleven artists are illustrated.

32. Beardsley, John. "Art with Spirit." *Elle Decor* (March 1991): 90-97.
Brief description of the exhibition of the collection of Geoffrey Holder at the Katonah, New York museum. Details about how Holder's life history formed the structure for his art collection.

33. Beardsley, John. "Discovering Black American Folk Art." *Portfolio* (May 1983): 86+.
Article about the ways in which Beardsley and Jane Livingston went about discovering the artists included in the exhibition "Black Folk Art in America, 1930-1980 for the Corcoran Gallery—talking with collectors, curators, dealers, art historians, newspaper reporters, and others. Describes visits, to artists and others. Illus.

34. Beasley, Conger, Jr. "Primitives Seek Isolation, A Private Vision." *Forum: Visual Arts/Mid-America* 12, no. 1 (January 1987): 10-11.
Author says "the best practitioners [of primitive art] flourish outside" any academic tradition, the demands of a culture, or the strictures of history. Talks of complete isolation, social alienation, and the artist taking as inspiration "his" solitary view—and then provides three women, Grandma Moses, Clementine Hunter, and Elizabeth Layton, as examples. Beasley says that there is an absence of a flourishing school of primitive painters in the United States because we lack "an animating spiritual life."

35. Beato, Greg. "Alex Maldonado: California Painter of the Space Age." *Folk Art Messenger* 1, no. 4 (Summer 1988): 1, 3.
An essay on the life and art of the self-taught painter Alex A. Maldonado, who started at the age of sixty, when his sister Carmen bought him his first crayons and pencils. Describes the subject matter of his work and his artistic recognition. Illus.

36. Beck, Peter. "Investigating Outsider Art: Four Approaches." *Folk Art Messenger* 3, no. 1 (Fall 1989): 6-7.
Report on a symposium held September 23, 1989 at the North Carolina Museum of Art, in conjunction with the exhibition "Signs and Wonders: Outsider Art Inside North Carolina." Speakers were Eugene Metcalf, Charles Zug, Michael Hall, and Roger Cardinal. "Each approached from a different perspective the issues involved in defining outsider art and put a different spin on the same subject."

37. Benedetti, Joan. "Who Are the Folk in Folk Art? Inside and Outside the Cultural Context." *Art Documentation* (March 1987): 3-8.
The purpose of this article is "to summarize the current professional thinking on what is called 'folk art' as expressed in the writings of those who are acknowledged leaders in this still-emerging field; to point out the major inconsistencies in the use of the term 'folk art'; and to present some alternative terminology" used by Ms. Benedetti at the Craft and Folk Art Museum in Los Angeles. Praise for Simon Bronner and the "material culture" group. Says "we have found the nomenclature of anthropologists and folklorists to be more useful than that of art historians and critics."

38. Bergin, Beth, and Chris Cappiello. "Collecting Thoughts: An Interview with Randy Siegal, Atlanta." *Folk Art* 17, no. 3 (September 1992): 31-33.
Siegal has been collecting self-taught and outsider art for about fifteen years. Questions were asked about the focus of his collection, the origins of his interest in collecting, what inspires a purchase, his attitude toward galleries, his thoughts about the art, his involvement with the Museum of American Folk Art, and his thoughts about the future.

39. Berkman, Sue. "Primitive Urges." *Esquire* (March 1986): 25-26.
Introduces the "allure of folk art" to Esquire readers. Starts with a description of Howard Finster's design for the Talking Heads' album "Little Creatures." Continues with "early discoveries"—Grandma Moses, Morris Hirshfield, and a few others such as Justin McCarthy, Victor Joseph Gatto, Sister Gertrude Morgan, Jesse Aaron, and Elijah Pierce.

40. Bernstein, Fred A. "Comrades in Art." *Metropolitan Home* (February 1991): 33, 38, 51, 57.
Focus of the article is on dealer Phyllis Kind's support of contemporary Russian artists. This art dealer may be of interest to folk art aficionados because she has worked to promote important self-taught artists, including Howard Finster, as is mentioned.

41. Bishop, Robert. "The Affects and Effects of Collecting: Artists and Objects." *Ohio Antique Review* 10 (January 1984): 13-14.
Bishop argues for an aesthetic definition of folk art. Says this definition is what guides recent collectors of folk art. He questions the role of federal and state agencies in influencing collecting.

42. Bishop, Robert. "Letter from the Director." *The Clarion* 16, no. 3 (Fall 1991): 29-30.
Written just before his death, this letter provides an overview of the development to date of the Museum of American Folk Art.

43. "Black Folk Art in America: 1930-1980." *Folk Art Finder* 2, no. 6 (January 1982): 4-8.
Report on the Corcoran exhibition of self-taught black artists then on view. Four of the artists included in the exhibition are featured in this issue of Folk Art Finder: Elijah Pierce, Inez Nathaniel Walker, Joseph Yoakum, and Steve Ashby.

44. "Black Folk Art in America: 1930-1980." *Folk Art Finder* 2, no. 6 (January 1982): 5-8.
Article that responds to the Corcoran show named above with biographical and art information about Elijah Pierce, Inez Nathaniel Walker, Joseph Yoakum, and Steve Ashby, who were represented in the exhibition. Illus.

45. Blasdel, Gregg N. "The Grass Roots Artist." *Art in America* 56, no. 5 (September 1968): 20-41.
An early article on folk art environments. Author discusses the relationship of this art to the work of trained artists. Presents work of art-

ists Dave Woods, Clarence Schmidt, Jesse Howard, David Rousseau, S.P. Dinsmoor, C.E. Tracy, Fred Smith, Brother Joseph Zoettl, Steven Sykes, Father Mathias Wernerus, James Tellen, Ed Root, Herman Rusch, Harry Ponders, and Ralph Rockwell.

46. Bogan, Neill. "J.B. Murry/David Butler." *Art Papers* (March 1991).
Review of a Murry exhibition at Phyllis Kind in New York in December and one at the same time of David Butler works at Ricco/Maresca. Lots of description of the qualities of the art, the evidence of "African aesthetics."

47. Bonesteel, Michael. "Art on the Outside." *Chicago* (February 1990): 96-99, 111-112.
Much critical detail on William Dawson's background, the themes in his art, and his success. Relates Dawson's reaction to a reporter describing his work as "inspired by his African ancestry" and a "gift from God" while he was a guest at the Corcoran show in 1982. Illus.

48. Bookhardt, D. Eric. "Outsiders." *Art Papers* (May 1992): 47.
Review of an exhibition in New Orleans at Exhibit (X-Art) Showroom, March 1-31, 1992. Featured mainstream artists and self-taught artist "Alan St. James Boudreaux" [who usually signs his work Sainte-James Boudrôt]. Description of his "mortuary monuments inscribed with obituaries that read like epic poems, invocations of the halcyon lives of the recently departed."

49. Bookhardt, D. Eric. "Roy Ferdinand Jr.: Mixed Media Drawings." *Art Papers* (May 1991): n.a.
Detailed descriptions of Roy Ferdinand's art—"outsider art of a sort most people are not quite prepared to handle." The drawings are "sleekly engaging" and "hellishly disturbing" with their obvious familiarity with the terrors of the street.

50. Borum, Jenifer P. "Bill Traylor." *Artforum* 30, no. 8 (April 1992): 96.
Notice of three New York gallery exhibitions of the art of Bill Traylor. There is information on Traylor's life and opinions on the qualities found in his art. Reviewer calls the artist "a master storyteller." Illus.

51. Bostic, Connie. "Bessie Harvey: The Spirit in the Wood." *Artvu Magazine* (September 1991): 35.
Review of an exhibition at Blue Spiral 1 Gallery in Asheville, North Carolina, March 8-April 9, 1991 of forty-four sculptures of varied sizes, nine masks, several paintings on plywood, and works on paper. Biographical information and Harvey's view of the plight of women, black and white, especially in the South. Bostic says "Harvey's feminism is strong but tempered by gentleness and love." She quotes some of Harvey's views on women and on the responsibility of being an artist. Bostic sees influences from all aspects of Bessie Harvey's varied heritage in her work: Irish, Native American, and African-American, and says what she believes is the evidence. Illus.

52. Bowman, Russell. "Parallel Visions: The Relationship of Folk Art to Contemporary Art." *Folk Art Messenger* 5, no. 1 (Fall 1991): 5, 8.
About the influence of "primitive painting" on the work of trained artists. Bowman cites the American modernists of the 1920s and their collections of eighteenth century primitives; Andy Warhol's collection; Michael Hall's early exposure to Edgar Tolson; and the interest of Chicago artists in various "outsiders." Bowman concludes with his understanding of the reasons for the interest.

53. Brackman, Barbara. "Kansas Grassroots Art Association." *Folk Art Messenger* 4, no. 2 (Winter 1991): 9.
Information about the formation of the organization, founded to help in the preservation of environmental art, and its services, collections, and programs.

54. Brackman, Barbara. "Top Ten U.S. Sites." *Raw Vision* 3 (June 1990): 45-51.
Description and directions to grassroots environments that are open to visitors: Coral Castle, Ed Galloway's Totem Pole, the Orange Show in Houston, Watts Towers, James Hampton's throne at the National Museum of American Art, Paradise Garden, the Dickeyville Grotto, Dinsmoor's Garden of Eden, the Paper House in Maine, and Fred Smith's Concrete Park. Photographs and locations given for each site.

55. Bradshaw, Elinor Robinson. "American Folk Art in the Collection of the Newark Museum." *The Museum New Series* 19 (June 1967): 50, 51.
Description and comments on the work of Joseph Pickett. Reproduction of "Washington Under the Council Tree, Coryell's Ferry, New

Hope, Pennsylvania." Oil on canvas. [In the collection of the Newark Museum]

56. Braydon, Irene Ward. "Creative Growth Center." *Folk Art Messenger* 4, no. 4 (Summer 1991): 6.
Information about the center's program and the adjacent art gallery directed by Bonnie Haight. Says "over 100 artists with severe mental, physical and emotional disabilities defy stereotypes and their own limitations." Tells of the founding of the center in 1974 by Elias and Florence Katz and mentions a few of the center artists. Illus.

57. Brewster, Todd. "Fanciful Art of Plain Folk." *Life* (June 1980): 112-122.
Reports on new interest in folk art. Provides examples of artists working today: Howard Finster, Elijah Pierce, Mattie Lou O'Kelley, Miles B. Carpenter, Ralph Fasanella. Tells of life experiences that influenced their art. Many color illustrations of artists in their own spaces.

58. Brown, Christie. "Hooked." *Forbes* (3 April 1989): 159-160.
About the 100,000 objects in the "world's largest private collection of American folk art," owned by lawyer Barbara Johnson. Pictured is a wooden sculpture of Noah's ark with animals, by Pucho Odio.

59. Brown, Susan L. "Discovery—Possum Trot." *Connoisseur* (September 1982): 8-12.
Describes the "dream world" created by the late Calvin and Ruby Black in the California desert. Tells of the acquisition at auction of the works by Larry Whitely. Brown says it was "the most important acquisition of his career, a major twentieth century American folk art discovery."

60. Bryant, Elizabeth. "Terry Turrell At Mia." *Reflex* [*Seattle*] (July 1989): 29.
Brief critical notes on the art of self-taught Seattle artist Terry Turrell. Says "it has a purity to it . . . the work, reminiscent of prehistoric or tribal art, is created without an agenda."

61. Burrison, John A. "Afro-American Folk Pottery in the South." *Southern Folklore Quarterly* 42 (1978): 175-199.
The author says there was not a distinctly black American pottery tradition in the South, and details the evidence for his opinions. He writes several pages on "the face vessel controversy" and says he does not believe that these face jugs are distinctly Afro-American or African. Burrison comments on the politics of African-American folklore scholarship.

62. "California Folk Art Exhibition." *Folk Art Finder* 7, no. 2 (April 1986): 4-6.
About the exhibition "Cat and a Ball on a Waterfall: 200 Years of California Folk Painting and Sculpture." Biographical information on Carrie Van Wie, John Newmarker, and Ursula Barnes.

63. Campbell, Anna. "Shaping the Good Earth: A Catawba Valley Tradition." *Health First Magazine (Hickory, NC)* (October 1991): 39-41, 51.
About Albert Hodge, a self-taught potter, who did not begin work until an injury required him to retire early. Now he has face jugs in "at least twenty states and four museums." There is some information about the history of pottery-making in the area, and the artist gives credit to collectors who have encouraged him. Illus.

64. Campbell, Mary Schmidt. "Black Folk Art in America." *Art Journal* 42 (December 1982): 344-345.
Brief review of the book *Black Folk Art in America*, which accompanied the exhibition at the Corcoran. Reviewer regrets the emphasis upon "isolation, uniqueness, and individuality of each artist and of these artists as a group." She insists that their uniqueness must be in their ability to keep alive vital black traditions.

65. Cardinal, Roger. "Definitions and Distinctions in the Field of Folk Art." *Folk Art Finder* 9, no. 1 (January 1985): 14-15, 19.
Discusses the usefulness of definitions: "Specialists and lovers of art who discern important differences between the kinds of work they are encountering certainly feel a need for them. They may wish to attach particular virtue to a given type of art, or they may simply enjoy sorting things out as a way to achieve fuller understanding." He then provides his definitions for separate categories and discusses "folk art," "naive art," "popular art," and "outsider art." [Response to an article by Charles Rosenak, *Folk Art Finder* 8 (4) October-December 1987, 15]

66. Cardinal, Roger. "What Is Meant by Outsider Art Today?" *Folk Art Messenger* 5, no. 1 (Fall 1991): 8-9.

History and detailed discussion of the term "outsider art," beginning with the publication of *Outsider Art* "the first book about Art Brut, a term coined by Jean Dubuffet in France."

67. Carter, Pat. " 'Fox' Harris: A Forest of the Spirit." *SPOT* [*Houston Center for Photography*] (June 1991): 12-13.
About Felix "Fox" Harris, his personal background and experiences, his vision, and the folk art environment he created in North Beaumont, Texas. Tells about the material he used and his tools. The entire collection of over 100 totems and constructions is now in the permanent collection in the Museum of Southeast Texas in Beaumont. Harris died in May 1985. A portion of the work is on display in the museum courtyard. Photographs.

68. "Celebration for Howard Finster." *Folk Art Finder* 4, no. 5 (January 1984): 14-15.
Report on a sixty-seventh birthday party for Finster, and a visit to his Paradise Garden—with two poems for him by Jonathan Williams. Illus.

69. "Charles Butler." *Folk Art Finder* 8, no. 3 (September 1987): 12.
A biographical sketch of black folk artist Charles Butler (1902-1978) who devoted every spare moment of his time to carving. Butler was born in Montgomery, Alabama but moved to Clearwater, Florida in 1957 where he stayed for the remainder of his life. Using handmade tools, Butler carved relief panels of images that came to him as he worked. "These were of people, places, and scenes, some of a religious nature." In February of 1987 the History Museum in Charlotte, North Carolina held a one-man show of his work. Illus.

70. "Charley Kinney 1906-1991." *The Clarion* 16, no. 3 (Fall 1991): 18.
Notice of the death of Kentucky folk artist Charley Kinney at his home in Toller Hollow on April 7, 1991. Says he is best known for his storytelling watercolor pictures. [Accompanying photograph is mislabeled. It is of Noah Kinney, not Charley.]

71. "Charley Kinney (1906-1991)." *Folk Art Finder* 12, no. 3 (July 1991): 2.
Notice of the death of Charley Kinney at home on April 7, 1991. Brief background information and information about his art.

72. Cherry, S. Thad Jr. "Creations." *Folk Art Messenger* 2, no. 3 (Spring 1989): 5.
Cherry, a wood carver, talks about the art he likes to make. He grew up in North Carolina and moved to Waverly, Virginia in 1981. Says he used to see Miles Carpenter driving around; regrets that he never knew him but doesn't want to study his work for fear that people will think he (Cherry) copies them. Illus.

73. "Chicago: The Folk Artists Speak." *Folk Art Messenger* 5, no. 1 (Fall 1991): 1, 3-4.
About a panel presentation at the 1991 annual meeting of the Folk Art Society of America, with a transcription of the questions and answers. The panel was moderated by Frank Lewis. Four folk artists participated: sculptor Derek Webster, staff maker David Philpot, sculptor/environmental artist Mr. Imagination (all from Chicago) and Prophet William Blackmon from Milwaukee. Each artist responded to almost all the same questions on influences, reaction to labels, and whether or not they like visitors (all but Blackmon said "yes"). Photographs of the artists.

74. "Chief Rolling Mountain Thunder 1911-1989." *Spaces* (December 1989): 5.
Death notice for this grassroots environment artist. Information about the artist (Frank Van Zant in "real life") and the art site he built in Nevada. Illus.

75. "The Child Slave Rebellion." *Raw Books and Graphics* (1990): 163-174.
Brief information about artist Henry Darger with reproductions of text and art from the 19,000 page epic "The Adventures of the Vivian Girls."

76. Chittenden, Varick A. "Veronica Terrillion's House and Garden." *Folk Art Finder* 6, no. 2 (May 1985): 10-11.
Description of an upstate New York environmental work containing a log house, a garden of natural plants and handmade sculpture, and a pond with two stone islands occupied by cement figures. The project was started by Terrillion in 1952. Some, but not all, of the figures are religious. Information about the artist's background and the appearance of the site. Illus.

77. "Clementine Hunter." *Folk Art Finder* 2, no. 2 & 3 (May 1981): 14, 33.

Information about the life and work of the artist. Several illustrations.

78. "Clementine Hunter (1887-1988)." *Folk Art Finder* 9, no. 2 (April 1988): 2.
Obituary notice for Clementine Hunter, "who died in January 1988." Says she started painting memories of her plantation life when she was in her fifties. Notes that, because of segregation laws, she could not attend the first exhibition of her own paintings—except on Sunday when the museum was officially closed.

79. "Clementine Hunter 1885-1988." *Folk Art Messenger* 1, no. 2 (Winter 1988): 3.
Obituary notice says "Nationally known folk artist Clementine Hunter died on New Year's day." Information about themes in her painting.

80. Coblentz, Patricia L. "Harry Lieberman 'It Is Never Too Late to Paint.'" *The Clarion* (Winter 1978): 71-72.
Facts about Lieberman's life before and after coming to the United States, and about his beginning to paint, inspired by the boredom of retirement. Comments about his art and the featured subjects in "The Jewish Folk Art Calendar" for 1978.

81. Cogswell, Robert. "Two Tennessee Visionaries: Bessie Harvey and Homer Green." *Folk Art Messenger* 4, no. 4 (Summer 1991): 1, 3-4.
About influences on the art of Bessie Harvey and Homer Green and themes in their widely different art. Cogswell is the folk arts director for the Tennessee Arts Commission in Nashville. He has a lot to say about harmful behavior on the part of some collectors and dealers. Illus.

82. Cohen, Mell. "Gerard C. Wertkin Named as New Director." *The Clarion* 17, no. 1 (Spring 1992): 62.
Announcement of the appointment of Wertkin as director of the Museum of American Folk Art to succeed the late Robert Bishop. Tells of his previous work at the museum: administrative, educational, and curatorial.

83. Connell, E. Jane. "Elijah Pierce, Woodcarver." *Folk Art Messenger* 5, no. 2 (Winter 1992): 1, 3.
Pierce's life and position in his neighborhood in Columbus, Ohio. Written on the occasion of the hundredth anniversary of his birth and a major exhibition of his work "scheduled to open at the Columbus Museum in April 1992" [postponed to January 1993]. Illus.

84. Conwill, Kinshasha Holman. "In Search of an 'Authentic' Vision: Decoding the Appeal of the Self-Taught African American Artist." *American Art,* no. 5 (4) (September 1991): 2-9.
Asks questions about why mostly white, educated, affluent people collect the work of mostly poor, black, self-taught artists and do not show similar interest in the art of trained black artists. She presents a variety of possible answers and says power issues are there but are not the only reasons.

85. Cooper, Rev. Richard P. "Jory Albright." *Folk Art Finder* 13, no. 3 (July 1992): 14.
A sketch of a self-taught painter who uses oil on canvas and who makes his own frames. "Dandies, landscapes and railroads are his major themes." Illus.

86. Cotton, Gordon. "A Love Story of Life Itself: Ethel Mohamed's Life in Stitchery." *Southern Register* (March 1992): 14-15.
Reprint of a tribute to Ethel W. Mohamed, 85, of Belzoni, Mississippi, who died on February 15, 1992. Author describes Mohamed's love of her home surroundings and the reflection of this in her art. He shares his personal memories of the artist, who was his friend. Illus. [Reprint from the *Vicksburg Sunday Post,* February 23, 1992].

87. Cowin, Dana. "One Man's Windy City." *House and Garden* (October 1991): 110.
Brief notes on contemporary Brooklyn folk artist James Leonard, who "spins tales from copper." He picks up inspiration from the streets. One of his "moving tableaux" is a very urban wind machine—a car is repeatedly stripped for parts. Most of his metal pieces he calls "cut out memories." Illus., color.

88. Crease, Robert, and Charles Mann. "Backyard Creators of Art that Say: 'I Did It, I'm Here.'" *Smithsonian Magazine* (August 1983): 82-91.
Authors say "Across the United States untrained artists have transformed society's trash into their own private visions. Reports on some of them—Litto, St. EOM, Fred Smith, Laura Pope, Grandma Prisbrey—and community reactions to them. Notes preservation efforts. Illus.

89. Crum, Larry. " 'Doin' It for the Young 'Uns:' Clyde Jones and the Children." *Folk Art Messenger* 4, no. 4 (Summer 1991): 8-9.
Clyde Jones uses found wood, a chainsaw, and paint to make the animals he displays. The article focuses on his work with children in the local schools. Illus.

90. Cubbs, Joanne. "Eugene Von Bruenchenhein: Wisconsin Visionary." *Folk Art Finder* 5, no. 3 (September 1984): 13-14.
Information about the art created over a period of forty years. Details on his life and surroundings in his Milwaukee home. Illus.

91. Cubbs, Joanne. "Religious Visionaries at the Kohler Museum." *Folk Art Finder* 12, no. 2 (April 1991): 8-10.
Detailed information from the curator of the above named exhibition. Information about the three artists included: Simon Sparrow, Norbert Kox, and Mary LeRavin.

92. Cummings, Sue. "Reverend Finster: Paradise in a Paintbrush." *Spin* 1, no. 5 (September 1985): 51+.
About Howard Finster and his album covers for Talking Heads and for R.E.M. Details on his meeting David Byrne and also the singer from R.E.M. who first met Finster while a student at the University of Georgia.

93. "David Philpot Maker of Staffs." *Folk Art Finder* 13, no. 2 (April 1992): 22-23.
Discusses the artist and his work, with many quotes from Philpot. Tells how he started making his art and the materials he uses. Illus.

94. Davis, Felice. "American Folk Art in the Hemphill Collection." *Connoisseur* 176 (February 1971): 113-122.
Describes the years of Hemphill's collecting, "since he was eight" and what he has accomplished. "Not the least remarkable feature of Mr. Hemphill's collection is that, although it comprises about two thousand objects, it is housed in his small duplex apartment." Illus.

95. Deanne, Mary Anne. "A Kentucky Odyssey." *Folk Art Messenger* 2, no. 1 (Fall 1988): 1, 3.
Report of a trip to eastern Kentucky to visit with Noah Kinney, Hazel Kinney, Charley Kinney; to see the carvings of Minnie and Garland Adkins; to meet Junior Lewis, Linvel Barker, cane maker Denzil Goodpaster, and many of the other area artists. Photographs of the artists, with their art.

96. "A Density of Passions." *Folk Art Finder* 11, no. 1 (January 1990): 4.
The title refers to "an unusual exhibition in that the work of nine self-taught artists and six mainstream artists with a similar bent was shown side by side." The artists are listed and two of them, Gerald Hawkes and the Philadelphia Wireman, are described.

97. "Derek Webster." *Folk Art Finder* 6, no. 4 (November 1985): 15.
Article about Derek Webster, who moved to Chicago from Honduras in the mid-1960s. "Totally untrained, he began his art career making objects to embellish his garden." He makes sculpture from scrap wood nailed into "semi-human" forms and painted with commercial enamels. Illus.

98. Dermansky, Ann. "Bit by Bit." *Elle Decor* 2, no. 5 (June 1991): 66-71.
Article about the attraction of mosaic. Takes note of Simon Rodia's Watts Towers and the seven rooms of mosaic in the Brooklyn, New York apartment of Joseph Endicott Furey. Illus., color.

99. Dewhurst, C. Kurt and Marsha MacDowell. "Environments in Michigan." *Spaces*, no. 8 (n.d.): 6-.
Photographs and information on Walter Kinney's Antlers Bar, Clarence Hewer's pumping station murals in Lansing, Raymond Overholzer's Shrine of the Pines, Paul Domke's Garden, John Jacob's bottle house in Kaleva, and the "Lund's Scenic Garden."

100. "Dickeyville Grotto and Holy Ghost Park." *Folk Art Finder* 4, no. 3 (September 1983): 12-13.
About the building of this grassroots art site by Father Mathias Wernerus, starting in 1926. Brief description. The site in Dickeyville, Wisconsin is open to the public. Illus.

101. Dintenfass, Susan Subtle. "Elvis in Egypt." *California* (November 1989): 103-107.
Article about Oakland, California's Creative Growth Art Center and the artistic talents of some of their artists. Donald Paterson, Nelson Tygart, Dwight Mackintosh, William Tyler, and Regina Broussard are mentioned. Illus., color.

102. Dobies, Nancy. "Folk Art Environments." *Antiques West* 10, no. 4 (April 1990): 11, 20.
Information about Sanford Darling, Calvin and Ruby Black (with details on the Possum Trot site and how it worked), and Tressa Prisbrey. Also about the pieces from Darling and the Blacks at the Double K Gallery in Los Angeles.

103. Drexler, Sherman. "Martin Ramirez at Phyllis Kind." *Artforum* 14 (May 1976): 70.
Comments about the artist's background and his mental illness, with some opinions on the art. Tells what he believes Ramirez' obsessive repetition of line and theme signifies. One illustration.

104. Drohojowska, Hunter. "Post-Hollywood Furniture." *Connoisseur* (February 1987): 120-123.
About the background and creations of folk art furniture maker Jon Bok. Description of the house, covered with flattened beer cans, and his collections.

105. Dryden, Don, and Don Christensen. "Grassroots Artist: Emery Blagdon." *KGAA News* 8, no. 2 (1988): 1-2.
Article says Emery Oliver Blagdon (1907-1986) was a native of north central Nebraska. Biographical details follow, including that "at forty-eight years of age, having not had any previous artistic activity, he began painting and building sculptures that occupied him exclusively for his remaining thirty years." A description of the art environment follows, with information about the artist's intentions that the energy fields from his art work could help people. At Blagdon's death, his works were auctioned off, and Don Dryden others bought them. An exhibition of the work has been held in several places including, in November 1992, the show sponsored by the organization Intuit: The Center for Intuitive and Outsider Art.

106. DuBois, Peter C. "Do It Yourself." *Museum and Arts Washington* (July 1990): 20-21.
About the market and "worth" of "outsider and/or self-taught artists." Tells of prices of various paintings and mentions a number of galleries.

107. Dudar, Helen. "Mr. American Folk Art." *Connoisseur* (June 1982): 70-78.
The author describes a visit to the New York brownstone home occupied by Herbert Waide Hemphill, Jr. and his collection of American folk art. She describes some of the pieces and the history of the collection and says that while the environment is not serene, it is full of surprises. Photographs of Hemphill's home and collection.

108. Dwigans, Cathy, and Barbara Blackman. "Kansas Leads Nation in Grassroots-Art Environments." *Forum: Visual Arts/Mid-America* 12, no. 1 (January 1987): 4-6.
Written by founders of the Kansas Grassroots Art Association, who say the Midwest has more grassroots environments than other parts of the United States. They provide a definition of grassroots art, descriptions of characteristic use of materials, KGAA efforts at site documentation, and information on how to join the organization. Bibliography. Illus.

109. Early, Lawrence, and Ted Dossett. "Occoneechee Trapper." *Wildlife in North Carolina* (May 1987): 22-27.
Interview with Q.J. Stephenson of Garysburg, North Carolina talks about his life and experiences as a trapper "in this Roanoke River backwater for over fifty years." The interviewers note his uncommon appreciation and understanding of nature. Information about the museum he built near his house to show visitors his fossil and other discoveries. Article tells of his growing reputation as a folk artist. Illus.

110. Eaton, Linda B. "A Separate Vision." *Plateau Magazine* 60, no. 1 (1989): 2-32.
A quarterly publication of the Museum of Northern Arizona, in Flagstaff, this issue is devoted to the works of four nontraditional artists: Baje Whitethorne, Navajo landscape painter; Nora Naranjo-Morse, Santa Clara sculptor; John Fredericks, Hopi Cachina carver; and Brenda Spencer, Navajo weaver. Discusses their lives, their art, and the nontraditional aspects of their work. Many color illustrations.

111. "Ed Mann." *Folk Art Finder* 3, no. 1 (March 1982): 5-6.
Biographical description of the contemporary self-taught sculptor Ed Mann, who makes "kinetic toys." They are usually groups of figures that spring into action at the turning of a wheel or by hand pressure on various bars. Illus.

112. Edson, Richard. "Ned Cartledge." *Folk Art Finder* 11, no. 3 (July 1990): 10-11.

Article about the background and art of Ned Cartledge, who often creates works that make a strong social comment. Illus.

113. Edson, Richard. "Milton A. Fletcher (1896-1991)." *Folk Art Finder* 13, no. 4 (October 1992): 2.
Notice of the death of Louisiana folk painter Milton Fletcher with brief information about his art.

114. Eff, Elaine. "The Painted Window Screens of Baltimore, MD." *The Clarion,* no. 6 (Spring 1976): 5-12.
Eff tells about the community tradition of screen painting in a Baltimore neighborhood; the history and the artists. Illus.

115. Eliel, Carol S. "Parallel Visions: Modern Artists and Outsider Art." *Folk Art Messenger* 5, no. 4 (Summer 1992): 4-5.
Article about the focus of the "Parallel Visions" exhibition scheduled to be at the Los Angeles County Museum of Art October 18, 1992 to January 3, 1993. The exhibition "will investigate the roots of modernism by examining relationships between works of modern and contemporary artists and that of compulsive visionaries." Illus.

116. "Elijah Pierce: Woodcarver." *Folk Art Finder* 13, no. 1 (January 1992): 4-7.
About the life and art of barber and woodcarver Elijah Pierce. Includes a description of the upcoming retrospective exhibition of his work at the Columbus Museum of Art, Ohio.

117. Eller-Smith, Lisa. "Reuben A. Miller's Windmill Zoo." *Folk Art Messenger* 4, no. 1 (Fall 1990): 10.
Describes the yard full of windmills at the home of R.A. Miller and a little about the artist's life and work. Illus.

118. Ellis, Nancy. "The Sand Art of Eugene 'Baatsoslanii' Joe." *Focus/Santa Fe* (June 1989): 21, 23.
Discusses his art form using sand instead of paint. "I like to call it 'creative sand 'art' rather than 'sand painting,' " he says, describing his artistic move from totally traditional work to his present contemporary interpretation of Navajo life and legend. Information on his life, influence of his grandfather, why he no longer does any traditional sand painting—he believes the market has been flooded by those who have no understanding of the sacred meaning behind it.

119. "Emma Lee Moss." *Folk Art Finder* 4, no. 1 (March 1983): 13-14.
Information about the background and art of Emma Lee Moss, born in Tennessee and a long-time resident of Texas. Discusses how she started painting, using material that belonged to the children of the household she worked for in Austin. She put her art aside when she married and moved into her own home. Then she started painting again in 1978.

120. "Enrique Rendon 1923-1987." *Folk Art Messenger* 1, no. 2 (Winter 1988): 6.
Brief notice about the death of carver Enrique Rendon on April 16, 1987. Rendon was from Velarde, New Mexico and "worked in the *santero* tradition, carving and painting saint's figures from aspen and cedar."

121. "Environmental Art in California, A Sampling." *Folk Art Finder* 7, no. 4 (October 1986): 6-11, 14.
Information about three folk art environments—Simon Rodia's Watts Towers, Baldasare Forestiere's underground gardens in Fresno, and Grandma Prisbrey's Bottle Village. Elsewhere in this issue there is mention of Romano Gabriel's wooden garden on permanent display in Eureka's Old Town and a description of the now disappeared Emeryville Flats. Illus.

122. "Environmental Art in New Jersey." *Folk Art Finder* 10, no. 2 (April 1989).
Lists the environments included in the exhibition "Two Arks, A Palace, Some Robots, and Mr. Freedom's Fabulous Fifty Acres."

123. "Environmental Photos at Museum of Modern Art." *Folk Art Finder* 11, no. 1 (January 1990): 14.
"Since January, 1988 Vincent Borrelli, a Massachusetts photographer, has been traveling around the country making a photographic record of important environmental folk and outsider art." Tells of his work on exhibition at the Museum of Modern Art. He has ten photographs in the exhibition including one taken at Father Philip K. Wagner's Grotto Shrine and one of Albert (Kid) Mertz's workshop.

124. Epstein, Gene. "The Art and Times of Victor Joseph Gatto." *The Clarion* 13, no. 2 (Spring 1988): 56-63.
Tells how Gatto was orphaned, grew up in the mostly Italian end of Greenwich Village, and spent years in prison and working low-paying jobs. Facts about Gatto's style and technique. He received much attention from writers, collectors and dealers, but, says Epstein, his personality prevented him from the success and financial well-being he otherwise might have earned. Illus.

125. Epstein, Gene. "The Art of Becoming Gatto." *Raw Vision* 6 (June 1992): 20-23.
Article about painter Joe Gatto's life, his paintings, and the energy he put into his work. Epstein says that although he received a lot of positive critical attention early on in his painting career, he was forever in financial difficulties. Illus.

126. "Ernest 'Popeye' Reed." *Folk Art Finder* 4, no. 2 (May 1983): 12.
A biographical sketch of carver Popeye Reed, "a well-known figure in Jackson County, Ohio, where he was born in 1924." He started carving when he was fourteen, and although he has used a variety of materials he prefers native sandstone. "Reed carves Indians, animals and portraits but his most intriguing pieces are interpretations of the gods and goddesses of Greek mythology."

127. Everts-Boehm, Dana, and Jeanette De Bouzek. "New Mexican Hispano-American Carving in Context." *The Clarion* 16, no. 2 (Summer 1991): 34-40.
Discusses a "new breed of carvers" —those who specialize in large animal sculpture. Describes the influence of Felipe Archuleta. Includes interviews with Leroy Archuleta, Ron Rodriguez, "Jimbo" Davila, and Mike Rodriguez. Illus.

128. Ezell, Carolyn W. "The Anything Art of Jimmie Lee Sudduth." *Highlights for Children* (June 1991): 16-17.
About all the natural materials and found objects Sudduth uses to make his art and the subject matter he most often chooses. Illus.

129. Fagaly, William A. "Sister Gertrude Morgan." *Arts Quarterly* [*New Orleans Museum of Art*] 10, no. 1 (January 1988): 17-19.
Information on Sister Morgan's life and the art she made to support her religious work and convictions. "Sister Morgan always believed she was foremost a missionary of Christ and a visual and performing artist second." Information on the subject matter and material of her art. Notes an exhibition of approximately seventy of Morgan's works at the New Orleans Museum of Art.

130. Fagaly, William A. "Hand Made Art." *Ricochet* (March 1988): 63-64.
Descriptions of some self-taught Louisiana artists. Includes Sister Gertrude Morgan, Clementine Hunter, David Butler, John Landry, J.P. Scott, Bruce Brice, Willie White, and Royal Robertson. Color illustrations of a Scott boat, Willie White on his porch, and a Bruce Brice mural.

131. "A Family of Folk Artists: The Painting Perkinses." *Folk Art Finder* 2, no. 1 (March 1981): 4-.
"The Painting Perkinses" are three folk artists from one family who paint "bright homey canvases of rural Pennsylvania." Background information about the mother, Ruth Perkins, who was born in 1911 and started painting when she retired from the restaurant business; the father, Clarence Perkins, who started later; and the daughter, Mary Lou, who lives in Ohio. Describes differences in their styles. Their work is in the permanent collection of the Museum of American Folk Art and in Robert Bishop's *Folk Painters of America* (E.P. Dutton, 1979). Illus.

132. "A Family Story: The Remarkable Work of Cochiti Potters Vangie and Anthony Siuna." *Focus/Santa Fe* (October 1990): 13-15.
About Vangie Siuna's start as a creator of storytellers at Cochiti Pueblo, taught by her mother, who told her to develop her own style. In 1981 Vangie entered her work at Indian Market in Santa Fe, taking first place among non-traditional storytellers, and now her family is involved with helping her. Says she likes to innovate and over the years has added new versions of the storyteller doll. Illus.

133. "Fasanella Honored in NYC." *The Clarion* 15, no. 4 (Fall 1990): 22.
Tells of a Gracie Mansion reception given by New York mayor David Dinkins to honor "one of America's best-known twentieth century urban folk artists." Information included about the Immigrant Family Labor Heritage Project,

which is committed to purchasing the Fasanella painting, "Family Supper," from a private collector for the Ellis Island Immigration Museum [see *The Clarion* Fall 1991, pp. 14 and 18 for news of the successful conclusion to the fund drive].

134. "Fasanella's "Family Supper" Dedicated." *The Clarion* 16, no. 3 (Fall 1991): 14, 18.
Report about the purchase of the painting, "Family Supper," after a successful fund-raising drive by several organizations. The painting was to be installed in the Great Hall at the Ellis Island Immigration Museum. Tiny illustration of the painting included.

135. "Felipe Archuleta 1910-1991." *The Clarion* 16, no. 1 (Spring 1991): 16.
Obituary notice about the death of Archuleta after a long illness. He is referred to as "a giant among contemporary American wood carvers."

136. "Felipe Archuleta (1910-1991)." *Folk Art Finder* 12, no. 2 (April 1991).
Information that Archuleta died of a brain tumor on January 1, 1991 at the age of eighty. Tells a little about his background and about some of the exhibitions in which his work has appeared. Says his son, Leroy, and nephew, Ron Rodriguez, "who had assisted him in his work, now continue the Archuleta style of carving with their own distinctive variations."

137. Ferris, William Jr. "Black Folk Art and Crafts: A Mississippi Sample." *Southern Folklore Quarterly* 42 (1978): 209-241.
About an exhibition of mostly traditional arts and crafts at the Center for Southern Folklore. Two artists talk about their work: Luster Willis of Crystal Springs and James "Son" Thomas of Leland, Mississippi.

138. Ferris, William Jr. "If You Ain't Got It in Your Head, You Can't Do It with Your Hands: James Thomas, Mississippi Delta Folk Sculptor." *Studies in the Literary Imagination* 3 (1970): 89-101.
Describes the work of James "Son" Thomas, his sculptured animals, human figures, and skulls. Ferris provides background for the belief that there is evidence of African influence in the work.

139. Ferris, William Jr. "Visions in Afro-American Folk Art: The Sculpture of James Thomas." *Journal of American Folklore* 88 (1975): 115-132.
Ferris says Thomas' sculpture represents his individual projection of personality and inspiration from his dreams and that the work is "a major affirmation of Afro-American culture, but it is not a result of direct linear transmission from other Afro-American artists to younger ones."

140. Field, Agnes. "Roger McKay." *Folk Art Finder* 13, no. 3 (July 1992): 12.
A sketch of a self-taught carver, Roger McKay, who makes relief carvings of many different subjects and recently has started making whirligigs. Says that "most of the material for his sculpture and whirligigs—wood, metal, fabrics, comes from the river banks or the city dump." McKay lives in Astoria, Oregon. Illus.

141. Finore, Diane. "Art by Bill Traylor." *The Clarion* (Spring-Summer 1983): 42-48.
Article about the discovery, working methods, and art of Bill Traylor. Author says Charles Shannon, who is said to have discovered Traylor, did not ask him many questions, "for fear of breaking the spell." Notes.

142. Flanagan, Michael. "University of Wisconsin-Milwaukee Features Kentucky Art." *Folk Art Messenger* 4, no. 1 (Fall 1990): 4.
Profile of the museum by its director, who says the interest of the museum is "in presenting outsider images." A number of the exhibitions that fulfill this interest are noted.

143. "Florence Deeble." *Folk Art Finder* 6, no. 1 (March 1985): 11.
Tells about the yard art built by retired school teacher Florence Deeble, who lives just around the corner from S.P. Dinsmoor's Garden of Eden in Lucas, Kansas. Illus.

144. "Fly Away Home." *Art and Antiques* (October 1991): 39.
Listed here only for the sharp color photograph of a birdhouse by the late artist Willie Massey (1910-1990). It is made of found objects and painted in bright colors. Illustrations of his work are infrequent.

145. "Folk Art Animations." *Folk Art Finder* 1, no. 6 (January 1981): 5-9, 15, 18.
This issue of the *Folk Art Finder* featured three contemporary folk artists who create art objects moved by wind or electricity. The three are Marvin Warren of Marshall, Arkansas, William R. Brinley of Meridien, Connecticut, and

Ed Larson of Libertyville, Illinois. Information included about the artists and their art. The last named artist, Ed Larson, is not self-taught but considers himself a folk artist. Although he is not included elsewhere in this book, others agree with his self-designation. His art work is available at the Brigette Schluger Gallery in Denver, Colorado.

146. "Folk Art at National Museum of American Art." *The Clarion* 17, no. 2 (Summer 1992): 12.
Notice of the exhibition "Folk Art Across America" installed for an "indefinite period" at the National Museum of American Art. The exhibited materials are from the permanent collection.

147. "Folk Art from the Rosenak Collection." *Folk Art Finder* 11, no. 4 (October 1990): 7, 23.
Report on the "The Cutting Edge" exhibition, scheduled to open at the Museum of American Folk Art on December 6, 1990, and the two-day symposium to be held in conjunction with the opening.

148. "Folk Art Jubilation." *Folk Art Messenger* 1, no. 3 (Spring 1988): 3-6.
About an exhibition of eleven regional artists, curated by John D. Morgan, at the Sixth Street Marketplace in Richmond, Virginia. Artists: Edward Ambrose, John B. Anderson, Vernon Burwell, Miles Carpenter, Abe Criss, "Uncle Jack" Dey, Tom Gordon, James Harold Jennings, Clyde Jones, S.L. Jones, and W.C. Owens. Photographs of the artists.

149. "Folk Art U.S.A. Since 1900." *Folk Art Finder* 1, no. 3 (July 1980): 12.
Detailed description of the exhibition of the same name as the above title at the Abby Aldrich Rockefeller Folk Art Museum. "Collected by Herbert Waide Hemphill, Jr., the display reveals the rich variety of folk art that continues to be made in this country. The material consists of 57 pieces by American artists working since 1900."

150. "The Folk Artists Speak." *Folk Art Messenger* 1, no. 1 (Fall 1987): n.p.
Artists were asked, "Why do you make art?" Replies came from Marion Line of Richmond, Virginia; Allen Wilson of Summerville, Georgia; James Harold Jennings of Pinnacle, North Carolina; and Sabinita Lopez Ortiz of Cordova, New Mexico.

151. "The Folk Artists Speak." *Folk Art Messenger* 1, no. 2 (Winter 1988): 6.
The question asked of folk artists around the country was, "Is it important to you to preserve and/or exhibit your work, and why?" Answers included came from Sabinita Lopez Ortiz, Allen Wilson, Robert Gilkerson, S.L. Jones, Donny Tolson, Noah Kinney, and Hazel Kinney.

152. "The Folk Artists Speak." *Folk Art Messenger* 1, no. 3 (Spring 1988): 10.
A question was asked of artists, "What materials do you use and why do you use them?" and was answered by Sabinita Lopez Ortiz, Robert Gilkerson, Charley Kinney, Noah Kinney, Donny Tolson, S.L. Jones, and Hazel Kinney.

153. "The Folk Artists Speak." *Folk Art Messenger* 1, no. 4 (Summer 1988): 6.
Responses to questions about sources of inspiration for their art, what got them started, and how they decide what to 'do next' in their work. Replies reported from Vernon Burwell, Vollis Simpson and Arliss A. Watford. Illus.

154. "The Folk Artists Speak." *Folk Art Messenger* 2, no. 1 (Fall 1988): 6.
Hugo Sperger, Hazel Kinney, Noah Kinney, Charley Kinney, Marvin Finn, Earnest Patton, John Anderson, Charlie Lucas, and Bessie Harvey answer a question about the sources for their ideas for art.

155. "The Folk Artists Speak." *Folk Art Messenger* 2, no. 2 (Winter 1989): 8.
Responses to the question "How did you get started making art?" and "Where do you get your ideas?" Artists responding were Ronald Cooper, Jessie Cooper, Minnie Adkins, R.O. Dalton, Mary T. Smith, Geneva Beavers, and Minnie Black.

156. "Folklife in Florida." *Folk Art Finder* 4, no. 4 (November 1983): 4-9.
Article that features information about the art and the lives of four Florida artists: Mario Sanchez, wood carver; Stanley Papio, welded sculpture; Jesse Aaron, wood sculptor; and E.A. "Frog" Smith, memory painter.

157. Fowler, Miriam. "Artists of Alabama, Unite!" *Alabama Magazine* (July 1990): 18-23.
About the New South School and Gallery in Montgomery in 1939 and 1940.Tells about the artists who started it, their desire that all "unite that the South may realize its cultural possibil-

ities." Reports on the 1990 exhibition assembled to show the work of four of the artists involved in the School. Also included in the 1990 exhibition is work of Bill Traylor, who was first promoted by New South artists. Illustrations include Traylor.

158. Fox, Nancy Jo. "Liberties With Liberty: The Changing of an American Symbol." *The Clarion* (Winter 1986): 38-47.
Article written during an exhibition of the same name at the Museum of American Folk Art. On page 27 is a color illustration of a whirligig by James Leonard. Very little from the twentieth century was included in this exhibition, however.

159. Foy, James L., and James P. McMurrer. "James Hampton, Artist and Visionary." *Psychiatry and Art* 4 (1975): 64-75.
Biography of Hampton, including his visionary experiences. Discussion of his work, The Throne of the Third Heaven, including the materials used, construction methods, and symbolic meaning. Authors compare Hampton's work to that of others, including Simon Rodia and Clarence Schmidt.

160. "Frances Montague." *Folk Art Finder* 11, no. 4 (October 1990): 17.
"She calls herself 'Lady Shalimar' and claims that the pictures she creates are all self-portraits. Her paintings, usually of costumed lady performers, are delicately patterned and embellished with glitter, sequins and other shiny material." She is a participant in the HAI program. Illus.

161. Frankel, Claire. "Outside's In." *Art and Auction* (October 1992): 102-109.
This article is a survey of outsider art and includes a discussion of its increasing popularity. Information about American and European "outsiders" is included with the statement that American "outsiders" are more "naive" while European "outsiders" are in mental institutions. Many illustrations include Chelo Amezcua, Gregory Van Maanen, Peter Charlie Besharo, John Podhorsky, Howard Finster, Henry Darger, Joseph Yoakum, and J.B. Murry. Finster is on the cover. The article mentions the upcoming exhibition "Parallel Visions" at the Los Angeles County Museum of Art. There is a sidebar to this article with information about collectors,

quoting the same people who are always quoted and the same stories that are always repeated. The sidebar was written by Eve M. Kahn.

162. "Fred Smith's Wisconsin Concrete Park." *Folk Art Finder* 2, no. 2-3 (May 1981): 4-5, 36.
Notes about Smith, description of the site, preservation by the Kohler Foundation, public access, and illustrations.

163. French, Christopher. "Like a Word of God Spoken this Instant." *The Museum of California* (March 1986): 11-14.
Discussion and description of the art and artists in the exhibition "Cat and a Ball on a Waterfall." Specific artworks discussed are those by John Abduljaami, Dalbert Castro, Sanford Darling, Calvin and Ruby Black, and Tressa Prisbrey.

164. "The French Quarter's Artistic Store Manager." *Coin Launderer and Cleaner* (June 1990): 16-21.
About self-taught artist Mike Frolich who managed a "Washateria" in the New Orleans French Quarter that was covered floor to ceiling with his paintings. There is background on his life, his paintings, and the miniatures he carved and put together. Notes that his first formal exhibit was "last fall at the Contemporary Arts Center in New Orleans in a show titled 'Outta Site: Beyond the Emerging,' an exhibit of outsider art." Illus.

165. Fuller, Gerald. " 'Matchstick Artist' Finds Peace in His Work." *Mid-Atlantic Antiques Magazine* (April 1990).
The article describes in detail the materials and tools used by Gerald Hawkes to make his art and the symbols and meanings he places in it. There is also some biographical information.

166. Fussell, Fred. "Clouds Over Pasaquan." *Spaces* (December 1989): 2-3.
Tells about the efforts to save the Pasaquan art site built in Buena Vista, Georgia by the late St. EOM, the failure to convince the Columbus Museum to serve as more than a temporary storehouse for "loose objects" from the site, and the need for a "more permanent solution."

167. Gablik, Susi. "Art Alarms: Visions of the End." *Art in America* (April 1984): 11-15.

Critical review of the exhibition "The End of the World" at the New Museum in the Soho area of New York. One of the pieces exhibited, and illustrated in the article, is a painting by the Rev. Howard Finster.

168. Gaver, Eleanor E. "Inside the Outsiders." *Art and Antiques* (June 1990): 72-86, 159-161, 163.
Author says a gallery show on Rodeo Drive, of the art of Howard Finster, inspired her "to find out how the art world was treating Finster and his fellow outsiders." She traveled 7,600 miles and had nothing good to report—all collectors and dealers are thieves according to Gaver. No complexities dealt with here; more of an "expose" than a serious-minded report. Good illustrations of the art and photographs of the artists.

169. "Gayleen Aiken." *Folk Art Finder* 3, no. 5 (January 1983): 13-14.
Description of the artist in her home "in a poorer section of Barre, Vermont" and conversations with the artist during a visit. Tells about her life-sized jointed figures and images in paintings of her imaginary "Raimbilli Cousins." Illus.

170. "Georgianna Orr." *Folk Art Finder* 2, no. 5 (November 1981): 12-13.
Sketch describing the artist's life and her work. Orr was born in California and moved later to Gilchrist, Oregon. Religion is the subject of her paintings. She started to paint after a rare illness and a promise to God as a result of being spared. Illus.

171. Gibbs, Jocelyn. "Visions of Home: Preserving America's Folk Art Environments." *Whole Earth Review* [*Sausalito, CA*] (September 1986): 106-111.
About several grassroots art environments and the battles to save them. Photographs by Seymour Rosen of the Shaffer Hotel in New Mexico, Herman Rusch's Prairie Moon Park, Watts Towers, Romano Gabriel's Wooden Garden, Rolling Thunder Monument, the Gehrke's windmills, and several others.

172. Glasgow, Andrew. "Royal Robertson: Paranoid Prophet." *The Arts Journal* [*Asheville, NC*] (September 1989): 18-19.
Glasgow talks about a day spent with Louisiana folk artist Royal Robertson and says being with such a disturbed person "raised a lot of ques-

tions about dealing and collecting." Says these issues are not new and cannot be ignored.

173. Goheen, Ellen R. "Narrative Enriches Personal Images." *Forum: Visual Arts/Mid-America* 12, no. 1 (January 1987): 18.
Information on the life and art of memory painter Marijana Grisnik. The author describes an exhibition of Grisnik's work, mostly pieces from the Kansas State Historical Society Collection. Goheen says Grisnik "is a folk artist with strong Croatian roots who taught herself to paint and has spent the past dozen years documenting the rich ethnic life of the Strawberry Hill area of Kansas City, Kansas." Illus.

174. Goldin, Amy. "Problems in Folk Art." *Art Forum* (June 1976): 48-52.
Review of the exhibition "Folk Sculpture U.S.A." at the Brooklyn Museum, curated by Herbert Waide Hemphill, Jr. Notes that this is an exhibition by a champion of folk art accompanied by an art historian's essay that denies there is such a thing. Analyzes the two and discusses definitions of high art and folk art.

175. Goldstone, Bud. "A Conservation Story: Simon Rodia's Watts Towers." *Folk Art Messenger* 5, no. 4 (Summer 1992): 6.
Mentions the building of Watts Towers over a period of three decades by Simon Rodia, who left the project in 1954 to be with his family in Martinez, California. Tells of the city's determination to destroy the Towers as "dangerous" and the tests performed to prove that this wasn't true. Goldstone, an engineer, describes the construction in detail and the three conservation programs for the Towers during their history.

176. Goleas, Janet. "Artist, Philosopher, Indian Chief: Rolling Thunder's Mountain Museum." *Art Express* 1, no. 1 (May 1981): 26-31.
A detailed description of the monument built by Chief Rolling Thunder in the Nevada desert. The author describes the various parts of the monument/museum and tells of the chief's explanations—"a story for every particle." Illus.

177. Gordin, Ellin. "Abby Aldrich Rockefeller Folk Art Center Reopens." *Folk Art Messenger* 5, no. 3 (Spring 1992): 10.
Profile of the museum that includes a description of the new and the renovated buildings and the expanded facilities. Notes the galler-

ies and the collections. Hours and the price of admission are included.

178. Gordon, Ellin. "Folk Art Society Award Given to Robert Bishop." *Folk Art Messenger* 5, no. 1 (Fall 1991): 10.
Tells of the presentation of the annual award of distinction to the late Robert Bishop and enumerates his many contributions to the field of folk art. Previous award winners include Howard Finster and Herbert Waide Hemphill, Jr.

179. Goresik, Sue. "The Hardest Christmas." *Ohio Magazine* (December 1987): 44-46.
Discusses the 1930s Depression years and how hard it was in small-town Ohio. The article and the magazine cover contain color illustrations of paintings by self-taught artist Paul Patton who remembers these times.

180. Gorisek, Sue. "Paintings by Paul Patton." *Ohio Magazine* (January 1987): 23-26.
Painter Paul Patton recalls his growing up in Rix Hills, Ohio—now withered away—in his "memory paintings." Nine examples of his art, in color, accompany this article.

181. Gottlieb, Shirle. "Seeking Outsiders." *Artweek* (December 1984): 1-2.
Review of "Pioneers in Paradise: Folk and Outsider Artists of the West Coast," at the Long Beach, California Museum of Art. Gottlieb says "this is like no exhibit I've ever seen." She describes many of the works of art and tells of the stories behind them. She concludes by noting that some have complained that this work "isn't art" or that it has no place in a museum. Gottlieb says it does and definitions should change, not the art.

182. "G.R.A.C.E." *Folk Art Finder* 3, no. 4 (November 1982): 6.
Description of the program called GRACE (Grassroots Art and Community Enterprise) founded by Don Sunseri in northeastern Vermont in 1976. It started out in three nursing homes and later expanded to include people from senior centers and private homes. Sunseri does not teach, "He simply provides art materials, a workspace, and the encouragement for the residents to pursue their own ideas." The exhibition of GRACE artists in New York, "Images of Experience," is described.

183. "Grassroots Artist: Art Beal." *KGAA News* 5, no. 4 (September 1985): 1.
Many details about Arthur Harold Beal, also known as "Dr. Tinkerpaws" or "Captain Nittwitt." Discusses his buildings in Cambria Pines, California, just south of San Simeon. His environmental creation was declared an historic landmark in 1981, and is now owned by the Art Beal Foundation. Biblio. Illus.

184. "Grassroots Artist: Bryce Gulley." *KGAA News* 10, no. 4 (1991): 1.
Bryce Luther Gulley left his home and family in Seattle one day in 1929 and "disappeared" in Arizona. After recovering there from tuberculosis, he built an elaborate structure in the desert. Article describes the site in some detail. When Gulley died he left it to his surprised wife and daughter. The latter now runs "Mystery Castle," as it is called, as a tourist attraction. Access information, bibliography included. Illus.

185. "Grassroots Artist: Cap Harvey." *KGAA News* 2, no. 4 (June 1982): 1.
Information on the artist's Driftwood Museum, dismantled in 1946 soon after his death. Description of his Coos Bay, Oregon home, his work as a ship's pilot. He made human caricatures, assembled from driftwood and other found objects, that he called Sea Goofs. There are eight pieces of his work in the Kansas Grassroots Art Association Museum.

186. "Grassroots Artist: Charlie Fields." *KGAA News* 5, no. 2 (March 1985): 1.
Detailed description of the painted decorations on the exterior and interior of Field's home near Lebanon, Virginia. Biographical details, including that he lived most of his 83 years in the area. Quotes his neighbors saying that Fields changed the patterns—stripes, checks, polka dots—but that the dots were his favorite. There were many yard decorations too. Everything is gone now. There are a few pieces on display at the Museum of Appalachia in Norris, Tennessee. Biblio. Illus.

187. "Grassroots Artist: Dave Woods." *Kansas Grassroots Art Association Newsletter* 1, no. 1 (September 1980): 1.
Feature article about Dave Woods of Humboldt, Kansas. Description of his yard art,

photos of the artist. Says after his death, hundreds of pieces were donated to KGAA. In 1975 Wood's work was reassembled into an exhibition at the University of Kansas Art Museum. KGAA has the material cataloged and stored. Illus.

188. "Grassroots Artist: Ed Root." *Kansas Grassroots Art Association Newsletter* 1, no. 2 (December 1981): 1.
Biographical information on Edward Ernest Root, who was born in 1866 in Naperville, Illinois and later moved to Kansas. He spent nearly twenty years arraying his farm with glass-studded concrete monuments and other constructions. Most of the works were lost when the area was flooded for a reservoir built in central Kansas. Several hundred pieces were saved by Root's sons and are now in the KGAA Museum. Biblio. Illus.

189. "Grassroots Artist: Ed Galloway." *KGAA News* 2, no. 3 (March 1982).
About Ed Galloway's "Monument to the American Indian" in Oklahoma. Description of the site tells about the objects there and about Galloway. [*KGAA News*, 3 (1) reports on a project to help Galloway's family clean up and maintain the site. *KGAA News*, 7 (3) has an update on restoration progress.]

190. "Grassroots Artist: Edward Leedskalnin." *KGAA News* 3, no. 3 (June 1983): 1.
About the builder of Coral Castle in Florida, twenty-five miles south of Miami and open to visitors. Lots of detail on what is there. Biblio. Illus.

191. "Grassroots Artist: Elis Stenman." *KGAA News* 4, no. 4 (September 1984): 1.
Elis Stenman, of Pigeon Cove, Massachusetts, built a house and completely furnished it with used newspapers. The article includes information on construction details and describes some of the objects he made. It opened in 1942 as a tourist attraction. Biblio. Illus.

192. "Grassroots Artist: Florence Deeble." *KGAA News* 7, no. 3 (1987): 1.
An environment of concrete miniatures of landscapes remembered from travels. The artist lives just down the street from S.P. Dinsmoor's Garden of Eden, at 129 Fairview, Lucas, Kansas but says her inspiration was a concrete garden in Norton, Kansas. At the time of this writing she was "building Mt. Rushmore." Biblio. Illus.

193. "Grassroots Artist: Flavian B. Sidiaren." *KGAA News* 9, no. 2 (1989): 1.
Decorated house and yard of Sidiaren, who lives on "the big island of Hawaii in the town of Honomu, northwest of Hilo on the northern edge of the island, across the road from the post office." He has built an environment he calls Kayumangui, "which translates into 'Good Luck to You'." The article provides details on the appearance of the environment. Illus.

194. "Grassroots Artist: Fred Smith." *KGAA News* 8, no. 1 (1988): 1.
About Smith's famous roadside museum, now called the Wisconsin Concrete Park. Description of the site and over 200 sculptures of "people, animals and tableaux." Information on the artist's life, the materials he used and the restoration undertaken by the Kohler Foundation.

195. "Grassroots Artist: Ida Kingsbury." *KGAA News* 10, no. 2 (1990): 1.
Tells of the rescue of this garden of wooden creations from their site in a Houston suburb just as they were about to be destroyed. About 500 pieces were saved. Biblio. Illus.

196. "Grassroots Artist: Inez Marshall." *Kansas Grassroots Art Association Newsletter* 1, no. 4 (June 1981): 1-2.
Details on the life and the limestone art of Inez Marshall, who ran a museum featuring her work only, the Continental Sculpture Hall, and was an automobile mechanic on the side. Some of the art pieces are described. Illus.

197. "Grassroots Artist: James Hampton." *KGAA News* 11, no. 2 (1992): 1-2.
Information on the life of James Hampton and the throne he created, which is now the centerpiece of the folk art installation at the National Museum of American Art. Mentions Lynda Roscoe Hartigan's years spent studying Hampton's work. Notes other artists in the display in the new folk art galleries at the National Museum. Bibliography. Illus.

198. "Grassroots Artist: Jeff McKissack." *KGAA News* 4, no. 3 (June 1984): 1.
Biographical and other information about McKissack and the creation of The Orange Show. Includes facts about its rescue from

demolition and how to visit the site in Houston.

199. "Grassroots Artist: John Greco." *KGAA News* 5, no. 3 (June 1985): 1.
Story about John Greco who studied for the priesthood but ended up a lawyer in Waterbury, Connecticut. There he built "a replica of the Holyland, to teach people about the Bible and the principles of Catholicism." Many details about the appearance of this now-destroyed site. [Many issues of *KGAA News, The Clarion,* and *Folk Art Finder* carry notices about the futile efforts to save the site from destruction.]

200. "Grassroots Artist: Paul M. Dobberstein." *KGAA News* 8, no. 4 (1989): 1.
Description of an early, religiously inspired grotto in West Bend, Iowa. It was started in 1912 and expanded until Dobberstein's death in 1954. Notes construction, materials used, theme, and says this was the inspiration for the Dickeyville grotto of Father Wernerus in Wisconsin. Says it is open for visitors from June to mid-October: two blocks off Iowa Hwy 15A at the north end of West Bend. Telephone (515) 887-2371.

201. "Grassroots Artist: Pop Shaffer." *KGAA News* 9, no. 4 (1990): 1-2.
Article about "Pop" Shafer, who built and decorated the Shaffer Hotel and Rancho Bonito, in Mountainair, New Mexico. Details about his life and the decoration of the hotel and the dining room, which "housed his collection of wood sculpture, several hundred 'critters,' as he called them, carved from tree limbs that suggested animal forms to him." The hotel and Rancho Bonito, which served as Shaffer's workshop and hideaway, are on the National Register of Historic Places. Shaffer's granddaughter and her husband allow visitors April through October, but only "when the gate is open."

202. "Grassroots Artist: Rasmus Peterson." *KGAA News* 10, no. 3 (1991): 1.
The Peterson Rock Gardens in Oregon are described. The "crop of colored rock he cultivated may have grown from his frustration with the climate and soil of his central Oregon farm," according to his stepdaughter. Information on the artist's life. The site is open daily, has an admission fee, and is located between Bend and Redmond, seven miles south of Redmond on US 97, then two and a half miles west. Telephone (503) 382-5574.

203. "Grassroots Artist: Romano Gabriel." *KGAA News* 3, no. 1 (December 1983): 1.
Feature article on the wooden painted flower garden of artist Romano Gabriel. Description of the Eureka, California site and the successful efforts to save it after Romano's death. Biblio. Illus.

204. "Grassroots Artist: S.P. Dinsmoor." *KGAA News* 8, no. 3 (1989): 1.
Biography of Dinsmoor and family, their migration to Lucas, Kansas, and Dinsmoor's strong support of the populist political movement in the 1980s. Tells about the Garden of Eden site he built and restoration efforts to preserve it at Second and Kansas Streets in Lucas. Telephone (913) 525-6395.

205. "Grassroots Artist: Willard Watson." *KGAA News* 6, no. 2 (March 1986): 1.
Feature article on Willard "The Texas Kid" Watson, who has a yard in Dallas filled with his homemade art. It is described as "a forest of found objects and sculpture." Says Watson and his wife like to have visitors at 6614 Kenwell in Dallas, near Love Field. Biblio. Illus.

206. "Grassroots Artists: Emil and Veva Gehrke." *KGAA News* 6, no. 1 (December 1986): 1.
The Gehrkes built hundreds of windmills from junkyard materials and placed them in their yard in Grand Coulee, Washington. Emil made the constructions; Veva painted them. He was eighty at the start of the project, she was sixty-two. Says a portion of the work was saved; some are on the Coulee City-Grand Coulee Highway, others at a Seattle City Light substation at Freemont Avenue North and North 105th Street in Seattle, Washington.

207. "Grassroots Artists: Paul and Matilda Wegner." *KGAA News* 6, no. 4 (September 1986): 1.
Description of the Wegners' building, "The Glass Church and Peace Garden," a sculptured environment inspired by a visit to the Dickeyville Grotto. The couple and their son Charles built over thirty free-standing sculptures, a church, a garden, and a roadside pulpit—all surrounded by a decorative fence. The property was purchased by the Kohler Foundation as part of its efforts to preserve

the work of visionary artists in Wisconsin. Biblio. Illus.

208. Green, Jonathan. "Leslie Payne: Visions of Flight—A Reconstruction." *Folk Art Messenger* 4, no. 3 (Spring 1991): 1, 3, 4.
Green says "through imitation and homemade construction, Leslie Payne, a poor black fisherman, reinvented himself as Airplane Payne—the proprietor, manager and pilot of the Airplane Machine Shop Company." Describes the creations of Payne using found objects, "aircraft that were vehicles for a series of fantasy flights." Green tells of his project to restore some of the airfield objects and of their exhibition, along with photo and video documentation of the site. [The exhibition was at the Ohio State University Wexner Art Center, January 26-February 24, 1991.]

209. Greenfield, Verni. "Tressa Prisbrey: More than Money." *Raw Vision* 4 (March 1991): 46-51.
Background on Tressa Prisbrey's life and her creation of Bottle Village. Quotes from Prisbrey's own stories and recollections. Description of the site. Illus.

210. Gregson, Chris. "Miles Carpenter: The Man and His Art." *Folk Art Messenger* 2, no. 3 (Spring 1989): 1, 3.
Biographical information about the artist, including the information that "Carpenter enjoyed the success his art brought him, both the money and the acclaim." Information about the work and the way it evolved over the years.

211. Groshek, Matthew, and Leslie Bellavance. "The Work of Wonder." *Art Muscle: A Bi-monthly Publication of the Arts* [*Milwaukee*] 6, no. 3 (April 1992): 27-29.
Information about the "Grotto Shrine," built by the Rev. Philip J. Wagner in Rudolph, Wisconsin. Description of the site, the labor to build the environment, and information about Wagner. The site may be seen and is maintained by the parish of St. Phillip the Apostle in Rudolph. Illus.

212. Grossman, Bonnie. "Alexander A. Maldonado 1901-1989." *The Clarion* 14, no. 2 (Spring 1989): 32.
Notice of the death of Alex A. Maldonado on February 10, 1989 after a brief illness. Information on his life and his art with a photograph of the artist.

213. Grossman, Bonnie. "Alexander Maldonado (1911-1989)." *Folk Art Finder* 10, no. 3 (July 1989): 13.
Obituary notice for the California artist Alex A. Maldonado with information about his background and his art. Illus.

214. Grossman, Bonnie. "Alex Maldonado Dies at 87." *Folk Art Messenger* 2, no. 3 (Spring 1989): 2.
Notice of the death of this California painter and brief information on Maldonado's career as an artist.

215. "A Guide to the Permanent Collection." *The Clarion* (Mid-summer 1978): 27+.
The issue is a pictorial guide to the collection of the Museum of American Folk Art. All periods and forms are included. There is a foreword by Robert Bishop and a history of the museum from 1961-1978 by Adele Earnest.

216. Guralnick, Margo. "Out of This World." *Art and Antiques* (February 1987): 64-67.
About the life of Eugene Von Bruenchenhein. Describes a life of poverty, isolation, and absolute commitment to his art. Says that only a few days after Von Bruenchenhein's death, one of his few friends, a policeman, took his art to a museum, "which aroused a flurry of attention." Illus.

217. Haardt, Anton. "Calvin Livingston." *Folk Art Finder* 11, no. 4 (October 1990): 12.
Sketch about the background and art of Calvin "Red Dog" Livingston. Says he worked for a while with his cousin Charlie Lucas. Haardt details the material he uses and her opinion of his work.

218. Haardt, Anton. "Juanita Rogers." *Folk Art Finder* 3, no. 4 (November 1982): 12-13.
Sketch about the life and art work of rural Alabama artist Juanita Rogers, who made mud pieces and paintings. Illus.

219. Haardt, Anton. "The Zig Zag Zoo." *Folk Art Finder* 11, no. 1 (January 1990): 13.
About a folk art environment in Newport, Oregon created from driftwood by Loran Finch. Nearly all the creations are representations of animals. Illus.

220. Hackley, Larry. "Donny Tolson, Young Kentuckian." *Folk Art Finder* 3, no. 2 (May 1982): 12-13.
Biographical sketch about Donny Tolson, the

son of famous wood carver Edgar Tolson. Information about the younger Tolson's life and art.

221. Hackley, Larry. "Discoveries in Contemporary Kentucky Canes." *Folk Art Finder* 13, no. 2 (April 1992): 14-17.
Describes cane making in Kentucky as a thriving tradition. "As of this writing, over 150 contemporary walking stick makers have been identified." Tells of early influential cane makers, traditional motifs, and some motifs that are more spectacular. Hackley presents examples of two types in detail: "bird handle canes" and "natural forms." Illus.

222. "HAI Collection of Outsider Art." *The Clarion* 16, no. 3 (Fall 1991): 18.
Report of an exhibition of the HAI collection at City Gallery in New York September 23-November 1, 1991. Says the HAI Collection brings together the work of mentally disabled New Yorkers who have participated in HAI's art workshop over the past ten years.

223. "Hall Collection Goes to Milwaukee Art Museum." *The Clarion* 15, no. 2 (Spring 1990): 24.
Notice of the acquisition, through purchase and gift, of "one of the country's premiere private collections." Notes "highlights" of the collection. Illus.

224. Hall, Michael D. "The Mythic Outsider." *New Art Examiner* (September 1991): 16-21.
About the distinctions in concepts that separate the folk art of the folklorist and that of the folk art collector. "The debate continues because ideas of folk and ideas of art vary so much in the minds of people." Discusses impact of the "outsider" on American modernism.

225. Hall, Michael D. "The Problem of Martin Ramirez: Folk Art Criticism as Cosmologies of Coercion." *The Clarion* (Winter 1986): 56-61.
Hall presents a "mini-history" of interpretations of the material called folk art. He describes current definitions of outsider art, and expresses his discomfort with the consequent interpretation of Ramirez. Hall says that he finds it is in its cultural connectedness that art is compelling and that a study of the work of Ramirez show him quite connected. Illus.

226. Hall, Michael D. "You Make It with Your Mind: The Art of Edgar Tolson." *The Clarion* 12, no. 2-3 (Spring-Summer 1987): 36-43.
Information about Edgar Tolson and a visit by Hall to discuss Tolson's art, his motivations, and "the thematic framework for his sculpture." Illus.

227. Hammond, Margo. "The Soho of the South." *Physicians Lifestyle Magazine* 2, no. 3 (March 1990): 16-18.
Brief article on the "art scene in New Orleans." One of the galleries described is the Gasperi Gallery, a pioneer folk art gallery founded in about 1980 and now located in the warehouse district. Color illustration of a David Butler piece.

228. Handelman, David. "Holy Art." *Rolling Stone* (20 April 1989): 65-68.
About Finster's art and the messages he paints "to get the world straightened out." Description of the building of Paradise Garden, Finster's predictions that his own end is coming soon. Illus.

229. Hancock, Butler. "The Designation of Indifference." *New Art Examiner* (October 1992): 21-25.
Detailed reasons for Hancock's belief that "contemporary American self-taught art is an integral part of contemporary art, by any critical scale used to measure it." His evidence is primarily the work of living African-American self-taught artists. Hancock points out that critical attention is often focused on the artist rather than on the art. He says "To dictate that the self-taught artist must first be discussed as a potential victim can become as benignly colonial as the attitude it seeks to remedy." Illus.

230. Hankla, Susan. "Retrieval—Art in the South." *Southern Exposure* (May 1984): 44-46.
Review of an exhibition by the same name at a gallery in Richmond, Virginia. Works by Miles Carpenter, Minnie Evans, Nellie Mae Rowe, Howard Finster, S.L. Jones, Sister Gertrude Morgan, W.C. Owens, Juanita Rogers, Mose Tolliver, and Bill Traylor. "Most of the art was contributed to the exhibition by schooled artists who have, in their work, benefitted from collecting it." Illustrations of eight of the artists' works.

231. Hardee, Rodney, and Janet Fischer. "Edward Ott." *Folk Art Finder* 12, no. 4 (October 1991): 15.

Information about painter Edward Ott, who was born August 29, 1914 in Massillon, Ohio. Ott graduated from high school and then went to work for a steel company. Eventually he passed an exam to become a master plumber and builder and owned his own business. Ill health forced him to retire and to move to a warmer climate. He started painting in Florida, when he was seventy. Ott uses acrylic on canvas board. His subjects come from his memories of real life events. Illus.

232. Harper, Glen. "Outside the Main Stream, Folk Art in Our Time." *Art Papers* (July 1988): 51-52.
Review of the above named exhibition at the High Museum in Atlanta. Harper says "the exhibition concentrates on the work itself rather than on the many disputes surrounding folk and outsider art." Comments on a number of the works and the artists. Illustration of a Charlie Lucas piece.

233. Hartigan, Lynda Roscoe. "Collected with Passion." *The Clarion* 15, no. 3 (Summer 1990): 34-41.
An excerpt from Hartigan's book on the Hemphill folk art collection, most especially that part acquired by the National Museum of American Art and to be exhibited at that institution. Notes. Illus.

234. Hartigan, Lynda Roscoe. "Folk Art at the National Museum of American Art." *American Art Net Work: A Research Newsletter for Scholars of American Art and Culture (Smithsonian/National Museum of American Art)* 4, no. 2 (September 1991): 6-8.
Description of folk art collecting at the National Museum of American Art and issues that require scholarly attention in this field of interest. A few of the issues mentioned are problems of definition, the origins of creativity, a reexamination of aesthetic and cultural attitudes, the relationship of the work of idiosyncratic contemporary folk art to the mainstream, and the appropriate approach to folk art by mainstream art historians.

235. Hartigan, Lynda Roscoe. "The Hemphill Folk Art Collection." *Antiques* (October 1990): 798-809.
About the contents of the Hemphill collection, with information on the art and the artists included. Hartigan says Hemphill ignores the boundaries between craft, art, and popular culture and has altered our concepts of taste, innovation, tradition, function, and community. Illus., color.

236. Hauser, Arnold. "Popular Art and Folk Art." *Dissent* 5 (1958): 229-237.
Detailed analysis of the development of certain concepts in the art world, some of which are dangerous to the artist. Talk of what attracts whom in the art world, including the folk art world.

237. Heath, Leanne B. "An Art of Simplicity." *Southern Homes/Atlanta* (May 1987).
Article about the growing interest in folk art and the way people place it in their homes. Among the artists represented are Nellie Mae Rowe, Lizzie Wilkerson, Mattie Lou O'Kelley, Mose Tolliver, Ned Cartledge, Linda Anderson, Knox Wilkinson, and others. Information on the artists included. Illus.

238. Heath, Leanne B. "Don't Knock Knox." *Art and Antiques* (September 1990).
A brief notice of Georgia artist Knox Wilkinson and the subjects he chooses to paint. Illustrated by a "Portrait of Loretta Lynn" and a photograph of the artist.

239. "Helen Pickle." *Folk Art Finder* 2, no. 4 (September 1981): 12.
Brief sketch of the artist Helen Pickle and her paintings of the rural south. Illus.

240. Hill, Michael. "Interview—Norman Scott 'Butch' Quinn." *The Worker Poet* 12 (1987).
Quinn talks about his favorite artists, the music he likes best, and the material he uses in his art, in this publication from Franklin, Pennsylvania.

241. Hitt, Jack. "The Selling of Howard Finster." *Southern Magazine* (November 1987): 52.
Author reports on visits to Howard Finster and various dealers, mentions Z.B. Armstrong and Sam Doyle, and says that the promotion of folk artists is "art-world hype." Quotes John Vlach as saying "Howard Finster is a wacko" and that "folk art is any funny-looking painting by some guy who is slightly off the edge." The author makes nasty remarks about all the dealers and pickers he meets. The photographs are nice.

242. Hoffman, Alice J. "History of the Museum of American Folk Art." *The Clarion* 14, no. 1 (Winter 1989): 36-63.
Author calls the article an "illustrated timeline." Presents a year-by-year report of events and exhibitions in the museum with major acquisitions, people, special events, and growth of membership. Illus.

243. Hoffman, Alice J. "The Museum of American Folk Art." *Folk Art Messenger* 2, no. 3 (Spring 1989): 6-7.
Detailed information about the Museum of American Folk Art in New York City. Describes services, projects and programs, exhibitions, and publications.

244. Holt, George. "Walter and Dorothy Auman, Potters." *NC Arts* [*North Carolina Arts Council*] (March 1992): 7.
Reports on the deaths of these well-known potters, killed when their van was struck by a load of lumber. Discusses their Seagrove Pottery and their contributions to keeping North Carolina potteries active.

245. Holt, Steven, and Michael McDonough. "Why We Love Folk Art." *Metropolitan Home* (April 1989): 88, 91.
Deplores the neglect of folk art environments such as that of Grandma Prisbrey's Bottle Village, which is illustrated in color. Says the reason to love folk art is not because it is "quaint and cute," but because it is a "powerful mirror held up to our pluralistic culture, just like high art." Traylor illustration too.

246. "Holyland U.S.A." *Folk Art Finder* 1, no. 5 (November 1980): 12.
Article provides a detailed description of artist John Greco's grassroots art site. The unhappy fate of this site in Waterbury, Connecticut may be traced in the *Folk Art Finder* as follows: January/ February 1984, 4 (5) 2, "Holyland USA Vandalized"; September/October 1984 5 (3) 3, "Holyland USA Update" (about the first-time closing of the site to visitors); January/February/March 1987 8 (1) 9, "Holyland USA's Future in Doubt" (about the death of artist John Greco and the plan of a group of nuns to tear the place down); April-June 1987 8 (2) 3, "Holyland Support"; October-December 1988 9 (4) 12-13, "Holyland USA: A Crisis and a Call for Help;" April-June 1989 10 (2) 11, "Holyland USA: A Meeting" (about a meeting between the Save Holy Land committee and the Catholic Campaigners for Christ who want to tear the site down); April-June 1990 11 (2) 10, "Holyland USA—A Finale" (about the arrival of the bulldozers).

247. Horn, Wanda. "N.Y. Art Enthusiasts Get Taste of the South." *Inregister* [*Baton Rouge*] (December 1990): 2.
About a Folk Art Explorer's Club trip to Louisiana, organized by the Museum of American Folk Art. Reports on some of the activities and that the group "heard a talk by Tommy Whitehead about Louisiana folk artist Clementine Hunter."

248. "Howard Finster, Man of Visions: A Retrospective." *Folk Art Finder* 10, no. 4 (October 1989): 8-9.
Review of the exhibition at the PaineWebber Art Gallery in New York City starting September 21, 1989. Biographical notes on Finster and on his "soaring popularity." Illus.

249. "Howard Finster's Folk Art Church." *Folk Art Finder* 2, no. 4 (September 1981): 7.
Finster describes his plan to expand his property in order to have a church.

250. Howarth, Lisa N. "Black Art: Ancestral Legacy." *The Southern Register* (December 1991): 10-11.
Comments on two exhibition catalogs: "Black Art, Ancestral Legacy" and "Next Generation." Howarth says "Not much is said, as usual, about how African-American folk or self-taught artists view scholarly claims about "Africanisms" in their work. She has a number of questions and doubts about the scholarship in the two books.

251. Howlett, Don, and Sharon Howlett. "Folk Heroes Cast in Concrete." *Historic Preservation* (May 1979): 35-38.
About the restoration of Fred Smith's Concrete Park, a folk art site in Wisconsin. The Howletts, who were hired to do the restoration, describe their experiences and methods. There is background on the site and its creator. Illus.

252. Huffman, Allen W. "Traditional Pottery of the Catawba River Valley." *Folk Art Messenger* 3, no. 2 (Winter 1990): 6-7.

About the tradition of pottery production in the above named section of North Carolina, and "the last of the traditional potters" there, Burlon B. Craig of Vale, who is pictured with a very large face jug.

253. Hughes, Robert. "Finale for the Fantastical." *Time* (1 March 1982).
Review of the Corcoran show, "Black Folk Art in America 1930-1980." Assumes that "white" folk art is dead. Speaks of the religious impulse as the dominating vision of the exhibition. Illus.

254. "Images of Experience." *Folk Art Finder* 3, no. 4 (November 1982): 6-7.
Brief article telling about three elderly self-taught artists in the exhibition "Images of Experience" at Pratt Institute. The artists mentioned were Roland Rochette, Stanley Marcile, and Desider Lustig. The curators were Ellen Schwarz, Amy Brook Snider, and Don Sunseri. Illus.

255. "In Memory." *The Clarion* 14, no. 1 (Winter 1989): 25.
Announcement of the deaths of J.B. Murry, who succumbed to cancer at the age of eighty on September 18, 1988 in rural Georgia, and Tressa "Grandma" Prisbrey, who died in San Francisco on October 8, 1988.

256. "Inez Marshall." *Folk Art Finder* 6, no. 1 (March 1985): 9-10.
In 1963 auto mechanic Inez Marshall opened the Continental Sculpture Hall in Portis, Kansas, to exhibit her work. Marshall created 450 pieces of limestone sculpture using only hand tools. She received her inspiration from "voices" and from childhood memories. Her carving began when she was recovering from a serious back injury and continued until October 1984 when she fell ill and died at age seventy-seven. Her life's work was auctioned off to pay her bills. Before this happened, KGAA was given the opportunity to document and photograph the entire collection.

257. "Inez Nathaniel Walker circa 1911-1990." *The Clarion* 15, no. 4 (Fall 1990): 23.
Obituary notice for Walker that tells about her life-long poverty, her imprisonment in Bedford Hills, and her later confinement at the Willard Psychiatric Center.

258. "Intuit Presents Its First Lecture Series, Fantastic Spaces." *In'tuit* 1, no. 1 (March 1992): 4-5.
Tells of a lecture series about "the world of environments created by self-taught artists." John Maizels, publisher of *Raw Vision,* gave an overview of environments in Europe, Asia, and Africa. Susanne Demchak of The Orange Show: A Folk Art Foundation in Houston did the same for the United States. Restoration specialist Don Howlett talked about three Wisconsin environments.

259. Irwin, John Rice. "Dow Pugh." *Folk Art Finder* 2, no. 4 (September 1981): 4-6.
Information about Pugh's background, how he started making art, and the growing interest in him by folk art collectors. Illus.

260. "Isidore Moskowitz." *Folk Art Finder* 2, no. 1 (March 1981): 12.
Sketch about a Hungarian-born (1896), self-taught painter who came to the United States at age seventeen and worked as a tailor until he and his wife were able to open an ice cream parlor business. He retired in the 1960s and lived in Florida. "At age seventy Moskowitz began making pencil sketches on scraps of paper. A gift of three colored felt-tipped pens from his son launched him into color." His themes are memories of his life, nature, and current events. His work is in the permanent collection of the Museum of American Folk Art. Illus.

261. "Jack Forbes." *Folk Art Finder* 3, no. 1 (March 1982): 7.
Sketch about painter Jack Forbes, who was born in California and lived with his mother in Novato while he drove a cab in San Francisco to make a living. He executed paintings on canvas with oil or acrylic. Author says "Jack Forbes' paintings are a sharp contrast with his autobiography. His many-peopled nostalgic paintings convey a sense of tranquility." His life did not. Illus.

262. "James Bright Bailey." *Folk Art Finder* 3, no. 1 (March 1982): 12-13.
Sketch of Bailey, who was born in 1908 and lived most of his life not far from Charlotte, North Carolina. Includes information about his life, his disability and retirement at age fifty-nine as a result of having worked in an asbestos plant, and his wood carvings. Details on the kind of wood he uses and his tools. Illus.

263. "Jankiel ("Jack") Zwirz 1903-1991." *The Clarion* 17, no. 1 (Spring 1992): 16-17.
Notice of the death of this self-taught painter, who lived in Memphis, Tennessee and was a survivor of Nazi horror during World War II. Brief information on his life and art. Photograph of the artist.

264. Jannot, Mark. "Outside In." *Chicago* (July 1992): 78-83, 99-101.
Author gives an overview of major issues confronting those interested in the field: definitions; aesthetics; the art versus the artist and which is more important; labels; prices and other matters of the market place; questions about integrity; whether or not the "in-ness" of outsider art will destroy it; and much more. There is a focus on the awareness of outsider art in Chicago with a point of view that only Chicago has had a consistent and serious appreciation of this art over the years. Information about the early and steady interest in non-academic art by Chicago artists and gallery owners. Reports of conversations with artists. Many illustrations of art and artists including David Philpot, Eugene Von Bruenchenhein, Lee Godie, Mr. Imagination, and Simon Sparrow.

265. "Jargon Society Exhibits Southern Visionary Folk Art." *Folk Art Finder* 6, no. 2 (May 1985): 4-5.
Information on the founding of the Jargon Society by the poet Jonathan Williams, at Black Mountain College in 1951. Details provided about the project named in the title above and the results: publications, exhibitions, archives, preservation efforts. The first exhibition contained 300 works by twenty visionary artists from nine southern states. Among the artists shown were Annie Hooper, Bernard Schatz, St. EOM, Georgia Blizzard, Leroy Person, Howard Finster, Sam Doyle, William Owens, Dilmus Hall, and James Harold Jennings. At the end of the article there are biographical sketches of Annie Hooper, Georgia Blizzard, and Bernard Schatz with information on the art. Illus. [Information on the Jargon Society is also in *KGAA News,* 5 (4) Fall 1985]

266. Jarmusch, Ann. "Mysterious Stranger." *Art News* (September 1986): 166.
An article about the objects made by the anonymous creator called the Philadelphia Wireman. Tells of their discovery and the impression made on various art people. Photograph of one piece.

267. "Jeff McKissack." *The Orange Press* [*Newsletter of the Orange Show Foundation*] (March 1991).
Interview in a publication of The Orange Show: A Folk Art Foundation, which took place between Tom Sims and Orange Show site builder Jeff McKissack, just before McKissack's death. McKissack describes how he built the structures, the materials he used, the ideas for a "side show," and the fact that he must live in poverty to support his vision.

268. "Jesse 'Outlaw' Howard: A Brief Biography." *In'tuit* 1, no. 1 (March 1992): 1.
Information on Jesse Howard's youth, where he worked and traveled, and his settling down on twenty acres in Fuller, Missouri in 1944 "which would become his family's final home." Tells about his signs—their placement, their content, what the environment looked like, his neighbors' attitude toward them. Information on a scheduled exhibition of his works by In'tuit. Sources given. Illus.

269. "Jimmy Lee Sudduth." *Folk Art Finder* 3, no. 5 (January 1983): 12.
Details about Fayette, Alabama artist Jimmy Lee Sudduth with special emphasis on the materials from nature he uses to paint on scrap plywood.

270. "Jimmy Williams." *Folk Art Finder* 11, no. 1 (January 1990): 12.
Jimmy Williams carves wood in his spare time, when not working for a North Carolina furniture company. He was born in 1946, in Marion, North Carolina. Don Glugover of Devotion House Antiques in Valdese, North Carolina (who supplied the information for this sketch) says Williams "sells his work sporadically when he is in need of money." Illus.

271. "J.M. Kohler Voyages Exhibit." *Folk Art Finder* 7, no. 3 (July 1986): 4-5.
Description of a three-part exhibition at the Kohler Arts Center in Wisconsin. One of these parts is "Sightings: Boat Images by Outsider Artists," which includes work by Leslie Payne, Walter Flax, Frank Wolfert, David Butler, Howard Finster, William Hawkins. The exhibition was on view May 18-August 10, 1986.

272. "Joe Barta." *Folk Art Finder* 1, no. 5 (November 1980).
Article about the Wisconsin woodcarver, Joe Barta, who built a Museum in Spooner, Wisconsin to house what was then about 500 small carvings. He then decided to carve the story of Christianity and made eighty-five carved figures, life-size, of the Last Supper and other religious scenes. Illus.

273. "Joe Hardin 1921-1989." *Folk Art Messenger* 3, no. 3 (Spring 1990): 7.
Notice about the death of Joe Hardin. "Severly crippled by rheumatoid arthritis since he was a child, Joe Hardin lived a life full of loneliness, pain and poverty. He started painting in the 1970s and had only recently received any recognition." Hardin died December 25, 1989 in Birmingham, Alabama.

274. "John Ehn and Old Trapper's Lodge." *Spaces*, no. 6 (June 1987): 1.
Feature article about Ehn and the environment he created. In addition to the biographical details and the description of the site, there is information on the efforts being made to preserve it. Illus.

275. "John (Frank) Vivolo." *Folk Art Finder* 13, no. 4 (October 1992): 14.
Brief information about Frank Vivolo's life and art. He is the son of the late folk carver John Vivolo. Frank is a carver too.

276. "John Greco (1895-1986)." *Folk Art Finder* 7, no. 3 (July 1986): 2.
Notice of the death of John Greco, who created the environment Holyland USA in Waterbury, Connecticut. Greco died March 9, 1986. Information on his life and the site he created.

277. "John 'Jack' Savitsky 1910-1991." *The Clarion* 17, no. 1 (Spring 1992): 16.
Notice of the death of Pennsylvania coal miner/painter Jack Savitsky with brief biographical details and a photograph of the artist.

278. "John ("Jack") Savitsky 1910-1991." *Folk Art Messenger* 5, no. 5 (Spring 1992): 5.
Notice of the death of Savitsky on December 4, 1991 at the age of eighty-one "of a heart attack following surgery."

279. "John Vivolo (1887-1987)." *Folk Art Finder* 8, no. 3 (September 1987): 2.
Notice of the death of Vivolo at his home in Bloomfield, Connecticut three months after his hundredth birthday. "We will remember him as a friend, a creative artist, a man of enormous energy, one who managed his life with a fierce independence up to his last months."

280. "John Vivolo at 100 Years." *Folk Art Finder* 8, no. 1 (January 1987): 5.
Information about the life and accomplishments of John Vivolo with an illustration of one of the painted and carved wooden figures for which he is noted.

281. "John Vivolo, Connecticut Folk Sculpture." *Folk Art Finder* 1, no. 1 (March 1980): 8.
Descriptions of the artist/carver John Vivolo and the wooden carved figures he called "my wooden children." Says that in his later years the painting seemed to become as important to Vivolo as was the carving. Illus.

282. Johnson, Rhonda S. "Harmon Young: Georgia Wood Sculptor." *Southern Folklore Quarterly* 42 (1978): 243-256.
Details about the life and work of a wood sculptor of human statues who gets his ideas from dreams and visions. Illus.; black & white.

283. Johnston, Pat H. "E.R. McKillop and His Fabulous Woodcarving." *Antiques Journal* 33, no. 11 (November 1978): 16-18, 48.
Tells of looking for information about the artist, finding little documentation in libraries and eventually tracking down family members who shared memories. Information on pieces in museum collections. Illustrations of carvings.

284. "Jon Bok." *Folk Art Finder* 9, no. 3 (July 1988): 4.
Sketch about the life and art constructions of folk art furniture maker Jon Bok of Los Angeles, California.

285. Jones, Seitu. "Public Art that Inspires: Public Art that Informs." *Public Art Review* 2, no. 2 (September 1990): 8-9.
Written by an artist living in St. Paul, Minnesota, this essay is about the meaning of public art in African-American communities and his own "aspirations to create environmental artworks to honor, inform and inspire communities." Jones comments on the "yard art" of Derek Webster, with an illustration.

286. Jordan, George E. "Folk Art Finds Its Niche." *Louisiana Life* (July 1983).
Notes growth of interest in contemporary folk artists and says "as the artists work, scholars debate the possible explanations for the significance that has been placed on folk art in the Space Age." He says it is perhaps because the public was ready for something honest. Jordan says there was no gallery specializing in folk art until the Gasperi Gallery opened in 1980.

287. "Joseph Endicott Furey (1906-1990)." *The Clarion* 16, no. 2 (Summer 1991): 14.
Notice of the death of Joseph Furey, the creator of a mixed-media painted and decorated environment in his Brooklyn apartment. He died November 12, 1990 in Goshen, New York, where he had moved to live with his son. The art is described as "a spectacular collage of rooms that shimmer with color and excitement." Photograph.

288. "Joseph Laux." *Spaces,* no. 11 (June 1991): 3.
"Joseph Laux (1904-1991) died March 1, 1991 in a hospital near his Deptford, New Jersey home. Laux is known for his hand-crafted Fairy Garden he built next to his home." A description of the environment follows, with the information that his wife Eva will care for the garden. The garden included in the exhibition catalog for "Two Arks, A Palace, Some Robots, & Mr. Freedom's Fabulous Fifty Acres: Grassroots Art in Twelve New Jersey Communities" by Holly Metz. Illus.

289. Joyner, Phyllis, and Gerard Haggerty. "Folk Art at Fancy Prices: The Case of Thornton Dial, Sr." *Folk Art Messenger* 3, no. 3 (Spring 1990): 1, 3.
Review of an exhibition featuring several members of the Dial family of artists, at the Ricco/Maresca Gallery in New York. Says the paintings "evoke the specter of neo-expressionism." Although most of the article is about the art, the comment that "this show established record-breaking prices" and "provoked serious questions about the relationship between folk art and big business" (some of the paintings were priced as high as $50,000) resulted in an interesting response on corporate letterhead [see *Folk Art Messenger,* Summer 1990, p.2].

290. "Juanita Rogers (1934-1985)." *Folk Art Finder* 6, no. 2 (May 1985): 17.
Notice of the death from cancer of Juanita Rogers. "Juanita was known for her 'funny brick' sculptures of Raw Vision clay and her tempera paintings of animals and people. Her work was discovered and promoted by Anton Haardt of Montgomery, Alabama."

291. "Just Plain Folk." *Horizon* (March 1984): 37-43.
Excerpt from *American Folk Art of the Twentieth Century* by Johnson and Ketchum. Robert Bishop's forward from the book talks about what is folk art. He notes that there are artists today who work in the folk art tradition, but they are not folk artists. He says these neo-naives and marketplace inspired artists working in the folk art style should be judged for what they are and what they create. Illus., color.

292. Kahn, Alison. "Generations in Clay: The Potters of Seagrove, North Carolina." *National Geographic Traveler* (July 1989): 67-70.
Description of the countryside and farm community around Seagrove, North Carolina, "some forty backcountry miles south of Greensboro, where the potter's trade is a heritage." Describes thirty potteries and their wares, including "ugly face" jugs. Illustrations include a face jug by Billy Ray Hussey, and a map of the area.

293. Kalb, Laurie Beth. "Gene Autrey Western Heritage Museum." *Folk Art Messenger* 5, no. 2 (Winter 1992): 9.
Profile of the museum that focuses on the art and artifacts of the western United States. The collection includes six *santos* by Enrique Rendon. The museum is located in Griffith Park in Los Angeles.

294. Kallir, Jane. "Grandma Moses, The Artist Behind the Myth." *The Clarion* (Fall 1982): 52-55.
Describes those who supported Moses, those who ridiculed her. Says her place is with the earliest artists—Kane, Hirshfield, Pippin—and since all of them died soon after being discovered by the art establishment, "only Moses had the opportunity to come to terms with art in a professional manner." Details on Moses' life, art, development as an artist. Illus.

295. Kallir, Jane. "John Kane: Modern America's First Folk Painter." *The Clarion* (Spring-Summer 1984): 49-55.

Kallir says "Kane was the first twentieth century American folk painter to win acclaim during his lifetime. He started a trend that fostered genuine folk artists such as Horace Pippin and Grandma Moses, and also an entire flock of pseudo-naives." Biographical information and artistic recognition.

296. Kangas, Gene. "Zoratti's Garden." *Folk Art* 17, no. 3 (September 1992): 42-47.
A cticle about Ohio self-taught artist Silvio Peter Zoratti, a native of Italy, with information about his personal history, his stone sculpture, concrete animals, and wood carvings. Illus.

297. Karlins, N.F. "Floretta Emma Warfel: Needleworker and Folk Painter." *Folk Art Messenger* 2, no. 4 (Summer 1989):8.
Biographical notes and description of her art. After years of doing needlework, Mrs. Warfel discovered that she could use embroidery paint from the tube to make a painting; using old cloth instead of canvas she began to make the colorful rural scenes of her memories. Illus.

298. Karlins, N.F. "Four from Coal Country: Friendships and the Contemporary Folk Artist." *The Clarion* 12, no. 2-3 (Spring-Summer 1987): 54-61.
Karlins argues that contemporary folk artists are impervious to influences on their style from their peers. She provides information on four artists in Pennsylvania—Jack Savitsky, "Old Ironsides" Pry, Justin McCarthy, and Charlie Dieter—and says their work was never influenced by the others, that the stylistic continuity in their paintings is a result of their psychological estrangement from life.

299. Karlins, N.F. "Norman Scott 'Butch' Quinn." *Folk Art Finder* 12, no. 2 (April 1991): 12.
Biographical information and description of the art. Quinn paints and sculpts using found materials. Illus.

300. Katherine, Anna. "Sylvia Johnson, Fabric Artist." *The Santa Fean* (August 1987): 52, 55.
About her background, both "native New Mexican and Anglo" and how it inspired the art she does now, from "thinking and feeling and dreams." She began by making pictures from fabric, broken jewelry, shells, feathers, and crystals. Now she more often paints on canvas with acrylics. Illus.

301. "Keller Sincerbox." *Folk Art Finder* 5, no. 4 November 1984): 14.
A sketch about a Bath, New York resident who started carving when he retired from his job at the Taylor Wine Company in 1981. One of his large wood sculptures is in the collection of Fenimore House, according to the article. Illus.

302. Kelly, True. "A Personal Tribute to William Massey, 1908-1990." *Folk Art Messenger* 3, no. 3 (Spring 1990): 7.
Details about the death of Willie Massey as a result of injuries sustained in a fire in his home in Kentucky. Includes information about his art and his exhibitions. Photograph of the artist.

303. Kent, Rosemary. "Sister Gertrude Morgan." *Andy Warhol's Interview* (September 1973): 41-42.
About Morgan's various activities to support her Everlasting Gospel Mission-riding the St. Charles Avenue street car, walking the streets of the French Quarter, singing her sermons for donations. At home in her mission, "Gertrude quietly painted her prayers." Information about her discovery by the art world.

304. "Kentucky's Fabulous Folk Art." *Southern Living* (May 1992): 2, 4.
Information about the development of the "Folk Art Collection" at Morehead State University in Kentucky. Says there are now fifty artists represented and over 400 pieces in the museum-like collection. Efforts of curator Adrian Swain are noted. Sketch about the home environment and life of artist Hugo Sperger is used to represent creative people in northeastern Kentucky. There is also information on the folk art marketing program at Morehead.

305. Kiah, Virginia. "Ulysses Davis: Savannah Folk Sculptor." *Southern Folklore Quarterly* 42, no. 2-3 (1978): 271-286.
Information on the artist's childhood, on his becoming a barber. Description of the barbershop where Davis' works were on display. The window and door frames were all carved in an abstract floral motif. Author describes the varieties of carving done by Davis. Quotes from Davis about his work. Illustrations of work, tools used.

306. Kimm, Todd. "New Discoveries in Mid-western Folk Art." *Folk Art Finder* 13, no. 4 (October 1992): 4-5.
About dealer Sherry Pardee who worked for three years as a folklorist in Iowa and found that approach too limiting as she shifted her interest from the works of traditional craft to the art of self-taught folk and outsider artists—motivated in part by her discoveries of "fascinating independent visions" and her frustration at their "exclusion." Tells about her discoveries to date of close to 30 self-taught artists.

307. Kind, Phyllis. "Some Thoughts About Contemporary Folk Art." *American Antiques* (June 1976): 28-32, 44.
Discusses terms, which the author says she would rather avoid, influences on mainstream American art, and the artworks of P.M. Wentworth, Joseph Yoakum, Martin Ramirez, and some others. Illus.

308. Kirwin, Liza. "Folk Art Resources at the Archives of American Art." *American Art Net Work: A Research Newsletter for Scholars of American Art and Culture (Smithsonian/National Museum of American Art)* 4, no. 2 (September 1991): 9-11.
Discusses the Archives of American Art and the collections of special significance to those interested in folk art. Among these are: the records of Edith Halpert's American Folk Art Gallery; correspondence, reports, photographs, and other printed material from Holger Cahill; the papers of Jean Lipman; the papers of Herbert Waide Hemphill, Jr., which include letters from artists Howard Finster, S.L. Jones, Miles B. Carpenter, Gustav Klumpp, George Lopez, Luis Tapia, Alex Maldonado, E.O.Martin, and Sister Gertrude Morgan; and correspondence and files from early folk art dealer Jeffrey Camp, who owned the American Folk Art Company in Richmond, Virginia. Kirwin describes difficulties of collecting documentation from non-traditional artists. She asks the question, "Does this out-of-the-ordinary art require new forms of documentation?" Materials from folk artists represented in the archives are noted.

309. Kirwin, Liza. "Documenting Contemporary Southern Self-Taught Artists." *The Southern Quarterly: A Journal of the Arts in the South* 26, no. 1 (September 1987): 57-75.
Describes collecting documentation on contemporary self-taught artists for the Archives of American Art, which houses papers of artists, collectors, and dealers. Says many of the elderly self-taught artists are illiterate, so that one has to substitute such records as videos, photos, slides, and site plans for written records. Illustrations include the yard environment of David Butler, Sam Doyle at home, Royal Robertson and his house and garden, Howard Finster in Paradise Garden, and others.

310. Klein, Susan, and Susan Rolenstreich. "The Acquisitor's Eye." *Art and Auction* 9, no. 10 (May 1987): 130-133.
Describes the scope of the Hemphill collection and the decision to place a core selection in the National Museum of American Art. Many individual pieces are described. Hemphill's history as a collector, writer, and museum curator is noted. Illus.

311. "Knox Wilkinson." *Folk Art Finder* 6, no. 4 (November 1985): 10-11.
Article about "the mildly retarded folk artist" from Rome, Georgia and how his talent was discovered when his mother enrolled him in a program that encouraged creativity in handicapped people. Article tells about the painter's subject matter and artistic recognition. Illus.

312. Kogan, Lee. "Living in a Brooklyn Folk Environment." *The Clarion* 15, no. 2 (Spring 1990): 51-55.
Article, with color illustrations, of the Brooklyn, New York apartment of Joseph E. Furey. Gives some background on Furey and descriptions of his art, which covered the surfaces of his apartment with his own designs from shells, stones, ceramics, and other found objects. Also tells of the two people who decided to live in the apartment in order to save it.

313. Kogan, Lee. "New Museum Encyclopedia Shatters Myths." *The Clarion* 15, no. 5 (Winter 1990-1991): 53-56.
Article discussing the research that went into theMuseum of American Folk Art Encyclopedia of 20thCentury American Folk Art and Artists, by Chuck and Jan Rosenak. One of the detailed examples provided by Kogan is the tracing of the life of artist "Peter Charlie" and

the discovery that his surname was Besharo, not "Bochero" as it is usually given.

314. Koota, Sharon D. "Cosmograms and Cryptic Writings: 'Africanisms' in the Art of Minnie Evans." *The Clarion* 16, no. 2 (Summer 1991): 48-52.
The author reviews the arguments that tie the art of Minnie Evans to African origins. Notes. Illus.

315. Kroll, Jack. "The Outsiders Are In." *Newsweek* (25 December 1989): 72-73.
About the growth in popularity and prices for twentieth century American folk art. Illustrations in color (Finster, Hawkins, Butler).

316. Kuspit, Donald B. "American Folk Art: The Practical Vision." *Art in America* (September 1980): 94-98.
Reaction to "the Whitney Museum's recent folk art exhibition"—works by 37 identifiable artists spread over three centuries. Kuspit challenges the romantic ideas that have been put forth as explanations for folk art. Says "there is really nothing mysterious about folk art; the clarity of folk painting may be attributed to the desire of the makers to produce useful records." Illustrations include John Kane and Steve Harley.

317. Kuspit, Donald. "The Appropriation of Marginal Art in the 1980's." *American Art* 5, no. 1-2 (December 1991): 133-141.
Says the climate of the 1980s facilitated "the commercial appropriation and intellectual administration of marginal art," that the "distinction between mainstream art and marginal art is a social construction," that "folk is a sociopolitical construction," and that much of this has to do with "official culture's unconscious uncertainty that its values are lasting."

318. Laffal, Florence. "Elijah Pierce's Walking Stick." *Folk Art Finder* 13, no. 2 (April 1992): 19.
Laffal quotes from a catalog [*The Grand Generation: Memory, Mastery, Legacy*] a description of Elijah Pierce's walking stick, which took him twenty years to complete. Says it is a thirty-six inch piece of wood, carved, painted, and decorated with rhinestones. The carvings are incidents from Pierce's life. Illus.

319. Laffal, Florence. "Spirits." *Folk Art Finder* 12, no. 2 (April 1991): 4-6.
Detailed review of the exhibition of the collec-

tion of Geoffrey Holder and Carmen De Lavallade at the Katonah Museum of Art with comments on individual pieces.

320. Laffal, Florence. "Toward a Democratization of Art." *Folk Art Finder* 8, no. 1 (January 1987): 4-5.
Author presents her evidence "that folk art today is evolving to be an art of all people, expressing the democratic spirit of our society."

321. Laffal, Florence. "What Is Folk Art?" *Folk Art Finder* 1, no. 1 (March 1980): 1, 4-5.
Discusses definitions and characteristic elements of folk art in terms of "Tools and Materials," "Perspective," "Color," and "Style."

322. Laffal, Florence, and Jules Laffal. "Categorizing Folk Art." *Folk Art Finder* 7, no. 1 (January 1986): 18-19.
The authors present a scale from "1" (Idyllic) to "5" (Raw Vision) and measure some contemporary folk artists against it.

323. Laffal, Jules. "The Future of Folk Art." *Folk Art Finder* 5, no. 2 (May 1984): 2-3.
Says folk art refuses to be bound by the folklorists' narrow definitions. Expects an "explosion of folk art" in the future and explains why.

324. Laffal, Jules. "The Life and Art of Walking Sticks and Staffs." *Folk Art Finder* 13, no. 2 (April 1992): 4-7, 28-31.
Notes that the walking stick has become popular with folk artists in recent years as an art form. Details the world history of staffs from the days of the Egyptian Pharaohs through various world cultures and on into the present.

325. Laffal, Jules. "Monetary Value of Folk Art." *Folk Art Finder* 7, no. 4 (October 1986): 4.
Says the monetary value of a work is determined by more than just artistic merit and details such factors as recognition, supply, age of the work, provenance, condition, and place of purchase. Mentions that dealers have expenses far beyond the purchase price of a work.

326. Laffal, Jules. "Review, The New Art Examiner's Special Issue on Folk Art." *Folk Art Finder* 13, no. 1 (January 1992): 2.
Five articles on folk/outsider art in the September 1991 issue of *New Art Examiner*, all of which appeared to have been carefully selected to grind somebody's ax, are commented upon by Jules Laffal. On Michael Hall: "In a dis-

cussion of outsiders one might expect some point of reference, but nowhere in the article are 'insiders' identified." On John Michael Vlach: "Given the tidal wave of usage—a decisive factor in language—which has been the fate of 'folk art,' Vlach's plea for a folklorist definition seems quite forlorn." About Roger Manley's concern for the impact of the marketplace on creativity, Laffal says, "worthy of serious thought." Julie Ardery's critiques of three periodicals in the field is said to provide a "lingering impression of carping and faultfinding." The article by artist Leroy Almon is the only positive one in the selection. [For the citation to each original article, look under author's name.]

327. Laffal, Jules. "William J. Dwyer." *Folk Art Finder* 4, no. 5 (January 1984): 4-6.
About an "outsider" artist who was admitted to a psychiatric hospital at the age of thirty-one, was let out until his behavior alarmed his family and others, and then spent the next sixteen years in a psychiatric hospital working on art projects. Tells about the kind of work he created and how prolific he was when in the hospital. Dwyer made over 300 paintings from 1960 to 1966. Laffal says "Dwyer's themes are architectural and symbolic, with a strong sense of stage, costume and drama." Moved to a nursing home, he abandoned his painting "without regret." Illus.

328. Laffal, Jules, and Florence Laffal. "Characteristics of Folk Art, A Study Presented at the American Psychological Association Conference." *Folk Art Finder* 5, no. 3 (September 1984): 2, 4.
A paper, "Demographic Characteristics of Contemporary Self-Taught Artists," presented at the annual convention of the American Psychological Association. Says the authors "devised a system for scoring artists on the basis of age, occupation, circumstances of beginning art, media, themes, subject matter, and style." Notes on results.

329. Laffal, Jules, and Florence Laffal. "Geographic Distribution of American Folk Artists." *Folk Art Finder* 5, no. 4 (November 1984): 2-3, 19.
From a study of American folk artists done by the Laffals, information on the geographical distribution by region, state, and ethnic background.

330. Laffal, Jules, and Florence Laffal. "Thematic and Stylistic Differences Among Memory Artists." *Folk Art Finder* 5, no. 3 (September 1984): 4-7.
Report on the examination of a number of works classified as "memory paintings," with conclusions that "as an art of a remembered past, it can be as unique in style and content as the individuals who create it."

331. Lamar, May. "Mose T's Daughter Annie Paints a New Picture." *Montgomery.* (August 1990): 12-14.
Says Annie Tolliver has been painting pictures for four years—with her father's famous signature. Marcia Weber, a Montgomery gallery representative, says some dealers are "not pleased" to hear they may have bought Annie T.'s and not Mose Tolliver's paintings. Annie Tolliver intends to sign her own work from now on.

332. Lampell, Ramona. "Cher Shaffer." *Folk Art Finder* 12, no. 4 (October 1991): 5-7.
In the introduction to this biographical sketch, Ramona Lampell notes that many collectors are disappointed to learn that Cher Shaffer is white and relatively young since they prefer their self-taught artists to be black and/or elderly, half-literate, and quaint. This biographical sketch is a detailed description of inspiration and motivation for art work written by this self-taught artist. (Shaffer is also neither half-literate nor quaint.) The artist, her husband, and her three children live in Parkersburg, West Virginia. Illus.

333. Langsner, Jules. "Sam of Watts." *Art and Architecture* (July 1951): 23-25.
The photographic essay that "initially brought national attention to the Towers" built by "Sam" Rodia in Los Angeles.

334. "Larry Whiteley 1934-1987." *The Clarion* 13, no. 2 (Spring 1988): 21.
Notice of the death of a well-known collector and dealer in folk art.

335. Larson, Kay. "Varieties of Black Identity." *New York* (2 August 1982): 522-53.
Comments on the art and artists in the "Black Folk Art" exhibition, originating at the Corcoran and at the time of this article on exhibit at the Brooklyn Museum.

336. Larson-Martin, Susan. "Pioneers in Paradise." *The Clarion* (Spring-Summer 1985): 55-61.
Detailed information on the exhibition named in the title. "First exhibition of its kind to trace the development of folk and outsider art of the West Coast, from the earliest days of settlement to present times."

337. Ledes, Allison Eckardt. "The Best in Folk Art—One Museum's View." *Antiques* (October 1990): 616, 620.
Review of the exhibition "Five Star Folk Art" at the Museum of American Folk Art, which consisted of "one hundred items covering all periods, chosen for their aesthetic excellence by pioneer collector Jean Lipman." Written with assistance from Robert Bishop, Elizabeth Warren, and Sharon Eisenstadt. Describes "recent trends" in the appraisal of folk art.

338. "Lee Godie Has Solo Show." *KGAA News* 10, no. 4 (1991): 4.
About Godie's first solo exhibition, at the Carl Hammer Gallery in Chicago, September 1991. Information on her background and "her impressions of her new found status in the mainstream of the art world." Illus.

339. Leighton, Fred. "Restoration of Paradise Garden." *Folk Art Finder* 9, no. 1 (January 1988): 1-2.
Leighton describes how he and three other students volunteered their time in the summer of 1987 to help Howard Finster begin restoration of Paradise Garden. Illus.

340. Lieberman, Laura C. "The Southern Artist: Clementine Hunter." *Southern Accents* (August 1987): n.a.
Says Clementine Hunter is the finest chronicler of the world of Cane River and Natchitoches, the oldest settlement in the Louisiana Purchase, established in 1714. Includes many biographical details. Tells of Cammie Garrett Henry, who made Melrose Plantation a cultural mecca, the residency of writer Francois Mignon, and Hunter's discovery of her own talent by using paints left behind by others. "She painted from her mind, not from things in front of her."

341. "Living Museum at Creedmoor." *Folk Art Finder* 10, no. 2 (April 1989): 6-7.
Tells of the conversion of a floor at this psychiatric center into a museum of patient art. Illus.

342. Lora, Mary Elaine. "The Tin Man." *Louisiana Life* (May 1982): 109-110.
Description of David Butler's yard art, before all the pieces were taken away and the environmental aspect of his work ceased to exist. Information about his life also.

343. Lorenz, Particia Brincefield. "A Different Passion: Hemphill Folk Art Collection Opens at the National Museum of American Art." *Folk Art Messenger* 4, no. 1 (Fall 1990): 1, 3.
Detailed review of the opening of the Hemphill Collection at the National Museum of American Art. Lorenz says it is now considered one of the museum's most significant collections. Exhibition based on the 427 works of art acquired since 1986 from Hemphill. Illus.

344. Lorenz, Patricia Brincefield. "The Herbert Waide Hemphill, Jr. Collection of American Folk Art." *Folk Art Messenger* 1, no. 3 (Spring 1988): 1.
Information about the collector and his impact on contemporary folk art. Illustrated with Howard Finster's portrait of Hemphill.

345. "Lorraine Gendron." *Folk Art Finder* 8, no. 1 (January 1987): 12.
Information about the background and accomplishments of Lorraine Gendron, who lives in Hahnville, Louisiana and makes a variety of sculptured pieces from Mississippi River mud that represent people and activities in her mostly Cajun community and in New Orleans. Illus.

346. "Louis Monza." *Arts Magazine* (June 1985): n.a.
Review of an exhibition of Monza's art. Commentary on its qualities, questions about labels to apply to the work, and a few background notes on the artist's life.

347. "Louis Monza." *Folk Art Finder* 6, no. 3 (September 1985): 14.
Brief sketch about the life and art of painter Louis Monza. "His themes center around political events and social injustice."

348. Lowe, Warren C. "Mildred Foster Clark, Floyd Clark." *Folk Art Finder* 4, no. 5 (January 1984): 12-13.
Biographical information about two of the artists included in the exhibition, "The Eyes of Texas," which took place in Houston in 1980. Says "Floyd Clark paints vivid compositions of

cats, angels, watermelons, flowers, and animals on cardboard or particle board. He also sculpts animals from red clay dug near his house and paints them with the same paint he uses on the boards." Mildred, who painted with acrylic on cardboard, with frames made by Floyd, died soon after the exhibition. Illus.

349. Lowry, Robert. "Steve Harley and the Lost Frontier." *Flair* (June 1950): 12-17.
Essay about the life of the artist and the inspiration for his paintings, "three great pictures" created in the Northwest in 1927 and 1928. All three paintings are reproduced.

350. Lubell, Ellen. "Martin Ramirez/Phyllis Kind." *Arts Magazine* (May 1976): 26.
Review of an exhibition at the Phyllis Kind Gallery February 14-March 13, with detailed commentary on such matters as subject matter, materials used, and style in the art of Martin Ramirez.

351. Lucas, Nora. "The Icons of John Perates." *The Clarion* (Winter 1980-1981): 36-41.
A Special Exhibition Catalog.
Life and art of Perates. Author says "the icons of John Perates are a true example of the translation of old-world aesthetic tradition into American folk art." Exhibition checklist. Nine black and white illustrations of his work.

352. Ludwig, Allan J. "Holy Land U.S.A.: A Consideration of Naive and Visionary Art." *The Clarion* (1979): 28-39.
Detailed description of the now destroyed site and the man who made it. Ludwig finds links with this work to that of other visionaries and to surrealism. Notes. Illus.

353. "Luster Willis 1913-1990." *Folk Art Messenger* 4, no. 3 (Spring 1991): 9.
Brief notice of the death of Luster Willis in Egypt Hills, Mississippi on October 26, 1990. Mentions his inclusion in several important exhibitions.

354. MacGregor, John. "AG Rizzoli: The Architecture of Hallucination." *Raw Vision* 6 (June 1992): 52-53.
About the discovery of A.G. Rizzoli's work by Bonnie Grossman of The Ames Gallery in Berkeley, California. There is biographical background on the artist, descriptions of his various projects and of "his role as 'transcriber' of heavenly messages and visions . . . who spent forty-two years as early architectural assistant to God . . . in the design of elaborate Neoclassical buildings required in Paradise." MacGregor also tells something about Rizzoli's prose communications and says that "no one seems to have known that for the final nineteen years of his life he was engaged in writing the third part of the Bible." Illus.

355. Maclagan, David. "The Art of Martin Ramirez." *Raw Vision* 6 (June 1992): 40-45.
The writer considers the art of Martin Ramirez, particularly his imagery and the relationship between his art and his psychological state. There is considerable attention to the work itself. The author does raise some questions asked too infrequently about the life situation Ramirez found himself in and the role it played in his mental state.

356. "Made with Passion: The Hemphill Folk Art Collection of the National Museum of American Art." *Folk Art Finder* 11, no. 4 (October 1990): 4-6.
About the exhibition at the National Museum of American Art and the special programs planned throughout the exhibition. Information on Hemphill.

357. Madison, Chris. "Not So Naive: Bay Area Artists and Outsider Art." *Folk Art Messenger* 1, no. 4 (Summer 1988).
Information about an exhibition in San Francisco that compares the work of self-taught and trained artists. "Outsider" artists included Grandma Prisbrey, David Butler, Howard Finster, Lanier Meaders, Martin Ramirez, Nellie Mae Rowe, Robert Gilkerson, and others.

358. Maizels, John. "Art Brut: A Definition." *Folk Art Messenger* 4, no. 2 (Winter 1991): 6-7.
History of definitions and relevant collections. Says "the European term Art Brut can be seen to define the ultimate in pure aesthetic expression. The roots of Art Brut in Europe lie in the fascination with the art of the insane." Tells of studies and collections and quotes Dubuffet. Describes the demise of the "totally isolated misfit, utterly free of cultural influences." Says Art Brut is "a direct link to the psyche, to the soul, to the root of all human creation, the purest and most powerful art of all." Illus.

359. Manley, Roger. "Hermon Finney." *Raw Vision* 5 (December 1991): 20-25.

Introduction says "Medium, clairvoyant or genius? The late Hermon Finney remains one of America's great undiscovered outsider artists. With a leaning toward the gruesome and the sensational, his highly effective and varied works form an impressive and complete oeuvre." Details on his life, the development of his art, the attitudes of his family and his church. Illus.

360. Manley, Roger. "Separating the Folk from Their Art." *New Art Examiner* (September 1991): 25-28.

Opinions on the harm done to folk artists by collectors.

361. Manley, Roger. "Ten Environments in the Carolinas." *Spaces,* no. 2 (n.d.): 6-7.

Illustrations and brief information is provided for each of the following environments: Sam Doyle, Annie Hooper, L.C. Larson, Hermon Finney, Jim Butts, Charlie Swaim, Henry Warren, Clyde Jones, George Morris, and Q.J. Stephenson. Many of these artists are now deceased.

362. Manroe, Candace Ord. "Collective Statement." *Country Home* (October 1989): 81-87.

Discusses the personal art collections of the late Robert Bishop, with many illustrations of his New York brownstone home showing the artworks in place.

363. Manroe, Candace Ord. "For Better or Worse." *Country Home* (February 1991): 23-26.

Article on "black collectibles." Includes photographs of a drawing by Bill Traylor and of a William Edmondson sculpture.

364. Manroe, Candace Ord. "Wisdom in Wood." *Country Home* (August 1990): 47-50.

About ninety-four year-old Glenn Sargent from Missouri, a former blacksmith and cabinetmaker turned artist. The author says his work shows a mastery of characterization. Several color illustrations of the people and animals he has carved and painted.

365. "Marcia Muth." *Folk Art Finder* 2, no. 2 & 3 (May 1981): 23-24.

Biographical sketch of self-taught artist Marcia Muth and discussion of her themes and the lifestyle and times of her early childhood—the 1920s and 1930s. She paints with acrylics on canvas or acrylics and ink on paper.

366. "Marilyn's Coat." *Folk Art Finder* 10, no. 1 (January 1989): 2, 19.

Discusses a woman who spent her life in a mental institution in Tennessee. "In her years of confinement spent largely in seclusion she began to embroider her life's story and her fantasies on a coat of hospital blue denim" using threads from old rags. Article says two museums want the coat.

367. Marks, Ben. "L.A. Diary." *New Work/Glass,* no. 38 (June 1989): 8-12.

Focus of this article is on Grandma Prisbrey's Bottle Village, her use of found objects, her irate neighbors, and the efforts of the group "Preserve Bottle Village" to save the site. The author says Prisbrey's work is a "fitting beginning to a survey of what's happening in the world of art and glass in Los Angeles; draws parallels with Prisbrey and some modern glass workers. Illus.

368. Martin, William. "What's Red, White and Blue . . . and Orange All Over?" *Texas Monthly* (October 1978): 121, 123-224.

Article about the Orange Show, "a razzle-dazzle piece of American folk art" in Houston. The author reports on his conversations with Jeff McKissack, creator of this unique site.

369. Marty, Kathy. "Impressions of a Folk Artist: An Afternoon with Elijah Pierce." *Journal of the Ohio Folklore Society* (1972): 29-36.

Marty describes listening to Pierce talk about his life and his art during a visit to his barbershop in Savannah.

370. Marvin, Patrice Avon, and Nicholas Curchin Vrooman. "Plains People/Common Wealth." *The Clarion* (Winter 1981): 59-62.

Examples, written and visual, of North Dakota folk art. The article is a report of the North Dakota field survey of its traditional folk arts; the usual concentration on "material culture." A few people creating uniquely individual art are mentioned.

371. Marxsen, Patti M. "Themes in the Work of Carlos C. Coyle." *The Clarion* 12, no. 1 (Winter 1987): 36-43.

Author says "the journey to an understanding of Carlos Cortez Coyle's work" begins in Ken-

tucky. She tells what is known of his life there, as well as in California, where for unknown reasons he moved, and where he painted most of his important work. Says he is difficult to classify. Marxsen groups Coyle's paintings according to theme and discusses sources for subject and color sense, as well as some specific paintings. Notes. Illus.

372. "Mary Shelley." *Folk Art Finder* 1, no. 4 (September 1980): 15.
Biographical information about Mary Shelley, a self-taught artist who makes relief carvings which she paints and varnishes. Illus.

373. Mather, Davis. "Felipe Archuleta—Folk Artist." *The Clarion* (Summer 1977): 18-20.
About Archuleta and the many animals he has carved. Says Archuleta is pleased at his success because he enjoys giving pleasure and receiving praise; troubled because the increasing attention has meant an invasion of privacy and a ceaseless sense of obligations.

374. McGill, Lynn. "Country of Art." *Atlanta Magazine* (August 1990): 12.
Brief mention, with photograph, of artist Knox Wilkinson, who says "fame is God and me working together." Describes his art, the fact that he is "mildly retarded," and notes the supportiveness of his family.

375. McGill, Lynn Burnett. "For Love Or Money?" *Atlanta Magazine* (February 1991): 55-57, 113-115.
About art collector Bill Arnett: "Controversy stalks Atlanta art collector and dealer Bill. Some say he exploits black primitive artists. Others call him their savior." Notes his relationships with the Dial family and Lonnie Holley. Comments from a number of gallery owners.

376. McGonigal, Mike. "Psychic Magnets: Ruminations on the Philadelphia Wireman and the Nature of the Fetish Object." *Raw Vision* 5 (December 1991): 48-52.
About the discovery of over seven hundred works by an unknown artist— called the Philadelphia Wireman—and what is imagined about them. References. Many illustrations.

377. McGonigle, Thomas. "Violated Privacy: Prose for Martin Ramirez." *Arts Magazine* 55 (October 1980): 155-157.
Discusses the painter, the person, being locked away—having one's life and work taken from one. Author's impressions of the art. Illus.

378. McKenzie, Barbara. "Unexpected and Plain Visions: The Architecture of Howard Finster's Chapel." *Art Papers* 9 (July 1985): 28-31.
Finster's constructions, built with ordinary materials and dreamed visions, especially the World's Folk Art Church. Author sees connections with "what the French call architecture douce," finds significance in the combining of diverse objects. Illus.

379. McLane, Roger. "Meaning and Money." *Dialogue, An Art Journal* 11, no. 4 (July 1988): 14-15.
Reviews developments in the interest shown in folk art, and then later in the art of the insane. Lists the number of terms that have sprung up. McLane says as a struggling student (when he began his collection), he was thrilled by the low price of folk art; as a struggling dealer, he did not feel the same. Talks about the artists and the effect of fame and money on their lives.

380. McPhee, Sarah. "Life into Art." *Art News* 85, no. 5 (May 1986).
Article, with illustrations, about Minnie Black at eighty-seven, "who lives alone in Laurel County, Kentucky, spends her days fashioning pterodactyls, snakes, birds, frogs, lizards, and a multitude of other creatures from the produce of her beloved gourd garden." Some information about her early life is included.

381. McWillie, Judith. "Lonnie Holley's Moves." *Artforum* (April 1992): 80-84.
McWillie discourses on her opinions about context and meaning in the art of Lonnie Holley. Holley's quoted statements about his art are clear. Illus.; color, black & white.

382. McWillie, Judy. "Another Face of the Diamond." *The Clarion* 12, no. 4 (Fall 1987): 42-53.
Article on the continuity of artistic and other traditions between Africans and African-Americans. Many artists and their work used to support this point of view. Illus.

383. Meadows, Mary. "Give Me a Louder Word Up." *Colorado Arts* (August 1992): 10.
Article describes some of the sixty pieces in the exhibition "Give Me a Louder Word Up" in Denver. Says the exhibition was divided

into three parts: "Traditions" including works by Naomi Polk and Sam Doyle; "Transitions" with art by J.B. Murry (the name of the show, she says, comes from one of his painted messages) and David Butler; and "Cutting Edge" with works by Lonnie Holley and Thornton Dial, Jr. [Other reviews have said Thornton Dial, Sr.—both were included.]

384. Mee, Susie. "Folk and Family: George and Benny Andrews." *The Clarion* 15, no. 4 (Fall 1990): 34-41.
About the well-known contemporary artist Benny Andrews, and his self-taught artist father, George. Information about the family, their personal histories, and their art. Illus.

385. "Memory Painters: Folk Art Directory Tabulation." *Folk Art Finder* 4, no. 1 (March 1983): 2.
Defines memory painters and their most frequent subjects and lists some examples: Anna Mary Robertson Moses, Ralph Fasanella, Marcia Muth, and Nounoufar Boghosian. Editors say that an effort to collect names for a directory of twentieth century American folk artists "reveals that the overwhelming majority of them are males . . . " and a high percentage of the women, but not the men, are memory painters.

386. Metcalf, Eugene. "Black Art, Folk Art, and Social Control." *Winterthur Portfolio* 18 (December 1983): 271-289.
Metcalf says "black fine artists have often been forced to conform to artistic traditions and forms that denied their unique cultural heritage and the reality of their American experience." Says blacks had from the earliest years practiced "aspects of the traditional arts of Africa until they were taught to be ashamed of their folk practices." Focus of the article: a critique of the Corcoran exhibition of black folk art—all from the "material culture" viewpoint.

387. Metz, Holly. "Grassroots Artist: Ben Hartman." *KGAA News* 10 (1) (1990): 1.
Hartman constructed a garden in Springfield, Ohio during the Great Depression, when he was out of work. He filled the yard with statues and miniature stone castles, cathedrals, and historic buildings. He died in 1944, but Mrs. Hartman "sustained his vision over the years, surrounding his three-foot-high structures with

plants and flowers." Detail about the site. Biblio. Illus.

388. Metz, Holly. "New Jersey Grassroots Art Exhibition." *Folk Art Messenger* 2, no. 3 (Spring 1989): 11.
About the exhibition "Two Arks, a Palace, Some Robots, and Mr. Freedom's Fabulous Fifty Acres: Grassroots Art in Twelve New Jersey locations." Metz, one of the organizers, says "this collection of photos, video documentation, site, artifacts, artists' biographies," and other material "puts the site-specific work in context." She describes some of the sites included. Illus.

389. Meyer, George H. "American Folk Canes." *The Clarion* 17, no. 2 (Summer 1992): 30-37.
Overview of the growth of interest in folk canes. The author says that "for convenience, folk canes can be divided into those made before 1970, and those made after that date." This article is mostly about "period" canes. Color illus.

390. Meyer, George H. "American Folk Canes—A Broad Overview." *Folk Art Finder* 13, no. 2 (April 1992): 8-11.
Article about the history of canes/walking sticks in the United States. Says he considers canes to be folk art if they were made by an untrained artist. Discusses matters of use, materials, and purpose. Describes the carved images used. Illus.

391. Miele, Frank J., moderator. "Folk, or Art? A Symposium." *The Magazine Antiques* 135 (January 1989): 272-287.
A "symposium in writing." The subject is the warring concepts of "folk," "art," and "material culture." All the art examples included are pre-twentieth century. However, the points of view continue into the present. Introduction by Frank Miele who "provoked the responses." The six respondents are David Curry, Kenneth L. Ames, John Wilmerding, Jean Lipman, Carter Ratcliff, and Tom Armstrong.

392. "Miles Carpenter Museum a Reality." *Folk Art Messenger* 1, no. 4 (Summer 1988): 3.
Tells about the refurbishing of Carpenter's white farm house in Waverly, Virginia, which contains artifacts, photographs, and clippings related to Miles Carpenter and his art. Says his son is lending work of the artist to the museum.

393. Miller, Herschel. "Clementine Hunter—American Primitive." *New Orleans Magazine* (December 1968): n.a.
Describes the land and the people where Clementine Hunter grew up—a world "evoking Faulknerian imagery with all the hopeless order of his brooding landscapes. You wonder how it is that nearly eighty-six years ago a Negro child was born . . . to labor in the cotton fields and then the kitchen for most of her given years, and then in the twilight of her life, to emerge with an artistic talent bordering on genius . . . two black hands moving with an expression neither time nor toil could kill."

394. Miller, Richard. "The Faces of Johnson Anderson." *Folk Art Messenger* 4, no. 2 (Winter 1991): 1, 3.
Tells about the art and the home of Virginia folk artist Johnson Anderson. "Johnson is a preacher who uses painting and music to reinforce the message of a ministry that began in 1923 after he had a vision." Many of his paintings are portraits. Illus. [Same issue, p.11, includes a review of an exhibition at the University of Richmond of Anderson's art.]

395. "Milwaukee Art Museum Acquires Hall Collection." *Folk Art Finder* 11, no. 2 (April 1990): 2.
Details on the acquisition of this significant collection of folk art, with prices quoted and names of some of the artists included.

396. "Minnie Black." *Folk Art Finder* 2, no. 6 (January 1982): 13-14.
Brief sketch about gourd artist (and musician) Minnie Black of East Bernstadt, Kentucky. Illus.

397. "Minnie Evans." *Folk Art Finder* 1, no. 5 (November 1980): 8.
One paragraph sketch about Minnie Evans and her art. Illus.

398. "Minnie Evans (1892-1987)." *Folk Art Finder* 9, no. 2 (April 1988): 2.
Obituary notice for Minnie Evans, "who died recently in a nursing home in Wilmington, North Carolina." Inspired by religious visions, she began painting in the 1940s, "but it took all of thirty years for her work to receive public recognition."

399. "Mixing Sacred and Profane." *New York* (23 March 1992): 10.
News note about collaboration of folk artist

Howard Finster and Mark Kostabi. Says the two are doing twenty-five pieces together. The article quotes an anonymous source as saying "It's highly commercial meets highly religious." One illustration.

400. Moody, Tom. "Willard Watson." *Art Papers* (July 1988): 46-47.
About the art and environment of a "Dallas folk artist and local character who has spent the last thirteen years turning his front yard into a sort of surrealistic theme park." There is a step-by-step description of the art in the yard, including but not limited to "a first-rate collection of Watson's sculpture." Moody, an artist himself, speaks of the "politics of self-expression." Illus.

401. Morgan, Charlotte. "Abby Aldrich Rockefeller Folk Art Center." *Folk Art Messenger* 2, no. 1 (Fall 1988): 5.
Information on the history of the collection, descriptions of exhibits, publications produced by the Center, and plans for expansion of the facilities.

402. Morgan, Charlotte. "The Bench and the Benchmaker: The Folk Art of Tom Gordon and Abe Criss." *Folk Art Messenger* 1, no. 1 (Fall 1987): 1-2.
Discussion of two self-taught artists "a world apart in life experiences" who were to be featured in a show at the University of Richmond. Tom Gordon, maker of oil pastel drawings, is a retired Virginia State Supreme Court Justice. Abraham Lincoln Criss, who makes wood figures, is the grandson of an enslaved person and worked in factories all his life. Details on the artists and the art. Illus.

403. Morgan, Charlotte. "A Blessing from the Source: The Annie Hooper Bequest." *Folk Art Messenger* 1, no. 3 (Spring 1988): 8-9.
Description of a symposium and exhibition sponsored by the Visual Arts Programs, North Carolina State University. The day-long symposium was dedicated to visionary art and artists in general and Annie Hooper in particular. Roger Manley was the curator. Tom Patterson read from his book on Howard Finster; John Dixon, a retired professor of religion, spoke on the topic "Icon and Idol: The Use of Images in Religion"; Randall Morris spoke about money and the potential for cheating the art-

ists; others spoke about Adolph Wolfi, Martin Ramirez, Armand Schultness, and Henry Darger; and Monika Kinley, curator of the Outsider Archive in London, presented the topic "International Visionary Art and the Archive." Morgan describes the art of Annie Hooper.

404. Morgan, Charlotte. "Clyde Jones' Haw River Animal Crossing and Henry Warren's Shangri La: Two North Carolina Folk Environments." *Folk Art Messenger* 1, no. 2 (Winter 1988): 1-2. Describes the work and backgrounds of the two creators of environmental art, Clyde Jones and Henry Warren. Illus.

405. Morgan, Charlotte. "Museum of International Folk Art Santa Fe, New Mexico." *Folk Art Messenger* 2, no. 2 (Winter 1988): 5. Information about the history and development of the museum, its collections, and its plans for future development.

406. Morris, Randall Seth. "Good vs. Evil in the Work of Henry Darger." *The Clarion* 11, no. 4 (Fall 1986): 30-35. Describes the art of Henry Darger: "delicately drawn the universe is at war." Morris says that in spite of all that has written about him, Darger remains enigmatic. Information about Darger's childhood and about his lonely life as an adult. Morris also discusses the art and its message, which he says is clear. Illus.

407. Morris, Shari Cavin. "Bessie Harvey: The Spirit in the Wood." *The Clarion* 12, no. 2-3 (Spring-Summer 1987): 44-49. About Bessie Harvey's hard life, how she started to make her "dolls," and the inspiration she receives from visions and from the wood she finds in the hills close to her home. The author compares Harvey's work to that of other self-taught artists and talks of links to her Afro-American heritage. Details on the art and its significance.

408. Morris, Steven. "Primitive Art of Clementine Hunter." *Ebony* (May 1969): 144-148. About Hunter's life on Melrose Plantation, "the tons of cotton and pecans she has picked, cooked for whites at the big house, raised five children and loved two husbands and buried them . . . produced a body of art that has made her known thousands of miles from the plumbingless wood cottage she rents near the Cane River. Hunter tells of her irritation at the noise

and "sometimes killins" at the neighboring plantation—inspiration for her painting "Saturday Night." Writer says "heart's perspective, not the eyes," gives unique charm to paintings by the aged plantation worker." Detailed critique of her paintings, which says she "compresses time: Her paintings show a succession of events—the beginning, the middle, the end of stories."

409. "Mose Tolliver." *Folk Art Finder* 3, no. 3 (September 1982): 12-13. Biographical sketch of the well-known Montgomery folk artist Mose Tolliver. Mentions a solo exhibition of the artist's work that took place at the Gasperi Gallery in May and the fact that Tolliver is included in *Black Folk Art In America 1930-1980.*

410. "Mr. Darling Paints His Dream House." *Life* (25 June 1971): 66-67. About Stanford Darling, a retired oil company technician who started painting for the first time when he was sixty-eight, soon after his wife died. "Armed with many colors and brushes he painted his way up, down, around, and through the house." Landscapes, mountains, rivers, fish, birds, fruit and flowers engulfed every surface. Illus.

411. Murry, Jesse. "Reverend Howard Finster: Man of Visions." *Arts Magazine* (October 1980): 161-164. Describes the variety and complexity of Howard Finster's work, revealed at a summer exhibition at the Phyllis Kind Gallery. Says "the subject was the apocalypse—a bearing out of messages about last things: a paradox of possible salvation and ultimate destruction by technology and the coming of a millennium in the Atomic Age." Discusses his verbal and visual imagery, his poetic visions, and the criteria for considering Finster's art. Illus.

412. "Museum of Appalachia." *Folk Art Finder* 2, no. 4 (September 1981): 4. Description of the thirty structures and more of the Museum of Appalachia and its displays and the folk art collection, which includes Minnie Black's gourd creatures, Dow Pugh's carvings, and Cedar Creek Charlie's "polka dotted items."

413. "Museum of International Folk Art Adds Girard Wing." *Folk Art Finder* 1, no. 4 (September 1980): 8-9.

About the new wing built to house the collection of 106,000 objects given to the museum by Alexander and Susan Girard of Santa Fe. Notes that the museum has "just recently added a number of works by living American folk artists, such as Miles Carpenter and Edgar Tolson."

414. "Museum Planned for Art of the Mentally Ill." *Folk Art Finder* 7, no. 3 (July 1986): 8.
Announcement of the initial stage of planning for the Baltimore area museum for the art of the mentally ill. Includes a request for donations of art. [The museum was later named the American Visionary Art Museum.]

415. "Nan Phelps 1904-1990." *The Clarion* 15, no. 4 (Fall 1990): 23.
Obituary notice about Nan Phelps, "a self-taught artist discovered by Dr. Otto Kallir," with details about her life. Says "her early paintings showed a feeling for form and pattern similar to that of nineteenth century limner paintings" and that her later work was much different: "she created strong, original paintings with contemporary subject matter."

416. Nash, Jesse W. "Rev. McKendree Long's Paintings." *New Orleans Art Review* (September 1989): 17.
Says Long's paintings, like the writing of Flannery O'Conner and Walker Percy, are evidence that Southern artists are haunted by God and that "he isn't a pleasant god either." Long was a Presbyterian minister, and his paintings are essentially a retelling or reimaging of the New Testament. The paintings are described as "exquisite."

417. Neilsen, Barbara. "A Head Full of Pictures." *Ford Times* (January 1989): 14-17.
About Clementine Hunter's life, her paintings—probably about "5000" of them—and the influence of Francois Mignon. Notes her fame, her inclusion in many important exhibitions, and that "the only art exhibit she ever saw was one of her own work in 1955 when, because of her race, she had to sneak into Northwestern State University's art gallery in Natchitoches."

418. "New Director, Museum of American Folk Art." *Folk Art Finder* 13, no. 2 (April 1992): 12.
Announces the appointment of Gerard C. Wertkin to succeed the late Robert Bishop as director of the Museum of American Folk Art. Brief notes on his background and plans for the museum.

419. "New Mexico Woodcarvers: The Lopez Family." *Folk Art Finder* 1, no. 4 (September 1980): 7.
Tells about *santero* carver George Lopez, seventy nine years old at the time this article was written, and how he learned his craft from his father, the famous Jose Dolores Lopez. Says Cordova, where the Lopez family lives, has a community of at least thirty woodcarvers and that carvings may be purchased directly from some of the family owned shops. Illus.

420. "News on Environments." *Spaces,* no. 8 (n.d. 1988?): 4-5.
Notes about preservation efforts for Watts Towers; Old Trapper's Lodge, moved to a site on the Pierce College campus in the western San Fernando Valley; the Walker Rock Garden in Seattle, now open for tours, led by a Friends group; a gloomy item about Kea's Ark in New Jersey; continuing efforts to save Nitt Witt Ridge; and the news that the scrap metal sculpture of Stanley Papio has been moved to the East Martello Museum in Florida.

421. "News on Environments." *Spaces,* no. 9 (December 1989): 6.
Information about the final destruction of Kea's Ark in New Jersey; notes about John Medica's Castle and Garden and how, at age eighty-nine, he can no longer maintain it; and the search for a sympathetic buyer for the Garden of Eden, built by S.P. Dinsmoor in Lucas, Kansas.

422. Niemann, Henry. "Malcah Zeldis: Her Art." *The Clarion* 13, no. 3 (Summer 1988): 49, 52-53.
Article about the sources and inspirations used by the artist Malcah Zeldis in her work. Says her objective is for her paintings to tell a story. Niemann discusses how her life experiences and her psychological struggles with them may have affected her art. Illus.

423. "Noah Kinney 1912-1991." *The Clarion* 16, no. 4 (Winter 1991-1992): 19.
Reports the death of Noah Kinney, brief facts about his life.

424. "Noah Kinney 1912-1991." *The Clarion* 16, no. 4 (Winter 1991-1992): 19.
Obituary notice for the Kentucky artist who "lived and worked his entire life on the family farm in Toller, Lewis County." Tells a little about his work and his family, and his links to the history of the area. He died September 24, 1991. His artist brother Charley died in April. He was survived by his wife Hazel who is also an artist. Photographs.

425. Norris, Tony J. "Art Preservation." *Folk Art Finder* 5, no. 2 (July 1984): 14.
Discussion of the legal concept of art preservation: "Principles underlying art preservation are that works of art have a value beyond their value as private property and that society as a whole has an interest and investment in the cultural capital created by artists. Therefore, the purchaser of a work of art has a social responsibility not to damage or alter it."

426. "Nothing Ventured." *Colorado Homes and Lifestyles* (September 1990): 20.
Says "Denver folk artist William Potts disproves William Shakespeare's quote, 'Nothing comes of nothing' with the extraordinary art he makes out of little or nothing. Potts carves fabulous scenes and figures from mere scraps of wood." Illustrations of the art, and the artist.

427. "O, Appalachia: Artists of the Southern Mountains." *Folk Art Finder* 10, no. 4 (October 1989): 2.
Information on the above named exhibition and the book that was published in conjunction with it. Three artists from the show are profiled: S.L. Jones, Hugo Sperger, and Minnie Adkins.

428. Ohrn, Steven. "Virgil Norberg." *Folk Art Finder* 4, no. 2 (July 1983): 4-5.
Information about the background of this Iowa folk artist who was born in 1930 and has worked as a welder, factory worker, and maintenance mechanic. He makes weathervanes of unique design and interest. His work is described in detail.

429. Ohrn, Steven. "Walter Seebeck." *Folk Art Finder* 4, no. 2 (May 1983): 6.
Sketch of an artist who appeared in Ohrn's book *Passing Time and Tradition,* the survey of Iowa folk art. Seebeck, along with Virgil Norberg, was considered more "individualistic" than the rest of those included in the book.

430. "O.L. Samuels." *Folk Art Finder* 10, no. 1 (January 1989): 14.
Sketch about O.L. (Ossie Lee) Samuels, who carves and assembles wood into wonderful sculptures of fantasy forms of people and animals. Samuels lives in Georgia.

431. "An Old Cook's New Art." *Life* (19 October 1953).
Brief notes and several photographs of Martin Saldaña and his art. Born in Mexico and a long-time resident of Denver, the former cook became a painter late in life.

432. Ollman, Leah. "Jon Serl." *ARTNews* 88, no. 4 (April 1989): 218-219.
Review of an exhibition at the Oneiros Gallery in San Diego, with a description and opinion about the art. Illus.

433. "On Preservation: What You Should Know." *Public Art Review* 3, no. 1 (March 1991): 9, 25.
Step-by-step advice from SPACES on preparing to save a folk art site, including the information that must be gathered; how to gain recognition for the site on the state and local level; gathering the artist's life history; sources of help to save a site; and how and what SPACES will do to help.

434. O'Neil, Peter. "Magnificent Obsession: The Irrepressible Rock Garden of Milton Walker." *Pacific Northwest* (July 1988): 56-57.
About the creation of a "latter-day Gaudi" in Seattle, Washington: a tower glittering with crushed glass, pebbles, and semiprecious stone; six "snowcapped mountains rise, taller than a man . . . in the lower reaches of the garden miniatures give way to human-scale structures: graceful arches of patterned stone with iridescent geodes: undulating walls of rock . . . and much more." Information about the artist and his family: how to arrange a visit.

435. Oppenheimer, Ann F. "Altered States, Alternate Worlds: An Outsider Art Symposium." *Folk Art Messenger* 5, no. 3 (Spring 1992): 1, 3-4.
Detailed report on the symposium held April 11, 1992 at the Oakland, California art museum that includes the names of all the program participants and their topics. Notes that "definitions" came up, but there were no conclusions.

436. Oppenhimer, Ann F. "Howard Finster's Skywalk: A Tunnel to Another World." *Folk Art Messenger* 5, no. 2 (Winter 1992): 6-7.

Report on new developments at Finster's Paradise Garden; one regarding marketing, one new construction. Oppenhimer says, as have others, that for Finster to slow down the production of his work might suit the purposes of the art market, but it would not meet his need to get his messages from God to people. She mentions the addition of a funeral chapel, with Howard Finster's coffin in it. Illus.

437. Oppenhimer, Ann F. "Miles Carpenter, The Woodcarver from Virginia." *Raw Vision* 5 (December 1991): 38-41.
About the life, artistic creations, and artistic recognition of Carpenter. Many photographs of the artist and his carvings illustrate this article.

438. Oppenhimer, Ann F. "Outside the Mainstream: Folk Art in Our Time: A Weekend to Remember." *Folk Art Messenger* 1, no. 4 (Summer 1988): 4-5.
Detailed description of the exhibition at the High Museum Georgia-Pacific Center, in downtown Atlanta. Includes descriptions of the art. Since there was no catalog, but only a brief brochure published, this is one of the few sources of information on this major exhibition. Illus.

439. Oppenhimer, Ann F. "Seer of Sun, Moon, and Stars: James Harold Jennings." *Folk Art Finder* 7, no. 4 (November 1986): 12.
A description of Jennings' property when it was an environment of brightly painted cutouts "made into movable ferris wheels, rows of Indians, Africans, Egyptians, and Mexican bandits, and trees filled with owls, parrots, and ravens."

440. Oppenhimer, Ann F. "Unto the Hills: Folk Art of Eastern Kentucky." *Folk Art Messenger* 3, no. 1 (Fall 1989): 8-10.
Ann Oppenhimer describes the cultural background of Eastern Kentucky and tells about some of the artists who live there. She concludes by saying "Times are changing for the formerly isolated, underexposed rural Kentucky artist. Kentucky artists are beginning to get more recognition and reward for their efforts." Illus.

441. Oppenhimer, Ann, and John Oppenhimer. "Abraham Lincoln Criss." *Folk Art Finder* 8, no. 2 (April 1987): 13.
Description of the environment and art work made by Abe Criss at his home west of Richmond, Virginia. Notes that his wooden objects are crafted with instinct more than sight, because Criss is legally blind. Illus.

442. Oppenhimer, William Mayo. "Milwaukee Art Museum: Fine and Folk—Can They Mix?" *Folk Art Messenger* 2, no. 3 (Spring 1989): 6-7.
Interview with Milwaukee Art Museum director Russell Bowman about the decision by the museum to spend $1.5 million for the purchase of the Michael and Julie Hall Collection of American Folk Art.

443. "The Orange Show." *Folk Art Finder* 5, no. 4 (November-December 19184): 7.
Description of this folk environment in Houston, Texas. Background information on Jeff McKissack, who built it, and how it was saved and kept open to the public after his death.

444. "Outside the Mainstream: Folk Art in Our Time." *Folk Art Finder* 9, no. 2 (April 1988): 4-7.
Information about the above named exhibition at the High Museum in Atlanta including some of the "special features" and gallery talks and appearances by artists. This article includes information about three of the artists in the exhibition: Vollis Simpson, Raymond Coins, and Clyde Jones. There are illustrations of the works of all three.

445. "Outside USA I." *Kunstforum,* no. 112 (March 1991).
Most of this journal issue is devoted to art in the United States. The section "Seven Souls" includes an essay by Sal Scalora and John Turner on Howard Finster; the section "Out of this World" presents twenty-five "portraits," visual and verbal, including Chelo Amezcua, "Peter Charlie" Bochero, Raymond Coins, Henry Darger, Dial Family, Theodore Gordon, William Hawkins, Mr. Imagination, Frank Jones, James Harold Jennings, John Kane, Justin McCarthy, Philadelphia Wireman, Horace Pippin, Anthony Joseph Salvatore, Jon Serl, Drossos P. Skyllas, Maurice Sullins, Simon Sparrow, Gregory Van Maanen, Eugene Von Bruenchenhein, and a few others that may or may not be self-taught or outsiders, depending on your definitions. Another section provides information by Sal Scalora on environments, accompanied by photographs: S.P Dinsmoor and the Garden of Eden, Walter

Flax and his fleet of ships, Romano Gabriel's Wooden Garden, James Hampton's Throne, Eddie Owens Martin and Pasaquan, Grandma Prisbrey's Bottle Village, Simon Rodia and Watts Towers, Clarence Schmidt and his house and garden, Fred Smith's Concrete Park, and Father Mathias Wernerus and Holy Ghost Park.

446. "Outside USA II." *Kunstforum,* no. 113 (May 1991).
This issue of the German art journal has an article, "Black American Folk Art" by Jane Livingston on the following men: Jesse Aaron, Steve Ashby, Richard Burnside, David Butler, Sam Doyle, William Edmondson, Willie Massey, J.B. Murry, Elijah Pierce, Royal Robertson, Henry Speller, James "Son" Thomas, Mose Tolliver, Bill Traylor, Willie White, George Williams, Luster Willis and Joseph Yoakum. Sal Scalora writes about eight black women artists: Minnie Evans, Bessie Harvey, Sister Gertrude Morgan, Clementine Hunter, Inez Nathaniel Walker, Nellie Mae Rowe, Mary T. Smith, and Juanita Rogers. The article by John Beardsley on Hispanic art in America includes artists Felipe Archuleta and Martin Ramirez. Illus.

447. " 'Outsider Art in New York City' Exhibit." *HAI News* (March 1992): 4.
Information about an exhibition in the fall of 1991 at City Gallery, the exhibition space of the New York City Department of Cultural Affairs, of the work of over fifty works by fourteen mentally ill artists who participate in HAI's Arts Workshop Program. Some of the works are described and there is the information that "for the first time, exhibited works of participants in the program are available for purchase at the Luise Ross Gallery" in New York. The careful measures taken to draw up sales agreements are described, as is the enthusiasm of the artists for sales of their art. Illus.

448. Owsley, David T. "William A. Blayney/Self-Taught Pittsburgh Painter." *Carnegie Magazine* (February 1980): 4-9.
Views of the work of a self-taught artist who painted works with religious themes. His earliest painting, says the author, is dated 1957 and follows his conversion to a deep commitment to religion. Says "most of Blayney's pictures appear to be painted dreams." Biographical details, scriptural sources for his work, many illustrations.

449. Palanker, Leslie. "Elliot Freeman." *Folk Art Finder* 13, no. 3 (July 1992): 15.
"In 1984 Elliot Freeman left his career as an ad copy writer and vowed to make twenty paintings a month for life. He has yet to break this personal promise." Elliot was born in New Jersey in 1953. He started to paint after an illness left him very depressed. He is "completely self-taught." Illus.

450. Pardee, Sherry. "Eight Self-Taught Artists from the Midwest." *Folk Art Finder* 13, no. 4 (October 1992): 5-9, 18-19.
Sherry Pardee, folklorist, professional photographer, and art dealer from Iowa City, Iowa presents biographical and art sketches of eight of her "discoveries": Oliver Williams, Anthony Yoder, Allen Eberle, Rollin Knapp, Nick Jovan, Phil Saunders, Paul Hein, and Walter Hendrickson, Jr. All of the artists are described here and elsewhere in this book except for Hendrickson, who paints subjects related to "outer space" but has for the time being given up painting in order to write science fiction. Illus.

451. Parsons, Pat. "Outsider Art: Patient Art Enters the Art World." *The Journal of Art Therapy* 25 (August 1986): 3-11.
Parsons discusses "a new category of art—the art of the emotionally disturbed—whose growing acceptance signals important changes in attitudes toward individual creativity on the part of the art world." Notes on Prinzhorn, Morgan-thaler, interest of Dubuffet and his coining the term "Art Brut," Cardinal's publication *Outsider Art;* early exhibitions by gallery owners Phyllis Kind, Rosa Esman, and the Cavin-Morris Gallery. Parsons then profiles "Two American Outsiders," Inez Nathaniel Walker and Martin Ramirez. Parsons does not like the lumping together of folk art and outsider art.

452. Parsons, Pat. "Outsider Artist Inez Nathaniel Walker Dies." *Folk Art Finder* 11, no. 4 (October 1990): 15.
"The noted black self-taught artist Inez Nathaniel Walker died May 23, 1990 at the Willard Psychiatric Center in upstate New York. She was assumed to be in her early 80s." Details on her life are included. Illus.

453. Parsons, Pat. "Primal Portraits: Adam and Eve as Seen by Twentieth-Century American Self-Taught Artists." *A Report* 8, no. 2 (1990): 1-4.
About an exhibition at the San Francisco Craft

and Folk Art Museum. Essays by Parsons and others on outsider art, "Adam and Eve: A Serpent's View," and the history of the Adam and Eve myth. Includes black & white illustrations of works by Edgar Tolson, Aaron Birnbaum, Jack Savitsky, Rodney Hardee, Annie Hooper, Justin McCarthy, Carlos Cortez Coyle, Dewey Blocksma, and Linda Anderson.

454. Parsons, Pat. "Walt Scheffley." *Folk Art Finder* 9, no. 4 (October 1988): 10.
Illustrated sketch of Vermont artist Walt Scheffley who, during a period when he had to care for his invalid wife "started painting—on the side of his barn, walls, and doors in his house, and on the backs of circular slabs of tree trunks." Scheffley now paints with house paint on masonite. His scenes look like meticulous memory paintings until they are examined closely. Then one sees that "there is a surreal blend of old and new, real and unreal."

455. "Pat Thomas (1918-1984)." *Folk Art Finder* 6, no. 2 (May 1985).
Notice of the death of memory painter Pat Thomas of Milwaukee, Wisconsin who died August 11, 1984. "She began painting in 1972 at the urging of friend and mentor, collector Richard Flagg, who recognized her talent as a naive artist. She had a one-person show at the Milwaukee Art Museum, and her work is in numerous collections."

456. Patterson, Tom. "Outsider Art: What Is it, Where Is It, Who's Making It, Who's Paying Attention to It and Why?" *SPOT* [*Houston Center for Photography*] (June 1991): 5-6.
Discusses definitions of "outsider" art and the increasing interest in it by collectors and museums. Details some of the controversies and questions that come up in the folk/outsider art arena. Photographs of the artists in their environments accompany the article, including George Morris at his "Gotno Farm," Vollis Simpson, James Harold Jennings, and the Shangri-La site by Henry Warren.

457. Patterson, Tom. "Roadside Art: Beating a Path to the Homemade World of James Harold Jennings." *Art Papers* (November 1987): 26-31.
With prefatory warnings about "the greedy, unscrupulous dealer" who buys a work and sells it later at double the price, and that those newly aware of the wonders of folk art "tend to lack

any real depth of appreciation," Patterson describes his own initial interest in "outsider art." Describes meeting James Harold Jennings, with information about his work, his inspiration, and guidance from his dreams.

458. Patterson, Tom. "St. EOM's Pasaquan: A Promising Future." *The Clarion* 13, no. 1 (Winter 1988): 52-55.
Description of a folk art environment in Buena Vista, Georgia. Facts about its creator, the late St. EOM, and the efforts to restore, conserve, and preserve this colorful art environment. Illus.

459. Patterson, Tom. "Tour—Seven Georgia Folk Artists." *Brown's Guide to Georgia* 9, no. 12 (1981): 44-58.
Introduction to the topic of folk art and folk art environments. Information on the now dismantled site created by Laura Pope. Describes in detail the following sites with information about the artists, the way the environment looks, and travel directions: St. EOM and Pasaquan in Buena Vista, Howard Finster's Paradise Garden, the home of Nellie Mae Rowe, Ulysses Davis, Carlton Elonzo Garrett, E.M. Bailey's yard art in Atlanta, and the works of Dilmus Hall in Athens. Illus.

460. Patton, Phil. "The Art of Innocence." *Metropolitan Home* (September 1989): 107, 109-111.
Notice of growing interest, by collectors, in outsider art. Mentions Howard Finster, "Son" Thomas, David Butler, Sister Gertrude Morgan, Sam Doyle, Bill Traylor, Mose Tolliver, and Simon Sparrow, with color illustrations of their work. [Some of the "facts" need confirmation.]

461. Patton, Phil. "He Drew the Blues." *Esquire* (September 1991): 66.
A few facts about Bill Traylor's life, the brief interest in his art after the appearance of an article in *Collier's Magazine* in 1946, and the reemergence of interest in the now dead artist whose paintings and drawings, sold for $10 to $25 in his lifetime, now sell for "from $10,000 to $28,000." Illus.

462. "Paul Friedlein's Inspiration Point." *Folk Art Finder* 6, no. 2 (May 1985): 8-9.
Tells of the building of Inspiration Point, a stone house, an outdoor grotto, and stone

monuments on a bluff overlooking the Mississippi River in Jolly Ridge, just south of Gutenberg, Iowa. Started in 1950 when the builder was in his late sixties. Details of the three groups of monuments and information about Friedlein's character. Illus.

463. Paulsen, Barbara. "Eddie Arning: The Unsettling World of the Texas Folk Artist." *Texas Journal* 28, no. 1 (September 1985): 35-38.
Detailed commentary on the art, some facts about his life. Describes his unique way of using "print sources." Illus.

464. Petterson, Diana. "Clementine Hunter 'Pictures in My Head.'" *American Visions* (October 1988): 27-29.
About Hunter's life on the Melrose plantation, her paintings, and the acclaim they brought. Says Hunter's "is a storytelling kind of painting, done from simple memory, incorporating life scenes and feelings with the use of vibrant bursts of color and form."

465. Pileggi, Nicholas. "Portrait of the Artist as a Garage Attendant in the Bronx." *New York Magazine* (30 October 1972): 37-45.
Article about Ralph Fasanella, his painting, and his life. Says Fasanella wants to document working-class heroism and the left-wing idealism of the 1930s and 1940s. Reports on Fasanella's early experiences: as a kid lugging ice and how he used what he saw in later paintings; in reform school for running away; organizing activities; fighting Franco during the Spanish Civil War. Also discusses his politics. Fasanella says he worked pumping gas because "I was a Red, old man. Every time I'd get a job in a factory or machine shop somebody would come in and see the boss, and the next day they'd let me go."

466. "Pioneers in Paradise: Folk and Outsider Artists of the West Coast." *Folk Art Finder* 6, no. 1 (March 1985): 4-8.
Written at the time of the exhibition named in the title above, this article lists the artists included in the exhibit and provides biographies for five of them: Russell Childers, Marcel Cavalla, Rose Erceg, Alex Maldonado, and Romano Gabriel.

467. Place, Linna Funk. "Written Words Add Coherence to Folk Art Exhibition." *Forum: Visual Arts/Mid-America* 12, no. 1 (January 1987): 7-9.

A description of the touring exhibition, "Word and Image in American Folk Art," which focuses on works that employ words as part of the overall image. Descriptions of specific pieces of art in the exhibition, and the ways words are used in them.

468. Polt, Renata. "Ames Gallery of American Folk Art." *Northern California Home and Garden* (June 1989): 34-35.
Profile of the gallery and the proprietor, Bonnie Grossman. Tells of her feelings about folk art, about the various definitions attached to the art, and the one she prefers. She says "I love folk art's human element and the fact that these objects touched people's lives." Grossman says discoveries are the best part of the work. She describes her travels to buy folk art, which she chooses by quality of content, color, and form.

469. Porcelli, Joyce. "Silvio Peter Zoratti: A Major New Discovery in 20th Century American Folk Art." *Antique Review* [Ohio] (May 1991): 38-40.
Article tells about the background of the artist, his life in Italy and in the U.S., and his family. There is a description of his yard, where much of the art was placed and of the qualities of the art pieces themselves. Eighteen black-and-white photographs of the artist and some of his works accompany the article. Porcelli describes Zoratti's work as "filled to overflowing with energy and excitement" and says that Zoratti was "prolific."

470. Portis, Richard. "An Unlikely Black Picasso." *MD* (May 1984): 127-132.
Reports critical opinions of Mose Tolliver's work and describes a visit to his home in Montgomery, Alabama. Describes his techniques, materials, and some of the frequently used images. Illus.

471. "Potters' Spotlight: Billy Ray Hussey— 'A Visionary Folk Artist'." *Southern Folk Pottery Collectors Society*, no. 2 (December 1991): 3.
Article about the background and work of this North Carolina potter. Illustrations of his work.

472. Prince, Dan. "Crisis in Holyland." *Spaces* (n.d.[1988?]): 1-3.
Richly detailed description of John Greco's seventeen-acre reconstruction of Bethlehem and Jerusalem, "built of concrete, discarded mannequins, purchased statues, scrap iron,

lumber, plaster, and wire." Says during the site's heyday in the 1960s, Greco conducted tours of "over 40,000 visitors per year." Describes the efforts to save the site.

473. Prince, Daniel C. "Environments in Crisis." *The Clarion* 13, no. 1 (Winter 1988): 44-46, 48-51.
Author tells of battles to save grassroots or folk art environments. Looks at three such environments: Kea Tawana's 100-foot ark in Newark, New Jersey; John Greco's Holy Land, USA in Waterbury, Connecticut, and John Ehn's Old Trapper's Lodge in California. Illus.

474. Prince, Daniel C. "Giants of Tennessee: The Primitive Folk Sculpture of Enoch T. Wickham." *American Art Review* 2, no. 6 (September 1975): 90-103.
Describes the fifty concrete statues created by Enoch Wickham. Prince says that "Wickham has never received the acclaim he properly deserves, and since his death the statues have been severely vandalized." Tells about the twenty years it took the artist to create this environment, his techniques of construction, his source of inspiration, and his neglect as an artist. Prince tells about Wickham's family, the uneasy reactions of neighbors, and lack of official interest in preservation and protection.

475. Prince, Daniel C. "Howard Finster's Paradise Garden: A Plan for the Future." *The Clarion* 13, no. 1 (Winter 1988): 56-57.
About the building of Paradise Garden by Finster and the incredible effort to maintain it. Reports plans to find support to help the Finster family with this task.

476. "Queena Stovall." *Folk Art Finder* 2, no. 2 & 3 (May 1981): 16, 17, 33.
Information about artist Queena Stovall and the subjects she chose to paint. Illus.

477. "Ralph Griffin 1925-1992." *The Clarion* 17, no. 1 (Spring 1992): 17.
Notice of the death of root sculptor Ralph Griffin of Girard, Georgia. Says he used driftwood, both logs and roots, that he found along a small stream that crossed his property. Photograph of the artist.

478. "Rambling On My Mind: Black Folk Art Of the Southwest." *Folk Art Finder* 9, no. 2 (April 1988): 10-11.
Information about the above named exhibi-

tion organized by the Museum of African-American Culture in Dallas, Texas. Two artists from this exhibition are written about briefly. They are Ike Morgan and John W. Banks. Illus.

479. Rankin, Allen. "He Lost 10,000 Years." *Colliers* (22 June 1946): 67.
Color photographs of Bill Traylor surrounded by his work. Includes biographical information, physical conditions, and information on the organization New South and their exhibition of Traylor's work. Rankin believes Traylor's work looks like that of prehistoric cave artists.

480. Reed, Lisa. "Bob Versus the Art Snobs." *Manhattan, Inc.* (June 1990): 110-113.
Author describes an exhibition at the Museum of American Folk Art. Says Robert Bishop is not like other museum directors. "Not for him the quasi-religious, quasi-academic rhetoric of talent and genius, of composition and execution, of transcendence—the Church of Art." Art snobs do not think he is serious, she says, but he is serious—about discovering new species of folk art, about marketing his museum to people. "He is giving folk art back to the folks."

481. Regas, Jenne. "Harold Everett Bayer: Toledo, Ohio Folk Artist." *The Clarion* (Winter 1980-1981): 48-51.
Discusses Bayer, who was born in February 1900 in Cleveland, Ohio. Descriptions of his artwork, which is in the permanent collection of the Museum of American Folk Art. Recollection of farm life in rural Ohio is his central theme. Illus.

482. Reginato, James. "Folk Art's Old Guard." *Town & Country* 144, no. 5116 (January 1990).
About those who began the folk art collecting craze—Electra Havemeyer Webb, Abby Aldrich Rockefeller, Jean and Howard Lipman, and others. Mention of current collecting and Herbert Hemphill is included, with his interests and opinions noted.

483. "Reinventing the World: The Photography of Folk Art Environments." *SPOT* [*Houston Center for Photography*] (June, 1991): 9-11.
A portfolio of photographs of environments, which includes artists' statements and biographies. This is a selection of the images

presented at the Houston Center of Photography in an exhibition "Reinventing the World," curated by Liz Claud and Jean Caslin, at the center from September 7 to November 4, 1990. Sixteen photographs.

484. "Religion in Folk Art." *Folk Art Finder* 1, no. 5 (November 1980): 1, 4-9, 12-15.
Contemporary folk artists often draw their inspiration from the Bible or other religious teachings. Examples provided from the lives and art of Harry Lieberman, James Hampton, Howard Finster, John Greco, and Joe Barta. Information includes biographical facts and descriptions of the art. Illus.

485. "Religion in Folk Art." *Folk Art Finder* 1, no. 5 (November 1980): 4.
Information on religious themes in early America folk art and their continuation into contemporary folk art. Illus.

486. "Reverend Richard Cooper." *Folk Art Finder* 13, no. 1 (January 1992): 18.
Biographical sketch of self-taught painter Richard Cooper. He uses acrylics and oils and sometimes adds wood cutouts. His themes are rural life as he remembers it and as he experiences it now.

487. Rich, Joe. "Homeless Poets." *Versus* (November 1990): 12-16.
One of the people who is a subject of this article about street artists in Nashville, Tennessee is Robert Roberg "a Mennonite minister who ran away from the Vietnam War whose ministry these days is on the streets." He is described as having a "visual ministry, stressing his message through paintings of Biblical scenes." Some details about his life, his beliefs. Illustration of the artist with one of his paintings.

488. "Robert Bishop (1938-1991)." *Folk Art Finder* 13, no. 1 (January 1992): 19.
Obituary notice for Robert Bishop, director of the Museum of American Folk Art who died on September 22, 1991. Facts about his background and his accomplishments. Illus.

489. "Robert E. Smith." *Folk Art Finder* 9, no. 3 (July 1988): 13.
Sketch about the life and art of Robert E. Smith: "in his early sixties . . . paints, writes, sings, and plays several musical instruments." He lives in Springfield, Missouri. Smith began to draw af-

ter a long stay in a hospital. "Smith's paintings are filled with people and animals in dense, action-packed space."

490. "Robert Gilkerson." *Folk Art Finder* 7, no. 3 (July 1986): 14.
Information about Gilkerson and about his work. Says "thrust of the work is a kind of irreverent spoof on modern life." Tells about a controversy with the police department over his work. Notes that he is included in the exhibition "Pioneers in Paradise." Illus.

491. "Rod Rosebrook." *Folk Art Finder* 4, no. 1 (March 1983): 5-6.
Description of Rosebrook's early life, his collection of old tools and metal objects, and the museum and fence made from the collection. Illus.

492. "Rodney Hardee." *Folk Art Finder* 5, no. 3 (September 1984): 14-15.
Sketch of the life and work of Hardee, a Florida self-taught artist. Illus.

493. "Roland Rochette (1887-1986)." *Folk Art Finder* 7, no. 1 (April 1986): 10.
Obituary notice about the death of memory painter Roland Rochette of Greensboro, Vermont who died February 3, 1986 at the age of ninety-eight. Information about his life as a farmer and how he started to paint to supplement his income.

494. " 'Room for Everyone' —A Report on the Washington Folk Art Meeting." *Folk Art Finder* 4, no. 5 (January 1984): 17-19.
Author notes the speakers in the program and their topics. John Vlach gave the traditionalists' view of definitions; Metcalf said that one cannot ignore any longer history, politics, and power in efforts to understand folk art; Hemphill said there is no definition that will please all and that is a waste of time "to backtrack into semantics." The afternoon luminaries included Henry Glassie, Simon Bronner, Sheldon Posen, and Kenneth Ames, among others. The second day consisted mostly of museum people, with discussions on the effects of collecting—led by Robert Bishop.

495. Rosen, Seymour. "An Art of Unpretentious Joy: Preserving America's 'Folk Art Environments'. " *SPOT* [*Houston Center for Photography*] (June 1991): 6-7.

Starts with a definition of contemporary folk art environments and the efforts of the organization SPACES to find and document them. Notes the efforts of a number of groups to save various sites. Several environments are shown.

496. Rosen, Seymour, and Cynthia Pansing. "Saving American Folk Art Environments." *Raw Vision* 1 (March 1989): 36-41.
Detailed descriptions and information on the work of the California-based organization SPACES.

497. Rosenak, Charles. "A Visit with Steven Ashby." *The Clarion* (Winter 1980-1981): 63.
Description of Steve Ashby's home in 1980 with its many assemblages in his yard and the appearance of the space where he worked and information about his life. Rosenak notes that Ashby died shortly after the visit.

498. Rosenak, Charles. "Issues and Opinions." *Folk Art Finder* 8, no. 4 (October 1987): 15.
Opinions on definitions, especially on Roger Cardinal's use of "outsider" as a reference to a style of art. [See response under Cardinal, *Folk Art Finder* 9 1 (January-February 1985) 14-15, 19.]

499. Rosenak, Chuck. "Artist and Daughter Reunited." *The Clarion* 16, no. 2 (Summer 1991): 16.
Brief notes on the reunion, after many years, of artist Lee Godie with her daughter Bonnie Blank.

500. Rosenak, Chuck. "Carved in Cottonwood." *New Mexico Magazine* (August 1987): 42-49.
Tells about nontraditional Navajo artist Johnson Antonio and his cottonwood carvings. Says his figures represent life on the Bisti, the arid territory of northwestern New Mexico where he lives. Includes biography.

501. Rosenak, Chuck. "Exhibition Review: 'It'll Come True'. " *Folk Art Messenger* 5, no. 4 (Summer 1992): 8-9.
Review of an exhibition that was held in Lafayette, Louisiana in April and May of 1992 and then reopened at the Contemporary Arts Center in New Orleans. Included sixty-eight objects by artists David Butler, Henry Ray Clark, Roy Ferdinand, Jr., Royal Robertson, Sulton Rogers, J.P. Scott, Xmeah Sha Ela 'Re El, Herbert Singleton, Mary T. Smith, and "Artist Chuckie" Williams. Includes information about collectors Sylvia and Warren Lowe, upon whose collection the exhibition was based.

502. Rosenak, Chuck. "Felipe Benito Archuleta: August 23, 1910-January 1, 1991." *Folk Art Messenger* 4, no. 2 (Winter 1991): 8.
Death notice for Archuleta, who died of a brain tumor on January 1, 1991. Rosenak says he is the founder of the "non-*santero* carving tradition" in the U.S. Southwest. Notes about his work, his recognition, and his fame.

503. Rosenak, Chuck. "Folk Art is Alien to Cultural Aesthetics." *Folk Art Messenger* 5, no. 3 (Spring 1992): 8-9.
Advice to the new collector. Rosenak tells readers where to go, what to look for, and books to read. He warns people about artists whose response to market demands has made their art less desirable, reports his belief on the dangers of shopping in the southeastern United States, Kentucky and West Virginia, and says "Then there's a whole new phenomenon: a school of southern African-American artists who are deliberately trying to forge careers out of expressing their blackness in art." He wonders about "catering to the 'tourist trade'. " His final recommendations are: "Sharpen your vision, trust your eye, and collect what appeals to you."

504. Rosenak, Chuck. "A Folk Tradition Rediscovered." *Folk Art Finder* 7, no. 1 (January 1986): 12.
Many details about the home and background of Navajo folk artist Mamie Deschillie. Rosenak describes how Deschillie rediscovered the art of making mud toys similar to the ones her mother had made in the Navajo tradition and how she has branched out into cutouts and collages. Illus.

505. Rosenak, Chuck. "Op, Pop, Insider or Outsider." *Folk Art Finder* 2, no. 4 (September 1981): 14-15.
Auther discusses how he and wife Jan first became interested in the art and their experiences as collectors.

506. Rosenak, Chuck. "Rediscovering Andrea Badami." *The Clarion* 12, no. 2-3 (Spring-Summer 1987): 50-53.
About the life of artist Andrea Badami on both sides of the Atlantic, including the story that

he started painting in 1960 when art in a gallery looked like "junk" to him. He did not appeal to art collectors and dropped out of sight for some time, says Rosenak, until he resurfaced in the exhibition "A Time to Reap." In 1978 he moved to Arizona, where he continued to paint. Illus.

507. Rosenak, Chuck. " 'Uncle' Sam Doyle is Gone." *Folk Art Finder* 7, no. 1 (January 1986): 2.
Obituary notice for Saint Helena Island, South Carolina folk artist Sam Doyle. Says Doyle was a great artist though he probably never realized it. Illus.

508. Rosenak, Jan. "Jankiel Zwirz 1903-1991." *Folk Art Messenger* 5, no. 2 (Winter 1982): 8.
Information about Jack Zwirz, who died in Memphis, Tennessee on October 16, 1991 at the age of eighty-seven. Tells of the artist's background and the subject matter of his art.

509. Rosenberg, Willa S. "Malcah Zeldis: Her Life." *The Clarion* 13, no. 3 (Summer 1988): 48, 50-51.
Discusses Malcah Zeldis as a child in Detroit and in Israel as a wife and mother who had no time for her own life—which was the way she believed it was supposed to be. Neither her father nor her husband encouraged her earliest artistic efforts. She started to paint seriously after her children were grown and her marriage fell apart. Reports on her recognition by a Brooklyn College professor and her artistic successes. Lists of museums with her paintings in their collections. Illus.

510. "Roy Kothenbeutal." *Folk Art Finder* 8, no. 1 (April 1987): 5.
Kothenbeutal made "do-nothing machines." These were motorized and made from found objects and memorabilia. The artist was born in 1903 on an Iowa farm and was living in Minnesota when this article was written. He continued to make these mixed-media objects until Parkinson's disease made it too hard for him to work. Provides details about his life and the information that his work was in the exhibition, "Ties That Bind." There is a picture of his art accompanying this article.

511. Rumford, Beatrix T. "Williamsburg's Folk Art Center." *The Clarion* (Winter 1978): 57-66.
History of the growth and development of the Abby Aldrich Rockefeller Folk Art collection. At this writing there were 1,800 objects. Photographs of works in the collection.

512. Russell, Candice. "A Separate Reality: Florida Eccentrics." *Folk Art Finder* 8, no. 3 (July 1987): 4-8.
Exhibition review that includes articles about the artists shown: John D. Gerdes, who made among other things in the exhibit, flashing robots; George Voronovsky, a memory painter; and the visionary paintings of "Mr. Eddy" Mumma. There are brief notes on the lives and art of each artist, and illustrations.

513. Ryan, Bob, and Yvonne Ryan. "Clementine Hunter: A Personal Story." *Louisiana Life* (September 1981): 28-42.
Article that discusses Clementine Hunter, by people who visited her regularly. Facts about her life, how she came to paint. Many color illustrations of her work, a bibliography, and key exhibits.

514. "Sadie Kurtz." *Folk Art Finder* 6, no. 3 (September 1985): 5.
Information on the background of artist Sadie Kurtz (1889-1973) who became an artist at age sixty-eight to alleviate her boredom when she retired from a successful career as a milliner. Exhibitions that have included her work are listed, including "A Time to Reap: Late Blooming Folk Artists."

515. "Saint EOM (1908-1986)." *Folk Art Finder* 7, no. 3 (July 1986): 13.
Tells about the death of Eddie Owens Martin, St. EOM, the builder of the site called Pasaquan. Notes on his life, his creation, and the preservation efforts that have already begun to save the art environment from destruction.

516. Sanders, Fred, and Milton Brock. "Lanier Meaders: Folk Potter." *Foxfire* 16, no. 1 (March 1982): 3-16.
Photographs of the workplace of Lanier Meaders, "the best known folk potter in North Georgia." In addition, there are several of his face jugs including one on the cover of this issue of *Foxfire*. The Fall 1983 issue of *Foxfire* features additional information on the Meaders' pottery.

517. Santiago, Chiori. "Exploding the Context: Outsider Art." *Oakland Artscape* 1, no. 1 (July 1992): 1, 4.
Report about the artists featured in the symposium on outsider art organized by the Creative Growth Center. The symposium, "Altered States, Alternate Worlds," took place at the Oak-

land Museum in April 1992. The author notes the "poignant contrast between the huge impact of their accomplishments and the smallness of their lives." Mentioned are Henry Darger and Hermon Finney. The Creative Growth Center and its program is described.

518. Saraf, Irving. "Grandma's Bottle Village: The Art of Tressa Prisbrey." *Folk Art Messenger* 5, no. 4 (Summer 1992): 7.
Brief description of Bottle Village and the making of the film on the subject by Light and Saraf. Mention is made of the "wit, creativity and pizzazz" of Prisbrey. Photo. of the artist.

519. Savitt, Mary Lou, and Jack Savitt. "Jack Savitsky (1910-1991)." *Folk Art Finder* 13, no. 2 (April 1992): 2.
Announcement of the death of painter/coal miner Jack Savitsky on December 4, 1991 at the age of 81. Tells of the materials he used, his introduction to Herbert Hemphill by his friend Sterling Strauser, and some of his artistic recognition.

520. Scalora, Sal. "Gifted Visions." *Folk Art Messenger* 2, no. 1 (Fall 1988): 8.
Scalora describes an exhibition at the University of Connecticut, with the above title, during September 1988 which focused on the works of twenty black American folk artists. The exhibition included, among others, Bessie Harvey, J.B. Murry, Walter Flax, and Royal Robertson.

521. Schjeldahl, Peter. "Martin Ramirez at Phyllis Kind." *Art in America* 64, no. 3 (May 1976): 114.
Review of a Martin Ramirez exhibition. Information about his hospitalization, his illness, his motifs, and the execution of his art. Says his drawings have as much to do with mental illness as Moby Dick has to do with the whaling industry.

522. Schwartz, Stuart. "Jeff Williams." *Folk Art Finder* 5, no. 2 (May 1984): 12.
Biographical information about Jeffrey Conrad Williams who was born in 1958 and raised near Salemburg, South Carolina. He carves what he sees in the wood. His tools are a hatchet, chisel, and file. The wood is stumps, tree limbs, and fence posts. He paints his carvings. In this article it is said that Williams sells from his home. Illus.

523. Schwartz, Stuart C. "Selected Traditional Potteries to Visit." *Folk Art Finder* 9, no. 1 (January 1988): 18.
Author provides a list, arranged by state, of traditional potteries to visit. Each item includes the name of the town, the name of the pottery, and some of the wares produced there. Illus.

524. Schwartz, Stuart C. "Southern Traditional Pottery: A Revival and a Demise." *Folk Art Finder* 9, no. 1 (January 1988): 8-9.
Author says recent publications about traditional Southern pottery has increased interest in the wares, but, he believes, as the old potters die, so do the traditions. Illus.

525. Schwindler, Gary. "The Columbus Museum of Art." *Folk Art Messenger* 4, no. 3 (Spring 1991): 8.
History of the establishment of the museum with description of the permanent collection and its mission. The author says that the museum has begun to feature "the work of regional self-taught artists." He notes the acquisition of the 200 works by woodcarver Elijah Pierce.

526. Schwindler, Gary J. "Southern Folk Images." *Dialogue, An Art Journal* (September 1985): n.a.
Review of the exhibition "Southern Folk Images" at the Perkins Gallery of the University of Akron, Ohio, April 4-27, 1985 which included the art of David Butler, Bill Traylor, and Henry Speller. Schwindler finds Butler's work especially compelling, Traylor's "the classiest" of the three, and Speller somewhere in between—and tells more about his opinions of the art.

527. Schwindler, Gary J. "William L. Hawkins." *Dialogue, An Art Journal* 11, no. 4 (July 1988): 12-13.
Schwindler reports on his visits with William L. Hawkins. Says he was "intrigued by his career and unique pictorial language." Article tells of Hawkins' youth on a Kentucky farm and his move to Columbus, Ohio. Schwindler says "The importance of farm life to Hawkins' art cannot be exaggerated." More details included on his artistic inspirations and sources.

528. Schwindler, Gary J. "William Hawkins: Master Storyteller." *Raw Vision* 4 (March 1991): 40-45.

About the self-taught artist who "left a remark-able body of brilliant pictures that are as spec-tacular and unique as the man himself." Details on Hawkins' background, the development of his artistic talents, and the critical recognition of his work. Illus.

529. Sciorra, Joseph. "Reweaving the Past: Vincen-zo Ancona's Telephone Wire Figures." *The Clari-on* (Spring-Summer 1985): 48-53.
Illustrated article about Vincenzo Ancona of Brooklyn, New York, who makes animal and human figures from the discarded mul-ticolored wire used to install telephones.

530. "Sermons in Wood: Carvings of Elijah Pierce, an Ohio Barber, Win Acclaim of International Art World." *Ebony* (July 1974): 67-69, 72, 74.
Tells of Pierce's critical success and success with the public. Pierce is quoted as saying "Every piece I got carved is a message . . . a sermon, you might say." Says his discovery and promo-tion by Columbus sculptor Boris Gruenwald resulted in critical attention. Illustrations; color, black & white.

531. Shannon, Charles. "Bill Traylor's Triumph." *Art & Antiques* (February 1988): 61-65, 95.
Shannon's view of his place in the discovery of Bill Traylor and his art, including preserva-tion and promotion efforts. Illus.

532. Sharpe, Karen. "Gallery: Creative Growth, Oakland." *Northern California Home and Garden* (December 1988): 32-33.
About the program at the Creative Growth Art Center, for people with mental, emotional, and physical disabilities, and the gallery that sells their work. Commentary on the art and some of the artists, including Eleanor Hackett, Dwight Mackintosh, and Donald Paterson. Illus.

533. Shearin, Margaret. "Mark Casey Milestone." *Artvu Magazine* (September 1991): 39.
Review of the "first gallery exhibition" of this self-taught artist. Descriptions of the work. Shearin notes the way Milestone combines the usual qualities of folk art with a more sophisti-cated vision and says that he has done a lot of self education about art history. Shearin con-cludes "all in all Mark Milestone's first show was an entertaining collection of works which rev-eal an interesting form of artistic development" and she considers what the results may be if

he continues in the folk art style and in the study of art history on his own.

534. Sherman, Joe. "Getting Creative With Amaz-ing GRACE." *Smithsonian* (November 1992): 76-87.
The article is about the founding and develop-ment of the Vermont organization G.R.A.C.E. by Don Sunseri and the growth in popularity of "outsider art." The the article tells about some of the artists, including Gayleen Aiken, Dot Kibbee, Harrie Griggs, Theda Baker, Marion Nelson, Roland Rochette, Richie Delisle, and others. Illus.

535. Siegel, Randy. "Interview: Knox Wilkinson." *Art Papers* (March 1986).
Siegel, an art collector and friend to Knox, says "Knox is more than a great artist. He is a great human being." In the interview they talk about school, Knox's strong belief that God gave him this talent, inspiration and sources for his paintings, and how he feels about success and recognition as an artist.

536. Silbert, Peter. "Art & Baseball: Reflections on Drive, Discipline, and Play." *Artist Trust* [*Seat-tle*] (June 1990).
Author says "baseball has been an element of artistic consideration and expression since its inception. Eleven artists of diverse disciplines offer their insights on the game." Tim Fowler, self-taught artist, says he thought about carv-ing baseball players for years. Photograph of "Carpenter's Baseball," fir, walnut, oak sculpture, 1989.

537. "Sketchbook: Outside In." *Art and Antiques* 9, no. 1 (January 1992): 19.
Report on the opening at the Carl Hammer Gallery in Chicago, with featured artist Lee Godie in attendance. There is a color photo-graph of Godie and her daughter. Tells of the interest of Chicago trained artists in the work of the outsider artist. Mentions the new organi-zation "Intuit."

538. Smith, Linda Jones. "Futures." *Country Home* (October 1989): 120-124.
A brief article on the growth of the market for folk art, antique and contemporary. Illustra-tions of Eddie Arning and Alex Maldonado works. Several galleries are mentioned.

539. "Smithsonian Acquires Hemphill Collec-tion." *Folk Art Finder* 8, no. 2 (April 1987): 2.

News about the sale/gift of mostly contemporary folk art by Herbert Waide Hemphill, Jr. to the National Museum of American Art. Says "the sale of 378 works in a collection of 2,500 creates barely a noticeable space here and there in Bert Hemphill's crowded apartment."

540. Solis-Cohen, Lita. "Three Academics Sell their Folk Art." *Maine Antique Digest* (February 1990): 34A-35A.
Discusses three ways to dispose of an art collection: the sale of the Michael and Julie Hall Collection of 273 pieces valued at $2.3 million to the Milwaukee Art Museum, the largest single purchase ever made by that museum; the selling of the "thirty-five year collection of offbeat folk art" assembled by Bates Lowery, at the Janet Fleisher Gallery in Philadelphia; and fifty paintings and sculptures belonging to Robert Bishop auctioned at Sothebys.

541. Sondheim, Alan. "Unnerving Questions Concerning the Critique and Presentation of Folk/Outsider Arts." *Art Papers* 13, no. 4 (July 1989): 33-35.
Questions about the nature of the contact between the artists and the buyers/dealers.

542. "Southern Folk Pottery." *Country Collectibles* (September 1991): 62-63.
Discusses the popularity with collectors of "traditional face jugs, animal figurines, and other whimsies." Brief information on pottery and potters. Illus.

543. Spurrier, Jeff. "Hot People: Jon Bok." *Metropolitan Home* (August 1989): 32G.
Photo of Jon Bok and bull terrier Birdie. Article says "castoffs are the raw material for Bok's one-of-a-kind creations . . . his inspiration is folk art, where humble materials such as bottle caps and broken tiles can turn glorious." The untrained Bok declares that the folk art tag suits him fine.

544. Starr, Nina Howell. "Perspective on American Folk Art." *The Clarion* (Spring 1979): 24-31, 49.
The author says it has been her "mission for twenty years to gain recognition for the existence of folk art and folk artists of today." She reports the resistance of all those who insist that folk art died with the nineteenth century and discusses what she does to counter that opinion. Illus.

545. Steel, David. "The Making of an Exhibition: Signs and Wonders: Outside Art Inside North Carolina." *Folk Art Messenger* 2, no. 4 (Summer 1989): 1, 4.
Tells of finding outsider artists for the exhibition, the difficulties involved in choosing nineteen of the one hundred found for the exhibition. Illus.

546. Stegner, Wallace. "Depression Pop: Bad Times and the Art of R.D. Ginther." *Esquire Magazine* (September 1975): 79-83, 154.
Discusses the social history of the 1930s as documented by self-taught artist R.D. Ginther. Details too about the life of Ginther the cook, union organizer, "Wobbly," and artist. Description of his work as "detailing the desperate homeless lives he saw and painted." Ginther's view is "from the bottom, most of the time from Skid Road—the original one along Yesler Way in Seattle, not one of the later copies miscalled Skid Row by the unknowing." Stegner writes mostly about the history of the times and concludes, "if Skid Road had an historian it was the self-taught working man artist named Ronald Debs Ginther." The article has nine illustrations of the art from the seventy-nine paintings in the collection of the Washington State Historical Society in Tacoma, Washington.

547. Stevens, Mark. "Devotees of the Fantastic." *Newsweek* (7 September 1987): 66-68.
Critical review of the exhibition "Hispanic Art in the United States," put together by John Beardsley and Jane Livingston. Author says that after seeing this richly varied show, cheap stereotyping becomes difficult. Exhibit includes 180 works by thirty artists, including some folk artists.

548. Stiller, Micki Beth. "Virgil Perry." *Folk Art Finder* 13, no. 2 (April 1992): 20-21.
Carver Virgil Perry makes unique carvings of people, birds, and cypress wood and paints them with enamel. Illus.

549. Stone, Lisa. "Grassroots Artist: Tom Every." *KGAA News* 11, no. 1 (1992): 1.
Information about a grassroots art environment in Baraboo, Wisconsin. Every works with salvage, helped by son Troy and wife Eleanor. His site, called "The Fancy," was

located on Highway 12, just south of Baraboo, at the time of this writing, but it is movable. The Everys welcome visitors. Illus.

550. Stowers, Michael. "Folk Art that Comes to Life." *Popular Mechanics* (May 1983): 105, 206-208.
Discusses Georgia artist Carlton Garrett who carved farm equipment and other representations of rural Georgia life and often animated them by a motorized system boxed in below the carving. Information on life experiences that influenced his work and taught him his skills. Many illustrations plus plans for a "whirly toy."

551. Sunseri, Don. "Larry Bissonnette." *Folk Art Finder* 10, no. 1 (January 1989): 15.
Sketch about Bissonnette, who "draws images on paper and board with paint, crayons, markers, and tape." Included are more details on his techniques and his subject matter. Information on his background too. He is "developmentally disabled." Illus.

552. Svedlow, Andrew. "Urban Folk Artist has a Mission." *Forum: Visual Arts/Mid-America* 12, no. 1 (January 1987): 17.
Discusses Ralph Fasanella and his desire to portray the struggles of working class immigrant people. "As a working-class, self-taught painter . . . he is dedicated to seeing that his art transforms people."

553. Swain, Adrian. "Charley Kinney, 1906-1991." *Folk Art Messenger* 4, no. 3 (Spring 1991): 9.
Notice of the death of Charley Kinney. Details about where he lived and his art, music, and storytelling. He died April 7, 1991, having spent his life on the family tobacco farm in Toller Hollow, near Vanceburg in eastern Kentucky. Illus.

554. Swain, Adrian. "The Folk Art Collection at Morehead State U." *Folk Art Finder* 12, no. 4 (October 1991): 8-9.
Swain notes that Kentucky folk art, with the exception of a few collectors and pioneering scholars, won much greater recognition and appreciation outside the state than in it. In the spring of 1985 the Folk Art Collection was established as the first public collection in the state with an emphasis on contemporary regional folk art. Swain describes the growth and development of the collection and the plans

for educational programs to reorient local awareness. He also mentions the folk art marketing program. Illus.

555. Swain, Adrian. "Ronald and Jessie Cooper." *Folk Art Finder* 12, no. 4 (October 1991): 10-11.
Swain discusses the work of these two contemporary folk artists and their lives. He tells how their art developed over time and says "Now, although Jessie and Ronald collaborate on some pieces and often share the same palette and subject matter, the work of each is clearly distinguishable." Illus.

556. "Sybil Gibson." *Folk Art Finder* 6, no. 3 (September 1985): 15-16.
Biographical details on the hard times and hard life of Sybil Gibson. Says critics have offered high praise, but she remains poor. Information about her painting materials and techniques. Illus.

557. Talbot, Mary. "A Mingling of Spirits." *Newsweek* [*International edition*] (9 March 1992): 49.
Review of an exhibition at the Intar Gallery in New York City, "The Migration of Meaning" of nine artists who, according to curator Inverna Lockpez, represent a melding of found objects with secular and devotional symbols from African, European, Carribbean, and American Indian traditions. James "Son" Thomas is included.

558. Tamulevich, Susan. "Black Mountain Bard." *Mid-Atlantic Country* (July 1990): 36-39.
Biographical information about Jonathan Williams, "poet, rambler, and champion of the uncommon." Describes his home in North Carolina. Mentions his involvement with "outsider artists" and the Jargon Society.

559. Tannous, David. "Report from Washington." *Art In America* (June 1982): 33+.
Discusses "Black Folk Art in America: 1930-1980" at the Corcoran. Also says "more than with most exhibitions, the catalogue is of great value."

560. Taylor, Ellsworth. "Evan Decker." *Folk Art Finder* 3, no. 5 (January 1983): 15.
Biographical sketch of Kentucky carver Evan Decker, who, in 1941, "began carving environmental figures which depicted what he called 'the good old days.' These environments were

populated with fearless cowboys, subservient women, farm buildings, animals, and furniture."

561. Taylor, Terry. "The 'Unknowing' Art of Georgia Blizzard." *The Arts Journal* (August 1988): 12-13.
Article about her "compelling work in clay." Biographical information includes how she learned about working clay from her older sister. Says she has no preconceived notions of the shape each vessel will assume as she works with coil or slab techniques. The figures and features of each pot are carved or applied. Blizzard says working a piece is "like talking to myself." Making art is a therapeutic process in which she works out her personal demons.

562. "Ted Gordon Exhibits at Collection de L'Art Brut." *Folk Art Messenger* 4, no. 2 (Winter 1991): 8.
Quotes a self-description of Los Angeles artist Ted Gordon. The article says "his truth takes place in his drawings." Describes his art. Illus.

563. "Ten California Environments." *Spaces* 1, no. 1 (1982).
Information about the following folk art environments: Art Beal's Nitt Witt Ridge; the "signs and objects" of Miles Mahan; William Averett; Albert Glade and his "Enchanted Garden"; Litto Damonte; Bert Vaughn's Desert View Tower in El Centro; John Ehn's "Old Trapper's Lodge;" John Giudici; and Grandma Prisbrey's Bottle Village. Notes on each. Illus.

564. "Ten Wisconsin Environments." *Spaces,* no. 4 (n.d.): 4-5.
Introductory material about the John Michael Kohler Art Center and its strong advocacy for grassroots artists. Also notes, descriptions, and photographs of works of the following: Father Mathias Wernerus, James Tellen, Paul and Matilda Wegner, Dave Seidler, Fred Smith, Frank Oebser, Mary Nohl, Tony Flatoff, Nick Englebert, and Herman Rusch.

565. "Texas Folk Art." *Folk Art Finder* 3, no. 2 (May 1982): 4-7.
Article about three artists whose works were exhibited in the "Texas Folk Art" show of 1978. These artists are Eddie Arning, Fannie Lou Spelce, and Ezekiel Gibbs. Includes information about their lives, their work, and their artistic recognition. Illus.

566. Theis, Susanne. "Harmonious Madness: Handmade Personal Spaces in Houston." *The Orange Press* [*Newsletter of the Orange Show Foundation*] (July 1992).
An essay with background information and descriptions about several creators of grassroots art in Houston: Jeff McKissack, who built "The Orange Show," John Milkovisch, who built "The Beer Can House," Cleveland Turner, "The Flower Man," Bob Harper, "The Fan Man," and Sylvester Williams, who has been "junking" for many years and has his yard art arranged to tell stories.

567. Theis, Susanne. "Harmonious Madness: Handmade Personal Spaces in Houston. Part II." *The Orange Press* [*Newsletter of the Orange Show Foundation*] (September 1992).
The second part of an essay about folk art environments and yard art in Houston, Texas. This one includes information about "Pigdom" created by Victoria Herberta; the "fantastic community of creatures" made by Ida Kingsbury; the yard art of the late Timiteo Martinez, now preserved by the grandnephews who live in his house; "OK Corral" created by Howard Porter; and the corner fence constructed of objects fished from the Gulf made by the late Kay Shelton.

568. Theis, Susanne Demchak. "The Garden Environment of Ida Kingsbury." *SPOT* [*Houston Center for Photography*] (June 1991): 8.
Background on The Orange Show in Houston and a description of the life and art garden of Ida Kingsbury. Discusses the near loss of the artwork after Kingsbury's death, because of longstanding family feuds, and the successful efforts to save it just in the nick of time. Photographs.

569. "Theodore Gordon." *Folk Art Finder* 3, no. 1 (March 1982): 13-14.
Sketch of the life and art of self-taught artist Ted Gordon. Quotes the artist as saying that each portrait he draws is "but a tentative installment in one interminable self-portrait." Illus.

570. Thompson, Mildred. "Portrait of Benny Andrews." *Art Papers* (July 1988): 6-9.
In this interview, mainstream artist Benny Andrews talks about, among other topics, folk art and the trained artists who use it as a

resource. He also has some things to say about a "black aesthetic." His self-taught artist father George Andrews is also mentioned.

571. Thompson, Roy. "Defining Traditional Southern Folk Pottery." *Southern Folk Pottery Collectors Society,* no. 4 (March 1992): 1, 4.
Author lists the criteria used to define the parameters of traditional folk pottery. He says "the method of production is an inherent and essential element of the aesthetic value of traditional Southern folk pottery" and that the Society was founded to help preserve and extend the appreciation of this pottery. Thompson notes that there are today folk potters who have "never wood-fired a piece or dug their own clay." He says the work may have appeal and merit, but it is not traditional.

572. Thompson, Roy. "Face Jugs, Chickens, and Other Whimseys: Vernacular Southern Pottery." *Folk Art Finder* 13, no. 3 (July 1992): 16-19.
Information about the traditional ways of making pottery in the South and how "little has changed with the methods used by today's vernacular potters." Notes that while salt glazes predominate as stoneware coverings in other areas, southern ware is "alkaline glazed in green or brown and is lustrous in appearance." Additional information about the typical glazes and forms, and the information that face vessels did not originate in the South as is commonly believed. Kiln openings are described and a checklist of potters is provided. The author also gives information about the Southern Folk Pottery Collectors Society. Illus.

573. Thorson, Alice. "The Temptations of 'O, Appalachia'." *New Art Examiner* (October 1990): 28-30.
Author fears that the attraction of contemporary folk art is an escape. Says this art could be used "as a weapon in the arsenal of anti-intellectuals." Says "in the censorious '90s, folk art may prove the perfect antidote to offensive art." Illus.

574. Tickel, Joni. "Arousing More than a Smile." *Taos Magazine* (May 1989): 24-26.
About the life and art of Joel Lage, who makes found-object sculptures. Includes an interview with the artist. Lage says "the piece occurs to me on the ground. It is really as if they assemble themselves." Illus.

575. "The Ties That Bind." *Folk Art Finder* 8, no. 2 (April 1987): 4.
Description of an exhibition organized by the Contemporary Arts Center in Cincinnati, Ohio, "The Ties That Bind: Folk Art in Contemporary American Culture." It includes over sixty objects by thirty-two contemporary folk artists. Describes the organization of the works into "sections that reflect the artists' responses to the modern world." Three artists from the exhibition are written about in the issue. They are Roy Kothenbeutal, William Hawkins, and Charley Kinney.

576. "Time Magazine Declares Folk Art Dead." *Folk Art Finder* 3, no. 2 (May 1982): 2-3.
Response to the remark made in a review of the Corcoran show that white folk art is dead and black folk art is soon to follow—with the *Time* editor's reply to Florence Laffal's letter.

577. "A Time to Reap: Late Blooming Folk Artists." *Folk Art Finder* 6, no. 3 (September 1985): 4-7.
Description of the exhibition named in the title above, with a list of speakers at a related symposium at Seton Hall University. There is also biographical information about three artists included in the exhibition: Lizzie Wilkerson, Sadie Kurtz, and Jon Serl. Illus.

578. Tobler, Jay. "The Cutting Edge." *Folk Art Messenger* 4, no. 3 (Spring 1991): 4-5.
Review of the Museum of American Folk Art exhibition "The Cutting Edge: Contemporary American Folk Art from the Rosenak Collection." Tobler was favorably impressed and described some of the objects in the collection. Illus.

579. Tobler, Jay. "The Language of Art: U Dig Me?" *Folk Art Messenger* 3, no. 2 (Winter 1990): 4-5.
Discusses the use of language in the art of Sam Doyle and links it to "traditional African-American communication." Photographs of Sam Doyle's yard, paintings, and the man himself.

580. Tobler, Jay. "Lonel Talpazan: Traveler in Space." *Folk Art Messenger* (Spring 1990): 8.
About the life and work of visionary artist Lonel Talpazan, for whom UFOs are a frequent subject. Author says the artist's "affinity for the technology of the future" reminds him of the work of California painter Alex Maldonado.

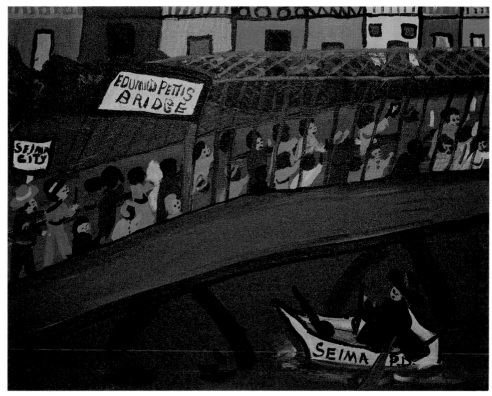

1.

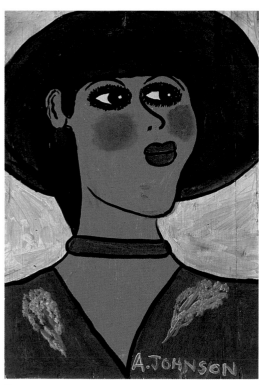

2.

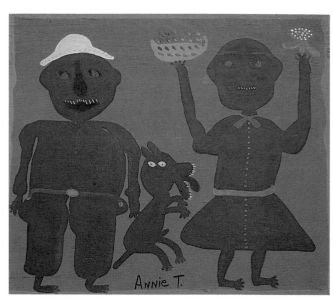

3.

1.
Bernice Sims
Selma March 3/65, 1991
Acrylic on canvas;
16" x 20"
Courtesy: Cotton Belt Gallery

2.
Anderson Johnson
Woman in Sunday Hat, 1991
Oil on canvas board;
18" x 24"
Private collection

3.
Annie Tolliver
Family with Dog, 1991
Acrylic on wood;
27" x 32"
Collection: Betty-Carol Sellen
Photo: Cynthia J. Johanson

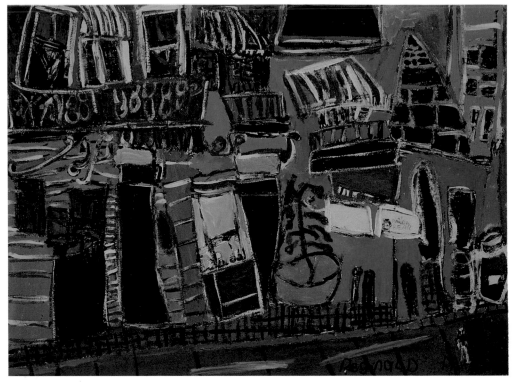

4.

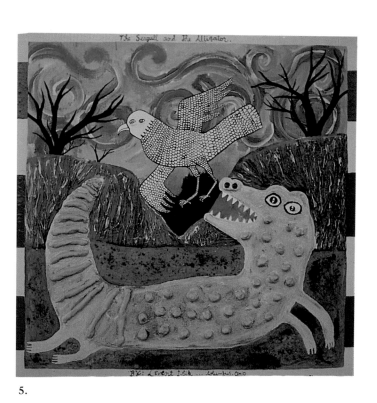

5.

6.

4.
Reginald Mitchell
Bourbon Street, 1992
Acrylic on artist board;
14" x 19"
Courtesy: Barrister's Gallery

5.
Levent Isik
Seagull and the Alligator, 1991
Paint, mixed media;
23.75" x 24"
Collection: Gerald W. Adelman

6.
Annie Lucas
Sumerian Woman with Jesus,
1991
Mixed media on canvas;
28" x 33"
Courtesy: Bockley Gallery

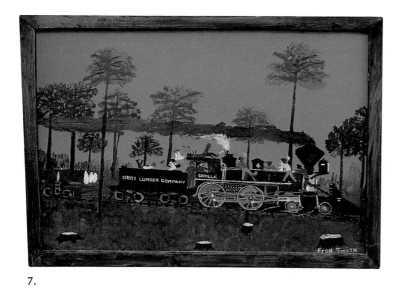

7.

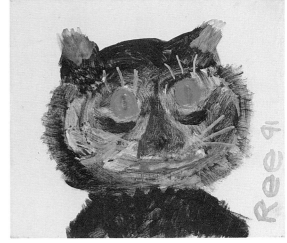

8.

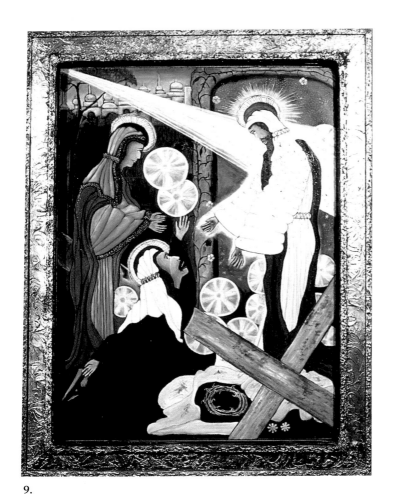

9.

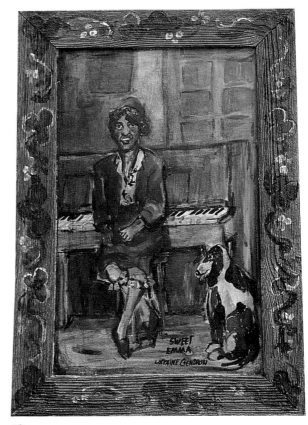

10.

7.
E.A. "Frog" Smith
Train Satilla 1897, 1987
House paint on masonite;
17.25" x 24"
Collection: Cynthia J.
Johanson

8 .
Ree Brown
Cat, 1991
Oil and gouache on paper;
3.5" x 4"
Courtesy: Pulliam-
Deffenbaugh-Nugent

9.
Lorenzo Scott
When Thomas Say Jesus Hands,
1985
Oil on canvas;
42" x 48"
Courtesy: Modern Primitive
Gallery

10.
Lorraine Gendron
Sweet Emma, 1986
Oil on board;
16" x 20"
Collection: Betty-Carol Sellen
Photo: Cynthia J. Johanson

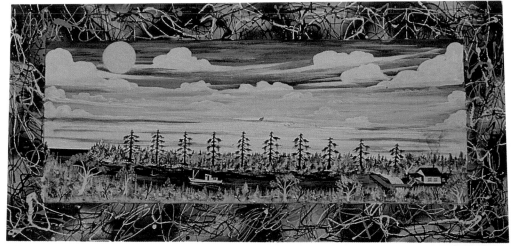

11.

12.

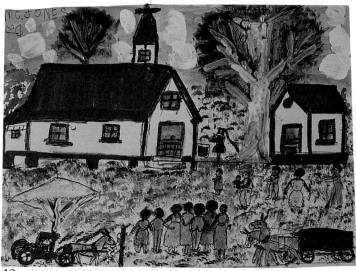

13.

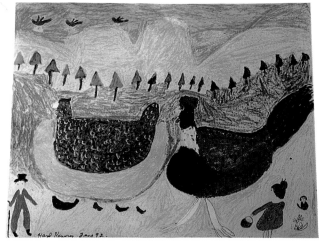

14.

11.
Mike Frolich
Land/Seascape, c. 1980
Acrylic on masonite;
19" x 39.5"
Collection: Betty-Carol Sellen
Photo: Cynthia J. Johanson

12.
Walter Tiree Hudson
The Last Supper, 1989
Acrylic and tempera on paper;
9" x 12"
Courtesy: G.H. Vander Elst

13.
M.C. "5¢" Jones
Church Reunion, 1990
Pen and watercolor on paper;
11" x 14"
Private collection

14.
Hazel Kinney
Chickens, Noah, Hazel, 1992
Oil crayon on paper;
22" x 28"
Private collection

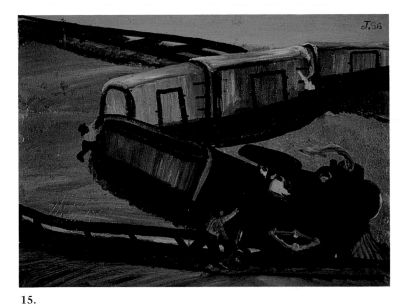

15.

16.

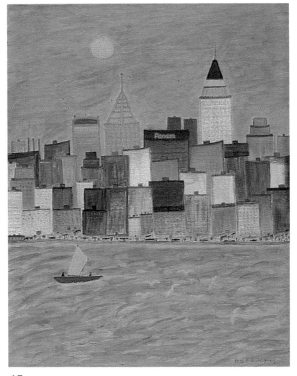

17.

18.

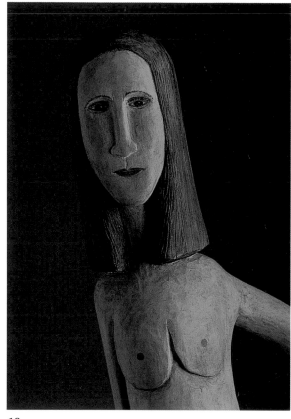

19.

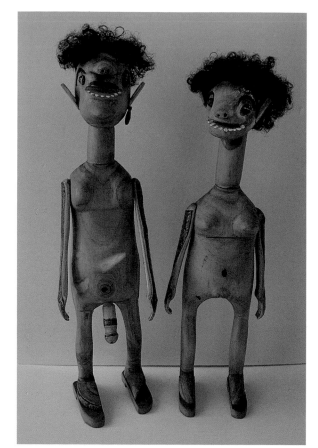

20.

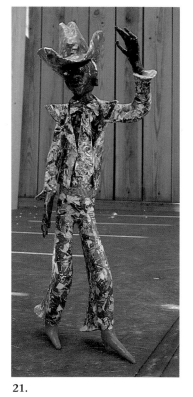

21.

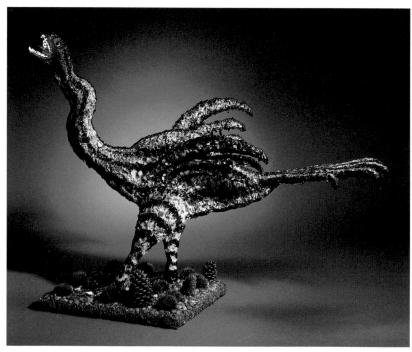

22.

19.
Michael Van Auken
Exercise in Silver Maple (detail),
1992
Carved and painted wood;
65" x 35" x 11.25"
Photo: Chris Eaton

20.
Abraham Lincoln Criss
Adam and Eve, 1988
Wood, mixed media;
29.5"; 28"
Courtesy: Lynne Ingram
Southern Folk Art

21.
Patrick Davis
Dude, 1991
Paper, glue, and varnish;
12"
Collection: Martha Burt
Photo: Cynthia Johanson

22.
Q.J. Stephenson
Prehistoric Bird, 1991
Mixed media;
26" x 35" x 14"
Courtesy: Lynne Ingram
Southern Folk Art

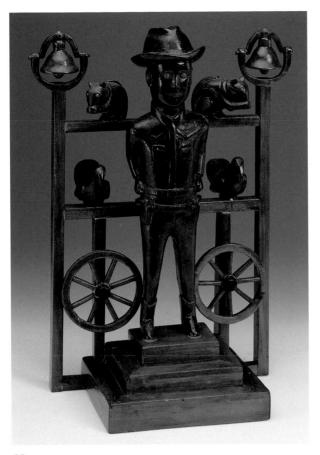

23.

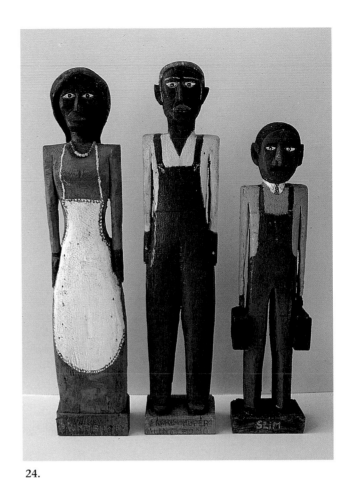

24.

25.

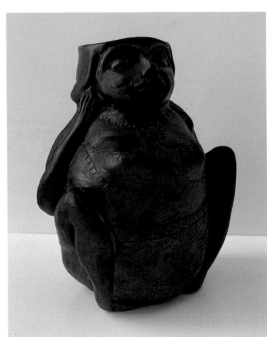

26.

23.
Evan Decker
Self-Portrait as a Cowboy,
c.1945-1960
Carved and assembled wood;
16.25" x 12.125" x 5.75"
Collection: Huntington
Museum of Art
Photo: Dale Brown

24.
Arliss Watford, Sr.
Sharecropper's Family, 1989
Paint, beads, wood;
29" x 28.5" x 25"
Courtesy: Lynne Ingram
Southern Folk Art

25.
Troy Webb
Doll, 1988
Mixed media;
25"
Courtesy: Lynne Ingram
Southern Folk Art

26.
Georgia Blizzard
Barroom Flower, 1991
Low-fired clay;
12.5" x 9.5" x 8"
Courtesy: Lynne Ingram
Southern Folk Art

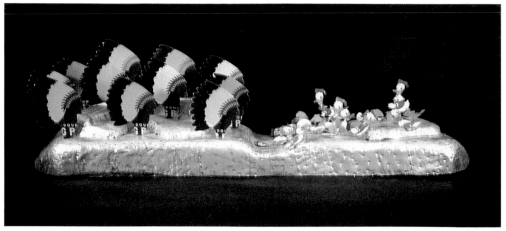

27.

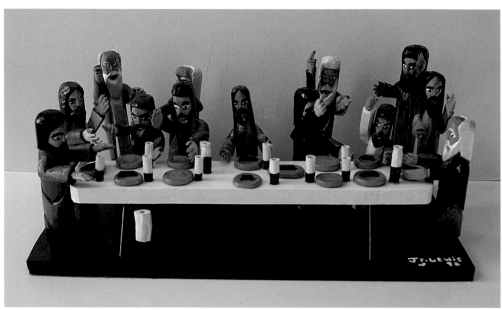

28.

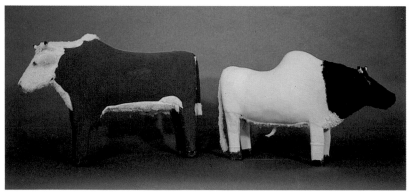

29.

27.
Joel Lage
Homage to Chief Crazyhorse,
1991
Found objects;
10" x 24" x 8"
Courtesy: Leslie Muth Gallery

28.
Junior Lewis
The Last Supper, 1992
Carved and painted wood;
8.5" x 20.5" x 10.5"
Private collection

29.
Dan Hot
Two Bulls, 1992
Mixed media carving;
8" x 12" x 5"
Courtesy: Leslie Muth Gallery

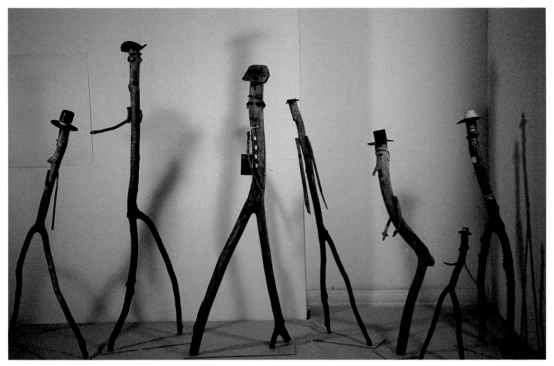

30.

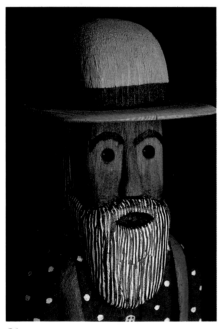

31.

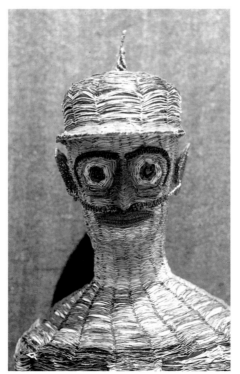

32.

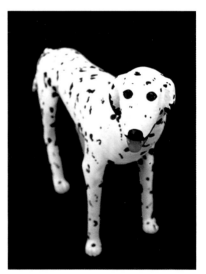

33.

30.
Lee Steen
Wood Figures, c.1940-1950
Wood, paint, mixed media;
56" to 36"
Courtesy: American Primitive
Gallery

31.
J. Olaf Nelson
Farmer (detail), 1991
Carved and painted wood;
22"
Photo: Geoffrey Carr

32.
"Mad Mac" McCaffrey
Hessian (detail), 1987
Telephone wire;
53"
Collection: Charles and Mary
Auerbach

33.
Walter Barkas/Rivkah Swedler
Dalmatian, 1991
Carved and painted wood;
15" x 28" x 10"
Courtesy: MIA Gallery

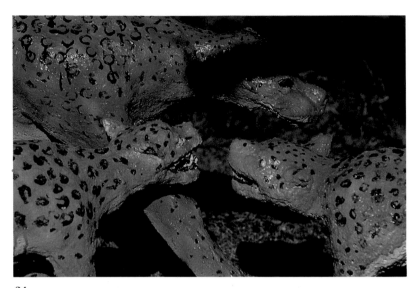

34.

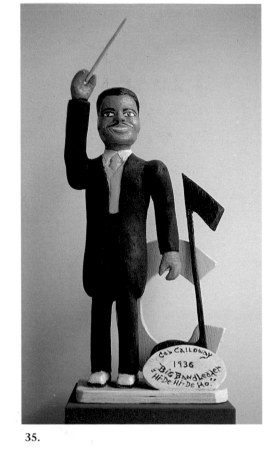

35.

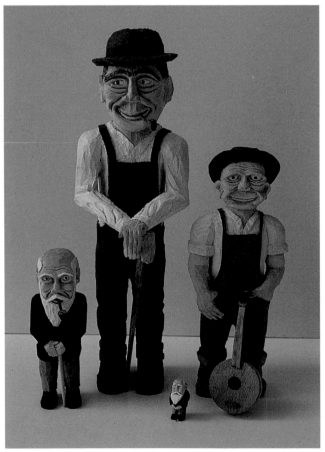

36.

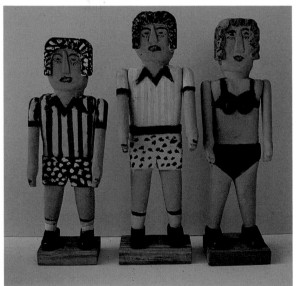

37.

34.
Vernon Burwell
Leopards, c.1985
Cement, wire, paint;
20" x 36" each
Photo: Roland L. Freeman

35.
Bill Potts
Cab Calloway, 1990
Carved and painted wood;
28" x 12" x 12"
Courtesy: MIA Gallery

36.
Sam Drake
Male Figures, 1992
Paint on wood and gourd;
13.75," 9.75," 6," 1.5"

37.
Ernest "Dude" Baker
Son, Father; Mother; 1992
Carved and painted wood;
16"; 14"; 12"
Private collection

38.

39.

40.

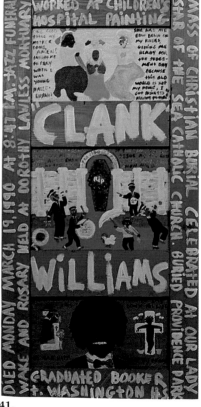

41.

38.
Gregory Van Maanen
Effigy, 1985
Acrylic on canvas;
24.5" x 20"
Courtesy: Cavin-Morris, Inc.
Collection: Victor and Irene Zion
Photo: Ellen Page Wilson

39.
Ike Morgan
Couple Against Yellow, 1989
Acrylic on paper;
26" x 21.5"
Courtesy: Leslie Muth Gallery

40.
"Creative" G.C. DePrie
Pharaoh Entombed, 1991
Pencil on paper;
24" x 36"
Collection: Eason Eige
Photo: Dale Brown

41.
Sainte-James Boudrôt
Clank Williams, 1990
Paint on wood;
48" x 24"
Collection: Kurt Gitter and Alice Yelen

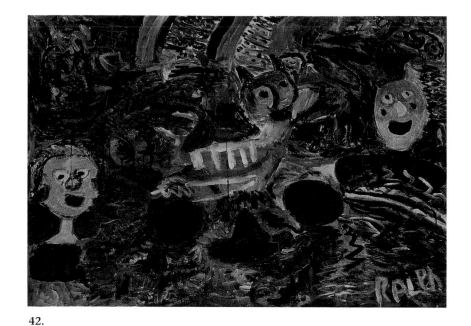

42.

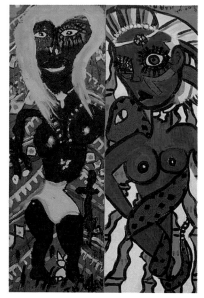

43.

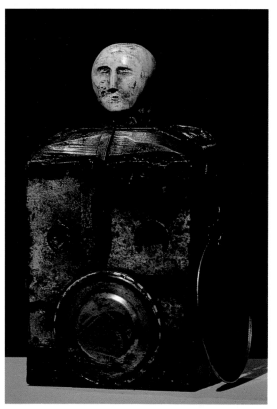

44.

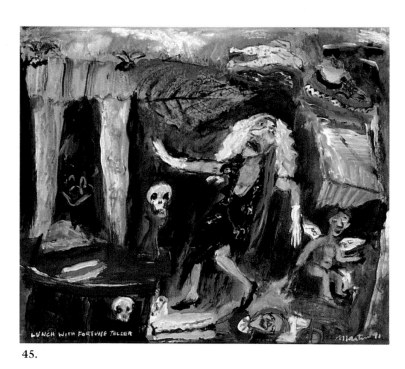

45.

42.
Ralph Bell
Untitled, 1987
Acrylic on masonite;
48" x 72"
Courtesy: Dean Campbell

43.
Joseph Hardin
*Red Native Woman; Blue Native
Woman,* 1988
Acrylic, mixed media on board;
30" x 10"; 30" x 10.5"
Collection: Cynthia J.
Johanson

44.
Terry Turrell
*Ping Pong,*1992
Mixed media, found objects;
15" x 9" x 6.5"
Courtesy: MIA Gallery

45.
James Martin
Lunch with Fortune Teller, 1991
Tempera on paper;
18.75" x 21.5"
Courtesy: Pulliam-
Deffenbaugh-Nugent

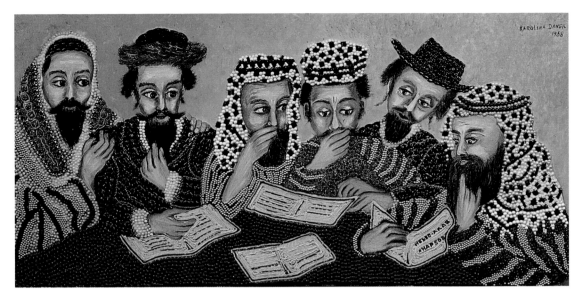

46.

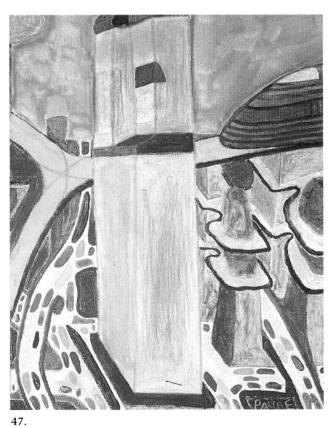

47.

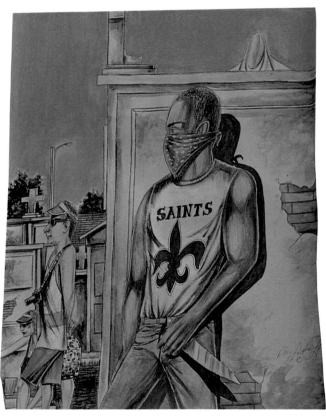

48.

46.
Karolena Danek
Arab-Hebrew Rhapsody, n.d.
Beads, paint, mixed media on
canvas;
24" x 48"
Courtesy: Sailor's Valentine
Gallery

47.
Paul Esparza
Metrolink Farebox and More Too,
1992
Acrylic and pencil on canvas;
16" x 20"
Courtesy: Sherry Pardee

48.
Roy Ferdinand
New Orleans, St. Louis Cemetery,
1991
Ink and tempera on poster-
board;
28" x 22"
Courtesy: Barrister's Gallery

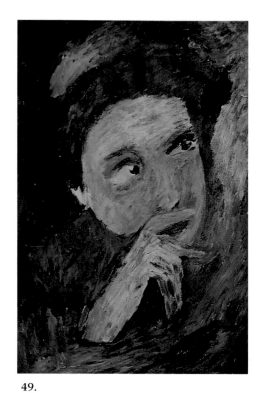

49.

50.

51.

52.

53.

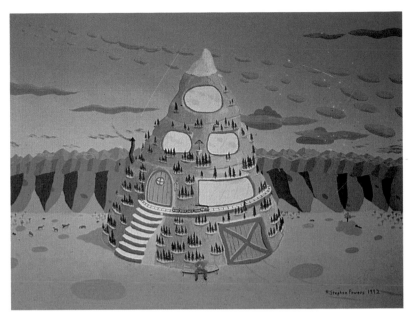

54.

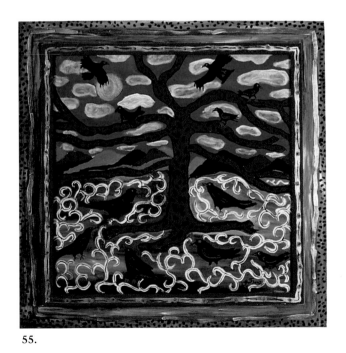

55.

56.

53.
Donald Walker
Untitled, 1992
Oil on artist board;
18" x 12"
Courtesy: The Ames Gallery

54.
Stephen Powers
Mountain House, 1992
Acrylic on canvas;
18" x 24"
Courtesy: MIA Gallery

55.
Sarah Rakes
Crows' Parliament, 1991
Oil, acrylic on canvas and
wood;
41" x 41"
Courtesy: Marcia Weber/Art
Objects Inc.

56.
Norman Scott "Butch" Quinn
*Six Owls Show Their First
Feathers,* 1991
Mixed media on canvas;
18" x 24"
Photo: Cynthia J. Johanson

57.

59.

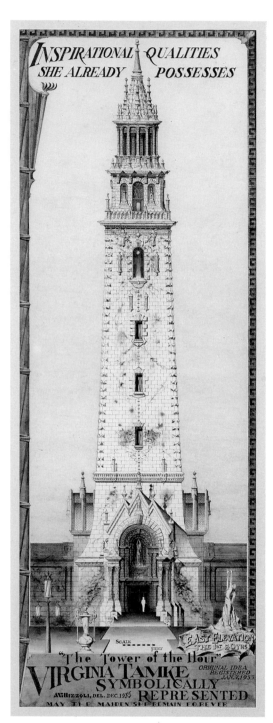

58.

57.
Chelo Amezcua
La Exotica, n.d.
Ink on paper;
28" x 22"
Courtesy: Cavin-Morris, Inc.

58.
A.G. "Achilles" Rizzoli
Virginia Tamke Symbolically Represented (S-2), 1935
Colored ink on rag paper;
34" x 12"
Courtesy: The Ames Gallery

59.
Samuel Gant
Marine Life, 1988
Tempera on paper;
25" x 38"
Courtesy: National Institute of Art and Disabilities

581. "Tressa 'Grandma' Prisbrey 1896-1988." *Spaces* (December 1989): 4.
Notice of the death of the creator of Bottle Village. Description of the site, a photograph of Prisbrey, and information about the committee formed to preserve Bottle Village.

582. Trillin, Calvin. "A Reporter at Large—I Know I Want to Do Something." *New Yorker* (29 May 1965): 72-120.
Identified as "a major essay" by many, this presents full documentation of the struggle to preserve Watts Towers. Includes detailed information about Simon Rodia.

583. Tromble, Meredith, and John Turner. "Striding Out on their Own: Folk Art and California Artists." *The Clarion* 13, no. 3 (Summer 1988): 40-47.
Discusses possible connections and exchanges and influences between self-taught and trained California artists. Notes the interest in folk artists by some Chicago academic artists. Illus.

584. "Troy Webb." *Folk Art Finder* 10, no. 3 (July 1989): 12.
Sketch about a folk artist from the hills of Tennessee. He was a sawmill worker and a coal miner. Now retired he carves wooden people, as do several other members of his family. Illus.

585. Tully, Judd. "Black Folk Art in America." *Flash Art* (November 1983): 32-35.
Review of the "Black Folk Art show," which had just arrived in Los Angeles after opening at the Corcoran Gallery of Art in Washington, D.C. The author describes the art and includes detailed opinions. Illus.

586. Turner, John F. "The Golden Road: Traveling with Howard Finster." *Folk Art Messenger* 3, no. 1 (Fall 1989): 1, 5.
Turner describes the time he has spent with Finster since 1981, gathering information for his biography of the preacher/artist from Summerville, Georgia. Illus.

587. Turner, John F. "Howard Finster Man of Visions." *The Clarion* 14, no. 4 (Fall 1989): 38-43.
This is an excerpt from the book of the same title by Turner. Illus.

588. Turner, John F. "Paradise Garden: Howard Finster Man of Visions." *Raw Vision* 2 (December 1989): 8-15.
This article is abstracted from the book by Turner, which was published by Knopf in 1989. An opening paragraph describes Paradise Garden and its beginnings. This is followed by Howard Finster describing his work, God's work, and building the garden. Includes photographs and a "rough ground plan."

589. Turner, John F. "Tom Wilburn." *Folk Art Finder* 4, no. 2 (May 1983): 15.
A biographical sketch of self-taught carver Wilburn, who carved from packing case scraps at the Ford Motor Company where he worked. Most of his carvings were of co-workers. Illus.

590. "Two California Folk Artists: Bob Carter and Nounoufar Boghosian." *Folk Art Finder* 1, no. 4 (September 1980): 1, 3, 5, 18.
Biographical sketch of the two artists with illustrations. "One is a native born artist living in northern California and the other is a Turkish-born Armenian who makes her home in southern California." The article includes information about the art and illustrations.

591. "Two Folk Artists Receive Kentucky Arts Award." *Folk Art Finder* 7, no. 1 (January 1986): 10.
Article says the Kentucky Arts Council selected ten artists to receive prizes of $5,000 each in 1985. The recipients were chosen for "excellence, creativity, and individuality." Although it is rare for a folk artists to be chosen for a prize, that year there were two: Denzil Goodpaster and Carl McKenzie. Brief descriptions of each artist's work.

592. "Two Mississippi Folk Artists: Theora Hamblett and Ethel Mohamed." *Folk Art Finder* 1, no. 2 (May 1980): 3-4.
Biographical information and descriptions of the art of these two women artists. Illus.

593. Van Horn, Donald. " 'Carve Wood': The Vision of Jesse Aaron." *Southern Folklore Quarterly* 42 (1978): 257-270.
Detailed information from interviews with Jesse Aaron, a Florida self-taught artist who discovered his art in a vision he had after giving up his nursery work. He needed work so he prayed for direction. Aaron says "God put the faces in the wood." Illus.

594. Van Sickle, Andrew. "God's Last Red Light." *Clifton Magazine: The Magazine of theUniversity of Cincinnati* 15, no. 3 (March 1987): 38-43. About Finster's visions and their influence on his life work. Lots of detail about the Garden. Tells of the work of Beverly Finster, Michael Finster, Allen Wilson, and Chuck Cox, with some information about them.

595. Van Sickle, Andrew. "Howard Finster, God's Artist." *Dialogue, An Art Journal* 11, no. 4 (July 1988): 18-19.
Report of a visit to the home of the artist, "a virtual one-man sacred movement with over 8,000 numbered paintings to his credit," Finster tells of the time he first experienced the religious visions that have fueled his life ever since. Van Sickle says "In 1975, Finster was discovered by two authors, Jane and Michael Stern, who featured him in their book Roadside America. His reputation grew quickly after Jeff Camp went to see Finster (after reading the Sterns' book) and transported hundreds of his religious works to New York and Chicago." Tells about family involvement in the art.

596. Vergara, C. "Kea's Ark." *Folk Art Finder* 8, no. 3 (July 1987): 13-15, 17.
Detailed description of the building of the ark. Information on the community where the ark was built, on battles to save it, and Kea's successful and ingenious method to move it to another lot. There is an account of Kea Tawana's early life too. [*Folk Art Finder* 9 (4) October-December 1988, 1 tells of the lost battle to save the Ark.]

597. Vergara, C. "Kea, the New Ark and Newark." *Spaces,* no. 7 (December 1988): 1.
Author provides a detailed description of the ark itself, the setting for this monumental piece, and the material used by creator Kea Tawana. Vergara also tells about the government's hostility to the ark.

598. "Vernon Burwell 1914-1990." *Folk Art Messenger* 4, no. 4 (Summer 1991): 10.
Obituary notice for Burwell, seventy-six, who died in Rocky Mount, North Carolina on December 10, 1990. Information on his art and on inclusion in exhibitions. Illus.

599. "Veronica Terrillion's House and Garden." *Folk Art Finder* 6, no. 2 (May 1985): 10-11.
Description of the upstate New York environ-mental work that was inspired by artist/builder Terrillion's religious beliefs. Illus.

600. Vidoli, Pierre Gilles. "Bok to the Future: And Two Other Tales of L.A." *Details* (July 1988): 113-115.
Full-page photograph of Bok sitting on one of his chair creations, another of an art work alone. Article features Bok and two other people from the Los Angeles art scene. A few details of his early background, working in Los Angeles, his sudden blindness, and his cure after consulting with parapsychologists and psychic advisors. Works in the backyard of his house, accompanied by his dog Birdie.

601. Vincent, Gilbert T. "Lavern Kelley: A 20th-Century Folk Artist in a 19th-Century Tradition." *Art and Auction* 9, no. 10 (May 1987): 134-139.
Article about the upstate New York self-taught artist Lavern Kelley. Information about his family, his farm life, and his art, including themes, materials, and tools used.

602. "Visionary Images from the South." *Folk Art Finder* 9, no. 1 (January 1988): 4-7.
Notice of the exhibition "Baking in the Sun" with details of the lives and the art of three people included in the exhibition: Henry Speller, Royal Robertson, and Mary T. Smith. Illus.

603. "A Visionary Salesman." *Journey: The Magazine of the Coca-Cola Company* 2, no. 4 (February 1989):
Article about Howard Finster with brief notes about his Paradise Garden and much more about his use of the Coca-Cola image in his art. Color illustrations.

604. Vlach, John Michael. "Plain Painters." *The Clarion* 13, no. 3 (Summer 1988): 29-33.
Excerpts from "the forthcoming book," *Plain Painters: Making Sense of American Folk Art,* by Vlach, who presents arguments for alternative terminology to "folk" art and an alternate evaluation, too.

605. Vlach, John Michael. "The Wrong Stuff." *New Art Examiner* (September 1991): 22-24.
Vlach says folk art is made only in the context of work and community and connected to "folk groups." Says "common sense and better judgment have been suspended so that works

of arrested talent could be celebrated as master-pieces," a reference to what most museums and collectors call folk art.

606. Volkersz, Willem. "Mixed Baggage: A Decade of State Folk Art Surveys." *Folk Art Finder* 10, no. 1 (January 1989): 4-5.
Discusses the surveys inspired by the American Bicentennial. Volkersz says the surveys have given credit to all the groups that make up the population, clearly supporting cultural diversity at least in folk art. Says the more tradition-al ones focused narrowly on traditional objects. The range is "from selections of predominant-ly traditional objects (Idaho, Oregon, Vermont, and Wisconsin), to exhibitions which dis-played more personal and expressive works (Kentucky, Michigan, the Northwest, the West Coast, and North and South Carolina)." Talks of dangers inherent in the folklorist viewpoint.

607. Volkersz, Willem. "Is It Folk, Primitive, Grass-roots, or Art Brut?" *Forum: Visual Arts/Mid-America* 12, no. 1 (January 1987): 2-3.
A "brief look at the history of defining Ameri-can folk art." Notes the different groups involved—artists, art historians, art critics, museum curators, collectors, folklorists, and cultural anthropologists. The result is a litany of terms—folk, self-taught, primitive, early American, unacademic, naive, visionary, grass roots, and so on. Author proceeds with a his-tory of defining American folk art, which he says began in the 1920s. Illus.

608. Volkersz, Willem. "Smith's Paintings Are Drawn from Experience and Observation." *Fo-rum: Visual Arts/Mid-America* 12, no. 1 (January 1987): 16-17.
Article about painter Robert E. Smith, his life, his artworks, themes, and inspirations. Discuss-es the definition of Smith as a "folk artist." Illus.

609. Volkersz, Willem. "Who Is You?—American Folk Artists and Their Audience." *Raw Vision* 1, no. 1 (1989): 6-12.
Describes experiences, cultural traditions, and "some very uniquely American qualities" that have helped shape American folk art. Notes "climate, topography, frequent lack of building materials, an alien environment," and the mix-ture of European and non-European traditions as some of the significant elements. The em-phasis on individuality and the entrepreneur-ial spirit of American culture are evident in the visual exuberance of American folk art and its increasing acceptance by the public. Tells about the folk art he has examined. Illus.

610. Wade, Marcia. "Folk Art's Future: Toward the Contemporary." *Antique Monthly* (March 1992): 45-47.
Discusses the increasing market value of con-temporary folk art, as nineteenth century ob-jects become harder to find. Mentions Burgess Dulaney, Willie Massey, R.A. Miller, Willie White, Mose Tolliver, Jimmy Lee Sud-duth, and Bill Traylor. Illustrations include Malcah Zeldis, Mr. Imagination, and two faux folks.

611. Wahlman, Maude Southwell. "Religious Symbols in Afro-American Folk Art." *New York Folklore* 12, no. 1-2 (1986): 1+.
Author says that African-American influence on America's folk art is not as well document-ed as the influence on the history of music, dance, and speech. "Yet it is possible to trace Afro-American innovations as they adapted African techniques, aesthetic traditions, and religious symbols to the needs and resources of a New World." Describes process called "creolizing" and claims works of certain folk artists are examples, including Bill Traylor, Nellie Mae Rowe, and James "Son" Thomas.

612. Walker, Maridith. "Bill Traylor: Freed Slave and Folk Artist." *Alabama Heritage,* no. 14 (Sep-tember 1989): 18-31.
Many details about Bill Traylor's life and "the 1500 drawings he produced" on the streets of Montgomery. Notes the fame that came af-ter his death. Many photographs and illustra-tions of the drawings from the collection of Charles, Shannon.

613. Walker, Phillip. "James 'Son' Thomas." *Bomb Magazine,* no. 6 (n.d.).
Interview with Thomas that provided answers about how Thomas started working with clay, the earliest figures made, why he started to make skulls ("to scare my grandfather with . . . it worked but he made me take it out of the house"), and where he gets his human teeth. Illus.

614. Walsh, Carolyn. "William Miller and Ric[k] Bryant." *Folk Art Finder* 13, no. 2 (April 1992): 20-21.

About the backgrounds, artwork, and inspirations of these two Kentucky stick carvers, William Miller and Rick Bryant. Illus.

615. Wasserman, Abby. "From the Heart: California Folk Art." *The Museum of California* (May 1986): 16-19.
Discusses and describes the exhibition "Cat and a Ball on a Waterfall" and says the fifty-nine artists represented have different visions and styles, yet many elements in common, which Wasserman lists. Includes information from curator Harvey Jones about the genesis of the exhibition. Quotes from others about the importance of the art. Several works are described by their creators. Illus.

616. Wecter, Elizabeth. "Animal Carvers of New Mexico." *The Clarion* (Winter 1986): 22-31.
Article about carvers Felipe Archuleta, Ron Rodriguez, Alonzo Jimenez, and others who created pieces that Wecter gave to the Museum of American Folk Art. Illustrations of art, and the artists.

617. Weeks, Dan. "Extraordinary Folk Art from the People of the Southern Mountains: Appalachian Treasure." *Traditional Home* (June 1990): 74-81.
Photographs and brief commentary on Appalachian folk art mentions several of the well-known artists—all the Coopers (Calvin is not Jessie's husband, as labeled), Minnie Adkins, Herman Hayes, Cher Shaffer, the Kinneys, S.L. Jones, Dilmus Hall, Carleton Garrett, Oscar Spencer, Hugo Sperger, and others. Quotes from collector Ramona Lampell.

618. Weissman, Julia. "Harry Lieberman, Jewish Naive Artist." *Midstream* (May 1974): 35-44.
Tells about Lieberman's reputation with the art public and how he began painting at seventy-eight; describes his style and says "his paintings (and his sculptures) are remarkably radiant with color, composition, and action." Tells of his use of Jewish folklore and literature for inspiration.

619. Weissman, Julia. "Malcah Zeldis: A Jewish Folk Artist in the American Tradition." *The National Jewish Monthly* (September 1975): 2-5.
The author attempts to place Zeldis in the context of a folk art tradition that goes back to the eighteenth century. She also says Zeldis is "a naive or primitive artist because she, is un-trained and self-taught—a basic characteristic of folk artists." Weissman talks about Zeldis' style, her subject matter, her inspirations, and experiences. Illus.

620. Wertkin, Gerard C. "Dr. Robert Bishop (1938-1991): A Personal Memoir." *The Clarion* 16, no. 4 (Winter 1991-1992): 35-40.
About the life, interests, and accomplishments of Robert Bishop as director of the Museum of American Folk Art and in other arenas of his life. Written shortly after Bishop's death.

621. "What Is Folk Art? What Is Outsider Art?: An Open Forum." *Folk Art Finder* 11, no. 2 (April 1990): 4-7.
Responses from several people involved in the field to the above questions in the title. Those who provided definitions and explanations were Robert Bishop, Didi Barrett, Sal Scalora, Susan Hankla, and Pat Parsons.

622. "Wibb Ward." *Folk Art Finder* 4, no. 1 (March 1983): 6.
In 1969 this Oregon logger started to carve bears with his chain saw. His bears, carved from driftwood found on nearby beaches, are displayed among trees and bushes on land next to his home. Illus.

623. Wilkie, Nashormeh N. R. "American Visionary: Gerald Hawkes." *Folk Art Messenger* 2, no. 2 (Winter 1989): 9.
Detailed information about the Baltimore artist including that he credits a mugging as his impetus to start making art. He is described as a visionary artist. He uses match sticks to create "two and three dimensional abstractions with geometrical motifs and numerical symbols," and he uses these symbols to express his ideas about religion, family, and nature. Illus.

624. "William Dawson 1901-1990." *Folk Art Messenger* 3, no. 4 (Summer 1990): 5.
Brief obituary notice announcing the death of carver and painter William Dawson, with photographs of the artist and the art.

625. "William Hawkins (1895-1990)." *Folk Art Finder* 11, no. 3 (July 1990): 11.
Brief notice of the death of Columbus, Ohio artist William Hawkins, who made bold brilliant paintings and mixed-media constructions and received critical acclaim and attention from museums and collectors. Says he died

January 23, 1990, shortly after his work appeared in two major exhibitions.

626. "William L. Hawkins 1895-1990." *Folk Art Messenger* 3, no. 3 (Spring 1990): 7.
Notice of the death of Hawkins on January 23, 1990 "in Dayton, Ohio from complications from a stroke suffered in November."

627. "William Lawrence Hawkins: 1895-1990." *The Clarion* 15, no. 2 (Spring 1990): 24.
Notice of the death of Hawkins on January 23, 1990 from complications following a massive stroke. He died in Columbus, Ohio. Brief information about his early life, his discovery as an artist, and the sources for his art. Says his work may be found in the Museum of American Folk Art and the National Museum of American Art. Photograph of the artist.

628. "William R. Dawson: 1901-1990." *The Clarion* 15, no. 4 (Fall 1990): 23.
Obituary notice about Dawson with details on the artist, his art, and his public recognition. Photograph of the artist at work.

629. Williams, Jonathan. "The Art Man and the Wizards: Travels with the Omnivorous Bill Arnett on the Southern Outsider Trail." *Artvu Magazine* (March 1991): 26-31.
Williams describes traveling with Bill Arnett in Kentucky and Tennessee. Information on Arnett's background and his financial arrangements with a number of artists, of which Williams approves. Among the places visited are the "ruins" of Enoch Wickham's outdoor environment in Palmyra, Tennessee and the homes of Joe Light, Henry Speller, and Felix Virgous in Memphis. Photographs by Guy Mendes.

630. Wilson, Cleo. "Intuit Group Forms in Chicago." *Folk Art Messenger* 5, no. 3 (Spring 1992): 5.
Report on the new organization Intuit: The Center for Intuitive and Outsider Art "established to celebrate artists who are motivated by a unique personal vision and who demonstrate little influence from the mainstream art world." Wilson describes initial activities of the group and plans for the future.

631. Wilson, James L. "Clementine Remembered." *Louisiana Life* (March 1989): 28-32.
About Clementine Hunter's long life of hard work and her discovery of painting after she had "already lived over 50 years." Wilson says work dominated her life but not her memory or her art: "She painted with honesty and with a surprising sense of joy." Illus.

632. Wilson, Jess D. "It Happened Here." *Cooperative Spotlight Newsletter* [McKee KY RuralElectric Co-op] (January 1973).
Article with numerous photographs about Minnie Black and her gourd museum. "All the animals and people in the museum are made from gourds. She raises all manner and sizes which she fastens together, using clay to add features."

633. Wilson, Judith. "Black Folk Art: A Vision Endures." *Museum* (March 1982): 38-41.
Review of the exhibition "Black Folk Art in America" exhibition at the Corcoran. Commentary on the works and information on the lives of the individual artists. Author concludes that in spite of recognition, "where there is vision, art can thrive against all odds." Illus.

634. Winkler, Allan. "Dexhimer's Images Hold a Child-Like Charm." *Forum: Visual Arts/Mid-America* 12, no. 1 (January 1987): 12-13.
Describes his first encounter with Dexhimer's work, then meeting the artist, who lived in a rural area in Missouri. Tells of driving down a winding country road and coming upon the artwork nailed to trees, sitting on the ground —paintings and sculpture, hundreds and hundreds of them. Winkler tells of continued visits with the artist and provides background on his life. Soon after Dexhimer began to receive attention for his art, he died. Illus.

635. Winthrop, Mort. "American Folk Art: Hanging Money on Your Wall." *The Robb Report* 8, no. 1 (January 1984): 82-92.
The subject of the article is art as an investment. Author describes "the life of a Jack Savitsky painting from $10 pop art for tourists to the walls of a gallery to the hands of a 'big New York art collector ($250)' to the cover of a folk art book published by a fancy Madison Avenue publisher." Talks about art of Grandma Moses, Morris Hirshfield, Howard Finster, Nellie Mae Rowe, Elijah Pierce, Jack Savitsky, and Ralph Fasanella.

636. Wintman, Elaine. "Seymour Rosen and SPACES: Saving our Sites." *The Clarion* 13, no. 1 (Winter 1988): 47.

About the efforts of Rosen and his organization SPACES to document and save grassroots art environments.

637. Wintman, Elaine. "Folk Art Environments and 'SPACES.'" *Public Art Review* 3, no. 1 (March 1991): 8-9.
Discusses the work of Seymour Rosen and the organization SPACES, which works to save folk art environments and to bring positive attention and support of others to both the genre of these art environments and to specific sites. Reports on various projects and activities of SPACES.

638. "Wisconsin Folk Art." *Folk Art Finder* 4, no. 3 (September 1983): 4-9.
Says "folk art in Wisconsin is abundant and highly visible." Notes projects of the Kohler Arts Center. In addition to listing six environmental art works—Mathias Wernerus' grotto in Dickeyville; Ernest Hupenden's wall murals in Valton; Nick Engelbert's concrete figures and castles in Hollandale; James Tellen's figures in Sheboygan; Paul Wegner's mosaic monuments in Sparta; and Herman Rusch's garden of objects of embedded concrete—the article includes biographical and art sketches of Josephus Farmer, Anna Louisa Miller, Frank Wolfert, and Father Wernerus. Illus.

639. Worthington, Eva Maria. "Naive Art—An Overview." *The Clarion* (Fall 1978): 26-29.
Describes a "lively demand" for naive art since early 1950s. Author believes "a certain fatigue and disillusion about contemporary art" is a possible reason: "a yearning for something more spiritual." There is a brief sketch of the history of naive art and an inclusion of the quotation "He who tries to be naive is not." Illustration of New Orleans artist Vivian Ellis and several Europeans.

640. Wright, R. Lewis, Jeffrey T. Camp, and Chris Gregson. "John William (Uncle Jack) Dey." *The Clarion* 17 (1) (Spring 1992): 34-40.
Article about the life and art of this Virginia painter. Tells about his growing up, his work and his painting. His nickname, with which he signed his paintings, came from neighborhood children. The authors say Dey's work is a personal vision. "His memory paintings, an observation of life mixed with his complex inner emotions are emblematic." They say his repeated image of black crows hovering over the landscape "presents us with a feeling of entrapment." Additional commentary on the art and the artist follows. Illus.; black & white.

641. Yau, John. "Bill Traylor." *Artforum* (March 1986).
Family biography, "Shannon's discovery." Calls Traylor's work simultaneously abstract and figurative—"tender, funny, vivid, and mysterious." Review of an exhibition at Hirschl & Adler Modern.

642. Yood, James. "Et in Arcadia Ego?" *New Art Examiner* (April 1992): 24-26.
A review of the exhibition "Thrift Store Paintings" launches a consideration of the "either/or" battle between those who believe in art in many places, "High" and "Low," and those who believe the only real art is that which is created outside the mainstream. He singles out the organization Intuit as a perpetrator of this latter viewpoint. [There is a very strong reaction from John Maizels in the "letters" column in the September 1992 issue of New Art Examiner to which Yood replies in the same column, 2-3.]

643. Yood, James. "Mr. Imagination." *Artforum* (April 1990): 179.
Review of a gallery exhibition that describes Mr. Imagination's work: sandstone sculpture, found objects that are covered with bottle caps and painted portraits, and brushes with a "flat-top hairdo above the faces painted beneath."

644. Young, Stephen. "A Conversation with James 'Son' Thomas." *Art Papers* (November 1989): 24-25.
Describes a visit to the Thomas home, his art, his community. Thomas tells of the uncertainties of life as a grave digger, playing the blues, and his art. Illus.

645. Ziegesar, Peter von. "Folk Art Influences Contemporary Artists." *Forum: Visual Arts/Mid-America* 12, no. 1 (January 1987): 14-15.
Discusses the influence of folk art on contemporary art. Discusses the Chicago Imagists and their use of "the reclusive, the peculiar, the religious, the insane."

NEWSPAPER ARTICLES

Newspaper articles listed come from collectors' files, gallery files, and newspaper offices when a reference was found in a printed bibliography. A substantial number of newspaper publishers now have their records on computer, including author and title. A random check of newspaper offices proved that even when the article in question was several years old, the publisher could find it. A number of newspapers are now microfilmed and available in libraries. Articles from papers that are not microfilmed usually may be obtained from the publisher. Every library system has reference books that provide information helpful in locating where newspaper titles are published. All annotations in this section were written by examining the articles.

Many of the articles are brief reviews of shows or exhibitions. Most such articles included said something about the artist(s) and/or the art (rather than being simply an announcement of the event). Since much of the annotating was done from photocopies, it was often not possible to tell whether the illustrations were in color or black and white.

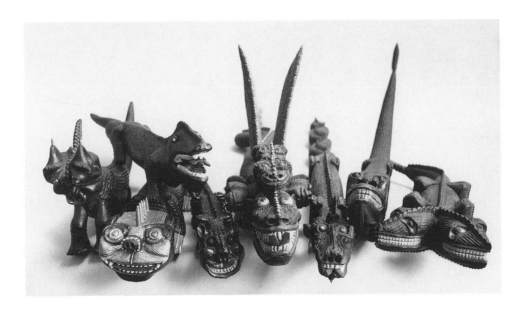

1. Abramowitz, Michael. "The Outsider's World: In Chicago, The Hot Art of Longtime Bag Lady Lee Godie." *Washington Post,* 9 September 1991. Opening for Lee Godie works at the Carl Hammer, with Godie in attendance. Describes her reactions to the opening. Information about her life in the streets and her popularity with collectors. Mentions other Chicago interest in outsiders. Illus.

2. Albright, Thomas. "Unspoiled Bay Area Art." *San Francisco Chronicle* (San Francisco, CA), 29 August 1974. Review of an exhibition, "Art Naif," at the San Francisco Museum of Art. Brief descriptive information on Bay Area artists: Peter Mason Bond; Alexander Maldonado; Esther Hamerman; Deborah J. Wilkins, who "fills pages with obsessive ink drawings of African masks and faces that often become part of larger masks and faces"; and Nathan C. Adams, who "crams images of demons, deities, and God knows what all into a dense web which he calls 'Temple of a Thousand Fantasies'. " Six other artists mentioned.

3. Allen, Neal. "Liquid Current Steams Mini-Circus." *Sunday Freeman* (Kingston, NY), 9 March 1980, Tempo section. About the water-powered circus, figures and other objects created and installed by Alipsio Mello outside his home on Napanoch, New York. Mello was a mason in upstate New York's waterworks until his retirement. "Now he has created his own waterworks," says the reporter. Driven by a stream, "there are lumberjacks sawing wood, a mother rocking her baby, woodchoppers pounding their axes, even a boy lifting a bucket out of a well." The circus and other scenes are described too. Notes on Mello and his family. Illus.

4. Allen, Nelson. "Orange Art: The Fruit of Inspiration." *San Antonio Express-News* (San Antonio, TX), 2 June 1990. Describes the Houston art environment, The Orange Show, created by Jeff McKissack. Tells how it was put together, facts about his life, and how the site is now used by the Orange Show Foundation. Mention is made of the Beer Can House, another Houston yard art environment. Illus.

5. Allen, Teddy. "Chuckie Keeps Right on Drawing." *Shreveport Times* (Shreveport, LA), 16 August 1990. Description of the artist's home, filled with paintings of his favorite subjects—celebrities, mostly from the music world. Facts about his life, how prolific he is at painting, a critical opinion or two. Illus.

6. Ament, Deloris Tarzan. "A Child of Art." *Seattle Times* (Seattle, WA), 27 August 1989. About Pacific Northwest painter James Martin, who paints whimsical images from his personal mythology. His paintings frequently include lions and eggbeaters and are done on scrap paper. Illus.

7. Angelini, Jill. "Hearth's Warmth is His Vision, Bits of Refuse are the Materials." *Jersey Journal* (Northern New Jersey), 15 May 1991. Information about self-taught artist Michigan Jackson; his life in Dearborn, playing football at the University of Michigan—which he now considers a complete waste of time—his wanderings about "experimenting with all kinds of employment." Now he lives in a YMCA and walks along the docks of Hoboken, New Jersey picking up salvage to create what he calls his "firepieces." Includes descriptions of his work and information about motivations.

8. Ardery, Julie. "Charley Kinney—An Original Man Who Lived the Old Way." *Lexington Herald-Leader* (Lexington, KY), 19 August 1991. About Charley Kinney, and his brother and sister-in-law, Noah and Hazel. Written on the occasion of his passing, Sunday, April 7, 1991. There are many descriptive details of his background (especially how he belonged to the old days), his family and community, and his art and music. Photograph of Charley.

9. Armour, Terrence. "Imagine That: Sandstone Art." *Chicago Tribune* (Chicago, IL), 13 September 1987. About artist Mr. Imagination and his art—material, tools, look of his sculptures, and his work with children. Illus.

10. "Art Show in Roanoke Fuels Old Debate." *Richmond Times-Dispatch* (Richmond, VA), 10 August 1990. Review of three exhibitions at the Roanoke

Museum: "O, Appalachia," "Fine Folk: Art n' Facts From the Rural South," and a show of Miles Carpenter's work. Describes folk art controversies, especially those around definitions and the importance of the art, and also of the growing interest in it. A few of the art works are described.

11. "Arts Center to Exhibit Works of Former Slave." *The Montgomery Advertiser and Alabama Journal* (Montgomery, AL), 19 November 1989.
Announcement of the exhibition at the Fine Arts Center in Nashville of Bill Traylor drawings. Background on his life and his discovery "as he sat on the streets and produced 1,500 drawings."

12. Aust, Ed. "Artistic Expression Is the Key to Creative Growth." *Montclarion* (Oakland, CA), 10 November 1987.
Focuses on the Creative Growth Art Center's exploration of the artistic potential of disabled people. Dwight "Scotty" Mackintosh and his drawings illustrate the Center's purpose.

13. "Author, Artist Moffett Dies." *St. Augustine Record* (St. Augustine, FL), 17 January 1989.
Obituary notice for the self-taught painter and author Langston Moffett. Notes about his background and his artistic recognition. Photograph of Moffett.

14. "Baglady Artist Lives on Street as Paintings Bring Big Bucks." *Star* (Chicago, IL), 13 March 1990.
Says Lee Godie's paintings of glamorous women from the 1930s and 1940s sell for larger sums in galleries, but can be bought relatively cheaply directly from her on the street. Discusses her attitudes toward people, and the way she works.

15. Baker, Kenneth. "California's Folksy Eccentricity." *San Francisco Chronicle* (San Francisco, CA), 13 April 1986.
Review of the exhibition "Cat and a Ball On a Waterfall: 200 Years of California Folk Painting and Sculpture" at the Oakland Museum. Reviewer discourses about the relevance of "primitive" art to modern artists in the mainstream. He describes some of the objects and the folk art environments included in the exhibition with considerable detail. Illus.

16. Baker, Kenneth. "Folk Art Displays Temptation in Eden." *San Francisco Chronicle* (San Francis-

co, CA), 4 August 1990.
Review of "Primal Portraits: Adam and Eve as Seen by Self-Taught 20th Century Artists" at the San Francisco Craft and Folk Art Museum in Fort Mason. The guest curator was Pat Parsons. The exhibition featured many examples of carvings. Artists exhibited included Edgar Tolson, Sabinita Lopez, and Dwight Mackintosh. Illus.

17. Baker, Linda. "Sybil Gibson: She Likes Making Something Out of Nothing." *Daily Mountain Eagle* (Alabama), 24 February 1984.
A brief biographical article about Sybil Gibson and her discovery of painting at age fifty. Her paintings are done on recycled paper, often grocery bags, depicting childhood memories. Illus.

18. Bartlett, John. "From the Outside Looking In: 'Butch' Quinn's Impoverished Life Is No Pretty Picture, But His Art Makes Him Rich in Accolades." *Times-News* (Erie, PA), 7 May 1989.
Describes Butch Quinn's "bleak cold apartment" in northwestern Pennsylvania and his growing reputation as an "outsider" artist with a unique vision.

19. Baudouin, Richard. "The Art Makers of the South." *Times of Acadiana* (Lafayette, LA), 12 August 1992. 20-22.
Brief information, with photographs of the work, about self-taught artists David Butler, Howard Finster, Royal Robertson, Burgess Dulaney, Sulton Rogers, and J.P. Scott.

20. Baudouin, Richard. "Lowe-Brow Art: Warren and Sylvia Lowe Roam the Backroads In Search of Artists Who Defy Labeling." *Times of Acadiana* (Lafayette, LA), 12 August 1992. 20-22.
Article about collectors Warren and Sylvia Lowe and how they became interested in "outsider art." They are quoted as especially enjoying the thrill of the search for artists and getting to know the artists personally. Mention is made of their major exhibition "Baking in the Sun" and there hope that a museum in the South will provide an appropriate home for at least a part of their collection. "Warren is vague about the size of his holdings—anywhere from 2,000 to 8,000 pieces . . . The true number is in the upper end of that range, insists Sylvia." [See also an accompanying article by Baudouin about several of the artists; "The Art Makers of the South."]

21. Baxter, Missy. "Lloyd Mattingly Gets to 'Root' of Answer in Artistic Terms." *Pioneer News* (Shepherdsville, KY), 10 June 1991.
Article on Lloyd "Hog" Mattingly, who recreates in miniature historical events or places. He also creates sculptures from cedar roots, painting them to make unique creatures.

22. Beach, Laura. "Hemphill Collection Goes to the Smithsonian: A Significant Step for American Art." *Antiques and Arts Weekly,* 13 February 1987.
The reporter says that "news of one of the most important public acquisitions of American folk art in this century set the town buzzing as public and private collectors speculate how and where deal was hatched," who else was in the bidding, the pleasure and disappointment over where the collection is to go.

23. Bell, Bill. "Happy to Shell Out for New Apartment." *New York Daily News,* 27 January 1992.
Description of the interior environment created by Joseph Furey in his Brooklyn, New York apartment. Using 75,000 objects including shells, beans, and much more, he decorated every inch of the walls, doors, ceilings—beginning his work the week after his wife died; "an outlet for his grief says his son." Addison Thompson and Lesa Westerman, sent to the site by a museum in order to document it in photographs, decided to rent the apartment to keep the art from being destroyed.

24. Bettendorf, Elizabeth. "Folk Artist: George Colin Creates a World Full of Color." *State Journal* (Springfield, IL), 4 October 1987.
Article describes the art objects of many subjects, designs, and bright colors that fill the yard and home of self-taught artist George Colin and his wife, Winnie.

25. Black, Jack. "Jimmy Lee Sudduth's Paintings to Be Exhibited at Art Museum." *Fayette County Broadcaster* (Fayette, AL), 23 September 1971.
Describes the thirty-five works on exhibit at the Fayette, Alabama art museum. Sudduth recalls his paintings made from an early age. Details his use of natural materials in his paintings.

26. Blum, Walter. "Art with a Difference: Wonderous Works from Disabled Artists." *San Francisco Examiner* (San Francisco, CA), 17 August 1986, Image Section.
Article about a showing of art at the Chevron Gallery in San Francisco, California. The art works, from the Institute of Arts and Disabilities, were created by people with severe developmental problems. Illus.

27. Bonesteel, Michael. "The Mysterious Master of Michigan Ave." *Chicago Reader* (Chicago, IL), 8 January 1982.
A detailed biography of Lee Godie, Chicago's street artist, starting with her discovery in front of the Art Institute of Chicago in 1968. Illus.

28. Bonner, Thomas Jr. "Reappraising a Louisiana Treasure." *Times-Picayune* (New Orleans, LA), 6 November 1988.
Review of the book by James L. Wilson on Clementine Hunter. Calls it "an excellent book" with "many color plates beautifully reproduced." Includes details on the contents of the book.

29. Bookhardt, D. Eric. "The Saturn Bar and Other Mysteries of the Universe." *Times-Picayune* (New Orleans, LA), 9 January 1983, Dixie Magazine.
Article about the "legendary" Saturn Bar on St. Claude Avenue and its showcase for artists of the Ninth Ward including self-taught Mike Frolich, "who used to hang out there." Color photograph of proprietor O'Neil Broyard and his life-long friend Frolich.

30. Bourgoyne, J. E. "Delta Blues Singer 'Son' Thomas Hospitalized in Miss." *Times-Picayune* (New Orleans, LA), 28 July 1991.
Talks of the hospitalization of James "Son" Thomas, with suspicions of cancer, and includes comments from his children. Focus is primarily on the contributions by Thomas to the Delta blues. Reporter briefly mentions his sculptures. Illus.

31. Braden, William. "An Art Treasure Tossed Out on Streets." *Chicago Sun-Times* (Chicago, IL), 2 June 1990.
Details the eviction of Lee Godie from a downtown Chicago hotel. The importance of Godie's work is discussed. She is referred to as "Chicago's most renowned painter of outsider art." Illus.

32. Braselton, Jeanne. "Sharing the Art of a Friendship." *Rome News-Tribune* (Rome, GA), 1 October 1989.

About a unique exhibit of the work of Knox Wilkinson at Schroeder's New Deli in Rome, Georgia. (Schroeder is a childhood friend of Wilkinson's). Illus.

33. Breed, Allen G. "Works by Elliott County Art Colony Gaining National Reputations for Some." *Lexington Herald* (Lexington, KY), 26 December 1991.
 Writer tells about the many artists in Eldridge Hollow and the way they work together to market their art and mentions Minnie and Garland Adkins, Junior Lewis, Tim Lewis, Linvel Barker, and Charles Keeton. Includes comments on the work by Adrian Swain of Morehead University. [Reprinted from the *Courier-Journal* (Louisville, KY) Saturday, December 21, 1991 with the title "Art from Adversity."]

34. Brown, Fred. "Artist Whittles Out National Reputation." *Knoxville News Sentinel* (Knoxville, TN), 21 December 1987.
 Biographical article on Troy Webb, an Appalachian wood carver. Using buckeye wood, Webb carves animals and people on his front porch in Hamlintown, Tennessee.

35. Brown, Heidi Nolte. "Folk Artist Paints Virginia History and Lore." *Richmond News Leader* (Richmond, VA), 4 January 1991.
 Information about the life and art of painter Ann Murfee Allen. Describes her upbringing and her historical research and how these influence her paintings. Illus.

36. Brown, Patricia Leigh. "Living for Folk Art, and In It, Too." *New York Times*, 3 January 1991, Home Section.
 Describes the environmental folk art of the Beer Can House, the Flower Man, and the Orange Show, all in Houston; the Rev. Howard Finster's Paradise Garden in Summerville, Georgia; the Garden of Eden in Lucas, Kansas; and one or two others. Mentions people and organizations involved with folk art. Illus.

37. Budd, James. "Finster Endeavors Draw National Acclaim." *The Summerville News* (Summerville, GA), 9 September 1982.
 An article that describes Finster's religious beliefs and his success with the art community. A tour of Paradise Garden and the art displayed is reported in detail, as are the efforts Finster has made to purchase and install a chapel in Paradise Garden.

38. Burchard, Hank. "Native Sense for New Art." *Washington Post*, 27 September 1991.
 Review of an exhibition at the National Museum of Natural History of "intensely original creations" by four Native American artists who have "defied the conventions of commerce." Organized by the Museum of Northern Arizona, the artists are Baje Whitethorne, painter; Nora Naranjo-Morse, clay sculptor; John Fredericks, carver; and Brenda Spencer, weaver. Illus.

39. Burkhart, Dorothy. "Fine Folks: Popular Art that Blurs Distinctions." *San Jose Mercury News* (San Jose, CA), 24 November 1985, Arts & Books Section.
 Review of the exhibition "Pioneers in Paradise: Folk and Outsider Artists of the West Coast." Describes the appeal of the show, background of its development. Mentions some of the artists with critical comments on their art. Writer concludes that the best work here argues against distinctions between high and low art—and "sheds new light on how and where the two meet." Illus.

40. Burkhart, Dorothy. "The Uncommon Art of the Common Man." *San Jose Mercury News* (San Jose, CA), 27 January 1985, Arts & Books Section.
 Review of an exhibition organized by Georgianna Lagoria, director of the de Saisset Museum of Santa Clara, California. Pieces came from Bay Area collections. Discussion about definitions and elements of folk art. Makes comparison to trained artists. Describes some of the artists' works: Sybil Gibson, Clementine Hunter, Jimmy Lee Sudduth, Bob Carter, others. Illus.

41. Calas, Terrington. "Naive Artist Has Sophisticated Voice." *Times-Picayune* (New Orleans, LA), 2 February 1992.
 Review of an exhibition of the works of Jimmy Lee Sudduth at the Gasperi Gallery in New Orleans. Description of the subjects of his paintings and the materials he uses. Reviewer says Sudduth "may be a dispassionate observer, but he is also nearly obsessive in his fervor for artmaking." Illus.

42. Caldecott, Tom. "Creativity in Common: California Folk Artists Take Bold Approach to Art." *Montclarion* (Oakland, CA), 29 April 1986.
 An article about the inspiration for the Oakland Museum exhibition of works by Califor-

nia artists outside the academic background; includes descriptions of some pieces.

43. Callahan, Nancy. "Plywood for His Canvas, Turnip Greens for Paint, Old House as Subject." *Christian Science Monitor*, 23 July 1980.
Interview with Jimmy Lee Sudduth, who says he started drawing pictures in the dust as a child. Details of the natural materials he uses for pigments.

44. Calta, Marialisa. "Portrait of the Artist as Elderly." *New York Times*, 7 January 1990, Education Life Section.
Description of the art program "Out and About" for the elders in Lamoille County, Vermont. Illus.

45. Campisano, Kathleen. "Jack Baron on Display." *Island Packet* (Hilton Head, SC), 15 May 1988.
Detailed description of Jack Baron's paintings—part of an exhibition at the Red Piano Gallery in Hilton Head, South Carolina.

46. Carroll, Patty. "Inner Canvas: Capturing the Spirit of Chicago's Artists." *Chicago Tribune* (Chicago, IL), 22 September 1991, Magazine Section.
Five-page excerpt from Carroll's book *Spirited Visions, Portraits of Chicago Artists*, which focuses on portraits of artists and a response to their work. Mr. Imagination is a featured artist. Illus.

47. Cate, Barbara. "The Cutting Edge: Contemporary American Folk Art." *Antiques and the Arts Weekly*, 1 February 1991.
Discusses visits to the home of Jan and Chuck Rosenak, to prepare for the "Cutting Edge" exhibition at the Museum of American Folk Art, which featured items from their collection. Says "most of the objects are from the last two decades; seventy artists from twenty-three states, twenty-two black, eight Native American, seven Hispanic, and fifteen are women."

48. Chadwick, Susan. "Artist Lets Fate, Whimsy, Mold His Colorful Figures." *Houston Post* (Houston, TX), 28 July 1990.
About Houston folk artist Patrick Davis. Details on his background, his community, and his art. Tells about working with Jesse Lott. Illus.

49. Chadwick, Susan. "Beer Can Architect Hated to Cut Grass." *Houston Post* (Houston, TX), 18 May 1990.
Story about John Milkovisch and his Beer Can House. Tells of wife and sons and their effort to maintain it since Milkovisch's death. The house at 222 Malone Street in the West End is said to be one of Houston's most familiar folk art sites. Illus.

50. Chadwick, Susan. "Folk Artist Draws One More Chance." *Houston Post* (Houston, TX), 29 January 1991.
Reports on the parole of Henry Ray Clark, who had served three years of a thirty-year sentence for possession of cocaine. Details about his life in the streets and the attention he has gained from the art world. Illus.

51. Chadwick, Susan. "Houston's Fan Man." *Houston Post* (Houston, TX), 18 May 1990.
Says "in the Third Ward the life is in the streets," and on one of these streets is "the colorful and startlingly sophisticated yard environment of Robert Harper." Detailed descriptions of the sculpture and life of Harper who calls his creation "The Third World." Illus.

52. Chadwick, Susan. "A Lonely Woman's Flowering Paradise." *Houston Post* (Houston, TX), 18 May 1990.
Discusses Ida Kingsbury, the recluse who had "turned her spacious yard into a flowering paradise crowded with imaginary characters she had made"; her miserable family; and the "darkly humorous" environment she created.

53. Chadwick, Susan. "Magnificent Obsessions." *Houston Post* (Houston, TX), 18 May 1990.
Article about folk art environments in general and the ones in Houston in particular. Tells of the difficulties of trying to preserve such places.

54. Chadwick, Susan. "Pretty Boy Painting to Stay on the Outside." *Houston Post* (Houston, TX), 21 July 1992.
Article about Henry Ray Clark, "the Magnificent Pretty Boy," out of prison on bail and painting a mural on the side of a building, owned by his artist agent William Steen, while awaiting a new trial. Tells of Clark's certainty that he will win his case and then become famous making art. Reporter notes that Clark has made his drawings in the past only when he is in prison.

55. Clegg, Nancy. "The Old Folks at Home." *Denver Westwood* (Denver, CO), 31 July 1906.
Review of an exhibition "Sixteen Contemporary Folk Artists" at the Brigitte Schluger Gallery. Some of the artists exhibited were Martin Saldaña, Mary T. Smith, B.F. Perkins, Columbus McGriff, Edward Larson, Richard Luis "Jimbo" Davila, Ned Cartledge, Patrick Davis, and Sulton Rogers. Comments on folk art in general and about the work of several of the artists. Illus.

56. Clurman, Irene. "Whittler Constructs Art from Scraps, Ingenuity." *Rocky Mountain News* (Denver, CO), 15 February 1987, Entertainment Section.
About the art and background of self-taught black artist Bill Potts, who began making art at the age of fifty. Potts uses wood he finds or that friends bring him and "any paint that comes his way." Lots of detail about the artist and his work.

57. Coley, Gwen. "Mose T: Most Popular Artist Is at Heart of Folk Art." *Anniston Star* (Anniston, AL), 21 January 1990.
Details on Mose Tolliver's family background, the accident that caused him to quit working and start making art, and a critical opinion or two. Micki Beth Stiller, a Montgomery gallery owner, says "his work is refreshing and appealing because it is simple, yet bold, powerful without being overbearing."

58. Conn, Sandra. "Absolut Big Break for These Two Chicago Artists." *Crain's Chicago Business* (Chicago, IL), 12 August 1991.
Commissions of artworks by "two of the city's best-known black artists, Mr. Imagination and David Philpot." Describes what the artists will do for Absolut, and says the ads with the work should appear around February, 1992. Illus.

59. Conner, Sibella. "Preacher and Artist: From His Faith Mission, Anderson Johnson Paints With Abandon." *Richmond News Leader* (Richmond, VA), 1 February 1991.
Description of the artist's very poor neighborhood in Newport News, Virginia and his Faith Mission, which is his church and his home. Describes his art and the religious visions that inspire it. Written on the occasion of an exhibition of the artist/preacher's work at the Marsh Gallery, University of Richmond.

60. Conroy, Sarah. "Battered Tables, Broken Chairs . . . and a Vision." *Durham Morning Herald* (Durham, NC), 7 August 1973.
Describes a visit to various exhibits at the Smithsonian Institution in Washington, D.C., with particular attention to James Hampton's "Throne of the Third Heaven."

61. Conroy, Sarah Booth. "Moonshine Jugs and $8 Million: A New Museum Setting for the Rockefeller Folk Art Collection." *Washington Post*, 26 July 1992.
Describes the new addition and facilities at the Abby Aldrich Rockefeller Folk Art Center in Williamsburg, Virginia. The collection is briefly described, with specific mention of pieces by Edgar McKillop and Edgar Tolson.

62. Constable, Lesley. "Childlike Sense of Wonder Pops Out Merrily at Exhibit." *Columbus Dispatch* (Columbus, OH), 11 August 1991.
Review of exhibition featuring Columbus artist Levent Isik. Some information about his life, his interest in the work of Columbus outsiders, and how it inspired him to begin painting. Detailed descriptions of some paintings in the exhibit. Illus.

63. Constable, Lesley. "Delightful Stories Highlight Intimate Exhibit of Folk Art." *Columbus Dispatch* (Columbus, OH), 14 August 1988.
Review of an exhibit of two Ohio folk painters, Paul Patton and Tella Kitchen. Both artists document their early life with scenes from their memories. "Each painting is a narrative." Illus.

64. Constable, Lesley. "Gallery Moves 'Forward' by Drawing Artists Statewide." *Columbus Dispatch* (Columbus, OH), 28 July 1991.
Review of an exhibition "Straight Forward" at the Elijah Pierce Gallery in Columbus, which presented the art work of fifteen African-American men from several Ohio cities. Self-taught artist Ralph Bell is included in the review.

65. Constable, Lesley. "Isik Conveys Warmly Human, Humorous Visions." *Columbus Dispatch* (Columbus, OH), 13 September 1992.
Reviews the work and recognition received by Levent Isik since he began "serious painting" in 1989. Tells about the art he makes and frequent images. Illus.

66. Constable, Lesley. "Outlooks in Exhibit as Fresh as a Child's." *Columbus Dispatch* (Columbus, Oh), 30 May 1992.
Review of an exhibition in the Elijah Pierce Gallery "intended to showcase works by artists who have a physical disability." Says Ralph Bell's acrylic paintings on canvas "occupy a much deserved place of honor." Descriptions of several of his works are provided. "His inimitable style forwards an array of fanciful people, animals, flowers, suns and houses, all presented frontally and layered one upon another in every color. They seem to come straight from the subconscious."

67. Constable, Lesley. "State Fair: Breadth, Excellence Reign at the Winning Art Exhibit." *Columbus Dispatch* (Columbus, OH), 4 August 1991.
A review of works displayed at the Ohio State Fair exhibition. There are several pieces of outsider art, including Levent Isik, Ralph Bell, and a tribute to William Hawkins by artist Lee Garrett.

68. Conwell, Douglass. "A Time of Promise and Sharing." *New Mexican* (Santa Fe, NM), 2 August 1987.
A feature on Marcia Muth, self-taught artist, who paints of subjects from the first third of the twentieth century—a period of a certain American innocence, according to Muth. Illus.

69. "Cooperstown Show Focuses on Rural, Urban Folk Artists." *Daily Star* (Oneonta, NY), 17 April 1992.
Exhibition "New York Folk: Rural and Urban Self-Taught Artists" at Gallery 53 Artworks in Cooperstown, New York which opened May 2. Rural artists include Lavern Kelley, Charles Munro, Janet Munro, and Gary Rathbone. Urban artists are Bertha Halozan and Sulton Rogers. Illus.

70. "Craftsmen, Artisans Show Wares at Picnic." *Licking Valley Courier* (West Liberty, KY), 11 July 1991.
About Minnie Adkins' picnic, and who was there: collectors, writers, gallery owners, museum people—and artists.

71. Crawford, Byron. "Carving Out Success: Clever Tennessean Uses Chain Saw to Fashion Wood into Works of Art." *Courier-Journal* (Louisville, KY), 13 June 1988.
Chainsaw carver L.D. Cooper of Jamestown, Tennessee, talks about his art. He carves mostly from white pine and cherry logs, making large Indians, owls, eagles, and three-foot figures called "hillbillies." He dreams of making a sixty-foot dinosaur. Illus.

72. Crawford, Byron. "Couple Remember Folks who Helped Them to Success." *Courier-Journal* (Louisville, KY), 28 June 1991.
Minnie and Garland Adkins recall how they got started making their wooden figures. The publication of *O, Appalachia* thrust them into the limelight. "Each summer they hold a picnic to express their thanks to the people 'from around' who have helped them." Photograph of the artists.

73. Crawford, Byron. "Gourd Lady Snows Letterman, Charms Carson, Wins Nation's Heart." *Courier-Journal* (Louisville, KY), 2 May 1988.
Kentucky "Gourd Lady" Minnie Black tells of her adventures on the David Letterman Show and the Tonight Show with Johnny Carson. Her gourds are painted and decorated to resemble animals, birds, people, and reptiles. She even makes musical instruments from the gourds. Illus.

74. Crawford, Byron. "Seeing Birds in the Trees: Man Draws Beauty from Limbs with Saw." *Courier-Journal* (Louisville, KY), 10 August 1990.
James Koop, of Henryville, Indiana, uses his chain saw to carve mostly owls and ducks, using dead trees as material. He reluctantly sells his work, but is not trying to make money. He hopes to carve a bear and cub when he finds the right tree. Illus.

75. Creekmore, Judy. "River Mud Catapults Artist to National Fame." *L'Observateur/The Observer* (La Place, LA), 29 November 1990.
An interview with Lorraine Gendron, primarily known for her Mississippi mud sculptures. She also paints in oils and creates scenes by wood carving. She tells how she got started creating art based on Louisiana culture. Illus.

76. Crowder, Joan. "The Inside On the Outsiders." *Santa Barbara News-Press* (Santa Barbara, CA), 3 August 1990.
Review of an exhibition of outsider artists at the Frances Puccinella Gallery in Carpenteria, California. Review includes information about the artists included: James Harold

Jennings, Jimmy Lee Sudduth, Benjamin F. Perkins, the Rev. Howard Finster, R.A. Miller, James "Son" Thomas, George Williams, Mose Tolliver, and Mary T. Smith. In addition to the biographical data there is descriptive information about the art and mention of definitions.

77. Cunniff, Joe. "Three Masters Highlight Current Gallery Exhibit." *Lincoln Park* (Lincoln Park, IL), 1 November 1989.
Exhibit at Yolanda's Gallery in Chicago that included self-taught artist Marcia Muth, whose paintings reflect the quieter times of the early twentieth century. Most of the information is about the artist, who is said to be "concerned not with major historical events, but with the ways in which people of the 1920s and 1930s lived and worked."

78. Damikolas, Tina. "Thumbs Up—Discovery." *Claremont Courier* (Claremont, CA), 21 March 1992.
Article about the program at the First Street Gallery and Art Center in Claremont, California that has a program for developmentally disabled adults. Mention is made of some of the artists included in the program and the fact that their art may be purchased. Illus.

79. Dandridge, Myra L. "Disabled Express Themselves with Art." *Washington Post,* 6 December 1990.
The work of Gary Oliver is displayed at Very Special Arts—gallery exhibiting work by artists with physical or mental disabilities. Oliver's work is done with oil crayons on paper; he relies on stripes, primarily in red, blue, and brown.

80. Daniels, Mary. "Bobby Washington: Carving a Big Stick." *Chicago Tribune* (Chicago, IL), 8 September 1991, Home Section.
Washington explains the symbolism of snakes on his carved walking sticks. Although known mainly for his staffs, he prefers his large carved heads.

81. Dawson, Victoria. "Colors Run Wild at Artist's Washateria." *Times-Picayune* (New Orleans, LA), 25 September 1989, Metro Section.
Discusses the life and art, including years of hard drinking and hard times, of Mike Frolich, who is "proud of his place in the universe: attendant, overseer, and artist-in-residence of the only washateria/art gallery in the United States." Description of his art and his preparations, at sixty-seven, for an exhibition at the New Orleans Contemporary Art Center.

82. DeCarlo, Tessa, and Susan Subtle Dintenfass. " 'Outsider' Art is Inside Now." *Wall Street Journal,* 8 May 1992.
Reports on a symposium "Altered State, Alternate Worlds" at the Oakland Museum in California in April. Tells of the series of illustrated lectures "ranging from Darger's sometimes gruesome, always elegant composed collages to Grandma Prisbrey's house made of bottles, from Joseph Yoakum's humanoid landscapes to Joseph Furey's fantastically decorated apartment." Lists the speakers and notes the exhibition of Dwight Mackintosh artworks at the Creative Growth Gallery.

83. DeFee, Leta Adele. "Clementine Hunter Show Holds Some Surprises." *The Town Talk* (Alexandria-Pineville, LA), 22 May 1987.
Review of an exhibition at the Alexandria Museum. Calls Hunter an artist of "modest competence." Critic is surprised at "the variety of style and presentation" and that "some of the earlier works show greater ability than later examples."

84. Delfiner, Rita. "Just Plain Folks." *New York Post,* 4 March 1977.
Written at the time of Robert Bishop's appointment as the director of the Museum of American Folk Art. Bishop tells of his involvement at age thirteen in the antiques field and his passion for American folk art.

85. DesJardins, Vincent. "Home Is Where the Art Is." *LA Weekly* (Los Angeles), 26 May 1901. 11 (25),
About the work and inspiration of self-taught folk art furniture maker Jon Bok. Illus.

86. Dickinson, Carol. "Folk Art Emerging from the Fringes." *Rocky Mountain News* (Denver, CO), 28 July 1991.
A brief "status report" on folk art's diversity, illustrated with two exhibits at local galleries. The Arvada Center exhibits works ranging from the Lakota and Ute tribes to Ukrainian egg-dyeing to woodcarvings by black artists. The Brigitte Schluger Gallery shows contemporary black folk artists such as Patrick Davis and Ike Morgan.

87. Diggs, Mitchell. "All It Took Was Time." *Birmingham Post-Herald* (Birmingham, AL), 17 September 1990.
About Thornton Dial and his discovery by William Arnett. Includes biographical information about Dial and the appeal of his art beyond folk art aficionados.

88. Domini, John. "Balloon Heads and Dreamsville." *Willamette Week* (Portland, OR), 11 October 1990.
An exhibit that contrasts an academically trained artist, Amy Estrin, with a ninety-two-year-old self-taught memory painter, Ruza Erceg.

89. Donnelly, Sandi. "She's Painting to Speak the Gospel in a New Form." *Times-Picayune* (New Orleans, LA), 12 December 1972.
Describes Sister Gertrude Morgan's art at a gallery in the French Quarter of New Orleans. Tells of her work with orphans and how she took to the streets to raise money for them.

90. Dorsey, John. "Building a Museum for Visionary Art: Hoffberger's Visionary Plans Are Meeting with Success." *The Sun* (Baltimore, MD), 3 March 1991.
Discusses the efforts of Rebecca Hoffberger to establish the American Visionary Art Museum in Baltimore. This museum will be devoted to self-taught artists not influenced by academic, mainstream art.

91. Dotson, James. "Naive Art." *Augusta Chronicle/Augusta Herald* (Augusta, GA), 4 September 1988.
Information about "naive" artist Jake McCord of Thomson, Georgia. He is city worker by day and a painter by night. Bright colors dominate his paintings of animals, especially tigers, birds, people, and flowers. Illus.

92. Drennen, Eileen M. "The Ascension of Thornton Dial." *Atlanta Journal-Constitution* (Atlanta, GA), 29 July 1990.
Talks about importance of Thornton Dial's work beyond traditional folk painting, including him with contemporary masters Picasso and Matisse. There is a sidebar piece on collector Bill Arnett and his relationships with black self-taught artists, including Dial, Lonnie Holley, and Charlie Lucas. Illus.

93. Drennen, Eileen. "Pasaquan: A Place Outside of Time." *Atlanta Journal-Constitution* (Atlanta, GA), 17 April 1988, Atlanta Weekly Section.
Describes author Tom Patterson's discovery and subsequent relationship with artist Eddie Owens Martin—St. EOM. The environment called Pasaquan and its fate after the artist's death is discussed. A lengthy article with much biographical information and photographs. Illus.

94. Drennen, Eileen. "Stalking the Wild Art: Tom Patterson Chronicles Howard Finster and Other Southern Men of Vision." *Atlanta Journal-Constitution* (Atlanta, GA), 11 June 1989.
Article about author Tom Patterson, featuring his recently published book, *Howard Finster, Stranger from Another World.* Recalls Patterson's first visit to Paradise Garden in 1980 and subsequent visit with Finster. Illus.

95. Drennen, Eileen. "Tin Man with a Heart of Gold." *Atlanta Journal-Constitution* (Atlanta, GA), 10 February 1991.
Feature article on R.A. Miller and his whimsical art, much of it fashioned from scraps of sheet metal. Tells of Miller's emergence into the folk art scene, his transition to painting, and his philosophy of marketing his work. Illus.

96. DuBois, Peter C. "Who Needs Picasso?: Some Alternatives to $36 Million Paintings." *Barron's,* 2 January 1989.
Discusses the growing marketability of the works of self-taught artists. Names and describes some of the galleries that carry this work, quotes Shari Cavin-Morris on "definitions," and gives prices for works in recent sales.

97. Earle, Joe. "Artist Paints Heartfelt Thanks to Firefighter." *Atlanta Journal-Constitution* (Atlanta, GA), 5 October 1989.
Naive painter Bill Bowers presents The Roswell Volunteer Fire Department with a painting for saving his life after a heart attack. Bowers paints busy themes of an historical nature, which he calls an escape from the modern world. Illus.

98. Ellena, Nick. "Bob Carter Leads a Double Life." *Chico Enterprise-Record* (Chico, CA), 27 November 1983.
Tells of Bob Carter's work as a logger and discovery of painting at age forty-five. He paints

to keep busy on rainy days. Tells of his inspirations for painting—his lonely days as a logger in the California woods and his experiences as a painter.

99. Elson, Martha. "Painting Grandmother Is 'the Genuine Article' to Collectors." *Courier-Journal* (Louisville, KY), 27 December 1987, Section H.
Discusses Blanche Bryant's primitive or folk art paintings. Her subject matter is memories from her childhood in West Virginia. Illus.

100. Ely, Ed. "Louis Monza Leaves a Legacy of Primitive Art." *Easy Reader,* 28 June 1984.
An obituary for "primitive artist" Louis Monza; discusses his legacy of work. Provides biographical information and describes the artist's beginnings and later success.

101. "The Enigma of Uncle Bill Traylor." *Montgomery Advertiser* (Montgomery, AL), 31 March 1940.
Information about Bill Traylor and his art, written during his lifetime. Describes the exhibition on the walls of the New South Gallery. Refers to Traylor as "the old Negro," in racist, unflattering terms. Illus.

102. Ensor, Deborah. "You Can Enter Finger's World from the Barbershop Gallery." *Taos News* (Taos, NM), 6 August 1992. Tempo.
Details about the life and art of Ernie Finger who was born in Connecticut and moved, via horseback, to Taos in 1969. "Since then he has lived in the mountains all around Taos. Living through only a month each of spring, summer and fall and nine months of winter." Says "he is a true mountain man, a world foreign to most people of the twentieth-century." Tells of the gallery owner going into the woods to find Finger and also tracking down the few people who own his work. Reviewer says "Finger not only does rather amazing art work, stuff which he does to pass time, or to feel creative or to make a statement—he has a rather amazing sense of things. Things in the world, feelings in the air. The big picture so to speak." Describes works on exhibit and tells why Finger moved from carving and whirligigs to making found-object art assemblages. Illus.

103. "Ex-Slave's Art Put on Display by New South: Bill Traylor, 85, Draws Things as He Sees Them." *Alabama Journal* (Montgomery, AL), 5 February 1940.
Announcement of the exhibition of his work. Comments on his art, which it says has "roots deeply within the great African tradition." Illus.

104. Fair, Kathy. "Strokes of Fortune Lift Artistic Inmate: Houston Gambler's Work Acclaimed." *Houston Chronicle* (Houston, TX), 20 January 1991.
Article about Henry Ray Clark, "the 'Magnificent Pretty Boy,' a street-educated hustler from Houston's Third Ward, a self-proclaimed gambler, drug dealer, womanizer, and three-time convict turned artist." Information about attention from the art world, including his discovery by Houston artist William Steen and the praise for his work from Hemphill. Steen and others worry about what will happen to Clark "when he is released from prison on Monday." Illus.

105. Flora, Doris. "Folk Artist Depicts Religious Themes with Stick Figures." *Tuscaloosa News* (Tuscaloosa, AL), 28 January 1989.
Discusses Fred Webster and his folk carvings of Biblical scenes, with some biographical information.

106. "Folk Artist Featured in 'Alabama Heritage'. " *Loundes Signal* (Fort Deposit, AL), 9 November 1989.
A review of an article about Bill Traylor and artist Charles Shannon, who recognized Traylor's genius in the 1940s. Shannon was responsible for preserving much of Traylor's work, thereby enabling its full appreciation nearly fifty years after his death.

107. Fowler, Carol. "Cat and a Ball on a Waterfall." *Contra Costa Times/Time Out* (Richmond, CA), 28 March 1986.
Review of exhibit at Oakland Museum of Art, which provides a survey of California folk art. Describes some of the artists and how they work.

108. Freedman, Alix M. "Art Being Her Bag, This Bag Lady Wins Acclaim in Chicago." *Wall Street Journal,* 27 March 1985.
The habits and lifestyle of Lee Godie are detailed. Discusses her "pricing structure," the storage of her paintings in a public locker, and use of the bus station as her personal gallery. The author did not succeed in buying a painting. [Reprint: Alix M. Freedman. "Portrait of the Artist as a Bag Lady" *Chicago Sun-Times* Tuesday, April 16, 1985.]

109. Frost, Cathy. "This Fundamentalist Uses Paintings, Plants to Spread the Word." *Wall Street Journal,* 2 July 1986.
A review of Howard Finster's work at the PaineWebber Art Gallery in New York City; includes a detailed description of his Paradise Garden.

110. Fuller, Jim. "You Wooden Believe It." *Star Tribune* (Minneapolis, MN), 24 July 1990.
Article with lots of detail on the art, the life, and the Museum of Woodcarving of Joseph T. Barta from Spooner, Wisconsin. Describes some of the over 500 pieces made—some small wood carvings and some, including the Last Supper, life-sized. Illus.

111. Gamino, Denise. " 'Outside Art' Brings Pride." *Austin American-Statesman* (Austin, TX), 2 April 1989, Section B.
About Ike Morgan, his confinement in a mental hospital, and the discovery of his art. Says "in the midst of insanity, the genius of Ike Morgan has been discovered." Many biographical details about the artist. Morgan says he creates his art "just for the fun of it." Illus.

112. Gangelhoff, Bonnie. "An Artist with a Touch of Glass." *Houston Post* (Houston, TX), 22 July 1984, Magazine Section.
The artwork and life background of Houston self-taught artist and Baptist preacher Vanzant Driver, who makes miniature churches from shattered glass he collects from discards. Illus.

113. Giovannini, Joseph. "Collector's House: Quiet Surprises." *New York Times,* 31 March 1983.
Describes the home of Robert Bishop in the Chelsea section of Manhattan. The renovated duplex is "furnished with many 17th and 18th century pieces with a major focus on Bishop's 20th century American primitive folk paintings." Illus.

114. Gold, Anita. "Art Expo Promises to Be a Showcase for the Imagination." *Chicago Tribune* (Chicago, IL), 3 May 1991, Section 7.
An announcement of the twelfth annual Chicago International Art Exposition, with information about the Carl Hammer Gallery's booth and the display of the art from paint brushes made by Mr. Imagination.

115. Gordon, Michael. "Innocence Found in Mose T's World." *Auburn Plainsman* (Auburn, AL), 16 November 1989, Village Life Section.
Discusses the philosophy of Mose Tolliver and how it is expressed in his work. Quotes Tolliver's source of inspiration as being "ideas in my head."

116. Grady, Bill. "The Algiers Killings: 10 Years Later." *Times-Picayune* (New Orleans, LA), 8 November 1990, Section A.
A remembrance of the killing of a New Orleans police officer and the violence that followed, including the killing of artist Herbert Singleton's sister, Sherry Singleton. Folk art carver Herbert Singleton and others were illegally detained. Illus.

117. Grady, Bill. "Folk Artists' Fame Is Too Late for the Fortune." *Times-Picayune* (New Orleans, LA), 22 March 1990, Section A.
Artist Willie White complains that work he sold for $5 to $20 is on sale in local galleries for up to $1200. One local gallery owner has joined forces with collectors to sell White's work, giving him one-third of the proceeds. Other gallery owners are not so sympathetic. Illus.

118. Grady, Bill. "Success A Nice Surprise for Dryades Street Artist." *Times-Picayune* (New Orleans, LA), 5 February 1987, Section B.
Magic markers and poster paper are the tools of self-taught artist Willie White. He hangs his work on the fence outside his home and has been selling it faster than he can make it to collectors from as far away as Venice, Italy. Illus.

119. Gragg, Randy. "Critics Choice—Jon Serl." *The Oregonian* (Portland, OR), 10 May 1991.
An exhibit at Jamison/Thomas Gallery of the fantastic work of self-taught artist Jon Serl. Serl's work covers the full range of human emotion.

120. Gragg, Randy. "Unusual Show Focuses on Contrasts in Works of Kerns, Monza." *The Oregonian* (Portland, OR), 25 January 1990.
A review of a show contrasting artist Maude Kerns and Louis Monza, one academic and one self-taught, who flourished at the same period. Discusses the choices both artists made that prevented them from achieving greater status in the art world. Illus.

121. "Grandma Prisbrey, 92, Eccentric Known Worldwide for Folk Art in Bottle." *Los Angeles*

Times (Los Angeles, CA), 8 October 1988, Village Section.
Obituary for Tressa (Grandma) Prisbrey, who created an environment made from bottles and cement. Her Bottle Village contained thirteen buildings on a one-acre lot.

122. Green, Roger. "Former Sawmill Worker Turns to Whimsical Art." *Times-Picayune* (New Orleans, LA), 29 April 1988, Lagniappe Section.
Describes exhibit of sculptures by David Butler at Gasperi Folk Art Gallery. Discusses the colorful metal cut-outs of real and imaginary animals.

123. Green, Roger. "Minister, Imagists, Linked by Vision." *Times-Picayune* (New Orleans, LA), 24 September 1989.
Green says "Gasperi Gallery has inaugurated its handsome new headquarters in the Warehouse District with two impressive exhibits—one of religious paintings by the late Rev. McKendree Robbins Long of Statesville, North Carolina" and the other of Louisiana artists associated with the Visionary Imagist school. Most of the balance of the article provides information about McKendree and his art.

124. Green, Roger. "NOMA Exhibit Pays Tribute to Primitive Artist." *Times-Picayune* (New Orleans, LA), 17 March 1985.
A review of the New Orleans Museum of Art's exhibition of the work of Clementine Hunter on the occasion of her hundredth birthday.

125. Green, Roger. "A Primitive Vision of Heavenly Bliss." *Times-Picayune* (New Orleans, LA), 19 October 1985.
A review of an exhibit of the Rev. Howard Finster's work at the Gasperi Folk Art Gallery. Describes paintings, sculpture, and glass paintings.

126. Greenwald, Jeff. "Natural Axe." *San Francisco Chronicle* (San Francisco, CA), 14 December 1986, Image Section.
Photographs of artist John Abduljaami and the yard where he works on his large wood sculptures. Description of his work techniques; information on his family, his life.

127. Grossman, Bonnie. "Finding Folk Art." *Antiques West Newspaper,* July 1987.
Bonnie Grossman of The Ames Gallery in Berkeley, California describes a buying trip to the midwest and to New York. She describes visits to dealers, galleries, and in New York, three collectors. Notes prices, successes, and disappointments.

128. Gruener, Jordan. "Demand and Supply for Folk Art." *Arizona Daily Star,* 3 July 1988, Home Section.
The life and artistic successes of Tucson folk artist William Holzman, who makes whirligigs and folk art furniture. Illus.

129. Guida, Bill. "Tunnel Vision." *Reader* (Chicago, IL), 25 May 1984.
Illustrated article about Chicago self-taught artist Wesley Willis. Willis does much of his drawing on city streets and in the subways. He is especially known for his drawings of trains and of Chicago architecture.

130. Gunts, Edward. "Britons Set Sights on Visionary Art: Body Shop Owners May Donate $3 Million for Baltimore Museum." *Sun* (Baltimore, MD), 29 May 1992.
Article about prospects and plans for the American Visionary Art Museum in Baltimore. Tells of hopes for a major donation so that facility construction may begin and the support of elected government officials and others for the project. Says Maryland's national legislators have introduced legislation that "would make the project the official national museum of visionary art." Illus.

131. Gunts, Edward. "A Museum Design Born of Creative Visions." *Sun* (Baltimore, MD), 3 March 1991.
Article on the proposed American Visionary Art Museum. The main focus will be an old building—the Trolley Works. Says that this curved building will have complementary additions that "echo" the original building.

132. Haferd, Laura. "The Madness of Mac." *Beacon Journal* (Akron, OH), 2 June 1991. Beacon Magazine.
Folk artist Wayne "Mad Mac" McCaffrey of Akron, Ohio, is profiled. He fashions sculpture from wire, often with a social and/or political statement. Illus.

133. Hall, Jacqueline. "Delightful 'Folk Art' Full of Surprises." *Columbus Dispatch* (Columbus, OH), 10 December 1989.
Review of exhibition, "Traditions/Non-Tradi-

tions: Contemporary Folk Art in Ohio." Discusses the meaning of folk art, describes some examples of the art. Says the best memory paintings in the show are by Paul Patton. Show of eighty pieces—paintings, drawings, sculpture, textiles—all from Ohio. Illus.

134. Hamblin, Brian. "Artistic Freedom: Richmond's National Institute of Art and Disabilities Opens a New World to the Developmentally Disabled." *Vacaville Reporter* (Vacaville, CA), 31 January 1991.
Article describes a number of artists in the program and their art work, with illustrations.

135. Harrington, Richard. "The Folk Artist in Paradise: The Rev. Howard Finster, Painting What He Preaches." *Washington Post,* 8 May 1992.
Description of a visit to Paradise Garden, with the information on how and why Finster decided to paint. Says that he and his wife have moved away from the garden and Finster visits with people only on Sundays. Notes that Finster is suffering from ill health, particularly diabetes and arthritis. Reporter says five out of fifteen grandchildren do "folkish art" and mentions Michael Finster. Notes the exhibition of Finster works at the Govinda Gallery in the Georgetown neighborhood of Washington, D.C., where Finster attended the opening, and that Finster had just finished a mountain goat, "number 24000 212" of his works.

136. Hawkins, Margaret. "Godie's Paintings Reflect Her Bold, Bag-Lady Life." *Chicago Sun-Times* (Chicago, IL), 20 September 1991.
A review of the first solo gallery exhibition of the works of Chicago artist Lee Godie at the Carl Hammer Gallery. Discusses the fate of Godie's work since her placement in a nursing home. The writer pays nearly as much attention to the art as to Godie's life style. Illus.

137. Hays, Jim. "Appalachian Art Shines Its Own Light." *News-Sun* (Springfield, OH), 12 September 1991.
Reviewer of the "Local Visions" exhibition at the Springfield Museum of Art finds the artworks have a "fundamental integrity" and that the viewer is "spared the usual claptrap of specious sophistication." He says in the animal carvings of Noah Kinney, Garland Adkins, and Linvel Barker one encounters the "essence of the creature." He also approves of the lack of ambiguity in religious paintings: "The righteous enjoy the sublime transports of paradise, the sinners writhe in hellfire." Illus.

138. Heilenman, Diane. "Contemporary Arts Center in Cincinnati." *Courier-Journal* (Louisville, KY), 30 November 1986.
Critic Heilenman describes "The Ties that Bind: Folk Art in Contemporary American Culture" as an exhibition of the works of outsider artists that presents their commentary on contemporary culture. She notes the inclusion of Rosetta Burke, who "transformed a world she didn't like—her Detroit ghetto—into one she did. She arranged her street-side 'temple' of painted barrels, old tires and piles of found objects, in front of her house according to a personal logic . . . Burke preached there, becoming a cause for local artists and folk art collectors." Eventually objecting neighbors caused the site to be bulldozed. A large color photograph and one barrel, it is noted, are part of the exhibition.

139. Heilenman, Diane. "Craft Exhibits Represent the Functional and Artistic." *Courier-Journal* (Louisville, KY), 10 January 1988.
Review of a two-part exhibit, with more than 200 objects spanning two centuries, that "charts the historical flow of crafts from utilitarian rural objects to post-industrial art form." Presents information about the issue of art versus craft. One part, "Beyond Tradition: Contemporary Forms," includes works by fifty contemporary Kentucky artists. The other part, "Bluegrass Tradition," is an historical overview of 168 objects. Irwin Pickett, curator of the first-named exhibition, says the controversy over art versus craft is "frivolous." Patrick Ela, curator of the other exhibition, does not agree.

140. Heilenman, Diane. "Folk Art Brightens Competition at State Fair." *Courier-Journal* (Louisville, KY), 23 August 1992.
About a work of self-taught carver Cletus Hardy, Sr., art critic Heilenman says, "the slightly larger-than-life carved and painted bust of Martin Luther King, Jr. is a handsome example of heartfelt and strongly expressive portraiture "

141. Heilenman, Diane. "Kentucky Art and Craft Gallery." *Courier-Journal* (Louisville, KY), 16

October 1989.
A discussion of carved canes or walking sticks made in Kentucky. The occasion is an exhibition, "Sticks: Historical and Contemporary Kentucky Canes," at the Kentucky Art and Craft Foundation Gallery which surveys nearly 150 walking sticks, the carvers who make them, and why they carve.

142. Heilenman, Diane. "Liberty National Bank Gallery." *Courier-Journal* (Louisville, KY), 4 March 1990.
Review of "Outsider: A Southern Sampler," curated by Kentucky sculptor and art dealer Larry Hackley. Includes works by Edd Lambdin, R.A. Miller, Raymond Coins, Mary T. Smith, Howard Finster, James Harold Jennings, and Willie Massey.

143. Heilenman, Diane. "Morehead State University." *Courier-Journal* (Louisville, KY), 21 July 1991.
A review of a comprehensive exhibition of the folk art from northeast Kentucky that says this exhibit places the art and its creators in a cultural context.

144. Heilenman, Diane. "Portland Museum." *Courier-Journal* (Louisville, KY), 5 August 1990.
This exhibit, "Raising Cane," showcases the carving of William R. Miller and Rick L. Bryant, displaying 63 of their wooden walking sticks. Says their work is not limited to one theme and has been greatly influenced by the works of earlier Kentucky carvers.

145. Heilenman, Diane. "Swanson Cralle Gallery." *Courier-Journal* (Louisville, Ky), 24 February 1991.
Information about an exhibit of the paintings of artist Mark Anthony Mulligan. Heilenman describes the work and tells a little about the artist, and talks of "meanings" in his art.

146. Heise, Kenan. "Chicago Artist William Dawson, 88." *Chicago Tribune* (Chicago, IL), 4 July 1990.
Notice of the death of prominent wood sculptor William Dawson, with a lengthy commentary on his life and his work. Dawson had a major retrospective at the Chicago Public Library just prior to his death.

147. Henderson, Christine. "Art." *Willamette Week* (Portland, OR), 13 June 1991.

Brief notice of a show at the Jamison/Thomas Gallery—included because Robert Gilkerson made Henderson so angry that the review has been referred to elsewhere, because of the nature of her comments. She calls his work "ugly," "misogynistic," and "schizoid."

148. Hewlitt, Jennifer, and Andy Mead. "Noah Kinney, Carver, Dies." *Lexington Herald-Leader* (Lexington, KY), 25 September 1991, Section B.
Death notice for Noah Kinney. Discusses his discovery and career as a wood carver. Includes a photograph of the artist with some of his wood figures.

149. Heyne, Diana. "Menagerie of Artists, Animals, Populates Show." *Lexington Herald-Leader* (Lexington, KY), 14 July 1991, Section B.
A group exhibit at the Heike Pickett Gallery featuring many Kentucky folk carvers. Included are Jim Lewis, Marvin Finn, Garland and Minnie Adkins, Ronald and Jessie Cooper, and Denzil Goodpaster.

150. Higgins, Jim. " 'Local Visions' Now Being Seen on Tour." *Milwaukee Sentinel* (Milwaukee, WI), 2 November 1990.
Review of show "Local Visions" on exhibit at the Milwaukee Art Museum. Says it ranges from "the bizarre and purely personal to full blown masterpieces." Comments on the art of Hugo Sperger. Details on the program at Morehead State University in Kentucky established to help local artists.

151. Hill, Hart. "The School of Hard Knocks." *Westword* (Denver, CO), 22 July 1992.
Review of the exhibition "Give Me a Louder Word Up," at the Metro State Center for the Visual Arts in August. Calls it an astonishing collection of art by self-taught African Americans. Comments on Lonnie Holley, J.B. Murry, Thornton Dial, Sr., and Royal Robertson. Illus.

152. Hodges, Donna. "Feliz Navidad: Christmas Traditions of Mexico Carry on in Skagit County." *Skagit Valley Herald* (Mt. Vernon, WA), 21 December 1991.
Information about people in the Skagit Valley of Washington State with roots in Mexico and how they combine two cultures in their celebrations. Self-taught artist Jesus Guillen and his family are included in the article.

153. Holbert, Ginny. "In With the Outsiders: Dealer Embraces Art of Special Folks." *Chicago Sun-Times* (Chicago, IL), 4 February 1990.
About the Carl Hammer Gallery in Chicago. Tells about his initial discovery of outsider art and his becoming a "pioneer dealer" in the field. Describes some of the artists he carries including Simon Sparrow, Lee Godie, and others. Illus.

154. Holg, Garrett. "William Dawson Carves Art Career With Friends." *Chicago Sun-Times* (Chicago, IL), 4 March 1990.
Article on the background of folk artist Dawson and his success as an artist. Many of his works are described. Information about the Chicago Public Library Cultural Center celebration of the eighty-eight-year-old artist's first retrospective exhibit, a presentation "of more than 250 sculptures and paintings dating from 1970 through 1989."

155. Howell, Beverly. "Local Artist Displays Primitive Folk Art in JDJC." *Brewton Standard* (Brewton, AL), 16 January 1989.
Jefferson Davis Junior College's art museum displays the primitive folk paintings of Bernice Sims.

156. Hunt, Steve. "Self-Taught Artists Share Spotlight at Folklife Festival." *Messenger-Inquirer* (Owensboro, KY), 19 August 1991, Section C.
An article about self-taught artists at the Kentucky Folklife Festival, in conjunction with the exhibit "Kentucky Spirit: The Naive Tradition" at the Owensboro Museum of Art in Owensboro, Kentucky.

157. Hutson, Chad. "People of the Land: Artist Records Heritage of the Field." *Skagit Valley Herald* (Mt. Vernon, WA), 7 September 1990.
Describes migrant life of Mexican-American agricultural worker Jesus Guillen and his art. He paints the scenes from the fields to "record the migrant worker's contributions to society." He also makes carvings from entwined natural tree branches and figures from molded cement. Illus.

158. "Jack Savitsky—Lansford's Coal Miner-Artist." *Valley Gazette* (Lansford, PA), January 1992.
Report of the death of Savitsky in the Coaldale State Hospital, December 4, 1991, at the age of 81. Details of his forty years as a coal miner, his artistic successes, and the illnesses that plagued him in his last years, including black lung disease. Says the "2000 paintings covering every inch of wall space in the family home" are being sent by Mrs. Savitsky to their son's gallery in Macungie, Pennsylvania. Large portrait of Savitsky accompanies the article.

159. Jackson, Lily. "She's Painting Nostalgia Romps Through the Past." *Times-Picayune* (New Orleans, LA), 17 September 1984, Section Q.
Feature piece on the primitive paintings of May Kugler, who paints from memories of her childhood.

160. Jensen, Dean. "Experts Acclaim Street Artist." *Milwaukee Sentinel* (Milwaukee, WI), 19 October 1983.
Simon Sparrow is a street artist who makes both drawings and assemblages. Says his work is an extension of his religious sermons.

161. "Jimmy Lee Sudduth Paintings to be Exhibited at Museum." *Broadcaster* (Fayette County, AL), 23 September 1971.
Details of Sudduth's childhood and how he started drawing with homemade charcoal. He is best known for painting with mud, using clay, and making colors from natural sources.

162. Johnson, Barry. "Art Makes Life Worth Living for Three Women." *The Oregonian* (Portland, OR), 8 June 1988.
"Her Strength Is in Her Principles" is an exhibition of three older women artists. Ruza Erceg is a self-taught water colorist whose subjects are pre-World War I Yugoslavia. Marjorie MacDonald does collages. Elizabeth Layton's drawings are her therapy and express her feminist politics.

163. Johnson, Barry. "Louis Monza Lino Prints Spotlight Gallery Show." *The Oregonian* (Portland, OR), 25 February 1986, Section D.
An exhibition of the work of Louis Monza at the Jamison/Thomas Gallery, focusing on his lino prints, which are political in nature. His oil paintings, drawings, and terra cotta sculpture are also displayed.

164. Johnson, Patricia C. "Art Created in Isolation: Outsiders Set Apart by an Inner Spirit that Moves Them." *Houston Chronicle* (Houston, TX), 6 December 1990.

Review of an exhibit titled "American Outsiders: Visionaries" at the Davis/McClain Galleries. Discussion of terms and how "outsiders" differ from other artists. Details on the art works and lives of Bill Traylor, Frank Jones, Martin Ramirez, Henry Darger and mention of Joseph Yoakum, P.M. Wentworth, Henry Ray Clark, and the Philadelphia Wireman all of whom are included in the gallery exhibit. Illus.

165. Johnson, Patricia C. "A Joyful Exuberance Distinguishes Folk Art of Rev. Howard Finster." *Houston Chronicle* (Houston, TX), 2 September 1990.
The traveling exhibition "The Road to Heaven Is Paved by Good Works: The Art of Reverend Howard Finster" is reviewed. Provides biographical information. Finster's popularity and place in American culture is discussed. Illus.

166. Johnson, Patricia C. "The World Created by Ida Kingsbury." *Houston Chronicle* (Houston, TX), 19 August 1990.
The yard environment of Ida Kingsbury of Pasadena, Texas is described in rich detail. Includes biographical information. Over 100 of her pieces were exhibited at Houston's Children's Museum. Illus.

167. Kaukas, Dick. "Art Au Naturel: Mark Anthony Mulligan Work Expresses This Artist's Joy for Life." *Courier-Journal* (Louisville, KY), August 1908, Features.
Louisville, Kentucky self-taught artist Mark Anthony Mulligan's paintings are described and detailed biographical information is provided. Illus.

168. Kaukas, Dick. "The Whittler." *Louisville Times* (Louisville, KY), 11 April 1987, Scene Section.
Article about Marvin Finn and his wooden animals, created with a band saw and knife. There is some information about Finn's life, too. Illus.

169. Kemp, Kathy. "His Bible Stories Are Hewn by Hand." *Birmingham Post-Herald* (Birmingham, AL), 8 September 1986.
Retired school principal Fred Webster's wood carvings of Biblical scenes are discussed. Information about his start in carving and how he works.

170. Kemp, Kathy. "His Work is God and Gourds." *Birmingham Post-Herald* (Birmingham, AL), 10 July 1987, Kudzu Magazine.
About Benjamin F. Perkins' painted gourds and "the total Perkins environment." Also includes comments by Robert Cargo on Perkins' paintings and his place in folk art.

171. Kemp, Kathy. " 'Outsider' Artists Hear Distinctive Muse." *Birmingham Post-Herald* (Birmingham, AL), 4 November 1991.
Report on art in the exhibit "Orphans in the Storm" at the 1024 Gallery in Birmingham. The works in the exhibit are by twenty-one artists, most from Alabama and the collection of Anton Haardt. Information on the definition of "outsider art." Included were the late Boosie Jackson and Sybil Gibson, among all the usual well-known Southern artists. Proceeds from the exhibition to be used to help finance a documentary film by Pat Gallagher of Jubilee Films on outsider art. Illus.

172. Kennedy, Ted, Jr. "They'll Astonish You." *Washington Post,* 11 June 1989, Parade Magazine.
The author discusses the organization called Very Special Arts, which provides people with disabilities the opportunity to participate in art programs. Features the work of painter Willie Britt and sculptor Michael Naranjo.

173. Kimmelman, Michael. "Folk-Style Evocations of a Life and a Culture." *New York Times,* 23 August 1991.
A review of an exhibit at the Museum of American Folk Art of the works of Harry Lieberman, a primitive painter whose subjects are based on the Bible, Jewish folklore, and his childhood in Poland.

174. Klein, Julia M. "Tapping Into a Creative Wellspring in Kentucky." *Philadelphia Inquirer* (Philadelphia, PA), 21 April 1991.
A feature article on the traveling exhibit organized by Morehead State University entitled "Local Visions: Folk Art from Northeast Kentucky." Highlights the work of Linvel Barker, Carl McKenzie, Hugo Sperger, and Ronald and Jessie Cooper. [Also published in *Las Vegas Review-Journal,* April 26, 1991.]

175. Knight, Barbara. "Local Folk Artist Has One Man Show." *Autauga Times* (Prattville, AL), 6 June 1990.
An article about Calvin Livingston, a painter who uses bold colors, textures, and vivid im-

ages. Livingston is a cousin of Charlie Lucas, whom he credits with helping him develop as an artist.

176. Kohen, Helen L. "Only in Florida." *Miami Herald* (Miami, FL), 19 April 1987.
Review of the exhibition "A Separate Reality: Florida Eccentrics" at the Museum of Art in Fort Lauderdale. A few of the artists described in the review are Langston Moffett, Edward Leedskalnin, Jesse Aaron, Purvis Young, Mario Sanchez, Earl Cunningham, and Stanley Papio.

177. Krance, Magda. "Scraggly Bag Lady in Men's Shoes One of Chicago's Popular Artists." *Houston Chronicle* (Houston, TX), 28 April 1985.
Describes Lee Godie's life and her paintings. Discusses the growing interest in her work outside of Chicago and the influence of fame on her recent works.

178. Kutner, Janet. "Folk Art With the Fire of Life." *Dallas Morning News* (Dallas, TX), 15 December 1990.
Enthusiastic review of an exhibit at the Barry Whistler Gallery called "Inside/Outside" that says "the energy generated here is a direct result of the artists' lack of formal training. Rather than looking to art history texts or museum exhibits as sources of inspiration, these artists rely on their imaginations and life experiences. Many are elderly so they have full lives to draw upon for subject matter." Artists included Benjamin F. Perkins, Jimmy Lee Sudduth, Royal Robertson, Burgess Dulaney, Howard Finster, Ike Morgan, Mose Tolliver, R.A. Miller, the "Rhinestone Cowboy," Patrick Davis, Sybil Gibson, and several others.

179. Lambert, Janet. "Artist Overcomes Obstacles, Paints With Watercolors." *Westside Messenger* (Columbus, OH), 26 March 1984.
Tells about early efforts of artist Ralph Bell, who cannot use his hands, to paint. Describes the special apparatus he uses to paint with his head. Says growing recognition of the artist has contributed favorably to the quality of his life. Illus.

180. Land, Mike. "Artist 'Annie T.' Follows in Father's Footsteps." *Montgomery Advertiser* (Montgomery, AL), 28 October 1990, Arts & Entertainment Section.
About Annie Tolliver becoming an artist in her own right, her family life, and the controversy over "who paints what" in Tolliver art. Includes descriptions of differences in the art works of the two. Says "families, friends, apprentices sharing in the work of an artist is an age-old tradition." Notes other folk art families—the Finsters, the Dials. Opinions from Anton Haardt, Marcia Weber, and others about the controversy.

181. Leneck, Lena. "Old and Naive." *Portland Downtowner* (Portland, OR), 20 January 1986.
Article about Jon Serl and Marjorie McDonald, two older naive artists living in the West. Provides brief biographical information and describes the work of both artists. Illus.

182. Lerner, David. "Visions." *Express* (Berkeley, CA), 31 October 1986.
News about the artists at Richmond, California's Institute for Art and Disabilities and the Institute founders Florence Ludins-Katz and Dr. Elias Katz. Illus.

183. Lester, Paul M. "Recalling Countless Livelihoods." *Times-Picayune* (New Orleans, LA), 1 August 1978.
A detailed feature article about "Chief" Philo L. Willey, with many photographs. Pictured sitting by the fence in Jackson Square in New Orleans, Willey recalls his life and his start in painting.

184. Lewis, Jo Ann. "Grass Roots." *Washington Post,* 5 May 1983.
Review of an exhibition at the Anton Gallery in Washington, D.C. called "Grass Roots Art." Reviewer calls it "one of the most refreshing shows in months." Notes growth of interest in contemporary folk art since the Corcoran exhibition, "Black Folk Art in America." Ten self-taught artists included at the Anton Gallery. Some of these were Howard Finster, Edgar Tolson, Earnest Patton, Carl McKenzie, Sam Doyle, and Inez Nathaniel Walker.

185. Linck, Anna. "Local Visions: A Look at Rural Appalachia." *Daily Times* (Porthsmouth, OH), 3 November 1991.
Review of the "Local Visions" exhibition at Southern Ohio Museum. Reviewer says "realism mingles with symbolism in the distinctive grassroots art expressions contained in the exhibit." Art pieces are described, and

those of Minnie Adkins, Garland Adkins, Linvel Barker, and Noah Kinney are pictured.

186. Lipson, Karen. "An Exhibit of Outsiders: The Art of Madness." *Newsday* (New York, NY), 3 January 1990.
A general survey of events related to "outsider art" that includes: an exhibition at the Phyllis Kind Gallery in New York that features eighteen outsider artists including Joseph Yoakum, Martin Ramirez, and Henry Darger; an auction at Sotheby's; an exhibition of Howard Finster's work at the PaineWebber lobby gallery in midtown Manhattan; plans for an exhibition at the Parsons School of Design; and comments and opinions on outsider art from various people including John MacGregor. Illus.

187. Litwin, Sharon. "Capturing One Man's Vision of the South." *Times-Picayune* (New Orleans, LA), 1 February 1987.
An article about the filming of David Butler for inclusion in the documentary, "The Mind's Eye." Details the hectic schedule of the filmmakers in New Orleans and southwestern Louisiana with "the reluctant artist as the center piece."

188. Livingston, Jane. "The Gentle People Who Make Folk Art." *Washington Post,* 16 March 1982.
Detailed account of the work of putting together the exhibition "Black Folk Art in America, 1930-1980," by its chief curator Jane Livingston. Describes how the artists were found and the basis for choosing among all who were identified. Describes visits to some of the artists in their homes.

189. "Lloyd Mattingly Builds on a Foundation of Caring." *Courier-Journal* (Louisville, KY), 17 July 1991.
Describes Mattingly's assistance to various civic groups—using his craftsmanship to build a float for elementary school students. His model city of Lebanon Junction, Kentucky as it was in the 1920s is featured.

190. Long, Frances. "Primitive Folk Artist Works with Pocket Knife." *Times Georgian* (Carrollton, GA), 9 February 1985.
Report about Leroy Almon and that his folk art carvings won the Governor's Award Bronze Medal in Georgia. Includes detailed biographical information and references to his teacher, Elijah Pierce.

191. Ludlam, Jane. "Ike and George." *Houston Press* (Houston, TX), 1 August 1991.
Article about Ike Morgan and his art on exhibit at a restaurant. Most of the more than fifty works on display were portraits of George Washington. Considerable attention is given to description of the art itself.

192. Lugo, Mark Elliott. "Prices, Exhibits Show that Folk Art Has Come of Age." *San Diego Union and Tribune* (San Diego, CA), 7 June 1985.
Article starts with information about prices of early folk art at a Christie's auction in New York and continues with a detailed review of the exhibition "Pioneers in Paradise: Folk and Outsider Artists of the West Coast."

193. Lyon, Christopher. "Sparrow's Ethnic and Religious Roots Influence His Art." *Chicago Sun-Times* (Chicago, IL), 25 January 1985.
Simon Sparrow's pastels and pencil drawings at Phyllis Kind Gallery are described. His roots in both the South and Africa are explored.

194. MacDonald, Ginny. "Just Call Him Mose T." *Birmingham News* (Birmingham, AL), 3 November 1991.
About Mose Tolliver's artistic successes with descriptions of the activity swirling around him at home. Tolliver tells some of the reasons why he paints what he does. Illus.

195. MacDonald, Heather. "On Their Way Up: Neighborhood Center for the Arts Clients Are Becoming Renowned Artists." *The Union* (Grass Valley-Nevada City, CA), 26 October 1991.
lustrated article about the success of the artists at the Neighborhood Center for Artists, "a program for people with developmental delays." Description of the program and work of some of the artists including Spencer McClay and Larry Mills.

196. Marranzino, Pasquale. "Life Was Precious for Martin Saldaña." *Rocky Mountain News* (Denver, CO), 2 October 1965.
Tells of the passing of Martin Saldaña at ninety-one, and something about his life and his art. Born in Mexico, he spent most of his life as a cook. He did not paint until the Denver Children's Museum invited him, by mistake, to attend their Saturday morning classes. In a *Life Magazine* article in 1953 he was called "Denver's Grandpa Moses." Illus.

197. Martin, Margaret. "At 96, She Paints What She Knows." *The Times* (Shreveport, LA), 29 March 1981.
Report of a surprise ninety-sixth birthday party for Clementine Hunter. Friends found her at a place up the Cane River.

198. Martin, Margaret. "Clementine Hunter: Beloved Artist Soon to Celebrate 100th Birthday." *The Times* (Shreveport, LA), 26 January 1986.
Story about birthday celebrations planned on the occasion of Clementine Hunter's hundredth birthday. Tells of her early life and her success as an artist. There is an insert entitled "Clementine Fakes Easy to Spot."

199. Martin, Margaret. " 'Five Cents' Cashing In On Art Talent." *The Times* (Shreveport, LA), August 1923.
A biographical article about M.C. "5¢" Jones in which his painting technique is detailed. His subjects are usually from his memories.

200. Marvel, Bill. "A Most Colorful 'Outsider': Valton Tyler Gets Deserved Attention." *Dallas Times Herald* (Dallas, TX), 3 May 1986.
Lengthy art review of the work of Tyler, facts about his life and mentions the shows he has had. Says "Artist's creations offer brush with naive surrealism."

201. Mason, M. S. " 'Self-taught' artists lose 'primitive' label." *Rocky Mountain News* (Denver, CO), 19 July 1992.
The reviewer describes in some detail her positive reactions to the art in the exhibition "Give Me a Louder Word Up." She dislikes earlier terminology for this work. Believes the artists are "unprejudiced by the art schools."

202. Maxfield, David M. "By the People, For the People." *San Francisco Chronicle* (San Francisco, CA), 1 October 1990.
Review of the Hemphill Collection acquired by the Smithsonian Institution's National Museum of American Art. Reporter asks the question: "What exactly is folk art?" and provides a sample of answers, with artifacts to illustrate them.

203. Mayer, Barbara. "Twentieth Century Folk Art Finds Place in the Sun." *Potomac News* (Woodbridge, VA), 8 March 1991.
About the exhibition at the Museum of American Folk Art, based on the collection of Chuck and Jan Rosenak, which was to travel throughout the country during the next two years. Also describes how the Rosenaks' developed their interest in twentieth century folk art and how they began to collect it. The Rosenaks' philosophy of collecting is detailed. Other information on the existence of contemporary folk art is included too.

204. McCoy, Mary. "Galleries: Isolation in Unison." *Washington Post,* 29 September 1990.
Notice of the exhibition of twenty-two artists' works at the Tartt Gallery in Washington, D.C., with brief descriptions of the works of R.A. Miller, Howard Finster, Leroy Almon, Georgia Blizzard, Alexander Bogardy, and Marcus Staples. Says the elderly Bogardy "gradually filled his Washington apartment with finely crafted religious scenes" and Marcus Staples "addresses the impact of racial oppression on both personal and national identity in his frightening painting of an encounter between a white man and black woman in a colonial field."

205. McGill, Douglas C. "Minnie Evans, 95, Folk Painter Noted for Visionary Work." *New York Times,* 12 December 1987, Obituaries.
A death notice rich in detail about Minnie Evans' career as a folk artist. Her start in the 1940s and discovery by Nina Howell Starr in the 1960s are featured. Photo of artist.

206. McKean, Marcia. "Achilles Rizzoli: The Architecture of Hallucination." *Antiques West Newspaper,* June 1992.
Information about Achilles Rizzoli and the discovery of his work by Bonnie Grossman, the director of The Ames Gallery in Berkeley, California. Grossman came across the work of this unknown artist/draftsman in 1990 and has spent the last two years putting together the pieces of Rizzoli's life and studying his art. Says "he appeared on the surface to lead a quiet unassuming life. But his fantasy life was something else. A.G. Rizzoli the visionary spent forty-two years of his life as the 'earthly architectural assistant and transcriber to God,' creating a series of extremely sophisticated exquisitely detailed writings and drawings" The article describes the various cycles of his work, among them the novels and other writings (terrible, says Grossman) and the "elaborate colored ink drawings that

were symbolic sketches of people known to Rizzoli and represented as buildings." The other cycles of work are described, too, as is John MacGregor's reaction to it. McKean notes that italicized quotes in this article are from a biography-in-progress, *Amplifying Achilles: a Biography of A.G. Rizzoli,* by Bonnie Grossman, which will include an essay entitled "The Architecture of Hallucination" by MacGregor. Illus. [A sidebar on the phenomenon of and interest in so-called "outsider art" is included in the paper.]

207. McKenna, Kristine. "Inside the Mind of an Artistic Outsider." *Los Angeles Times* (Los Angeles, CA), 12 November 1989, Calendar.
Jon Serl reminisces about his various careers—actor, dancer, female impersonator and finally as an artist. He has been painting since the late 1940s and is still active at age ninety-seven.

208. McLaurin, Tim. "Created Landscapes: A Vision of Paradise in Georgia." *New York Times,* 19 May 1991, Magazine.
A feature on Howard Finster's Paradise Garden near Summerville, Georgia. Describes the surrounding area and suggests places to stay and eat while visiting. Gives biographical information on Rev. Finster. Includes map.

209. McMullan, Jean. "Folk Artists Find Inspiration from Within." *Baton Rouge State Times* (Baton Rouge, LA), 26 April 1989.
Review of an exhibition of twenty Southern folk artists at Gilley's Gallery entitled "Outsiders Looking In: Memories, Visions, and Fantasies." There is description of the work of Clementine Hunter, Sister Gertrude Morgan, David Butler, Raymond Coins, Sam Doyle, the Rev. Howard Finster, Willie White, Marion Conner, and Heleodoro Cantu. Others included in the exhibition were Thomas May, Jerry Brown, and Mary T. Smith. Illus.

210. McQueen, Tracy L. "Raising Canes." *Messenger-Inquirer* (Owensboro, KY), 13 September 1992.
An illustrated article about the personal history and the artworks of self-taught stick carver Gary Lawton Hargis. Detailed information on the canes and their construction.

211. "Mental Patient's Art Astonishes Experts." *Houston Post* (Houston, TX), 9 April 1989.
Article about Ike Morgan that says he is hospitalized for schizophrenia and that creating his paintings is the only thing he seems to enjoy.

212. Mignon, Francois. "Cane River Memo." *Natchitoches Enterprise* (Natchitoches, LA), 3 August 1961.
Author writes about the fame of Clementine Hunter and her inclusion in collections around the country, but not often in the homes of her native city. Tells of teaching Hunter to sign her paintings and her refinements on the letter "c."

213. Mihopoulos, Effie. "Just Folks." *Reader* (Chicago, IL), 17 May 1991.
Lengthy review of the traveling exhibition "Local Visions" then in place at the gallery of the School of the Art Institute in Chicago. This article differs from others about the same exhibit in that it concentrates on the artwork itself.

214. Milloy, Marilyn. "Buck Dial is as Surprised as Anyone to Learn His Work is Considered Art." *Courier-Journal* (Louisville, KY), 21 October 1990.
Biographical information about Thornton "Buck" Dial, Sr. Describes his work background in Bessemer, Alabama, his family, and his art. Mentions how much his work sells for in galleries.

215. "Minister Succumbs." *Statesville Record & Landmark* (Statesville, NC), 8 May 1976.
Obituary for Rev. McKendree Robbins Long, Sr. Says "He was an artist, minister, evangelist, and writer. In later years he combined his study of the Bible with his art and poetry in paintings that illustrated much of the Book of Revelation."

216. Minton, David. " 'Folk Art' Display Has Simple, Fun Works by Kentucky Artists." *Lexington Herald-Leader* (Lexington, KY), 10 June 1990.
Describes an exhibit, "Kentucky Folk Art," at the Triangle Gallery, with sixteen artists from the area. Includes Calvin Cooper, Minnie Adkins, Edgar Tolson, Russell Rice, and others.

217. Minton, David. "Folk Art Exhibit Full of Surprises." *Lexington Herald-Leader* (Lexington, KY), 17 July 1988.
Fourteen artists, mostly from eastern Kentucky, are on exhibit at the Triangle Gallery. Artists mentioned include Ronald and Jessie Cooper, Marvin Finn, Junior Lèwis, and Tim Lewis.

218. Minton, David. "Primitive Sculptor Weds Paint and Knife." *Lexington Herald-Leader* (Lexington, KY), 7 July 1991.
The wood sculpture of J. Olaf Nelson is described as "a marriage of the paint brush and the knife." Examples are on exhibit at the Kentucky Art and Craft Foundation Gallery.

219. Miro, Marsha. "Folk Artist in Tune with His Times." *Detroit Free Press* (Detroit, MI), 24 August 1990.
About Willie Leroy Elliott and his sculptures made of "leftover stuff" on display at the Hill Gallery. Discusses his growth as a folk artist and his use of contemporary social and political themes.

220. Moore, Bill. "Outsider Artist." *Wisconsin State Journal* (Madison, WI), 26 February 1989.
A discussion of what an outsider artist is, illustrated with Wisconsin-based artists Simon Sparrow, Carter Todd, and Guy Church.

221. Moore, Didi [Barrett]. "Santa Fe Folk Art: Funny and Ferocious/Animal Artistry: Folk Figures from the Southwest Take on New Shapes." *New York Times,* 3 June 1984.
Article about New Mexican carvers Felipe Archuleta, Alonzo Jimenez, Leroy Archuleta, and "Jimbo" Davila.

222. Nelson, James R. "Critic Discovers Exceptional, Exciting Exhibit." *Birmingham News* (Birmingham, AL), 22 November 1987.
Describes an exhibit at the Birmingham Museum of Art featuring the works of Joe Hardin and Fred Webster. The bold paintings of Hardin are discussed, as are the biblical carvings of Webster.

223. Nelson, James R. "Sudduth's Art: A Spontaneous Experience." *Birmingham News* (Birmingham, AL), 30 July 1978.
Discusses Jimmy Lee Sudduth's paintings made "with dirt and simple pride." At an exhibition at the Birmingham Museum of Art, Sudduth's paintings reveal his perception of the world.

224. Newell, Mary. "Art at the Airport: 'Colors'. " *Gainesville Sun* (Gainesville, FL), March 1902.
Tells of art placed at the Gainesville Regional Airport "both to welcome visitors and also for local residents to enjoy." Describes the acrylic paintings of Alyne Harris–"skilled and original" user of color. Tells of the importance of religion to Harris and her liking for angels. Photographs of artist and her work.

225. Newman, Barry. "Folk Art Finder: Uncovering the Works of Untrained Artists Takes a Lot of Looking." *Wall Street Journal,* 30 July 1974.
An article about folk art dealers Jeff and Emily Camp. Tells anecdotes about their American Folk Company in Richmond, Virginia, and of their searches for artists. Discusses controversies regarding the value of contemporary folk art. Some of their discoveries included Russell Gillespie, "Uncle Jack" Dey, and Miles B. Carpenter.

226. Nogaki, Sylvia Wieland. "Northwest Chainsaw Artists Carve Out a Niche." *Seattle Times* (Seattle, WA), 9 July 1991.
Article about chainsaw carvers of the Pacific Northwest featuring Rocky MacArthur, Pat McVay, and Steve Backus, all from Whidbey Island, Washington. Outlines the difficulties these artists have encountered with galleries. "However, their growing popularity has produced increased recognition, including the attention of the Museum of American Folk Art."

227. Norman, Tyler. "Obsessions on Display." *Atlanta Journal-Constitution* (Atlanta, GA), 23 August 1992.
A "quick guide" to the South's unique museums that includes a color photograph and information about Joseph Zoettel's environment, "Ave Maria Grotto."

228. Nusbaum, Eliot. " 'Local Visions': Outsider Art Wins Following." *Des Moines Register* (Des Moines, IA), 27 January 1991.
Review of the traveling exhibition "Local Visions," which discusses the social and cultural setting of the art and its creators, "who come from the poorest part of the state," and also discusses the problems of definition of folk art. Nusbaum says "definitions in this area are a little hard to come by—and then to make them stick." Brief comments on the art and the work. Illus.

229. Ollman, Leah. "Old Painter with Refreshing Vision Trains His Eye on the Ties that Bind." *Los Angeles Times* (San Diego County edition), 17 November 1989.
A review of the showing of Jon Serl's paintings at the Oneiros Gallery, San Diego. The

exhibit reflects twenty years of Serl's work. Says although in his late nineties, Serl's style is fresh and bold.

230. Ollman, Leah. "Painter, 95, Draws on Child Within for Unfettered Style." *Los Angeles Times* (San Diego County edition), 17 December 1988.
An exhibit of Jon Serl's paintings at the Oneiros Gallery in San Diego is announced in this mostly biographical article. Includes a discussion of Serl's style and "art brut." Author says "nothing escapes Serl's visual hunger."

231. "One Man's Five-Room Love Story." *Washington Post,* 19 October 1989.
Describes the environment created by Joseph Furey in his Brooklyn apartment after the death of his wife. His "obsessive" art is compared to Simon Rodia's Watts Towers in Los Angeles. The Brooklyn Museum is attempting to preserve Furey's creation.

232. "Orleanian Featured." *Times-Picayune* (New Orleans, LA), 21 June 1973.
Report of feature story about New Orleans artist Vivian Ellis in a German picture magazine. Tells of her success as a naive artist in Europe. A few details are given about her life in Germany and before that in New Orleans. She is "receiving acclaim in Europe for her gaily-hued naive paintings."

233. Ornstein, Susan. "Appealing Originality Marks Art." *Miami Herald* (Miami, FL), 8 March 1987, Keys News.
Self-taught artist Jack Baron of Key West has work exhibited at East Martello Museum and Gallery. Baron paints wildly colorful portraits. Baron's work is characterized by his use of polka dots.

234. Orr, Kim. "Meet Your Gallery Director: Keeping Art and Artists Alive and Well in Baton Rouge: Shelby Gilley Turned His Hobby Into a Full-time Job." *Baton Rouge Sunday Advocate* (Baton Rouge, LA), 22 January 1989, Magazine.
Discusses gallery owner Shelby Gilley's background. Says that he started out handling nineteenth century paintings and prints and early Louisiana artists and that the gallery is best known for offering the art of Clementine Hunter and other Southern artists. Now "Gilley is interested in a group of artists who produce work known as 'outsider art.'"

235. Osburn, Annie. "Marcia Muth: A Storyteller in Paint." *New Mexican* (Santa Fe, NM), 11 March 1988.
Self-taught artist Marcia Muth talks about her discovery in 1975 that she could paint. She discusses moving from the law library at the University of Missouri to the founding of Sunstone Press in Santa Fe.

236. Ouillette, Jenine C. "Jack Baron's Art Show: It's a Real Party Event." *Key West Citizen* (Key West, FL), 1 March 1991.
Report on the annual art show of folk artist Jack Baron, "Key West's sophisticated naif." Baron displays nearly one hundred pieces at the Key West Women's Club. All of his work is related to Key West: its people, its cats, and its houses.

237. Ouillette, Jenine C. "Woman's Club Celebrates Christmas in March." *Key West Citizen* (Key West, FL), 1 March 1992.
Fundraising party that features the paintings of Jack Baron. Color photographs of his work illustrate the article.

238. "Outsider Artist Inez Walker Dies." *Antiques and Arts Weekly,* 17 August 1990.
An obituary detailing the artistic life of Inez Nathaniel Walker. Walker started drawing while an inmate at a New York correctional facility and flourished from 1972 to 1980, when she dropped from sight. She was found in 1986 at the Willard Psychiatric Center in upstate New York, where she died.

239. Paine, Janice T. "'Local Visions' Often Universal." *Milwaukee Sentinel* (Milwaukee, WI), 26 October 1990.
Review of the opening at the University of Wisconsin Milwaukee Art Museum of the exhibition "Local Visions: Folk Art from Northeastern Kentucky." Information on the artists and their visions. Tells of the folk art program at Morehead.

240. Papajohn, George. "'Nouveau Realist' School of Art." *Chicago Tribune* (Chicago, IL), 8 March 1992.
A "humorous" article about yard art and how the neighbors may feel about it. Mostly they don't like it. There is a photograph of sculptor Charles Smith, who lives on the east side of Aurora, Illinois and who has converted his yard into "a museum with statues he sculpted from

raw materials to depict black history from the 1700s to the present."

241. Parks, Cynthia. "Primitive Impressionist Has a Passion to Paint." *Florida Times Union* (Jacksonville, FL), 26 August 1990.
About Alyne Harris, her passion to paint, and the influences of her childhood memories. Comments on her life and background, including how she signed up to take art classes and the instructor "just kind of let her go," respecting her self-taught style.

242. "Party Highlights . . ." *Sunday Advocate* (Baton Rouge, LA), 11 November 1990.
Report on the Museum of American Folk Art, Folk Art Explorer's Club visit to Baton Rouge, to Gilley's Gallery and to the Rural Life Museum, where they met self-taught artist Steele Burden. Photographs.

243. Patterson, Tom. "Art for Dinner: Lively Works Deck Restaurant's Walls." *Winston-Salem Journal* (Winston-Salem, NC), 20 January 1991.
Describes an exhibition of eighty works of art by ten outsider artists at a small restaurant, Southern Lights. Artists include James Harold Jennings, Howard Finster, Mary T. Smith, Clyde Jones, Mose Tolliver, R.A. Miller, Jimmy Lee Sudduth, and Royal Robertson, whom the author believes is the best.

244. Patterson, Tom. "A Master 'Outsider' Artist Casts a Knowing Eye on the Human Condition." *Winston-Salem Journal* (Winston-Salem, NC), 1 May 1988.
Reviews the importance of Bill Traylor's work on the occasion of an exhibition of sixty of his works in Winston-Salem, North Carolina. Biographical details of the artist's life are included along with Patterson's definition of outsider art.

245. Patterson, Tom. "Milestone: Debut Presents Most Entertaining Show in Town." *Winston-Salem Journal* (Winston-Salem, NC), 9 January 1991.
Critical review of the artworks of Mark Casey Milestone on the occasion of an exhibition of his work at the Urban Artware Gallery. Gives many details about the art. Says the work of self-taught artist Milestone is "consciously naive" and at the same time "the hip, ironic humor that comes through in some of the work makes it clear that Milestone is not some naive recluse."

246. Patterson, Tom. " 'Outsider' Is In: Whimsical Experiments Hold Surprises." *Winston-Salem Journal* (Winston-Salem, NC), 5 May 1991.
Patterson describes the home environment and art of James Harold Jennings and says he is very popular with collectors. Illus.

247. Peers, Alexandra. "Glory Days Gone, Prices of Folk Art Return to Roots." *Wall Street Journal,* 16 April 1991.
About the falling prices of folk art, especially those which were highly inflated during the prosperous 1980s. Main focus is on eighteenth and nineteenth century pieces, but also mentions Sotheby's February auction in New York, where twenty-nine percent of folk art items failed to sell. The work of William L. Hawkins is mentioned.

248. Piatt, G. Sam. "Carving Couple Gain Acclaim." *Sunday Independent* (Ashland, KY), 12 January 1992.
A description of the marketplace successes of Minnie and Garland Adkins and how this success has "spurred development of a regular colony of artists in the area." The Adkins give credit to Adrian Swain of Morehead and Eason Eige of the Huntington Museum of Art for their success. Article notes that the two have worldwide popularity but the local people don't understand it.

249. Pincus, Robert L. "Fanciful Folk Art Has 'Ball'. " *San Diego Union* (San Diego, CA), 25 May 1986.
Curator Harvey Jones selected more than one hundred works by fifty-five artists for the exhibition "Cat and a Ball on a Waterfall." This article reviews the exhibition and discusses alternative definitions and terms used in relation to folk and outsider art.

250. Pincus, Robert L. "Paintings by Jon Serl, 94, Still Vital." *San Diego Union* (San Diego, CA), 5 January 1989.
Review of exhibition of Jon Serl's work at Oneiros Gallery. Describes some of the paintings in great detail.

251. Pincus, Robert L. "Serl: Art and Nature." *San Diego Union* (San Diego, CA), 31 March 1991. Arts Review,
A review of a show of Jon Serl's work, "Pink Lady with a Carp," at Oneiros Gallery. The im-

pressive range of Serl's work is discussed and illustrated by paintings in the exhibition.

252. Pincus, Robert L. "The World According to Serl." *San Diego Union* (San Diego, CA), 18 January 1987.
A detailed article on Jon Serl and his painting. Tells of his first show in 1981 at the Newport Harbor Art Museum. Includes a discussion of terminology of folk art, naive art, and outsider art. Contains biographical information about Serl.

253. Pittman, Robyn. "Fame is Swift for Fledgling Artist." *St. Petersburg Times* (St. Petersburg, FL), 24 February 1992.
Article about self-taught artist Robyn "The Beaver" Beverland of Oldsman, Florida, who has a rare genetic disorder, and about his recent beginnings as a painter.

254. Poindexter, Marshall. "For Flemingsburg Couple, Folk Art is Creative, Spiritual Outlet." *Lexington Herald-Leader* (Lexington, KY), 15 February 1989.
Reviews exhibit of work of Ronald and Jessie Cooper at the Triangle Gallery. Ronald Cooper tells of a car accident that injured his legs. He turned to carving to rid himself of nightmares. Article says Jessie turned to painting on furniture and other things to sooth her nerves as her husband healed.

255. Pollock, Duncan. "Recognition Arrives for Martin Saldaña." *Rocky Mountain News* (Denver, CO), 7 February 1971.
Martin Saldaña died unknown and insolvent in 1965. His primitive paintings were treated as a curiosity. Mostly because of the efforts of Lester Bridaham, a Denver art teacher, his work is exhibited in Amsterdam and London.

256. Polston, Pamela. "Looking for Art in All the Wrong Places." *Vermont Times* (Burlington, VT), 16 May 1991.
"Insider art," an exhibition in the Fletcher Library curated by Peter Gallo, attempts to break down arbitrary distinctions between academic art and "lawn sale art."

257. Price, Anne. "Clementine Hunter Myths Laid to Rest." *Capitol City Press* (Baton Rouge, LA), 13 November 1988, Magazine.
A very positive review of the book *Clementine Hunter, American Folk Artist,* by James Wilson. Tells of records he found to refute myths about her age, birthplace, and painting. Reviewer says the book is well researched and informative.

258. Price, Anne. "New Yorkers 'Explore' BR Folk Art." *Capitol City Press* (Baton Rouge, LA), 11 November 1990.
Report on the visit to Baton Rouge of the Museum of American Folk Art, Folk Art Explorer's Club. Notes the various places visited, including the Rural Life Museum to meet Steele Burden and Gilley's Gallery to hear a talk by Tom Whitehead on Clementine Hunter.

259. Quinn, Paula. "Exhibit Salutes the Tobacco Farmer." *Courier-Journal* (Louisville, KY), 13 September 1987.
Written on the occasion of an exhibition at the Kentucky Museum about creative traditions past and present. Comments on the work of R.O. Dalton, Helen LaFrance Orr, Denzil Goodpaster. Illus.

260. Raines, Howell. "Here She Is, Miami Herald, in Birmingham." *Birmingham News* (Birmingham, AL), 20 June 1971.
This article presents detailed information about the life and art of Sybil Gibson and her return from Florida to her Alabama home. Title refers to an article in the *Miami Herald,* May 30, 1971, by Griffin Smith, where the author asked about the disappearance of the "Miami" artist Sybil Gibson.

261. Rankin, Allen. "Rankin File: He'll Paint for You—Big 'Uns 20 Cents; Lil 'Uns, a Nickel." *Alabama Journal,* 31 March 1948.
Talks about Bill Traylor, the attention received from the artworld in the past years, and that he was now being mostly ignored. Says "Bill Traylor is now 95. Hidden away in the Bragg Street backyard of one of his 25 children, he sits in the shade and dozes." Says Traylor misses the cardboard people used to bring him, and the paints. Rankin says "if you go find Bill out at his house, 314 Bragg Street," he will paint you a picture for twenty cents. Photograph of Traylor by Albert Kraus.

262. Raymond, Paulie. "Jack Baron: Sophisticated Naif." *Key West Citizen* (Key West, FL), 2 March 1990.
A preview of Baron's third annual show, "The Conch Republic." The artist painted all the

buildings in Key West with flags in front of them. Recalls his move to Key West and discusses his painting. Includes brief biographical information.

263. Raynor, Vivien. "Art: Folk Art Fun and Fanciful." *New York Times,* 30 December 1984.
Review of an exhibition at the Stamford, Connecticut Museum and Nature Center, "Folk Art: Then and Now." Provides background on activities and interest in American folk art. Comments on the artists exhibited, including Howard Finster, Sophy Regensburg, "Pucho" Odio, the "incomparable" Bill Traylor, Sister Gertrude Morgan, and "for sheer zing," the red devil of Miles Carpenter. Raynor notes "famous names Joseph Pickett, Morris Hirschfield, Inez Nathaniel Walker and, of course, Anonymous." Illus.

264. Raynor, Vivien. "Art: Folk Themes and Memories in Show by Nine Black Women." *New York Times,* 21 August 1988.
Review of an exhibition at the Aetna Institute Gallery in Hartford, Connecticut. Review showing the usual response of Raynor to contemporary folk art says "they are called naive, primitives, folk artists or outsiders, but 'para-artists' might be a more accurate term." Describes Mary T. Smith as one who "who slaps painted outlines and silhouettes of figures onto bits of board and corrugated metal Folk art authorities have perceived in her efforts an African quality yet they seem closer to the scrawls of not terribly talented Western children." A few others get similar treatment (Clementine Hunter, Sister Gertrude Morgan). Limited approval is given to Minnie Evans, Nellie Mae Rowe, Inez Nathaniel Walker, and Patsy Billips. Juanita Rogers is mentioned. Bessie Harvey is said to be an artist "who appears to aim for something beyond narcissistic self-satisfaction." Illus.

265. Raynor, Vivien. "Art: The Outsiders, at Rosa Esman Gallery." *New York Times,* 17 January 1986.
Review of a group exhibit at the Rosa Esman Gallery, focusing on outsider art. Discusses art of the insane, "art brut," and other similar terms.

266. Raynor, Vivien. "Contemporary Folk Art from Three Collections." *New York Times,* 23 February 1992.
Reporter refers to the "childlike art done by adults" at the Rockland Center for the Arts. The art is from the Hemphill Collection, the collection of Mr. and Mrs. Richard Sears, and Rubens Teles. The exhibition, "Contemporary American Folk Art," featured art by Malcah Zeldis, "Uncle Jack" Dey, Andy Kane, Pucho Odio, Inez Nathaniel Walker, Sister Gertrude Morgan, Leroy Almon, and many others.

267. Raynor, Vivien. "Exercising the Mind as Well as the Eye." *New York Times,* 13 August 1989.
The exhibit, "A Density of Passions," at the New Jersey State Museum, is reviewed. Artists considered visionaries are shown with self-taught artists, to invite viewers to compare and contrast them. Self-taught artists included Ted Gordon, Gerald Hawkes, Rev. Howard Finster, Frank Jones, Joseph Yoakum, the Philadelphia Wireman, and Gregory Van Maanen.

268. Raynor, Vivien. "Folk Art—Real and Artificial." *New York Times,* 2 February 1986.
Critical review of the exhibition at the Newark Museum, in New Jersey, of works by William Edmondson and David Butler. Says neither artist benefits from the juxtaposition—"a result of the Newark Museum having inherited bodies of work by the two." The article is full of contradictory impressions and evaluations of each artist's work.

269. Raynor, Vivien. "Gallery View: A Gentle Naif from Alabama." *New York Times,* 26 September 1982.
A comprehensive article on Bill Traylor and his art, with biographical information and with critical attention to Traylor as an artist.

270. Read, Mimi. "Clementine Hunter." *Times-Picayune* (New Orleans, LA), 14 April 1985, Dixie.
About a "pilgrimage to the home of the ninety-nine-year-old painter whose fanciful images of plantation life adorn some of America's poshest living rooms." Tells of celebrities' interest in her and her lack of interest in them. Author says that though some prominent whites in Natchitoches support Clementine Hunter, the black community is largely indifferent.

271. Reif, Rita. "Folk Art Museum Gets a Home After Years on the Move." *New York Times,* 13 April 1989.
Robert Bishop, newly named director of the Museum of American Folk Art, talks about his plans to expand the museum's collections, move it to a new building, and establish it as a major scholarly facility. Provides biographical information about Bishop.

272. Reif, Rita. "Folk Museum Homeward Bound." *New York Times,* 21 July 1990.
Article about the future home of the Museum of American Folk Art—new quarters at its old address. Planned opening will be in 1993 or 1994. The new building plans started in 1979 with the purchase of the brownstones at the new museum site (scheduled for demolition), removal of tenants, and fundraising.

273. Reif, Rita. "Presenting Folk Art's Greatest Hits." *New York Times,* 30 September 1990.
Several years ago Jean Lipman discussed with Robert Bishop, director of the Museum of American Folk Art, her opinion that the quality of folk art was in decline. Their conversations resulted in the museum's show, "Five Star Folk Art," plus a book of the same name, presenting one hundred pieces of "some of the greatest." Some of the art is described, as is the selection process.

274. Reif, Rita. "Robert Bishop, a Folk-Art Expert and Museum Director, Dies at 53." *New York Times,* 23 September 1991.
An article written on the occasion of the death of the Museum of American Folk Art's director, Robert Bishop. Details the career of Bishop and his leadership in expanding the museum's scope. Bishop broadened public awareness of folk art and raised money to further this mission of the museum. Includes biographical information.

275. Reif, Rita. "The Whimsical Walking Stick: Beyond a Fashion Statement." *New York Times,* 12 July 1992.
Review of the exhibition, "Step Lively: The Art of the Folk Cane," at the Museum of American Folk Art. Includes information on the social history of the walking stick and about collecting them now. Quotes George H. Meyer, whose canes make up the exhibition and who has "collected American folk-art versions of canes for 15 years," as saying "canes were made in every American state and in Europe, Asia and Africa." Meyer finds folk art canes the most appealing, says Reif, for "their spontaneity and individualism."

276. Reno, Doris. "Hill-Billy Artist from Hell-for-Certain Creek." *Miami Herald,* 16 January, 1941.
Information about the background and painting of Kentucky artist Clarence Wooten, who was living in a housing project in Miami at the time the article was written. Tells how he ran away from home in 1919 at age fifteen to join the army and his adventures that followed. He tried art school but dropped out. He says he believes "the way to learn to paint is to paint." Illus.

277. "Rich Colors of Mexico Seen in Guillen's Work." *Anacortes Reporter* (Anacortes, WA), 31 July 1963.
Article about the paintings of self-taught artist Jesus Guillen. Information on his background in Mexico and the United States. Tells about his desire to document the work and contributions of farm laborers in his art. Says that while he is "too busy to paint during the summer, Guillen roughs in work that he wants to do, while it is still in his head, and sets it aside for winter when there is not so much work to do." [Reporter misunderstood a remark Guillen made about artist Guy Anderson. Anderson is his friend, not his teacher.]

278. Rive, Dave. "Collector: Outsider Art." *Times-Picayune* (New Orleans, LA), 5 November 1989.
Discusses the expansion of Barrister's Gallery into outsider/folk art, with the addition to the gallery staff of A.J. Boudreaux. The art of wood sculptor Herbert Singleton and drawings of Roy Ferdinand are described.

279. Rive, Dave. "Picture This: Life on New Orleans' Streets." *Times-Picayune* (New Orleans, LA), 18 May 1990.
A profile of Roy Ferdinand, Jr., a folk artist whose drawings invoke the street life in his New Orleans neighborhood. His relationship with Barrister's Gallery and its impact on his drawing is outlined. Says Ferdinand's subjects are not comfortable—drugs, violence, and "uncompromising portraits." Illus.

280. Robinson, Jim. "Elliott Native Found Calling by Accident." *Sunday Independent* (Ashland, KY), 23 February 1992.

Article about stonecarver and cane maker Tim Lewis. Says that when the brakes failed on the coal truck he was driving, and he had to slam into a hill to stop, Tim Lewis decided that "enough was enough" and he quit and started to work full time on his art. Information about his art, the pieces he has made, and his receiving a $5,000 grant from the Kentucky Arts Council. Illus.

281. Rose, Christopher. "The Accidental Artist: Reggie Mitchell, Folk Artist, Paints with the Eye of an Innocent." *Times-Picayune* (New Orleans, LA), 19 January 1992.
Details of the life of a recently discovered African-American artist from the "hostile environs" of the Calliope Projects. Says "At 32, he's been ripped off and shot at more times than some of us have gone to the movies." Mitchell's works are called bold and colorful evocations of New Orleans life. Article includes detailed descriptions of the art. Illus.

282. Rosen, Steven. "Art Show Radiates Individualistic Flair." *Denver Post* (Denver, CO), 5 August 1991.
Review of a folk art show at the Brigitte Schluger Gallery in Denver that calls the non-traditional folk art "a fresh alternative" for those tired of looking at traditional folk art. Says these artists are more interested in "expressing their particular vision with whatever material is at hand." Artists noted are Benjamin F. Perkins, "Jimbo" Davila, Columbus McGriff, "Uncle Pete" Drgac, the "Rhinestone Cowboy," Mary T. Smith, Patrick Davis, and Ike Morgan. Two color illustrations.

283. Rosen, Steven. "Inner-visions Come to Life in 'Word Up'. " *Denver Post* (Denver, CO), 19 July 1992.
Descriptions of art in the exhibition "Give Me a Louder Word Up."

284. Russell, John. "A Remarkable Exhibition of Black Folk Art in America." *New York Times,* 14 February 1982, Art.
A review and discussion of the 1982 Corcoran exhibition of "Black Folk Art in America, 1920-1980." Features twenty artists selected by curators Jane Livingston and John Beardsley including William Edmondson, James Hampton, Elijah Pierce, George Williams, Bill Traylor, Sister Gertrude Morgan, and others.

285. Rust, Carol. "The Orange Show." *Houston Chronicle* (Houston, TX), 26 November 1989, Texas.
The history of the creation of The Orange Show, "the product of every spare moment in Jeff McKissack's day for more than two decades." The article provides a lot of information about his life and dreams. Tells about how he gathered the cast-off materials to build the site and what neighbors and others had to say about his project. Describes McKissack's disappointment at the lack of visitors to the Orange Show and his death just seven months after it opened. Many color illustrations.

286. Saft, Marcia. " 'Flights of Fancy:' Birds of Folk Art." *New York Times* (Connecticut Edition), 30 December 1990.
The show at the Charles Plohn Gallery at Sacred Heart University in Fairfield, Connecticut featured birds done by contemporary folk artists in a variety of mediums. It was curated by Daniel C. Prince. Illus.

287. Saft, Marcia. "Works of American Folk Art are Shown in Stamford." *New York Times* (Connecticut Edition), 29 December 1985.
Review of "Rebuilding Liberty: Old and New Themes in American Folk Art," displayed at the Hotel Stamford Plaza. This exhibit is curated by Daniel C. Prince and represents a broad spectrum of folk art. Illus.

288. Salter, Charles Jr. "Artistic Visions from Untrained Eyes Show Staying Power." *News and Observer* (Raleigh, NC), 15 December 1991.
Article discussing the market for outsider art. Many museums are becoming involved by having shows and buying whole collections, although some museums are uncertain and "are waiting for a major museum to open an outsider exhibit."

289. Salter, Charles Jr. "Artist's Creatures of Habitat: Works from Stone, Bone, and Imagination." *News and Observer* (Raleigh, NC), 15 December 1991.
Q.J. Stephenson maintains an environment called the Earth Museum of Northampton and Halifax Counties. It contains fossils and petrified wood, some of which he uses to make what he calls "prehistoric art." He sets the fossils and wood into concrete paintings.

The article includes some biographical information. Color illus.

290. "Sam Brown's New-Found Talent Leads to Orders from Louisville Art Gallery." *Licking Valley Courier* (West Liberty, KY), 11 June 1992. Tells how Brown started to carve in the fall of 1991 and how Minnie Adkins, upon seeing his work, encouraged him to keep on with it. His work is now in the gallery shop of the Kentucky Art and Craft Foundation in Louisville. Brown, who carves mostly on weekends, works for a coal mining firm.

291. Sanders, Luanne. "Assembly-Line Art." *Creative Loafing* (Atlanta, GA), 25 May 1991.
An article on Howard Finster and "his folk art factory." It explains how Finster's son and grandsons prepare work for him to finish. Interviews with Phyllis Kind and Rick Berman indicate they have no problem with this approach, believing that it meets Finster's goal of spreading his message. Also describes the art of Finster's son and grandsons. Illus.

292. Sanford, Susan. "I Just Want to Paint My Pictures." *Montgomery Advertiser/Alabama Journal* (Montgomery, AL), 8 February 1981.
Painter Mose Tolliver's success is discussed by Robert Bishop, director of the Museum of American Folk Art, and Mitchell Kahan, curator of painting and sculptor at the Montgomery Museum of Fine Arts. Discusses Tolliver's popularity with collectors and the qualities found in his work. Mentions that some of the paintings are the work of family members.

293. Schmick, Mary T. "Rev. Finster's Garden of Eden." *Chicago Tribune* (Chicago, IL), 2 April 1989, Arts.
Describes a visit to Finster's home in rural Georgia with an attempt to give the reader the feeling of visiting Paradise Garden. Contains biographical information, explains Finster's inspiration, and discusses how much money he has made.

294. Schweid, Richard. "Just Folks: Art from Untrained Hands." *Tennessean* (Nashville, TN), 16 May 1991.
Discusses Alvin Jarrett, a self-taught carver from central Tennessee. Quotes Dan Prince as saying "In self-taught artists, there is not a lack of technique, there's just a completely different technique than is being taught in art schools." Illus.

295. "Sculptor Has a Personal Vision." *Detroit Free Press* (Detroit, MI), 5 March 1989.
Article about sculptor Willie Leroy Elliott, Jr., who uses only recycled materials. His work often deals with the theme of how society could be better. The show reviewed was at the Hill Gallery in Birmingham, Michigan. Illus.

296. Sells, Bill. "Seawall Sculptor Attains Dual Honor." *The Currents* (Newport News, VA), May 1931.
M. "Spike" Splichal wins "best in show" honors at twentieth annual Seawall Art Show in Norfolk, Virginia. He creates clay sculptures of small and colorful creatures.

297. Semans-Herald, Sandy. "Preserving the Past: Historical Models Reflect Area's Riverfront Heritage." *Courier-Journal* (Louisville, KY), 4 July 1990, Neighborhoods.
The historical replicas of Lloyd Mattingly and their ability to convey the history of the region are highlighted with a display at the People's Bank of Bullitt County.

298. Shaw, Barrett. " 'Hog's Golden Memory Hobbies: Lebanon Junction History in Miniature." *Bullitt Weekly* (Lebanon Junction, KY), 9 March 1983.
Details Lloyd "Hog" Mattingly's replica of Lebanon Junction, Kentucky as it appeared in the first years of the twentieth century. Many of the buildings are built from memory, and each building has its story. Mattingly's sculptures made from oddly-shaped tree knots are briefly mentioned.

299. Shepherd, Denise. "Artist from Fayette 'Made Town Famous'. " *Tuscaloosa News* (Tuscaloosa, AL), 31 January 1988.
Reporter quotes Jimmy Lee Sudduth as saying matter-of-factly "I'm the one who made this town famous." Article describes his paintings and their subject matter. Also describes his tinting of mud using mashed berries, flowers, and grass.

300. Shere, Charles. "Creative Growth a Key Focus for Art." *Tribune* (Oakland, CA), 13 October 1983.
A tribute to the Creative Growth Center in Oakland, California, which provides art instruction

and studio space to disabled artists. Says the work done at the center challenges the traditional standard used to evaluate contemporary art.

301. Shere, Charles. "Once-Earthy Folk Art Has Lost Impetus of Innocence." *Tribune* (Oakland, CA), 23 March 1986, Calendar.
The definition and future prospects of folk art are discussed in this critical review of the opening of "Cat and a Ball on a Waterfall: 200 Years of Folk Painting and Sculpture" at the Oakland Museum.

302. Simon, Richard. "Folk Art as a Craft Goes Well Beyond Tradition." *Sacramento Union* (Sacramento, CA), 17 April 1986.
Art review of the "Cat and a Ball on a Waterfall" exhibition at the Oakland Museum. The reviewer relates the art on display to that of other eras and genres. He comments on the quality of the art, preferring the earlier works displayed to the more recent.

303. "Sister Gertrude Funeral Set." *Times-Picayune* (New Orleans, LA), 23 July 1980.
Notice of the death of painter Sister Gertrude Morgan on July 8th. Information about her life, her preaching, her art, and her discovery by E.L. Borenstein, who operated a gallery at the present site of Preservation Hall in New Orleans.

304. Smith, Griffin. "Sybil Gibson, Artist, Where Are You?" *Miami Herald* (Miami, FL), 30 May 1971.
While writing this review of the paintings of Sybil Gibson, the author ponders the use of the word "primitive" and determines he prefers the European term "naive." Says Gibson has disappeared. The exhibit at the Miami Museum features thirty-eight paintings by Gibson. Photo of artist. [See article by Howell Raines about Gibson's reappearance in Alabama.]

305. Smith, Roberta. "Conference Ponders Nature of Crafts." *New York Times,* 22 January 1990.
Describes a symposium of artists, art historians, curators, museum directors, dealers, and critics gathered to discuss "a neglected history —twentieth century American crafts." One goal was to clarify how museums might better serve the growing crafts field. Also considered was the line between art and craft, declared "ever more blurred on the contemporary front."

306. Smith, Roberta. "Operating in the Gap Between Art and Not Art." *New York Times,* 23 December 1990.
The expanding definition of folk art is explored. Its entry into the mainstream is noted with the exhibition planned by Los Angeles County Museum, "Parallel Visions: Modern Artist and Outsider Art." The major part of this article is a critical review of the exhibition "Made with Passion: The Hemphill Collection in the National Museum of American Art."

307. Smith, Slade. "Vanity Novelty Garden: A Conversation with Tamara Hendershot." *Antenna* (South Miami Beach, FL), 26 April 1991.
Interview with South Miami Beach gallery owner Hendershot about the outsider artists she carries.

308. Smith, Virginia Warren. " 'Southern Folk Expressions' Is Three-Pronged Powerhouse." *Atlanta Journal-Constitution* (Atlanta, GA), 4 August 1991.
Review of an annual three-part folk art exhibition in the north Georgia mountains. Tells about the art and artists on view. [Call (404) 782- 2440 for annual schedule]

309. Smith, Wes. "Folk Goes Gallery: Will Success Spoil the Self-Taught Outsiders of the Art World." *Chicago Tribune* (Chicago, IL), 22 April 1990.
Discusses the popularity of folk art in general, and the work, background and marketing of Salisbury, Illinois artist George Collins. The marketing is described in detail as are Collins' reactions to it. Illus.

310. Snider, Alan. "Local Artist Gains National Recognition." *Western Star* (Bessemer, AL), 1 August 1990.
Information on the discovery and artistic successes of Thornton Dial. Biographical information. Illus.

311. Solis-Cohen, Lita. "What Price American Folk Art?" *San Francisco Chronicle* (San Francisco, CA), 8 March 1987.
Says "Herbert Waide Hemphill's well-traveled collection of American folk art was bought by the Smithsonian's National Museum of American Art in a 'bargain sale' for $1.4 million in December." Information about the sale and about Hemphill. Details about the history of looking for a location for the collection from

Michael Hall, "who acted as agent for the sale of the Hemphill collection."

312. Solnit, Rebecca. "Issues of Definition and Inspiration." *Artweek*, 7 June 1986.
Review of the California exhibition, "Cat and a Ball on a Waterfall." Solnit says "definitions have lost all their meanings—distinctions between fine and folk have been 'exuberantly' lost." She discusses the characteristics of the art.

313. Speakman, Sherry. "Appalachian Artist Charley Kinney Dies." *Lewis County Herald* (Vanceburg, KY), 10 April 1991.
Reports the death of Charley Kinney at his home in Taller Hollow: "Kinney's lifetime ended in his humble dwelling within yards of the home where he was born and raised." His art is described, including favorite themes, and it is noted that though his talents were not understood locally, they brought him fame elsewhere. Adrian Swain is quoted as saying Charley Kinney was "a thoughtful and observant man, his attentions were directed intensely at the natural world around him." Swain points out that Kinney lived a life closer to the ways of the past than to the usual style of the late twentieth century. Illus.

314. Speakman, Sherry. "Appalachian Artist Noah Kinney Dies." *Lewis County Herald* (Vanceburg, KY), 2 October 1991.
Reports the death of artist Noah Kinney. Tells of his wood carvings and musical talents. He is described as a kind and generous man, and a photograph of the artist is included.

315. Spencer, Richard. "Art Institute Helps Disabled Express Their Creativity." *Tribune* (Oakland, CA), 19 February 1986.
The program of the Institute of Art and Disabilities in Richmond, California is described. Illus.

316. St. John, Michael. "Sparrow's Art Takes Flight." *Wisconsin State Journal* (Madison, WI), 15 April 1984.
Describes the work of Simon Sparrow, exhibited at a local restaurant. Talks about his drawings and detailed assemblages. His early life and background are related.

317. Starr, Nina Howell. "The Lost World of Minnie Evans." *Bennington Review* (Bennington, VT), June 1969.
The author sees a relationship in Minnie Evans' work to the many peoples of Trinidad—Caribbean, East Indian, Chinese, and "western aboriginal elements"—from which her great grandmother's great grandmother was taken as a slave. Minnie Evans does not accept these explanations for her use of imagery and color.

318. Steadman, Tom. "Surrounded by Strange Visions." *Greensboro News and Record* (Greensboro, NC), 1 February 1992.
About Mike Smith and Lisa Eller-Smith, their collection, and their "At Home Gallery." Says the gallery is responsible for a current exhibition of folk art at the Southern Lights restaurant in Greensboro. The artwork on the walls at the Smith home is described—Richard Burnside, Howard Finster, Michael Finster, James Harold Jennings, Jack Savitsky, Mose Tolliver, Bernice Sims, Jimmy Lee Sudduth, Q.J. Stephenson—with brief information about the artists and their work. Illus.

319. "Steele Burden Really Is at Home at the Museum." *State Times* (Baton Rouge, LA), 8 August 1984.
Steele Burden and his relationship with Louisiana State University's Rural Life Museum, which was formerly his family home, is discussed. His paintings and sculptures are mentioned, but the primary focus of the article is on Burden as a landscape designer for the university.

320. Steirer, Stephanie. "Visiting Artists Animate Crafts in Mind of Illinois Children." *Daily Egyptian* (Carbondale, IL), 6 February 1991.
At a program for children, Mr. Imagination, David Philpot, and Simon Sparrow discuss what inspired them to create art.

321. Stephens, Steve. "Handicaps Overcome Through Art of Painting." *Columbus Dispatch* (Columbus, OH), 7 May 1986.
Article about people with disabilities who are in an art program at United Cerebral Palsey's Grace Kindig Center in Columbus and who will be included in a national touring art exhibition sponsored by Very Special Arts. Artist Ralph Bell is included in the exhibition. Dean Campbell, from the Center, says "One of the important things to me is that Ralph's art is valued on its own, not just because he is handicapped."

322. Stumb, Patricia C. "Childhood Memories Inspire Sims' Folk Art." *Brewton Standard* (Brewton, AL), 24 September 1991.

Bernice Sims' paintings are compared to those of Grandma Moses. Sims started painting late in life and her subjects are her memories from childhood and from the Depression era. She attempts to show a time when things were simpler, "though not necessarily easy."

323. Subtle, Susan. "Just Plain Folk Art." *San Francisco Chronicle* (San Francisco, CA), 16 October 1987.

Information about several folk art exhibitions in the California Bay Area. About labeling difficulties, says that "actually it is several styles lumped under a general label, not totally accurate for any one style." Describes "American Mysteries: The Rediscovery of Outsider Art," an exhibition at the San Francisco Arts Commission Gallery; an exhibition at the Creative Growth Center in Oakland where the work of William Tyler is "not to be missed"; an exhibition at the former Primitivo Gallery of shipyard worker turned artist Ruben Lopez Dominguez, "who began painting at fifty-five when he was given oils and brushes by his niece"; and an exhibition of the paintings of Esther Hamerman at the Ames Gallery in Berkeley. Says "Esther Hamerman's paintings are not of sweet houses and gardens, but of ships, bridges, boats and villages in her life's migration from Poland to Vienna, to Trinidad, to Israel and finally to San Francisco." Illus.

324. Svetvilas, Kanchalee. "Just People in 'Just Folk' Exhibit." *Iowa City Press-Citizen* (Iowa City, IA), 10 July 1991.

A report about an exhibition curated by Sherry Pardee at the Arbor Gallery in Iowa City. It includes works from six self-taught Iowa artists and one artist from Missouri: Randy Norberg, Phil Saunders, Oliver Williams, Howard Dailey, Paul Hein, Leslie Freswick, and Betty Haesler.

325. Swain, Adrian. "Local Artist Pays Tribute to Folk Artist Charley Kinney." *Morehead News* (Morehead, KY), 16 April 1991.

Written after Charley Kinney's death on April 7, the article describes Kinney's life, his community, his music, and the folk art he made, both traditional and non-traditional. Illus.

326. Swetzof, Paul. "Artist Depicts Marine Environment." *Tundra Times* (Alaska), 3 October 1988.

Article about self-taught artist June Walunga, a Siberian Yupi'ik from Gambell, a village on an island in the Bering Sea. Author says Walunga's oil on canvas paintings "allow an observer the opportunity to see marine mammals and the island environment from the perspective of a Yupi'ik's dedication to her people and the land and wildlife which sustains them." Says "it is her ability to convey this to us which is the value of her work." At the time of this writing the artist lived in Anchorage.

327. Swift, Harriet. "Outsiders Looking In." *Oakland Tribune* (Oakland, CA), 30 June 1991.

A feature article on the "outsider" art phenomenon. The lives and works of Dwight Mackintosh and Howard Finster are used to epitomize the outsider artist.

328. Tallmer, Jerry. "Simple, Simply Terrific Exhibit." *New York Post,* 10 January 1992.

Review of an exhibition of Bill Traylor's art at Hirschl & Adler Modern that includes information about the life of the artist and comments on the qualities of the art. Illus.

329. Thomas, John D. "Howard Finster's Heirs in Art." *Atlanta Journal-Constitution* (Atlanta, GA), 26 April 1992.

Illustrated article about people in Howard Finster's family who make art. They are his son, Roy, his grandson, Michael Finster, and his grandson, Allen Wilson.

330. Thompson, Roy. "Face Jugs, Chickens and Other Whimseys: Vernacular Southern Pottery." *Antiques and the Arts Weekly,* 16 March 1990.

Describes traditional potters, with some background on southern folk pottery. Includes photographs of the work of Charles Lisk, Marie Rogers, John Brock, Judy Brown, Edwin Meaders, and Burlon Craig.

331. "Three Masters Highlight Current Gallery Exhibits." *Lincoln Park* (Lincoln Park, IL), 1 November 1989.

Contains a detailed biography of one self-taught artist, Marcia Muth, "who is concerned not with major historical events, but with the way in which people of the 1920s and 1930s lived and worked."

332. Tower, Ann. "Woodcarver Left Mark on Art World." *Lexington Herald-Leader* (Lexington,

KY), 14 September 1984.
Tells of the death of Edgar Tolson "at eighty after a long illness." Provides details about his life and his art. Notes Michael Hall's early support and efforts to bring attention to Tolson's art. Photographs of Tolson included.

333. Tower, Ann. "Louisville Artist Marvin Finn Is Still a Kid at Heart." *Lexington Herald-Leader* (Lexington, KY), 16 December 1984.
Article about Marvin Finn on the occasion of an opening of an exhibition of his wood carvings and toys at Triangle Gallery.

334. Townsend, Bob. " 'I Try to Do Everything I Can': Potter Berman Throws Energy into Folk Art Gallery." *Atlanta Journal-Constitution* (Atlanta, GA), 22 September 1991.
Berman Gallery owner Rick Berman is profiled. He attributes his gallery's success to Howard Finster, who also inspires Berman with his unfailing energy. Illus.

335. Trost, Cathy. "This Fundamentalist Uses Paintings, Plants to Spread the Word." *Wall Street Journal,* 2 July 1986.
Details on the artistic recognition of Howard Finster by galleries, collectors, and museums and a description of Paradise Garden. Reporter quotes admirers who say Finster is "still a preacher first and foremost, creating art as a way to attract people to God, faith and his garden."

336. Troup, Randy. "Brewton Artist Paints Memories." *Anniston Star* (Anniston, AL), 28 January 1989.
Memory painter Bernice Sims is highlighted. Her growing popularity and place in the art world is discussed in an interview with Robert Cargo, an Alabama gallery owner. Includes some biographical information.

337. Turner, Elisa. "Folk Art Finds Home at Two Local Galleries." *Miami Herald* (Miami, FL), 3 October 1990.
The reporter says "fascination with folk art is on the rise" and describes the artists and art carried by two local galleries. Tamara Hendershot's "Vanity Novelty Garden" features anonymous objects found throughout the state and also works by self-taught artists Mose Tolliver, Benjamin F. Perkins, Fred Webster, and R.A. Miller. The other gallery features those who work "in the spirit of folk art."

338. Tyson, Janet. "Folk Art Hard to Define but Style Has Caught On." *Forth Worth Star-Telegram* (Fort Worth, TX), 31 July 1988.
Interview with Frank Miele about his gallery work and his opinions of folk art. Notes folk art is a source of inspiration for twentieth century fine artists and that many of them are collectors of folk art.

339. Tyson, Janet. "The Other Artists." *Forth Worth Star-Telegram* (Fort Worth, TX), 31 July 1988.
Article about "outsider/folk" art in general and the folk art sites of "The Texas Kid" with his pickup truck covered with statues and a yard filled with raffish sculptures and Carl Nash. Nash's yard on the east side of Ft. Worth is filled with projects such as a four-piece robot band and a totem pole called "goddess of electronics."

340. Van Biema, David. "So Outside He's In, Howard Finster Paints What He Sees—Visions of Angels, Devils and Elvis." *People Weekly,* 6 July 1987.
Anecdotes about how Finster started painting, of his success with art gallery audiences and collectors, and his album covers for R.E.M. and Talking Heads. Photographs of Finster's Paradise Garden.

341. Vanderknyff, Rick. "Artwork on the 'Cutting Edge'." *Los Angeles Times* (Orange County Edition), 15 June 1991.
A review focusing on the California artists Ted Gordon and Jon Serl represented at "The Cutting Edge" exhibition. Illus.

342. Versace, Candelora. "Recalling Simple Pleasures of Bygone Era." *New Mexican* (Santa Fe, NM), 4 September 1992. Pasatiempo.
Interview with Marcia Muth with information about her background in the midwest and the fact that her background and her upbringing during the Depression are the major sources for her paintings filled with people and activity. Mention is made of the exhibition at the College of Santa Fe Fine Arts Gallery.

343. "Very Special Arts Gallery Exhibits Disabled Artists from Across the Country." *PT Bulletin* (of the American Physical Therapy Association), 19 December 1990.
About the sponsoring organization and artists in the exhibit. Focuses on Michael Naranjo, a Tewa of Santa Clara Pueblo, who came back blind from Vietnam, had to give up painting,

and is now a sculptor. Also some information about Tennessee artist Bryan Adams, who makes sketches and watercolors. There were fifty artists in the exhibition.

344. "Victor Joseph Gatto Dies at 71; Plumber-Boxer Became Artist." *New York Times,* 27 May 1965.
Obituary notice provides details on Victor Joseph Gatto's background, his work experiences, his participation in the sidewalk art shows in his Greenwich Village neighborhood, and a history of his recognition as an artist.

345. Wallace, Phil. "Local Painter Has First Brush with National Fame." *Clarion-Ledger* (Jackson, MS), 25 October 1990.
Review of painter Ken Alvey's work, which is displayed at Washington, D.C.'s Very Special Arts Gallery. Alvey's painting is his escape from extremely painful arthritis.

346. Wells, Ken. " 'Outsider Art' Is Suddenly the Rage Among Art Insiders." *Wall Street Journal,* 25 February 1992.
About current interest in outsider art, its beginnings in Europe and the establishment of the Museum of Art Brut. Quotes John Maizels, the publisher of *Raw Vision,* as saying "currently this is the most exciting thing in the entire art world. Nothing else can touch it." Others who agree with this point of view are also quoted, including Kurt Gitter, Roger Cardinal, and Rebecca Hoffberger.

347. Wells, Melissa. "McCord's Railroad Street Showcase Attracts Attention." *McDuffie Progress* (McDuffie City, GA), 1987, Progress Pride Annual.
City worker J.T. (Jake) McCord and his paintings are discussed. Farm life, remembered from his childhood, and women are frequent subjects. Includes biographical information.

348. Weser, Marcia G. "Enter 'Through the Looking Glass'. " *San Antonio Light* (San Antonio, TX), 22 July 1990.
Review of an exhibition at the Carver Cultural Center curated by Bernice Williams "which draws on sensibilities that are not art school-trained and art-market based." Williams "uses the term 'differently abled' to describe these black Texas artists." Works described are by Ike Morgan, Arthur Grant, "KT," and Brian Joseph.

349. White, Virginia A. "Area Folk Artists' Work Gains National Attention." *Sunday Independent* (Ashland, KY), 13 September 1987.
About northeastern Kentucky folk art and its promotion by the marketing program at Morehead State University. Tom Sternal, head of MSU's art department, says "this is economic development" and "it is in keeping with the university's regional goals." Artists who are noted and who have benefitted from the program are Charley Kinney, Noah Kinney, Minnie Adkins, and Garland Adkins. Tells how Adrian Swain helped Minnie Adkins get started on the road to her present fame as a folk artist. There are photographs of each of these artists and descriptions of the art.

350. Whittinghill, Ann. "The Artists." *Messenger-Inquirer* (Owensboro, KY), 16 August 1991.
Reports on the photo-documentary "Spirited Kentuckians" that accompanied the exhibition "Kentucky Spirit: The Naive Tradition" at the Owensboro Museum of Fine Art. The black-and-white images are by photographer Charles W. Manion and present "an individual focus on forty-two of the exhibiting artists."

351. Whittinghill, Ann. "Simple Pleasures: New Exhibit Spotlights Self-Taught Kentuckians." *Messenger-Inquirer* (Owensboro, KY), 16 August 1991.
"Kentucky Spirit: The Naive Tradition" is an exhibition of over 300 self-taught Kentucky artists. The works displayed will be part of the permanent collection of the Owensboro Museum of Fine Art.

352. Whittinghill, Ann. "Western Kentucky Artists Inspired by Past and Present." *Messenger-Inquirer* (Owensboro, KY), 16 August 1991.
A detailed listing of self-taught western Kentucky artists represented in the "Kentucky Spirits" collection. Discusses themes commonly used: religion, social conditions, environment, and patriotism.

353. Wiley, Walt. "Stroke of Art Was Accident." *Sacramento Bee* (Sacramento, CA), 19 January 1984.
This article discusses Bob Carter's life before discovering painting and his acceptance as an American primitive by the Sacramento Crocker Art Museum. Rich with details of his early life.

354. Wilkerson, M. P. "Marker May be Placed Near Traylor's Doorway." *Montgomery Advertiser* (Montgomery, AL), 2 June 1991.
Reports on an attempt to honor artist Bill Traylor by installing an historical marker near the doorway where he worked on the streets of Montgomery. Also mentions the research efforts of local art dealer Marcia Weber to trace Traylor's family.

355. "William Dawson, 88, Folk Artist, 'Just Started Whittling'." *Chicago Sun-Times* (Chicago, IL), 4 July 1990.
An obituary for William Dawson, who died of a stroke on July 1, 1990. Tells of his artistic accomplishments after retiring in 1970, when he began carving figures out of various materials he picked up in the streets.

356. Williams, Don. " 'Artists Three:' Folk Artists Play Off What They Can Find." *Knoxville News-Sentinel* (Knoxville, TN), 5 December 1989.
About an exhibition of three artists—Bessie Harvey, Sammie Nicely, and Mark Garrett. Defines folk art as "an unstudied, intuitive kind of art made from materials that come to hand." Illus.

357. Williams, Mara Rose. "Annandale Artists Use Unconventional Media." *Atlanta Journal-Constitution* (Atlanta, GA), 3 May 1991.
Artists from Annandale Village, a community for developmentally disabled adults, display their work in conjunction with well-known folk artist Knox Wilkinson, who is also developmentally disabled.

358. Williams, Shirley. "Folk Art by a Couple of Nice Folks." *Indiana Weekly* (Louisville, KY), 12 February 1992, Courier-Journal Special Publication.
Carvers/painters Melissa Cox and Herb McAleese, Jr. were discovered recently by a Kentucky folk art collector. Their walking sticks, animals, and human figures are now featured at the Swanson/Cralle Gallery in Louisville. Information about the backgrounds of the young couple, their building of their own home, and their art. Illus.

359. Wilson, Emily Herring. "Green Animals Around the Moon." *Christian Science Monitor*, 22 February 1983, Home Forum.
A profile of Minnie Evans with some biographical information. Discusses the influences on her paintings and drawings. Illus.

360. Wohlwend, Chris. "Carving A Spiritual Niche." *Atlanta Journal-Constitution* (Atlanta, GA), 11 August 1991.
Article about Georgia carver Leroy Almon, Sr. Tells about his background, family, and his art. Almon worked with Elijah Pierce in Ohio and later moved home to Georgia to establish himself as an artist. Illus.

361. Wood, Cy. "David Butler Practices Primitive Form of Art." *Daily Review* (Morgan City, LA), 31 August 1973.
Describes the environment of metal sculpture created by David Butler. His beginning "by making a fence" is described.

362. Zimmer, William. "Art: Individualism at the Katonah Gallery." *New York Times*, 9 December 1984.
Review of an exhibition that includes descriptions of the works of Howard Finster, Malcah Zeldis, Ralph Fasanella, Willene Allison, Joseph Polinski, William Hawkins, Justin McCarthy, Felix A. Lopez, Felipe Archuleta, and others. Illus.

AUDIOVISUAL MATERIALS

In keeping with this book's intention to provide information about materials that the reader will be able to find, the audiovisual materials in this chapter were available for rental or purchase at the time this list was prepared; two titles listed may be viewed at museums only. Titles found, but for which distribution or rental agencies could not be found, were excluded. If more than one distributor was available, then the one with the lower price was listed. Quotation marks around annotations mean that the description comes from a published source rather than from personal viewing.

The Center for Southern Folklore in Memphis, Tennessee and the Center for the Study of Southern Culture in Mississippi publish audiovisual catalogs and update them from time to time. The *Film & Video Locator,* published annually by R.R. Bowker and available in many libraries, may be helpful in looking for videos, but it appears that inclusion of a title in the Locator does not necessarily mean that one can find it anywhere. If your interest in films and videos is great, you may wish to investigate The Program for Art on Film. A joint venture of the Metropolitan Museum of Art and the J. Paul Getty Trust, this is a computerized film database with a fee for membership and for each search. Their literature indicates that they include folk art-related materials.

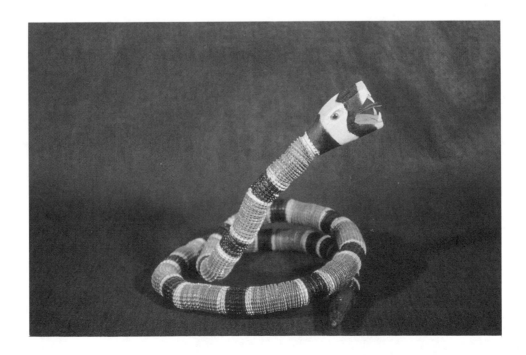

1. *Afro-American Tradition in Decorative Arts.* Prod. Peter Wood and Richard Ward. New Perspectives. Durham, NC: North State Public Video, 1987. VHS video. Purchase: $60 VHS. Rental: $35 for one week. North State Public Video, PO Box 3398, Durham, NC 27702 (919) 682-7153 Running time 20 minutes/color.

 "The rich African American tradition in such folk arts as pottery, quilting, metal-working, basketry, and woodcarving is revealed. There is consideration of how traditions survived and the origins, meanings, and continuities of the art forms are discussed."

2. *Altered States, Alternate Worlds: A Symposium.* Prod. Creative Growth Art Center. Dir. Kauzmir Communications. Oakland, CA: Creative Growth Art Center, 1992. VHS video. Write for prices. The video comes in four parts and is available separately or as a four-part set. Contact Creative Growth Art Center, 355 24th Street, Oakland, CA (510) 836-2340 Running time 120 minutes per tape/color.

 This video is an uncut recording of the entire symposium sponsored by the Creative Growth Art Center at the Oakland Museum on April 11, 1992. Tape ffl1 contains the lecture by Roger Cardinal, "Maker, Image, Meaning." Tape ffl2 includes Roger Manley, "Hermon Finney: Mind Over Matter" and Gladys Nilsson, "Joseph Yoakum, Chicago Artist." Tape ffl3 includes John MacGregor, "Henry Darger: Borrowed Images: The Invention of the Collage-Drawing" and Allen S. Weiss, "The Grotesque and the Desublimated: Michael Nedjar's Dolls." Tape ffl4 is a continuation of Weiss; a presentation on environments by Seymour Rosen; a presentation by Didi Barrett, "Joseph Furey's Urban Fancy; and the question and answer dialogue between audience and speakers.

3. *'And So It Goes' Frank Oebser—Farmer/Artist 1900-1990.* Prod. Karla Berry and Lisa Stone. Dir. Karla Berry and Lisa Stone. Oshkosh, WI: Prairie Fire Productions, 1989. VHS or 3/4 video. Rental: $50 Purchase: $75 individuals, $250 institutions. Karla Berry, 310 Waugoo Avenue, Oshkosh, WI 54901. (415) 235-0294 Running time 19:40 minutes/color.

 "Frank Oebser worked for some seventy years operating a dairy farm in rural Wisconsin. Retirement released Oebser from the continual cycle of farm chores; though his seventy-some years of intimate involvement with the mechanical inventions of farming had a profound effect on his imagination. He spent the years of life to him left combining and transforming the sounds and materials of antique farm implements with figural sculpture, resulting in a continuum of kinetic, sculptural installations. The works were arranged throughout the yard and farm buildings. Oebser referred to this environment as his 'Little Program.' Visited by thousands of people, some saw this as a roadside attraction, others thought it an outstanding example of highly original, multi-faceted sculpture." Producers Berry and Stone started visiting the artist in 1984. "And So It Goes" offers a glimpse of Oebser's vision. The site was dismantled in 1989.

4. *The Angel That Stands By Me: Minnie Evans Paintings.* Prod. Allie Light and Irving Saraf. Dir. Allie Light and Irving Saraf. San Francisco, CA: Light-Saraf Films, 1983. VHS or 3/4 video or 16mm film. Rental, film only: $50, one day, one film [other options, contact distributor]. Purchase: $75 VHS; $320 3/4; $390 16mm (price goes down for multiple purchases of 3/4 and 16mm). Light-Sharaf Films, 131 Concord Street, San Francisco, CA 94112. (414) 469-0139 Running time 28:30 minutes/color.

 Minnie Evans, eighty-eight years old at the time and living in Wilmington, North Carolina, is seen visiting an exhibition of her paintings done over the years, and expressing her pleasure at seeing them again. She tells about the inspiration for her creations, and says her teacher was "the angel that stands by me." She talks about her mystical visions and her family. There are many scenes from her home, her church, and her family life. Includes a reunion of many generations of her family, with her 101-year-old mother, her three sons, and others. This film has received many well-deserved awards.

5. *The Art of Theora Hamblett.* Prod. University of Mississippi. University, MS: University of Mississippi Division of Contuining Education, 1966. VHS video. Purchase: $75 VHS. Center for the Study of Southern Culture, University of Mississippi, University, MS 38677. (601) 232-5993 Running time 22 minutes/color.

"This video depicts Theora Hamblett, the Mississippi artist most frequently classified as a primitive, along with her works. In her words she describes her early love of color as well as the sources of inspiration for individual paintings. Many of her paintings are shown."

6. *Black History/Black Vision.* Prod. Lynne Adele. Dir. Luther Bradfute. Austin, TX: Archer M. Huntington Art Gallery/University of Texas Press, 1989. VHS video. Purchase: $19.95. Sales Department, University of Texas Press, PO Box 7819, Austin, Texas 78713. (800) 252-3206
Running time 41 minutes/color.

Documentary featuring black self-taught Texas visionary artists John W. Banks, Ezekiel Gibbs, Frank Jones, Naomi Polk, Rev. Johnnie Swearingen, and Willard "The Texas Kid" Watson. Shows the art, the artists, and where they lived. The artists or family members talk about life experiences and the influences and inspiration for the art. The segment on Frank Jones was filmed in prison by John Mahoney. Rosalie Taylor talks about her mother Naomi Polk and Mrs. Banks tells about the community life and the art of her husband John Banks.

7. *Boneshop of the Heart: Folk Offering from the American South.* Prod. Scott Crocker and Toshiaki Ozawa. Dir. Scott Crocker and Toshiaki Ozawa. 1991. VHS; 16mm film. Purchase: VHS $295. Rental: VHS $60; 16mm film $60. Distributed by University of California Extension Media, 2176 Shattuck Avenue, Berkeley, CA 94704 (510) 642-0460
Running time 60 minutes/color.

"This film introduces six self-taught artists from the southeastern United States who create art in response to their experiences with racism, adversity, and religion. Enoch Tanner Wickham filled his property near Clarksville, Tennessee, with cement and scrap metal sculpture. Charlie Lucas in Alabama makes found object sculpture and built his home from scrap. Vollis Simpson creates whirligigs in North Carolina; Thornton Dial used to bury his art in his backyard; Bessie Harvey sculpts wood into faces that come to her in a vision; and Lonnie Holley creates objects from sandstone in Alabama."

8. *Brother Harrison Mayes, Middlesborough, KY.* Prod. Eleanor Dickinson. Dir. Eleanor Dickinson. San Francisco, CA: Eleanor Dickinson, 1980. VHS or 3/4 video. Purchase: $30 VHS; $35 3/4. Write or call for special rates for multiple program purchases and for shipping costs. Eleanor Dickinson, 2125 Broderick Street, San Francisco, CA 94115. (415) 922-3733
Running time 47 minutes/black & white.

"In-depth interviews and documentation of a fascinating religious folk artist who preached the Gospel, until his death in 1985 at the age of ninety, by creating 1,200-pound reinforced concrete crosses and hearts with religious messages and placing them along U.S. highways. Shows his hand-built house in the shape of a cross with multiple religious symbols and devices and his relationship to cathedral builders."

9. *Brothers in Clay: The Story of Georgia Folk Pottery.* Prod. Nancy Anderson. Dir. Nancy Anderson. Macon, GA: Museum of Arts and Sciences/WMAZ-TV, 1989. VHS video. Purchase: [call for prices]. Resource Services Coordinator/Georgia Humanities Council, 1556 Clifton Road, NE, Emory University, Atlanta, Georgia 30322. (404) 727-7500
Running time 56 minutes/color.

Written by John Burrison, this video "explores the origins of Georgia folk pottery through the families who created utilitarian vessels. Gives technical insight into finding, digging, and ageing clay; turning pottery on a wheel; building kilns; and the glazing and turning of the ware. Tells how pottery was used, bought, and sold."

10. *Can You See Black?* Prod. Lewis Allen and J. Mitchell Johnson. Dir. J. Mitchell Johnson and Don Lenzer. Fort Worth, TX: J. Mitchell Johnson Productions, "Available on or before December 1993." In production. Distribution planned for Nationwide PBS, International TV, Home Video. Information from J. Mitchell Johnson, PO Box 125, Fort Worth, TX 76101 (817) 927-5782
Running time 58 minutes/color.

"Features interviews with the artists in situ, for the most part in their homes—in many cases they are at work. Intercut are scenes from the exhibit, Black Folk Art in America: 1930-1980, which were filmed in Chicago and work displayed in the homes of the artists."

11. *Carved Stories, Painted Dreams: A Glimpse at Four California Folk Artists.* Prod. Donna Reid. Dir. Donna Reid. Oakland, CA: Oakland Museum, 1986. VHS video. Purchase: [call for price]. Oakland Museum, 1000 Oak, Oakland, CA 94607. (510) 273-3005
Running time 28 minutes/color.

Subjects of this video are artists Dalbert Castro, John Abduljaami, Miles Tucker, and Marlene Zimmerman.

12. *Coral Castle: The Mystery of Ed Leedskalnin.* Prod. David Clarke. Homestead, FL: Coral Castle, 1986. VHS video. Purchase: [call for price]. Coral Castle, 28655 South Federal Highway, Homestead, FL 33030. (305) 248-6344
Running time 15 minutes/color.

A "video postcard" about Ed Leedskalnin who created the Coral Castle environment in Florida in hope of winning back his lost love. Many of the stone structures are shown, with information on how they were constructed.

13. *Delta Blues Singer: James 'Sonny Ford' Thomas.* Prod. Bill Ferris and Josette Rossi. Memphis, TN: Center for Southern Folklore, 1970. VHS video or 16mm film. Rental: $35. Purchase: $60 VHS; $400 16mm. Center for Southern Folklore, PO Box 226, Memphis, TN 38101. (901) 525-3655
Running time 44 minutes/black & white.

"Portrait of Delta bluesman and folk artist James Thomas. Filmed at parties and juke joints near Leland, Mississippi. Thomas is seen sculpting clay figures, performing and relaxing with his family at home."

14. *Elijah Pierce, Woodcarver.* Prod. Carolyn Jones. Columbus, OH: Ohio State University, 1974. 16mm film. Purchase or rental: call for prices. Ohio State University, Department of Photography and Cinema, 156 West 19 Avenue, Columbus, OH 43210. (614) 422-2223
Running time 20 minutes/color.

"Describes the life and work of Elijah Pierce, with his painted wood carvings, and discusses the inspiration for his work. There is also discussion about growing up in Mississippi, the son of an ex-slave."

15. *Everything That Grows and Moves Around: The Art of Lizzie Wilkerson.* Prod. Gary Moss. Dir. Terrence Gibney. Georgia State Educational Media, 1983. VHS video. Purchase: $50. Center for the Study of Southern Culture, University of Mississippi, University, MS 338677. (601) 232-5993
Running time 13 minutes/color.

"Lizzie Wilkerson grew up the youngest of twenty-one children in rural Covington, Georgia. She began to paint at age seventy-seven after a life as a sharecropper and maid. She produced animated and colorful paintings in the naive style. Mrs. Wilkerson talks about her themes, techniques, and feelings about making art. Many colorful images of her work."

16. *Fannie Lou Spelce: Folk Artist.* Prod. Sandra Mentz and Larry Cormier. Texas Peoples Series. San Antonio, TX: Institute of Texan Cultures, 1978. VHS video. Purchase: [write for price]. Institute of Texan Cultures, The University of Texas at San Antonio, Box 1266, Hemisphere Plaza, San Antonio, TX 78294. (512) 226-7651
Running time 25 minutes/color.

"Describes painter Fannie Lou Spelce of Austin, Texas and discusses her motivations for painting, her techniques, and her life at the turn of the century, which provides her with much of her subject matter."

17. *Folk Art.* Prod. Handel Film Corp. Dir. Irene Antonovych. Art In America, Part 6. West Hollywood, CA: Handel Film Corp., 1979. VHS video and 16mm film. Purchase: $89 VHS [call for 16mm film price]. Handel Film Corp., 8730 Sunset Boulevard, West Hollywood, CA 90069. (800) 395-8990
Running time 28 minutes/color.

"Explores the products of art which was and is created by self-taught people in both urban and rural America. Includes early folk art and twentieth century folk artists who tend to create more for their own enjoyment. Examples include Indian figures in the Nevada desert, the Garden of Eden in a small town in Kansas, and the Watts Towers in Los Angeles."

18. *Folk Artist of the Blue Ridge.* Prod. Colonial Williamsburg Foundation. Williamsburg, VA: Colonial Williamsburg Foundation, 1963. VHS video. Not for sale or rent; may be seen upon request at the Audiovisual Library,

Colonial Williamsburg Foundation, Williamsburg, VA. (804) 229-1000
Running time 17 minutes/color.

"Presents a selection of Harriet French Turner's paintings arranged to suggest seasonal patterns native to her beloved Blue Ridge Mountains. Shows Mrs. Turner at work in her Virginia home."

19. *The Folk Way.* Prod. George Carey. Dir. George Carey. Owings Mills, MD: Maryland Center for Public Broadcasting, 1976. VHS video. Purchase: [call or write]. Maryland Center for Public Broadcasting, Owings Mills, MD 21117. (301) 356-5600
Running time 60 minutes/color.

"Folklorist George Carey visits many folk musicians and craftspeople. One of the people visited is Baltimore screen painter Richard Oktavec."

20. *Four Women Artists.* Prod. Judy Peiser and William Ferris. Memphis, TN: Center for Southern Folklore, 1977. VHS video and 16mm film. Purchase: $45 VHS; $350 16mm film. Rental: $35. Center for Southern Folklore, PO Box 226, Memphis, TN. (901) 525-3655
Running time 25 minutes/color.

"Examines the traditions, memories, and visions guiding the art and lives of novelist Eudora Welty, quilter Pecola Warner, embroiderer Ethel Mohamed, and painter Theora Hamblett. Each woman speaks about how her environment has influenced her work. The women are filmed at home and their work is seen in that setting."

21. *Gayleen.* Prod. Jay Craven. Dir. Jay Craven. St. Johnsbury, VT: Catamount Arts, n.d. VHS video. Purchase: $30. Catamount Arts, 60 Eastern Avenue, PO Box 324, St. Johnsbury, VT 05819. (802) 748-2600
Running time 27 minutes/color.

"This film—not exactly a documentary—was made by, with, and about Vermont self-taught artist Gayleen Aiken. She stars in the film, uses her artwork throughout, and did the soundtrack herself."

22. *Give My Poor Heart Ease.* Prod. Yale University Films. Dir. Bill Ferris. New Haven, CT: Yale University Media Design Studio, 1975. VHS video. Purchase: $40 VHS. Center for the Study of Southern Culture, University of Mississippi, University, MS 38677. (601) 232-5993
Running time 20 minutes/color.

"Personal account of the blues experience in a variety of locations, from juke joints to Parchman Prison. Includes footage of clay sculptor James 'Son' Thomas."

23. *Grandma Moses.* Prod. Jerome Hill. Falcon Films, 1950. 16mm film. For addresses of several rental collections which have this film see *Film & Video Locator* published annually by R.R. Bowker and available in most libraries.
Running time 22 minutes/color.

"Shows Grandma Moses' life as an old lady and as an artist. Her early life, often portrayed in her paintings, is described by the commentator Archibald Macleish. Pictures her at work and points up her technique of applying paint. Many of her paintings are shown."

24. *Grandma's Bottle Village: The Art of Tressa Prisbrey.* Prod. Allie Light and Irving Saraf. Dir. Allie Light and Irving Saraf. San Francisco, CA: Light-Saraf Films, 1982. VHS or 3/4 video or 16mm film. Rental, film only: $50 one day, one film [other options, contact distributor]. Purchase: $75 VHS; $320 3/4; $390 16mm film (price goes down for multiple purchases of 3/4 and 16mm). Light-Saraf Films 131 Concord Street, San Francisco, CA 94112. (415) 469-0139
Running time 28:30 minutes/color.

"Grandma Prisbrey built her first bottle house to hold her collection of 17,000 pencils. This was the beginning of her Bottle Village in Simi Valley, California. Prisbrey, eighty-four years old in the film, guides the viewer about her brilliant houses built from salvage from a local dump. The film show her talking about her life, doing some work, and explores her creativity, pizzazz, and sense of the absurd."

25. *Hand Carved.* Prod. Appalshop. Dir. Herb E. Smith. Whitesburg, KY: Appalshop, 1981. VHS, Beta. Purchase: $49.95. Appalshop, 306 Madison Street, Whitesburg, KY 41858. (800) 545-7468. The 16mm film version is for sale for $450 from the Center for the Study of Southern Culture.
Running time 88 minutes/color.

Film about Chester Cornett and his making furniture the old way. "There are times when you realize that the entire world and even universe is no larger than the spirit and mind of a single human being . . . Chester Cornett is a hero, a gentle survivor of hard times, bad luck, lost love "

26. *Handmade: Conversations About African-American Art and Artists.* Prod. Peter Wood and Richard Ward. New Perspectives. Durham, NC: North State Public Video, 1986. VHS video. Purchase: $60 VHS. Rental: $35 for one week. North State Video, PO Box 3398, Durham, NC 27702 (919) 682-7153
Running time 20 minutes/color.

"From slave-made pottery in colonial South Carolina to visionary art in twentieth century Washington, D.C., this program shows the range of African influence on African-American art and artists. Basket weavers near Charleston, South Carolina trace traditions and techniques passed through generations of African-Americans from sixteenth century Africa. In eastern North Carolina, elder woodcarver William Young shows his striking sculptures, paintings, and other works Interviews with archaeologist Leland Ferguson and art historian Richard Powell examine the complex amalgam which is contemporary African-American Art."

27. *Howard Finster: Man of Visions.* Prod. Julie Des-Roberts and Randy Paskal. Dir. David Carr. Los Angeles, CA: No Hands Productions, 1987. 16mm film and VHS video. Purchase: $190 VHS. Write for information about 16mm film. First Run Features, 153 Waverly Place, New York, NY 10014 (212) 243-0600
Running time 20 minutes/color.

" 'Howard Finster: Man of Visions' is a powerful film documenting the famed Southern folk artist. He labels himself as 'a stranger from another world' and his paintings as 'sacred art.' The film explores the relationship between a backwoods, untrained artist and the mass media which promotes him, and the public which embraces him. Features interviews with Phyllis Kind, a Soho, New York gallery owner; Victor Faccinto, an artist and former curator; Rick Berman, an artist and Atlanta gallery owner; Michael Stipe, collaborator with Finster; Andy Nasisse, artist and art professor; and Jesse Murry, art critic and former Yale art professor."

28. *Howard Finster: Painter of Sermons.* Prod. Genia McKee, John Lewis, and James Smith Pierce. Berea, KY: Berea College Appalachian Museum, 1988. May be viewed at the Berea College Appalachian Museum upon request.

This slide/tape show was prepared to be shown in conjunction with an exhibition of Finster's art at the museum. Finster talks about his visionary experiences that influence his work. There are slides of Finster, his Garden of Paradise, and his art.

29. *Hundred and Two Mature: The Art of Harry Lieberman.* Prod. Allie Light and Irving Saraf. Dir. Allie Light and Irving Saraf. San Francisco, CA: Light-Saraf Films, 1981. VHS or 3/4 video or 16mm film. Rental, film only: $50, one day one film [other options, contact distributor]. Purchase: $75 VHS; $320 3/4; $390 16mm film (prices go down for multiple purchase of 3/4 and 16mm). Light-Saraf Films 131 Concord Street, San Francisco, CA 94112. (415) 469-0139
Running time 28:30/color.

"Harry Lieberman, at age 102, shares his art, philosophy, and love of life in this film which describes his transformation, upon retirement, into an artist. The film shows the connections between his art and his life. Lieberman is shown painting and sculpting. His paintings celebrate Talmudic lore and Jewish life in his Eastern European village."

30. *I Ain't Lying: Folktales from Mississippi.* Prod. Bill Ferris. New Haven, CT: Yale University Media Design Studio, 1975. VHS video and 16mm film. Purchase: $40 VHS; $315 16mm. Rental $30 VHS. Center for Southern Folklore, PO Box 226, Memphis, TN 38101 (901) 525-3655
Running time 22 minutes/color.

"This film captures the humor and drama of black folktales in Leland and Rose Hill, Mississippi." James "Son" Thomas is one of the storytellers.

31. *J.B. Murry: Writing in an Unknown Tongue; Reading Through the Water.* Prod. University of Georgia. Dir. Judith McWillie. Athens, GA:

University of Georgia, 1986. VHS video. Purchase: $50. Center for the Study of Southern Culture, University of Mississippi, University, MS 38677 (601) 232-5993
Running time 15 minutes/color.

"J.B. Murry is a self-educated African-American visionary from Georgia who celebrates ritual 'writing in the Spirit' and water divination. This documentary raises issues about the relationship between the spiritual and the aesthetic in the art of religious visionaries. Many of Murry's works are shown."

32. *James "Son" Thomas.* Prod. University of Georgia. Dir. Judith McWillie. Athens, GA: University of Georgia, n.d. VHS video. Purchase: $50. Center for the Study of Southern Culture, University of Mississippi, University, MS 38677 (601) 232-5993
Running time 17 minutes/color.

"Renowned Delta Blues singer, 'Son' Thomas is also a gifted clay sculptor. Filmed at his home in Leland, Mississippi this treatment juxtaposes Mr. Thomas' creative life with the harsh realities of poverty in Mississippi. Features several musical performances and a sequence showing how he works clay to create his famous sculptures of the human skull."

33. *Jeff's Tour: A Video of the Creator of the Orange Show.* Prod. Ken Hudson and Gary Jones. Houston, TX: The Orange Show: A Folk Art Foundation, 1991. VHS video. Purchase: $50. The Orange Show, 2402 Munger, Houston, TX 77023 (713) 926-6368
Running time 20 minutes/color.

Tapes of Jeff McKissack's voice heard while he was touring guests through his creation, the Orange Show, coupled with photographs of the site in progress and as it looks today. Ken Hudson and Gary Jones made this video by matching an audio tape of McKissack's giving a tour of the site with photographs.

34. *Just Puttering Around: The Art of William Holzman.* Prod. Nicholas Spark with Sally Sumner. Tucson, AZ: Nick Spark, 1992. VHS video or Beta. Purchase: $19.95 VHS; $24.95 Beta. Rental available. PO Box 43414, Tucson, AZ 85733 (602) 621-1877
Running time 11 minutes/color.

The film is a profile of William Holzman, an eighty-eight-year-old retired farmer who found a "second career" as an artist. "In the garage of his Tucson home, this self-taught artist has created hundreds of objects that range from furniture with animal shapes to whirligigs complete with animated animals and people. Each is bedecked with a bold and brilliant paint scheme, complete with slashing brush marks and geometric patterning. 'Just Puttering Around' attempts to document both Mr. Holzman's creative and working process, while presenting at the same time insight into the nature of his art."

35. *Kindred Spirits: Contemporary African American Artists.* Prod. Clayton Corrie. Dir. Christine McConnell. Indianapolis, IN: Station KERA, 1992. VHS video. Purchase: $24.95. Station KERA, PO Box 68618, Indianapolis, IN 46268 (800) 368-5372
Running time 30 minutes/color.

"Bold color. Divine inspiration. Program which explores the lives and works of celebrated African-American artists. Their brilliant originality emanating from a single source—African roots. The artists talk of inspiration inspired by their rediscovery of Africa, in many cases by there visits there. Bessie Harvey is the one self-taught artist included. She is seen walking in the woods, looking for roots to use in her sculpture. Harvey says "I am not the artist. God is the artist." Many examples of her work are shown.

36. *Lights! Camera! Art* . . . Prod. Ron Sheets. Oakland, CA: Video City Productions, 1992. VHS video. Purchase: $15 VHS. Creative Growth Art Center, 355 24th Street, Oakland, CA 94612 (510) 836-2340
Running time 12 minutes/color.

"Take a look inside Creative Growth Art Center. This nationally recognized visual arts center in Oakland, California provides new concepts for working with disabled adults." Shows the artists at work.

37. *Local Voices: North East Kentucky Folk Art.* Prod. Adrian Swain. Morehead, KY: Morehead State University, 1990. VHS video. Purchase: $30. Folk Art Collection, Morehead State University, 119 West University Boulevard, Morehead, KY 40351 (606) 783-2760
Running time 11:10/color.

Features Charley Kinney, Noah Kinney, Ronald and Jessie Cooper, and Minnie and Garland Adkins. Scenes of the art and the artists.

38. *Made in Mississippi: Black Folk Art and Crafts.* Prod. Bill Ferris. New Haven, CT: Yale University Media Design Studio, 1975. VHS video and 16mm film. Purchase: $40 VHS; $300 16mm film. Rental: $30. Center for Southern Folklore, PO Box 226, Memphis TN 38101 (901) 525-3655
Running time 20 minutes/color.

"Seven unique folk artists, ranging from a quilt maker to a clay sculptor, discuss their work and recall how they learned their crafts." James "Son" Thomas and Luster Willis are among the people shown.

39. *Malcah Zeldis: "The Better Way Show."* Prod. Good Housekeeping. VHS video. King Features Entertainment, Educational Film Division, 235 E. 45th Street, New York, NY 10017 (212) 682-5600
Running time 28 minutes/color.

Interview with Zeldis with shots of her work. Information about her background and how she came to make art. Demonstrates how lack of self-esteem, particularly in a sexist society, can work against a woman's ambition to do what she is moved to do.

40. *Mario Sanchez: Painter of Memories.* Prod. Jack Ofield. Dir. Jack Ofield. Three American Folk Painters series. Hudson, NY: Bowling Green Films, 1980. VHS video or 16mm film. Rental: $35 VHS. Purchase: $120 VHS. For information on 16mm film, please inquire. New Pacific Productions, PO Box 12792, San Diego, CA 92112. (619) 462-8266
Running time 17:30 minutes/color.

"In wood-chiseled reliefs that are colored with Grumbacher paints mixed with castor oil and applied with dime-store brushes, seventy-year-old Mario Sanchez recollects the Key West, Florida neighborhood of his youth. Although today one still glimpses the gleaming clapboard houses lining the streets now traversed by pedestrians and modern conveyances, the white buildings intricately detailed with elaborate balconies in Sanchez' works serve as backdrops to long-gone pushcart vendors, chil-

dren's goat carts, processions of family members, colorful funeral marches and fish peddlers pursued by strings of cats, all surveyed by occupants of rocking chairs lining the front porches of those same imposing houses. Sanchez' soft-spoken observations on his techniques and his subject matter are heard against footage showing him at work in the shaded courtyard of his home"

41. *The Meaders Family: North Georgia Potters.* Prod. Office of Folklife Programs. Washington, D.C.: Office of Folklife Programs/Smithsonian Institution, 1978. VHS video and 16mm film. Purchase: $70 VHS; $340 16mm film. Rental: $13 VHS, for three business days; $20.50 16mm film for three business days. Pennsylvania State University Audiovisual Services, Special Services Building, University Park, PA 16802 (800) 826-0132 [title order #33090]
Running time 31 minutes/color.

"A study of four members of the Meaders family of Cleveland, Georgia as they work at their kiln. Their pottery was established in 1893, and the style and technology they use has remained intact to a large extent. The family is seen working at every step in the process, from digging and grinding and firing."

42. *Minnie Black's Gourd Band.* Prod. Appalshop. Dir. Anne Johnson. Whitesburg, KY: Appalshop, 1988. VHS or 3/4 video. Purchase: $29.95 VHS, Beta. Appalshop 306 Madison Street, Whitesburg, KY 41858. (800) 545-7467
Running time 28 minutes/color.

"Minnie Black is a 90 year old woman who grows gourds in her East Bernstadt back yard, and from them makes interesting art and musical instruments. In the video she talks about the secrets of growing gourds, takes the viewer on a tour of her gourd museum, and gives tips on making gourd art while highlighting her favorite creations—a double-headed donkey and a 'griffen beast.' Other scenes are of Minnie Black's attendance at a gourd convention and of her Gourd Band playing."

43. *Missing Pieces: Georgia Folk Art 1770-1976.* Prod. Steve Heiser. Dir. Steve Heiser. Tucker,

GA: Georgia Council for the Arts and Humanities, 1976. VHS video and 16mm film. Purchase: $30 VHS; film price upon request. Odyssey Productions, 2800 NW Thurman Street, Portland, OR 97210 (503) 223-3480 Running time 28 minutes/color.

"Featured in the film are Mattie Lou O'Kelley, a self-taught painter; Ulysses Davis who carves wooden figures; Lanier Meaders, a potter who makes face jugs in addition to his other wares; and two environmental artists, St. EOM of Pasaquan in Buena Vista and Howard Finster of Paradise Garden in Summerville. Each artist narrates his or her part of the film, with descriptions of the art work and personal background, motivations, and style of the artist. The introduction to the film provides information on early Georgia folk art."

44. *Mississippi Delta Blues.* Prod. Josette Rossi, Judy Peiser, and Bill Ferris. Memphis, TN: Center for Southern Folklore, 1974. VHS video and 16mm film. Purchase: $40 VHS; $260 16mm film. Rental: $30. Center for Southern Folklore, PO Box 226, Memphis, TN 38101 (901) 525-3655 Running time 18 minutes/black & white.

"Rare footage from the 1960s reveals the vanishing world of live music found in juke joints, shops and house parties." Includes footage of James "Son" Thomas.

45. *Mississippi Roads.* Prod. Mississippi PBS. Mississippi Roads. n.d. VHS video. Purchase: $15.95 VHS (for each program). Center for the Study of Southern Culture, University of Mississippi, University, MS 38677 (601) 232-5993 Running time 30 minutes each program/color.

"A series of fifty-eight titles, each video one-half hour long, which travels to all areas of the state visiting interesting people, places and events. Segments on arts and crafts, food and music are in each program, as well as a lead feature." Title #3 includes artist Ethel Mohamed; title #4 includes the Mississippi Museum of Art, and Luster Willis; title #12 includes Helen Pickle; title #19 includes woodcarver Abdul Jabaar Mohammed; and title #45 is about "McComb's yard art."

46. *The Monument of Chief Rolling Mountain Thunder.* Prod. Allie Light and Irving Saraf. Dir. Allie Light and Irving Saraf. San Francisco, CA:

Light-Saraf Films, n.d. VHS or 3/4 video or 16mm film. Rental, film only: $50 one day, one film [other options, contact distributor]. Purchase: $75 VHS; $320 3/4; $390 16mm film (price goes down for multiple purchases of 3/4 and 16mm). Light-Saraf Films 131 Concord Street, San Francisco, CA 94112 (415) 469-0139 Running time 28:30/color.

"At age 71, Chief Rolling Mountain Thunder is seen with his young wife and small children at the monument he created in the Nevada desert. His concrete and stone house with many decorations of forms and arches is shown. His sculptures portray Indian heroes, family, and friends. He created the monument because of a message received in a dream. The film captures the tragedy of his life, his painful isolation, the beauty of his work and his creative process. It contains a remarkable scene in which he sculpts a complete piece on camera."

47. *Nellie's Playhouse.* Prod. Center for Southern Folklore. Dir. Linda Connelly Armstrong. Memphis, TN: Center for Southern Folklore, n.d. VHS video and 16mm film. Purchase: $30 VHS; $225 16mm film. Rental: $30. Center for Southern Folklore, PO Box 226, Memphis, TN 38101 (901) 525-3655 Running time 14 minutes/color.

"Nellie's Playhouse provides an overview of the art of Nellie Mae Rowe, her sculptures, dolls and paintings. It also captures the high spirits that moved her to create, a process she describes with animation and humor as she tells of the spontaneity of her art and her passion 'not for high things but for just junk.' "

48. *O, Appalachia: Artists of the Southern Mountains.* Prod. Marilyn Davidson. Huntington, WV: Huntington Museum of Art, 1989. VHS video. Purchase: $25. Huntington Museum of Art, Park Hills, Huntington, WV 25701 (304) 529-2701 Running time 32 minutes/color.

Occasioned by an exhibition, "O, Appalachia," at the Huntington Museum. Starts with scenes inside the museum and then goes to the home of Minnie Adkins near Isonville, Kentucky and the home of the Rev. Herman Hayes in Hurricane, West Virginia. Two basket makers are also included.

49. *O, Appalachia: Artists of the Southern Mountains.* Prod. Millard Lampell, Jim Brown, and Ramona Lampell. Dir. Jim Brown. VHS video. In production. For information: Lampell, Route 1, PO Box 308A, Meadow Bridge, West Virginia 25976 (304) 484-7224
Running time 60 minutes/color.

Film features the following artists: Cher Shaffer, Noah Kinney, Charley Kinney, Minnie Adkins, Garland Adkins, S.L. Jones, Elmer Richmond, and Charlie Lucas.

50. *Oregon Woodcarvers.* Prod. Baross Films. Dir. Jan Baross. Oregon: Baross Films, 1979. VHS video and 16mm film. Rental: call for price. Portland State University, Continuing Education Film and Video Library, 1633 SW Park, PO Box 1383, Portland, OR 97207 (603) 725-4890
Running time 24 minutes/color.

"A view of the work, lives, themes and philosophies of four Oregon carvers, each of whom represents a different part of the state—mountains, forest, sea, and eastern desert country."

51. *Orphans in the Storm.* Prod. Anton Haardt. Dir. Anton Haardt. Montgomery, AL: Anton Haardt, 1993. VHS video. Anton Haardt Gallery, 1220 South Hull Street, Montgomery, Alabama 36104 (205) 263-5494. "In production" at this writing. Call for price and details.
Running time 30 minutes/color.

There is some footage that briefly considers some of the artists in the traveling exhibition "Orphans in the Storm." The film concentrates, however, on Juanita Rogers (which is "the only film available on this artist"), Mose Tolliver in the 1980's, James "Son" Thomas, Jimmy Lee Sudduth, Benjamin F. Perkins, Charlie Lucas, and Calvin Livingston.

52. *Outside the Mainstream: Southeastern Contemporary Folk Art.* Prod. High Museum. Atlanta, GA: High Museum, n.d. 88 slides/audio cassette. Rental only: $25 for a three-week loan plus UPS charges. High Museum of Art, Education Department, 1280 Peachtree Street NE, Atlanta, GA 30309 (404) 892-3600 x570

An educational slide/cassette kit featuring ten contemporary folk artists from the southeastern United States. Contains eighty-eight slides, an audiocassette that includes the voices of the artists, and a teacher's handbook. It is appropriate for children and adults. It was intended for teachers but may be rented by others.

53. *Outsider Artists in the HAI Collection.* Prod. Workshop Program Director HAI. New York: Hospital Audiences, Inc., 1991. VHS video. Purchase: $20. Office of the Workshop Program Director, Hospital Audiences, Inc., 220 West 42nd Street, New York, NY 10036 (212) 575-7695
Running time 6 minutes/color.

Introduction to seven outsider artists who are represented in the HAI collection.

54. *Poem of Rodia.* Prod. University of Southern California. Los Angeles, CA: University of Southern California Cinema Division, 1966. 16mm film. [call for prices] USC Film Distribution Section, Cinema Division, University Park, Los Angeles, CA 90007 (213) 740-2311
Running time 4 minutes/black & white.

"A poetic interpretation of Watts Towers in Los Angeles. Exploration of the visual poetry of an architectural work of art, a handmade monument created out of refuse by Simon Rodia, an Italian immigrant."

55. *Possum Trot: The Life and Work of Calvin Black.* Prod. Allie Light and Irving Saraf. Dir. Allie Light and Irving Saraf. San Francisco, CA: Light-Saraf Films, 1977. VHS or 3/4 video or 16mm film. Rental, film only: $50 one film, one day [other options, contact distributor]. Purchase: $75 VHS; $320 3/4; $390 16mm film (price goes down for multiple purchase of 3/4 or 16mm). Light-Saraf Films 131 Concord Street, San Francisco, CA 94112 (415) 469-0139
Running time 28:30/color.

The life and work of Calvin Black, who left Tennessee, panned gold in California, and lived for twenty years in the Mojave Desert with his wife Ruby in an isolated shack twelve miles from Barstow. He built Bird Cage Theater, where the nearly life-size dolls he created performed and sang in voices recorded by Calvin. The film presents two levels: "Calvin's legacy—the grotesque figures moving in the desert wind, the theater with its frozen 'actresses,' protected by his widow from a world

she views as hostile. The other level is Calvin's vision as only film can show it—the dolls move and sing and dance as he imagined them and the Bird Cage Theater comes to life."

56. *Queena Stovall: Life's Narrow Space.* Prod. Jack Ofield. Dir. Jack Ofield. Three American Folk Painters series. Hudson, NY: Bowling Green Films, 1983. VHS video or 16mm film. Rental: $35 Purchase: $120. For 16mm film, please inquire. New Pacific Productions, PO Box 12792, San Diego, CA 92112. (619) 462-8266 Running time 18 minutes/color.

"The every-day life of the every-day past is re-created in Queena Stovall's oil paintings of her home in rural Virginia near the Blue Ridge Mountains. Ninety years old at the time the film was made, Stovall reminisces about her husband and large family and points out details of country life captured on her canvases Not only are the lives of southern whites depicted with skill and affection, but Stovall has also painted the homes of neighboring blacks with equal fidelity. Especially dramatic because these paintings become even more complex upon close inspection "

57. *Ralph Fasanella: Song of the City.* Prod. Jack Ofield. Dir. Jack Ofield. Three American Folk Painters series. Hudson, NY: Bowling Green Films, 1982. VHS video or 16mm film. Rental: $50 VHS Purchase: $175 VHS. For 16mm film, please inquire. New Pacific Productions, PO Box 12792, San Diego, CA 92112 (619) 462-8266 Running time 25 minutes/color.

"Red-brick, wire-faced buildings enclosing regimented lines of reform school boys; an ice vendor's truck parked in front of storefront businesses; crowded city streets lighted by brightly hued apartment windows; and workers marching in a union parade are scenes from Ralph Fasanella's childhood and adult experiences that he has transformed into vivaciously colored, intricately detailed paintings. The self-taught artist's recollection of his troubled youth, his hardworking immigrant parents and his labor organizing activities back the camera's glimpses and perusals of his many works "

58. *Rev. Howard Finster From God Paints A Picture (Painting #4,575).* Prod. Eleanor Dickinson. Dir. Eleanor Dickinson. San Francisco, CA: Eleanor Dickinson, 1987. VHS or 3/4 video. Purchase: $30 VHS; $35 3/4. Write or call for price for multiple program purchase and for shipping charges. Eleanor Dickinson, 2125 Broderick Street, San Francisco, CA 94115. (415) 922-3733 Running time 94 minutes/color.

"A study of the most famous folk artist of the second half of the 20th century. Thirty minutes of the Rev. Finster's beliefs as a preacher followed by a real time section, lasting forty-five minutes, showing Finster painting a picture, followed by a section of Finster singing hymns over slides of his Paradise Garden in Summerville, Georgia."

59. *The Screen Painters: A Documentary on Baltimore's Unique Folk Art.* Prod. Elaine Eff. Dir. Elaine Eff. Baltimore: 1988. VHS video and 16mm film. Purchase: $35 VHS. Painted Screen Society, PO Box 12122, Baltimore, MD 21281 Running time 28:40/color.

This film was made by Elaine Eff, Baltimore City Folklorist, after twelve years of research and documentation of the lives and history of Baltimore's screen painters. First created for privacy, these colorful screens numbered close to 10,000 in the Depression years. Now, since the availability of air conditioning, there are about 3,000. Several screen painters are shown: Al Oktavec, Ted Richardson, Johnny Eck, Dee Herget, Frank Cipolloni, Ben Richardson, and Tom Lipka. [Review: *Folk Art Messenger* 1989 9].

60. *Separate Visions.* Prod. Museum of Northern Arizona. Flagstaff, AZ: Museum of Northern Arizona, 1989. VHS video. Purchase: $19.95 VHS. Museum of Northern Arizona, Route 4, Box 720, Flagstaff, AZ 86001 (602) 774-5211 Running time 40 minutes/color.

A portrait of four self-taught artists: Baje Whitethorne, Navajo landscape painter; Nora Naranjo-Morse, a Santa Clara sculptor; John Fredericks, Hopi Kachina carver; and Brenda Spencer, a Navajo weaver. Each of these artists has grown up with both modern and traditional influences and is now dealing with the issues that come from "breaking through boundaries of traditional Native American art into what western society calls 'mainstream' art." The artists are filmed at home, at work, with their families, and making their art. They talk about their sources and inspirations and speak of "two worlds."

61. *Sermons in Wood.* Dir. Carolyn Jones Allport and Raymond L. Kook. Memphis, TN: Center for Southern Folklore, 1976. VHS video or 16mm film. Rental: $40, VHS only. Purchase: $50 VHS; $385 16mm film. Center for Southern Folklore, PO Box 226, Memphis, TN 38101 (901) 525-3655
Running time 27 minutes/color.

"Examines the life and art of Elijah Pierce, a master craftsman who carves intricate relief sculptures in wood. Pierce, a native of Mississippi, has spent half a lifetime preserving episodes from his life and the Bible in expressive, brightly painted sculpture."

62. *Shared Visions/Separate Realities.* Prod. Judith Page and James Byrne. 1987. VHS video. Purchase: $50. Center for the Study of Southern Culture, University of Mississippi, University, MS 38677 (601) 232-5993
Running time 21 minutes/color.

Features artists David Butler, a self-taught artist and retired sawmill worker, and John Geldersma, a university professor and artist. The relationship of the two is discussed by Geldersma, whose combined home and studio in Breaux Bridge, Louisiana is featured. Views of Butler's former home with several of the remaining exterior sculptures are shown. Butler is interviewed at his current residence. Richard Gasperi, a long-time collector of Butler's work, is also interviewed.

63. *Southern Folk Artists 1980-1990.* Prod. Eleanor Dickinson. Dir. Eleanor Dickinson.VHS or 3/4 video. In production. Contact Eleanor Dickinson, 2125 Broderick Street, San Francisco, CA 94115. (415) 922-3733
Running time 5 to 8 minutes each/color.

"Miscellaneous short tapes of art and interviews with folk artists, quilters, signmakers, etc., such as: Dilmus Hall, Athens, Georgia; Sister Idessa Powell, Lake City, Tennessee; Mattie Mae Lawson, Washington, D.C.; Van Buren Lanham, Mill Creek, West Virginia; and Carleton Garrett, Flowery Branch, Georgia."

64. *Unbroken Tradition.* Prod. Appalshop. Dir. Herb E. Smith. Whitesburg, KY: Appalshop, 1989. VHS or 3/4 video. Purchase: $150 VHS;. $200 3/4. Appalshop, 306 Madison Street, Whitesburg, KY 41858 (800) 545-7467
Running time 28 minutes/color.

"Jerry Brown of Hamilton, Alabama is the ninth generation of potters in his family. The video follows Brown as he digs his clay, works it, turns, glazes, and burns it in his wood-using, groundhog-style kiln. Along the way he talks about how pottery has shaped the life of his family."

65. *Well Known Stranger: Howard Finster's Workout.* Prod. Elizabeth Fine. Dir. Robert Walker. Blacksburg, VA: CIMA Productions, 1988. VHS and 3/4 video. Purchase: $50 VHS. Center for the Study of Southern Culture, University of Mississippi, University, MS 38677 (601) 232-5993
Running time 28 minutes/color.

A documentary about Howard Finster the Summerville, Georgia folk artist, seventy-two years old at the time. "Finster describes the visionary experiences that led him to become a painter of 'sacred art.' He also sings and plays the banjo. This video takes an intimate look at the artist as he conducts a workshop (or 'workout' as he calls it) on his many and varied methods of art making."

66. *Women of Cane River.* Prod. Tom Whitehead. Dir. Mark Cottrell. Natchitoches, LA: Northwestern State University, 1980. VHS video. Purchase: $25. Center for the Study of Southern Culture, University of Mississippi, University, MS 38677 (601) 232-5993
Running time 20 minutes/color.

This film documents the stories of four women over the 250-year history of the Natchitoches, Louisiana area and their roles as cultural transfer agents. One of the four women portrayed is Clementine Hunter.

ARTISTS

Listed alphabetically, are twentieth century self-taught artists who paint, sculpt, carve, draw, make assemblages, create art environments, and make pottery face jugs or other pots that serve as a surface for a sculptured form. Forms such as decoys, quilts, and other pottery are excluded—not because they are not greatly admired or not considered as important as the art forms listed, but because each of these has a separate and extensive literature of its own, too vast to include here.

The specific people named are included because an interested person can gain access to their art in at least one of the following ways: it is carried by galleries; it is in the permanent collection of a museum or museums; it has been in-

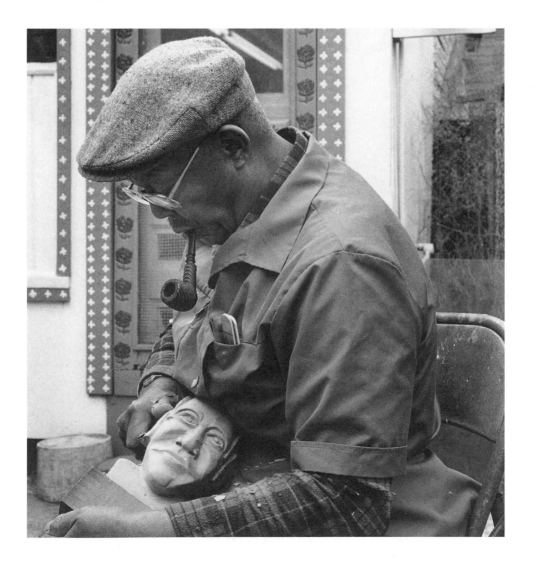

cluded and illustrated in publications; and/or the artist will show an interested person the work. Grassroots art environments are included if they may be visited or if they have been well documented and illustrated. All artists listed by galleries and museums were included (except in a few cases where no information was supplied and I could not find other sources). Information on the artists comes mostly from gallery owners, a few collectors, from published sources, and in some cases from personal visits to the artists. The biographical entries are deliberately brief and serve mostly the purpose of identification. Where published information on an artist is scarce or nonexistent, longer entries have been provided.

The index is an essential part of this book. It provides cross-reference from each artist to publications, galleries, museums, and other resources through which one may learn about the artist or see his or her work. When only one gallery carries the artist's work, it is mentioned in the biographical entry as well as in the index. For entries that mention no galleries, check the index to see who handles that artist. A mention of an exhibition or publication in an artist's entry does not mean that it is the only resource pertinent to that artist; the index should be checked for others.

JESSE AARON
(1887-1979)

A Florida wood sculptor, who said that God told him to "go carve." He could see human and animal forms in the wood he found and he let them out. Aaron used a chainsaw. His figures have a crude and appealing look. Galleries carry his work.

JOHN ABDULJAAMI
(b. 1941)

A wood sculptor in Oakland, California. His works vary in size. Early works were nearly always political. Recently he has carved some benevolent looking birds and animals. Virginia Brier Gallery in San Francisco has his sculpture in an interior garden. Galleries carry his work.

JOSEPH ABRAMS

In his eighties, lives in Miami Beach, Florida. He sits all day on a sheetless bed and makes paper hats; hats nothing like those that children make. The hats are made with newspaper, painted with watercolors, acrylics, poster paints—whatever he finds or is given. Abrams trims the hats with things collected over the years. One of his creations has been acquired by the American Visionary Art Museum in Baltimore. He is represented by Vanity Novelty Garden in Miami Beach.

J.R. ADKINS
(1907-1973)

Began to paint in 1969 when the pain of arthritis forced him to retire. His painting, which is illustrated in Johnson and Ketchum and Hemphill and Weissman, varies from humorous to historical to landscapes. Frank J. Miele Gallery in New York carries his work.

MINNIE ADKINS
(b. 1934)
GARLAND ADKINS
(b. 1928)

Probably the best known artists in Kentucky. The fame is deserved: not only is the art of the highest caliber, but so are the people. They are very supportive of their talented neighbors and have helped them gain recognition for their art. Minnie grew up in eastern Kentucky and as a child liked to carve slingshots, birds, and animals. Garland met Minnie when his car got stuck in the mud near Minnie's house. They spent many years in Ohio working and raising their son. When they returned to Minnie's homeplace in the 1980s, she began to do some serious carving. She carves and paints animals and scenes from the Bible. Among her favorite subjects are bears, foxes, 'possums, Noah's Ark, and Daniel in the Lion's Den. Her animal designs are now on quilts; the designs are drawn by Minnie and the quilt tops are sewn by neighbors and friends. Garland works with Minnie. He cuts and roughs out some of the wood and dries the pieces in a wood-fueled "smokehouse." Their well-known horse image is carved and finished entirely by Garland. Galleries carry their work.

GAYLEEN AIKEN
(b. 1934)

Lives in her hometown of Barre, Vermont. She uses words and pictures to tell the story of her life, portraying especially the adventures of her imaginary Raimbilli Cousins and some wonderful cats. She has been part of the G.R.A.C.E. program, and her work may be seen in galleries.

JORY ALBRIGHT
(b. 1950)

Lives in Altoona, Pennsylvania. In high school Albright started painting watercolors and played guitar in a rock and roll band. He worked on the railroad for about two years. In 1972 he turned his apartment into an art studio. He paints with oil on canvas and makes his own frames. He paints "dandies, landscapes, and railroads." He has traveled, and that has been recorded in his paintings. His work is in the permanent collections of the Southern Alleghenies Museum of Art and Altoona's Railroaders' Memorial Museum and is also available for purchase from dealer/collector Pat McArdle (412) 371-4767. The artist enjoys visitors at his home/studio but asks that you call first: (814) 943-6178.

MABEL ALFREY
(b. 1902)

Lives in Morehead, Kentucky. She was an elementary school teacher for many years and moved to Ohio at one point in her life to be a school principal. She works in oils and creates bold semi-expressionistic paintings with a variety of subject matter. In 1992 she was still active.

ANN MURFEE ALLEN
(b. 1923)

Born in Emporia, Virginia, and lives now in Richmond. She started painting in about 1967. Her subjects come from her reading, especially newspaper articles, and from history. She likes to do research on historical topics and then paint them. She also paints memories of her own community. Her work may be seen at the Meadow Farm

Museum in Richmond. In the fall of 1992 there was an exhibition of her paintings at the Miles Carpenter Museum. You may call her at (804) 232-2892.

DAVID ALLEN
(b. 1925)
A cane carver who lives in Homer, Louisiana, with his wife, Rosie, a quilt-maker. His ornately carved and painted walking sticks contain images of snakes, alligators, animals, and flowers. His work is in The Ames Gallery in Berkeley. He is often at the Jazz and Heritage Festival in New Orleans. One may order work di-rectly from him by calling (318) 927-3966 or writing to him at 1210 Jefferson Street, Homer, LA 71040.

LEROY ALMON, SR.
(b. 1938)
Lives in his hometown of Tallapoosa, Georgia. He makes bas-relief wood carvings that are painted. His subject matter is usually religious. He often portrays people battling Satan. Other themes are the evil temptations in contemporary life such as drugs and materialism and racism directed at black people. His work is in galleries. He welcomes visitors but by appointment only: (404) 574-5052.

JOY ALSTON
(b. c.1957)
Lives in Baltimore, Maryland with her husband, an "Arabber" (traditional street vendor who sells from a pony-drawn wagon), and six children. She makes watercolor paintings that focus on "the everyday lives of Baltimore's African-Americans." Often her subjects are the Baltimore Arabbers and their carts

and ponies. She has made some three-dimensional wooden constructions too. Her work has been included in two exhibitions, one at the Baltimore Museum of Art. The other has published a catalog that illustrates her work. Her work may be seen by calling Roland Freeman at (202) 882-7764.

FRED ALTEN
(1871-1945)
Known for his carvings of all kinds of animals, many of which he put in cages. He kept his art a secret during his lifetime. Alten has been exhibited frequently, often with illustrations, has been written about and included in museum collections.

DAVID ALVAREZ
(b. 1953)
Raised in Oakland, California, and now lives in New Mexico. He spent several years carving under the direction of Felipe Archuleta but now his own style has emerged. His work is illustrated in Wendy Lavitt's *Animals in American Folk Art*. Galleries carry his work.

LOUISE ALVAREZ
(b. c.1962)
Lives in New Mexico. She is a carver of small animals, which she paints with latex house paints. She is the daughter of Ben Ortega and David Alvarez is her husband. Her work is at Galleria Scola in Oakland, California.

MAX ALVAREZ
(b. 1952)
Born in San Francisco and raised in Oakland, as was his brother David. He moved to Santa Fe in 1979. He started carving as a

hobby and now does it full time. Alvarez works with cottonwood that he gathers himself. He carves animals such as pigs, coyotes, roosters, bears, squirrels, and skunks as well as African animals. One collector believes Max Alvarez is "the most versatile of the New Mexico carvers and can do any animal." He is represented by American West Gallery in Chicago.

KEN ALVEY
Began painting with acrylics in the late 1960s to "brush away his arthritis pain." His paintings are of small towns and rural areas around where he lives in Jackson, Mississippi. He may be contacted through Very Special Arts.

EDWARD AMBROSE
(b. 1913)
Born in Strasburg, Virginia, and now lives in Stephens City. He carves wood sculpture and paints it. He makes a wide range of subjects but his political caricatures are his best work. His favorite wood is basswood. He sells figures at the truck stop in Stephens City.

CHELO AMEZCUA
(1903-1975)
Born in Mexico and grew up in Del Rio, Texas. She began drawing at an early age but received little encouragement for her art and little education of any kind. Amezcua (her full name was Consuelo Gonzales Amezcua) used her own imagination and any readily available material to make her art. Colored ball point pens and heavy cardboard were frequent choices. Her distinctive drawings are intricately patterned with long flowing lines. Her work has been called "romantic and unrestrained ar-

tistic creation." Her work is represented by Cavin-Morris Gallery in New York.

TOBIAS ANAYA
(1908-1988)
Lived and worked all his life in the beautiful little town of Galisteo, New Mexico. Anaya made small, unpainted sculptures from wood and other found objects. Galleries carry his work.

LINDA ANDERSON
(b. 1941)
Comes from Floyd County, Georgia. She is the fourth of five children born to a tenant farming family. She left school at age thirteen and became a carpenter. She had to quit working outside the home to care for her retarded child. Anderson believes her painting comes from God as an answer to a prayer for help: "Beautiful pictures started to appear in my head." Anderson paints with oil on linen or oil crayons on sandpaper. She also does wood carving. Her subject matter comes from her own experiences and surroundings. Galleries carry her work.

FRED J. ANDERSON
(b. 1949)
Lives in Naknek, Alaska, where he was born. He is a sculptor who uses marble and mixed media (wood, stone, leather, fur, bird feet). His work has been exhibited at the Visual Art Center of Alaska in Anchorage, 1975; the Anchorage Historical and Fine Arts Museum, 1977; and in a group show at the Smithsonian, in 1978. He is self-taught. An Alaskan says she is sure he is still working and probably could be contacted through his village.

JOHN B. ANDERSON
(b. 1952)
Lives in Louisa County, Virginia. He is a certified welder by trade. When he started making art he did wood carving. He said his work started very small, moved to "table size," and now is really large scale. In addition to wood carving, which he still does, Anderson now makes welded sculpture. He finds the metal easier to handle than wood and that more "creative depth" is possible. His wood sculpture may be people, animals, or abstract images. At the time of this writing, Anderson was making a sculptural piece from a dead black oak in his father's front yard. His metal sculpture may be abstract or realistic. He is currently setting up a new studio that will display twelve outdoor sculptures and eight or nine indoor ones, so that people may see the range of his work and so that in the future he will have objects available for exhibitions. Since his work sells well, he often has nothing available when he receives an invitation to a show. If you are interested in the work, write to him at Route 1, Box 130, Louisa, Virginia 23093 or call him at (703) 967-1494.

STEPHEN ANDERSON
(b. 1953)
Lives in Rockford, Illinois. He started painting in 1976 after he was discharged from the Navy. He makes his own "canvas" and paints for his art. His paintings are "pointillistic" and his most popular themes are perfect women, goddesses or otherwise, from the past. Phyllis Kind Gallery in Chicago carries his work.

ALPHA ANDREWS
(b. 1932)
From rural North Georgia. The daughter of a sharecropper, she picked cotton as a child to help support the family. Married at nineteen, she had five children and soon after became a widow.

One of the children required special care; the rest she managed to support and encourage through college. After years of community service on a volunteer basis, she became an ordained minister. Andrews has the distinction of being the only white woman invited to preach in several black churches. She started painting in 1983, was discovered by an Atlanta gallery owner, and sold a few paintings. She stopped for awhile because of family responsibilities and then, in 1990, started again after a disabling car accident. Andrews is best known for her scenes of Southern life. Recently she has begun to paint the psychic visions and dreams she has always had but never revealed outside the family. In 1992, Fenimore House purchased a painting for their permanent collection. Charles Locke in Duluth, Georgia sells her work.

GEORGE ANDREWS
Lives in Madison, Georgia, and has been a painter since he was a little boy. He has painted his house and most of the objects in it, turning his home into a total art environment. Recently he has used oil and enamel on canvasboard furnished by his mainstream artist son Benny. The two artists shared an exhibition recently: "Folk: The Art of Benny and George Andrews." The catalog has colored illustrations of George's work.

RIVKA ANGEL
(1899-c.1982)
Came to the U.S. from Russia when she was four. She was "highly respected and well-reviewed" in her lifetime. She "started out as an outsider." She was best known for her large paintings using "encaustics." Epstein/Powell in New York carries her work.

MURPHY ANTOINE
"About 62" years of age, lives in New Orleans. Antoine, a black man, is a highly skilled and well-paid welder who makes art only in his spare time. He makes wood reliefs that show skill in carving but are tourist art. On the other hand he carves beautiful canes with animal heads and snake images that are sold at Barrister's Gallery.

JOHNSON ANTONIO
(b. 1931)
Lives on Navajo lands in the Lake Valley section in New Mexico. Although it is not part of the Navajo tradition to carve, Antonio started when he was in his fiftiess. He carves "for money to support his family and out of the desire to communicate to others the spirit of his people and their animals." Antonio whittles dried logs with a pocket knife and paints the figures with watercolors and gouache. His work is in galleries.

FELIPE ARCHULETA
(1910-1991)
Described as "the best of the New Mexican carvers" by many. He has also been described as an important link between the sacred *santero* tradition and a contemporary art form. He is written about and exhibited frequently. The essay by Christine

and Davis Mather in the catalog *Lions and Tigers and Bears, Oh My!* is a detailed source of information about Archuleta. There is an illustration in Johnson and Ketchum. Galleries sell his carvings.

JOSEPH ARCHULETA
see **ROBERTO ARCHULETA**

LEROY ARCHULETA
(b. 1949)
Worked in Denver, Colorado, for many years until he tired of life in the big city. He returned home to Tesuque, New Mexico in 1973 and started working with his father Felipe. He uses cottonwood, a chainsaw, and small tools, as did his father, to make his well-regarded carvings. His work is in many galleries.

MIKE ARCHULETA
A New Mexico carver who makes animal forms from cottonwood. No background information was located. His work may be found at The Rainbow Man Gallery in Santa Fe.

ROBERTO ARCHULETA
(b. 1956)
JOSEPH ARCHULETA
(b. 1967)
Self-taught folk artists from Espanola, New Mexico. The Archuleta name goes back in history to one of the original colonizers that came with the Onate expedition to northern New Mexico. Roberto, age thirty-six, is an elementary school teacher who has always done woodwork. When his brother Joseph made him his apprentice, Roberto took to carving art right away. Joseph, who is twenty-five years old, is "the hunter." He is an outdoorsman and enjoys working with wood.

When he is not working on folk art he is trapping, fishing, or hunting. Their designs are original and inspired by nature. Their work is available at The Rainbow Man Gallery.

BOB ARMFIELD
(b. 1952)
Part of the Oakland Pottery, comes from High Point, North Carolina. He apprenticed for five years with Walter and Dorothy Auman in Seagrove, North Carolina. Armfield uses alkaline and albany glazes on his face jugs. Faces are formed on the surfaces of slender, elegant turned vessels and are distinctive with their stark, shallow, surprised-eyed expressions. Armfield also makes roosters based on an old design by Arie Meaders of Georgia. His roosters and face jugs are burned in a wood kiln. His work is available from Lynne Ingram Southern Folk Art in New Jersey.

LARRY ARMISTEAD
(b. 1935)
A black artist who was born in Stamford, Connecticut, and lives in Cos Cob. He worked as a welder. He suffered a debilitating stroke in 1986, which paralyzed his right side and obliterated his speech. At Christmas he was given some markers and paper, and "he found a new voice." He began to draw his family, famous people, birds, and animals. Then he started using oil paints and canvas. Martin Luther King, Jr. is his inspiration. His work is handled by Dan Prince.

Z.B. ARMSTRONG
(b. 1911)
Lives in Thomson, Georgia. He fashioned wood and other

found objects into elaborate calendars. The calendars and other constructions are usually painted white and patterned all over with a grid of red and black using magic markers. Armstrong made the calendars to predict the date of the end of the world. He is now in a nursing home and not doing his art any more. Galleries carry his work.

EDDIE ARNING
(b. 1896)
Raised on a farm in Germania, Texas. He was diagnosed as schizophrenic and institutionalized for most of his adult life. He began to draw when offered material by an art teacher in a nursing home. At first Arning drew only animals; then he began to make drawings based upon newspaper stories, magazine photographs, advertisements, and other examples of popular culture. He has been written about frequently. His work is included in many museums. Galleries carry his work.

STEVE ASHBY
(1904-1980)
Made figures of plywood and other found objects. He is written about extensively and his work is in museum collections. His work is illustrated in Johnson and Ketchum.

JOSEPH P. AULISIO
(1910-1973)
Born in Old Forge, Pennsylvania and later lived in Stroudsburg. He painted portraits of family and friends and landscapes. The majority of his works remain with his family. His art may be seen in many published sources including the book by Hemphill and Weissman, the one by Johnson and Ketchum, and the Rosenak encyclopedia.

FREDDY AVILA
(b. 1955)
A Latino artist who lives in Dallas, Texas. He was born in the Yucatan. His work was discovered by Leslie Muth. Avila sculpts with found wood, which he paints in bright, bold colors. Avila believes that the work he does is the work of God; he puts himself in God's hands and the work flows through him. He makes some pieces that are shrine-like; others are animals. Galleries carry his work.

JAMES BACKMAN
Lives in Anchorage. He is a self-taught sculptor who works primarily in wood. "He creates meticulous assembled wood sculpture" and in 1986 won the Artists Fellowship Award from the Alaska State Council on the Arts. His work is in the Alaska State Museum and the Frederick R. Weisman Foundation in Los Angeles. For additional information contact the Alaska State Council on the Arts.

MADISON BACKUS
(b. 1922)
Lives in Brooklyn, New York, after growing up in eastern North Carolina. He is a mover who captured attention by the scenes he painted on his vans. He now paints on transportable panels in enamel. His most frequent subjects are his memories of childhood in Colerain, North Carolina and images from favorite television programs. Sale of Hats in New York carries his work.

ANDREA BADAMI
(b. 1913)
Born in Omaha, Nebraska. After going back to Italy and returning a couple of times, he settled in Omaha until retirement in 1978, when he moved to Tucson. Information about his paintings and his life is in publications including Hemphill and Weissman and the Rosenak encyclopedia. Cognoscenti Gallery in Baltimore has his art.

E.M. BAILEY-"BAILEY'S SCULPTURE GARDEN"-ATLANTA, GEORGIA
In a small yard next to his home, Bailey (1903-1987) built a collection of monuments and shrines. Working chiefly with plaster or cement, he built figurative sculptures and vase forms, often embellished with paint. His best-known piece is his Hank Aaron statue. There is a monument to John F. Kennedy and some fanciful figures. The garden is located at 396 Rockwell, S.W. in Atlanta.

JAMES BRIGHT BAILEY
(b. 1908)
Lived most of his life in Marshfield Township, North Carolina. He started carving after he had to retire at age fifty-nine as a result of exposure to asbestos. Bailey made many carvings of small figures using his favorite wood, maple, and small tools. He had to stop carving in the early 1980s because of increasing ill health. Renee Fotouhi Gallery carries his work.

ELISHA BAKER
(b. 1922)
A disabled saw mill worker who lives in southeast Kentucky. He made his first cane over thirty years ago for his own use. The

canes usually have, according to Larry Hackley, "his unique braced handle." Recent works are more colorful than were his earlier ones. He uses cedar, cherry, and walnut and carves with a pocket knife. Most of his canes have a head at the top; recent ones may feature a full figure. The shaft is carved and painted with decorative patterns, often with a cage of marbles under the head. The heads may be of a religious figures such as Jesus, Roman soldiers, King Herod, or such popular figures as Elvis, Dolly Parton, or Daniel Boone. His work is found in galleries.

ERNEST "DUDE" BAKER
(b. 1920)

Born in Roger's Chapel, Powell County, Kentucky, and now lives in Slade. Baker had eight brothers and four sisters and his father ran a country store. He quit school after the eighth grade because he "found it too confining." He worked in a saw mill and on the railroad. Born partially sighted, Baker is now legally blind. "Dude" Baker, his wife, his brother, and his wife's brother were quite wellknown locally for their church music played on the radio station. Baker sang and played the harmonica. In 1989 his wife of thirty-eight years died. He had been devoted to caring for her during her illness from two strokes. After her death, when, he says, he was "beside himself with grief," his long-time friend and neighbor, Carl McKenzie, convinced him to try his hand at carving to occupy his time and his mind. Baker says he tried a long time to make a walking stick with a snake before he succeeded. He now carves canes and a variety of human figures

—"families," bathing beauties, birds, and animals. His work shows a definite McKenzie influence but has its own appeal. He believes he is "supposed to do" what his mentor showed him, but as time passes he is developing more images of his own. His work has found its way into the homes of some collectors though he is reluctant to sell for fear of tax problems, since he is on disability. Galleria Scola in Oakland, California has his work.

JAMES WALLACE BAKER

A memory painter from Ohio who has been called a "master storyteller." His paintings, usually of rural scenes, are filled with action and color and may be seen at Sailor's Valentine Gallery in Nantucket.

SAMUEL COLWELL BAKER
(1874-1964)

Born in Shenandoah, Iowa. He painted "naive painting" with oil on canvas. His subjects were landscapes and religious themes. His work was included in the book by C. Kurt Dewhurst, *Religious Folk Art in America*. His work is also in the Hemphill and Weissman book and in the permanent collection of the University of Nebraska Art Galleries. The John Fowler Gallery in Hawaii carries his work.

BALTIMORE GLASSMAN
(b. 1930s)

Comes from Moundsville, West Virginia, and now lives in Baltimore. His name is Paul. He has a limited education, having dropped out of school at the age of fourteen or fifteen to work and help his family. He came to

Baltimore in the mid-1950s, after serving in the Navy during the Korean War. Paul began making his mixed-media messages in about 1983. He works on the sidewalk "along a stretch of busy highways cluttered with junkyards, body shops, and bars." He is vague about his life away from his sidewalk workplace. Paul's works are messages that represent his ideas about life; he enjoys explaining them to people. His ideas come from the Bible and the U.S. Constitution. The art Baltimore Glassman creates usually incorporates broken glass, found objects, and glitter. He first traces a drawing, then paints over the design and adds found objects, and finally prints his messages. His work is in galleries.

E.A. BANKS

From Parrish, Alabama. He makes walking sticks and small carvings. Banks uses a variety of woods native to Alabama such as ash, sourwood, white pine, dogwood, hickory, sumac, and several others. Sailor's Valentine Gallery in Nantucket carries his work.

JOHN W. BANKS
(1912-1988)

Lived most of his adult life in San Antonio, Texas. His interest in drawing, which he had enjoyed as a child, was revived after a long hospital stay. He painted the history of black life in rural southern Texas. He used ballpoint pen, crayon, and magic markers, on cardboard mostly. His work is in the permanent collection of the San Antonio Museum of Art and the Leslie Muth Gallery in Santa Fe carries his work.

LARRY BANNOCK
(b. 1948)

Comes from the part of uptown New Orleans called "Gert Town." This is a center of activity for the Mardi Gras Indians. These black groups dress in elaborate feathered and beaded costumes, which take a year to make, and take part in Mardi Gras celebrations. One person who has turned this work into a "true art form" is Larry Bannock, the chief of the Golden Star Hunters. His work is at Barrister's Gallery in New Orleans.

WALTER BARKAS
(b. 1938)
RIVKAH SWEDLER
(b. 1946)

Live in the woods near Home, Washington. Barkas is from New York and Swedler from Hawthorne, California. Walter is a carver and Rivkah a former fiber artist. They have been collaborating for over ten years. "In art and in our lives we strive to enjoy our environment and yet live in harmony with it, taking only what we need" The creatures they make are made from a variety of woods, often with "fur" made from shredded bark. These animal forms may be painted or burned, or the wood left natural. They use recycled materials as much as possible. Mia Gallery in Seattle represents their work.

LILLIAN BARKER

Lives in eastern Kentucky with her carver husband Linvel Barker, and helps him with the fine sanding of his pieces. She makes some small animals of her own. Lillian has also taught herself to paint, using acrylics and canvasboard. Her subjects are stories from the Old Testa-

ment. Since she is color-blind her husband or grandson Jay helps her choose her colors. She works at the dining room table, which, she says, "gets cleaned off three times a year" since she started painting. Her grandson Jay, sixteen, is starting to paint too. Her work is in galleries.

LINVEL BARKER

Lives in eastern Kentucky after many years away, including thirty years of working in an Indiana steel mill. His wife Lillian worked there too, for an auto parts manufacturer. After retirement they moved back to the area where Lillian had grown up. Linvel had a hard time with retirement and neighbor Minnie Adkins suggested he try his hand at carving. He eventually gave in and tried it; the results have been magnificent. His animal carvings have an elegance of design not often found in folk art and the finely finished surface adds to their beauty. He gets his logs from the Morehead area and a family member with a sawmill cuts them into chunks. Then Linvel drys them in a gas-heated shed, with gas from the family well. The woods he uses are linwood, poplar and buckeye, which is two-toned. Galleries carry his work.

LOIS BARNETT
(b. 1961)

From San Pablo, California, and has been working at the National Institute of Art and Disabilities since 1988. She has a degenerative eye disease, "yet she makes art work that is a pleasure to behold." Her subject matter is landscape and also birds, butterflies, and flowers. "She builds her work up with

many small strokes in bands of colors, blending together at their borders giving the work an ephemeral quality." She uses very bold colors. "Lois takes great pride in her art and keeps close tabs on her exhibitions and sales." Her art is at the Institute's gallery.

JACK BARON

Moved to Key West from New York City in 1977. He had worked for years selling objects used for department store window decorations. He did not start painting until he relocated to Key West. Baron is a well-regarded and often-exhibited self-taught artist in Florida. His paintings are described as "having a few solid forms interspersed with shapes filled with small dots of vibrant contrasting color." His subjects—people, places, and cats—always relate to Key West. Many of his paintings are of black people in Key West: often people would get off at the bus stop in front of Jack Baron's house and he would ask them to pose. They became the willing subjects of some of his best paintings. Jack sells his own work from his home/studio at 802 Truman Avenue, Key West, Florida 33040 (305) 294-3629. It is also available at the Key West Art Center and Lane Gallery in Key West.

JOSEPH THOMAS BARTA
(1904-1972)

Born in Illinois, went to college there, and became a coach and teacher. He also did a lot of traveling. He started carving full-time when he was just over age forty. He built a museum (see the Museums chapter) to house his collection of about 500 small carvings of people

and animals. He also built many life-sized figures to portray the story of Christianity.

ART BEAL-
"NITT WITT RIDGE"-
CAMBRIA, CALIFORNIA

Art Beal (1886-1992) was living in a nursing home at the time of his death. Beal built winding stairways, paths, arches, walls, rooms, patios, fences, and other structures on a hillside using shells, concrete, rock, and countless found objects. Beal, who "hated it when people did not double the 't' in 'Nitt' and 'Witt'," collected everything written about the site and wrote in the correct spelling. On a recent visit to the site, at least ten cars in a half-hour stopped by to look at the environment, part of which may be seen from the street (the whole site is closed for restoration), and the viewers enjoyed the opportunity to share stories of their visits to Beal in the past. There is a newly activated preservation group for this site (which needs support and contributions, of course) and many writings about Beal. One of the best is by Warren Westland. This site is located at 881 Hillcrest, just off Main Street in Cambria.

GENEVA BEAVERS
(b. 1913)

Raised on a large farm near Durham, North Carolina. She has lived in Virginia for more than forty years and has been married for fifty-three. Mrs. Beavers started painting in 1974 after her twenty-five-year-old her son was killed in a motorcycle accident. She said that as a child she had liked to draw, but both her mother and her teacher told her it was "a waste

of time." Mrs. Beavers does both painting and plaster sculpture. In the paintings she likes to use very bright colors with figures outlined in black and with lots of patterning. For her sculpture her husband builds an armature for her and then she slowly adds layers of plaster. In both painting and sculpture her favorite subjects are animals, "not real ones, kind of distorted, but even the children recognize what they are." Her latest creation was a 500-pound dragon. Mrs. Beavers lives in Chesapeake, Virginia, and you are welcome to visit her and purchase her art work directly. Call for an appointment: (804) 488-0189.

GENE BEECHER
(b. 1909)

From Houston, Texas, and now lives in Lakeland, Florida. Most of his life he was a musician with his own dance band. He took up painting after he retired and moved to Florida. His medium is acrylic on board and his subjects are usually portraits of the elderly. The Tartt Gallery in Washington, D.C. has his work.

DWIGHT JOSEPH BELL
(b. 1918)

Born in Rockingham County, Virginia, and now lives in Staunton. He was injured during his difficult birth and consequently could not to learn to read or write. His sister, Lena, says "He is smart and gifted in so many other ways. He does beautiful drawings from memories and from looking at pictures, he makes airplanes and whirligigs, dogs, cats—most anything anyone would want." Bell always lived with his mother, and when she died in 1977 "he was a lost soul" and quit working. Now he

is working again. Linderman Folk and Outsider Art in New York has Bell's work for sale.

EDGAR BELL

Lives in Hodgenville, Kentucky. He is a carver. He makes walking sticks with carvings of "west wind faces," snakes, and human figures. His work is finely done. A shop called "The Little Green House" on route 31-E in Athertonville, Kentucky carries his sticks.

RALPH BELL
(b.1913)

A remarkable African-American/Cherokee artist, who lives in Columbus, Ohio. He was taken from his home at age nine and lived in a state institution for sixty years. Now he lives in a residential facility. Bell has cerebral palsey and cannot walk or use his arms. He uses a special helmut-like apparatus with an attached brush to paint colorful works at the United Cerebral Palsey Center, where he has been creating art for about five years. He is an inspiration to everyone there. He has created a painting device similiar to his own for children with disabilities. Bell is a person of warmth and humor and also an extremely talented artist. His works are colorful and the images command attention. In a rather abstract background one finds an occasional flower, human figures, and cunning animals. Often the people are painted with no arms; since Ralph cannot use his, they seem rather unimportant to him. He has been represented in numerous shows in the Columbus area and his reputation is growing. For information about his work contact Dean Campbell at United

Cerebral Palsy (614) 279-0109 or at his home (614) 228-8214. Also, check with the Leslie Muth Gallery in Santa Fe, which may be representing the artist soon.

PETER CHARLIE BESHARO
(1898-1960)

Immigrated to rural Pennsylvania from Syria early in the century. None of his neighbors knew about his art until it was discovered after his death. His work has been written about and exhibited many times—sometimes mistakenly under Peter Charlie Boshero or just "Peter Charlie." His is included in the Hemphill and Weissman book and the Rosenak encyclopedia. Phyllis Kind Gallery in Chicago and New York represents his work.

ROBYN "THE BEAVER" BEVERLAND
(b. 1958)

Lives in Oldsmar, Florida. He has a very rare disease called Wolfrand Syndrome, which has left him blind in one eye and only partially sighted in the other. He also has diabetes and a mild case of cerebral palsy. He is a cheerful person whose world is his family, his Bible, and his art. He paints "from his own mind's experiences" and uses housepaint and plywood or cardboard. Many galleries sell his work.

AARON BIRNBAUM
(b. 1897)

Came to the United States from eastern Europe at the age of nineteen. He made his living as a tailor. This background is reflected in his painting by his frequent use of templates in his work, just as tailors do. He started making art when he was

around age sixty-five, soon after his wife died. He paints on any object he finds, and creates scenes from his memories, views of the streets of New York, and artistic commentary on the human condition. A recent painting, "Woman's Work Is Never Done," has a six-armed woman doing six tasks at once. At ninety-seven (his birthday was July 18), he is still working and an exhibition of his work is planned for the Museum of American Folk Art in 1994. Galleries carry his work.

LARRY BISSONNETTE
(b. 1957)

A self-taught artist who lives in Winooski, Vermont. He has a learning disability and missed out on any formal education. The complex techniques he uses for making his art and the frames that are a part of it are described in detail in the Rosenak encyclopedia. Two Vermont galleries sell his work.

CALVIN AND RUBY BLACK-"POSSUM TROT"-YERMO, CALIFORNIA

This dismantled site exits only in books now, but many articles and photographs memorialize it. These include the Johnson and Ketchum book, the Rosenak encyclopedia, and the book by Hemphill and Weissman. Light and Saraf made a film about the site, and some pieces are in museum collections. Individual pieces from the site are available in galleries.

CRAIG BLACK
(b. 1954)

From Gary, Indiana. As a boy he traveled with his family, first to Beaumont, Texas and then to Baton Rouge, Louisiana, where

he met his wife, whom he married in 1973. They now have two children. In 1976 they moved to the gatehouse at Houmas House, an historic plantation on the Mississippi River where Craig is the caretaker and grounds keeper. He likes living at Houmas House, "especially at 5:00, when it closes to the public." He does not like to be involved with people or with the gallery scene. He has been painting for a long time and uses layers and layers of paint to "create his fantasies and give dimension to his work." The frames "grow" right out of the paintings and incorporate found objects like pieces of wood, tree branches, a turtle shell: whatever fits the theme and mood. He discovered not too long ago that he could work with clay and "find the three-dimensional qualities he had been searching for in his work." Since he does not know anything about glazing, he paints his sculptured fantasy pieces with acrylics. Several galleries represent his work.

MINNIE BLACK
(b. 1899)

Comes from Laurel County, Kentucky. She creates wonderful objects, mostly fantasy animals and other creatures, from the gourds she grows on her property, and she displays themin her Gourd Museum next door to her house. She also makes musical instruments using her gourds. Minnie Black is often written about, and her work may be seen in a film and museums. Her home is in East Bernstadt, Kentucky. She welcomes visitors, but asks that one please telephone first "because at my age you just never know." She is listed in the directory. (In 1991

when Minnie Black was only ninety-two, three persons far younger—including the author —arrived exhausted on a hot June day to find her hoeing in her large backyard garden.) She does sell a few "extra pieces" from her Gourd Museum, and occasionally a piece will make its way into a Kentucky gallery.

"PROPHET" WILLIAM J. BLACKMON
(b. 1921)

Came from Michigan and now lives in Milwaukee, Wisconsin. He is committed to preaching the word of God through his revival center and his paintings. His themes in his art are "family values" and the dangers to be dealt with along the road to heaven. The Bible and his visions are his inspiration. Prophet Blackmon does not want visitors. His community is too dangerous and he himself could be endangered if there is public attention to his art in his neighborhood. His work is available in galleries.

EMERY BLAGDON
(1907-1986)

A native of north central Nebraska. He was a hobo and then a farmer. He started making art when he was nearing fifty. He constructed what he called his "healing machines." Dan Drydon, who met Emery in 1975 and wrote about him in *KGAA NEWS*, described his work: "When I entered his shed/studio, my vision was in shock. Lights danced on the thousands of bits of foil and wire and ribbon. It was as if the universe had come into the dark little shed and all the stars were contained in the great mass." Drydon and Don

Christensen write more about Blagdon in the article (see bibliography) and describe his art further. When he died, Blagdon left nearly a hundred paintings and over 600 sculptures, which were purchased at auction by Drydon, Christensen, and Trace Rosel. These have been shown as a traveling exhibit since 1989. The organization Intuit sponsored "The Healing Machines of Emery Blagdon" at the East and West Galleries in Chicago, Novenber 6-December 27, 1992.

RICK BLAISMAN

About thirty-seven years old, from eastern North Carolina. He was a commercial fisherman, but was injured on a trawler and left with a crushed foot. For a year and a half he was forced to live the life of the homeless while waiting for his disability claim to be processed. During that time he often ate in soup kitchens and slept wherever he could find shelter. He started making boats, all kinds of boats, to pass the time. His art form is cardboard sculpture. Except for glue and watercolors, his works are created strictly from trash. The boats are made out of a variety of recycled objects, including cardboard boxes, cigarette filters, oatmeal (for texture), and paint. To give his boats a weathered look, he uses a kind of paint usually employed to undercoat an automobile, then paints another coat on top. He has been known to bake his pieces in the oven. At a show in Carteret, Blaisman's piece "U-Boat" won first prize in sculpture. Tartt Gallery in Washington, D.C. carries his work.

WILLIAM ALVIN BLAYNEY
(1917-1986)

A self-taught painter who grew up in Pittsburgh and later moved west. He died in Oklahoma. In 1957, while still in Pittsburgh, he began painting religious paintings that have been called a "remarkable personal vision." His works may be seen in books and museums.

GEORGIA BLIZZARD
(b. 1919)

Lives in Virginia. Half Apache and half Irish, she learned traditional open kiln firing techniques from her Indian father. Her work ranges from utilitarian pieces to pots with faces and figures. Her face and figure pots express a variety of moods and are very powerful. The work is carried by galleries.

ANDREW BLOCK
(1879-1969)

Born in Denmark and migrated to the U.S. He eventually settled in Solvang, California. He started painting when in his seventies and from then on painted night and day. He documented the Danish community in Solvang and also painted his memories of Denmark, historical scenes, Biblical stories, and seafaring activities. His work is included in several publications including the Rosenak encyclopedia.

CARL BLOCK
(b. 1956)

Born in Richardson, Texas, and is now a school teacher in Waxahachie. He makes face jugs with "faces that appear in his mind." He started making these after an accident in which he lost part of his hand. Block uses

colored slips on his face jugs, which range from four inches to over two feet in size. He uses a Texas earthenware clay, and glazes of his own formula. He fires the jugs in his backyard kiln. His work is available at the gallery in Waxahachie, Texas.

DEWEY BLOCKSMA

A self-taught artist who has more sophistication than most because of his education and training for the medical profession. He has been labeled an "outsider." His art—mixed-media assemblages—was included in the exhibition "Primal Portraits" at the San Francisco Craft and Folk Art Museum in 1990. Blocksma is in the Johnson and Ketchum book, and his work is carried by Brigette Schluger Gallery in Denver.

MACEPTAW BOGUN
(b. 1917)

Born in the Bronx and lives in New York City. He worked at a variety of jobs and was ordained as a minister in 1951. He says that he "paints with the guidance of angels." He draws with charcoal on canvas and then adds oil. He has not painted since 1986. He is included in the Rosenak encyclopedia, the Hemphill and Weissman book, and museum collections.

ALEXANDER BOGARDY
(1900-1992)

From Baltimore, Maryland, lived most of his adult life in Washington, D.C. Bogardy identified himself as a Hungarian gypsy, though his family denies it. He was a featherweight boxer and fought as "The Baltimore Kid." He played the violin and was a cosmetologist. He wrote a book called *Hair and Its Social Importance,* which may be found at the Library of Congress, in which he speaks of hair as "an organ of the body and directly connected to spiritual roots." He paid careful attention to the depiction of hair in his paintings. Described as "a quiet man and a devout Catholic," Bogardy died in June 1992 in a nursing home. His paintings on canvas have an almost exclusively religious orientation. The themes are often taken from the Bible and are somewhat "architectural." He took a class in mechanical drawing in order to illustrate ships for the Department of the Navy. His paintings reflect this in that his buildings are rendered with perfection while his figures and animals seem to float in the air, as a result of having had no art training of any other kind. He started painting in the late 1960s and worked for only about a decade. The Tartt Gallery in Washington, D.C. carries his work.

NOUNOUFAR BOGHOSIAN
(b. 1894)

A Turkish-born Armenian who came to the United States in 1913 and moved to California in 1949, after the death of her first husband. She turned to painting at age sixty-five when her second husband suggested she try it. The subject matter of her paintings is important events in the painter's life and religious visions from her dreams. Her work is included in books and museums.

JON BOK
(b. 1959)

Lives in Los Angeles. Bok began making folk art furniture in 1985, and shortly after he found out he was going blind. Consulting with physicians brought no help, so he gave up for a while and tried to adjust to the ever-increasing loss of vision. A friend suggested a healer who "helped Bok heal himself." His sight returned. Bok's art furniture was featured in a show at the Gasperi Gallery in 1991. His work is sold in galleries.

HAWKINS BOLDEN
(b. 1914)

Lives in Memphis, Tennessee. A twin, he believes a head injury caused by his brother led to his eventual blindness. In the 1960s he began making sculpture. He makes mask-like images with faces punched into such objects as frying pans, traffic signs, and cooking pots. He also makes life-sized figures from found objects including metal, clothing, and carpet strips. His work is in galleries.

MILTON BOND
(b. 1918)

A native of Connecticut, lives in Stratford. He is one of the few contemporary self-taught artists who does reverse glass painting. He started doing art work about the time he retired. He paints boats and city scenes, using clear glass and oil paint. There is considerable information about the artist in the Rosenak encyclopedia. His work is available at Galerie Bonheur in St. Louis.

PETER MASON BOND
(1882-1971)

Born in Australia and came to San Francisco in 1905. He built an environment of signs and paintings called "PEMABO's Peace Garden" in San Francisco,

which expressed his religious and philosophical beliefs. He also made oil paintings. His environment was dismantled about 1972. There is a photograph of the site and a painting illustrated in *Twentieth-Century American Folk Art and Artists* by Hemphill and Weissman. He was included in the exhibitions "Cat and a Ball on a Waterfall" and "Pioneers in Paradise."

MARY BORKOWSKI
(b. 1916)
Lives in Dayton, Ohio. She "tells stories with needles and thread." Many of the stories are about her experiences and the experiences of those around her. She makes the thread paintings using her own technique. Borkowski also paints on masonite or canvas with acrylics. Her work has been exhibited and appears in the Rosenak encyclopedia and in Hemphill and Weissman.

SAINTE-JAMES BOUDRÔT
(b. 1948)
A native of New Orleans. According to Andy Antippas, "he creates a form of 'mortuary art' so pure in conception and execution it is difficult to convince collectors that it is not a genuine part of the rich tradition of New Orleans folk art." Using obituary notices collected for many years from the pages of New Orleans newspapers, Boudrôt uses them, along with relevant Christian symbolism, to create a tripartite memorial with visual imagery and words about the deceased. All of this is painted in bright colors on the wooden panels of discarded shipping crates. Self-taught Boudrôt, who is also A.J. Boudreaux of Barrister's Gallery and a former attorney, thinks of

his works as "compositions," not art. His work is in galleries.

JAMES BOUTELL
(c.1963-1992)
Lived in Hayward, California. He died February 25, 1992 from injuries received two weeks before when he was struck by a car. He had been a well-liked and talented artist at the National Institute of Arts and Disabilities for six years. "Jimmy was one of NIAD's truly gifted artists . . . His work had an exuberant style. His love of process came through in his choice of bright colors and the expressive marks he made with brush, crayons, fingers—anything he could move with speed and abandon." The gallery at National Institute of Art and Disabilities in Richmond, California represents his work.

ROY BOWEN
(b. 1947)
Born in Houston, Texas, and now lives in a small town northeast of Dallas. Bowen is a self-taught carver. "Roy works with three-dimensional objects, carved stone, wood, shaped metal, and found objects. A typical piece would be a human face carved in stone with inlay, deer antlers, and mounted on a wood backing with copper appointments." Robinson Galleries in Houston carries his work.

NORMAN BOWENS
(b. 1950)
A forty-two-year-old black man who lives in Greenville, South Carolina. He was a street person for a long time, and now has very serious medical problems. "All his life he has made stuff out of paper and glue because he could do it anywhere. With wood, you need a place." Using

magazines such as *Southern Living* and *Architectural Digest* for inspiration (he finds them in trash bins), he builds 20-room houses out of paper, old toweling, and twigs. The houses are very elaborate, completely furnished, and landscaped on the outside—lounge chairs on a deck have woven seats and backs, made from paper, trees are twigs, flowers are paper, grass is toweling, one recent house had a satellite dish. Everything on the interior is furnished, including bathroom fixtures and paintings on the walls. The gallery owner's husband is a building contractor and has begged her not to sell a single one. Bowens has now started to build ships. His work is at the Mary Praytor Gallery in Greenville, South Carolina.

BILL BOWERS
(b. 1930)
Born in Boston, Massachusetts, and lives in Georgia. This "naive, self-taught artist likes lots of action in his work, which is sometimes historical—Custer's Last Stand, the Battle of the Alamo— or such modern scenes as Junkyard—Used Auto Parts, The Wrecking Ball, Freeway." He has been in a number of exhibitions in Georgia. Charles Locke in Duluth, Georgia sells his work.

LOY BOWLIN-"THE RHINESTONE COWBOY"- McCOMB, MISSISSIPPI
The Rhinestone Cowboy, in his eighties, lives in a small white frame house just outside of McComb. From a distance it could not look more ordinary. Up close and on the exterior there may be a little more patterned design around doors and windows than most people

have, but step through the front door and you are dazzled. There is color everywhere, and it just shines with glitter, rhinestones, foil, and other objects that reflect light, all arranged in beautiful paper cutouts and painted squares and rectangles with intricate patterns. The furniture is painted and decorated too, as is the car in the garage. The car is featured in a recent movie called "Art Cars" produced by Harold Blank. Bowlin, in his younger days, dressed in sequined and glitter-covered clothing and drove his matching Cadillac around town. In the spring of 1992 Bowlin was in a nursing home and was not expected to return home. In the fall of 1992 he was at home and receiving visitors with pleasure. The people at the "Welcome to Mississippi" office on I-55 coming up from Louisiana have the directions to Bowlin's house. His niece and nephew live next door to him. Bowlin wants to preserve his environment and does not wish to sell art work off the walls of his home. He does make other pieces for sale. His work is in galleries.

LEON BOX

Not well-known, nor is there much information about his life. He was discovered in 1980 in a state mental hospital in Austin, Texas, by a few collectors. His work consists of small drawings on paper and may be seen at the Leslie Muth Gallery in Santa Fe.

WILLIE BOYLE
(b. 1939)

Born in New Orleans, Louisiana. He lived during his youth in St. Roch in the Eighth Ward and attended Shaw grammar school until he dropped out in the eighth grade. He "spent time in Angola Penitentiary related to heroin use," says Boyle, and it was there that he started making art. Boyle makes several kinds of art. He carves walking sticks; looks for discarded objects, which he welds into sculpture; and also does drawings that remind some people of the work of Minnie Evans. He now lives with his wife in Arabi, just east of New Orleans. Barrister's Gallery carries his work.

MARIE BRADEN
(b. 1950)

A self-taught artist from Paris, Kentucky. She still lives in Kentucky, now close to Morehead. Braden is a painter who works with oils. Her work is expressive of her personal inner concerns. It may be seen at Morehead University at the Folk Art Sales Gallery and in the museum.

TERRY BRAXTON

Born in Florida and still lives in that state, in Thonotosassa. He is part Seminole. Braxton is a chainsaw carver of distinctive and interesting animals and birds. Modern Primitive Gallery in Atlanta, Georgia carries his work.

BRUCE BRICE
(b. 1942)

Lives in his home town of New Orleans. Self-taught, he began as a sidewalk artist on Jackson Square in 1969. The subjects in Brice's paintings are most often reflective of New Orleans history and culture. Many details about Bruce Brice and his life and work appear in publications. The artist's works are available at the Gasperi Gallery in New Orleans and annually at the Jazz and Heritage Festival in the same city.

FREDDIE BRICE
(b. 1920)

Raised in the South and now lives in New York City. He once worked painting ships in the Brooklyn shipyards. Brice started painting his large-scale works in 1983, using acrylics on boards. His images are most often animals, interiors, watches, and clocks, for which he mostly uses a black-and-white color scheme. Brice was in an exhibition at Ricco/Maresca in 1990. As contemporary labels go, he is probably an "outsider." Sale of Hats in New York carries his work.

HERMAN BRIDGERS
(b. 1912)

Lives in North Carolina and has worked as a handy man and grave digger. He built the Shady Grove Church, where he holds services. He makes black-and-white painted figures that decorate his house, yard, and the local cemetery. The figures are silhouettes with minimal features. Robert Reeves in Atlanta sells his work.

JOAN BRIDGES
(b. 1934)

A native of Natchez, Mississippi. She now lives in Pineville, Louisiana, near Alexandria. When she was just a child, this self-taught artist's mother died while her father was away, and she and her four sisters were sheltered by a "caring black woman named Annie" until the father returned, removed the children, and put them in an orphanage. This trauma is reflected in Bridges' paintings. Every painting is a story; a frequent memory is liv-

ing with Annie. Joan Bridges has suffered from depression for many years and paints to work herself out of it. The wax medium she uses is derived from candle wax, blended with crayons of various colors. Her technique of painting with melted wax provides a translucent relief of colors and layers. Some of her works are more abstract designs than figures. Some of her paintings include her poetry. Her work is carried by galleries.

HARRY BRIDGEWATER

A man with a "life sentence and no possibility of parole" at the Louisiana State Prison in Angola. Originally from New Roads, Louisiana, he is a black man in his mid-fifties. He is a carver of great skill and is said to be prolific. An example of his work seen by the author was of a very large (displayed on top of a chest) horse-pulled carriage with people. The faces on the people and even the horses were quite brilliantly executed. He also carves mirror and picture frames and lamp bases with such images as cowboys, movie stars, singers, and other popular figures. His work may be seen from time to time at the Hayes Gallery in New Orleans, and at the 927 Gallery on Royal Street, also in New Orleans. Bridgewater often has work at the two annual prison art shows, one in April and one in October. Some people, but not all, who know his work have successfully ordered works in advance. You may try it by writing to: Henry Bridgewater, #63353, Oak 2, Louisiana State Prison, Angola, LA 70712. You cannot send money, and you must show up at the prison on art show day.

HERRON BRIGGS

A man in his seventies who lives in South Carolina. He makes "large, beautiful, wonderful" whirligigs out of wood and lawnmower parts, which he paints. Briggs is a lawnmower repairman and a gardener who performs yard work for other people. ("He has 300 tomato plants and sunflowers as tall as his house.") The whirligigs are "planted," too, in his vegetable and flower gardens. Mary Praytor Gallery in Greenville, South Carolina carries his work.

FRANK BRITO, SR.
(b. 1922)
Born in Albuquerque and now lives in Santa Fe. He says his heart surgery more than ten years ago provided the chance to find out that he could make a living with his carving. He never went back to any other work. Brito, who has been described as "more innovative than many of the _santeros_" also makes small animals. FRANK BRITO, JR. has also been described as a _santero,_ but the author has only seen animal carvings, which are "among the best." Santa Fe galleries sometimes carry their work.

CHARLES BROCK
(b. 1925)
Started carving and making objects when he was a little boy. Now a wood sculptor, Brock used to make objects from leather until it was too costly to use it. He has been married "forty-some years" to his wife Barbara, and retired after thirty years in the military. Brock makes art, not craft or decoys. His sculptures of birds, fish, and other animals are quite special. Snakes and egrets are favorite subjects. His work may be seen

at the Jazz and Heritage Festival in New Orleans, or you may contact him at 816 Lakewood Drive, Picayune, MS 39466 (601) 798-6314.

JOHN BROCK

Grew up in Georgia and Alabama and now lives in Virginia. He was an apprentice for Charles Counts, a traditional pottery in Rising Fawn, Georgia. After his move to Virginia, he began to make face jugs, figures, and animals. His face jugs are said to be "remarkably sculptural and distinctive." The Southern Folk Pottery Collector's Society has his work.

KELLY BROUSSARD
(b. 1963)
From Opalousas but now lives in Lafayette, Louisiana. Her family roots are Cajun and Indian. She has "two cats and two brothers." She is a high school dropout but has hopes of going to college some day. Kelly says her art is "something she has to do" and that for her "making art is a resistance to death." She started drawing as a child and likes color and abstract design. She started painting in 1990. She also found a lot of broken glass and dried bones and started using these in her work too. Her work may be seen at Southern Tangent Gallery in Sorrento, Louisiana.

REGINA BROUSSARD
(b. 1943)
A resident of Oakland, California. She has been a client of the Creative Growth Art Center since 1978. "Her art has been the means to communicate a very personal narrative of women and squirrels in a park-like world." A staff member sug-

gested that the ever present-squirrels became important to the artist after an initial visit to a park and may represent "running freely" to her. "Watching Regina draw, one is aware of her calm confidence in graphic representation. Her pen defines the contours of objects as seen from her internal world. A world which is colorful, inviting, full of food and free of gravity." Her work is available at the Creative Growth Art Center Gallery in Oakland, California.

BETTY BROWN
(b. 1932)
Born in Maysfield, Georgia, and is a memory painter. She also contributes to the painting of the assemblages made by her husband, Rutherford "Tubby" Brown. Galleries carry her work.

CARL BROWN
see H.A. BROWN

CHARLIE BROWN
(b. 1949)
LOUIS BROWN
(b. 1924)
Charles Brown comes from seven generations of potters. He runs the Brown Pottery in Arden, North Carolina, opened in 1924 by his grandfather. The Browns have been making face jugs longer than any other pottery in the South, according to a publication of the Southern Folk Pottery Collector's Society. Charlie makes face jugs and buggy jugs and is starting to produce swirl jugs. He says he likes making face jugs: "Each face is different and interesting to do and I try for a certain look—mean, stupid or whatever." LOUIS BROWN is the son and nephew of the founders of Brown's Pottery, the pottery now run by his son Charlie. The Browns use clay dug around Arden and turn functional items as well as face jugs. Louis Brown usually "faces jugs" that have been turned by Charlie. His faces have a "devilish appearance" as the eyes are angled up and out from the nose and are long ovals rather than round. Louis Brown uses alkaline glazes and burns in both electric and wood-burning kilns. Lynne Ingram Southern Folk Art carries their work.

CHRIS BROWN
Best described as a developing artist. He is about twenty-two years old and lives in Winston-Salem, North Carolina. He is a high school dropout who became involved with drugs, which has left him with a chronic illness. He spends all his time now making art. Chris is self-taught and hasn't seen much art work except for that of his friend Mark Casey Milestone. He paints a variety of figures and then cuts them out and turns them into free-standing objects. He still has a way to go but he is worth watching. At Home Gallery has his work.

DONNIE BROWN
Lives in Frenchburg, in eastern Kentucky. He makes beautiful, careful carvings of people doing things. Often they are tableaux of country life. Recently the Kentucky Art and Craft Gallery in Louisville displayed a magnificent ark with lots of animals. Brown's works are in natural unpainted wood. He also makes bird houses. In addition to the gallery named above, his work is at Eccola in Milwaukee, Wisconsin.

H.A. BROWN
(b. 1897)
An elderly south Georgia wood carver who makes wooden snakes and canes, which he paints. There is a photograph of one of his canes with a snake and a carved hand on page 71 of the Lampell's book *O, Appalachia*. Henry's brother CARL BROWN is also well-known as a carver. Canes are available from Mary Praytor Gallery in Greenville, South Carolina.

JERRY BROWN
From Hamilton, Alabama, is the ninth generation of his family to make pottery. He uses traditional methods and makes face jugs and other stoneware. His work is available at Appalshop in Kentucky and at several of the galleries listed in this book.

LOUIS BROWN
see CHARLIE BROWN

OSCAR BROWN
A client of the art program of Hospital Audiences Incorporated. He paints every day, creating paintings from his imagination. He often uses markers and crayons on black paper. On some of his work he uses watercolor, too. Some of his art is "purely decorative," and others are exotic interpretations of animals and faces. Luise Ross Gallery in New York carries his work.

REE BROWN
(b. 1926)
Born in Utah and graduated from Utah State University in 1950. He moved to Seattle in 1967 and has lived there since except for a brief time in San Mateo. Brown was trained as an accountant and worked for

many years in the office of a large oil company "but gave that up years ago." Ree Brown and friend Jay Steensma, a trained artist, used to have an antiques shop but now travel around the Seattle area—from Everett to Tacoma—"to find anything sellable; it's an interesting life, but not much money." Brown says he was always interested in art, but never tried it until the late 1970s. He started by copying well-known painters, then gave that up and started drawing on his own. Now he works in tempera and oils. He draws animals, groups of people—he likes to look at people and draw them while sitting in a public place, "but they don't look like anybody," he says. "And," he says, "there aren't many places any more that give space and time to an artist who wants to sit and watch and draw." Brown's work is both soft and strong, gentle and humorous—very well done and appealing. He is represented by two galleries.

RUTHERFORD "TUBBY" BROWN
(b. 1929)
Born in Jefferson, Georgia, and graduated from the University of Georgia in 1950. He served in the army during the Korean war and was stationed in Hawaii. Upon his return to Georgia, he and his brother ran a grocery business for thirty-five years. Brown says that he dreams at night what he will build. He creates assemblages and other works of painted wood and tin. His work is simple, colorful, and fanciful and often based on the Bible. Betty Brown, his wife, contributes to the painting of his assemblages. Galleries carry his work.

SAM BROWN
(b. 1954)
Raised in and lives in Moon, Kentucky. He has lived all his life in Kentucky, has been married twenty years, has two sons, and works for a coal mining company. He did his first carving in 1982, of a store his parents had owned. He never carved again until nine years later, when his grandfather passed away and he "carved him." Folk artist Minnie Adkins has encouraged him to pursue his carving. He carves a number of human figures such as a carpenter with hammer and square in hands, a farmer setting tobacco, a fisherman, and a businessman. His work is finished looking and skillfully carved. Sam carves with a small knife and prefers basswood and poplar. The Kentucky Art and Craft Gallery has Brown's work, or you may contact him directly at Box 19350, Highway 172, West Liberty, KY 41472.

RICK BRYANT
see **WILLIAM MILLER** and **RICK BRYANT**

DELBERT BUCK
A young carver who lives in the Navajo nation. He makes wood carvings of animals, people, and vehicles, which are all brightly painted. Leslie Muth Gallery in Santa Fe carries his work.

STEELE BURDEN
(b. 1900)
Lives in Baton Rouge on the grounds of the Rural Life Museum of Louisiana State University in Baton Rouge. The site is Burden's ancestral home, which he gave to the University along with donors Ione Burden, his sister, and Mrs. Pike Burden, his

widowed sister-in-law. The artifacts in the various buildings on the grounds are the result of Burden's travels about the state to seek them out. Burden was a landscape gardener at LSU and in the process of his work, he met artist Paul Cox. Cox would go out and find clay and suggest Burden try his hand at sculpting. He tried it and has continued it to this day. He makes the figures and paints them but does not do his own firing. The glaze is a white crackle finish. He has made about 300 different images, many containing political commentary such as his "Pigs at the Trough." He paints too—"just dabbles," he says. "I like to do swamp scenes; there is something intriguing about the swamp, the cypress." His work is at Gilley's Gallery in Baton Rouge and Hayes Antiques in New Orleans.

RICHARD BURNSIDE
(b. 1944)
Moved with his family from Baltimore, Maryland, to South Carolina when he was five years old. He lived in Charlotte, North Carolina for a number of years after serving in the Army and now resides again in South Carolina. Burnside paints on found objects such as paper bags, plywood, gourds, and pieces of furniture, using whatever paint he can find. One of his most well-known images, recurring frequently, is of a rather round flat face. He also paints snakes, tigers, turtles, and other figures. His work is carried by many galleries.

BRUCE BURRIS
(b. 1955)
From Wilmington, Delaware, originally and is usually classi-

fied as an "outsider" artist. Several years after his beginnings and many gallery shows, he attended the San Francisco Art Institute for a year so arguably he shouldn't be included here. It did not change his art, however, and the same type of galleries continue to represent him. His work reflects upon his experiences with working for the poor and castaways of our selfish society. Burris' painting are heavily patterned, with brilliant color, and usually packed with words and imagery. He borrows images from many sources including "pop culture's labels and logos." There are many details written about the artist elsewhere. His work is available from galleries.

VERNON BURWELL
(1914-1990)

The son of sharecroppers, married in 1942, worked for the railroads, and settled in a pleasant neighborhood in Rocky Mount, North Carolina. He had to retire in 1975 because of eye problems that were eventually remedied, and he began to make cement sculpture in his carport attached to the house. The year or two before his death, Burwell did not work very much on his art, because he was so saddened by the illness of a daughter. Burwell is known for his concrete and painted sculpture of cats, tigers, people (often busts), and political figures. Sometimes they are large as life and other times smaller. His work is in private collections and North Carolina Wesleyan College. It may be seen there and in publications.

LLOYD "BUZZ" BUSBY
(1906-1992)

A barber who lived in Alabaster,

Alabama, with a house near the highway. He put many art objects he created in his yard including wooden people, all of whom had names. His art was created from wood and mixed-media. He sold some smaller pieces, often jointed wooden human figures with smiling but not "cute" faces. His work is in galleries.

CHARLES BUTLER
(1902-1978)

Born in Montgomery, Alabama, and spent most of his adult life in western Florida, working in local hotels. Late in life, with no training and with tools he made himself, he started carving. He carved historical figures, landscapes, and Bible stories in wood relief. Some works appear sparse and others are filled with detail. Some claim that his work reflects his African-American heritage. American Primitive Gallery in New York has his work.

DAVID BUTLER
(b. 1898)

Lived in Patterson, Louisiana, and is now (1992) in a nursing home in St. Mary's Parish. He is one of the most famous of the twentieth century folk artists and is known for the tin sculptures, intricately cut-out and painted, with which he decorated his yard and house. Butler has been the frequent subject of articles and papers, and his work has appeared in numerous gallery and museum exhibitions. He is also a subject of controversy about the "destruction of his environment" through pressure to sell individual pieces. Others say he sold pieces of his art "quite willingly." His work is in many galleries.

EDWARD PATRICK BYRNE
(1877-1974)

Started painting in a Missouri retirement home at age eighty-nine and was actively painting during his last year of life at ninety-seven. The walls of his room were covered with paintings and his favorites, such as the horses, were framed next to his bed. Earlier in life he had painted the whole living room of his Missouri farm house in stripes of two alternating colors. He also painted the out buildings on the farm and built many bird houses. In addition to other images, Byrne is noted for his abstract and futuristic architectural paintings. Newspapers and magazines, and information from the classified pages of the local paper, were used as sources for his art. His work may be seen at the Double K Gallery in Los Angeles.

ARCHIE BYRON
(b. 1928)

Lives in Georgia and founded Atlanta's first black detective agency. He has worked as a brickmason and security guard, operates a gun shop, and is an Atlanta City Council member. His earliest pieces were root sculpture. Now he starts with a flat piece of wood, mixes sawdust and glue, and uses his hands and a knife to form his subjects. The result is a "relief surface." When they are dry he paints them with an airbrush. He also makes some free-standing figures, which represent "religion, sexuality, ancestry." Galleries carry his work.

SALLY CAMMACK
(b. 1948)

Lives on a small farm in Cyn-

thiana in north central Kentucky, where she grows the gourds that serve as the "canvas" for her landscape paintings. Her work reflects everyday experiences in the small community where she lives. Her work is in the Owensboro Museum's permanent collection and is sold at Kentucky Art and Craft Gallery in Louisville.

HELEODORO CANTU
(b. 1935)

Born in Baton Rouge, Louisiana, and has lived there all his life. His grandfather owned a hot tamale business, built houses, and also sculpted in his spare time. The elder Cantu moved his family and tamale business from Monterrey, Mexico to Baton Rouge in 1915. In 1926 he sold the business and moved back to Mexico, but Heleodoro's father ran away from Mexico and returned to marry his sweetheart in Baton Rouge. Heleodoro Cantu did not begin painting or carving until 1970, when he was recovering from open heart surgery. For his sculpture he uses the very fine green, rust red, and coppery wires from inside a TV. He makes flowers, hummingbirds, butterflies, trees, dancing human figures—all delicate and rather abstract. His paintings are of local scenes, small towns and bayous, that are not at all sentimental. He shows a great ability to capture the special light on surfaces in southern Louisiana. His work is at Gilley's Gallery in Baton Rouge.

KACEY CARNEAL
(b. 1935)

Born in Richmond and now lives in Gloucester, Virginia. She started painting full time in 1985, deciding to put her art first and then let everything else follow. She has documented the area where she lives, in Naxera, a small farming and fishing community on the Severn River—which she believes "has not changed much in 300 years." Her more recent paintings are built upon her feelings about present social issues—"women's issues," "men's issues," "greed"—often suggested by titles of books or articles. The director of the Meadow Farm Museum in Richmond calls her work "inspired." Edelstein/Dattel in Memphis, Tennessee carries her work.

MILES B. CARPENTER
(1889-1985)

Born in Pennsylvania but moved to Waverly, Virginia, as a child. He worked in a saw mill and after retiring continued to operate an icehouse. He carved a little before retirement, but took up carving seriously after his wife died in 1966. He made "root monsters" and carvings of human figures, many of which he painted in latex house paint. His work may be seen in a number of publications and museums. The Miles B. Carpenter Home and Museum in Waverly, Virginia has about sixty pieces of Carpenter's art.

RAY CARPENTER
(b. c.1949)

Born and raised in Madison, Wisconsin. His wife, Vicki, works outside the home, and he works at his art full time and assists more than is usual in the parenting of their six children. He carves and assembles pieces from one inch to six feet. Some he paints and some are left natural. He burns some of the surfaces and then adds marble eyes. He makes very unusual animals, fish, and fanciful creatures. His work is available at the Glaeve Gallery in Madison.

BOB CARTER
(b. 1928)

Born in Turley, Oklahoma. In the 1930s he was orphaned and sent to live with an older brother in Sacramento, California. They later moved to a logging area in Plumas County. Carter discovered his talent when looking for ways to alleviate boredom on wintery days when there was no work. He went from being a logger most of his life to managing a lumber yard. Carter paints with acrylics on masonite, or sometimes on a logger's hard hat. His subject matter is his own environment, the towns of his area, and the work that is done there. Bob Carter's work is carried by The Ames Gallery in Berkeley, California.

FRED CARTER
(1911-1992)

A self-taught artist from Clintwood, Virginia. He first moved to Clintwood from his birthplace in Dickinson County as a young man to work in his uncle's store. He settled there and became a successful businessman, builder, landscape architect, and nurseryman. He did not begin to paint and carve wood until he was fifty. By this time he had also become a collector of Appalachian artifacts. Much of his work expresses his anger at the environmental destruction of the land and the injustices against people that society does nothing about. His painting and sculpture range from abstract to realistic. Among his art works are a carved statue

of a starving mountain woman and her children, a painting of the destruction caused by strip mining, and a wooden bust of a miner with black lung disease. Some of his other work reveals the beauty of the human spirit, too. In 1988 there was an exhibition of Carter's work called "Toil and Transcendence" at the Berea College museum. Fred Carter built the Cumberland Museum for the artifacts he found and the art that he made. It is located on McClure Avenue in Clintwood. The museum is open seven days a week but hours vary, so it is best to call ahead. The telephone number is (703) 926-6632.

NED CARTLEDGE
(b. 1916)
Raised in rural northeastern Georgia but has lived since high school in Atlanta. He does his well-known carvings "to make statements on issues and situations which I believe are of importance to the average American." The Vietnam War inspired his first political commentary. Cartledge is represented in museums and numerous art galleries.

MARIE ROMERO CASH
Born in the 1940s in Santa Fe and still lives in New Mexico. She is a self-taught artist who follows in the tradition of *santero*-making. Her work is available through Caskey-Lees in Topanga, California.

PRISCILLA CASSIDY
(b. 1935)
Born in Cartersville, Georgia. She attended school in Georgia and Ohio, where she finished the ninth grade. Although she was interested in art as a

teenager, it was not until 1984 that she began actively to pursue art as a hobby. She is foremost a memory painter, whose themes vary from light-hearted scenes of schoolyard playgrounds to shocking depictions of the Ku Klux Klan. Religion plays an important role in her life and her paintings. Her religious paintings include scenes from both the Old and New Testaments. She frames her paintings herself and paints on plywood with latex house paint. Her work is available from galleries.

MANUEL CASTAÑEDA-WHIRLIGIGS-KINGSVILLE, TEXAS
Manuel Castañeda (b. 1924) lives in the Kingsville area of Texas where he was born. This area is flat and relatively treeless, and the wind gusts and blows constantly. A visit to the Castañeda home reveals a world of colorful, carefully made whirligigs, all simultaneously spinning, twirling, and twisting in the wind. Since his retirement from work as a carpenter at the Kingsville Naval Air Station fifteen years or so ago, Castañeda has made over forty whirligigs. He experiments with many materials and images, which may be seen in his yard. The only material he buys is paint.

DALBERT CASTRO
(b. 1934)
A Maidu from eastern central California. He is a self-taught painter whose themes are images of traditional life and scenes from Maidu Indian folklore. Castro worked most of his life as a logger and lives in Auburn, California. His work was

exhibited in "Cat and a Ball on a Waterfall" and is included in the published catalog.

MARY ANDERSON CAYCE
(b. 1910)
Born in Owensboro, Kentucky, where she still lives. As a young child she watched in fascination while her Stockholm-born father carved wood sprites. Her bas-relief and free-standing sculptured forms are modeled from clay and gypsum and then painted with acrylics. Environments containing dozens of pieces are her favorite format. Her works are in the Owensboro Museum. Having suffered a stroke recently, Cayce has not been able to work.

JENNIE CELL
(1905-1988)
Born in Charleston, Illinois. Her work focuses on subjects involving the rural life. Beginning her painting career at age fifty, Cell was frequently quoted as saying that she painted "what I remember, not what I see." She was called by one art critic "one of the very few true American primitive painters." Her work can be seen in the permanent collections of the Tarble Arts Center and the National Museum of American Art.

CHIEF ROLLING MOUNTAIN THUNDER-"ROLLING THUNDER MONUMENT"-IMLEY, NEVADA
The Chief (1911-1989) built a monument to the American Indian in the Nevada desert. It has been described in many publications, and there is a Light/Saraf film about the site. There is a support group, and tours may be arranged; see the

chapter on "Organizations." This environment is described in the Hemphill and Weissman book. Rolling Thunder Monument is located just off Highway 170, southwest of Winnemucca, Nevada.

RUSSELL CHILDERS
(b. 1915)
From Oregon. His carvings reflect the sorrow-filled memories of his childhood—he was committed to a state institution when he was only ten years old. His severely ill mother failed in all her efforts to have him returned to her during the last days of her life. Childers remained locked up as a deaf-mute for thirty-eight years. In the 1960s a mandatory review of long-term patients revealed that he was neither deaf nor mute. He was released to foster care and given remedial assistance. Childers carves maple and oak into delicate figures. His self-portraits and early family scenes are described as "strong and heartbreaking." Galleries carry his work.

GUY CHURCH
Lives in Madison, Wisconsin, and is "in his late 30s." He does figurative work, drawings on paper. His gallery describes the work his art as "very personal work." He is represented by Bockley Gallery in Minneapolis.

WILLARD CHURCH
(b. 1929)
Born in Ronceverte, West Virginia, and lives there still. He worked at a number of jobs, his last one at a liquor store. He retired in 1990 and he and his wife have spent the last year traveling and staying with each of their six children. Now they are back

in their home town. Church paints using automobile paint on masonite. He likes the masonite board because it allows for a hard surface and "the paint doesn't soak in." He uses different kinds of automobile paint, sometimes on the same painting because when the two different paints meet it "creates interesting actions." He also likes a lot of texture and so uses a paint brush only occasionally. He prefers to use blades, feathers, and leaves. His subjects are often inspired by looking in the encyclopedia. His work is in a number of private collections. He may be called at (304) 647-9960.

FLOYD O. CLARK
see **MILDRED FOSTER CLARK**

HENRY RAY CLARK
(b. 1936)
Born in Williamson County, Texas, and has lived since then in Houston and the Texas State Prison in Huntsville. He makes elaborate patterned drawings that have been referred to as "kaleidoscopic." He paints obsessively when in prison and was discovered at a prison art show in 1989. It seems his painting stops whenever he is back on the streets. Leslie Muth Gallery in Santa Fe represents his work.

MARK CLARK
A self-taught artist in his early thirties, who lives in Winston-Salem. He takes his own black-and-white photographs, and in the processing, turns them into surrealistic images. These he uses as a backdrop for his three-dimensional "sculpture," which is created from the photos and related found objects, wood,

and his written works. Urban Artware carries his work.

MILDRED FOSTER CLARK
(1923-1980)
FLOYD O.CLARK
(1913-1985)
Lived in Jefferson, Texas, and collaborated on making art for about twelve years. Floyd Clark started out making frames with rubber tire strips and other found objects for Mildred's paintings. Then he started his own paintings, naive in style, of cats, angels, watermelons, flowers, and animals. Mildred Clark painted as a child, applying the pigment to the same sacks she used for picking cotton. Their work was included in the exhibition "Eyes of Texas" in 1980, and Mildred died soon after. The Leslie Muth Gallery in Santa Fe carries their work.

WILLIAM CLARK-"JUNKYARD ROBOTS"-NEWTONVILLE, NEW JERSEY
William "Robot Man" Clark (b. 1956) is the second of five children of a Seventh Day Adventist pastor. His father taught him to be an auto mechanic and he then opened a shop of his own. When Clark lost his license to drive, "he was devastated" and to fill his time started to make very complex robot figures from junk. A number of these are on display outside his auto repair shop in Newtonville. Most of the robots are at EL & M Automotive Recycling in Hammonton, New Jersey, where they may be purchased. Holly Metz wrote about Clark in her book about New Jersey environments.

REX CLAWSON
(b. 1933)

Moved from Texas to New York City in approximately 1940. He has "a highly individual style and his paintings have an enameled quality." Epstein/Powell in New York City carries his work.

REV. ST. PATRICK CLAY
(b. 1917)

Lives in Columbus, Ohio. He is the assistant minister of a Baptist church there and once worked in coal mines. Clay makes assemblages from found objects, inspired by visions he has had. Some of the materials he uses include foam rubber, tooth picks, and wood, which he then paints. His work was included in the exhibition "New Traditions/Non-Traditions: Contemporary Folk Art in Ohio" in 1990. Sale of Hats in New York carries his work.

ROBERT CLEMENT
(b. 1914)

Lives in North Carolina. He makes whirligigs that have figures on them, often birds and sometimes people, and paints these figures with bright colors and polka-dots. At Home Gallery in North Carolina has his work.

JESSIE COATES
(b. 1950)

Lives in Baton Rouge, Louisiana, with her husband, Leroy. They have two sons. Coates is a "primitive artist" who has received many awards as a Louisiana folk artist. She paints family and rural scenes of black life in Louisiana. Her paintings are available at Gilley's Gallery in Baton Rouge.

CLARK W. COE- "KILLINGSWORTH IMAGES"- KILLINGSWORTH, CONNECTICUT

Coe built this "unique water-powered environment," which no longer exists, for the pleasure of his grandchildren. It consisted of moveable life-sized figures. There are pieces in the Killingsworth Historical Society and the Museum of American Folk Art, and the environment is described by Hemphill and Weissman. [For another water-powered environment see the entry under Alipio Mello.]

RAYMOND COINS
(b. 1904)

Born in Virginia and moved later to North Carolina, where he worked at tobacco-related tasks until 1976, when he retired. He does stone carvings and human and animal figures in bas-relief. Some of his figures are "dressed" by his wife. Coins also does carvings in wood. His work has been included in numerous exhibitions and books and is available in thirteen of the galleries described in this book.

JERRY COKER
(b. 1938)

Born in Dewitt, Arkansas, but has lived most of his life in Florida; he now lives in Gainesville. He started painting in the 1970s and is entirely self-taught. "Jerry paints with acrylic on board. His paintings are colorful and tend to be impressionistic." He also makes tin masks. His work is carried by several galleries.

JIM COLCLOUGH
(1900-1986)

From Oklahoma. He moved to Westport, California, when he retired around 1961 and took up woodcarving. His carved wooden pieces represented both ordinary people and political figures. These figures often expressed his political views, making fun of authority figures and society. His carved figures were sometimes jointed and nearly always painted. His work is in many publications and may be seen at The Ames Gallery in Berkeley.

GEORGE COLIN

A retired employee of Pillsbury Mills who lives in Springfield, Illinois. Colin and his wife lived in poverty until he was discovered by a Chicago promoter, who built an outlet for his work. Colin makes folk art furniture; cuts out plywood figures of people and animals and paints them with very bright colors; and paints bright pictures, often on cardboard or scrap wood. Many of his works are for sale at George Art in Chicago. He will sell some things direct if you come to his house, which is actually in Salisbury, between Springfield and New Salem.

ANDREW COLLETT
(b. 1940)

A canemaker from Kentucky. His work was featured at the exhibition "Sticks: Historical and Contemporary Kentucky Canes" in 1988. Anton Gallery in Washington, D.C. carries his work.

BILLY F. CONLEY
(b. 1959)

Born and raised in eastern Kentucky. He says that it is important to him to learn to make art that will "communicate the farming, religion, and lifestyle of our rural area." He believes art

is a way to show one's heritage. "I had training in security and alarm systems, but when I try to talk about it around here they tell me about shotguns and hound dogs." He now works in a store as a handyman and carpenter. Conley is still carving "whatever comes to mind." He is a developing artist and will show you his works on request. Look for him in Sandy Hook at Sheepskin Road on top of the hill, off Main Street, or call (606) 738-4454.

MARION CONNER

Lives in Baton Rouge, Louisiana. He began making canes and drawings in 1988; when business in his auto repair shop slows down, he starts carving. He calls his unique canes "Walking around Louisiana." He finds wood in an area and carves it to depict the locale where he found the wood. He says he looks at the shape of the wood and an idea takes form; then his imagination takes over. His work is available in several galleries.

SANDRA CONNER
(b. c.1940)

Has had emotional problems most of her life because of encephalitis. In art she has been able to find herself. She has been called original, innovative, and "always totally herself." She works in tempera and then "rubs, rolls, and textures the paint." She also does work with embroidery threads and sculpture. "In whatever medium she works, the vitality and originality are outstanding qualities." Her work is exhibited at the National Institute of Art and Disabilities Gallery in Richmond, California.

SUSAN CONNER

A Louisiana artist who paints brightly-colored primitive work on natural wood shapes and on canvas. Her colors are very bright and her inspiration "religious," but her symbolism is more ancient or tribal-looking than the usual Christian iconography. Southern Tangent in Sorrento, Louisiana has her work.

HELEN CONTIS
(b. 1907)

Came to this country from Kallina, Greece, as a bride at age twenty-one and settled in Pittsburgh in November 1928. She spent her early life as a wife, mother, and homemaker. She turned to painting in 1973 when her husband, painter Peter Contis, died. Helen uses acrylics and paints pastoral scenes of Greece as well as Pittsburgh scenes and imaginary landscapes. Pat McArdle had a show of paintings by Helen Contis and Peter Contis in Pittsburgh in the fall of 1992. For information on the art, call McArdle at (412) 371-4767.

PETER CONTIS
(1890-1973)

Born in Vlahokerasia, Greece, and came to the United States in 1909. He settled in Pittsburgh, Pennsylvania, where he owned a restaurant. When he retired at age seventy-four he began to paint studies of nature and views of Pittsburgh and Greece. He also painted places visited by the family. "The artist painted in flat planes of color over which he added meticulous detailing. He would dab on dots in contrasting tints for highlights which lighted his compositions with a festive air. He would paint buildings with varying scale and placement, adding streets,

bridges and autos at odd angles. He seldom painted people or animals." Contis "was a perfectionist who did not let anyone see his work until it was completely finished and framed to his liking," according to Robert Bishop (*Folk Painters of America,* 1970, p. 110). Contis' work also appears in the Hemphill and Weissman book. Pat McArdle at (412) 371-4767 carries his work.

CALVIN COOPER

Of Wallingford, Kentucky, immersed himself in woodworking and creating decorative objects after his retirement from the Kentucky Department of Transportation. He finds his medium, wood, in Kentucky forests and uses the wood's natural shape to create sculpture with a distinctly personal style. The pieces reveal his tongue-in-cheek humor through the portrayal of unexpected or awkward moments. Cooper's subject matter is varied and includes natural themes, realistic scenes, and fantastic and imaginative creatures. His work is in the Museum at Morehead State University in Kentucky and in many galleries.

EDWARD COOPER
(b. 1915)

Born and raised in Mississippi. He is a retired employee of the Department of Agriculture in that state. While he started carving in his youth, he has produced most of his work since his retirement. His carved works include "small painted coffins with lids that may be flipped open to reveal the decedents, articulated wooden snakes and fish." Dean Jensen Gallery in Milwaukee carries his work.

JESSIE COOPER
(b. 1932)
RONALD COOPER
(b. 1931)

Live in Flemingsburg, Kentucky. Both Jessie and Ronald were raised in northeastern Kentucky. They married when she was sixteen and he was seventeen and ran a country store for a number of years. Work in the store and raising their four children led Jessie to put aside her early interest in art. A series of unfortunate events resulted in their leaving the store and moving to Ohio, where Ronald worked in a factory and Jessie worked as a checker in a supermarket. Ronald suffered subsequent ill health and a crippling car accident. Making art turned out to be therapeutic for both Ronald and Jessie. Jessie Cooper paints, often on pieces of furniture and other found objects. She sometimes creates a three-dimensional scene in a dresser drawer or chest. Focusing primarily on religious subject matter, Jessie's work also deals with autobiographical subjects and social commentary. The art that Ronald Cooper makes is a result of projects to encourage his recuperation. Ronald now sculpts figures and other objects from lumber and found wood, which he then paints in bright thick paint. His subject matter is predominantly Biblical; many pieces feature snakes or devils. Both Jessie and Ronald Cooper's work is for sale at the Morehead University Folk Art Sales Gallery and in many other galleries listed in this book.

L.D. COOPER
(b. 1941)

A steelworker turned hog farmer in Jamestown, Tennessee, who started carving figures with a chain saw in about 1967. He carves very large human figures (e.g., his Indians are seven to nine feet tall), smaller Indians, and owls, eagles, and three-foot figures he calls "hillbillies." In a 1988 newspaper article, he says "I think I'm getting better all the time." Jamestown, Tennessee is about thirty miles south of Albany, Kentucky. Cooper's work is displayed in his yard.

REV. RICHARD P. COOPER
(b. 1938)

Born in Pittsburgh but has spent most of his life in rural Pennsylvania. A Lutheran minster, he made his first painting, a farm scene filled with childhood memories, in 1975. Cooper has not a lot of time to paint, so his production is low. His work is in the John Judkyn Memorial in Bath, England and Pennsylvania's Johnstown Museum. His work does appear in galleries and at one time was at Webb & Parsons. Recently he was in an exhibition at the Southern Alleghenies Museum called "Three Western Pennsylvania Folk Artists."

RONALD COOPER
see JESSIE COOPER

RUTHIE COOPER
(b. 1968)

Lives in Flemingsburg, Kentucky, and makes painted figures, creatures and devil-like constructions from animal bones. She is married to folk artist Tim Cooper. Her work is available at Morehead State University Folk Art Sales Gallery.

TIM COOPER
(b. 1957)

Lives in Flemingsburg, Kentucky, and creates animals, insects, and devil figures, which he constructs out of wood, vinyl, metal, and other found materials and then paints. He is the son of Jessie and Ronald Cooper. Galleries carry his work.

HELEN CORDERO
(b. 1916)

Lives at Cochiti Pueblo in New Mexico. She was the creator of the contemporary storyteller doll that first appeared in 1964. Her work is inspired by memories of her grandfather, and she has said that when her two oldest children were killed one year apart, working helped her with the loss. She is not well and seldom works anymore. Santa Fe Galleries have her work from time to time, and the Museum of International Folk Art has a large collection. Storyteller dolls are now made by around 200 people, and a few of them are very good. Hemphill and Weissman describe Cordero's work.

CHESTER CORNETT
(1913-1981)

Born in Kentucky and was a traditional chairmaker but is known in the folk art world for his carved wooden cross complete with a Christ figure. The cross was once attached to the bow of an "ark," but when the anticipated flood did not occur, the art was dismantled. There is a very clear illustration in the catalog *Folk Art of Kentucky* and a film about him.

GEORGE COTRONA
(b. 1912)

From Westchester County, New York, worked as a machinist and still carefully crafts his pieces in metal. He makes "Rube Gold-

berg" devices–"the male figures (denoted by mustaches and other outward signs) are usually cross-dressed and somewhat hermaphroditic." He also makes whirligigs. Prince Art Consultants in Connecticut handles his work.

LONZO COULTER, SR.
(b. 1916)
Born in Arkansas and now lives in New Orleans. He decorates panels of cardboard with pencils and crayon drawings, occasionally embellishing them with Mardi Gras beads and doubloons. Coulter's work was in the recent exhibition "Contemporary American Folk Art: The Balsley Collection." He tacks his drawings to the side of his home at 500 Philip Street, near the St. Thomas projects, in New Orleans, Louisiana.

MARTIN COX
Lives in Ezel, Kentucky, and is a carver of sticks. His work is available at the sales gallery at Morehead State University.

MELISSA COX
(b. 1967)
HERB McALEESE
(b. 1965)
This couple met in 1985 at a concert in Louisville. Both are natives of Elizabeth, Indiana. The couple have been together for seven years. Both artists carve and paint and make objects such as walking sticks, fish, snakes, frogs, and other images. They paint with oils or acrylics, depending on the wood being used. Sometimes it's auto paint that they decide will enhance the work. At first McAleese did all the carving, and Cox did the painting. Now, Cox carves too. Cox and McAleese have many

family members who make art. Swanson/Cralle in Louisville and Leslie Howard in New York are galleries that carry their work.

PAUL COX
Lives in Elliott County, Kentucky, and makes clay animals, unfired but painted. His work is available at the sales gallery at Morehead and also at Sailor's Valentine Gallery in Nantucket.

ROBERT COX
A Kentucky stick carver, his work may be seen at Morehead State University.

CARLOS CORTEZ COYLE
(1871-1962)
Born in Kentucky and went to a high school run by Berea College. He moved around enough that several states claim him as "their" artist. After his retirement in 1948 he moved to his last home, in Florida. Coyle is written about frequently. Most of his work is in the permanent collection at Berea College. Hemphill and Weissman describe his work.

GOLMON CRABTREE
Kentucky born and raised and one of several "bird handle" carvers from the south central part of Kentucky. He is a carpenter and maintenance man for a school and also drives the school bus. He makes canes, small wooden toys, picture frames, and small figures of people and animals. Crabtree carves with a pocket knife and uses cedar and various tropical woods salvaged from pallets made in South America. He uses paint for accents and shellacs his carvings. In addition to canes with bird handles, Crabtree's images

include figures of Indians, Daniel Boone, Dolly Parton, and snakes and other creatures. Galleries carry his work.

BURLON CRAIG
(b. 1914)
Of Vail, North Carolina, follows a tradition that began in the nineteenth century to make his pottery. Every step of the way he uses old time methods. He started making pots when he was fourteen. In 1984 Craig won a "National Heritage Fellowship." The face of a Burlon Craig face jug has protruding eyes, wide eyebrows that meet at the bridge of the nose, and a grin filled with square teeth cut from china plates. Galleries carry his work.

JAMES CRANE
(1877-1974)
Lived in Maine for most of his life. He is best known for his paintings of ships, which may be seen in publications, including Hemphill and Weissman, and museums.

L.W. CRAWFORD
(b. 1942)
From Whitehall, Alabama, a small town near Montgomery. He started to make various objects—boats, churches, houses, crosses, picture frames—with matchsticks when he "first went to the penitentiary" in 1962. Later, after he got out, he and his ex-wife Annie Tolliver had a son, and he started making large art objects. He has been sent to prison again but is soon to be released. Collectors have sought his work, especially his crosses. Perhaps his work will soon again appear in Montgomery area galleries. He was included in the exhibition "Outsider Artists in Alabama," and the exhibition

"Outside the Main Stream" at the High Museum in 1988.

MICHAEL F. CREESE
(b. 1945)
Lived in Syracuse, New York, until he moved to San Antonio, Texas, in 1968. He says about himself, "As a self-taught artist, I work with acrylics because of its quick drying and its bright colors. I create happy scenes of life as I see it" Creese has won several awards for his art including one at a Black Heritage Show in 1988. He works as a letter carrier for the post office. Galleries carry his work.

ABRAHAM LINCOLN CRISS
(b. 1914)
Lives in New Jersey now after spending many years on family land in Cumberland, Virginia and turning his yard into a zoo of many animal creatures. Criss makes wooden figures of people and animals that are carved and assembled in a somewhat fantastical mode. There is also some painted detail on the work. Since his move to New Jersey, Criss is doing more drawing than carving. His work is carried by galleries.

MELVIN CROCKER
MICHAEL CROCKER
These brothers are north Georgia potters who run the Crocker Pottery. They are the sons of a farming family who took up pottery on their own as adults. They make face jugs in a contemporary manner by making a pot from a mold and adding the face later. Galleries carry the work.

CHUCK CROSBY
(b. 1957)
Born in New Orleans. He is a self-taught "outsider" artist who has "created compulsively since he was a child." He became depressed after a severe nerve injury left his painting arm useless. After much practice he got the other arm to take over and thus regained his ability to paint and draw. "Crosby paints from his imagination and from his life experience in a unique way, often with repetitive symbols derived from dreams and fears." He paints on any surface available—furniture, bottles, gourds, and canvas—with acrylics. At times the artist writes words along the borders. His work is available from Marcia Weber/ Art Objects in Montgomery, Alabama.

ROBERT CUMPSTON
Lives in Colfax, Illinois. He constructs figures, mostly animals, from parts of farm machinery he has collected over the many years during which he has been a farmer. His work is available at Eccola in Milwaukee.

EARL CUNNINGHAM
(1893-1977)
Painted brilliant colored landscapes and scenes of idyllic harbors. His background is given in detail in the Rosenak encyclopedia. Most of the work is in private collections. There are also paintings of Cunningham's in the permanent collections of the National Museum of American Art, the New Orleans Museum of Art and the Museum of American Folk Art.

KAROLINA DANEK
(b. 1913)
Lives in Caribou, Maine. She came to the United States from Poland in 1950 and had a gift shop in Worcester, Massachusetts. There, her first paintings, based upon the iconographic tradition in her homeland, were hung in the window. She made her versions of recognizable icons all lavishly embedded with beads and jewelry. Now she has departed from traditional imagery and paints contemporary world leaders placed within the context of their actions. Her inspiration comes from television, the newspaper, and research at her local library. She still uses her original technique of painted faces and beadwork to comment on contemporary folly. Two galleries carry her art work.

VIRGIL "SPOT" DANIELS
(b. 1920)
Lives in Arkansas. He used to have a moving company before he retired. Next door to it is a laundromat, and he painted the whole thing with his art. He paints on corrugated cardboard and is currently doing political portraits. Prince Art Consultants carries his work.

HENRY DARGER
(1892-1973)
Born and lived in Chicago. His childhood was spent in an orphanage, then, in error, a home for the feeble-minded. When he died his room was discovered to contain over 15,000 pages of text and 2,000 drawings representing his life's work: "The Story of the Vivian Girls in What is Known as the Realms of the Unreal of the Glandelinian War Storm . . . as Caused by the Child-

Slave Rebellion." The length of his "art life," according to John MacGregor, "was from 1962-1972." His work is "the story of another world torn by war" says MacGregor, who calls Darger a "compositional genius." Darger used the "Little Annie Rooney" comic strip figures for the basis of his collages. His work is written and discussed extensively. Galleries carry his work.

SANFORD DARLING- "HOUSE OF A THOUSAND PAINTINGS" -SANTA BARBARA, CALIFORNIA

This site exists now only in pictures. It is illustrated in many publications and Darling is written about extensively. It is sufficient to say here that the artist began to paint after his wife died and eventually covered every surface of his house, including furniture and appliances, inside and out. His paintings have been described as "sparse in detail yet bold in line and color." When Darling died his house was sold and the paintings disbursed. Galleries handle his work.

RICHARD LUIS "JIMBO" DAVILA
(b. 1955)

Born in Valley Forge, Pennsylvania, and did not come to New Mexico, where he lives now in El Rancho, until after he had dropped out of college in Arizona. He was first known for his brightly carved and colored snakes. Now he is making other figures. A recent gallery show in Denver featured a piece, "Lucky Catch," which was a well-carved sculpture of a chunky boy with a fish. Galleries carry his work.

PATRICK DAVIS
(b. c.1943)

A native of Guyana, Davis moved to Houston, Texas, in 1979. He makes sculpted characters—mostly men, some women, a few dogs—that are long, thin, have "an attitude," and often have their tongues sticking out. The dogs are painted white. The human characters have brightly patterned "clothing" that result from the artist's use of the pages of the *National Geographic* and other such magazines. Some recent figures have fabric garments, too. The basic interior structure of the figures comes from computer punch cards, press board, and filament tape. The figures, barefoot or with shoes, may be dressed in flowing robes or suits and ties—nearly always with hats. A critic has said of them, "they have the fluidity of dancers." Galleries carry his work.

RITA HICKS DAVIS

A "naive" painter who lives in Indiana. She paints detailed "at home" interiors of a time "when society made the home important." Her "love of times past inspires her work." (I don't know whether this is intentional, and I doubt it considering the artist's view, but it appears to me that the people in her ideal families look mean and not at all friendly toward each other.) Sailor's Valentine Gallery in Nantucket has her work.

ULYSSES DAVIS
(1914-1990)

Lived in Savannah, Georgia, for more than forty years and operated a barbershop. Between customers and after working hours, he decorated his shop with carved figures from wood. His themes were mostly religious, patriotic, and historical. He also carved some animals and made carved and painted wood reliefs. Davis has been written about and exhibited frequently. The King-Tisdale Cottage Foundation in Savannah (see "Museums") is raising money to install his works and barbershop permanently in Savannah, in fulfillment of the artist's last wishes (contributions are needed). Although Davis sold few of his works, there are some in private collections and pieces are available from two sources listed.

VESTIE DAVIS
(1903-1978)

Born in Hillsboro, Maryland, and left home at an early age to join the Navy. Eventually he settled in New York, and his paintings were discovered at the outdoor art show in Washington Square in New York's Greenwich Village. He is in the Rosenak encyclopedia and in Hemphill and Weissman's book.

WILLIAM R. DAWSON
(1901-1990)

A prominent self-taught wood sculptor and painter. He began sculpting after his retirement. He used scrap wood, sometimes adding chicken bones and paint. His heads and totem-like carvings depict strong facial features. Toward the end of his life he took to painting more. Dawson is featured in many exhibition catalogs and museums, and his work is available in galleries.

FRANK L. DAY
(c.1900-1976)

Born in Berry Creek, California. He was a Maidu and learned traditional legends and facts

about his people. He traveled a lot as a young man and then settled in California. He had to retire after an automobile accident and this revived his interest in painting. Using oil on cardboard and canvasboard, he painted the history of his people and their myths and traditions. His work appears in *Twentieth-Century Folk Art and Artists* by Hemphill and Weissman and other publications.

EVAN DECKER
(1912-1981)
Born in Wayne County, Kentucky, and lived in Delta, Kentucky, until his death. A farmer, carpenter, and builder all his life, he was a cowboy in his heart. His place was named "Home on the Range." Decker was fascinated with the west, which dominated his artistic life. Mostly a sculptor, he started painting toward the end of his life. He created over 100 pieces including a life-sized horse on which he used to sit and sing cowboy songs to his family. He created tableaux, animals, birds in trees, and added pieces to beautifully crafted furniture. Forty-two pieces of his work are in the Huntington Museum in West Virginia.

FLORENCE DEEBLE- "ROCK GARDEN & MINIATURES"- LUCAS, KANSAS
Florence Deeble was a school teacher. She and her roommate Christine Klontz first built a rock garden in Norton, Kansas. After they retired in the 1960s, they moved to Lucas. Deeble, who made this project on her own, began with a lily pond and went on to concrete miniatures of remembered landscapes seen while traveling, including Mt. Rushmore. Deeble, now ninety-one, enjoys having people drive up the alley behind her house to see the yard art and garden (it cannot be seen from the front of the house). She lives at 129 Fairview in Lucas, Kansas.

JOSE DEL RIO
(b. 1921)
From Puerto Rico and now lives in Walnut, California. "Jose is a self-taught artist whose colorful artworks reflect his culture, religion, and humanitarian nature. Birds, flowers, fountains, and the sun are drawn with bright color markers." Inspirational words in Spanish and English are included in his work. Jose del Rio's work has been exhibited in museums and galleries from California to Washington, D.C. Recent work was exhibited at the Ontario Museum of History and Art in California. One of his linoblock prints was chosen for the fall 1992 cover of the *Santa Monica Literary Review*. His work is carried by First Street Gallery in Claremont, California.

"CREATIVE" G.C. DE PRIE
(b. 1935)
Lives in Huntington, West Virginia, with his wife, and has a married daughter, Katherine. He was a barber for a time and served in the navy. De Prie says, "I believe I am out in the future, and I am psychic," and, he says, "my art is influenced by omens, and the fact that you can only live in the future, not the past or the present." De Prie suffers from a serious heart condition and "nerves" and so spends most of his time on his art. He says the pencil moves and he follows it.

He tried watercolors but didn't know how to use them. De Prie's most frequent subjects are human figures and architecture. When he draws the human figure, he draws it nude and then adds the clothes. He is fascinated with nursery rhymes, with a strange and sometimes unsettling twist on the traditional; Alice in Wonderland; and ancient places, Egypt in particular. Of Egypt he says, "I know about it, I don't know why." De Prie was included in the exhibition "Contemporary American Folk Art: The Balsley Collection" in 1992. Galleries carry his work.

MAMIE DESCHILLIE
(b. 1920)
Lives in the Navajo Nation. Some years ago she started making clay dolls, as her mother had done, and dressing them in scraps. Then she started making the cutouts and collages that have become admired by folk art collectors. She is written about in detail in the Rosenak encyclopedia and her work is found in several galleries.

ALVA GENE DEXHIMER
(1931-1984)
Born in Clarksburg, Missouri, and died in Syracuse, Morgan County, Missouri. Dexhimer could neither read nor write, but filled his art with copied words. Handicapped by a farm accident as a boy, he passed time by making objects for his own amusement and for passersby on the county road in front of his house. He had all kinds of bric-a-brac, found object creations and whirligigs in the yard. In a back shed were his paintings, hundreds of them. These paintings, "copied from the mass media, a tradition among folk

artists, but transformed by his stubborn sensibility, were done on whatever he could find, with house paint from Wal-Mart or donations." Dexhimer's work was in an exhibition "Deliberate Lives: A Celebration of Three Missouri Masters" in 1984 and is illustrated in the exhibition catalog *Word and Image in American Folk Art.*

"UNCLE JACK" DEY
(1912-1978)
Lived in Richmond, Virginia, and created paintings from his experiences and his dreams. A familiar image in his paintings is of black crows. He is written about in many publications, including the Hemphill and Weissman book. The Frank J. Miele Gallery in New York carries his work.

THE DIAL FAMILY
This family of great artistic talent will be identified here but not described for the person new to the field of folk art. There are already many sources of information about their work. THORNTON DIAL, SR. (b. 1928) is a painter and sculptor whose themes are relationships —between races, men and women, God and humankind. THORNTON DIAL, JR. (b. 1953) creates "compelling painting/ assemblages" that deal with racial issues and with relationships to nature. RICHARD DIAL (b. 1955), another son of Thornton, Sr., is a sculptor who uses his metal-working skills learned in a family business to make chairs that are really art pieces. Other family members whose art appears from time to time are his children, MATTIE (b. 1957) and DAN (b. 1960); his grandchildren, THORNTON III (b. 1973) and RICHARD, JR. (b. 1978); his relative, RONALD LOCKETT (b. 1965); his brother, ARTHUR (b. 1930); and his grandnephew, CARLOS (b. 1975).

GREG DICKENSON
An artist from Iowa whose two passions in life are his admiration for television newscasters and his love for Nabisco cookies. Since newscasters are "authority figures" who speak directly to us from the TV sets, Greg has painted almost every one of his "heroes," national or local, using different colors and set designs and varying the digital time showing when the newscaster is on. "Greg embraces American pop culture and celebrates it," including Nabisco cookies, "with buoyant enthusiasm in his work and daily life." As a young child, Greg was autistic. After years of treatment and care he is now proud to be able to live on his own. His work is available from The Pardee Collection in Iowa City.

CHARLIE DIETER
(1922-1986)
Lived in Weatherly, Pennsylvania, and spent his life taking care of his mother. At age forty-seven, when she died, he went into a nursing home. He lived, it is said, "in his own private reality," which he drew upon for his paintings. His images included "familiar places, friends, and animals." He also drew his imaginary band. He is written about frequently and his work is carried by two galleries in New York.

S.P. DINSMOOR- "THE GARDEN OF EDEN" -LUCAS, KANSAS
Dinsmoor (1843-1932) was a Civil War veteran and a strong supporter of the Populist political movement in the 1890s. He spent thirty years building the Garden of Eden site populated with numerous concrete figures representing social commentary and Bible stories. There are numerous illustrations and writings about this site. It is open to the public at Second and Kansas Streets in Lucas. Call (913) 525-6395.

CARL DIXON
A wood carver from Jackson, Mississippi. He started carving as a hobby while working as a brick mason. No longer able to continue to make a living in Jackson, Dixon moved to Houston, Texas. The Leslie Muth Gallery in Santa Fe represents his work.

PAUL M. DOBBERSTEIN- "GROTTO OF THE REDEMPTION"- WEST BEND, IOWA
This is the earliest of the many midwestern grottos. Father Dobberstein began work on it in 1912 and continued until his death in 1954. He built nine individual grottos depicting scenes from the life of Christ. The structures are encrusted with natural materials such as rocks, polished stones, and shells. The site is open for guided tours from June to mid-October and at other times by appointment. The grotto is located two blocks off Iowa State Highway 15A at the north end of West Bend. Call (515) 887-2371.

BRIAN DOWDALL
(b. 1948)
Grew up in a small mining town near the mountains in Mon-

tana. After years of hitchhiking, sleeping in forests in the country and abandoned buildings in cities, Dowdall has settled down in Florida. An art dealer describes his work as "chunky, awkward, mysterious animals painted on cardboard with acrylics." Dowdall calls them "animal spirit paintings" and says that he chooses colors from "the sun, moon and fire and the earth, trees and water." Galleries carry his work.

SAM DOYLE
(1906-1985)
A lifelong resident of St. Helena's Island, where he attended Penn School, the first school for freed slaves. He lived in an area with a long and sustained African and African-American history and culture. His paintings depict people from his island, both legendary and local characters. He is well—known and written about frequently. Many galleries carry his work.

SAM DRAKE
(b. 1957)
Lives in Greenville, Kentucky. He started carving in 1991 when he and his wife Daisy saw a carving he believed he could do. With the encouragement of Daisy, he tried it and found that he had the talent. A native of Owensboro, Drake works for a landscape and garden supply firm. He uses basswood and whatever scraps he can find and paints his figures with acrylics. He says, "I pick up a piece of wood and whatever I think about, that is what I will carve." His work is in the Owensboro Museum collection, and he sells it direct from his home. For an appointment call (502) 338-5441.

BESSIE DRENNAN
(1882-1961)
Born in Woodbury, Vermont, where her family had lived for many generations. She was treated miserably by her family, and people in the community considered her odd. Then outsiders began to take her seriously and buy her work. She painted memories and also stories, some real and some fanciful. She was never given the respect or consideration due her in her own community during her lifetime. There is at least one of her paintings at the Vermont Historical Society, an annual fall exhibition of her works in Woodbury and a book with many illustrations by Jane C. Beck.

"UNCLE PETE" DRGAC
Lived in Texas and died in 1976, leaving behind 200 unique and eccentric enamel paintings on paper, cardboard and poster board. He was born on a Texas farm. His parents were Czech. He did not start to paint until after the death of his wife in 1962. Some viewers believe that his work resembles prehistoric cave paintings. Galleries carry his work.

VANZANT DRIVER
(b. 1957)
Came from Taft, Texas, and lives in Houston. Driver, a Baptist deacon by day at Christ Evangelistic Church, makes sculpture at night. For a time he concentrated almost exclusively on making churches because he felt it was part of the responsibility of his religious beliefs. Now he makes other images too. Driver uses broken glass of many different colors to build his shimmering sculpture, and Elmer's glue. He usually leaves the wooden

base of the sculpture unpainted because he thinks the natural wood is beautiful. He believes his works provide a spiritual message. Galleries carry his work.

EVERETT DRUIEN
(b. 1905)
A native of Kentucky and a resident of Hodgenville. He has worked with wood all his life. Jan Arnow, in her book *By Southern Hands,* tells about Druien's traditional carving of tool handles. He also makes carvings of Kentucky folk life and carves sticks. His work is in the Owensboro Museum of Fine Art and he was included in the exhibition "Sticks."

DIANE DUANY
(b. 1958)
Born in New York City and resides at the New York Psychiatric Hospital on Randall's Island. She is considered schizophrenic. Duany has painted in oils for many years and "shows complete confidence in doing the work." If you are curious to know and see more, visit Epstein/Powell in New York.

BILL DUFFY
In his "late thirties," lives in upstate New York, in Ft. Plain. He is a carver who spends all of his time carving. He is said to make very interesting animals, fish, and carrousels. His work is available at Leslie Howard in New York.

BURGESS DULANEY
(b. 1914)
Lives in Itawamba County in an isolated area of Northern Mississippi. He produces sculpture from red clay. Although his work is thought by some to re-

semble pre-Columbian figures he knows nothing of that art. He has never traveled and lives just a few feet from the log cabin where he was born. His work was included in the exhibition "Baking In the Sun" and is carried by Gilley's Gallery in Baton Rouge. He had stopped for a while but is now working again.

DONOVAN DURHAM
(b. c.1960)

Born in York, Pennsylvania, and "is said to be living in Atlanta." He is a black artist who makes "beautiful, oddly-stylized pencil drawings," which may be seen at Epstein/Powell in New York.

ALLAN EBERLE
(b. 1957)

From Iowa and has invented his own art movement, which he calls "Splintalism." He fragments his paintings into a mosaic of geometric shapes or what he calls "splintles." Each of the paintings is designed to be experienced in different phases: "the way we see them is a normal light; the way they appear with 3-D glasses; under black light; or in the dark, where they glow. At an exhibition of Eberle's art, "Splintal Wizardry" (Quad City Arts in Rock Island, Illinois, October 8-November 9, 1992), one could see the works in all their phases. Eberle is a "self-taught outsider artist" who devotes himself totally to the development of "splintalism" and art. His themes relate to pop culture, and he paints large canvasses using a combination of acrylic, neon, and glow paint. His work is available from The Pardee Collection in Iowa.

WILLIAM EDMONDSON
(c.1870-1951)

Born near Nashville, Tennessee. He started carving around 1932, inspired by a vision. Edmondson, one of the most highly regarded self-taught artists, carved gravestones, free-standing figurative sculpture, and garden ornaments using discarded blocks of limestone and tools made from railroad spokes. Animals, Biblical subjects, and secular figures were his dominant images. He is written about frequently, appears in the Hemphill and Weissman book, and is in many museum collections. A number of galleries represent his work.

JOHN EHN-"OLD TRAPPER'S LODGE"-WOODLAND HILLS, CALIFORNIA

John Ehn (1896-1981) worked for many years as a trapper in Michigan, before moving to California in 1941. He opened a motel and after watching a professional sculptor at work, decided he could do as well. He spent the next fifteen years filling his yard with sculptures of historical and fictional characters. He also made tombstones with tales of the west inscribed on them. The faces of many of his figures are life masks of his family. After Ehn's death, efforts to care for the environment were a hardship to his family, but at the last minute this monumental environment was moved to the campus of Pierce College in Woodland Hills in the San Fernando Valley, not far from its original site in Burbank, where it may be seen by visitors (818) 347-0551.

ABRAHAM ALBERTO EIDELMAN
(1898-1992)

Eighty-eight years old when he started to draw. He draws colorful observations of his life from his birthplace in Besarabia to Peru, Panama, the United States, and Canada. His images ranged from childhood pranks to being a farmhand to experiences as a salesman in Central America. "Eidelman created both interiors and exteriors, sometimes with humor and sometimes with pathos." His work is represented by The Ames Gallery in Berkeley, California.

JOHN ELDRIDGE
(b. 1967)

Lives in Isonville, Kentucky, and is a neighbor of Minnie and Garland Adkins. Eldridge carves canes with figures, using dogwood and maple. His designs are completed with enamel. He also carves and paints animals. His work is in the Morehead State University Folk Art Museum and the Owensboro Museum of Fine Art.

WILLIE LEROY ELLIOTT, JR.
(b. 1943)

Grew up in Alabama and now lives in Detroit. Elliott is a sculptor who uses wood, paint, and recycled material to create his sculpture. Many of his sculptured pieces make a strong statement on social issues and current events, and a strong artistic statement, too. His work is in galleries.

VIVIAN ELLIS
(b. 1933)

From New Orleans but has lived in Germany as a U.S. Army nurse

since 1961. Her Baptist minister father did not encourage her artistic talent, considering it a waste of time. Two of her favorite themes are stories from the Bible and scenes from her childhood. Her work has been described as having "rhythm and vitality." She has received great acclaim in Europe, but little attention in the United States. Her work is illustrated in the *World Encyclopedia of Naive Art* by Oto Bihalji-Merin, and occasionally it turns up for sale at Gasperi Gallery in New Orleans.

EMERYVILLE MUD FLATS ENVIRONMENT

An art environment that is no more, the sculpture was "created spontaneously by anonymous individuals." Constructions were made from driftwood, old tires, beer cans, plastic jugs, and any other usable item that drifted to shore from the San Francisco Bay. Started in the early 1960s and quite visible from the highway between Oakland and Berkeley, it is gone now—cleared because of the danger to nesting shorebirds. It can still be seen in photographs in the catalog for "Cat and a Ball on a Waterfall," in Karen Pfeifer and Douglas Kiester's *Driftwood Whimsey,* and in Seymour Rosen's *In Celebration of Ourselves.*

RUZA "ROSE" ERCEG
(b. 1898)

Born in Yugoslavia. In 1922 she and her husband first settled in Pennsylvania and then moved to Oregon, where she raised nine children. In the summertime she cares for her flower and vegetable garden. Erceg paints every day. Her eyes are beginning to fail, and she must now paint with her eyes only inches away from the surface. Erceg felt isolated after the death of her husband and in 1961 said to her daughter, Helen, that if she had a paint brush she would start to paint. She was soon supplied with materials and began. She paints images of her past in Yugoslavia that are colorful depictions of rural scenes and sometimes an occasional sailboat or a larger city. She paints in watercolor on paper and colored pencil on paper. Often she paints frame-like borders around her pictures. Her work is in galleries.

PAUL ESPARZA
(b. 1963)

From Illinois. He grew up in a large Mexican-American family of eleven children. Mentally retarded at birth, Paul is the only member of the family who has any interest in or talent for art. His family does not like his art work at all, but a social worker who sees Paul regularly thinks his art is "terrific" and encourages him to keep working. Paul's paintings "combine scenes of public commercial settings such as bowling alleys, supermarkets, arcades and RV parks with his own fantastical vision." Asked why he puts in some of the images he does, he replies, "fun." Esparza also does scenes of Catholic schools and churches and likes to draw penguins. He has done a whole series on penguins at the "Super Mall" in Minneapolis (a new mall that is the "talk of the midwest," with its 10,000 employees and a hundred shopping acres). Sherry Pardee, who discovered Paul's work, says it is really special and she is "smitten." The Pardee Collection in Iowa City carries his art work.

ANTONIO ESTEVES
(1910-1983)

Born in Rio de Janeiro and grew up on the streets of New York when his mother died soon after the family's arrival in the United States. He was a building superintendent until he was seriously injured when a boiler blew up. He started to paint while recovering from the accident. He painted both religious and secular subjects, on castoff furniture and boards. His work is illustrated in *A Time to Reap,* and is available at Epstein/Powell in New York.

DEBORAH EVANS

Lives in West Liberty, Kentucky. She is a young woman who creates carved and painted animals and assemblages. Her work may be seen at Morehead and at galleries.

MINNIE EVANS
(1892-1987)

Born in Long Creek, North Carolina, to a black family with its roots in Trinidad. Most of her images came from her dreams. It has been described as "primarily symmetrically patterned and vividly illustrated . . . the Book of Revelation influences her style." There is a Light/Saraf film, "The Angel That Stands by Me," about her life, her work, and her family. Galleries represent her work.

TOM EVERY- "THE FANCY"- BARABOO, WISCONSIN

Tom Every ("Dr. Evermore"), his work, and the help he receives from his wife and son are described in a *KGAA News* article by Lisa Stone. Stone describes this environment as "an

ingeniously complex monument to the history of electrical inventions and the imaginative power that brought them into being." For more than twenty years, Every has been collecting salvage (which was his business) and creating sculpture. His son Troy and wife Eleanor also work on the project. Troy has begun to sell his own sculpture. But "once purchased," says Stone, "the sculptures become satellites of The Fancy, and collectors find themselves unwittingly in its orbit." The Fancy is located on Highway 12 south of Baraboo, Wisconsin. The Everys welcome visitors.

JOSEPHUS FARMER
(1894-1989)
Born in rural Gibson Courts, near Trenton, Tennessee, the third of eleven children. Farmer's first attempts at carving involved making his own toys. He became a minister in 1922 and in 1931 founded El Bethel Apostolic Church in South Kinlock, Missouri. He also maintained a secular job until his retirement in 1960. After his retirement, he once again pursued his interest in wood carving and became well-known as a folk artist. Rev. Farmer depicted scenes from American folklore and history, as well as from the Bible. He has been the frequent subject of written articles and appears in exhibition catalogs. His work is carried by the Dean Jensen Gallery in Wisconsin.

MICHAEL FARMER
(b. 1952)
Lives in Louisville, Kentucky. He was encouraged to paint by his friend William Miller, the cane carver. Farmer began to paint

about 1990 to relieve his depression and consequent headaches. He "needed a way to communicate ideas he believed no one would hear." Farmer paints in acrylics on watercolor paper. His work is in the Owensboro Museum of Fine Art and Larry Hackley sells his work.

RALPH FASANELLA
(b. 1914)
Born in New York City and now lives in Ardsley. He is a very well-known contemporary folk artist who tells stories in his paintings, especially about immigrant families and working class people. He paints with oil on canvas. It may be seen in photographs and in publications. There is one in the Emigrant Museum at Ellis Island in New York. In 1992 the Museum of American Folk Art started a fundraising effort to acquire the painting "Subway Riders," which is to be installed at the subway station at Fifth Avenue and 53rd street in Manhattan. Hemphill and Weissman describe his art in *Twentieth-Century American Folk Art and Artists.*

NELSON FAUCHEAUX
Lives in Paulina, Louisiana. He worked in a plant in Louisiana until he was disabled. He started carving around 1990 to "relieve the boredom." His carvings, "realistic but rough," are very colorful fishes, birds, and other objects. His work is available at Southern Tangent in Sorrento, Louisiana.

JOHN LAWSON FELDER
(1912-c.1989)
The son of a San Antonio doctor. He was self-employed as an industrial engineer, with his own business of making ceram-

ic tile. Although he lived in San Antonio all his life, he traveled extensively. He was a self-taught painter who started around 1960. He painted mostly landscapes in oil, primitive but realistic. His work is carried by the Sol Del Rio Gallery in San Antonio, Texas.

ROY FERDINAND, JR.
(b. 1959)
A native of New Orleans. He dropped out of high school at seventeen and did not last very long in the Army either. He joined a gang, the Black Tigers, and sometimes entertained members with his drawings. Ferdinand worked as a security guard until his "efforts to settle his life were thwarted when his fiancee was brutalized and raped." Ferdinand ended up in a psychiatric ward at Charity Hospital for a while after this indicent. Ferdinand draws the people in his community, the people who share the harsh realities of being poor and black. He captures the scene: people in his art are violent, arrogant, angry, and filled with sadness and despair. "I see people," Ferdinand says, "with faces that say they haven't got out of life what they expected." Roy Ferdinand's drawings, on poster board using ink and tempera, are not "pretty," but they are powerful and important. His work is in galleries.

KATHLEEN FERRI
(b. c.1927)
A self-taught memory painter from Turtle Creek, Pennsylvania. She started painting six or seven years ago, after her husband died. Ferri does many paintings of places well-known to Pittsburgh area residents, such as "Kennywood park" and

the small industrial towns around Turtle Creek and the Westinghouse plant. The towns are painted the way they looked when she was a child. Her paintings contain lots of activity and her colors are bright and bold. Call Pat McArdle at (412) 371-4767 to see her work.

JOE FERRILLO
(c.1895-1989)
Born in Naples, Italy, and lived most of his life in New York City. He was a self-taught artist who painted with oil on canvas, and did some drawings. He frequently painted New York street scenes. For a short period in his life dealers tried to tell him what to paint, but he resisted them. A substantial amount of his work, which is held by a private individual, "is likely to appear on the market soon," according to a Chicago collector who has managed to acquire a piece or two.

"CEDAR CREEK CHARLIE" FIELDS
(1883-1966)
Began building projects and decorating his environment when his mother died in the 1930s. He repainted his house several times in various patterns. His favorite pattern was polka dots, especially red, white, and blue ones. He painted stoves, beds, walls, floors, and most other things. Outside, he made whirligigs, model planes with doll passengers, a suspension bridge over a creek, a Ferris wheel, and other structures; all were decorated. Fields welcomed visitors, especially on Sunday afternoons, when he dressed in a polka dot suit, shoes, and hat. The "environment" is gone. One can see his

work in publications and museums.

LOREN FINCH- "ZIG ZAG ZOO/ EL RANCHO FINCHO"- NEWPORT, OREGON
Loren and Helen Finch moved to property which they owned on the Oregon coast in 1968. Because Helen was quite ill and needed attention, Loren Finch stayed close to home and started decorating his home site. The result is a cheerful environment of driftwood and found object creatures. You can see this site from the coastal highway going south through Newport.

ERNEST FINGER
(b. 1941)
Comes from Bristol, Connecticut, and has lived in Peñasco, New Mexico since 1978. Finger was a meat cutter and has had many other jobs. He likes to travel and has crossed the country several times, including on bike and horseback. For a long time he has made wood carvings and whirligigs, painted with bright enamels, but now he is doing entirely different art. He looks for old things around the mountains—old glass, rocks, bones, and "junk"—and wires them together into assemblages. His work may be seen at the Barbershop Gallery in Taos, New Mexico.

MARVIN FINN
(b. 1917)
Born in "lowland Alabama" in a town called Clio. He moved to Kentucky in 1940. Mr Finn came from a family of twelve children and had five of his own. He is a widower, since 1966. Finn says "he really never wanted to be with others; he would much

rather be alone." He has always liked making things for himself. His father used to whittle, and Finn watched him a lot and "got interested that way." He often gets up in the middle of the night to work at the kitchen table. He uses scrap wood and says "I don't like to throw even a match stick away." Asked how he got started selling his work, Finn said "Man came along one day and asked . . . I started . . . daggone chickens." His favorite thing to make is machines—but people just want him to "make roosters." His brightly striped and polka-dotted birds, animals and roosters are sold in many galleries.

HOWARD FINSTER
(b. 1916)
Born in Alabama and lives in Summerville, Georgia. He started making art and building Paradise Garden in 1976, in response to God's demand that he make sacred art. His is the "last red light" before the Apocalypse. Finster is written about, exhibited, visited, and discussed more than any other contemporary American folk artist. Many complain about the quantity of his production and his use of assistants. But those are the complaints of the "art world" and they are irrelevant to Finster whose works are sermons, spreading his message— that is his purpose. Fifty-three of the galleries listed in this book sell works by Finster, as do many others including the shop at Paradise Garden.

HOWARD FINSTER- "PARADISE GARDEN"- SUMMERVILLE, GEORGIA
Howard Finster, the most exhibited folk artist in America,

merits a second entry here for his environment. In addition to individual pieces of "sacred art," Finster has created Paradise Garden—a place that is decorated by his art, shrines to his beliefs, and contains a "folk art church." There are sculptures around the garden, paintings on the walls of buildings, and on the Cadillac parked under a leaning shed. The sidewalks are cement embellished with found objects and mementos. Occasional chickens wander about. Finster used to greet people there every day, but now he is too tired and there are too many people. He has moved away from his little house on the property, and comes back to talk with people only on Sundays. He seems to be both very sincere and dedicated to his mission and it is a pleasure to meet him. Summerville is in northwest Georgia and once there, lots of people will be able to point the way to Paradise Garden.

MICHAEL FINSTER
(b. 1969)
Works at the gallery on grandfather Howard's property in Summerville, Georgia. In addition, he now works at his art full-time. He dropped out of school in the tenth grade, has been married for three years, and in the summer of 1992 he and his wife became parents of Devin. Michael says he started making art when he was five and started numbering his pieces, at his grandfather's suggestion, when he was twelve. In August of 1992 he painted number 2600. He said that unlike his grandfather Howard and his father Roy, who work on several pieces at once, he finishes one work at a time. Michael says that

"two years ago was my most prolific time. I painted all the time, every day, but then I got too nervous. I was getting so many orders I got to painting only what others wanted me to do, instead of being creative." He also says "all great artists had helpers and I need one too." His designs are done freehand (on his cutouts) with colors and patterns different on each one; he may repeat a cutout design, but not the colors or patterns. He likes to try new images. He makes a lot of monsters, birds, and snakes and other crawling things. His thick wood cutouts have a powerful sense of color. His paintings, on the other hand, usually contain religious themes and come from dreams and visions. They are often inspired by Bible readings, too. The paintings, more somber than his cutouts, take several days to complete and are not repeated. Michael Finster's work is in six galleries in addition to the one at Paradise Garden.

ROY FINSTER
(b. 1941)
Lives in Summerville, Georgia, and works in the Paradise Garden gallery on the edge of his father Howard's famous garden. Roy Finster paints large-scale primitive scenes of country life in addition to figural cutouts. Of all the Finster family artworks, Roy's are most like his father's. He is, however, moving away from his derivative cutouts and spends more time with larger paintings. His work is at the Paradise Garden gallery and at the Atlanta History Center's Swan Coach House Gallery.

BUDDY FISHER
Lives in Kentucky and carves canes, which are incised with

patterns and then painted. Southern Folk and Outsider Art in Washington, D.C. carries his work.

OMAH FITZGERALD
(b. c.1916)
A painter who is a native of Memphis, Tennessee. She uses oils and paints adult memories of her own experiences that gave her pleasure, more often places rather than people. When she puts people in her landscapes they are usually portrayed alone and isolated. Edelstein/Dattel in Memphis carries her work.

THOMAS JEFFERSON FLANAGAN
(b. 1896)
Born in and grew up near Columbus, Georgia. He taught for nine years in a public school and then became a Methodist minister. "His most prolific period as a painter in oils was during the 1950s and 1960s." His work is included in *Folk Painters of America* by Robert Bishop and in the permanent collection of the Columbus Museum in Georgia.

WALTER FLAX-"FLAX'S NAVY"-YORKTOWN, VIRGINIA
Walter Flax built a "navy" of many types of ships in the woods around his Virginia home. At one time there were more than one hundred of them. The environment is gone now except for photographs. There is one ship made by Flax in the National Museum of American Art.

MILTON FLETCHER
(1906-1992)
Born in Yazoo City, Mississippi.

He spent many of his adult years working for the YMCA in St. Joseph, Missouri, in Winston-Salem, and finally in Shreveport, Louisiana, where he established the Carver branch of the YMCA and organized a very successful credit union. His work portrayed many scenes from life on a farm, to the creation of jazz, hard times on a chain gang, boats on the Mississippi River, experiences on the railroad (he worked summers as a pullman porter to put himself through college). All reviews of his many exhibitions agreed that his "primitive" paintings all tell a story. In fact they usually do have stories written on the back of them. Fletcher spent his last years in a nursing home in St. Louis, wheelchair bound. A New Orleans collector of his work (Fletcher used to sell every year at Jazz Fest until he got too old) said that Fletcher did not trust galleries—"he got the price he set on his paintings, but little recognition." Galerie Bonheur carries his work.

JESSE K. FLOWERS, JR.
(b. 1925)
Born in Washington, D.C. He now lives by himself, except for his dog, on a farm in Virginia. He carves wood and logs that he finds and then paints them. He carves "standup figures" according to a sister in Louisville, and he makes colored-pencil drawings of people and people with animal heads. Most of his figures are fanciful. His work is at Swanson/Cralle Gallery in Louisville and one may visit another of the artist's sisters in Alexandria, Virginia by calling Janet Kealey (703) 941-7106

JACK FLOYD
(b. 1924)
Born in McKenzie, Tennessee and moved to Austell, Georgia, in 1948. Floyd is a retired electrician. He makes carved wooden canes, which he paints. Some of his images are lifelike snakes, eagles, American flags, people, flowers, and a great variety of animals. Galleries carry his work.

BALDASARE FORESTIERE-"UNDERGROUND GARDENS"-FRESNO, CALIFORNIA
A vast underground environment that started when Forestiere wanted to reach the rich soil beneath his seventy acres of land so he could realize his dream of growing citrus fruit. The trees, with large skylights overhead, thrived, and so did the environment as Forestiere spent forty years creating rooms, gardens, walkways, archways, and much, much more. After Baldasare Forestiere died, the site was opened to visitors until the early 1980s, and the Underground Gardens Conservancy was formed. Now a family feud over the use of the property has stopped visitors and support projects.

TIM FOWLER
A young man who lives in the Seattle area and has been carving since he was about fourteen and his father gave him a Case pocket knife and told him it would last until he lost it. "I still have it but the blades are worn to nubs." He has spent a lot of time traveling but now feels pretty settled down. He says that for subject matter he depends on his own experiences. Many of his themes concern the issue of humans versus technology. One of his frequently photographed sculptured pieces is of a monstrous squatting man in the process of gobbling up a cozy neighborhood. It is called "Real Estate Developer." MIA Gallery carries his work.

SYLVIA FRAGOSO
(b. c.1962)
A woman with Downs Syndrome. She is very proud of being an artist. She paints what she sees in nature "transformed into a magic synthesis of color and design." Love of color is evident in her paintings and "realism has no place in her art." The National Institute of Art and Disabilities in Richmond, California shows her work.

JOHN FREDERICKS
Lives in Phoenix, but does some of his carving at his home in Kykotsmovi. He is self-taught in that he has had no formal art training, though he has worked with friends. He is a Hopi Kachina carver, but his carvings do not follow traditional religious patterns—they are sculpture. Fredericks considers his work art, not religion. Examples of his art are reproduced in color in the quarterly publication from the Museum of Northern Arizona, *Plateau,* 60(1) in an article by Linda B. Eaton. His work is in the Museum of Northern Arizona and is sold in galleries in Arizona and New Mexico.

PAULINE FREDRICK
(b. 1921)
Has lived in California all of her life. Using crayons as a child, Pauline exhibited a remarkable color sense. Now working with oil pastel and watercolors she produces work that possesses

deep rich tones. Images from Pauline's personal life and the color of the clothing she wears resonate in her paintings. Tea parties, dolls, coffee cups, pots, and trains are all recurring themes in her work. Direct application of line paired with color washes and reworked surfaces express her confidence and energy. Her work is available at the First Street Gallery in Claremont, California.

ALBERT FREEMAN

A "mystery artist" who is the subject of ongoing research by Robert Cargo in Tuscaloosa, Alabama. Cargo has approximately 160 pieces of his work. It is believed that at least at one time he lived in Lowell, Massachusetts. Freeman's subjects include many animals, portraits of some men and many women, cowboys on horseback, and horse-drawn carriages. He painted polka-dotted "frames" around the edges of his paintings. The work may be seen at the Robert Cargo Gallery, though it is not for sale. There is a Freeman "Lion" in *Animals in American Folk Art* by Wendy Lavitt.

ELLIOT FREEMAN
(b. 1953)

Born in Livingston, New Jersey. He now lives in southern California. In 1984 he left his career as an advertising copy writer and vowed to paint twenty watercolors a month for the rest of his life. He has yet to break that promise. Elliot began painting after an illness left him depressed and dissatisfied with the world. His paintings are a "visual diary of life's strange and awkward moments." Leslie Howard in New York carries his work.

MIKE FROLICH
(b. c.1922)

Grew up in the Ninth Ward of New Orleans. According to his stories, his travels started when he hopped a steamship bound for Nicaragua at the age of twelve. His paintings often portray romantic and strange seascapes and landscapes, with an exotic cast to content and color. At another time of his life he was part of the family-owned Frolich Brothers Marine Diving business and traveled the world from corner to corner. All along the way he painted, and for years was "artist-in-residence" at the Saturn Bar just east of the French Quarter, where he painted a huge mural of "the history of the world." He had a wife, who left him because of his heavy drinking, and a son and daughter. His son was killed at the age of seventeen in an auto accident. He met Ann and Marie Cusimano, who needed a manager for their Burgundy Street "Washateria," a coin-operated laundry. Frolich took the job and moved into a small room in the back and set up his home and "studio." Frolich soon had the walls of the Washateria hung with his colorful art. Area residents came to treat the place as an art gallery, and it was listed in a French guide book as a "place to see" in New Orleans. Ann Cusimano said Frolich "painted like crazy, almost frantic in his application of paint, frantic to finish the work." During the last twelve years he worked at the Washateria he did not drink, but previous habits took their toll and Frolich had a stroke while at work in the early summer of 1991. He is now in a nursing home. The Cusimanos sold the laundry business in 1992 (to a man who did not like the art and was going to throw it out). They made an arrangement with Gasperi Gallery to take the art that Frolich had previously given to them. They and Frolich will benefit from sales. The art is now at the Gasperi Gallery in New Orleans.

JOSEPH E. FUREY
(1906-1990)

Created a colorful mixed-media painted and decorated environment in his five room Brooklyn, New York apartment. The retired ironworker created a "dazzling collage on the walls, doors and ceiling of his apartment. He used paint, shells, lima beans, mirrors, wallpaper and small ceramic tiles." He also painted polka-dots and other designs and covered everything with a shiny varnish. He started the project in 1981 when his wife died. Before he himself died, he went to Goshen, New York to live with a son. The environment may be seen in pictures.

ROMANO GABRIEL- "WOODEN SCULPTURE GARDEN"- EUREKA, CALIFORNIA

Romano Gabriel, a skilled carpenter from Italy who moved to Eureka, California after World War I, found the local growing climate inadequate to his needs. So he built a garden "planted" with carved and brightly painted figures cut from fruit boxes. The garden grew to the point where his house was hidden; it contained political and religious figures, scenes from Italy, and figures from his imagination. A few of the pieces were animated. After Gabriel's death in 1977, a huge community effort spearheaded by Dolores and Ray Vel-

lutini resulted in the installation of the wooden garden into a protected space. Gabriel's Garden may be seen at 305 Second Street in Eureka, California and is open daily. A bird made by Gabriel is in the collection of the Kansas Grassroots Art Association. There are many written references to Gabriel, and the color illustration on the cover of the exhibition catalog *Pioneers in Paradise* is a detail from the Garden.

ED GALLOWAY- "TOTEM POLE PARK"- FOYIL, OKLAHOMA

Galloway built a brightly painted conical sixty-foot-tall totem pole as a monument to American Indians. He also built numerous smaller pieces and a museum to house his collection of fiddles. All the structures were embellished with designs and painted. The site restoration for this park was started by the Kansas Grassroots Art Association in the 1980s. Today the park belongs to the Rogers County Historical Society. Totem Pole Park may be viewed on Highway 25A east of Foyil, Oklahoma.

SAMUEL GANT

A forty-eight-year-old California man who is deaf and without speech, and is "constantly frustrated by his inability to communicate with others." His paintings are described as usually abstract. Colors are rich and dark, with repetition of colors, shapes, and sizes. "Very often he adds unintelligible symbols that have deep meaning for him. His painting and sculpture evoke a sense of isolation and loneliness." Gant is a gifted black American artist who conveys through his art what he cannot

say in words. National Institute of Art and Disabilities Gallery has his work.

CARLTON GARRETT
(1900-1992)

Spent most of his adult life in Flowery Branch, Georgia. His wood sculpture recreates scenes from the past and often depicts rural Georgia and folk heroes. He drew on his knowledge of mechanics to animate his work. Garrett died after a long illness on October 21, 1992. A good source of information about him is the book *O, Appalachia*. His work is in the High Museum of Art in Atlanta. Appalachia Folk Art in West Virginia and Texas sells his work.

HAROLD GARRISON
(b. 1923)

Lives in Weatherville, North Carolina. He carves political and social commentaries in wood in a gun-like format with figures that move when the rubber-band operated trigger is pressed. He is famous for his images called "water-gate guns." These have been illustrated in publications. He also makes wood-carved flowers and other objects that are more likely to be available. His work is carried by Southern Folk and Outsider Art in Washington, D.C.

VICTOR JOSEPH GATTO
(1893-1965)

Born in Greenwich Village. He was a plumber, boxer, and much more, who painted images from the interior world of his imagination. For detailed information read "The Art of Becoming Gatto," by Gene Epstein in *Raw Vision* 4. *Animals in American Folk Art,* by Wendy Lavitt, and the Hemphill and Weissman book

illustrate his work. Galleries carry his work.

REGINALD K. GEE
(b. 1964)

Resides in Milwaukee, Wisconsin, where he was born. He is described in the catalog "Contemporary American Folk Art: The Balsley Collection" with the statement: "Gee's images are concerned with events of life for a young black man living in a large northern city. He creates a visual collage of activities which depict the struggles of street life." He has been included in numerous exhibitions such as, in 1991, "Visions of Our Own" at the University of Wisconsin-Milwaukee. His work is available from John Balsley/Diane Balsley in Wisconsin.

EMIL AND VEVA GEHRKE -"WINDMILLS"-GRAND COULEE, WASHINGTON

Emil Gehrke made hundreds of windmills from material salvaged from the junkyards in about twenty-five nearby towns. His wife Veva painted them all, about three hundred in number. Gehrke, born in 1884, lived until 1979. Veva was born in 1902 and died in 1980. Since her death their work has been preserved. Some of it is in a fenced enclosure on the Grand Coolee Highway, and a few pieces are in Seattle at a City Light substation at Fremont Avenue North and North 105th Street. An article, "Grassroots Artists: Emil and Veva Gehrke," appeared in *KGAA News*. Their work was part of the exhibition "Yard Art" at the Boise Art Museum in 1991, and is included in the exhibition catalog.

LORRAINE GENDRON
(b. 1938)

Born in California and moved with her family to Louisiana when she was eleven. When her mother began suffering from arthritis, Gendron left school to take care of the younger children. Thirty-seven years ago she married and moved to Hahnville, where she still lives. "I married a Cajun at 17," she says, "and thought I'd moved to Disneyland! I love the bayous and the people. I lived someplace else long enough to know it's different here and this is home." This love for Louisiana culture and bayou country is reflected in her work. She had always liked drawing as a child. She makes Mississippi mud sculpture, sculptured scenes from cutout wood—her husband Louis cuts wood and digs the clay and cleans it—and she paints in oils, too. Some of her subjects include Cajuns in regional settings, New Orleans musicians, the Mardi Gras Indians, "Second Liners," and religious scenes. Her art pieces are interesting and extremely well done. She captures the special feeling of a special place that is southern Louisiana. Lorraine Gendron welcomes visitors. Call first for an appointment (504) 783-2173. Galleria Scola in Oakland, California carries her work.

CHARLES W. GIBBONS
(b. 1894)

Born in Ngaraard village, Palau, Caroline Archipelago. Details of his early life and background are given in the *World Encyclopedia of Naive Art,* by Oto Bihalji-Merin. He started to paint in 1959, concentrating on depicting traditional Palauan life. His work was exhibited at the University of Washington in 1971 and at the University of Guam in 1973. John Fowler in Hawaii carries his work.

EZEKIEL GIBBS
(1899-1992)

Born in Houston, Texas. He was a farmer all of his working life. Married for 63 years, he and his wife had nine children. He started painting at a senior citizens' program after the death of his wife left him depressed and lonely. He used pencil, pastel, and tempera. He often outlined the subject first, then filled in with bright colors and surrounded the forms with dots and dabs of color. His subjects were the familiar people and events of his life, especially his family history. Leslie Muth Gallery in Santa Fe carries his art.

SYBIL GIBSON
(b. 1909)

Began painting in 1963 when she was fifty-four years old. Her difficult years, in which she was beset by health and financial problems, pushed her to the breaking point and, in 1971, just after her work had attracted the attention of the Miami Art Museum, she "disappeared" and returned to Alabama. In Birmingham she lived in a seedy hotel, continued to paint, received high praise from critics, but sold few paintings. In 1981 she moved to a facility for the elderly in Jasper, Alabama. Her art, usually depicting people and animals, is painted with tempera on paper bags. Its subtlety of color and impressionistic quality comes from her practice of wetting the bag and painting the image before it dries. It is possible to fill in biographical details from writings about her life. Her work appears in nine galleries.

REGINE GILBERT
(b. c.1900)

Born in Austria and lived in Brooklyn, New York, and later Palm Beach, Florida. Gilbert raised two sons alone. She was a writer, spiritualist and painter "accepted with Grandma Moses as a primitive artist." She created boldly colored paintings of nature. Knoke Gallery in Atlanta carries her work.

ROBERT GILKERSON
(b. 1922)

From Oakland, California. He worked for many years as a mechanic, machinist, and miner in Northern California's logging and mining regions. Gilkerson makes constructions from natural and manufactured castoffs. The forms may be of people, animals, or monsters, painted in bright colors. Gilkerson says that each one has its story. His work is carried by The Ames Gallery in Berkeley.

RUSSELL GILLESPIE
(b. 1922)

Born in a log cabin in North Carolina, the state where he still lives. He is an ordained Baptist minister who is married and has raised three children. He farms and raises tobacco on a small scale, and still preaches occasionally. He creates "peaceable kingdoms" from found wood, including roots and knots. Animals and birds made from roots and knots and gourds are part of the scenes. Several galleries carry his work.

JOHN GILLEY
(b. 1963)
Lives in Frenchburg, Kentucky. He is married, has two children, and grandchildren, too. For years he was a heavy-equipment operator—"anything on rubber, I can run it," says Gilley. Then he had a heart attack and bypass surgery and became disabled. Now he stays up most of every night making his art. He searches for wood that "looks right" and creates birds from pine knots sitting on various branches and "trees," often painted with Wal-Mart paint. He also searches the countryside for small and medium sized boxes, installs a flock of painted birds, then "shuts the door" and decorates the box itself. The contents are usually a surprise to the unsuspecting browser. Gilley works in a shed behind his house. Several galleries carry his work.

RONALD DEBS GINTHER
(1907-1969)
Lived most of his adult life in Seattle, a good part of it on the original "Skid Road." He was a union official and a member of the Industrial Workers of the World. He championed the rights of the working class and recorded their desperation in the 1920s and 1930s. He considered his art a record of the true story of the times. Eighty of his paintings are in the Washington State Historical Society in Tacoma. Ginther was included in the catalog for "Pioneers in Paradise," and Wallace Stegman wrote an article about his life in *Esquire*.

LEE GODIE
(b. 1908)
Has been a well-known street artist in Chicago for many years. She now lives in New Elgin, Illinois, has Parkinson's disease, and no longer paints. Many publications tell of her work. Her work is in the Carl Hammer Gallery in Chicago and the Gasperi Gallery in New Orleans.

CAROLINE GOE
"Was, and maybe still is, a classic New York bag lady. She was discovered several years ago at her 'spot' on Avenue B by Barry Cohen. Cohen purchased from Goe whenever he traveled to New York and could find her. Since she had no telephone, Cohen would write her a card suggesting a time to meet. One can only guess, but it is quite likely that Goe's small pieces of canvas, and perhaps even her oil paint itself, were scavenged from the trash cans used by mainstream artists in the neighborhood. Caroline Goe disappeared in 1989." Tartt Gallery in Washington, D.C. has some of her work.

WILLIAM O. GOLDING
(1874-1943)
A black artist from Savannah, Georgia. He made portraits of boats and seascapes in watercolor and crayon on paper. Holding was a seaman and recorded many of the ports he visited. He is written about in several publications.

DENZIL GOODPASTER
(b. 1908)
Lives near West Liberty, Kentucky, a half mile from where he was born. He was a farmer, producing tobacco, corn, hay, cattle, and sorghum until he stopped at age sixty-five when he "got too old." He started carving his well-known walking sticks—sculptures in the round —in the 1970s when he quit farming. Frequent images are colorful spiraling snakes, bathing beauties, Dolly Parton, and an occasional nude. He starts his pieces with a hatchet and finishes them with a knife. He occasionally makes small animals. His wife makes quilts. Galleries carry his work.

MARION GOODWYNE
Lives in Napoleonville, Louisiana, and is a "primitive painter" of landscapes of rural south Louisiana and of her memories. Her paintings demonstrate an authenticity that is sometimes lacking in the genre. Southern Tangent carries her work.

TED GORDON
(b. 1924)
Comes from Louisville, Kentucky, and after spending his teenage years in New York now lives in San Francisco, California. He is known for his "compulsive line drawings, often brightly colored, of the human face." Galleries carry his work.

W.J. GORDY
(b. 1910)
From Griffin, Georgia. Mr. Gordy comes from a family of potters. His father was well-known for his work, as is his brother, "D.X." W.J. Gordy makes a number of shapes and functional objects. About one-fourth to one-third of his production is face jugs. His work is sold by Southern Folk and Outsider Art in Washington, D.C.

MIKE GRANATT
MARGARET GRANATT
Mike is a native of Buffalo, New York. He spent some time in New Mexico while in the Air

Force and there developed an interest in woodcarving and sculpture. He came to Oakland, California in 1969. Margaret grew up in Hawaii, went to college in New Jersey, and eventually moved to Oakland. Mike carves wooden figures out of pine and redwood; Margaret paints them with vivid colors, usually in acrylics. They sell their works on the streets of San Francisco and at Galleria Scola in Oakland.

JOHN GRECO-"HOLYLAND USA"-WATERBURY, CONNECTICUT

All the efforts in the world failed to stop the destruction of one of the largest folk art environments in the U.S., built by attorney John Greco "as an educational and visual aid for better understanding the Bible and the life of Jesus Christ." The church bulldozed it. A small part of the "Bethlehem" section and the catacombs remain and may be visited.

HOMER GREEN
(b. 1910)
Born in Coffee County, Tennessee. During his working years he was at times a carpenter, blacksmith, dairyman, factory worker, and utility lineman. He began carving small objects in cedar and then decided to "try something" and started cutting larger figures with a chain saw. He makes many animals including dinosaurs, alligators, turtles, and cows—and some figures strictly from fancy. At first he left them plain, but when he applied polka-dots with some leftover paint, his wife Rilda really liked them, and that became his standard. When Rilda died in 1989 he stopped working for a while

but now is carving again. Galleries carry his work.

CARL GREENBERG
Writes titles on most of his paintings, "song" titles such as Watermelon Songs, Barber Songs, Clown Songs. "Greenberg assigns a theatrical relationship to his subjects," although the relationship is not always clear to others. Greenberg works methodically but spontaneously, applying acrylic paint to paper or canvasboard without sketching anything first. His most frequent color choices are a rich mix of bright colors. Greenberg has exhibited with Very Special Arts in Washington, D.C., and his work is shown at the Luise Ross Gallery in New York.

MARY GREENE
Born in "in the 1920s" in Georgia, in the foothills of the Appalachian Mountains, the daughter of a poor sharecropper who died when she was small. Greene had little opportunity for any formal education and is a self-taught artist. She has severe arthritis. She is deeply religious and believes her talents are God-given. "She started painting at age 60, about six years ago." Her paintings relate to her memories and document the lifestyle of many country people in the 1920s and 1930s. Mary Greene paints in oil on canvas with "bright, cheery colors." Three Georgia galleries carry her work.

REX GRESSETT
(b. 1937)
Born in Denver, Colorado, and now lives in New York, in a shelter for homeless people in the Bronx. He is a self-taught art-

ist and does visionary paintings, oil on canvas, which frequently feature "little green men" and are attracting the attention of collectors. He sells his paintings on the streets of New York, often near the Museum of Modern Art.

RALPH GRIFFIN
(1925-1992)
Lived all his life in Burke County, Georgia. His art work is found wood that is carved a little and enhanced with some paint to bring out the animal or person within. Galleries carry his work.

RAY GROWLER
RUBY GROWLER
Husband and wife live in Shiprock, New Mexico, in the Navajo nation, where both were born. They work together and make carved animals of wood and cover them with real hides—goat or sheepskin—and attach wooden legs. This work is carried by Leslie Muth Gallery in Santa Fe.

JESUS GUILLEN
(b. 1926)
Born in Coleman, Texas. His father was a Mexican citizen and his mother a Latina from an old Texas family. Jesus lived in Mexico for a while as a young boy and delighted in watching his Tarascan Indian paternal grandparents make pots. Young Guillen began to paint on paper sacks, using natural dyes made from earth and plants. In 1935 Jesus' father died, the family returned to Texas to work in the cotton fields, and so began his life as a migrant. He was nine years old. He followed the crops for years, teaching himself to read and write English and

Spanish—and he never stopped painting. The migrant trail brought Guillen to La Conner, Washington, in 1960 and "he knew immediately that he was home." In 1961 his wife and children joined him there. Now settled down and with a job in one place, Guillen painted more and more, and also made sculpture. His work vividly reflects the migrant's life. He has a story to tell: "It is about hard work and the desire of migrants to be recognized for their work in the fields." This story unfolds on his canvases. Guillen also makes sculptured figures that he places around his home and his yard. Twisted bent twigs and vines are stripped of bark and then soaked in water so he can shape them into abstract sculpture. There have been several exhibitions of his work including a solo exhibition at the Whatcom Museum in Bellingham, Washington October 17, 1992-January 10, 1993. Jesus Guillen will show and sell his work from his home in La Conner. He will send photographs also. Call for an appointment (206) 466-3876.

BRYCE GULLEY-"MYSTERY CASTLE"-PHOENIX, ARIZONA

Bryce Gully abandoned his home and family in Seattle and disappeared into the Arizona desert when he discovered he had tuberculosis. He recovered while building a huge house that eventually had eighteen rooms, thirteen fireplaces and a chapel with an organ. He built it all without blueprints, adding rooms and stairways as he went along. He left "the castle" and surrounding small sculptures he made to his wife and daughter, The site is open to the public October through June. It is located in Phoenix at 800 East Mineral Road (602) 268-1581.

DELORES HACKENBERGER

From Pennsylvania. She is a "naive" painter of Amish life and uses acrylics on canvas. Leslie Muth Gallery in Santa Fe has her work.

DILMUS HALL
(1900-1987)

Born in Oconee County, Georgia, into a tenant farming family. After serving in the Army in Belgium during World War II, he lived in Athens, Georgia. Before being stopped by arthritis, Hall made sculpture—some of the devil in various activities, and some of fanciful human and animal figures. He built his statues of metal, wood, and clay. After his arthritis became too painful for him to continue making sculptures, he began to make drawings. His work is in the Huntington Museum in West Virginia and is carried by several galleries.

BERTHA A. HALOZAN

Born in Vienna but has lived in New York City a long time now. Her "Statue of Liberty" paintings are her most interesting work. On the back of every painting she pastes press reviews of her appearances as a cabaret singer. She recycles old frames, incorporating them into her work. Halozan was recently included in an exhibition "New York Folk: Rural and Urban Self-Taught Artists" in Cooperstown, New York. Her work is at Espiritu Gallery in New York, Gallery 53 Artworks in Cooperstown, and sometimes she sells pieces on the streets of New York.

THEORA HAMBLETT
(1895-1977)

Born in Paris, Mississippi. She was known for her sparse dream paintings. "She emphasizes the point of view of the observer . . . her paintings depict the onlooker's perspective while observing a vision." Her work is in many museums and books. She is included in the Rosenak encyclopedia and in Hemphill and Weissman. Edelstein/Dattel in Memphis carries her art.

ESTHER HAMERMAN
(1886-1977)

Born in Poland and died in New York. From 1950 to 1963 she lived in San Francisco. Hamerman and her family fled the Nazis in 1938 and lived in the British West Indies during the war. Her daughter and son-in-law encouraged her to paint when she was in her sixties. For the rest of her life she spent most of her time painting her memories—not at all bucolic—of a childhood in Poland and Austria, experiences of war and flight, and of her new life in New York and San Francisco. Her work is illustrated in *a Time to Reap*. The Ames Gallery in Berkeley, California carries her work.

RAY HAMILTON

Raised on a farm in the South and often draws farm animals. He also includes "magical quasi-human figures." He paints complex compositions, often incorporating words and letters. Hamilton uses a broad range of colors and media. Several galleries carry his work.

LARRY HAMM

Lives in Morehead, Kentucky. He is a wood carver who makes

a variety of constructions and images including small animals, models of log cabins and "Elvis." His work is carried by the Morehead University Folk Art Sales Gallery.

LOUIS EMIL "SLINGSHOT" HAMM
(1896-1976)

Came from Santa Clara, California, and died in Vallejo. His father, a Piute, was a carver; his mother was Spanish. He was a sharpshooter, accordion player, horseman, and wood sculptor. He was a World War I veteran, he and his wife were circus performers. For thirty-five years he was in show business, climbing to featured billing on the Orpheum circuit in the West and the Keith-Orpheum circuit in the East. He was the "compleat cowboy"; a rider and a roper. Eventually he went to work at the Mare Island shipyard in California, as a chipper, caulker, and grinder, until he retired at age seventy. He carved panels, snakes, canes, and totems. Main Street USA in Venice, California carries his work.

JAMES HAMPTON- "THE THRONE OF THE THIRD HEAVEN"- WASHINGTON, D.C.

James Hampton (1909-1964) and his "Throne of the Third Heaven of the Nations Millennium General Assembly" is installed on the first floor of the National Museum of American Art. His work has been studied by Lynda Roscoe Hartigan, appears in Hemphill and Weissman, and is written about frequently. His own writings and papers are in the Archives of American Art.

RODNEY HARDEE
(b. 1954)

Born and lives still in Lakeland, Florida. He lives with his wife and children and works for a food machinery factory. He has been painting for about twenty years, but in a more concentrated manner for the last ten. Over the twenty-year period he has produced about 170 paintings. He paints in a flat, "primitive" style with bright colored acrylics on plywood or canvasboard. His most frequently painted images are of cats, Adam and Eve, local country scenes, and portraits of women. Tyson's Trading Company in Micanopy, Florida carries his work.

JOSEPH HARDIN
(1921-1989)

Lived in Birmingham, Alabama. He suffered from rheumatoid arthritis from the age of seven, which confined him to a wheelchair. Hardin drew men and women, the women often nude, and also animals, birds, and flowers. Details of his art may be found in the Rosenak encyclopedia and the recent exhibition catalog *Outsider Artists in Alabama*. His work is available at several galleries.

CLETUS HARDY, SR.
(b. 1927)

Lives in Louisville, Kentucky. He started carving in 1986. He first carved some small figures and then started carving heads of historical and religious figures. His first effort came about when his sister-in-law asked if he could do a bust of her son Todd, who had been left in a semi-coma by an auto accident. He said he could not; she insisted and he tried it and succeeded. He has received recent attention

for busts of Martin Luther King, Jr. and Abraham Lincoln. He says he "carves anything that comes into my mind." His work takes form from religious inspiration, too. He may be contacted by calling (502) 361-3431.

GARY LAWTON HARGIS
(b. 1947)

Born and raised in Owensboro, Kentucky. His parents came from the Cumberland Mountains area. Hargis says: "My work has been influenced by travel. Most of my education has been in the woods." He is a self-taught woodcarver who draws inspiration for his creative designs from nature. His walking stick designs include whimsical animals, political, spiritual, or environmental themes, and snakes. A recent newspaper article described in great detail the variety of found objects he incorporates into his canes: gem stones, snake skin, deer hooves and antlers, and grape vines (see the newspaper article by Tracy L. McQueen, "Raising Canes" in the *Messenger-Inquirer*). His work is carried by Hackley Gallery in Kentucky and Very Special Arts in Washington, D.C.

STEVE HARLEY
(1863-1947)

Born in Ohio. Soon after, the family moved to Scottsville, Michigan, where he lived most of his life. He made "landscape paintings of great detail." He is included in numerous written resources including the Hemphill and Weissman book. All three known paintings of his are in the Abby Aldrich Rockefeller Folk Art Center in Williamsburg, Virginia.

ROBERT HARPER-"THE FAN MAN"-HOUSTON, TEXAS

The folk art environment of Robert Harper, *Drew at Napoleon in Houston,* was made from an incredible variety of objects discarded by others. There were many "skeletons" of electric fans and when the blades would all start whirling in the wind, the neighborhood children couldn't resist them so Harper built a fence of discarded bakery racks around the site. Susanne Theis of the Orange Show Foundation says "Although his work seems completely purposeful, sophisticated and even ritualistic, he swears it isn't." On January 19, 1992 Robert Harper lost his mother and his home in a fire. A fund to help him (the house was not insured) has been established and checks payable to "The Orange Show/Fan Man Fund" may be sent to the Orange Show Foundation in Houston (see chapter on organizations for the address).

ALYNE HARRIS
(b. 1943)

Has lived all of her life in Gainesville, Florida, with the exception of three childhood years spent in Milwaukee. She is a distant relative of Jesse Aaron. When she was sixteen, during the time she worked for Jesse's wife, Jesse made her a table. All her life she has been compelled to create. Even as a young child, Harris pored over whatever picture books were available to her, and her mother encouraged her interest in art. She also found a creative outlet by acting in school plays. The drive and determination to paint has not dimmed as she has aged. She is driven to paint, often all night, and panics when she does not have the funds to buy more paint. Harris has always had domestic service jobs—cooking, cleaning—until recently. She is now working in a restaurant. Harris is a self-taught visionary artist, who has the natural ability to choose color and plan the design as she executes her paintings. Her original expressions on canvas are varied and include flowers, religious pictures (including "haints"), scenes of black people nearly always at labor, and memory scenes from childhood. Her work is available at several galleries.

BEN HARRIS
(b. 1945)

Born in Fuquay-Varina, North Carolina. As he grew up he worked on the family's small tobacco farm. Later he moved to Raleigh, and held a variety of jobs in construction work, including welding. In 1977 Harris moved to Los Angeles and found work as a welder. During the 1984 Olympics he was inspired to create his first piece of sculpture, a figure of raw steel called "Olympic Runner." His work was discovered by folk art dealer Larry Whiteley, who gave Harris his first showing in 1985. Two southern California galleries carry his work.

JIM HARRIS
(b. 1958)

Born in Kirkwood, Missouri, and lives in Owensboro, Kentucky. He has traveled a lot to perform construction work, and this has influenced his carving. The majority of the works by Harris are caricatures of people, but he also carves animal figures. He carves basswood and paints the figures with acrylics. His work is in the permanent collection of the Owensboro Museum and is sold at the Little Green House in Hodgenville, Kentucky.

BEN HARTMAN-"HARTMAN ROCK GARDENS"-SPRINGFIELD, OHIO

Hartman filled his relatively small yard with statues, miniature stone castles, cathedrals, and other historic buildings. There are models of the White House and Independence Hall, a scene from the Oregon Trail, boxer Joe Lewis, the Dionne Quintuplets, religious scenes, and many more. Informants say the garden still exists and may be seen at 1905 Russell Avenue. In Springfield take Yellow Springs Street (Rt. 68) to McCain Street, turn right. The garden is on McCain and Russell.

BESSIE HARVEY
(b. 1929)

Lives in Alcoa, Tennessee. She is a profound, wise woman, who gives strength and support to her children, grandchildren, and great-grandchildren. She has had visions most of her life, which have influenced her root sculpture. She creates strong spiritual figures from found wood. Most of her recent work deals with black people's experience. She said during a visit to her home that she has gone to the library to look at African art and that it did not look to her like anything she has done. Bessie Harvey also does drawings. She has been written about frequently and her work appears in many galleries.

"CAP" HARVEY-"DRIFTWOOD MUSEUM"-COOS BAY, OREGON

Captain Lewis Harvey was a ship's pilot. He used to walk on the beaches a lot and pick up pieces of driftwood that resembled human forms. He would add found glass, shells and other items and fashion caricatures he called "Sea Goofs." They soon took over the house and yard. After his death in 1946 his "Driftwood Museum" was dismantled. Eight of his driftwood figures are in the KGAA Museum.

RODNEY HATFIELD
(b. 1947)

Grew up in Pike County, Kentucky. He tried college for a couple of years, choosing five majors during that time, mostly to "run away from the coal mines." New he is a self-taught "everything": musician, actor, and artist. His constructions, painted objects of wood and metal, "sometimes convey an almost whimsical look" and at the same time his work is influenced by the faith healers he grew up around. He says his art is spontaneous, not intellectual and he doesn't know what it will be until it happens. Hatfield lives in Lexington, Kentucky. Swanson/Cralle Gallery in Louisville carrries his work.

GERALD HAWKES
(b. 1943)

Lives and works in Baltimore. He makes matchstick sculptures from burned matchsticks dyed with color from earth, coffee grounds, grape juice, and other natural sources. He works with household glue and razor blades, making many geometric forms, which have symbolic sig-

nificance. Hawkes is written about in several sources; his work is sold by Carroll Greene in Savannah, and once in a while by Gasperi Gallery.

CONSTANCE HAWKINS
(b. 1962)

Lives in Atlanta, Georgia. She is a mentally challenged artist who "enjoys painting zoo scenes, city scenes, religious works, and flowers." She creates paintings in vivid colors, with pleasing aspects, using acrylics on canvas. Constance is able to work part-time in food service, but hopes to be a full-time artist. Her work is available through Modern Primitive Gallery in Atlanta.

WILLIAM HAWKINS
(1895-1990)

From Columbus, Ohio, is one of the best-known contemporary folk artists. He used plywood, masonite, and found objects, painted with semi-gloss enamel, to create his spirited bold images of buildings, animals, and other scenes. He often incorporated his name and birthdate into a painting. There are many written references to Hawkins, and his work is in several galleries.

T.A. HAY
(1892-1988)

A Kentucky native, and a tobacco farmer until the age of eighty. He served in World War I, during which he was wounded. "After his wife died, T.A. filled his final years by recreating his rural life in miniature, slowly turning the seven rooms of his house into what amounted to a museum of pre-industrial agriculture," according to James Smith Pierce. Detailed descriptions of his art

and more information about his life are included in the catalog *Folk Memories: T.A. Hay.* His work may be found in galleries.

HERMAN L. HAYES

A woodcarver and has been a Methodist minister for almost thirty years. He makes intricate carvings of all sizes from small people on toothpicks and golf tees to figures six feet tall. He is best known for his carving of miniature people in various settings such as a church or a sports stadium. The tiny carved faces have individual "looks." He uses basswood and buckeye most frequently, and leaves the carvings in their natural finish. He is included in the book *O, Appalachia.* He welcomes visitors to his home workshop in Hurricane Ridge, West Virginia but call first—(304) 562-6411. His carvings are sold at the sales shop in the Huntington Museum and in a number of galleries.

PAUL HEIN
(b. c.1936)

From Iowa. He began painting thirteen years ago, when he had time off from working. He spent Sunday afteroons in the basement working on his art. Paul especially likes to paint flowers—"They're peaceful," he says. His work is available from The Pardee Collection in Iowa City.

BILLY HENSON

"Has singlehandedly revived the South Carolina folk pottery tradition. He is the only traditional potter in the state renowned for the Edgefield tradition whose wares are so avidly collected today." Billy started his own pottery from materials left from the family pottery. He does

everything in the traditional way and produces utilitarian ware as well as face jugs. The Southern Folk Pottery Collectors Society shop in Robbins, North Carolina carries his work.

WOODY HERBERT

A Navajo wood carver who lives in the Navajo Nation, New Mexico. His carved animals are covered with a clay-like substance and painted. They may be from one to five feet tall. His work is at the Leslie Muth Gallery in Santa Fe.

VICTORIA HERBERTA-"PIGDOM"-HOUSTON, TEXAS

Victoria Herberta Zeisig (she doesn't use her last name) lives in a purple house near downtown Houston. Her house used to be brightly decorated for every season but then the city made her give up her inspiration, her pet pig Jerome, and Victoria hasn't been herself since. Susanne Theis has written about the site and believes the house is still worth a look (get directions from the Orange Show Foundation).

DEE HERGET

A Baltimore "screen painter" who is one of the artists featured in the film "The Screen Painters: A Documentary of Baltimore's Unique Folk Art. The screens are painted in such a way that a person can see out, but passersby cannot see in. They are painted with certain customary scenes or, as in Harget's case, sometimes with designs requested by the customer. Herget became a screen painter in 1977, when she quit a civil service job because of hearing loss. Herget is very busy. You supply the screen, and patience, and she will paint it. Her telephone number is (410) 391-1750.

JOE HERNANDEZ

A New Mexico carver. His work may be seen at Galleria Scola in Oakland, California.

CHESTER HEWELL
(b. 1950)

From Gilversville, Georgia. His family has been making pots for one hundred years and more. He uses a wood-fired kiln; the blue in his glazes is from Milk of Magnesia bottles. He makes face jugs. Galleries handle his work.

MATTHEW HEWELL
(b. 1972)
HEWELL FAMILY

Matthew is a member of a traditional Pottery family in Georgia's Hall County. He began working at the wheel when he was three years old. The Hewell Pottery is known for its gardenware, which is shipped all over the world. Several family members make face jugs too. Other potters in this family are his father CHESTER (b.1950), his brother NATHANIEL (b. 1976), and his grandmother GRACE. Matthew Hewell uses an alkaline glaze and burns in a wood kiln. His faces have large, round eyes and round hollow mouths with broken porcelain teeth. The bottom half of the face is generally heavy and protruding, suggesting jowls. Nathaniel's face jugs have pinched-looking faces. Hewell face jugs are carried by Lynne Ingram Southern Folk Art.

DWAYNE HEWSON
(b. 1961)

Born in Bowman, North Dakota, and lives in Yellville, Arkansas. Self-taught woodcarver Hewson has been carving for nine years. His carvings are very detailed. In addition to wood, he also executes carvings from antlers and bone. Hewson recently relocated from Texas to the Ozarks to be nearer several famous woodcarvers, whose works he greatly admires. His work is at Very Special Arts Gallery in Washington, D.C.

HAROLD HINCKLEY

A retired farmer, in his late sixties, who lives in Colliersville, New York. He works with found objects and old farm machinery to weld together small figurative sculptures. He leaves them unpainted but sometimes embellishes them with copper wire or coiled springs. Gallery 53 Artworks in Cooperstown carries his work.

MORRIS HIRSHFIELD
(1872-1946)

Born in Poland, came to New York City in 1890. He worked in the garment industry, and as a young man he showed considerable talent as a carver. In 1937, because of poor health, he retired from the business he had established and turned to painting. His work is very well known, and frequently illustrated in books. Women and animals were his favorite subjects, often set off by rich painted draperies of fabric.

ALBERT HODGE
(b. 1941)

A North Carolina folk potter who taught himself to turn, glaze and fire his own clay works after becoming aware of contemporary face jugs being made in Catawba County. He did not come from one of the tradition-

al pottery families. His work is highly prized by collectors who applaud his departure from traditional methods and art forms. Hodge uses a variety of alkaline glazes and turns both single clay bodies as well as swirl jugs. He fires in an electric kiln. His bright-eyed, open-mouthed face jugs are expressively detailed with teeth, mustaches, eyebrows and hair. He also makes jugs with animals and snakes. Albert's wife, Peggy, creates faces on many of the vessels and their work is signed by either or both. The work is available from Lynne Ingram Southern Folk Art.

MACK HODGE
(b. 1937)
Lives in Pineville in southeastern Kentucky. He worked in coal mines in Kentucky and factories in Ohio, and then moved back to Kentucky. He carves small wood sculptures of figures doing work such as farming or coal mining. He also carves animals, country churches, canes. His work is illustrated in the *Sticks* exhibition catalog and in *Folk Art of Kentucky*. His work is at the Kentucky Art and Craft Gallery in Louisville.

LONNIE HOLLEY
(b. 1950)
Born in Birmingham, Alabama, and lives there still. He spent most of his youth in foster homes and reform schools. He now has a large family of his own, with his five youngest children living with him. His yard is a huge environment of assemblages made from other people's discarded objects. In addition he paints and makes carvings from cast-off sandstone from a nearby foundry. His work is highly

thematic and centers on the human condition. He is wonderful to watch when he is working with children, as he does in the fall at the Kentuck Festival. Holley is written about frequently and numerous galleries carry his work.

ERIC HOLMES
Lives in a residence in Miami Beach for psychiatric patients. He attended college earlier in his life but is without art experience. He has stories for each of the paintings he does. His large painted boards are often of women, and his palette varies from bright primary colors to somber dark ones. His work is in the permanent collection of the American Visionary Art Museum in Baltimore, and available from Vanity Novelty Garden in Miami Beach.

JULIET HOLMES
(b. c.1953)
A "highly emotional, vibrant person who lives a great deal in fantasy land. Her pictures reflect her personality in their exuberance and vitality." She does figurative work intermingled with abstract design. She paints people, buildings, and animals, and often uses felt-tip pens. Her work is available at the gallery of the National Institute of Art and Disabilities.

CAMILLE HOLVOET
(b. 1952)
Born in San Francisco and lives there now. When Holvoet entered the Creative Growth art program in 1982, she was noted as a talented young woman with obsessive behavior patterns. In the following years, she has used her obsessive energy to create direct, powerful, and intensely

moving images in her artwork. Holvoet has a photographic visual memory. Her drawings, paintings, and sculpture are often camera-like stills of past experiences and present perceptions. She often mixes real and dream images, light fantasy and disturbing psychological insights in the same works. Her artwork is always vibrant, intensely colored, and compelling. Holvoet's artwork is exhibited regularly and available for sale at Creative Growth Gallery.

SOL HOLZMAN
Lives in New York State. When he retired from his job as a shoe salesman, his son taught him to carve. He creates carved figures, sometimes tall and thin, sometimes chunky and legless, depending on the wood scraps available. His work is available from The Ames Gallery in Berkeley.

WILLIAM HOLZMAN
(b. 1903)
Says that the day he was born in North Freedom, Wisconsin, it was such a stormy day with so much snow that his father had to get out and make a path for the midwife. He weighed six pounds, "but there are no records to prove I was born." He went to Tucson, where he now lives, because of the health problems of his first wife, who has since died. Later he married his present wife, whom he met when his son married her daughter. Holzman worked in copper mining, shipping ore and building company towns for mining companies. He was a union man, but unemployed about half the time. Then he was a warehouseman for twenty

years, until he retired in 1972. After he quit a "retirement job" as a church custodian, he and his wife decided to spend their time fishing, but they never caught anything (which also meant there were no fish to clean—a "plus" in his eyes). One day his wife refused to go, deciding to sew instead, whereupon he went to his shop to whittle. Holzman made wildly colored windmills, doll houses, small animals, book ends, and other objects out of plywood. He started taking his creations to the outdoor market in Tucson in 1979. One day, a woman attending a glass convention in town bought a windmill and set it up at her hotel. Everyone wanted one, and soon he was sold out. Galleries carry his work.

ANNIE HOOPER
(1897-1986)
Lived on Cape Hatteras and filled her house and out buildings with thousands of figures inspired by the Bible, work she made to fight off loneliness. Her work was saved by the Jargon Society and the pieces are now in the collection of North Carolina State University in Raleigh. In 1994 there will be a major exhibition of the work at the university and a catalog will be published.

ALVA HOPE-ENVIRONMENT-STEPHENVILLE, TEXAS
Alva Hope (b. c.1906) is eighty-six years old, an ex-cowboy and farmer who lives in central Texas, in Stephenville, which is near Waco. A few years ago, a plastic milk bucket flew out of a passing pickup truck and landed in Alva's front yard. He figured he could either throw it

away or "do something with it." More than three years and 200 whirligigs later, Alva Hope has created a fanciful found-art environment that all his neighbors can participate in. Children bring their old toys to adorn the plastic buckets he cuts and paints. Adults drop off everything from band-aid cans to straw hats. Around Alva's place, a simple wind becomes an amazing phenomenon as row after row of plastic babies and cows and arrows and buckets spin in every direction. The bright paintings on the buckets include self-portraits and occasional cryptic messages to people in Alva's life, both living and dead." Some of his work is available at Leslie Muth Gallery in Santa Fe.

CHARLIE HOPKINS
(b. 1926)
BETTY HOPKINS
(b. 1923)
From Illinois, Charlie from Edgar County and Betty from Georgetown. They now live in Georgia. Charlie worked as a supervisor of county roads in Illinois for many years. They began making birdhouses in the late 1980s, after Charlie had surgery. He constructs the birdhouses and Betty paints them. The birdhouses are replicas of "regular" buildings and houses, often with such touches as porch furniture. Southern Folk and Outsider Art in Washington, D.C. carries their work.

DAN HOT
Lives in the Navajo Nation in New Mexico. He carves bulls and other animals of great character, using fabric and sheep wool over wood forms. Often his animals are anatomically com-

plete. His figures range from one to five feet in size. His work is available at two Santa Fe galleries.

JESSE HOWARD
(1885-1983)
Lived in Missouri and created an environment with thousands of signs expressing commentary on politicians, taxes, government regulations, and his neighbors, who tried to have him locked away. His work is in the Kansas City Art Institute and the Museum of American Folk Art. He was the subject of an exhibition sponsored by the organization Intuit, "Free Thought, Free Speech, and Jesse Howard Is My Name" in May 1992. Hemphill and Weissman describe his art. Occasionally his signs will turn up for sale.

FELIX "FOX" HARRIS-"FOREST"-BEAUMONT, TEXAS
Harris (d. 1985) was commanded by God to make art and so he did by using found objects and filling his yard with "constructions and totems," creating an amazing forest alive with color and movement and his vision and spirit. The site is dismantled but may be seen in a publication and at the Museum of Southeast Texas, in Beaumont.

SYLVANUS HUDSON
(b. 1911)
Born in Athens, Georgia. He is a "self-taught naive artist" who began producing artwork in his fifties, when he made pieces to sell at his church. Working in a variety of media, including paintings and driftwood sculpture, his most common work is objects made of broken and colored glass. Weathervanes An-

tique Shops in Thomson, Georgia carries his work.

WALTER TIREE HUDSON
(b. 1943)

Born in Virginia. He was formerly married, and has two sons. After dropping out of school, he served in the U.S. Army. He obtained his high school equivalency degree in 1968. From 1972-1978 he hitchhiked over 200,000 miles, systematically covering forty-eight states and other points of interest. Tiree, as he is called, has been in three mental hospitals over the years, but is now living on the "outside" with the help of disability payments. He has been painting for over ten years, first with chalk on the walls of an apartment building that his brother owned and now on art board, canvas, and found materials. He says "Topography has become the object of interest in my art. Some say it is wanderlust, well, maybe so, but it is a form of 'full art' also." His paintings are filled with characters and symbols that can be "living guardians, spirits, or just a breeze or the wind. Also warnings and other indications." He has produced over 60 notebooks, some 1,500 pages, with more than 10,000 pencil drawings in each, describing his "full art." All this "picture writing" is part of Tiree's struggle to function and stay healthy against what he perceives to be an uncaring and hostile society.

His work is available in galleries.

YVONNE HUDSON
(b. 1966)

Born in Oakland, California, and now lives in Richmond. Her life has been a struggle, due to cerebral palsy, but she is a person with determination, pride, and talent. She is dedicated to producing her art, and comes to the studio six days a week to work. Although she has difficulty writing, she has tremendous control over her drawing and painting. She has been in many exhibits in California. She works in tempera, felt pen, and clay; her subject matter is primarily animals. The National Institute of Art and Disabilities Gallery in Richmond, California carries her work.

HARVEY HULL

A cane carver from Kentucky. His canes are often carved with snakes and have heads representing donkeys and other animals. His work is carried by Southern Folk and Outsider Art in Washington, D.C.

CLEMENTINE HUNTER
(1887-1988)

One of the most important and well-known folk artists of the twentieth century. She grew up in northern Louisiana, picked cotton, and always worked hard for other people. She started painting around 1964 and was encouraged by Francois Mignon, a frequent resident at Melrose Plantation. Hunter "used pure colors, with no attempt at modeling, scale, or perspective." She consistently portrayed the lives of black people in her countryside. There are numerous written works about her, including descriptions in the Hemphill and Weissman book and *Clementine Hunter: American Folk Artist,* by James L. Wilson. Galleries carry her work.

JOHN W. HUNTER

Born in Texas and started carving when he was a boy. He was also a minister of his church. He liked to work with found objects and could work marvels with a downed tree branch, creating carved figures. His work is carried by many galleries.

ERNEST HUPENDEN-"PAINTED FOREST"-VALTON, WISCONSIN

The "Painted Forest consists of murals covering the walls of a 33-foot by 60-foot lodge hall." They were painted by Hupenden in the early 1900s and restored by the Kohler Foundation in the 1980s. Lisa Stone calls them "a brilliantly cohesive personal vision." Maintained by the Historical Society of Upper Baraboo Valley, they are open summer months and by appointment.

BILLY RAY HUSSEY

Grew up in Seagrove, North Carolina, where he lived near the Owens Pottery. He made his first sculpture at the age of ten. His first face jugs were actually jugs turned by M.L. Owens, on which he made the faces. Billy Ray is the only folk potter who works in both earthenware and stoneware. He makes humorous face jugs and figures of animals and people. Several galleries carry his work.

CHARLES W. HUTSON
(1840-1936)

An early New Orleans self-taught artist. He was born in South Carolina, fought in the Civil War, and was captured by the Yankees. He was a teacher for many years and moved to New Orleans in 1908. Hutson started to paint at age sixty-five, and was quite prolific. In his earliest years as an artist he produced several hundred pastel

sketches, which he "worked with great delicacy, all delicately and finely drawn." In the 1920s he turned primarily to watercolors, with some pastels and oils. "During this period he used much bolder methods of grouping shapes and gave greater attention to patterns . . . ". He became more abstract in his last years. "He was always able to capture the essential character of nature." His major subject matter was New Orleans, the Gulf Coast, and nature in Louisiana and Mississippi. There were approximately thirty exhibitions of his work, including ones at the Delgado (now New Orleans) Museum of Art and The Phillips Collection. One of Hutson's works is illustrated in *Twentieth-Century American Folk Art and Artists* by Hemphill and Weissman; other publications also include illustrations. Museum collections that have his work include: Lauren Rogers Museum of Art in Laurel, Mississippi; The Phillips Collection; Montgomery Museum of Fine Arts; and the Mint Museum in North Carolina. Gasperi Gallery in New Orleans carries his work.

ELIZABETH WILLETO IGNAZIO

Navajo carver whose work is carried by Leslie Muth Gallery in Santa Fe.

LEVENT ISIK

Grew up in Montreal and lived in Cleveland before settling in Columbus, Ohio. He started painting in 1989, inspired by the works of other Columbus artists. Isik says his "main influences are William Hawkins, Morris Hirschfield, Van Gogh, and Mr. Imagination." He is self-taught. He paints twelve hours a day, ev-

ery day. Isik paints many images of what he has known, seen, and imagined. He produces "mixed-media paintings," but this hardly describes his wide variety of techniques. He paints cityscapes, wildly fanciful animals, superwomen, and angels, using a variety of patterns, colors, and built-up surfaces that above all fit the subject he is portraying. His work has been in numerous exhibitions in a very short time. Lesley Constable, in a Sunday, September 13, 1992 review in the *Columbus Dispatch* of a show in Columbus, says "His visual lexicon adds up to a playful, warmly humanistic vision filled with homey wisdom and more than a dash of bawdy humor." Objects Gallery in Chicago carries his work.

LOLA K. ISROFF
(b. 1920)

Born in New York City and now lives in Akron, Ohio. She is a sophisticated, well-educated, and travelled writer. She started painting "by accident." She could not describe in words some vintage buildings for a book she was writing, and in reaction used a neighbor child's watercolors to "paint away" her writer's block. When reaction to her art was favorable she continued and has been painting ever since, switching to acrylics on paper. She paints many subjects, especially cityscapes. Her work is illustrated in the exhibition catalog *Interface* and in *American Folk Art of the Twentieth Century,* by Johnson and Ketchum.

BOOSIE JACKSON
(1881-1966)

Born in Union Springs, Alabama. He was a carpenter, tomb-

stone maker, fix-it man, and artist who, without any training or much formal schooling at all, achieved considerable sophistication and perfection in his art. He created a menagerie of brightly painted cement monsters around his house, including a ten-foot high cement milk pitcher and large, foreboding creatures such as nail-toothed serpents and open-mouthed alligators that appear to have had the job of "protecting his home from evil" by scaring away ill wishers. None of his work remains intact except a few isolated pieces, discovered and salvaged by Anton Haardt just a few days before the site was completely demolished. Jackson also carved walking canes and painted on paper. One of only three of his paintings known at this time is a large enamel-on-masonite piece entitled "This Is a French African Building," which depicts a large building supported by two oversize dogs, and is in a carved wood frame incorporating common southern delicacies such as sweet potatoes, watermelon, corn, and turnip greens. A few of Jackson's pieces that remain may be seen (but not purchased) at the Anton Haardt Gallery in Montgomery.

EDDIE JACKSON
(b. 1900)

Born in Richmond, Texas. He moved to Houston in 1938, where he worked for twenty years as a metal cutter. He was forced to retire due to illness in 1968. He got bored with retirement and started drawing, sometimes all night, after receiving encouragement from a senior citizens center. Jackson was included in the *Eyes of Texas*

exhibition in 1980. Leslie Muth Gallery carries his work.

MYLES "MICHIGAN" JACKSON
(b. c.1927)

Born in Michigan and now lives in Hoboken, New Jersey, at a YMCA. He has been a steel worker, coal miner, and taxi driver. He makes "firepieces" to emulate a hearth, which he believes every home should have. He says "The hearth has been lost. It used to be the center of man's universe, not only for physical warmth but for visual and social warmth, too . . . An apartment without a fireplace is not a home, but you can do the job with a firepiece." His constructions are made from salvage, including antique dock spikes and ball bearings, and found wood. His works are meant to be used and handled. Some have components that can be moved from place to place to evoke the feeling of building and stoking a fire. His pieces have been exhibited, and are available from Leslie Howard in New York.

SCOTT JACKSON

Makes carved, painted figures. One example seen is a person with a cane, carved wide-brimmed hat, and two carved birds on his shoulders. Kentucky Art and Craft Gallery carries his work.

ETHEL JARET

A participant in the HAI program for mentally ill artists in New York City. She paints figures, flowers, and animals. Her fish have faces that wear delicate smiles. Her cats also have smiles that hint at secrets. Jaret has a rich sense of color, whether working in watercolor, colored

pencil, or marker. Renee Fotouhi Gallery East in East Hampton, New York carries her work.

ALVIN JARRETT
(b. 1904)

Born near Rockvale in central Tennessee and now resides in the town itself. He carves old red cedar—wood he calls "slave wood" because it "has been around since the time of the slaves." He makes many forms, including totems rough hewn, with marble eyes), walking sticks, and small jointed figures that often are seated on chairs. His work is available at several galleries, and has been shown at the Smithsonian.

UNTO JARVI
(1908-1991)

Born in Saaksmaki, Finland. He came to the United States at the age of eleven with his mother and two sisters, to join his father. He worked for fifty years in construction, in nearly every state. In 1971 he settled in Kentucky with his wife Bernice, a native of Logan County. He first started painting in 1959 to pass time while recovering from an accident. When he came to Kentucky he began again, painting landscapes and rural activities. His most distinctive creations are shallow boxes faced with glass in which he arranged covered figures in front of a painted background. Jarvi's work is carried by galleries in Kentucky.

CHARLES JAY

A black artist from the Philadelphia area. His hobbies are chess and oil painting. He is influenced by Flemish oil paintings on panels, which he strives to emulate in his own work by using expensive paint, plus var-

nish and masonite. His work is available at Cognoscenti in Baltimore.

HARRY JENNINGS

From southeastern Kentucky, carves small wood figures in a style similar to that of other carvers of small animals. His work may be found at Kentucky Art and Craft Gallery.

JAMES HAROLD JENNINGS
(b. 1931)

Born in Pinnacle, North Carolina. He lived with his mother until she died in 1974. She was a school teacher, and tutored him from the fifth grade on. He used to work as a projectionist at a drive-in movie. This well-known North Carolina artist makes wooden constructions that offer a great variety of figures and groupings. He makes Indian figures, Elvis with guitar, angels decorated with symbols which reflect his religious beliefs, bird houses, "Tufgh" women beating up on men and/or the devil (who, as his titles reflect, he usually sees as deserving it), and some very large pieces such as his "Folk Art World" and his ferris wheels. Jennings' art works are very brightly-colored and patterned. The artist has appeared in numerous exhibitions and his work is illustrated frequently. He is represented in many galleries. James Harold Jennings and his many cats enjoy visitors. Even more, Jennings enjoys getting postcards (PO Box 558D, Pinnacle, NC 27043).

ALONZO JIMENEZ
(b. 1949)

Born and still lives in Santa Fe, New Mexico. He spent a great

part of his childhood and adolescence helping his grandfather herd goats. "There were no kids to play with. My family didn't have a car or a TV, but I always had a knife in my pocket to carve with." One day Alonzo met Felipe Archuleta while hitchhiking. "Felipe right away wanted me to work . . . Felipe made me laugh all the time. He spoke Spanish all day. Felipe loved me because I could stand a piece up real fast." Four productive years and a mutually beneficial relationship were the legacy of this chance encounter. In 1978, Alonzo started carving on his own. He continues to make animal woodcarvings of every size and description. He is perhaps best known for his cats, various African animals, and coyotes. His work is in the collection of the Albuquerque Museum, is illustrated in *Animals in Folk Art* by Wendy Lavitt, and is available at Davis Mather Gallery in Santa Fe.

EUGENE "BAATSOSLANII" JOE

Born and still lives on Navajo land in New Mexico and Arizona. As a child growing up he was very close to his grandfather and listened to his stories. For a while, Baatsoslanii worked with his father, a traditional sand painter, who "was careful not to violate the sacredness of the actual ceremony" when he did commercial sandpainting. Baatsoslanii makes "creative sand art"–contemporary interpretations of Navajo life and legend. He no longer does any traditional sandpainting. When he starts out, he says, "I have a vision in my mind, an outline of what I will paint." The artist's work is

available at Cristof's Gallery in Santa Fe.

ANDERSON JOHNSON
(b. c.1916)

A preacher in Newport News, Virginia. The walls of his Faith Mission are covered inside and out with hundreds of paintings, usually done on salvaged plywood or cardboard, or on canvas that is usually a gift. Johnson creates painted portraits of people and animals, Biblical images, and landscapes. He is quoted as saying "Sometimes I see a whole vision of something before I even pick up the paper. I'm a creator. I like to take nothing and make something of it. That's the way of the Lord." Linderman Folk and Outsider Art in New York has his work.

SUDIE JOHNSON
(1926-1991)

Lived in Wiregrass, North Carolina. She was born in Piney Green, near what is now the main gate of Camp Lejeune. Her mother was a housewife and her father (named "Waters") a farmer, laborer and rattlesnake milker by reports, but all Sudie remembered was that they traveled around the Southeast and elsewhere is a large shiny car until they settled east of Greenville in Pactolus, North Carolina in 1933. By the following year all six of the Waters children were wards of the state, ending up in different homes. She went to live with people named Carawan in Greenville's shantytown known as "Mill Village," and she would later say her legal employment at Greenville Spinners began when she was sixteen. Several years of long hours in the lint-filled air were to contribute to her life-long ill health.

She had one short and unsuccessful marriage to Robert Baker in 1949 and then married captenter Isaiah Johnson. They settled in Carteret County and had three children. In 1956, when she was thirty years old, she had trouble with her right arm, as a result of the textile work, and a doctor told her to squeeze a rubber ball. Instead she started to carve. She continued to carve for the next thirty-five years, creating images of people she knew, devils, angels, and fashionable women. She used scrap lumber and an occasional cypress knee. She painted most of the figures. When she ran out of wood she painted every surface in her house. Sudie Johnson was not interested in showing her art until just before she died and she agreed to an exhibition of her work at the Faut Gallery in Beaufort. [This information was supplied by folklorists Debbie and Mike Luster]. Occasionally there are carvings by Sudie Johnson at the Tartt Gallery in Washington, D.C.

SYLVIA JOHNSON
(b. 1947)

Born in New Mexico; her father was a third-generation New Mexican and her mother was a Canadian. She is married to "an idealistic school teacher," and she and her family live in a small mountain town near the Navajo reservation where her husband teaches. For many years Sylvia Johnson made uniquely detailed applique paintings, after teaching herself to sew. Now she has set aside her stitchery materials and is using canvas and acrylics, painting with as much interest and detail as her previous work. She is

represented by Cristof's Gallery in Santa Fe.

CLYDE JONES-"HAW RIVER ANIMAL CROSSING"-BYNUM, NORTH CAROLINA

Driving to the site the first clue that you are getting close is a sighting of a North Carolina forest filled with life-sized giraffes "grazing" among the trees. Then the house and yard is seen filled with incredible numbers of creatures. If you get lost any neighbor will tell you where "all that junk," to quote a local resident or two, is located. Clyde Jones (b. 1938) carves large roots and stumps with a chain saw. Many are further enhanced with house paint and found objects such as tennis ball "eyes," plastic eyelashes, and artificial flowers in their "hair." They look absolutely great together in his yard and in fact Jones does not like to sell them. He also does some large paintings of animals. Jones doesn't seem to mind visitors, especially children. His work is in galleries.

FRANK JONES
(1900-1969)

Born near Clarksville, Texas. His life was filled with tragedy. His father deserted his family just after Jones was born. When he was three his mother abandoned him on a street corner. He was taken in by a woman he called Aunt Della. He had one miserable experience after another, many the fault of an ugly racist society. In 1949 Della Grey was murdered, and Jones was convicted of the crime, though it was generally believed by all but the authorities that he was innocent. Jones served a life

sentence and died at the prison in Huntsville, Texas. While in prison he began drawing a series of "devil houses." There is much written discussion and interpretation of his work. His art is inspired by pain and genius. Several galleries carry his art.

JOAN JULENE JONES
(b. 1950)

A native of New Orleans. Joan (pronounced Jo-Ann) has three sisters and a brother. She was a foster child until she was fourteen, when she found her birth mother. Christened a Catholic, raised by a Baptist foster mother, the latter sent her to mass so as not to go against Jones' "real" mother and then took her to Baptist Sunday school. Jones says she had a happy childhood. After graduating from high school Jones joined the Marines and then, in the early 1970s, attended college for a year. In 1974 the welders' union brotherhood received a government grant to train people. Jones signed up to learn welding, but they really did not want her: a black woman with dreadlocks was not what they had in mind. She learned the skills and since has applied them to her art. Jones takes sheet metal, copper, and brass and welds them into sculptures that she paints with acrylics. She decorates some of her sculpture with found objects, including Mardi Gras beads, peacock feathers, and parts from old television sets. She cuts all of her pieces freehand, without a pattern. Her sculpture takes many forms, some of which, such as bands and jazz funeral processions, capture New Orleans culture. Other pieces—figures jumping rope or playing music, children sliding down a slide, a

child on a tricycle—are Jones' message to people, especially children, that we must capture the simple pleasure and fun of life if we are to survive. She wants to remind children, and the rest of us, to remember the possibilities of childhood. She says of her medium: "Metal will last. It is history." At the 1992 Jazz and Heritage Festival, Joan unveiled her first two life-sized pieces—a seven-piece "second line" group and a lady (Eve? a snake goddess?) whose skirt and hair are made up of colorful snakes. They are awe-inspiring. Jones especially likes to work with children and teaches art at a recreation site in a New Orleans Housing Project, for which they can afford to pay her very little. She is a "Louisiana Living Treasure" and one of twenty local artists who demonstrated their work at Jax Brewery near Jackson Square. Joan Jones creates inspired work, she gives of herself to the children of the community—all kids, black and white, flock to her—and she is homeless as of this writing. Her work is in Galleria Scola, Gilley's Gallery, Barrister's Gallery, and Southern Tangent.

M.C. "5¢" JONES
(b. c.1918)

Born in Eagle Shute, Louisiana, and lived most of his life on the J.W. Lynn Plantation between Belcher and Gilliam, where he was a laborer. He makes many memory paintings of plantation life, with some unusual touches—"he has been known to make the overseer black and the laborers white." In 1940 he had a dream in which God, Jesus, and a flock of sheep appeared, and he was instructed to use his

talent to paint. His works reflect the rural life he lives and his religious beliefs; he also paints nudes and self-portraits. Numerous galleries carry M.C.'s work.

RALPH JONES

A black artist from Gonzales, Louisiana who is self-taught and paints primitive works with a special quality that captures the flat, watery look of southern Louisiana. He is crippled by polio. Jones is a friendly person with a great sense of humor. Southern Tangent carries his work.

S.L. JONES
(b. 1901)

Born in Indian Mill, West Virginia, and lives in Hinton. For forty-seven years he worked as a carpenter-foreman for the Chesapeake and Ohio Railway. His abiding artistic passion has been the fiddle and banjo, which he taught himself to play. Shortly before retiring in 1967, Jones began painting. After his first wife died in 1970, Jones took up carving. His heads are usually asymmetrical; he roughs them out with a chain saw, and then refines the sculpture with hand tools. Since having a stroke, he has done more drawing than carving, with horses being one of his favorite subjects. He usually works in a shed in front of his house, but occasionally also draws in the house. His work is available in many galleries, and may also be seen at the National Museum of American Art.

JOHN JORDAN
(b. 1919)

Born in Stamford, Connecticut. He began sculpting by making his own toys. As an adolescent he worked with a local junkman. After World War II he had his own truck and began to search out discarded objects to use in found-object sculpture. In the 1950s he did floor refinishing and carpentry, which gave him access to fine woods, and he began to carve black walnut, cherry, and cedar. Since he retired he works at his art full time. He makes woodcarvings and found object sculptures. Dan Prince, who represents the artist (Prince Art Consultants in Stamford) believe Jordan's art shows influences from his African heritage.

NICK JOVAN
(b. c.1926)

Grew up in the Chicago area. He joined the Marines at seventeen to fight in world War II, then studied geology for two years and went off to northern Canada to prospect for various minerals. In 1953 he took up song writing and moved to New York. Fourteen years ago he returned to Illinois and took up painting. Ideas come to him from his many life experiences. He says his visions are so complete that he just transfers them to canvas to create a painting. He feels some "greater force" directs his work. Most of Jovan's work is a commentary on life's spiritual struggles or issues of the human condition. His work is represented by The Pardee Collection in Iowa City, Iowa.

JOSEPHINE H. JOY
(1869-1948)

Born in West Virginia. She lived in California from 1924 to 1942, where she worked at the Southern California Art Project from 1936 to 1939. She never formally studied art. In 1942, the Museum of Modern Art sponsored a traveling exhibition of her works. She was included in the exhibition "Cat and a Ball on a Waterfall" in 1986. Joy died in Peoria, Illinois. Her work may be seen at the National Museum of American Art.

LAVERN KAMMERUDE
(1915-1989)

Lived in Blanchardsville, Wisconsin, painted images of midwestern rural scenes from his memories. Starting late in life, he depicted the seasons of old-time farming in oils on masonite. He has been written about and his work is in the collection of the Wisconsin Folk Museum in Mount Horeb.

ANDY KANE
(b. 1956)

Born in New York and now lives sometimes in Philadelphia and sometimes in Chicago. He used to do "very primitive work" but has changed his style of late and says he "wants to be a real contemporary artist." He did not complete high school. His art work is illustrated in the book by Johnson and Ketchum. It is also in the collection of the Museum of American Folk Art and is available in galleries.

JOHN KANE
(1860-1934)

Numbered among the earliest of the twentieth century self-taught artists of importance. Biographical information is available from many sources. He was born in Scotland and lived in Pittsburgh as an adult. It has been said that "no artist equaled John Kane in portraying the industrial scene." For detailed information about him, read *John Kane, Painter*, by Leon Anthony

Arkus and check other references. Kane's work is in The Phillips Collection, the Museum of Modern Art, the Museum of Art of the Carnegie Institute, the Parrish Art Museum, the Metropolitan Museum of Art, and the Whitney. Galerie St. Etienne in New York carries his work.

EDWARD A. KAY
(1908-1988)

Born and raised in Detroit, Michigan. His keen observations of nature, politics, and urban life appeared in his art. He was fascinated by American Indian cultures, which influenced him to make totem creations and install them in his yard in Mt. Clemens, Michigan. In addition he made relief carvings on boards. Kay used images from politics, including political figures such as Jimmy Carter, Gerald Ford, Martin Luther King, Jr., and Nikita Krushchev to express his growing irreverence for authority figures. His work is included in *Made With Passion,* by Lynda Roscoe Hartigan and in the exhibition catalog, *New World Folk Art.*

BARBARA KEETON
(b. 1953)

Born in Paintsville, Kentucky, and now lives in Martha with her husband, Charles. Two of her four daughters are married, and she is a grandmother. Barbara Keeton began painting in 1992, using acrylics on paper. She uses strong color and a flat presentation in the naive style. She paints her Kentucky environment—the people and places she knows. She sells her works directly; call (606) 652-4981.

CHARLES KEETON

Grew up in eastern Kentucky, and had no education beyond elementary school. He says it has meant he has had to work very hard for very little pay. He wants more for his and wife Barbara's four daughters. Charles worked (and still does sometimes) with Minnie and Garland Adkins, who suggested he try to carve something from a block of wood he had brought them. He replied "No, I'll ruin it," to which they said, "It won't be the first time." He says he would not have made the first thing without the Adkins' encouragement, but with them he "just started." Among the animals he carves are a mother dog with three puppies, horses, and skunks. At first the Adkins' influence was apparent, but now he has developed a more individual style. He paints his wood carvings. His work is available in galleries.

RICKY KEETON

Lives in Elkfork, Kentucky. He carves large heads and figures and also walking sticks. His work is available at Sailor's Valentine Gallery in Nantucket.

LAVERN KELLEY
(b. 1928)

Born and raised in New York. He received no encouragement from his family for his art and never thought of himself as an artist. He worked as a subsistence farmer for over fifty years. He is a woodcarver, making and painting human figures, farm equipment, trucks, and cars. Drawings that he made in the 1950s are also available. In the summer of 1986 he was one of the state's first folk-artists-in-residence at Gallery 53 Artworks. There is an illustrated catalog of

his work, *A Rural Life: The Art of Lavern Kelley.* His works are in the permanent collections of the Smithsonian, Fenimore House in Cooperstown, and Hamilton College, and are available from Gallery 53 Artworks in Cooperstown.

CHARLEY KINNEY
(1906-1991)

Lived in Toller Hollow, Lewis County, Kentucky, his entire life. He is known not only for his art but for a lifestyle with an unbroken connection to the past. He once made clay busts of famous figures which he sold at state parks. After that he started drawing and painting, and his work proliferated after he stopped farming. His paintings tell a story, often about local history, legend, and observation. He is described in many written sources, including the numerous catalogs of exhibitions in which his work was included. Many galleries carry his work.

HAZEL BATEMAN KINNEY
(b. 1929)

Born in Mason County, Kentucky, and lives in Toller Hollow, near Vanceburg. Hazel was introduced to her husband, the late Noah Kinney, by her sister and brother-in-law when she was living in Flemingsburg taking care of her father. They married in 1960 and she stayed on in Flemingsburg until her father died about three months later, after which she lived with her husband until his death in 1991. Hazel has been painting for about "five or six years." She makes drawings on paper, or anything else she can find. Her earliest drawings were on scrap

lumber. She also paints on "odd rocks, the ones I find that are interesting." Her painting is done with oil crayons, markers, "whatever suits the material." Hazel paints some Biblical scenes, but most often she paints the countryside and the goings-on about her. Recently she has been making clay sculpture—small animals, characters from the Bible—and baking them in the sun. She paints them once they dry. Several galleries carry her work.

NOAH KINNEY
(1912-1991)
Born in Toller Hollow, Kentucky, and like his older brother Charley he never traveled far from home. He was known for his carved wood figures of animals. A trip to the Cincinnati zoo in the late 1980s expanded his repertoire of figures. Noah said, during a visit in 1991, that he "would have liked to have been a doctor but it was out of the question for a poor boy." He stayed on the family farm, was married thirty years, and in addition to entertaining visitors and neighbors with hand-carved puppets, he read a lot of history, anatomy books, and books about contemporary world events. His work is in many published references. Galleries carry his work.

ELVIN KING
(b. 1924)
Born in Bledsoe County, Tennessee, but moved to his current home of Sewanee when he was age three. He is a chain saw carver and is very productive and uses beautiful woods that he cuts himself. His favorites are black walnut, buckeye, and cherry. He makes a number of small animal figures. His work is in a gallery called Added Touch in Columbus, Georgia, and he sells his work from his home. He suggests you call first to be sure he is at home: (615) 598-5867. His house is on King's Road off I-65.

IDA MAE KINGSBURY
(1919-1989)
Created a most wonderful paradise of flowers and shrubs crowded with fantasy characters and animals in her yard in Pasadena, Texas. The story of the last-minute rescue of this folk art by Orange Show Foundation director Susanne Theis, with the help of friends, is very interesting. Theis struck a deal with the rubbish hauler who was at the site to cart it all away and with the help of volunteers saved a large portion of Ida Kingsbury's art. One hundred of the best pieces (there are about 500 altogether) were shown at the Houston Children's Museum in 1990 (fortunately for me they let adults in too). A permanent exhibition is planned at the Orange Show. To help raise the necessary funds for what couldn't be a better project, see "Friends of Ida Kingsbury" in the chapter on organizations.

TELLA KITCHEN
(1902-1988)
Born in Vinton County, Ohio, and lived in Adelphi, Ohio. She began to paint at the age of sixty-three, when her husband died and her son gave her a set of paints. Her personal style reflects her remembrances of an earlier time in her life. Her work is in the collection of the Museum of American Folk Art and is available at The Ames Gallery in Berkeley.

O.W. "PAPPY" KITCHENS
(1901-1986)
Born in Crystal Springs, Mississippi, and lived in Jackson. "Pappy" Kitchens' images are a direct and unselfconscious depiction of people and events from his personal history, as well as personal commentaries on contemporary social issues such as the Vietnam War, the women's liberation movement, and the population explosion. He uses humor and narrative, along with descriptive titles and inserted written comments. Galleries carry his work.

GUSTAV KLUMPP
(1902-1980)
Born in Germany and lived in Brooklyn, New York. He worked as a linotype operator. He painted in oils. His work is in the Museum of American Folk Art and the Museum of International Folk Art and is available from Cavin-Morris in New York and Janet Fleisher Gallery in Philadelphia.

ROLLIN KNAPP
(b. c.1950)
Lives in Iowa. He is diagnosed by doctors as schizophrenic, but with medication he is able to live on his own. His artistic talent has received notice since he was a child. Rollin mostly paints portraits of imaginary women friends and of presidents. He gives names to all the women he draws and feels they are special friends who keep him company. Rollin paints portraits by starting with a nose, placing it in the center of the canvas, and working out from there. He draws presidents from photographs, attempting to "capture their personality" by en-

tering a dream world. The Pardee Collection in Iowa City represents his work.

ROLAND KNOX
(b. c.1927)

Born in Connecticut, grew up there, and now lives in Atlanta. He was the janitor of a large art museum and now mows lawns and does other yard work. He started making art to pass the time when insomnia kept him awake. He stopped for some time, but recently began again. He tends to be obsessive and religiously inspired. He uses beads and costume jewelry to create religious collage pieces, most of which include symbols such as a cross or a Star of David. Other pieces are totally abstract. His work may be found at Modern Primitive Gallery in Atlanta.

"BAD" RAY KOMER

A man in his mid-fifties who was born in Sioux City, Iowa. Abandoned by his mother, Ray grew up in Father Flanagan's Boys Town in Nebraska. After leaving Boys Town, Ray spent three and a half years in the Air Force, but since he refused to shoot a gun he spent most of that time in the stockade. He hitchhiked to the San Francisco Bay Area, settling in Berkeley, where he spent thirteen years struggling to survive while living on the streets. Through the 1960s and 1970s Ray was institutionalized a number of times and made several suicide attempts. Since beginning his art activities in 1983, Ray enjoys a productivity and stability for which he is grateful. He states simply, "If I hadn't found painting and art, I would have killed myself by now!" His work is carried by the Double K Gallery in Los Angeles.

JAMES KOPP
(b. c.1954)

Lives in Henryville, Indiana. Kopp, who is a railroad section foreman, cuts firewood year round. He says he cannot pass a dead tree without looking for a limb that he could carve into something with his chain saw. He carves rough forms of such creatures as owls and ducks. He sells his carvings. To get to Henryville, take Highway 65 north from Louisville, turn onto Highway 31. Henryville is in Clark County.

HELEN KOSSOFF

Finds her subject matter, animals and people, in photographs from newspapers and magazines. After Kossoff has transformed the subject of her vision, the images bear minimal resemblance to their source. Animal and human subjects seem to have happy personalities. Kossoff fills her paintings with vibrant traditional as well as psychedelic colors. Her forms are flat. She fills the backgrounds of her works with geometric patterns. Her work was in an exhibition by Very Special Arts in 1991, and is described in the *HAI Collection of Outsider Art: 1980-1990.*

KAROL KOZLOWSKI
(1885-1969)

A Polish man, living in Brooklyn, New York, who spoke no English, was a blue-collar worker, and whose time away from work was spent making art and maintaining a small collection of exotic birds. He was a "loner" about whom not much is known. What has been discovered is included in a richly illustrated book, *Karol Kozlowski,* by Martha Taylor Sarno. She says this hard-working laborer cre-

ated "large, richly colored, intricate, and fanciful paintings, filled with blue skies, happy and affluent people, on a permanent holiday." The Abby Aldrich Rockefeller Folk Art Center in Williamsburg, Virginia has several of his paintings.

HAROLD KUETTNER
(b. 1930)

From Elgin, Illinois. He has worked most of his life as an accountant in Los Angeles and San Francisco. Kuettner started painting in 1972. He has never received formal art training, but he says that he has studied the works of other painters. He uses acrylics on canvas; the most prominent feature of his urban landscapes and portraits is the "screaming color." "It is what I've always liked the most about painting, the violent colors," says Kuettner. His work may be found in The Ames Gallery in Berkeley.

MAY KUGLER
(b. 1916)

Grew up in Reserve, Louisiana, and now lives in La Place. She has two sons and a daughter and is now a widow. No one has been able to come and eat at the dining room table since she started painting there because to "clean up" breaks her concentration. She takes food for family dinners to her daughter's. Kugler says "anger" was her initial inspiration for painting. She was full of anger from her childhood: her family was so poor she only had tops of shoes to wear to school and children made fun of her. A teacher accused her of cheating when she saw May's drawings and even when May drew in front of the teacher it only made the teacher mad because she didn't want to believe

Kugler was "good enough." Kugler spoke only French when she began school and was given a very hard time about it. Her family walked miles to the nearest Catholic church, "because they had no money to ride," and when they got there, were "constantly chased out of the pews, because they had no money to sit," the seats requiring a rental fee in those days. She says painting her memories has helped take the anger away. She usually figures in her paintings, wearing a red dress. Her memory paintings bear such titles as "I Did Not Cheat" (about her art when she was a child), "First Communion," "Bonfire on the Bayou," and "Picking Up Pecans." On the back of each painting is its story and a prayer. Her son frames her work in old wood. Her work is found in galleries.

DON LACY
(b. 1922)
Born in Indianapolis, Indiana, and now lives in Owensboro, Kentucky. He has been carving for about fifteen years. He makes painted wood carvings and also sculptures from found metal and railroad spikes. His first works, dating from 1980, were carved from a variety of woods, including hundred-year-old barnwood. He uses a mallet and chisel, and says "no power —trying to keep it pure." He sometimes paints the finished figures. Now he is experimenting more with metal, and limestone, which he finds along the river. He chisels the stone and then rubs it with sandpaper and water. Lacy has work in the permanent collection of the Owensboro Museum of Fine Art and sells his work at the museum's Omnicraft Art Fair in June.

"LADY SHALIMAR" [FRANCES MONTAGUE]
Produces paintings of performers, her "self-portraits." The subjects, almost always women, are dressed in elegant apparel appropriate for their parts in theater, ballet, or the circus. The brightly costumed women, dramatic against a white background, are decorated with glitter and sequins. Montague, about eighty-six years old, works every day. First she makes preliminary sketches and then enhances the imagery with watercolor, markers, sequins, glitter, and any other "flashy material." Her work is illustrated in the book about the HAI collection by Elizabeth Marks and Thomas Klocke. Several galleries carry her work.

JOEL LAGE
Comes from Osage, Iowa, and now lives in the village of Llano, New Mexico. He makes sculptures, for which all his materials come from northern New Mexico dumps. His tools are scissors, pliers, and an ice pick. According to a critic, "there is often humor in his work, sometimes it's satirical. His best pieces are elegantly simple expressions of pathos for the human condition." It is amazing what happens to a coffee can, aspirin tins, and bottle caps in his hands. Lage likes what the elements do to his found objects—the changes in color, the patina, the rust. About his found-object sculpture he says "That a castoff thing, resurrected by the mind and hand, can lift a heart . . . is a miracle." Most of his works are small, but not all of them. He is beginning to experiment with larger pieces. Several galleries carry his artwork.

JAMES LAMB
(b. 1926)
Born in Rockford, Illinois, and lives in Beloit, Wisconsin. He retired in 1970 after several jobs, the last of which was as a credit manager for a large company. He is a self-taught but relatively sophisticated artist who uses oil and acrylics to create "storyboard paintings" in which images illustrate sometimes fairly lengthy text that reflects his views on a variety of subjects. His work is available from John and Diane Balsley in Brown Deer, Wisconsin.

EDD LAMBDIN
(b. 1935)
A native of Kentucky. He has supported himself as a carpenter and by doing construction work. He lived for a short time in Ohio before returning to Kentucky, where he lives now. Lambdin spends a lot of time in the woods, looking for the unusual natural wood formations he uses in his sculptures, including burls, thigmatropic growths, and roots. He uses these found wood pieces to make such objects as snake handling people, monkeys, lizards, and various other critters. Often one critter is riding on the back of another. The major part of each sculpture is the found wood; some elements such as the body of a monkey or a human figure are turned on a lathe. Sculptures are painted with bright enamel in bold patterns of spots, stripes, and bull's eyes. Humor is always an important element in Edd Lambdin's work. The largest pieces are two and a half to three feet tall; some snakes are six to seven feet long. His work is in the Owensboro Museum and may be found in several galleries.

SHERMAN LAMBDIN
(b. 1948)
SHIRLEY LAMBDIN
Natives of Kentucky. Sherman is Edd Lambdin's brother. He has worked in the past as a construction worker, but is now disabled. Edd Lambdin's success inspired Sherman and Shirley to start making sculptures also. They often collaborate in their work, which is simpler than Edd's, and smaller and more linear. Their most usual images are birds, peacocks, horses with riders, babies riding pigs, simple twig figures, and various animals. The sculptures are painted with bright enamel, but with less overall patterning than is found in Edd Lambdin's work. Their work is represented in several galleries.

BONNIE LANDER
(b. 1951)
Born in Louisville and lives on a farm in Bethlehem in north central Kentucky. Her husband is a journalist. Lander is a painter and does her work on a variety of objects, including canvas, gourds, saws, walls, and barns. She is best known for her colorful and detailed rural scenes on gourds. Her work appears in the permanent collection of the Owensboro Museum and is sometimes available at Kentucky Art and Craft Gallery in Louisville.

SAMMY LANDERS
A black man in his late thirties or early forties. He is diagnosed as autistic and dyslexic and has lived for several years in a mental institution in Arkansas. He draws with colored pencil and colored ink pens, and occupies himself with architectural and plant form drawings, and some-times with humans, "which may be self-portraits." There are also two drawings of an attendant with a peg leg. As with Eddie Arning, he was given drawing materials in an art therapy class and has prospered with them. The dealer has seen only a small body of the artist's work and therefore does not wish to make any broad generalizations about it. Contact Lynne Ingram Southern Folk Art.

JOHN LANDRY, SR.
(1912-1986)
A native of New Orleans, Louisiana. Shortly after his retirement he began fashioning miniature replicas of elaborate Mardi Gras floats—the King's float, the Queen's float, and a number of others depicting large butterflies, dragons, and floats from the Zulu parade. Wires and Mardi Gras beads are the major elements in construction. Landry's work is illustrated and further described in the exhibition catalog, *What It Is.* Gasperi Gallery in New Orleans carries his work.

LONNIE LANDRY
Lives in Morgan City, Louisiana, where he runs a rather well-known seafood restaurant. He has painted scenes of the bayou for a number of years, and now is doing three-dimensional work that represents southern Louisiana. Southern Tangent in Sorrento carries his work.

PRICE LARSON
Born in McAllen, Texas, and worked in agriculture. He worked the fields with the farmers and their crews. Larson started painting in 1987, with whatever materials he could get. He used sheetrock for many of his works. He is a completely self-taught artist and when he is not painting, he is busy doing carpentry work. He uses colored pencil and oils. He paints his own experience; his landscapes are very precise and linear. His interiors, such as "At the Dance" or "At the Movies" show great swirls and washes of color and movement. Sol del Rio Gallery in San Antonio and Leslie Muth in Santa Fe carry his work.

TONY LASPINA
(b. c.1932)
Lived with his mother until she died. He has had no schooling. He now lives in a supervised home. Laspina has Downs Syndrome. "His greatest pleasure is going to his job to paint. He never misses a day." His paintings consist of broad vertical and horizontal brush strokes which interweave like the threads of a tapestry. The manipulation of his brush strokes plays a powerful role in his paintings. The colors vary but are always harmonious. Tony makes his own artistic judgments, knows exactly how he wishes to paint, and allows no interference. His work is available at the National Institute of Art and Disabilities Gallery in Richmond, California.

CAROLYN MAE LASSITER
(b. 1945)
Born in Baltimore, Maryland, and raised in Ahoskie, North Carolina. She grew up doing farm work: picking cotton and tobacco and working in the peanut fields. As an adult she and her husband, Edmond, moved to Cuernavaca, Mexico, where they lived with Nahuatl Indians. In 1979, Lassiter began experimenting with line draw-

ings on bark paper. From that time forward she developed her surreal imagery with recurring images of snakes, elephants, foxes, birds, and human portraits. She uses "ink, oil sticks, oil crayons, and oil pastels, often mixing the media." Lassiter, who now lives in Santa Fe, New Mexico, has works in several galleries.

RENE LATOUR
(b. 1906)

Born in France and came to the United States as a baby. He is a retired sheet metal worker who now lives in Florida. He had worked in commercial tin works making air conditioning ducts and similar products. He started his creative tin work in his garage after retiring, when the town where he lives would not allow him to erect a sign by the road to advertise his "odd jobs" business. First Rene made a very tall metal man and placed it out front. This was followed by a variety of tin figures, animals, and geodesic forms, some of which have applied materials such as pins, marbles, and other metals for details. One of his tin cowboys in tin the Museum of American Folk Art. American Primitive in New York carries his work.

JOSEPH LAUX-
"FAIRY GARDEN"-
DEPTFORD, NEW JERSEY

Joseph Laux (1904-1991) built his interpretation of an old English fortress with castles and moats, bridges, baskets, and more. He used rocks, shells and broken china embedded in concrete. The site is maintained by the family and may be seen in the yard that adjoins the family home on Rt. 41 in Deptford.

IVAN LAYCOCK

A retired auto worker who lives with his wife in rural northern Michigan. He makes whirligigs, birdhouses, and, more recently, paintings. His work is often of an erotic nature. Hundreds of these objects fill his workshop/garage. Linderman Folk and Outsider Art handles his work.

ELIZABETH LAYTON
(1909-1993)

Born in Wellsville, Kansas where she lived again for many years, after raising a family in Colorado. She started painting in the fall of 1977 when she stared into her looking glass and drew herself. All her work involves self-portraits, of an amazing variety and subject matter. "These self-portraits, besides reflecting the hopes and fears of the world, allowed her to win a thirty year struggle with depression." Layton's life is detailed in the catalog *Through the Looking Glass: Drawings by Elizabeth Layton*. Each painting is accompanied by a written description, which says it all—her "Garden of Eden" makes perfect sense. Her images record struggles with aging, sexism, fat, and a wide breadth of social concerns. Some incorporate considerable humor; others reflect the horror with which she, as a feminist, views certain social developments. Contour drawing is the essence of her style. She uses colored pencils and ink and covers surfaces with lines that provide form and background. Her work has a silvery, pale, and powerful appearance. She does not sell her original artwork. Reproductions may occasionally be purchased from galleries,

and the work may be seen in the above-mentioned catalog and in museum shows.

RODDY LEATH

From southeastern Kentucky. He makes small carved wood sculpture. His work may be seen at Morehead State University Folk Art Collection in Kentucky.

LAWRENCE LEBDUSKA
(1894-1966)

Born in Baltimore, Maryland. He returned with his family to Europe, where he studied the family trade of stained-glass making. He came back to the United States in 1912. A year later he was working as a decorative mural painter. He began painting portraits of friends and recollections of his childhood. He "shunned museums and training," wanting only to paint to please his friends. His work is in the Rosenak encyclopedia and the Hemphill and Weissman book, in the Metropolitan Museum of Art and the Museum of Modern Art in New York, and in the Abby Aldrich Rockefeller Folk Art Center in Williamsburg, Virginia. It is also available at Epstein/Powell in New York.

EDWARD LEEDSKALNIN-
"CORAL CASTLE"-
HOMESTEAD, FLORIDA

Edward Leedskalnin (1887-1951) created "Coral Castle," a massive sculptured coral environment twenty-five miles south of Miami. He constructed an open-air castle out of 1000 tons of stone, working alone. Leedskalnin was born in Latvia. At age twenty-six he was jilted by his sixteen-year-old fiancee and claimed that he built his monument to his lost love. He first built a monument in Florida City, then moved to

the present location near Homestead and began again. Many articles and books have included this site, including Hemphill and Weissman, and the people who opened the site as a tourist attraction produced a video of Coral Castle. It is open daily, 9:00-5:00.

DOLORES LEGENDRE

Born and reared on Bayou Lafourche in Louisiana. She paints memories and local history in a realistic style that captures the look of Cajun country. She pays attention to detail and color. She taught herself to paint. Her works are in oil, watercolor, and pen and ink. Legendre's work is available at Southern Tangent in Sorrento, Louisiana.

JAMES LEONARD

A contemporary folk artist who tells stories with his elaborate copper whirligigs. Often they tell tales of the urban environment of Williamsburg in Brooklyn, New York, where he lives. Others are his own memories and experiences, cut out in tin. They are quite elaborate and wonderful. One of the pieces is in the Museum of American Folk Art; another is in the National Museum of American Art. He can be contacted directly at 56 South 11th Street, #3W, Brooklyn, NY 11211. Call (718) 963-2641 for an appointment.

ABRAHAM LEVIN
(1880-1957)

A painter "of religious and genre pictures." His work is included in the book *Primitive Painters in America, 1750-1950* by Jean Lipman and Alice Winchester (Dodd Mead, 1950—not in bibliography), the book by Johnson

and Ketchum and in the catalog *Transmitters: The Isolate Artist in America.* Galerie St. Etienne carries his work.

CONNIE LEWIS
(b. 1956)

Lewis, intrigued by the carving of her husband, Leroy, decided that she could carve too. She started carving in 1989, after having made cloth figures and dolls previously. Connie Lewis uses linwood and acrylic paint to create her sculptures. Call (606) 738-4541 to inquire about her work.

JIM LEWIS
(b. 1948)

Born in Sandy Hook, Kentucky, and still lives there. He is married to Beverly Hay Lewis, and they have two adult children. Lewis worked beginning at age nineteen as a heavy equipment operator. He started carving on and off two years ago; then he was laid off and started making art full time. He is friends with Garland and Minnie Adkins, and their work inspired him to try it for himself. He thought "I could do this." When the company called him back he didn't go, but continued to make his art full time. He carves and paints colorful fish to sit on a table or hang on a wall; birds; forest animals, and a few fantasy creatures. One of his newest images is Jonah in the whale, with Jonah looking very uncomfortable. He also carves canes. Lewis uses basswood and poplar. He roughs out the shapes with a band saw, then finishes carving with a knife. He uses acrylic paints and finishes with a coat of polyurethane. Jim Lewis has work in many galleries and likes people to come by

because "I like to meet people." Call him at (606)738-5758.

JUNIOR LEWIS
(b. 1948)

Lives in Isonville, Kentucky. He is a tobacco farmer and has also drilled oil wells, worked as a carpenter, and worked for the state. He started carving around 1987; his first subjects were an Indian head and a devil head made out of blocks of wood. His interest in devil figures has grown to include "Devil Island," "Devil Boats," and a few others. He also carves Biblical scenes of great beauty—especially the Last Supper—and animals common to eastern Kentucky plus the occasional lion or tiger. He carves good alligators too. Junior Lewis roughs out the wood with a chain saw, then carves and sands the rest by hand. Arms, legs, and the devil's horns are pegged on. Much of his work is painted. Many galleries carry his work.

LEROY LEWIS
(b. 1949)

Lives in Isonville, Kentucky. He makes beautiful chairs and handsome rockers with hickory bark seats. He carves representational figures and animal forms and some "futuristic" ones. His carvings are painted with a glossy enamel paint. Galleries carry his work.

TIM LEWIS
(b. 1952)

Lives in Isonville, Kentucky, in a beautiful hillside home he is building himself with great care. He was born "right up the road." He is brother to Leroy Lewis and Junior is his cousin. Tim was in the Army and traveled around for six years. He has also done oil well digging, strip mining,

and logging. Driving a runaway truck on a mountain road discouraged him from continuing the work in logging. He says his first inspiration came from seeing what Junior Lewis was doing, and then Minnie and Garland Adkins encouraged him. Tim Lewis makes canes from the root-ends of small trees. These he paints elaborately to create a face or figure. He spends more time now making stone carvings that are becoming ever more impressive. Several galleries carry his work.

RAY LIBRIZZI
(b. 1907)
Lives in Pittsfield, Massachusetts, where he was born. He worked as a labor organizer in the South during the 1940s and had to flee Alabama to save his life. He finished high school after spending three years riding the rails, and then went to Williams College. For twenty years he was a reporter for a newspaper called *The Eagle.* He started painting in the early 1960s. He paints various subjects, and his images are said to have "great stength." Some have been referred to as "exuberant, boldly colored, allegorical . . ." His work is available from Prince Art Consultants in Stamford, Connecticut.

ROSE LICCARDI
"Somewhere in her eighties," according to the staff of the gallery which carries her work. She is entirely self-taught. Her son, a trained artist, bought her art materials when she became disabled by paralysis. She began to paint, using brightly colored acrylics to make her paintings. Her favorite subject is animals.

Renee Fotouhi in East Hampton, New York carries her work.

HARRY LIEBERMAN
(1876-1983)
Born in Poland and died in Great Neck, New York. Much of his painting was done in Los Angeles during the winter months he spent with his daughter and grandchildren. Details about his life, his culture, and his religion—all of which played a great part in his painting—are documented in the book *Harry Lieberman: A Journey of Remembrance,* by Stacy Hollander. Lieberman also made floral still lifes and clay figures. He is included in the Hemphill and Weissman book and is the subject of the film *Hundred and Two Mature: The Art of Harry Lieberman.* His work may be seen at the Seattle Art Museum and at the Museum of American Folk Art. Galleries carry his work.

JOE LIGHT
(b. 1934)
ROSIE LEE LIGHT
Born in Dyersberg, Tennessee, and lives in Memphis with his wife and ten children. He and several members of his family, including ROSIE LEE LIGHT, are artists. Light says that when he was in prison from 1960 to 1968, he "changed his ways" and converted to Judaism. He married Rosie Lee in 1968. Light uses found objects to make his assemblages, and as bases for his paintings, which are bright and semi-abstract. Rosie Lee Light also is a painter. The Rosenak encyclopedia discusses Joe Light, but not the rest of the family. Six galleries represent Joe Light's work, three of which also carry the art work of Rosie Lee Light.

MARION LINE
(b. 1919)
Born in Morristown, Tennessee, and now lives with her husband of fifty-one years in Richmond, Virginia. She had always wanted to be a painter but since there were no classes available in Morristown (the school had an art class but the teacher locked up the box of colors and Marion did not want to do black and white), she turned to music. This led to a forty-year career as a music teacher. She thought about painting through those years, and still thought it was out of the reach of "ordinary people." In 1976 she bought her first canvas and oil paints. She tried one art class which nearly ruined painting for her: the instructor insisted she try for "realism" and she could not and would not. Mrs. Line is a memory painter and paints her life. She started in 1983 and had her first solo exhibition in 1984. She divides the themes of her work as follows: memories of her family; scenery, especially the mountains around her home in Tennessee; Bible stories; paintings related to songs; and contemporary life and scenes in Virginia. Mrs. Line says "mainly I've had a good time. I've enjoyed my work and like to paint the 'up' side of life. Even my funerals are not that sad." The Eric Schindler Gallery in Richmond, Virginia carries her work.

CHARLES LISK
(b. 1952)
Born in Robbins and now lives in Vale, North Carolina. He was educated at Appalachian State University and around 1977 returned to Moore County to work at Pinehurst Pottery. After

his marriage he moved to Vale, leaving the Seagrove area and becoming part of the Catawba Valley heritage. His specialties are alkaline-glazed pieces and clear glass-glazed swirlware. His face jugs are in great demand. They are available from galleries.

ISRAEL LITWAK

Born in 1868 in Odessa, Russia. He lived a good part of his life in Brooklyn, New York. Litwak started painting at the age of sixty-eight when he was forced to retire. He liked to talk about his work, which often depicted landscapes. He used pencil, watercolors, and oil, and is sometimes compared to Rousseau. Litwak is included in *They Taught Themselves,* by Janis, and in *Twentieth-Century American Folk Art and Artists,* by Hemphill and Weissman. Galerie St. Etienne in New York has his work.

JAMES LITZ

A Vietnam veteran and self-taught artist who was born in Checktowaga, New York, and now lives in Depew, near Buffalo. He creates powerful and vibrantly colored "naive" images, including animals, houses, baseball games, Biblical stories, and childhood memories. He uses both acrylic and watercolor. Some of his paintings mix the real and the fantastical, the present and the historical, in an unusual way. Litz' work is in the permanent collection of Fenimore House and the Musee D'Art Naif in Paris. Gallery 53 Artworks in Cooperstown, New York represents his work.

CALVIN LIVINGSTON
(b. 1970)

Born in Tuskeegee, Alabama. Af-

ter the family moved around a bit, they settled in Autauga County, Alabama. Calvin is the cousin of Charlie Lucas, who has encouraged him. Livingston started out drawing, but now he makes constructions from found objects and uses vivid colors, textures, and bold images. Additional biographical material is included in the exhibition catalog *Outsider Artists in Alabama* (1991). Galleries carry his work.

RONALD LOCKETT
see **THORNTON DIAL**

REV. McKENDREE ROBBINS LONG
(1888-1976)

Born in Statesville, North Carolina. Perhaps he does not belong in this book, because he received art training as a young man, learning an academic style of portrait painting. He gave up art for evangelism for thirty years. In his seventies, Long completed two series of paintings: one set of illustrations interpreting the Book of Revelation, and a series called "The Woman In Red." Long has been described as an "outsider," and as an important visionary artist. These works from his later years were nothing like those he had done as a young man. Long has been described as having an "obsessive religious point of view." His work may be seen at the National Museum of American Art and Gasperi Gallery in New Orleans carries it.

WOODIE LONG
(b. 1942)

Born in Plant City, Alabama, and still lives in that state. He is the son of a sharecropper and his family moved around a lot.

Woodie painted houses for twenty-five years, and says he used to paint pictures on the walls of houses, then quickly paint over them before the owners came home. Long paints bright colors on paper of the happier memories he has of growing up in the South. Galleries carry his work.

GERD LONY

A Floridian of German birth who is "in his 70s." He lives part of the year in Florida and part of the year in Germany. He started painting eight to ten years ago, when he retired as an engineer. His paintings—faces, buildings, bridges, boats—are filled with recognizable images that have a rather abstract, dreamlike quality. Sometimes the images reflect the memory of a person who has lived in many places, for instance a cafe in Berlin surrounded by New York skyscrapers put down in an abstract compositional arrangement. Robert Reeves Gallery in Atlanta carries his work.

EUGENIA LOPEZ

Born in Cordova, New Mexico, and a member of the famous Lopez woodcarving family. Her carefully finished unpainted wood carvings are of traditional New Mexican subjects, especially saints. However, they have a more contemporary treatment. Caskey-Lees in Topanga, California handles her work.

EURGENCIO LOPEZ

A wood carver from the well-known family of carvers in Cordova, New Mexico. His figures, usually religious in subject matter, are cleanly carved unpainted cottonwood. His wife Orlinda Lopez sometimes helps

him. His work has been written about and illustrated in the exhibition "Santos, Statues and Sculpture: Contemporary Woodcarving from New Mexico" and is in the permanent collection of the Albuquerque Museum. He is now in his forties and lives in Cordova.

GEORGE T. LOPEZ
(b. 1900)
Born and lives in Cordova, New Mexico. Lopez is a senior member of the illustrious carvers of Cordova. Although much of his imagery is traditional, the style is strictly his own. He does not paint his figures, but lets "color" come from using different woods. He is included in the Rosenak encyclopedia, the Hemphill and Weissman book and other sources. Caskey-Lees in Topanga, California sells his work.

JESSE LOTT
(b. 1943)
Born in Simmesport, Louisiana, and now lives in Houston. He calls himself an urban folk artist. He says his sculptural technique is directly related to the urban environment—a combination of the natural resources of the urban community with the skill of an artist and the attitude of the primitive. He says his "forms and images express ideas found in the urban environment," and that he "collects, categorizes, and reassembles materials which provide evidence of the area and situation where they were collected." Some say Lott is self-taught; others disagree—I'll side with the former because I like his work and I wish to include him here! Leslie Muth Gallery in Santa Fe carries his work.

HARVEY LOWE-YARD ART-SHAW, MISSISSIPPI
Harvey Lowe has decorated his yard with some wonderful constructions. The whirligigs are made with crude carvings of people and numerous found objects. Many of the objects are painted red, to match the flowers. One of the major pieces recently appeared in a color photograph in an exhibition catalog, *Contemporary American Folk Art: The Balsley Collection.* Perhaps the rest of the pieces remain in the yard.

ANNIE LUCAS
(b. 1954)
Lives in Pink Lily, Autauga County, Alabama, with her husband Charlie. Though her hands were full with their six children, Annie still wanted the opportunity to paint. When Charlie suffered a disabling back injury, Annie took some of his paints to paint her first picture. The night before she did this, she had a vision of Jonah and the whale on the walls of their home. "Art was God's answer to my prayers." Annie had been doing cleaning work at a hospital and a nursing home. After she started painting she never went back. Her work was included in the exhibition *Outsider Artists in Alabama.* She combines paint and needlework on stretched cloth to interpret Bible stories. Several galleries carry her work.

CHARLIE LUCAS
(b. 1951)
Born in Prattville, Alabama, and lives in Pink Lily. His house is easy to identify because of the scrap metal creatures in place everywhere. As a child, one of fourteen, he made his own toys.

He had several jobs as an adult. When he suffered a disabling back injury, he took to making art full time. Now he bends, welds, and twists aluminum wire into larger than life people and animals. He also paints on boards. His work is available in many galleries.

DAVID LUCAS
(b. 1948)
Lives in a small town near Whitesburg, Kentucky. He is a self-taught painter who is documenting life in Kentucky. His series of coal mining scenes is now in the museum of the University of Kentucky. David and his wife have been doing research to document "the seven major Kentucky feuds." The book will include text, maps, and paintings. In addition to coal mining scenes, he paints the countryside, towns, and houses. His paintings are done in subdued, autumn-like colors and always tell a story. His work is available at Piedmont Gallery in Augusta, Kentucky.

EMILY LUNDE
(b. 1914)
Lives in Grand Forks, North Dakota. She is from Minnesota, and paints memories of her childhood there. Lunde raised her four children and then started working outside the home. When she retired in 1974 she began to devote more time to her art. She is known for documenting the lives of Swedish immigrant life at the turn of the century. Her work is in the Museum of American Folk Art and in the New York State Historical Society collection in Cooperstown, New York. Lunde is included in the Rosenak en-

cyclopedia and Epstein/Powell in New York carries her work.

BIRDIE LUSCH
(b. 1903)

Born in Columbus, Ohio. She moved with her family to Illinois and Michigan as a child, living on a farm. At the age of 20 she returned to Columbus, where she has stayed. Lusch's interest in the natural world "has turned her into a true ecologist . . . drawing upon almost everything she encounters in daily life much as a painter selects colors from a palette." Her work ranges from fairly conventional paintings, to painted assemblages incorporating found objects, and to collages using printed images from magazines. Gary Schwindler, in the exhibition catalog *Interface,* calls her art "remarkable, sharply observant, and highly literate." He says further that Birdie Lusch and her art conform most nearly to the criteria presented in the catalog's introductory essay for defining outsider art.

CHARLIE LYONS

Lives in South Carolina and makes airplanes out of scraps of tin and found objects. He uses wheels from old toys and makes the propellers from tin. Mary Praytor Gallery in Greenville, South Carolina has his work.

TED LYONS

A self-taught artist in his early thirties who is a native of Winston-Salem. He played in a lot of bands that became involved with folk artists. He feels his friendship with James Harold Jennings has influenced his art. Lyons builds up constructions on canvas using epoxy, caulking material, and layers of paint. He has also done a series of paintings on gourds that have different characters from history and from his imagination. Lyons reads a lot, and this has influenced his art. Urban Artware carries his work.

DWIGHT MACKINTOSH
(b. 1906)

Institutionalized at the age of sixteen and spent the next fifty-six years in mental institutions. In 1978, when there were mass releases from such institutions, he was introduced to the Creative Growth program in Oakland, California. Mackintosh is labeled an "outsider artist." Hour after hour, day after day, he has for the last fourteen years been drawing obsessively. He draws on plain white paper with a felt-tipped pen. His subject matter seems to be confined to human figures, mostly men, and vehicles. They also contain what looks like writing but is not intelligible. His work has been included in a number of exhibitions in Europe and the United States, including "Primal Portraits" at the San Francisco Craft and Folk Art Museum in 1990 and a one-man retrospective at the Creative Growth Center in California in April 1992. Galleries carry his work.

ALEX A. MALDONADO
(1901-1989)

Born in Mexico and came to the United States in 1911. His father died when he was in his teens, and Maldonado had to go to work. Later he worked in shipyards, as a professional boxer, and at a can company. His sister Carmen encouraged him to take up painting when he was sixty. Maldonado painted fantasies of the future; space travel and astronomy were among his fascinations. Galleries carry his work.

ED MANN

A wood sculptor of considerable talent. He worked for many years as a self-employed electrical contractor, and he and his wife, Zona, designed their own home in the Laurel Canyon section of Los Angeles. Mann makes carved wood "toys," often painted, that have many and amazing moving parts. His work may be seen at the Outside-In Gallery in Los Angeles.

JIM MARBUTT
(b. 1964)

Born in Chatooga County, Georgia, and now lives in Alabama. He is of Cherokee descent. In the late 1980s he started experimenting with carving large pieces of wood, using a chain saw as his primary tool. His figures are mostly Indians, ranging in height from one to twenty feet, and are painted once they are carved. His work is available at Southern Folk and Outsider Art in Washington, D.C.

ROBERT J. MARINO
(1893-1973)

Born in Blacksher, Alabama. He created fairly large sculptures carved or constructed from local woods. Some works are painted and some are decorated with Mardi Gras beads. His work is in the permanent collection of the Fine Arts Museum of the South in Mobile, Alabama.

HARRY C. MARSH
(1886-1983)

Born in St. Cloud, Minnesota. His father bought a tract of land in Florida in the 1890s, and the

family moved in an ox-drawn wagon. He worked on the railroad as a young man, then worked raising racehorses on a horse ranch in Texas. Eventually he moved to Tennessee. During the 1940s he was a sign painter for the Mid-South Fair. He painted recollections of the past events of his life, and religious themes, using oil on canvas or canvasboard (earlier works were sometimes on masonite). One of his paintings was used in the UNICEF calendar in 1976, when it featured "primitive art." Marsh and Theora Hamblett were the only two American artists represented. Marsh's work is carried by Edelstein/Dattel in Memphis, Tennessee.

DAVID MARSHALL
(b. 1936)

Born in Nassau County, New York, spent his childhood first in Virginia, and then near Kingston, New York. He left school at sixteen and became a field hand. He worked on and off as a paperhanger, painter, dairy-farm laborer, mink farmer, and factory hand, and put in several years in the Navy. Marshall carves individuals and groups—human and animal figures—from soft, water-shaped rocks. He uses more than forty knives, shaping the stones to a generally rounded conformation with details of clothes and faces. "Some of these pieces are humorous, some poignant, but each has a mysterious inner vitality of its own." Illustrations appear in the book by Johnson and Ketchum. The Ames Gallery in Berkeley, California carries his work.

INEZ MARSHALL-"CONTINENTAL SCULPTURE GARDEN"-PORTIS, KANSAS

Marshall created 450 sculptured pieces using Kansas limestone and hand tools. All of these pieces were displayed in her very own sculpture museum. Her inspiration came from "voices" and childhood memories. Marshall died at age seventy-seven in 1984. Her work was auctioned off to pay her debts. KGAA has a catalog and photographs of the entire collection. At some point, around 1990, someone bought the pieces obtained at auction by Florida collectors and returned them to Kansas.

BRAD MARTIN
(b. 1951)

From Greensboro, North Carolina. He uses a beveler and a swivel knife to create leatherwork that transcends simple craftsmanship. Tanned hide becomes an artist's canvas under Martin's hand, on which he carves the weathered face of a Cherokee Indian, the shadowed corners of a New Mexican adobe, the fleeting white tuft of a deer's tail. His work is carried by At Home Gallery in Greensboro, North Carolina.

CHRISTIAN MARTIN

About twenty-two years old and lives in New York City. He is from Florida. Martin, who has cerebral palsy, creates works on paper that are rather abstract dream images. He works in pen and ink. Art Inside Gallery in Florida carries his work.

EDDIE OWENS MARTIN
see ST. EOM

JAMES MARTIN
(b. c.1928)

An "outsider" artist in his sixties who has always survived by doing odd jobs. He dropped out of high school, studied writing at the University of Washington and submitted short stories for publication while he worked as a pattern maker at Boeing. He lives in Everett, Washington. Martin "spins out images from a private mythology. The symbols float in surrealistic combinations, rather like successive spreads of Tarot cards . . . fish draw a gypsy wagon, and Barbara Walters interviews a frog . . . it's apparent at a glance that Martin is not the product of a fine-art academy." A lion, his alter ego, is a frequent theme. Martin is friends with important artists—Tobey, Anderson, Graves—but has always stayed on the outside. Images from other painters sometimes appear in his work (Chagall and Picasso are his heroes). Often an image—cow, lion (he looks like the lion)—will be repeated and repeated, and then they disappear. He also collects eggbeaters, which sometimes appear in his paintings. His work is available from Pulliam-Deffenbaugh-Nugent in Portland.

SAM MARTIN
(b. 1926)

Born in Straven in Shelby County, Alabama, and still lives in Alabama. He is a third-generation carver of exceptional ability, from an Alabama coal-mining family. He carves small animals and walking canes, usually from a single piece of wood using a pocket knife. He uses sourwood, bay, maple, and various other woods, sanding them smooth once he has fin-

ished carving and giving them a coat of paste wax that gives the completed work the rich appearance of antique ivory. His work is shown in *Animals in American Folk Art* (W. Lavitt, New York, Knopf, 1990, p. 144). The Robert Cargo Gallery in Tuscaloosa carries his work.

TIM MARTIN
Born in Alabama and is a fourth-generation carver, the son of Sam Martin. He carves Indian heads, realistic, detailed pieces approximately eighteen to twenty-four inches high, occasionally larger, of cedar wood. He leaves them unpainted. His work is available at the Robert Cargo Gallery in Tuscaloosa.

ELUID LEVI MARTINEZ
Has been a *santero* since 1970 and began doing animal carvings in 1988. He also does Bible stories that show the influence of the southwestern desert. He lives in Santa Fe and sees visitors "by appointment only." Call him at (505) 983-4510 or (505) 982-8412.

TIMOTEO MARTINEZ-ENVIRONMENT-HOUSTON, TEXAS
Martinez came to Texas in 1916, sent by the U.S. oil company for which he worked in Mexico. In Houston he embellished his house with "gargoyles, tile borders, roof ridges, archways and other forms" so that the whole place became a work of art in itself. Susanne Theis of the Orange Show Foundation wrote about the site recently, which is still being maintained by his nephews. Call the Orange Show for location and information. Martinez also made paintings that were in the "Eyes of Texas" exhibition in 1980.

JENNIE MARUKI
Paints an elongated, standing female figure, usually wearing an ankle-length, belted dress. The figure, reminiscent of ancient Egyptian art in its flat frontal nature, recalls a woman of the 1940s. Maruki's figures, painted in dense watercolor against the background of white paper, appear to float on the page. The figures are accompanied by small animals, often monkeys or dogs, or a baby in a cradle. They are placed in simple landscapes with trees, flowers, or grasses. Of Japanese heritage, Maruki is originally from San Francisco. Following internment during World War II, she moved to New York City. Her works are in *The HAI Collection,* and are carried by galleries.

GREGORIO MARZAN
(b. 1906)
Born in Puerto Rico and lives in New York City. Now retired, he makes imaginative sculptures from found objects. Some of his images are quite fanciful, and others are realistic enough to be recognizable. The Statue of Liberty is a popular figure he recreates. He also makes small houses. His pieces are very colorful, with the color coming from the materials he uses; he does not paint them. His latest figures are mostly birds and mammals, "in relief and in the round." His work is illustrated in several publications. He was included in the exhibit "City Folk" sponsored by the Museum of American Folk Art in 1988. His work is in that museum's collection, as well as in the collections of El Museo del Barrio in New York City, and Fenimore House in Cooperstown, New York.

JOHN MASON
(b. 1900)
Born in North Carolina and now lives in Virginia. He worked on the railroads before retiring. Mason does primarily pictures using colored markers on paper or cardboard. His pictures are distinguished by images of stylized birds, often with the animated sun and moon. Other images include trains, building, trees, and other animals. His pictures are always prominently signed and dated. They are available at American Primitive Gallery in New York.

WILLIE MASSEY
(1906-1990)
Born in Warren County, Kentucky and lived there all his life, working as a tenant farmer. He died as a result of burns suffered in a fire in his home. Massey created many different forms and images using found objects and materials. He is possibly best known for his much-decorated bird houses complete with wingless birds, and sometimes a snake or two. There is a very fine and interesting piece, a carving of six people in a boat, at the Huntington Museum in West Virginia. Willie Massey is written about in many publications and wonderful stories are told of his kindness and his humor. Massey is a person one would have wanted to meet. Galleries carry his work.

MAE MAST-ENVIRONMENT-WEBSTER TOWNSHIP, MICHIGAN
Mae Mast is the family matriarch, in her eighties. She gradu-

ated from college in 1921 or 1922. She has decorated her home in Webster Township, kitty corner from Webster church, just northwest of Ann Arbor. As in many old midwestern homes, the center of the house is a log cabin to which other rooms have been added. Every inch of the interior is covered with decoration, as are all the exterior surfaces of the house and outbuildings.

RUTH MATTIE

Described as "a very eccentric older African-American woman" who paints "simple figures, some with wings, and floating heads." She usually painted on found materials—old boards, album covers, cookie sheets. Her subjects were single angels, angels with serpents, and little "spirit faces." Mattie was a migrant worker in Florida and is now believed to be living with relatives in San Bernardino, California. She is "in her 60s or 70s." Her daughter found the art, about 194 pieces, in a warehouse in Florida. Galleries carry her work.

LLOYD E. MATTINGLY
(b. 1923)

Lives in Lebanon Junction, Kentucky, and creates a variety of art and tells interesting stories about the area where he lives. He has built miniatures of all the buildings as they were in Lebanon Junction when he was growing up. He does not stop with the exteriors; lift the roof and you will find them furnished on the inside too. In a more contemporary vein, Mattingly makes creatures and critters, mostly inspired by the imagination of the artist and from roots and other found

wood that he paints in bright flat colors. Mattingly says his root creatures resemble the things of dreams mainly because of the curvature of the roots. He recalls hearing the older men gathered at his father's grocery store tell stories about "things in the woods and I think that is where I picked it up. I guess they're sort of like spooks." His work is available from Bruce Shelton/Folk Art in Nashville.

CLYDE MAUREY

About ninety-three years old. He lives in the Columbus, Ohio home where he and his wife spent sixty-seven years, before her death about two years ago left him very lonely. He retired as an electrician at the age of seventy or seventy-five. He does not think of himself as an artist, but at more of a "tinkerer." He plays the organ—a large one—at home. He once made himself a pipe organ with sixty keys, making the pipes and whistles himself. He has a shop in his basement that is in itself a work of art, "the workshop is beautiful, his tools are 'awesome,' " and he made them himself. He makes whirligigs that incorporate people and animals in action, such as an alligator with movable jaws. His works have a certain crudeness; they are painted with bright, attractive colors. Galleries carry his work.

R.G. MAXWELL
(b. c.1947)

Lives in Natrona Heights, in the Pittsburgh, Pennsylvania area. He does pen and ink drawings and makes collages from photocopies from books. His works are allegorical pieces, things from outer space. Maxwell

works on his art all the time, since the mid-1980s when he started staying home to take care of his parents. In September 1992 his work was exhibited for the first time, at the Turmoil Room in the Pittsburgh area. For information on Maxwell's art, call Pat McArdle at (412) 371-4767.

THOMAS MAY
(b. 1922)

A Kentucky carver of figures, and also canes decorated with heads and sequins. A teacher for thirty-two years, May became interested in cane making during his retirement. He carves only in the winter, he says, devoting his summers to working the land and caring for his garden, horses, turkeys, and geese. He lives with his wife Lucille in a house that was his father's in Langley, Kentucky. Characteristic of his tall, brightly colored walking sticks are the incised diamond-patterned shafts highlighted by the addition of plastic beads. At the top of the cane, May will carve a variety of personalities, including kings, soldiers, or an Uncle Sam. He uses yellow poplar, sassafras, maple, and dogwood, with acrylic paint. His work is in many of the galleries listed in this book.

JOE McALISTER

McAlister is "in his 40s" and lives somewhere in Texas. He paints on tin and adds tin cutout pieces for a three-dimensional effect. Every surface is painted. One observer said of the work "Joe McAlister's spiritual notions, expressed with paint on tin, are as busy as any of Red Grooms scenarios." His subjects are social issues, represented with a touch of humor. He casts an irreverent

glance at religion. Brigitte Schluger Gallery in Denver has his work.

WAYNE "MAD MAC" McCAFFREY
(b. 1924)

Lives in Akron, Ohio and is "a sometime preacher, country music guitarist, folk artist, and gadfly extraordinaire." He makes wire-sculpture art of great distinction out of telephone wires and plastered paper. Objects range from realistic alligators and other creatures to political portraits—none too flattering (some look rather like the devil himself). Some of his most recent works are allegorical picture boards which are wire-work landscapes with images and warnings of destruction. His work is illustrated in the catalog *New Traditions/Non-Traditions: Contemporary Folk Art in Ohio.* McCaffrey is seriously ill now and not working much, if at all. Many of his pieces are in private collections.

JUSTIN McCARTHY
(1892-1977)

Grew up in Weatherly, Pennsylvania, where he spent most of his life, although he lived in Tucson, Arizona during his last years. He came from an affluent family, with whom he moved to Paris after a favorite brother died. He was left on his own a lot, and spent time at the Louvre. He flunked out of law school, had a breakdown, and "drew to recover." After his family lost their money, he supported himself by raising and selling vegetables. McCarthy began painting in the 1920s, but was not "discovered" until 1962. He worked in many media and had a tremendous range of subjects, but his most frequent subjects were current entertainment personalities, particularly movie stars and sports figures. His work has been written about in Hemphill and Weissman, the Rosenak encyclopedia and exhibited frequently, and is carried by many galleries.

SPENCER McCLAY
(b. 1964)

Born in New Orleans and now lives in Grass Valley, California, where he attends the Neighborhood Center for the Arts, a program for people with developmental delays. He says that "Mardi Gras influenced me, with its wild and crazy clothes, beads, and balloons, cotton candy, floats, bands, and dancing in the streets." His work is three-dimensional hand-woven wall hangings that use mixed media fiber varying from heavy relief texture to simple sculptured forms. This work was influenced by a visit McClay paid to the Ivory Coast in 1990, where he "met a man weaving on a simple loom tied to a tree and weighted with stones. I loved the bright material of the clothes." His work is available from the Everett Davis Gallery of the Neighborhood Center for the Arts in Grass Valley, California.

JAKE McCORD
(b. 1945)

Lives in Thomson, Georgia, where he has made his living for more than twenty years cutting grass for the city. McCord was born in Lincoln County and the whole family, including Jake and his eleven brothers and sisters, worked planting and picking crops. McCord started painting around 1984 or 1985.

The sources of his art are television—he has six sets and plays at least two or three at all times—and his childhood. His favorite subjects are farm animals and house pets, women, and houses. He paints in bright colors on plywood. The work is "just for fun." Galleries carry his work.

RUTH MAE McCRANE
(b. 1929)

Born in Corpus Christi, Texas where her family had migrated from Louisiana. McCrane taught school and did have some art education—what was available to a black teacher in segregated schools. She herself did not start to paint until some time after her retirement in 1985. "Although her paintings have little scale or depth, they demonstrate great energy and activity." The people who fill her populated canvases are busy, actively involved in church affairs, childhood games, parties with music and dance, baptisms, storytelling, and family chores. Activities inside Houston's black spiritualist churches are a frequent theme. Ruth Mae McCrane's work is in galleries.

ERIC CALVIN McDONALD
(b. 1925)

Born in Brooklyn, New York. He now lives in the metropolitan Washington area. A former musician and cab driver, he had a stroke several years ago that left him unable to speak and paralyzed his legs and right arm. Prior to his stroke, McDonald did not make art. Now he draws with ink and felt tip on paper. Most of his themes come from popular media. McDonald's art is in the collection of the Na-

tional Museum of American Art and is sold by the Tartt Gallery in Washington, D.C.

GUILLERMO McDONALD
(b. 1928)

Lives in Albuquerque, New Mexico. He was born in Peru and is of Scottish-Peruvian descent. He has been pursuing his interest in painting since he was a little boy. He incorporates religious imagery in most but not all of his "jewel-like paintings." His work is illustrated in the exhibition catalog *Visions*.

MARJORIE McDONALD
(b. 1898)

Born in Akron, Indiana. She studied languages and history at Reed College and the University of Oregon, and followed her father in becoming a teacher. She spent forty years as a teacher, married and lost her husband, and helped institute the first high-school level Russian language curriculum in the United States. After she retired she did volunteer work but began to suffer from headaches. She began to pursue art, at the age of seventy-two, at the suggestion of a friend who thought it might take her mind off her pain. (It did not help; she still had migraines.) She made collages of dyed rice papers, which she shaped and to which she attached figures—often whimsical animals, dinosaurs, plants, birds, or people, simplified to flat shapes and touched with fantasy. They stand out against the rice papers dyed in the soft colors of the Oregon coast. Her work appears occasionally at galleries in the northwest.

JOE McFALL
(b. 1947)

Born in Daytona Beach, Florida. His family ran a rooming house and Joe's father died when he was an adolescent. Joe only rarely mentions his childhood. After serving in the Navy and working an odd job or two, McFall began to peddle second-hand goods around flea markets in the South. After trying a few other jobs and places, McFall and his wife settled in Tennessee, where they now live. He runs a junk and antiques shop and makes his whirligigs nearby. His pieces are quite large and portray wry commentary on social issues, sometimes with wit and sometimes with pain. Framboyan in New Orleans sometimes carries his work.

NAN McGARITY
(b. 1896)

Born in Avinger, Texas. She and her husband moved around Texas a lot and then when he retired they moved back to her birthplace. McGarity carved wood figures inspired by books and travel. Her early figures were large—an eight-foot totem pole inspired by a trip to the Pacific Northwest was her first piece. Later she made smaller animals and other creatures, some real and some fanciful. Some of her animal carvings—they have great faces—appear in the catalog *Eyes of Texas*. Leslie Muth Gallery in Santa Fe has her work.

COLUMBUS McGRIFF
(c.1930-1992)

A one-time bootblack of Cairo, Georgia, McGriff crafted figures of animals and machines out of wire for almost twenty-five years. He was born on a tobacco farm in the Havana, Florida area, where as a child of nine he first began to sculpt with scrap wire he found on the farm. He was a farm worker for much of his life, although he worked in a shoeshine parlor in New York City for several years. He moved to Cairo in the early 1970s, to help his sick mother. "Ingenious and spritely," McGriff's cars, trains, ducks, and dinosaurs have been hailed as inspired examples of naive art. In 1990 his work was featured as part of the Black Heritage Week exhibition at the Thomasville Cultural Center. McGriff never enjoyed more than brief flashes of public acclaim, and subsisted with the help of a small shoeshine and candy store that he operated in his house. A number of galleries carry his work.

HAL McINTOSH
(b. 1940)

Lives in Lanesville, New York. McIntosh served in the Marine Corps and lived in a number of places, including Newfoundland and in a wilderness area of Colorado. He developed techniques for making furniture, dwellings, and tools using his chain saw. He wrote *The Chain Saw Craft Book* in 1980, which he describes as a "survival book for hippies." Hal McIntosh has a huge repertoire of animal and other figures. He sells his work from his roadside workshop in Stony Clove, Greene County, New York.

KENNY McKAY

Likes to draw coffee cups. Animals, dinosaurs, fantastic beasts, human and quasi-human figures are often superimposed on the cup. McKay, one of the earliest and most regular contributors to the HAI

Collection, has been particularly creative and productive recently. Using his favored color, green, for faces, he has painted portraits of his friends. He has recently taken to writing puns and jokes on his paintings. He begins his works with a fluid contour drawing, sometimes focusing on a subject without a glance at the outline of his work. Once the image is outlined, he uses a brush to scrub watercolor onto the page, blurring the edges of adjacent colors. The result is a transparent overlapping of forms. His work is available at Luise Ross Gallery in New York.

LARRY McKEE
(b. 1941)
A Kentucky artist who makes walking sticks. His canes are illustrated in the exhibition catalog *Sticks* and are available in galleries.

CARL McKENZIE
(b. 1905)
From Snakey Hollow, near Slade, Kentucky. He carves all kinds of figures, animals, and birds—but mostly women. He started carving when encouraged by carver John Gordon, who died in 1939. He paints his figures with bright colored patterns. His Statue of Liberty figures are quite popular. McKenzie's wife Edna died in 1989, and during a visit in 1991 he was still quite sunk in grief and not carving much. He recently suffered a severe stroke, was in a nursing home, and may not be returning to his own home. McKenzie has been covered extensively in various publications, and many galleries carry his art.

EDGAR McKILLOP
(1879-1950)
Born in Henderson County, North Carolina. A self-taught and highly regarded woodcarver in the early part of the twentieth century, there are many written sources for information and illustrations of his work including the Hemphill and Weissman book. Pieces are in the permanent collections of the Henry Ford Museum in Dearborn, the Abby Aldrich Rockefeller Folk Art Center in Williamsburg, the Columbia, South Carolina Museum of Art, and the Ackland Art Museum in Chapel Hill.

JEFF McKISSACK- "THE ORANGE SHOW"- HOUSTON, TEXAS
The Orange Show is a work of folk architecture located in Houston's east end. Jeff McKissack (1902-1980) built it with found objects over a twenty-five year period to illustrate his philosophy of good health and nutrition. The Orange Show is the center project of a folk art foundation (see chapter on organizations) and sponsors many activities to develop community awareness and respect for grassroots art environments. McKissack's life and his environment are described in many writings and in a film. His site is located at 2401 Munger Street in Houston, (713) 426-6368.

SAM McMILLAN
(b. 1926)
Lives in North Carolina. He has made and repaired furniture, worked in tobacco warehouses, and worked as a handyman. He runs "Sam's Handcraft Shop." He paints furniture with images, dots, lines, and his name "Sam"

all in bright colors. His work is at Knoke Gallery in Atlanta.

JUDY McVAY
Runs an art gallery for chainsaw art—McVay's Woodcarving Farm —in the state of Washington, and she is one of the few women chainsaw artists in the Northwest. Others in her gallery who make chain saw art that is nice work—not hacked figures that have only the slightest resemblance to any creature living or dead—are PAT McVAY, a well-known carver from Whidbey Island, MIKE McVAY, STEVE BACKUS, and JACK LIVINGSTON. Many gallery owners and some collectors believe that no legitimate art can be made with a chain saw. As Pat McVay says, however, "It is the work, not the tool, that counts."

CLEATER "C.J." MEADERS
(b. 1921)
Born and raised in Mossy Creek, Georgia. His father, Cleater, Sr., was the son of John M. Meaders, "who started the dynasty when he opened the Meaders pottery in 1893. Cleater is Lanier Meaders' cousin. Cleater moved to Mobile and went to work at Warner Robbins. He returned to pottery full-time after retiring in 1978. His pottery is in Byron, Peach County, Georgia. He and his wife Billie Meaders "are the most active potters in the Meaders family." For information on galleries, see the list following the entry for Lanier Meaders.

DAVID MEADERS
The son of Reggie Meaders. His introduction to pottery came at the shop of his grandfather, Cheever Meaders. David drifted away from pottery but returned in 1984 with the help of his

Uncle Edwin. David and his wife Anita, also from a family of potters, have a pottery shop in north Georgia. They each make face jugs in addition to other ware. For sources, see the list following the entry for Lanier Meaders.

LANIER MEADERS
(b. 1917)
THE MEADERS FAMILY

Lives in Cleveland, White County, Georgia. He is the son of Arie and Cheever Meaders and is "the keeper of the family homestead and pottery." Lanier is the best known of the four sons of Arie and Cheever, and is ranked as "one of the true giants of 20th century Southern folk pottery." His face jugs have character, power, and vitality. JOHN R. MEADERS (b. 1916) is the oldest of the four brothers; REGGIE MEADERS is the third. Neither of them worked at pottery until after retirement. John was a farmer and "the Great Depression and World War II took Reggie away from pottery." John makes jugs and pitchers and specializes in a very unusual shallow chicken bowl. Reggie's face jugs are quite distinctive. They have somewhat small, recessed faces in "a style that is very much his own." EDWIN NEIL MEADERS (b. 1921) is the youngest brother. Edwin worked full time at a lumber mill but always helped at his father's pottery from his earliest years. In 1969, Edwin built his own shop. He makes only two items; the best known is his rooster. Southern Folk Pottery Collectors Society shop in Robbins, North Carolina carries the works of all the Meaders. For others check the following galleries' artist lists: The Ames Gallery, Berman Gallery, Modern Primitive, Sailor's Valentine, Lynne Ingram Southern Folk Art, Leslie Howard, Glaeve, and Southern Folk and Outsider Art.

CORA MEEK
(b. 1889)

Born in Malton, Illinois and has lived in the Charleston/Malton area for over one hundred years. "At 102½ years of age, Cora Meek is the oldest living artist represented in the folk art collection of the Tarble Art Center, and a recent recipient of an Illinois Arts Council Artist Fellowship Grant." Curator Donna Meeks says "Although working in the quilt tradition, Meek's quilting style is that of an outsider artist." Her designs include pure abstractions, among other objects. Meek is the only quilt maker included in this book, but making art at 102½ should make possible an exception to a "rule."

ALIPIO MELLO-ENVIRONMENT-NAPANOCH, NEW YORK

Alipio Mello (1898-1987), born in Portugal, worked for years as a mason in the waterworks of the Catskill Mountains in New York State. After retiring, Mello began to work on his water-powered circus of ferris wheels and whirligigs made of wood, aluminum, styrofoam, and recycled materials. The environment worked from a system of rain gutters, hoses, and tributaries, which he controlled from a nearby stream. The waterpower turned wheels and paddles that would animate characters such as woodchoppers, a mother rocking her baby, a boy lifting a bucket out of a well, and a bicycle rider. There were also numerous openwork spheres, structures, and towers that would spin from the force of the water. Mello began building the site in 1975, and continued until his death. After he died, the environment was left unattended. Trees fell on and creeping vegetation grew over the structures, and the flooding stream began to erode the figures. What remains of this wonderful environment is at the American Primitive Gallery in New York City.

FRANK MEMKUS
(1895-1965)

Born in Europe, probably in Lithuania, and moved to Milwaukee. He became a citizen in 1945. He lived most of his life in Tomahawk, Wisconsin. The only art work he ever created took him four years to build. Inspired by patriotism at the beginning of World War II, he built a whirligig that was more than five feet tall. It is very elaborate, having a cylindrical base constructed of wood with metal supports. In the middle there are propellers and wings that move, all topped by a figure with arms that move. The figure sits on a metal ring with flags all around. Everything is painted red, white, and blue. The whirligig is on exhibit in the folk art collection of the Art Institute of Chicago.

GAETANNA MENNA

Creates a recurring primitive male figure, whose nude body is visible under its clothing, frequently a conservative suit. Menna uses "points of focus, seen as dots on his drawings, to lay out the figure." The dots represent skeletal joints. A native of Brooklyn, of Italian parent-

age, Menna also makes copies of Old Masters. He is a contributor to the HAI Collection, and his work is available from Luise Ross Gallery in New York.

ANNA MERCIER

About sixty-eight years old. She comes from New Orleans, and has lived in Chicago for at least the last twenty years. She uses markers on file folders to make her art. She saves everything and incorporates it into her work. Sometimes she uses bags and rings from soda bottles. She makes big fluffy constructions "like a memory vase," and also draws on fabric. At first she was very decorative, but after her first show she has become more non-figurative. She is an incredible colorist. Her work can be found at See Upson County in Michigan. Call (616) 469-0809 or (312) 342-3950.

WESLEY MERRITT
(b. 1926)

Born and lives in central Michigan. As a boy he was troubled with problems resulting from spinal meningitis and left school after the fourth grade. He has worked as a beet farmer, a janitor, a furnace installer and handyman, but for the last dozen years he has managed to support himself and his wife Mabel through the sale of his carved animals plus buying and selling secondhand goods at flea markets. He lives in a trailer house on a single acre of desolate land, from which he has rarely strayed further than a single tank of gas in his battered pickup could take him. He does "travel" via television though, which also provides him with

constant inspiration for his art. Merritt lives a hundred miles or more form the nearest zoo, but he carves an ever-expanding bestiary of wonderful, primitive life-sized animals—dogs, birds, and bears, but also tigers, pythons, monkeys, and porcupines. His carvings are usually painted with house paint. A life-sized carving of a tiger is attached to his truck. His work is carried by galleries.

ALBERT "KID" MERTZ
(c.1910-c.1987)

A one-time prize fighter, hence the nickname, "Kid." He lived in a concrete block house in the woods in Nowago, Michigan, and decorated his house, along with virtually all his possessions, with colorful paint and witticisms. He had worked on an assembly line in Detroit, but after retiring he lived almost entirely off the land, foraging for nuts and berries, fishing and hunting and cultivating a garden. Mertz apparently believed that there was nothing in the world that could not be made more beautiful with paint. "In this regard he seemed to share the same opinion as 'Cedar Creek Charlie' Fields." Mertz gathered the beer bottles and cans that motorists threw from their cars and transformed them into striped and polka-dotted vessels. He painted the skulls of the fish he took from a stream behind his house. Every shovel or saw he owned bore his painted handiwork; he even painted his shoes and baseball caps. His painted artifacts have been widely shown in museum shows, and are in numerous collections. Dean Jensen Gallery in Milwaukee carries his work.

MORRIS MESSENGER
(b. 1936)

Born in Gila Bump, Arizona, four miles west of Brice. He now lives in Phoenix. Messenger is part Navajo and part Cherokee. He was raised on a farm but worked at thirty-seven different trades in his life and is now making very little art. Morris makes full-size figurative stone and wood carvings, works with tin, and paints figures and landscapes. John C. Hill in Scottsdale, Arizona carries his work.

FERD METTEN
(1893-1977)

Has twenty-seven works in the collection of the Tarble Arts Center. These exceptional works include complex dioramas of many carved and painted elements, figures, and moving parts made of walnut shells, assemblages, and wood carvings. Themes focus on rural scenes and subjects from the early part of the century. Others involve religious subjects, and there is one political diorama called Watergate (c. 1974). Metten was a farmer and self-taught woodcarver. He began assembling his carvings into dioramas during the early 1940s.

RALPH MIDDLETON

Born in New York. He is a black artist who roams the streets of the city and works in oil, acrylics, pen, and pencil. He is described as a street artist. Information is included in *American Folk Art of the Twentieth Century* by Jay Johnson and William C. Ketchum, Jr. Epstein/Powell carries his work.

MARK CASEY MILESTONE

A Winston-Salem artist in his early thirties. By some people's definitions he is an "outsider" artist. His work takes many forms, from moving pieces such as whirligigs to paintings. His work ranges from "too childlike" to almost "too professional." Some of his work is inspired from his fascination from youth with Halloween and death iconography. One viewer known to the author calls the work "confusing and enthralling." His work is available in several galleries.

JOHN MILKOVISCH- "BEER CAN HOUSE"- HOUSTON, TEXAS

John Milkovisch (1912-1988) retired from his job as an upholsterer in 1976. In the 1960s he spent his free time inlaying thousands of rocks, marbles, brass figurines, and metal pieces in concrete blocks and redwood. These he used to make patios, fences, and so on. He claimed this was done because he hated to cut grass. Then he started, after retirement, using the beer cans—tops, bottoms, sides, and pull tabs—to make curtains, mobiles, fences, sculpture, windmills, and wind chimes. He wired the beer can bottoms in long chains and hung them from the eaves of the house and all around the sides. He made a very attractive front gate with beer cans laid on their sides filling a "regular" gate frame. The house glistens in the light and tinkles in the breeze. It is possible to see the house easily from the sidewalk, but it is important to note that the house is occupied by the creator's family and one should not walk around the yard itself. The house is at 222 Malone in Houston.

HUB MILLER
(b. 1936)

Born in the Panama Canal Zone to a career army family and moved to Washington, D.C. when he was one year old. He now lives in Port Townsend, Washington. At the outbreak of World War II his father went to Europe and he and his mother traveled west to California. He spent a lot of time in the out-of-doors and did not do well in school, because it was too confining. He was already painting what he saw, including places in his own private world. Then his family was reunited at the end of the war and they lived in Vienna for a while. "Having earned an architectural degree, he arrived in Dallas at the end of the fifties and went into acting. Not acting on the stage, but in real life—becoming everything he was not . . . he had his own architectural firm, employees By the seventies it wasn't fun anymore and he began devoting his prime-time energy to painting." Soon he was free of all his money and property. The art work of the various periods contains elements of all the places he has lived, combined with a creative imagination sparked very early in childhood. Recurrent themes involve mountains and trees, sometimes with architectural overtones; frequently there will be a sense of vastness or loneliness. He also does paintings which are "direct translations of his dreams." Information supplied by Valley House Gallery in Dallas, which carries his work.

ANNA LOUISA MILLER
(b. 1906)

Comes from Eau Claire, Wisconsin. She started painting in the early 1940s, when she and her husband moved to Milwaukee. Miller occupied her time while her husband worked as a night watchman painting large, detailed oil paintings. After World War II and their return to their farming home near Augusta Wisconsin, Miller produced a collection of portraits, landscapes, and fantasy paintings. She stopped painting after her husband died in 1971. Her paintings have been described as possessing a visionary quality. The bulk of her work was given as a gift to Viterbo College in La Crosse, Wisconsin; pieces may also be seen at the Milwaukee Art Museum and the Kohler Arts Center in Sheboygan, Wisconsin. Several articles in the bibliography discuss her work.

R.A. MILLER
(b. 1912)

Raised in the rural south and now lives near Gainesville, Georgia. It is a great sight to approach his house on a windy day. The hilly approach is covered by his whirligigs twirling about (if too many purchasers have not been by that day). This sight also explains why many of his flat tin cutout pieces in galleries seem to have nail holes in them—they started out as parts of whirligigs. The painted figures on his whirligigs may be animals, images real and fanciful, devils, angels, and even neighbors such as the often immortalized "Oscar." Miller (he says he hates being referred to as "Reuben") paints cut-out tin forms, and also paints pictures on paper and board. A perusal of

the "Galleries" section and the index will provide evidence of his popularity. R.A. Miller's son, Robert, is beginning to make art too.

WILLIAM MILLER
(b. 1962)
RICK BRYANT
(b. 1963)

Miller and Bryant work together on carving walking sticks, wood figures, and "story boxes." William R. Miller was born in Louisville, Kentucky and lived in the Portland district for ten years before moving to a farm. Now William is back in the same district. Rick L. Bryant was born in Denver, Colorado and moved to Corydon, Indiana at the age of one. He moved to Louisville in 1982 and currently lives in Portland too. Bryant carved his first canes to help Miller walk after a work-related injury in 1984 left Miller with two crushed heels. He ended up carving several sets. Rick would carve them and William painted, stained, and varnished them. When they attended a cane exhibit in 1987 it was the first time they realized people carved canes as art. Now Miller and Bryant collaborate on all aspects of every stick they make. Figures on the sticks include snakes, turtles, frogs, ladybugs, worms, crawfish, ducks, owls, rabbits, and many, many more. Their work is good and only getting better. They also have made a number of devil carvings and assemblages. Their work has received many awards, and is available in several galleries.

LARRY MILLS
(b. 1947)

Born in Napa, Idaho and now lives in Grass Valley, California.

He has been making art for fourteen years. He exhibits extensively, and will be having a show at the Art en Marge Gallery in Brussels, Belgium. Larry has worked in a wide variety of two-dimensional media. His most recent work has been color woodcuts. He has also used pen and ink on paper, acrylic on canvas, and lino cuts and monotypes. Color, marks, and abstract forms appear, with recognizable objects in most of Larry's paintings, prints, and drawings. His work is available at the Everett Davis Gallery of the Neighborhood Center for the Arts in Grass Valley.

PETER MINCHELL
(1889-died, date unknown, after 1972)

Born in Germany and settled for a while in New Orleans before moving to Florida. Little is known about his background, but the Rosenak encyclopedia gives some information. Minchell painted watercolors on paper depicting the natural surroundings of the Gulf Coast. His work is illustrated in *Sotheby's Important Americana,* 1990 and *Folk Painters of America,* by Robert Bishop and *American Folk Art of the Twentieth Century,* by Johnson and Ketchum, and is in the permanent collection of the National Museum of American Art. Epstein/Powell Gallery in New York carries his work.

ROY MINSHEW
(b. 1950)

Born in southern Georgia, where he still lives. Prior to a stint in the Air Force, he worked variously as a fireman, sheet metal fabricator, trucker, machinist, and shoe repairman. The custom leather work in-

volved in repairing shoes was the catalyst that gave initial shape to Minshew's creative energy. In 1981, when his job at the shoe repair shop ended, he decided to pursue art as a career. Eventually he set up shop, hired employees, and began doing production carvings to ship to representatives all over the world. After two and a half years of production work, He became frustrated because he felt he was no longer doing anything creative. From 1989 on, Minshew has been home in his studio creating the kinds of pieces that give shape to his philosophy of life and art. He works in wood, and also does occasional small acrylics on canvas. He carves many animals, including dogs, goats, horses and pigs, ranging in size from one to five feet. They are done with great imagination, exaggerating physical characteristics to create a mood and emotional reaction in the observer (e.g., a dog with a too-large head, open mouth and big teeth seems to say "watch out," while another dog with an over-size red tongue lolling out and an anticipatory stance appears eager to greet all comers). Minshew also does carvings and paint-carving combinations on religious and political themes. His work is available at galleries.

DANIEL MINTER
(1961)

Born in Ellaville, Georgia. He was raised in Georgia and spent most of his life there until a recent move to Seattle. In 1981 he had training in graphic arts and worked for a utility company in Atlanta. His gallery believes he is "completely self-taught as a fine artist who carves representational and abstract wood

relief." Although he never thought he had invented the form, he also never heard of either Leroy Almon or Elijah Pierce nor does his work have a religious bent. Minter's work is painted wood relief and his major themes are social problems such as poverty, drugs and racism that plague the contemporary African-American. MIA Gallery is Seattle carries his work.

MR. IMAGINATION
(b. 1948)
A native of Chicago and has never ventured far from home. He is a self-taught artist who uses simple tools and material that is free for the finding. From chunks of discarded sandstone foundry molds such as the ones Lonnie Holley uses, he carves fantastic figures, monuments, and block lettered text. Another thing he shares with Holley is his devotion to sharing art with children. Some of his stone masks are embellished with found objects, and he makes faces on paint brushes, the bristles supplying the hair "like a new crew cut." Mr. Imagination lives on the north side of Chicago, and likes to interact with collectors, so call for an appointment: (312) 472-4523. Carl Hammer Gallery in Chicago represents his work.

JESSIE MITCHELL
Has been called by a friend "the weirdest guy in Ascension Parish," Louisiana. He uses anything he can find, including grass clippings, broken porcelain, mud, commercial clay, milk cartons, and whatever else is around. His assemblages have small human figures and animals imposed on their surfaces, and very long

titles. He also makes clay vessels with head shapes and faces. His work has to be seen—it is beyond my ability to describe—at Southern Tangent Gallery.

REGINALD "REGGIE" MITCHELL
(b. c.1960)
A native of New Orleans, Louisiana. He has a learning disability, and is fatherless, poor, black, and lived in one of the meanest projects in town (he recently moved out)—yet he still paints. Reggie loves to paint even though the neighbors mock him and his family is not particularly supportive. His architectural images and street scenes of New Orleans capture, in a most refreshing manner, the very essence of the city. "In bold color," according to a local art reviewer, "he evokes New Orleans life from jazz funerals and streetcars to the Superdome and cemeteries " Reggie Mitchell's works are available at galleries.

LANGSTON MOFFETT
(1903-1989)
Born in New England and lived in St. Augustine, Florida, from 1940 until his death. He was a writer of fiction, a journalist, and a self-taught painter since the 1930s. He once sold a painting to the Whitney Museum of American Art, but it was his only sale for many years. Phyllis Kind-Chicago carries his work.

ETHEL WRIGHT MOHAMED
(1906-1992)
Born in Webster County, Mississippi and lived in Belzoni. She was married to Hassan Mohamed, from Lebanon, for forty-one years and they had eight children. Her family was the

center of her life. She is noted for her colorful stitchery pictures of family memories. She has been written about frequently and her work is in museums. A remembrance of her life and art appears in the *Southern Register,* Spring 1992, and an obituary notice is in the Fall 1992 issue of *Folk Art.*

LONNIE MONEY
(b. 1949)
Born in East Bernstadt, Kentucky. He has been interested in wood carving all of his life. He believes he inherited his talent from his Swiss great-grandfather, who was a woodcarver. After leaving the business of dairy farming, Money found more time to pursue his carving skills, producing animal figures and canes. He uses some power tools, but prefers carving knives. He works mostly in pine, which he paints, but also carves unpainted objects from cherry or walnut wood. He makes walking sticks out of dogwood. His work is available from Kentucky Art and Craft Gallery in Louisville.

FRANCES MONTAGUE
see LADY SHALIMAR

LOUIS MONZA
(1897-1984)
Born in Italy and came to California in 1913. Monza began to paint "in earnest" around 1938 while recovering from a serious fall from a painter's scaffold. His subjects were varied, from landscapes to political allegories and social criticism. He made some spiritual paintings, though he disliked organized religion. He also made bronzes, terra cotta sculpture, and lithographs. There are a number of written materials about Monza;

his work is carried by several galleries.

EARL MOORE, SR.
(b. 1927)
From Rock Lick, Kentucky. He makes unpainted wood carvings of small animals and Biblical scenes. His work is in the museum at Morehead State University in Kentucky.

DEACON EDDIE MOORE
(b. 1910)
Born in east Texas, and now lives in Dallas. He was attracted to cemetery art, moved to Dallas in the 1940s and tried to take art lessons, but was not accepted because of segregation. He served as a police officer in California in the 1950s, and retired fifteen years ago. He now serves as a deacon in his Baptist church. Eddie Moore uses wood and other found objects to convey images that appeal to him. He carves scenes from rodeos, hunting and fishing trips, and religious figures. Most of his work is under two feet tall, and painted with acrylics. Eddie is a realist who tries to carve things as they appear. His work is available from galleries.

STEVEN MOORE
Is originally from Texas, and now lives in Diamond Bar, California. He incorporates his memories of rodeos into his drawings and paintings of longhorn steers, cowboys, horses, and dogs. Moore is forty-three years old and has been working at First Street Gallery and Art Center for two years. He has been a cover artist for the *Santa Monica Review,* a literary journal.

DONALD G. MORGAN-"JAMAICA"-WASHINGTON, D.C.
Donald G. Morgan has created a fifty-six-foot long, fourteen-foot wide model of the island of Jamaica in his front yard in northwest Washington, D.C. Build over the past ten years as a way to educate the public about his homeland, Morgan's model is a "superb example of urban folk art." The model depicts Jamaica's rugged coastline, mountains, rivers, underground lakes, waterfalls, white sand beaches, and tropical vegetation. It is contoured in concrete, surrounded by water and tropical fish. It has winding roads and a railway, industrial sites, historic towns, and valleys. "Jamaica" is at 1201 Kalmia Road, NW, Washington, DC 20012. Much of it can be viewed from the street, but there is a fence. If you call, Mr. Morgan is likely to invite you in and give you a tour—(202)726-8292.

SISTER GERTRUDE MORGAN
(1900-1980)
Born in Lafayette, Alabama and spent her childhood in columbus, Georgia. In 1934 it was revealed to her that he mission was to preach the gospel. She preached on the streets of Mobile and Montgomery, and then went to New Orleans in 1939. She opened an orphanage with two other women, and began to preach. Her spiritual expression included painting, gospel singing, and music. In 1957 she "became the bride of Christ," and white began to dominate her home and clothing. Her brightly colored paintings and painted objects were soon discovered by the art world, and much has

been written about her. Morgan is in the Hemphill and Weissman book and the Rosenak encyclopedia. Several galleries carry her work.

IKE MORGAN
(b. 1958)
Lives in the state hospital in Austin, Texas. He has been institutionalized for more than one-third of his life because of his schizophrenia. Art seems to be his main interest. His life is described in detail in other sources, as is his art. Most often, he makes portraits of people who, according to art dealer Leslie Muth, "always look a little troubled." Many galleries carry his art.

RONNIE MORGAN
From St. Francisville, Louisiana. He started carving about four years ago, when his wife Carolyn asked him to make a large rabbit from a sheet of plywood to put outside her antique shop for the Easter season. He said "no way,"—a sheet of plywood cost too much. He had a piece of cedar log in his yard, which he looked at to see what he could see, and carved a rabbit. His wife put it out front and someone asked to buy it within a couple of hours, so he made another. Then he started making other figures—people and animals—now he gets a lot of commissions. He was working on a life-size nativity scene when we visited (fourteen pieces), and had just finished carving one wise man. Two large cedar stumps stood nearby. Ronnie said he "saw the African wise man" in one of them, and the last wise man in the other. He had already carved "the one from Asia." He does not draw or

design anything in advance, but looks at the wood to see what is in it. He uses cedar and cypress—"lots of cedar around because of the tornados, but no cypress because the water level of the swamps is too high." Morgan sometimes helps with stripping, refinishing, and repairing furniture for his wife's antique business, but now he mostly carves. His work is available at Star Hill Antiques and Gifts, 4 miles south of St. Francisville on Highway 61, HC 69, Box 940, St. Francisville, LA 70775, (504) 635-6215.

ANNA MARY ROBERTSON MOSES
(1860-1961)

Lived most of her life in upstate New York—except for twenty years spent in the Shenandoah Valley of Virginia, where Moses would have been happy to stay had her "homesick" husband not torn up the family and transported them back north. According to gallery owner Randall Morris, "she may be seen as a bridge from the 19th century to the 20th century." She painted from her own experience. Many books have been written about her, including one she wrote herself. Some of these books are in the bibliography; many of these include additional bibliographical references. Oneal, in her biography *Grandma Moses: Painter of Rural America,* says Moses spent the last six months of her life in a nursing home in Hoosick Falls, New York. "She hated it. They wouldn't let her paint." Books by Otto Kallir and Jane Kallir contain many reproductions of her work. She is represented in numerous museums, including in Bennington, Vermont and

the Metropolitan Museum of art. Galerie St. Etienne in New York City sells her work.

JAMES KIVETORUK MOSES
(b. 1900)

Born on Seward Peninsula at Cape Espenberg, Alaska. He turned to painting in 1954 after being seriously injured in a plane crash, which ended his successful career as a trader of furs and dogs in Cape Espenberg and Siberia. In 1978 he was living in Nome. His works are in ink and colored pencil on paper, and usually depict Eskimo legends or rituals, showing many versions of a story. His work does not resemble traditional native art. His work is included in Hemphill and Weissman. Pieces are in the permanent collection of the Alaska State Museum in Juneau, and colored plates of two works appear in *Contemporary Art from Alaska.*

EMMA LEE MOSS
(b. 1916)

Lived in San Angelo, Texas until advancing years made it necessary to return to her family in Tennessee. Her first paintings were done in the 1950s using the paints that belonged to the children of her employer. She stopped after her own marriage and children and started again during the long terminal illness of her husband. The paintings are called "bright and optimistic" and there are always lots of people included in her work. Her work is illustrated in *Animals in American Folk Art* by Wendy Lavitt. Paintings and her papers are in the San Angelo Museum and galleries carry her work.

MARLON MULLEN
(b. 1963)

Mullen is able to hear but he cannot speak. "It is most fascinating to watch him paint," say the people at the National Institute of Art and Disabilities. "He puts his whole body behind each brush stroke, almost dancing to an inner rhythm as he paints." He has an intense painterly quality which he achieves through swift brush strokes overlaying color upon color. His images range far, from bridges to television sets to ice cream cones. Sometimes his paintings are abstract, sometimes not. His colors vary with his conception. "At times they are rich and dark, while at other time he achieves a luminosity of delicate opalescence." The National Institute of Art and Disabilities Gallery carries his work.

MARK ANTHONY MULLIGAN
(b. 1963)

Lives in Louisville, Kentucky. He has been diagnosed as having a mental illness similar in some ways to schizophrenia—but Mulligan says, "I call it retarded." He mostly keeps smiling and wanting to share his art and the songs he writes with many people. According to newspaper writer Dick Kaukas, his sketches and paintings, mostly Louisville scenes, "are dense, complicated urban landscapes usually done from the whimsical perspective of someone who might be hovering in a hot air balloon a could of hundred feet off the ground." And dominating every vista are the signs Mulligan loves—street signs, directional signs, commercial signs, railroad crossing signs . . . and many

more. Mulligan's work is carried by several galleries.

ED "MR. EDDY" MUMMA
(1908-1986)

Born in Milton, Ohio. He traveled around the country a lot, doing odd jobs until he married and settled on a small farm near Springfield, Ohio. After his wife died he moved to Florida, around 1966, to be closer to his daughter. Mumma suffered from diabetes, which eventually cost him both legs. "Mr. Eddy" painted mostly round-faced portraits of a man, though he occasionally did other images. He would not sell his paintings. The day Mumma died, according to information in the Rosenak encyclopedia, a folk art collector happened by and "arranged to buy between 600 and 800 of the artist's works. The family considered Mumma an eccentric and had no use for his paintings." Several galleries carry his work.

JANET MUNRO
(b. 1949)
CHARLES MUNRO

Born in Woburn, Massachusetts and grew up on a dairy farm. She married Charles Munro in 1968 and they both ran a dairy farm in up-state New York. Janet Munro does very detailed paintings in a "primitive" style of a period before she was born. I am troubled by "memory" paintings of things that the artist could not personally remember, but Munro is included in this book anyway. Charles Munro does painting on furniture, wood and masonite. He especially enjoys scenes of towns and old boats. Gallery 53 Artworks carries work by both of these artists. John Fowler and Knoke carry only Janet's work.

VALTON MURRAY

Born in Mesena, Georgia. He left school before completing the seventh grade and has never received any art training. But painting and creating are a major part of his life. Despite orthopedic and neurological problems that have handicapped him since birth, Murray works very had to support himself and his two small sons with his art, which he believes is a gift from God. He specializes in genre painting recalling his childhood in the South, and has been an active participant in programs and exhibitions sponsored by Very Special Arts Georgia. Several galleries carry his work.

J.B. MURRY
(1908-1988)

Born in Glascock County, Georgia and remained in that vicinity all of his life. He worked as a sharecropper and tenant farmer, marrying Cleo Kitchens, with whom he had eleven children. When he died in 1988 he had three great, great grandchildren and quite a few family members of the generations in between. Murry began making art after he had a vision in the late 1970s, after which he was able to "write in the Spirit" and "read through the water." He completed hundreds of vibrant, colorful paintings and drawings which incorporate his improvised script "Spirit writing," with or without other images that tend to be very "watery"—elongated, wavy, and graceful. His work is in museum collections, numerous exhibitions and exhibition catalogs, and many galleries.

RONALD MUSGROVE
(b. 1944)

Born in Washington, D.C. and now lives in Maryland. He was one of ten children of a fairly comfortable family, but still managed to do enough "on the wrong side of the law" to serve time for three felony convictions. While in prison, he was able to pursue a lifelong interest in art. The art he created in prison allowed him both personal satisfaction and a heightened sense of self-worth, plus he sold some of his paintings to fellow inmates and some "outsiders." Musgrove has continued to paint since leaving prison, and now pursues this interest during his spare time from his job. He is painting on a fairly regular basis. Religion is a large part of his present life and is the guiding theme of his daily conduct, as well as providing the subject matter for most of his works. The Tartt Gallery carries his work, and gave him a one-man show several years ago.

MARCIA MUTH
(b. 1919)

Lives in Santa Fe, New Mexico, and is a self-taught painter whose work should be better known. Born in Indiana, she has been an English teacher, writer, publisher, and librarian. After moving to Santa Fe, Muth and her longtime partner Jody Ellis started Santa Fe's first literary magazine, *The Sunstone Review.* Muth started painting in 1975; her themes are the ways in which ordinary people in the 1920s and 1930s lived and worked. Her paintings, acrylics on canvas or acrylics and inks on paper, are in a flat, linear style. Her stores, factories, tea parlors, corner groceries, and living rooms are well-furnished with objects of the time. These memory paintings record life

beyond the rural. Marcia Muth's work is in the permanent collection of the Museum of Fine Arts in Santa Fe, the Museum of Naive Art in Paris (France) and the Jewish Museum in New York City. There was an exhibition of her work at The College of Santa Fe in September 1992. Several articles in the bibliography discuss her work. She shows her work by appointment. Call (505) 473-2688 or write to 2336 Camino Carlos Rey, Santa Fe, NM 87505.

REGINA NAHA

A Hopi carver, which is an unusual circumstance for a woman since Hopi men are the traditional carvers. Naha carves figures of people and animals, and places them in an "environment" on a square piece of plywood. Her figures are carved with great skill and grace, and are carefully painted. One of her pieces is called "Navajo-Hopi Land Dispute:" A Hopi man in painted blue jeans and yellow sleeveless T-shirt is stringing a wire fence, his mouth pursed in a whistle while he works. Behind him a very angry-faced Navajo woman is cutting the fence with wire cutters. Naha's work is carried by Cristof's in Santa Fe.

NORA NARANJO-MORSE

A Santa Clara Pueblo sculptor who comes from a long line of pottery makers. She learned her basic skills from her mother, but her work is decidedly nontraditional. According to one reviewer, her work ranges from "ethereal icons to broad burlesques . . . they are sometimes poignant, occasionally ominous, often witty, and nearly always irresistible." She is best known for her clay people: the striped clowns of the pueblo plazas, and various characters such as "the Intellectual of Tuba City" and "Pearlene"—representing a Pueblo woman with "one foot in tradition and one foot in this other world . . . " Naranjo-Morse has work in Santa Fe galleries.

CARL NASH
(b. 1948)

Born in Lubbock, Texas and now lives in Ft. Worth. He is a self-taught artist and homeless man who says that God came to him in a dream and told him to make art. He is married and has several children. A black man with no art training, his work has appeared in several shows in the Dallas area. Nash is "so compulsive with his art that he has trouble holding jobs." He uses found objects in his work. He creates objects from six inches to twenty-five feet tall, made with whatever he has on hand. He says, "With art I started putting two and two together and instead of getting four I got six." Nash does paintings of animals and people, as well as wire sculptures, some of which resemble space creatures. He works a lot from dreams. He also makes penny boxes, designs, and space weapons from coins. Webb: Contemporary Folk Art in Waxahachie, Texas has his work.

J. OLAF NELSON

Born in Tulsa, Oklahoma. He moved to Kentucky in 1987 to pursue his dream of becoming a well-known carver. He lives in Lexington now with his wife Sandi and small son Christian Olaf. Nelson works full time as a medical technologist at a laboratory "to pay the bills." He would rather be at home carving more. He uses fir and white pine to carve his figures, paints them with watercolors and then coats them with polyurethane to protect them. His work is very "clean" and finely finished. His figures—all tall and thin— include Uncle Sam, a farmer, a man in a suit, a man sitting on a box with a fiddle in hand. Nelson's art was described, on the occasion of an exhibition of his work, as "primitive yet sophisticated." He says he can only carve what is in his mind, even when people ask for something. Kentucky Art and Craft Gallery sells his work.

MARIE NELSON

Lives in Los Angeles and makes artfully decorated baskets from telephone wire. They are similar to the baskets made by men in Zimbabwe and parts of South Africa. Marie Nelson, however, adds to her baskets such items as buttons, keys, chains, beads, and pins. Mrs. Nelson is a poor woman, and very religious. Her children and grandchildren appear from time to time, at the New Stone Age Gallery in Los Angeles, with her art to sell.

JACOB NEMOITIN
(1880-1963)

Practiced medicine in Stamford, Connecticut for fifty years, when that community was a factory and mill town. He was a Russian Jew and he and his family came to America to escape the pogroms and difficulties for Jews in his native land. Nemoitin came to Stamford in 1907. His medical practice focused on the immigrant community, among whom "he became a legend," treating all regardless of their ability to pay. He also was

a self-taught painter and sculptor. His images include people in Stamford, pastoral scenes from his home in Russia, and some still lifes. An exhibition of his work was held in Stamford in 1989. Prince Art Consultants in Stamford carries his work.

JOHN H. NEWMARKER
(b. 1927)

Born in Nevada and moved to California in 1954. He makes human figures, and sometimes animals, out of found objects and wood. His figures from tin cans and jar lids are among his best. Many of his figures represent special events or people in different occupations. The Ames Gallery in Berkeley, California carries his work which may also be seen at the Oakland Museum.

BENNETT NEWSOM
(1886-1973)

Born and died in Oakland, California. As a very young man he was a cadet aboard a steamship on the China run. This experience, travels with his wife, and printed materials were the sources for his prolific production of carved and painted sculptures. His work is available from The Ames Gallery in Berkeley, California.

B.J. NEWTON
(b. c.1930)

Has spent most of his time in prison in California. He has been in many shows of self-taught outsider artists after being discovered by Chicago artists Nilsson and Nutt. He makes symbolic and mystical paintings in oil. He "heard God speak to him one day in the prison yard at Folsom." His work may be seen in the exhibition catalog *Visions* and in *Twentieth-Century Folk Art and Artists,* by Hemphill and Weissman.

J.L. NIPPER

Lives in Beech Grove, Tennessee. He was born in Whoodoo, Tennessee. Nipper is a chain saw carver who makes large birds and animals from tree stumps. He paints his work with solid colors and polka-dots. For a time his work was very much like his mentor Homer Green, but now it is taking its own direction. One of his most interesting forms is his tree branches with crows. Bell Buckle Gallery in the Tennessee town of the same name carries his work.

GROVER NIX
(b. 1927)

Born in Forsyth, Georgia. He grew up in Thomaston and drove a bus in Atlanta for thirty-seven years. Although retired, he still drives part time. He is a carver, of bears, other animals, and birds. He likes to portray family groups of these animals, which he paints with lacquer after finishing the carving. He also carves hardwood canes. Modern Primitive Gallery in Atlanta and Southern Folk and Outsider Art in Washington, D.C. carry his work.

MARY NOHL-YARD ART-MILWAUKEE, WISCONSIN

At 7328 Beard Road, in the Fox Point area of Milwaukee, Mary Nohl has created an environment that is a "must see," although she has had training as an artist. The house is surrounded by a cyclone fence with barbed wire and in addition has a barking dog to protect the inhabitants and the environment from local vandals. Attached to the surface of the house are cut-out figures; hanging throughout the trees are white, ghostlike figures, probably of painted wood. Two interim "fence" sections, upon closer examination, are an arrangement of cast concrete faces. Many human and animal figures are placed throughout the garden—some of this world and some not. The figures seem "melancholy" and somewhat poignant. An exhibition catalog, *Mary Nohl: An Exhibition of Sculptures, Paintings, and Jewelry* gives details about her life, her art, and the pleasure it gives when people who stop to look.

RANDY NORBERG

Is the son of weathervane maker Virgil Norberg and lives in Iowa. He became interested in making wooden models of planes, cars, trolleys, and whirligigs in 1988, when he was eighteen years old. Some of his work is more craft than art, perhaps, but all of it is well done. His work shares the same quality of bright colors exhibited by his father's work—because Randy "shares" his father's paint. His work is available from The Pardee Collection in Iowa City.

VIRGIL NORBERG
(b. 1930)

Born in central Illinois and now resides in Iowa. Most of his life he worked as a welder and maintenance mechanic. These skills were easily transferable to his uniquely designed weathervanes. His themes are taken from Bible stories, circus performances, and military life, and are often a commentary on

modern life. The finest pieces are welded steel and are painted with enamels of brilliant oranges, greens, blues, and yellows. The work is included in the book by Johnson and Ketchum in the bibliography. Norberg's weathervane art is available from The Pardee Collection in Iowa City.

BILL NOTZKE-"JUBILEE ROCK GARDEN"-JUBILEE, ILLINOIS

Bill Notzke was an Illinois dairy farmer, born in 1891 in Jubilee Township, Peoria County, Illinois. His first major construction was a brick and glazed-tile dairy barn, an Art Deco vision built around the usual wooden dairy. His next project was a rock-studded plaza, and then several arches—one a memorial to his wife. Notzke inlaid his constructions with rocks and stars and crescent moons of rose quartz. When Notzke was alive his garden was planted with pink petunias. The Jubilee Rock Garden is very large and visible from the road. To see it, drive down Highway 150 near Brimfield, fifteen miles west of Peoria.

PUCHO ODIO
(b. 1928)

Born in Santiago de Cuba in Oriente Province, Cuba, and now lives in New York City. He uses found wood to create people, animals, birds, and other figures, then finishes the pieces with latex house paint. Odio's art is pictured in the Rosenak encyclopedia, *American Folk Art of the Twentieth Century,* by Johnson and Ketchum, and the catalog *Spirits.* His work is in the collection of the Museum of

American Folk Art and the John Judkyn Memorial in Bath, England. His art was sold at American Folk Heritage Gallery before it closed and I could not locate information as to where it may now be available.

FRANK OEBSER-"LITTLE PROGRAM"-WISCONSIN

In 1973 when he retired, Frank Oebser, a dairy farmer in rural Wisconsin for seventy years, started building fantastic yard art around his house and barn. Most of the pieces were mechanized. He also had an extensive collection of working antique farm machinery in his barn, peopled with life-sized figures stuffed with hay and dressed in castoffs. Thousands of people visited his site until it was dismantled in 1989. It may be seen in the film, " 'And So It Goes . . . ' Frank Oebser— Farmer/Artist, 1900-1990" produced by Karla Berry and Lisa Stone.

MATTIE LOU O'KELLEY
(b. 1908)

Lives in Decatur, Georgia. Her landscapes and memory paintings are well-known. She grew up in rural Bank County and did not begin to paint until she was almost sixty years old. She has been the subject of many books, and periodical and newspaper articles. Her work is in museums and galleries carry her art.

HELEN LA FRANCE ORR
(b. 1919)

Lives in Mayfield, Kentucky. She is a versatile self-taught artist from the western part of the state. Orr has been painting since she was a small child. Her subject matter is wide-ranging,

including landscapes, floral studies, religious themes, and memory painting of her own life. Orr also carves animal sculptures, makes very elaborate puppets, and is a quiltmaker. Orr, a black woman, has been in many shows and is in the permanent collection of the Owensboro Museum of Fine Art. Galleries carry her work.

GEORGIANA ORR
(b. 1945)

Born in Gridley, California, and now lives in Gilchrist, Oregon with her husband and family. When she was about thirty-four, she began illustrating passages from the Bible. She paints in very bright colors, using oils on canvas and acrylics on paper. Her works are available from the Jamison/Thomas Gallery in Portland, Oregon.

JOE ORTEGA
(b. 1966)

Born in Santa Fe, New Mexico, where he still lives. He has spent his lifetime close to many woodcarvers; his brother-in-law is David Alvarez, and his father Ben and brother Michael are well-known carvers of *santos.* So Joe has been surrounded by both *santeros* and carvers of wooden animals. At the age of twenty, Joe began to carve his own work, and has produced two series of small coyotes and little rabbits. He is beginning to explore other animals as subject matter. His work is available in galleries.

SABINITA LOPEZ ORTIZ

Continues a family tradition of carving *santos*—her grandfather was Jose Dolores Lopez and her father is George Lopez. She wanted to walk in their foot-

steps. Her works are often available at the Lopez and Ortiz Woodcarving Shop in Cordova, New Mexico on the High Road from Santa Fe to Taos, between Chimayó and Truchas. You can write to her at PO Box 152, Cordova, New Mexico 87523.

HOWARD ORTMAN
(1894-c.1970)

Born in Pennsylvania and moved to San Francisco when he was about twenty. He became a jeweler, married in 1923, and had no children. In his early seventies, working in a garage with tools provided by a friend, Ortman began carving his intricate, polished figures of mixed woods and marrow bones. The highly polished and detailed carvings are especially remarkable because he had lost most of the sight in one eye. His entire collection of over one hundred pieces was carved as therapy in a seven-year period, and never exhibited in his lifetime. The Ames Gallery in Berkeley, California carries his work.

EDWARD OTT

In his early seventies, is retired, and lives in Lakeland, Florida. He likes to paint people in groups—family and community scenes. Among his favorite subjects for painting have been black people and Amish people. He was the subject of a "sketch" written by Hardee and Fischer in the *Folk Art Finder*. Tyson's Trading Company in Mycanopy, Florida carries his work.

WILLIAM HENRY OVERMAN, JR.
(b. 1946)

Born in Gatesville, North Carolina and moved to Roanoke Rapids as an infant. He says his interest in glass and shining objects, which are now part of his art, comes from "the days spent in the old Rosemary Baptist Church with its beautiful stained glass windows." Overman does not label himself "folk," nor does he feel he is a total "outsider" since he is a professor of psychology at UNC-Wilmington. He is totally self-taught with respect to art. He calls his work "painting with glass." He uses glass, foil, and "glitter glue" on plywood or canvas. The result is that light bounces from behind the glass as well as from the surface. Every finished piece sparkles fiercely as you move past it. His themes deal with religious, spiritual, or psychological images. These images reflect his childhood upbringing in a traditional church and his interest in the complexities of human behavior. Overman says "My motives is making my work come from a compelling drive to create . . . to put my dreams and emotions into shining reflections of their content." Urban Artware Gallery in Winston-Salem has his work.

MARCO A. OVIEDO
(b. 1948)

A New Mexico native of Basque descent. He uses pine, aspen and cottonwood for his carvings of *santos*, other religious figures and animals. His family helps with the fine sanding and when his figures are painted, his wife Patricia Trujillo Oviedo does that work. His work may be found at the Oviedo workshop in Chimayó,

A.B. OWEN

Born in Vicksburg, Mississippi, and was an engineer for the telephone company before he retired in 1984. He started making his whirligigs, each with several moving parts, about ten years before retirement. His very reasonably-priced whirligigs are amusing and whimsical, not cute. Most, and the best, of his whirligigs are of his own design. Especially interesting are the Mississippi steamboats, the Model-T's, and the alligators with snapping jaws. Most years, Owen brings his work to the New Orleans Jazz and Heritage Festival and to Festival Acadiene in Lafayette, Louisiana. He also sells from his house, or by mail—Blake's Sawdust Shop, 215 Tanglewood Drive, Alexandria, LA 71303, (318) 442-9012.

M.L. OWENS
(b. 1917)

Born in Seagrove, North Carolina. He is the son of James and Martha Owens who began Owens Pottery there in 1895. As a young man, M.L. Owens began to guide the family pottery business. He became "partially retired" in 1978. Owens uses feldspar, alkaline glazes on his face jugs, which have a round-eyed, barred teeth look often compared to the look of Mayan images. His face jugs come in two sizes. Since his partial retirement, Owens does not often make face jugs. His work is carried by Lynne Ingram Southern Folk Art.

WILLIAM OWENS
(b. 1908)

Lives in Poplar Branch, North Carolina. Owens worked as a farmer and at various other jobs until he became a sign painter in 1941. In the early 1970s, he took up woodcarving. He made

"bathing beauties," Uncle Sam's, angels, and other figures— carved and painted in bright colors. He continued to paint and carve until 1986. It is rumored that he may start again with the help of his son. His work is illustrated in *Signs and Wonders,* and he is in the Rosenak encyclopedia.

ANGELA PALLADINO
(b. 1929)
Came from Sicily to the United States in 1958, and now lives in New York City. During recovery from surgery she began to sketch and her husband bought her some paints and urged her to try them. Her paintings are often images of nude women. The Rosenak encyclopedia says "she is not a feminist painter." In *Twentieth Century American Folk Art and Artists,* by Hemphill and Weissman she is quoted as saying, "I love my children . . . but I want to do something just for myself, just for myself"—definitely a feminist point of view. Each of the books mentioned carries illustrations of her work and information about the artist.

STANLEY PAPIO
(c.1915-1982)
Born in Canada. After moving all over the United States, he found his way to Key Largo, Florida, where he bought a small lot on Route 1 and went into business as a welder. He encouraged people to leave their oil cans and appliances on his property so he could use the junked metal for his welding. Then came the developers and upscale neighbors who hated him and his junk, and tried to get rid of him. He retaliated by welding

parodies of them and putting the finished work on his front lawn. He turned his welding shop into a museum. Papio got a lot of positive attention from the art world, but not from his neighbors. He died suddenly at the age of sixty-seven. Pieces of his environment may be seen at the East Martello Gallery and Museum in Key West.

ROSITA PARDO
(b. 1936)
Loves to draw and paint pictures of movie stars and dancers, as well as people she knows, both in motion and standing still. "Her pictures are primitive and simple, yet have a natural articulation which gives them a sense of reality." Pardo also paints large, brilliant flower forms imbued with intense individuality. Her work may be seen at the National Institute of Art and Disabilities Gallery in Richmond, California.

DONALD PATERSON
An artist with the Creative Growth Art Center in Oakland, California. He is developmentally disabled, speaking just twelve words, but "he has an enormous visual vocabulary." He is particularly sensitive to popular culture and its icons: Elvis Presley, King Tut, and Batman are frequent images in his work. Paterson has sculpted a recreation of Oakland's Paramount Theater, which now sits in the theater's lobby. On the tiny sculptured stage dances Elvis Presley with guitar. The marquee reads "Donald Paterson & Elvis." He makes paintings, sculpture, and tapestry. His work may be seen at the Creative Growth Center Gallery.

EARNEST PATTON
(b.1935)
Lives in Campton, Kentucky, and is a master of carved and painted figures. He has worked as a farmer, mechanic, and school bus driver. Patton said he never went to school: "I had to work." His broad range of subject matter includes folk heroes, religious figures, and figures from daily life. He says he puts snakes on most of his carvings. Patton says he started carving about 23 years ago, after seeing the work of Edgar Tolson. He says he "carves and quits, carves and quits." He also says the stories claiming he is related to Edgar Tolson are not true, "my wife is." His favorite wood to carve is linwood, and he often also uses poplar. He goes off in the woods and cuts his own wood with a chain saw. He roughs it out with a "chopping hatchet" and finishes with a carving knife, then paints them with machinery paint. Patton has been exhibited frequently and his work appears in many galleries.

PAUL W. PATTON
(b. 1921)
Born in Alliance, Ohio and lives now in Maple Heights. He was an elementary school principal and started painting in 1985, two years after he retired. Patton's paintings document the Ohio village of Rix Mills where he grew up. He was especially motivated after he found that the town as he remembered it had been mostly destroyed by strip mining. Patton has an eye for design in the intricate patterns and placement of people and structures in his paintings. Gary Schwindler, in a review, said of Patton "the paintings of Paul Patton are outstanding. The

juncture between recalled experience and the selective, intensified depiction of it is seamless. I find Patton's art totally convincing; I would not hesitate to call him a master of the genre." Patton's work is available from the Duncan Art Gallery in Hudson, Ohio and at Frank J. Miele Gallery in New York.

LESLIE J. PAYNE-"AIRFIELD"-GREENFIELD, VIRGINIA

Airplane Payne (1907-1981), as he liked to be called, built an environment where he lived on the Eastern Shore of Virginia. He constructed large, painted airplanes, and made a few other sculptures, mostly of boats and of patriotic themes. A writer has said, "through imitation and homemade construction, Leslie Payne, a poor black fisherman, reinvented himself as 'Airplane Payne'—the proprietor, manager, and pilot of the Airplane Machine Shop Company." This quote and much more detail may be found in an article by Jonathan Green in the *Folk Art Messenger*. His airplane constructions and airfield environment were not saved. Some of his sculpture pieces are in private collections. About the only access to his work is in photographs. One of his fishing boats is in the National Museum of American Art.

B. EUGENE PECK
(b. 1941)

Born in Mariba, Kentucky, and lives now in Bybee. He works as an electronics technician for the telephone company. In 1975 he hurt his back and could not work for a long time. His doctor told him to take long walks. Peck could not stand to look at

all the trash along the roadside, so he started whittling. Soon he was carving intricate faces and small carved heads. Sometimes he makes other figures, too. He does not plan what the image will be; he "takes what comes out." He leaves his carvings natural. A few of them are painted by his wife. The Morehead State University Folk Art Sales Gallery carries his work.

JOHN W. PERATES
(1894-1970)

One of the more famous contemporary self-taught artists. He was born in Greece and lived in Portland, Maine, at the time of his death. His carved, polychromed icons are definitely a reflection of his heritage. His work is written about and illustrated frequently. It is in the permanent collections of the Museum of American Folk Art, Milwaukee Art Museum, and the National Museum of American Art. In 1991 a piece brought in about $12,000 at a Sotheby's auction.

BENJAMIN F. PERKINS
(1904-1993)

Born in Alabama and lived there all his life, except for time out to serve in the marines and to study at the University of Virginia. Perkins could be listed as both a painter and an environmental artist because of the painted and decorated buildings on his property. He used red, white, and blue paint to depict patriotic and religious themes. These colors and themes may also be found on smaller-scale art works such as gourds, boards, and canvas. Two of his famous images are the King Tut Treasure and the Cherokee Love Birds. Some of these works display

bright yellows and oranges, or the colors of a peacock's tail. Brother Perkins died of "heart failure" the morning of January 13, 1993. His work is available in thirty-five galleries listed in this book.

"THE PAINTING PERKINSES"

The Perkinses are three folk artists from one family who paint bright pictures reflective of life in rural Pennsylvania. RUTH PERKINS, born in Jamestown, Pennsylvania in 1911, started painting in the 1960s after retiring from the family restaurant business. Her husband CLARENCE "CY" PERKINS started doing art, first with pencil and paper and later with oil on canvas, in 1976. MARY LOU PERKINS ROBINSON was inspired to try painting after a visit to her parents' home from her own home in Warren, Ohio. Ruth Perkins and her daughter focus on people in family gatherings. Their paintings include much detail. Cy Perkins most often paints houses and outdoor scenes. All three artists paint on canvas, the parents using oils and Mary Lou using acrylics. The Perkins family was represented by Jay Johnson's gallery before it closed after his death. In 1983 Ruth and Clarence lived in Transfer, Pennsylvania and Robinson lives in Warren, Ohio. Their work is in the Museum of American Folk Art in New York City and in the American Museum in Bath, England. Several publications also discuss their work.

JUDY PERRY
(b. 1947)

Born in North Tonawanda, New York. She is a "naive painter"

who creates very detailed canvases, and also paints her frames. Her images range from Victorian houses to beach scenes in Malibu. Her colors are primary and brilliant. "Her work is meticulous, neat, organized, and refreshing." Her work is available in galleries.

VIRGIL PERRY
(b. 1930)
Grew up in rural Bibb County and now lives in Hueytown, Alabama. He spent twenty-one years in the Air Force and then went to work for Continental Can Company from which he retired in 1990. In 1986 he started carving when his son-in-law brought him a small cypress stump from a flea market. His granddaughter asked him to carve a unicorn for her, and he could not do it. Then "I asked the Lord to reveal the unicorn. As I held the wood, I saw nothing but the unicorn." He started by carving owls, unicorns, and cats. Now he carves people. He also has started painting his figures. His work is in the exhibition catalog *Outsider Artists in Alabama* and several galleries carry his work.

LEROY PERSON
(1907-1985)
A retired sawmill worker when he took up carving and painting. He made numerous small sculptures including birds, fish, snakes, and people. Some of his structures are mysterious, more abstract than representational. His work may be seen in the exhibition catalog, *Signs and Wonders,* and over 200 pieces of his art are in the Lynch Collection at North Carolina Wesleyan College.

OSCAR PETERSON
(1887-1951)
Most often thought of for his astounding and beautiful fish decoys. He also made colorful and fine carvings of other creatures, however, as well as wood plaques. This latter work may be seen in illustrations in *Animals in American Folk Art,* by Wendy Lavitt and also in a book about Peterson, *Michigan's Master Carver,* by Ronald J. Fritz.

RASMUS PETERSON-"PETERSON'S ROCK GARDEN"-REDMOND, OREGON
Rasmus Peterson (1883-1952) came to the United States from Denmark in 1906. A farmer, Peterson had trouble growing produce in rocky eastern central Oregon. So, according to his stepdaughter, he planted a rock garden from his huge collection of Oregon agates, obsidian, petrified wood, malachite, and jasper. These are mortared into miniature buildings, lagoons, and bridges. The Peterson Rock Garden is open to visitors daily. It is located between Bend and Redmond, Oregon on U.S. Route 97, then 2/5 miles west (503) 382-5574.

NAN PHELPS
(1904-1990)
One of eleven children born to a poor family near London, Kentucky. She later fled her home and husband, and settled in Hamilton, Ohio. Her early works resembled works of nineteenth century portrait painters. In her later years she did totally different work, creating strong original paintings with contemporary subject matter. Her work is in the permanent collection of the Cincinnati Art Museum,

and is handled by Galerie St. Etienne in New York City.

PHILADELPHIA WIREMAN
The Philadelphia Wireman should perhaps be excluded from this list because he is anonymous. Nevertheless, his work exudes a powerful presence, easily as great and as uniquely identifiable as for any artist whose name is known. He was discovered when several hundred wire figures were found spilling from a box in front of a "transient home" in a black neighborhood in Philadelphia. The structures wrapped in wire encase street debris—a bottle cap, an earring, crumpled cellophane, for instance—a whole array of objects. The figures are about seven to eight inches high and, according to Randall Morris, "Very frontal . . . if you look at them long enough you see faces." Janet Fleisher Gallery in Philadelphia has this work.

IRENE PHILLIPS
A prolific artist and a major contributor to the Hospital Audiences, Inc. Collection. She paints subjects from her imagination, objects in her environment, animals, and people she knows. Her strongest works are abstracted ink drawings of figures on white paper. Other works are densely painted and abstracted almost beyond recognition. Phillips is distinguished by her enthusiasm to try new media and new subjects. Luise Ross Gallery in New York carries her work.

DAVID PHILPOT
(b. 1940)
Born in Chicago and still lives there, on South Bishop Street.

Philpot has been carving his elegant staffs, from Ailanthus trees, since about 1971. He says he got the idea for carving staffs from the movie "The Bible." He asked God for the talent and got it "with no instructions." To make the staffs he "listens to what the tree or wood says." Philpot was included in the exhibition *Black Art-Ancestral Legacy* at the Corcoran, for which a catalog was published. His work is available at Carl Hammer Gallery in Chicago.

AUDREY PICKERING
(b. 1924)
Has had bouts of depression since adolescence and has been hospitalized for them at various times. Since she started painting, these have almost disappeared. Although in contact with reality, she likes to live in her memories and she brings them into her paintings. "Themes recur that are of great importance to her—playing with her brother, family picnics, her marriage. Into this background of memories is woven a dreamlike tapestry of flowers, trees, bridges, and mountains." The beauty of her paintings, it is said, lies in her artistic judgment. Her work is available at the National Institute of Art and Disabilities Gallery in Richmond, California.

JOSEPH PICKETT
(1848-1918)
A self-taught artist of great importance, who bridged the nineteenth and twentieth centuries. He lived in New Hope, Pennsylvania, and took up painting late in life. Often his subjects are historical, or depict the countryside around New Hope. Sometimes both of these themes con-

verge, as in "Washington Under the Council Tree, Coryell's Ferry, New Hope, Pennsylvania," which belongs to the Newark Museum in New Jersey. The Whitney Museum of American Art and the Museum of Modern Art in New York have paintings by Pickett. Pickett's work is in galleries.

FRANK PICKLE
(b. 1933)
Born in Berryton, Georgia, and still lives in the area. Now retired, Pickle was in the textile business for twenty-four years. The youngest of seven children, he has been creating art since he was a child. Pickle sculpts fantasy animals out of wood, gourds, and electrical cables, and often gives them such names as "land shark," "river dragon," and "gourdzilla." They are typically very colorful. He also paints portraits of famous people he has admired, and carves small wooden figures. Galleries carry his work.

HELEN PICKLE
(b. 1915)
Born in Texas and moved to northern Mississippi after her marriage to Reuben Pickle in 1933. They had one son, who died in 1972. She suffered a series of strokes, which immobilized her left arm and leg. She took up painting at the urging of friends, to fight depression. Her paintings of the rural south, including tiny figures with outstretched hands, have a delicate, lacy quality. She uses acrylics on masonite; her husband makes her frames. Her work is included in the catalog, *Made by Hand: Mississippi Folk Art,* and in the permanent collection of the Mississippi State Historical

Museum. More recent information could not be located.

ELIJAH PIERCE
(1892-1984)
One of the most famous contemporary American folk artists. He was born in Mississippi, the son of a one-time enslaved person. Pierce traveled throughout the south and midwest and eventually settled in Columbus, Ohio, where he was a barber for over half a century. In the later 1920s, he renewed his boyhood interest in carving. By the 1930s he began making his religious art. His painted wood reliefs have been called "sermons in wood." Pierce has been exhibited and written about frequently, and numerous publications have illustrated his work. A large collection of works by Elijah Pierce is in the Columbus Museum of Art. A major exhibition, with a catalog, is scheduled for early 1993. Galleries carry his work.

WARREN H. PIERCE
(b. 1929)
Born in Fairfax, Louisiana and was the youngest of four children. He entered the army in 1946, was discharged from Letterman Hospital in 1949, and stayed on in San Francisco. He is divorced, has children, and lives in a small apartment which serves as both studio and home. He works in a vinegar factory. He started painting in 1976 when, in response to a dream, he went to his window one night and "a beam of light entered his forehead." His art was discovered in a second-hand clothing store. Pierce makes well-defined images of the trials and tribulations of contemporary life, using oil on canvas. He

says he adds salad oil to his paint and creates his unusual texture and outlines by using a method he describes as "swaving." The Ames Gallery in Berkeley, California carries his work.

BETTY COLE PINETTE
(b. 1939)
Lives in Brunswick, Maine. She began painting in 1976. Experimenting in a variety of media, nature is an inspiration for many of her pieces. Her paintings are becoming well-known among collectors in Maine. Very Special Arts in Washington, D.C. carries her work.

HORACE PIPPIN
(1888-1946)
Was the most famous black artist of his time and one of the greatest of any time. He painted his own memories and experiences, including growing up in West Chester, Pennsylvania and serving in World War I, where he was severely wounded. Pippin has received much attention from the art world, and there are numerous sources for reading about him and seeing his work. Seldon Rodman has written two books about Pippin. He is included in the Rosenak encyclopedia, and *Horace Pippin* (Washington, D.C.: The Phillips Collection, 1976) is a good source for color illustrations of his work. Pippin was included in the "Masters of Popular Painting" exhibition at the Museum of Modern Art in 1938. His work is in many collections, including Gallery of Art at Howard University, The Phillips Collection, Oberlin College, Metropolitan Museum of Art, Museum of Art of Carnegie Institute,

Pennsylvania Academy of the Fine Arts, Whitney Museum, Baltimore Museum of Art, Museum of Art of the Rhode Island School of Design, and Hirshorn Museum. The Archives of American Art has his "life story of art" and three separate memoirs of his military service. His work is represented by galleries.

ROSEMARY PITTMAN
(b. 1916)
Born in Cordova, Illinois and grew up on a farm in the corn belt, near the Mississippi River. She was a teacher and then a nurse in the South Pacific during World War II. Her husband, a geographer, was killed in the Philippines in 1948 while collecting soil samples, when their daughter was less than a year old. She moved to Seattle, Washington, and started to paint at about that time. Pittman tried taking a few classes but was not satisfied and went on her own way. Her paintings are often "quilt-like," with each contrasting square containing a face, a symbol, or some other image. She also does some painting relevant to Seattle history. The MIA Gallery in Seattle has her work.

JOHN PODHORSKY
Active in California about 1950, and little is known of his life. According to the information in the catalog for the exhibition *Pioneers in Paradise*, "His body of extant work is extraordinarily small though quite fascinating. It consists of drawings and paintings on paper, generally of architectural fantasies, bridges, small machines, which are occasionally accompanied by animals and trees. His style is a cur-

ious blend of heavily labeled geometric blueprint, full of eccentric descriptions, and playful, curvilinear counterpoint which allows the artist free rein to embellish certain details and define his flowers, animals and foliage. It is likely that Podhorsky had an interest in building, woodworking or carpentry, so evident is his concern with structural details." Galleries carry his work.

MELISSA POLHAMUS
(b. 1957)
A native of Ludwigsburg, Germany. This Virginia Beach artist began painting in 1990. She uses subtle tones of watercolor and black ink to create energetic and detailed visions of people, animals, and insects interacting with one another, with food, and with the geometrical patterns that surround them unrelentingly. Using primary colors mixed with earthy hues, Polhamus outlines in black ink the subjects of her work: a pink pig wrapped in lines and shapes, a green face overcome by vegetation, a huge insect working on a bright orange carrot, a woman with a fish-filled aquarium. Galleries carry her work.

JOE POLINSKI
(b. 1951)
Born in East Stroudsburg, Pennsylvania. He is a self-taught artist who is very political and issue-oriented. "He makes odd configurations and handles paint well. He has been exhibiting since 1980." His work is available at Epstein/Powell in New York.

NAOMI POLK
(1892-1984)
Born in Houston, where she lived all her life. She was forced

to give up formal education around the sixth grade, a fact she regretted. She had three children to raise alone after a white policeman murdered her husband. She worked hard to support her children and keep her dignity, refusing to accept the ill treatment common to a servant's life. She was ingenious in searching out ways to make a better living. The essay in *Black History/Black Vision* details the life of this very special woman. Polk considered herself a poet first and a painter second. Painting on found objects, she did a series of paintings with religious subjects, and another called "Lonesome Road" which expressed her view of life. Leslie Muth Gallery in Santa Fe carries her work.

JUAN POND

A self-taught artist who is in his "late 40s to early 50s." He has lived many lives; at present he is something of a vagabond who may show up at the gallery with work done in Taos, Aspen, or various places in Mexico. His works are sculpture and paint—wooden pieces he calls "plates" that hang on the wall and have other pieces attached to them. His recurring theme at present is "the highway with creatures as central objects." He says his plates are sculptured theatrical settings, compositions that depict an instant in time in any traveler's mind. He says further that his work is not a depiction of "road kills." He also has future plans to work with metal and return to working on canvas. Impressions II Gallery in Tucson, Arizona carries his work.

BRAXTON PONDER
(b. 1915)

Born in Lester, Arkansas and attended school in that state. He served in the Army from 1940 to 1946, and married Mary Lou O'Mary in 1942. They have just celebrated their fiftieth anniversary and are "active members of the Baptist church." He is a self-taught wood carver who was in the grocery business until his retirement in 1986, after which he began carving. He uses a pocket knife to carve his figures, which he then paints. He makes such images as animals, religious figures, and Noah's Ark. His work is available in galleries.

JOHN POPPIN
(1911-1992)

Born in Reading, Minnesota, where he was a farmer. He started producing art after retiring. Poppin was a sculptor whose principal medium was concrete, which he fashioned into animals—elephants, lions, dogs, pheasants—many of them lifesized. All of Poppin's figures are painted, and sometimes they are encrusted with dimestore jewelry, marbles, and other decorative filigree. Dean Jensen Gallery in Milwaukee carries his work.

WILLIAM E. "BILL" POTTS
(b. 1936)

Born in Des Moines, Iowa, and now lives in Denver, Colorado. He attended Drake University for a short time, majoring in sociology and psychology, and served in Vietnam as a medic. He makes detailed narrative wood carvings with themes from black history, the Bible, and western history. He also does full-sized figures of people and busts made from railroad ties. He uses any wood he can find, and paints his figures with house paint after carving them. Galleries handle his work.

STEPHEN POWERS
(b. 1958)

Born in Santa Cruz, California and now lives in Olympia, Washington. Powers has spent his life trying to figure out where he fits in, and how life is supposed to come together. After a short stint as an actor he entered into the family roofing business and began painting in all his spare time. "I have found that, having never owned a real house, painting houses and buildings gives expression to my interest in alternative architecture." Powers paints in acrylic on canvas and board, and his interest is in depicting structures that "others have not thought of and could possibly be built. At their lightest they are ideas and fantasies. At their deepest level they are reflections of myself." The structures are often puzzle-like, or look like game pieces, and others reflect in shape what is being housed in the building. For example, there is a bank in the shape of a coke bottle that says "No Deposit, No Return" on the outside, and a painting entitled "Dept. of Defense Lift Off Building" that is shaped like a missile. Each painting contains a lot of Powers' own social and political commentary, as well as an abundance of creative speculation. MIA Gallery in Seattle carries his work.

BARBARA PRESSLEY
(b. 1952)

Born and raised in Towns County in the north Georgia foothills, the youngest of ten children. She now works in a garment factory. She was attract-

ed to making art even as a child, but believed you had to go to art school, and her life offered no such possibilities. As an adult the desire to paint became so strong she taught herself. She works in oil on canvas and paints the scenery, the farm life, and the communities around her, sometimes with a touch of humor. Timpson Creek in Clayton, Georgia carries her work.

DANIEL PRESSLEY
(1918-1971)

Born in South Carolina and lived in New York from 1943 on, after spending time in Ohio. He died in Brooklyn. Biographical information may be found in the Rosenak encyclopedia and in *Black Art-Ancestral Legacy*. He was discovered at a sidewalk art show in Greenwich Village. Mostly known for his wood panel reliefs, he also drew and painted. Galleries carry his work.

TRESSA PRISBREY-"BOTTLE VILLAGE"-SIMI VALLEY, CALIFORNIA

Tressa Prisbrey (1896-1988) was a collector, especially of other people's castoffs. Her collections grew to such dimensions that they could no longer be contained in her trailer, so she set out to build something to house them. First she sought cinder blocks, but they were too expensive, so she started collecting bottles from the dump. A friend of her second husband, Al Prisbrey, says she used bottles to shame him into quitting drinking. Bottle Village was created between 1955 and 1972, but most of the major construction was finished by 1961. In those first six years, Prisbrey complet-

ed thirteen bottle houses, two wishing wells, a water fountain, several planters, two shrines, and a mosaic walkway embedded with all kinds of objects. Tressa Prisbrey died in 1988; many books and articles have been written about this woman of tremendous creative ingenuity. The village is closed to all but volunteers and researchers until certain code requirements are met. From the sidewalk, however, one has good views of the exteriors: Take Hwy 118E and exit at Tapo Canyon Road, turn right. When you reach Cochrane, turn left. Bottle Village is at 4595 Cochrane, and there is a resident caretaker.

LAMONT "OLD IRONSIDES" PRY
(1921-1987)

Born in Mauch Chunk, Pennsylvania and spent most of his working life with the circus. His personal experiences are a central theme of his work. He got his nickname,"Old Ironsides" when he survived an air crash during World War II. He was in a daredevil show after the war, but had to retire because of a heart condition. He started to paint when he entered a nursing home, around 1949. He painted circus scenes, patriotic themes, and personal experiences. There are numerous written references to his work, which is available in many galleries.

DOW PUGH
(b. 1906)

Born in Monterey, Tennessee. At the age of sixteen he left his Cumberland Mountain home to find work. Thirty-five years later, after his wife had died and his son was killed in an accident, he returned home and rebuilt his

mother's old log house. John Rice Irwin is quoted as saying "Pugh started whittling while waiting for firewood to dry out." He spent years digging up Indian artifacts. Later he made carved busts of famous people, along with birds, fish, and snakes. He also painted pictures, made heads from gourds, and decorated all his outbuildings with carved life-sized figures. The Museum of Appalachia has a permanent exhibition of his work, which is also carried by several galleries.

RUBY QUEEN
(b. 1925)

Was raised in Lawrence County, Kentucky, and now lives in Carter County. She and her husband, a farmer and retired factory worker, live on a ninety-acre farm on the edge of the village of Hitchins. Queen, who raised two children and worked at home, started painting about nine years ago, inspired by a friend who was a painter. She paints in oil and watercolor. Queen's work was included in "Images from the Mountains: A Traveling Exhibit of Appalachian Artists," November 1991—December 1991, sponsored by Appalshop. The exhibition sponsors said, "Her work captures the essence of days gone by in rural eastern Kentucky. She has won numerous awards and many of her paintings are in private collections and on exhibit in surrounding states." Ruby Queen will sell her paintings from her home, where you may write to her at PO Box 146, Hitchins, KY 42246 or call (606) 474-5638.

BOBBY QUINLAN

Is about forty-seven years old

and lives in the northern Kentucky-Ohio River Valley area. He started carving totemic pieces with intense symbolism about five years ago, after he had a heart attack. He uses a single piece of wood for each piece and carves with hand tools. He will occasionally use a chain saw to make single animals but does not like to do it because it is "too noisy." He has the designs for his work strictly in his head, and does not draw them first. He makes carvings that are very complex in their symbolism as well as birds, animals, and intricate bird houses. Quinlan's work is in the permanent collections of the Huntington Museum in West Virginia and the Morehead State University Folk Art Museum in Kentucky. His art is sometimes available at the Piedmont Gallery in Augusta, Kentucky.

NORMAN SCOTT "BUTCH" QUINN
(b. 1939)
Lives in western Pennsylvania, "a hard impoverished life constantly skirting the slippery edge separating the down-and-out and the irretrievable street people." He heats his three-room apartment with leaky roof with heat from the oven. He is a loner, but likes to talk to people, first about art, then about hunting, and then about anything you are willing to discuss. About his paintings he says "I set out to work in colors and the images just come to me. I start art with a line on canvas and I just keep adding to it. I like polka-dots." He works with wall paint, magic markers, and acrylics when he can afford them. He also creates works out of found objects such as bottle caps, tin cans, springs, and coils. Some of the resulting

assemblages are interesting critters. He also uses feathers in his work. Tartt Gallery in Washington, D.C. carries his work.

ISAAC IRWIN RABINOV
(1898-1980)
Grew up in New York City and received a B.A. in physics from the University of Chicago. He later moved to San Diego and worked as an X-ray technician. After retirement he began to make art. He was a self-taught artist who experimented with fired enamel on metal. He used unconventional methods of enameling, using the enamel as it if were paint, and enameled on salvaged street signs. He was interested in the technical side of enameling and developed his own kiln, machinery, and enamels. His subjects are dream-oriented, personal, and often derived from literary sources. His work is available at the Double K Gallery in Los Angeles.

MATTEO RADOSLOVICH-"WHIRLIGIG GARDEN"-WEST NEW YORK, NEW JERSEY
In 1947, Matteo Radoslovich (1883-1972) began to create whirligigs entirely out of wood. Later he incorporated other materials and soon the back yard garden was filled with moving and stationary figures and constructions. The family, according to several written reports, were not much interested in the art works, and were going to throw them out. Fortunately a folk art "picker" came along at the right time and the pieces were sold to collectors. Some are now in the Museum of American Folk Art and they are illustrated in the book by Lavitt.

SARAH RAKES
(b. 1955)
Born in the Ozark Mountains of Arkansas. Now she lives in an isolated area of Georgia near Tallulah Falls. She wanted to be an artist even as a child, and tried a few classes later but dropped out. Basically a self-taught artist, she visits museums, reads and studies. Her work is fairly sophisticated. She uses oil on canvas, acrylic on wood, oil pastels, gouache, and other mixed media. She uses bold colors and bold images. She believes we are "all in touch with the primal," and some of her paintings reflect this belief, such as "Lizard Pets at Night," "Lunar Babies," and her female nudes. Galleries carry her work.

MARTIN RAMIREZ
(1885-1960)
Born in Mexico, it is said, and died in California. Diagnosed as "chronic paranoid schizophrenic," Ramirez was institutionalized at a mental hospital in Auburn, California for the last thirty years of his life. About 1948 he began to make drawings. His tragic life, his discovery, and his art have received much attention. Refer to the many references in the bibliography.

KEVIN RANDOLPH
From New York City. After graduating from a special school, he came to Richmond, California to live with his father and stepmother. He now resides in a board and care home. He enjoys painting and printmaking, especially the latter. Randolph has "a strong sense of composition and is now refining his imagery." His work may be seen at the National Institute of Art and Disabili-

ies Gallery in Richmond, California.

LARRY RANDOLPH
(b. 1955)
Born in Oakland, California and still lives in that area. He is a thirty-seven-year-old black artist and poet who has been at Creative Growth Art Center in Oakland since 1988. Randolph has a genuine interest in and concern for others, which he exhibits in his art, poetry, and stories. His work is creative and original. He often augments his visual works with poetry and elaborate stories of each character. Randolph's artwork and world have a theatrical quality. His most intriguing works are large relief wood sculptures of different sets of twins. Each set is inspired by different media images and personalities, which Larry translates into his own unique vision using hot colors and his own pop style. Creative Growth Gallery carries his work.

GARY RATHBONE
(b. 1942)
Born in Princess Bay, New York. He is a self-taught woodcarver and has worked some with master folk artist carver Lavern Kelley. "Mr. Rathbone has been carving since his childhood, and especially enjoys creating painted figures. Composed potentially controversial tableaux, with moving parts activated by turning a wooden crank, are a special interest. His human forms are not particularly done to scale—and are often identified with droll names or titles. Subject matter includes historical and baseball themes as well as male/female relationships. Mr. Rathbone also enjoys doing commissioned pieces." He shows regularly in group shows at Gallery 53 in Cooperstown, New York, and also enjoys doing woodcarving demonstrations.

TIM RATLIFF
(b. 1959)
Born in Middleton, Ohio and now lives near Frenchburg, Kentucky. Ratliff makes whirligigs. He carves brightly painted animal sticks, birds, animals, and human figures. Ratliff is a printer by trade. Several galleries carry his work.

ERNEST "POPEYE" REED
(1919-1985)
Born in 1924 (or 1919, according to the information in the Rosenak encyclopedia) in Jackson, Ohio. He attended school through the eighth grade, was married, had three children, and divorced. Several publications have biographical information about Reed, including the Rosenak encyclopedia and the *Folk Art Finder* (see Index). Reed was self-taught, but definitely considered himself a professional artist. His favorite material for carving was sandstone. Subjects included people, animals, and figures inspired by Greek mythology. Reed's art was in a number of exhibitions including "New Traditions/Non-Traditions: Contemporary Folk Art in Ohio." His work is available in several galleries.

TIM REED
From Alabama. He makes whimsical, satirical whirligigs that are brightly painted. Robert Cargo Gallery in Tuscaloosa has his work.

ENRIQUE RENDON
(1923-1987)
Worked in the southwestern *santero* tradition. He carved and painted saints made from aspen and cedar, using only a pocket knife and chisel. He gave his carvings special touches that lend them a contemporary quality. His work is frequently exhibited and discussed in writing. It may be seen in the catalog *A Time to Reap* and other sources.

SOPHY REGENSBURG
(1885-1974)
Born and lived in New York City. A sophisticated woman, she started painting in 1952 when her doctor told her to "slow down" her volunteer work in a hospital. She taught herself to paint, using "casein on canvas." Her work is illustrated in *Twentieth-Century Folk Art and Artists,* by Hemphill and Weissman.

FREDDY REYNOLDS
(b. 1922)
Born in Washington, D.C. He spent a good number of years in New York City, living mostly in Harlem. He worked as a sleeping car porter on the trains and was active in the union. He knew many of the important names in black political circles when he was a young man. He is known by many people in Washington, D.C. where he lives once again. He is a well-regarded member of the Episcopal Church of St. Stephen's, known for its social action programs and its integrated congregation, where he is "honored for his art, for having poured his soul into his art." Reynolds' entire apartment is covered wall to wall and floor to ceiling with his creations. They fill his studio apartment to capacity. He makes his art from the things other people throw away—posters, plastic

flowers, empty food cans, pill bottles, paint, buttons, political memorabilia, and more. His underlying themes are religion and spirituality, "the brotherhood and sisterhood of all human beings," black people and culture, and maternal love. He feels a relationship to James Hampton and his work but, according to a friend, "does not have as elaborate a personal mythology." Reynolds has been written about in local papers. His work was in a major exhibition at Washington Project for the Arts in 1980. Efforts are being made to preserve his work as a unit. Freddy likes visitors, but he is not well so it would be best to check with his friends at St. Stephen's before planning a visit.

JESSIE DU BOSE RHOADS
(1900-1972)

Born in Coffee County, Alabama. She was descended from French Huguenot immigrants who first settled in North America near the Santee River in South Carolina in the late 1600s. She was a memory painter, depicting Alabama in the early years of the twentieth century. In 1961 she moved to Phenix City, Alabama, and started painting in an attempt to recover from a serious illness. She continued painting until shortly before her death. She wrote "Each painting is a brainchild which I try to express on canvas as I have known and experienced it, not by rule or regulation, but born from memories of my growing up on an Alabama farm and in a small town. What a joy it has been!" Her works are in the Columbus Museum in Georgia and also in the book *Memory Paintings of an Alabama Farm,* by Fred Fussell.

WILLIAM RHULE
(b. 1955)

Born in Jamaica in the small town of Belifield. He came to Houston in about 1988, when his mother and sister sent for him. In Jamaica he "worked for a white man from the U.S., entertaining foreigners from all over the world, until business fell off due to a hurricane." This "bossman" told him he had talent and must paint. Most of his work displays religious themes. His first painting was of a nativity scene. He uses sharp bright colors with a very flat perspective. He is very poor but believes "God will make a way for me." Robinson Gallery in Houston carries his work.

ROGER RICE
(b. 1958)

Born in Crawford, Mississippi. He is an African-American visionary artist who, in his younger days, was ordained as a fundamentalist minister. But he has given up the ministry completely to devote himself to painting. He is obsessed with the notion of the evil nature of man and his depiction of that nature is powerful. The paintings inspired by man's goodness are rare. A case in point is his "Last Judgment," where at least two-thirds of the space is given over to evil, while only about a third is reserved for the theme of redemption. Roger Rice works slowly. Twenty-seven pieces, his entire body of work, represent five years of labor. The participation of his Army reserve unit in the events in the Persian Gulf reduced his painting activities even further, but he has recently returned and resumed work. Robert Cargo, whose Tuscaloosa gallery carries his "intensely per-

sonal" work, is not sure that Rice is entirely self-taught.

RUSSELL RICE
(b. 1919)

A native of East Point, Kentucky, lives a half-mile from where he was born. He has had a lifelong fascination with wood but did not find time to devote to carving until his retirement several years ago from the Kentucky and West Virginia Gas Company. Rice says stick maker Thomas May convinced him to start making canes. He has been doing it now for about three-and-a-half years. He finds most of the wood on walks near his home. He selects lengths wrapped with vines because the twists and deformities they cause are an integral component of his carvings. Coiled segments become snakes and jagged roots are developed into animal antlers and free-form designs. His carving and painting of the completed canes is done with extreme care. Several galleries carry his work.

CAROL RICHARD

Lives in Raceland, Louisiana and is "an elderly woman" who has many religious visions. She believes she is supposed to share these visions as an inspiration to others. She paints her visions mostly on cypress knees. Southern Tangent Gallery in Sorrento, Louisiana has her work.

RODNEY RICHARD AND FAMILY
(b. 1929)

Lives in Rangeley, Maine near the Canadian and New Hampshire boarder. His father WILLIAM RICHARD (b. 1900) came to Maine in 1918, from New Brunswick, Canada. They are

Acadian French. William Richard has been well-known for his beautiful cedar fans which he carved. He is still alive as this is written, but in a nursing home. Rodney Richard was an independent logger; very conservation minded, he would not clear-cut any area. He got out when he realized it could be just a matter of time before he was injured. Carving is his livelihood now. He uses a chain saw and "can make anything I can see in my mind." He has been designated a master carver by the Maine Art Commission. Richard has a shop next to his house in Rangeley, on Rt. 4, where he sells his work and the work of his son, RODNEY "BUTCH" RICHARD, JR. who lives in Portland, Maine and comes home to Rangeley on weekends. He makes animals of the Maine woods. He paints his, his father does not. For information write or call: Rodney C. Richard, PO Box 183, Maine Street, Rangeley, Maine 04970 (207) 864-5595.

MARY SUE RICHBURG

Born in Birmingham, Alabama and is "60 years old or so." She has lived in Gonzales, Louisiana for thirty-three years. Richburg says she paints "for me—painting is a joy and a colorful expression to share." She paints scenes of local farms, villages, and a wonderful collection of humorous depictions of the Sisters of Charity, with whom she worked in New Orleans. Southern Tangent Gallery in Sorrento, Louisiana has her work.

MORTON RIDDLE
(1909-1992)
Born in Kentucky, where he first demonstrated an interest and

talent for woodcarving. He moved to Southern California in 1946, and lived in Whittier. He worked there, until retirement, as a clockmaker and repairman. Riddle carved wooden figures and painted signs and pictures. He is best known to the art world for his carved wooden dolls with jointed limbs and eerie faces. His work is sometimes available at the Outside-In Gallery in Los Angeles.

EUPLE RILEY
TITUS RILEY
The Rileys are potters working in Mantachie, in northeastern Mississippi. Each is a native of Peppertown, were neighbors since childhood, and married as teenagers. They work together with equipment Titus put together from old machinery. They are not from a traditional potting family. In addition to utilitarian objects, Euple likes to make small animal and human figures and Titus makes face jugs. They have also reinstituted a former Itawamba County custom and make ceramic grave markers. Peppertown Pottery, named after a small community south of Mantachie on Rt. 363, was established around 1983. Robert Cargo Gallery in Tuscaloosa, Alabama carries their work.

ACHILLES G. RIZZOLI
(1896-1981)
Born in Northern California to Italian Swiss immigrants. In 1915 the family relocated to the East Bay, and his father killed himself. Later A.G. and his mother moved once again to a small home in San Francisco, where he remained for the rest of his life. Rizzoli made visionary architectural drawings. "Riz-

zoli's buildings," according to Bonnie Grossman, who found the work and has been searching for facts about the artist and his life, "infinitely detailed in the Beaux Arts style, are representations of people that the artist knew. These imaginary buildings are conceived of as 'heavenly homes' or designated as 'symbolic sketches.'" Another portion of Rizzoli's work is the plot plan for a fantasy community. All were done between 1935 and 1945. His later work (1958-1977) was a collection of writings, illustrations, and architectural renderings. "Rizzoli was the earthly architect and transcriber for God." There are several writings on this newly discovered outsider artist. Watch for a book about Rizzoli that is currently being written. His work may be seen at the Ames Gallery in Berkeley, California.

ROBERT ROBERG
(b. 1943)
Born in Spokane, Washington, and now lives in Florida. Whatever his label, Roberg has spent years in a personal struggle over his desire to create and its relation to his religious beliefs. From this have been born paintings filled with his personal proclamation and faith, which are said to be quite powerful condemnations of evil, as he sees it. Unfortunately, that vision of evil includes a good deal of intolerance, as when he actively attacks gays and lesbians and blames them for the 1988 drought. He also rages against art that he sees as violating his religious convictions, such as Greek statuary, which he sees as pagan symbols. A number of galleries carry his work.

ROYAL ROBERTSON
(b. 1930)
Lives in Baldwin, Louisiana. A former sign painter, he is said to have traveled to the north and to the west before returning to Louisiana to care for his mother. His marriage, to Adele, ended after some nineteen years. He has led a solitary and difficult life since that time, troubled by the loss of his wife and disliked by his neighbors. His visionary paintings, often two-sided, usually have two themes—futuristic worlds with images of aliens and spacecraft, or vicious attacks on women in general and/or Adele in particular. The people who have visited him say it is a painful experience (see the article by Andrew Glasgow in *Art Journal*), and do not recommend bothering him. In August 1992 Hurricane Andrew totally destroyed his home and property. As this is being written, two collectors are helping Robertson file necessary papers with the federal government and otherwise helping him recover from his losses. Sixteen galleries carry his work.

MARY LOU ROBINSON
see **"PAINTING PERKINSES"**

ROLAND ROCHETTE
(1887-1986)
Born near Montreal. He and his family moved to the United States in the 1920s. He worked at a variety of jobs and eventually settled on a farm in Greensboro Bend, Vermont. When he retired he started making his memory paintings, which incorporate wood bark, stones, and branches into his acrylic paintings. His work is in the exhibition catalogs for *Always in Season* and *Images of Experience* at Pratt

Institute and is carried by Webb and Parsons Gallery in Burlington, Vermont.

SIMON RODIA-"THE WATTS TOWERS"-LOS ANGELES, CALIFORNIA
Simon Rodia, known to his neighbors as Sam Rodilla and to his mother as Sabato, immigrated with his family to the United States in the 1890s and settled in Pennsylvania. Eventually Rodia moved to the west coast and worked in rock quarries, logging and railroad camps, as a construction worker, and as a tile setter. In 1921 he bought a small triangular lot in Los Angeles and then spent the next thirty-three years building his towers by hand, using a tile setter's simple tools and a window washer's belt and buckle. Rodia adorned the towers with a mosaic of broken glass and pottery, tiles, sea shells, and ceramics. The tallest tower is 99.5 feet, a center column and spire reach a height of thirty-eight feet, and another spire is twenty-eight feet tall. There is also a gazebo with a circular bench, three bird baths, and a 140-foot long "south wall" decorated with tiles, pottery, glass, and hand-drawn designs. After many battles to save it and changes of jurisdictional hands, Rodia's Towers are now administered by the City of Los Angeles Cultural Affairs Department. They may be visited by the public and are located at 1765 East 107th Street in Los Angeles, not far from Century Boulevard or Wilmington Avenue (213) 485-2433.

BILLY RODRIGUEZ
Is "in his 60s" and lives in Santa Fe, New Mexico. He is the older

brother of carver Mike Rodriguez. He started later than many of the other well-known carvers to make his cottonwood animals. His animals are "wild animals"—they are "exuberant, representational but not sweet." They are available from Brigitte Schluger Gallery in Denver.

MIKE RODRIGUEZ
(b. 1948)
Born in Santa Fe and lives in Rowe Mesa, New Mexico. He has worked as a plumber, carpenter, actor, and gas station attendant. He started carving in 1978. He carves animals which are said to be particularly primitive and powerful. He uses cottonwood, hand tools, and various kinds of paint. Galleries carry his work.

RON RODRIGUEZ
(b. 1968)
Born in Santa Fe and lives there now. He is the grandson of Felipe Archuleta and has helped his grandfather and his uncle, Leroy Archuleta, at their workshop in Tesuque since he was an elementary school student. He makes bottle-cap snakes with cottonwood for heads and rattles, which he subsequently paints. His work is available in several galleries.

ROSE CASSIDY RODRIGUEZ
(b. 1916)
Lives in New York City. For many years she used oils and watercolors to paint her impressions of the streets and views of New York. Her work has been occasionally referred to as "primitive," but that term falls short of describing her art. "They are magical, captivating, portraits of New York—especially at night or in the rain or from

the water—at its very best." Her painting "Manhattan from the Queensboro Bridge, No. 1," painted in 1982, is worth a trip to Bath, England and the Judkyn Memorial where it may be seen. It depicts a hazy Manhattan skyline against a background of nighttime blue with twinkling lights on the bridge, which is in the foreground, and reflections on the river. A tug, almost lost in darkness, moves up the river. Rose Rodriguez has had exhibitions of her paintings in New York in the past. She is not well and is not working any more.

JOHN ROEDER
(1877-1964)
Born in Luxembourg and moved to Richmond, California were he lived until his death. He worked as a gardener. His first art work was in filling his own garden with a miniature village, life-sized cement figures, and a chapel. "Couple with Umbrella," painted concrete, is illustrated in *Cat and a Ball on a Waterfall.* After retirement, Roeder began to paint more, often including the words of some of his own poetry. Religion was an important part of his life and his art. Some of his earliest paintings were oil paint and sand on glass. His work is in the Oakland Museum.

JUANITA ROGERS
(1934-1985)
Born near Montgomery, Alabama. Rogers began making mud sculpture at an early age. She used cast-off materials and objects found in her surroundings in rural southern Alabama, where she lived the last years of her life. She also made drawings based upon what was on television. She has been written about

many times, and appears in the Rosenak encyclopedia. Anton Haardt Gallery has her clay figures on display. Galleries carry her work.

MARIE ROGERS
The only woman folk potter in the country who operates entirely on her own, Rogers lives in Meansville, Georgia. She is descended from potters and was married to the son of the last Georgia Jugtown potter, the late Horace Rogers. Rogers turns her ware on an old treadle wheel. "My husband's daddy had it in Upson County. It has been in our family over 100 years and was made in a blacksmith's shop." Marie Rogers makes face jugs and other forms. Galleries carry her work.

SULTON ROGERS
(b. 1922)
Grew up in Mississippi and eventually settled in Syracuse, New York. He learned something about carving from his father when he was young, and took it up again when he needed to have something to keep him awake during night shifts at a chemical plant. Rogers fashions snakes, vampires, "haints," bodies in coffins, twisted-looking faces, and some religious matter. He is written about in the Rosenak encyclopedia and is included in the 1992 exhibition catalog *It'll Come True: Eleven Artists First and Last.* His work may be seen in several museums, and is sold in numerous galleries.

MAX ROMAIN
(b. 1930)
Came to the United States from Port au Prince, Haiti when he was about twenty years old. He

worked as a doorman and security guard, and has recently retired. He began painting his visionary images in 1989. His first show was at the Donnell branch of the New York Public Library. He paints and draws intricate images that remind some people of the work of Minnie Evans. In theme his paintings can be religious or sexual. "There is a Haitian element, but they are not really Haitian." Galleries carry his work.

ANDREW ROMANOV
Lives in Inverness, California with his wife Inez who works at the San Francisco Museum of Art. Romanov is a self-taught artist. He does drawings and paints his own frames. His work is described as "naive, comical watercolors" and also "interesting cut-outs of boats." For further information and to see the work, call the artist at (415) 669-1357.

ED ROOT-ENVIRONMENT-WILSON, KANSAS
Ed Root (1867-1959) was born in Naperville, Illinois. He drifted about the west and then married a Kansan, Lydia, raised ten children, and farmed what had been his father's homestead. He built hundreds of concrete monuments and plaques embedded with small objects and broken colored glass. There were a few figurative pieces, but most were abstract assemblages. The Wilson farmland was flooded by the construction of a new dam soon after Root's death. Hundreds of concrete yard pieces were relocated to high ground by two of Root's sons. These have now been purchased by KGAA. Root has been the subject of a profile

in *KGAA News* (Winter, 1981) and in Gregg N. Blasdel's article, "The Grass-Roots Artist."

J.C. ROSE

From Hazel Green, Kentucky. He makes twig roosters and small carved and painted creatures. Galleries carry his work.

JOY ROSE

A self-taught painter from eastern Kentucky. She paints "landscapes and social commentary." Morehead State University Folk Art Sales Gallery handles her work.

ROD ROSEBROOK- ENVIRONMENT- REDMOND, OREGON

Rod Rosebrook (b. 1900) was born in Colorado, and moved with his family to eastern Oregon when he was ten. He went to high school for a while, then quit to work on cattle drives. For over 30 years he collected old tools and metal objects for his "Old Time Museum." Eventually he produced hundreds of constructions made from garden gates, which enclosed careful arrangements of tools. Some of the tools hung on his barn and others made up a fence along his property. The tools in the "Old Time Museum" and those hanging on the barn were sold to a museum, and the original fence was sold to a New York gallery. Now he has a new fence and new creations hang on the barn. All of this may be seen from the road. There are two roads leading south out of Redmond; take the older one, south of the main highway. Rosebrook's work is in the permanent collection of the National Museum of American Art and is illustrated in several books.

MARGARET HUDSON ROSS
(b. 1908)

A native of Owensboro in western Kentucky. Her paintings reflect experiences and memories of her life growing up there. She was a math teacher and started painting after her retirement. The majority of her paintings portray city life. Her work is in the permanent collection of the Owensboro Museum of Fine Art and is available from Heike Pickett/Triangle Gallery in Lexington, Kentucky.

MICHAEL ROSSMAN

About thirty years old. He lives in Bell Buckle, Tennessee, about fifty miles east of Nashville. He is apprenticed to Homer Green and carves in a similar style. He is recently divorced and not very happy; it is not clear that he will continue to work at his art. His work is available from Bell Buckle Crafts.

NELLIE MAE ROWE
(1900-1982)

One of the country's most highly regarded folk artists. She was a visionary artist who believed her art was a gift from God. Inspired by her religious visions, dreams, and daily life, she created paintings and sculpture. She is written about frequently, and many galleries carry her art.

HERMAN RUSCH- "PRAIRIE MOON PARK"- COCHRANE, WISCONSIN

Herman Rusch (b. 1885) created a two-acre garden and called it Prairie Moon Park. It contains more than forty objects ranging from birdhouses and planters to twenty-foot high "sun spires" crowned with mirrors to catch the sunlight. A large concrete cactus is "planted" in a garden plot. In 1979 the site was sold. Rusch's art has been kept intact, but its owners do not like visitors and keep dogs in the site area. It is possible to see a great deal from the road, so if you must, go—but people recommend that you do not get out of the car. There are photographs in several publications, and a taped interview with Rusch is on file at the Archives of American Art in Washington, D.C.

ST. EOM- "PASAQUAN"- BUENA VISTA, GEORGIA

The creator of this site, St. EOM (1908-1986), was a unique visionary artist who created a brilliantly colored and patterned assemblage of buildings, shrines, gates, and walls at his Georgia home. After thirty-five years in New York, "where he was a hustler, transvestite, model, dancer, artist, and fortune teller," St. EOM, born Eddie Owens Martin to a poor family of sharecroppers, built this Marion County art environment on four acres. He also produced paintings, sculptures, drawings, ceremonial costumes, and ritual objects. There is an organization dedicated to preserving Pasaquan and a book about it by Tom Patterson. The organization can provide information about how to visit the site. Galleries carry smaller works.

MARTIN SALDAÑA
(1874-1965)

Born in San Luis Potosi in Mexico and eventually settled in Denver, Colorado in 1912. In Mexico he was a cowboy. In Denver he worked as a cook. He started painting when he was seventy and continued up to the

time of his death. His love of animals—he painted bullfight scenes where all the sympathy is for the bull—and his memories of Mexico appear in his work. It has been said that his work has the feel of Mexican tapestries. Brigitte Schluger Gallery in Denver carries his work.

ANTHONY JOSEPH SALVATORE
(b. 1938)

Lives in Youngstown, Ohio. His background is written about in the Rosenak encyclopedia and he is included in the exhibition catalog *Muffled Voices*. Salvatore's inspiration is from the Bible. He combines acrylics, wax crayons, and oil pastels, rubbed to a shiny finish to create jewel-like works. Several galleries carry his work.

O.L. SAMUELS
(b. 1931)

Has been working with wood all his life. He was born in Wilcox County, Georgia and worked as a tree surgeon until a near fatal fall from a tree in 1982 and two heart attacks forced him to quit. He left home at age eight and worked as a pine raker and on Georgia farms. In earlier years he worked in Florida and New York City and returned to the South in 1960. O.L. fell into a deep depression after his illnesses. The words his great, great grandmother (a freed slave) told him long ago finally pulled him out of his sadness. She had told him that when people became depressed they would carve on a spool. O.L. took her advice and picked up some wood and started carving. "It started out to be a duck, turned into something else, and then turned into a mule head," he said. "I just start

and let it turn out like it wants to." Although O.L. is color blind he paints his carvings. He uses different colors and he said they seem to match up. "They ask me why I use so many colors and I say I want to be sure I get the right one." O.L.'s subjects include some people, a whole menagerie of animals (real and imagined) such as mules, alligators, snakes, dogs, and imaginative automobiles, his favorite form, which look as if they belong in a science fiction movie with their movable parts and colorful forms. His work is original. O.L. Samuels lives in Moultrie, Georgia. A number of galleries include his work.

MARIO SANCHEZ
(b. 1908)

A woodcarver and painter of old Key West. His life and his art document the history of the Cubans of Key West, descendants of cigar makers who came in the 1860s. The people and the places he portrays are "authentic." His wood reliefs are painted with bright colors. His work is both displayed and sold at the East Martello Gallery and Museum in Key West.

ALEX SANDOVAL
(1896-1989)

Born in New Mexico. He lived on his grandfather's farm, chopping wood for railroad ties. Later he worked in Arizona copper mines. Sandoval stated carving animals and religious figures after he retired in 1960. His work is illustrated in the exhibition catalog for *A Time to Reap* and he is included in the Rosenak encyclopedia.

THEODORE SANTORO
(1912-1980)

The son of Italian immigrants from Naples. Born and raised in Cleveland, Ohio, he moved to Oakland, California when he was in his mid-twenties and became a mechanical engineer. Santoro became mostly housebound in 1956 because of illness. He began carving, using simple hand tools and scraps of wood people brought him. He made animals, people, and religious and popular figures from the scrap wood. Sometimes he emphasized details with paint, such as the whiskers on a cat or the hair on a person's head, and sometimes eyes are made from upholstery tacks or beads. During his lifetime only his family saw his work except at Easter and Christmas, when he would create elaborate displays on his lawn. The Ames Gallery in Berkeley, California carries his work.

PHIL SAUNDERS
(b. 1947)

Born in Massachusetts and raised along the coastal area near Cape Cod. He has lived in the Midwest, in Missouri, for the last twenty years. He was severely neglected and abused as a child, which affected his emotional and intellectual growth. Eight years ago he began doing art as part of a therapy program. Much of his artwork reflects the coastal scenes of his childhood. He outlines his paintings in black ink and then fills them in with acrylic paints. The Pardee Collection in Iowa City represents his work.

JACK SAVITSKY
(1910-1991)

Born in Silver Creek, Pennsyl-

vania, and lived in Lansford. He was a coal miner for most of his life. When the mines he worked closed in 1959, he began to paint and draw. He painted in oils until 1984, when he was told by his doctor that the fumes were aggravating his "black lung" disease. He tried acrylics for a while, but did not like their fast-drying quality, so he switched to pencils, Prismacolor, and markers on paper. He is renowned for his colorful depictions of life around the hard coal regions of Lansford. Savitsky is famous and written about frequently. His work is in many galleries and museums.

BERNARD SCHATZ

Calls himself "L-15," and lives in the mountains of western Virginia. He once lived in California, where he became involved with 1960s culture such as forming a one-man band and selling art by the pound. He moved to Virginia in 1972. He creates reliefs and masks "inspired by primitive art and popular culture." He was included in the Jargon Society exhibit "Southern Visionary Folk Artists," and his work is available from Prince Art Consultants in Connecticut.

WALT SCHEFFLEY

Born in Pennsylvania about seventy years ago and moved to Vermont. He started painting when he had to take care of his invalid wife. At first he painted all the surfaces of his house with family portraits and Vermont scenes. His work, oils on masonite, always has as unexpected twist. At first glance they are only pleasant, carefully detailed scenes of a village, house, or shed in Vermont. Then if you look closely, there will be "a sur-

real blend of new and old, real and unreal." For instance, there is a painting of a village home with the expected family grouping on the front porch—and a UFO landing in the backyard. Scheffley's work is available at Webb & Parsons Gallery in Burlington, Vermont.

CLARENCE SCHMIDT- "HOUSE OF MIRRORS"- WOODSTOCK, NEW YORK

Clarence Schmidt's (1898-1978) marvelous environment burned years ago, so there is little to see now on Spencer Road in Woodstock, New York. Schmidt had worked as a stone mason. After retiring from that occupation he worked every day for more than thirty years building a rambling environment. Gregg N. Blasdel, in the periodical article "The Grass-Roots Artist" describes it: "Once a single cabin, his thirty-five-room, seven-story house was a labyrinth of passageways encrusted with tinsel-covered shrines and assemblages. It was surrounded by assemblages of junk, coated and bonded with tar, which were related to the natural landscape by mirrors, plastic flowers, and tinfoil-covered trees." The only way to see what Schmidt accomplished is to consult publications.

DUANE SCHNABEL

For nearly twenty-five years has dedicated his life to creating art. "The result is an impressive body of paintings, sculpture, encaustics and prints. Inspired and spontaneous, his mysterious art is imbued with the spirit of native peoples throughout the world. Schnabel's decorated and handmade frames enshrine the angelic and demonic spirit-

beings which inhabit his art." His work has been exhibited at the National Museum of American Art and is in museum collections in the Pacific Northwest, according to Oneiros Gallery in San Diego, California, which carries his work.

ROBERT P. SCHROEDER

An elderly carver from Thief River, Minnesota. He carves mostly domesticated animals, such as cows, horses, sheep, and pigs. For each piece he takes apart a cereal box and reconstructs it to serve as pedestals for his animals. Cognoscenti in Baltimore carries his work.

J.P. SCOTT
(b. 1922)

Lives in southeast Louisiana. He started working when he was fourteen years old and worked many years in a factory and in construction. His nephew lived with him until he died in 1970. Scott started devoting himself to art in the 1980s, after his retirement. All his materials are found objects. He picks up logs when they float by in the river. He makes boats, houses, and some whirligigs. He likes to make larger pieces because, he told me, "you can hurt your hands on small pieces." Gasperi Gallery in New Orleans carries his art work.

LORENZO SCOTT
(b. 1927)

Lives in Atlanta, Georgia. He is a house painter for a living, and a self-taught artist. Much of his work is a result of visionary experiences and audible conversations with God. He paints with oil on canvas or board. He makes his own frames with built up bondo and gold leaf for a

classical look. His works feature Biblical themes and are usually large and very colorful. There are plans for him to have a one-person show at the Museum of American Folk Art in 1994. His work is represented by Modern Primitive Gallery in Atlanta.

SALLY SCOTT

A Navajo who lives in the Navajo Nation in New Mexico. She makes very attractive and interesting carved wood and painted animal figures. Her work is in the museum shop at the Museum of Northern Arizona in Flagstaff.

FRANK SECKLER

Resides in New Mexico, where he recently moved from Colorado. Seckler has been sculpting for twenty-six years. He works with Corten steel to develop a three-dimensional sculpture expressing his interpretation of petroglyphs found in the Southwest. He starts with a drawing and transfers the subject to steel to create pieces ranging in size from one to twelve feet. He chose steel as his medium "because of the unique imbalances" that he can create. His work is featured at American West Gallery in Chicago.

ANISTACIO "TACHO" SEGURA

"Probably no longer living now." A carver of religious objects, he was still carving into his seventies, although he was partly paralyzed on his right side. "His work is appreciated for its dramatic statements of time, belief, and state of being. As primitive and crude as his works appear at first glance, each figure has the distinct talent of winning you

over." He used pine and cottonwood to create a simple religious form. His work is available from Art of the American Desert in Santa Fe, New Mexico.

HUSTON CLARK SEIBURTH

Self-taught in carving and painting. He lives in Maine along with his wife and son, in an area at the mouth of Fundy "almost halfway to the North Pole and sparsely populated." He is particularly fond of Christmas themes, researching them with his family and incorporating them into his work. He also portrays chickens, roosters, fish, animals, and humans. He was formerly a professional magician, cook, and baker, but by 1985 carving/wood sculpting had become his full-time vocation. He uses native white pine worked with hand tools. His work is known for fine detail and original designs. He says "I am not trying to recreate a legacy, as in reproducing works. I am attempting to create a new one." He sells his own work at: Christmas Tree Farm, HCF69, Box 288, Cutler, Maine 04626.

JON SERL
(b. 1894)

Born in Olean, New York and lives in Southern California. He was a child vaudeville performer, dancer, and Hollywood voice-over actor. He did not start painting until he was fifty. He paints expressionist figures drawn from his own experiences and imagination. A reviewer has said "Some painters paint with paint. Serl thinks with it . . . conjures with it." There are many writings about him and galleries carry his work.

XMEAH SHAELA'REEL

Born and raised in a family of seventeen children. Originally named David Jones, he grew up in east Texas, served in the Air Force, and then worked for the telephone company. Around 1976, he says, he was "chosen by the Lord to spread the message of salvation" and formed his own church, The Children of Christ of America. His paintings are meant to spread his message. Webb Folk Art Gallery in Waxahachie, Texas carries his work.

BOB SHAFFER
(b. 1942)

Born in Witchita, Kansas. He is half Cherokee and half French/German. He came to New Orleans in 1958 and now "lives across Lake Ponchartrain." Shaffer hunts, fishes, and crabs. In the process he has become very familiar with alligators, which often appear in his work. He used to carve only for family and friends. His wood carvings feature birds and creatures from the swamp and woods. "They have tremendous appeal." Hayes Antiques in New Orleans handles his work.

CHER SHAFFER
(b. 1947)

Lives in West Virginia. She was born in Atlanta and raised on a farm outside Fairburn in rural south Georgia. A self-taught artist, her work combines the mystical quality of her vivid and unique imagination with influences from the experiences of her childhood. Her work is included in the book, O, Appalachia. Appalachian Folk Art carries her work.

"POP" SHAFFER-"THE SHAFFER HOTEL & RANCHO BONITO"-MOUNTAINAIR, NEW MEXICO

Shaffer was born in Harmony, Illinois in 1880. At the age of thirteen he left school and entered the family blacksmithing business. He moved with his first wife and two children, first to Oklahoma and then to Mountainair. He later married for a second time and had one more child. He made his living as a blacksmith. While rebuilding his shop after a fire, he decided to add a second story and make it a hotel. He decorated the interior and exterior walls and furniture with painted designs. Then he added a collection of "critters" carved from tree limbs. He later added to his holdings and built a red, white, and blue cabin, Rancho Bonito, which served as his workshop and hideaway. Seven of his wooden figures are in the Museum of International Folk Art. The Hotel and Rancho Bonito are on the National Register of Historic Places. Shaffer's granddaughter lives at Rancho Bonito and gives tours from April through October, *if* the gate is open. It is located one mile south of Mountainair. This environment is described in several publications.

JOHN SHELDON
(b. 1937)

Born in Worcester, Massachusetts, and now lives in New York. His fascination for outer space and UFOs began when he was a child. Originally drawn to New York City to start an acting career, Sheldon soon stopped pursuing this goal and began drawing copies of astronomical pictures that he found in magazines. He then began painting. This went on for about seven years until he started to create alien-being sculptures. These sculptures, made out of latex, cotton, taxidermy eyes, and wire, are based on actual accounts described by people who believe they were abducted by other life forms. Leslie Howard Gallery in New York carries his work.

INEZ SHELL

Is in her sixties. She left rural South Carolina over forty years ago and lives in Maryland. Her works, done in wax crayons and watercolor, depict religious or historical subjects, and vivid recollections of scenes from her family's life as sharecroppers. It was while attending activities a few years ago in a Senior Citizen's Center that Mrs. Shell decided to try her hand at painting. Her work is available from Robert Cargo Gallery in Tuscaloosa, Alabama.

MARY SHELLEY
(b. 1950)

Born in Doylestown, Pennsylvania and now lives in Ithaca, New York. She makes carved and painted wood reliefs of barns, cows, diners, and gas stations, and recently has been depicting people and feelings from her dreams. This spiritual "Dreaming-Smiling series" was a response to the death from AIDS of her agent/friend Jay Johnson. These pieces relate to her feelings around death: "our insignificance as living beings when the immensity of the universe is considered . . . " She appears in several books, including the Rosenak encyclopedia, and her work has been included in a number of exhibitions. It is available from galleries. Also you may call her at her home in Ithaca, New York: (607) 272-5700 or (607) 273-6235. Shelley is at the Saturday Ithaca Steamboat Landing Farmers' Market from April to October.

ERWIN LEX SHIPLEY
(b. 1924)

Lives in Lexington, Kentucky. He is usually a prolific self-taught painter whose works are "created with a vibrant palette and bold brush strokes which contrast strongly with his representational narrative images of landscapes, flowers, crucifixion scenes, portraits, bar scenes—a wild variety of images." At the moment, Shipley lives in an adult foster care home. He stopped painting during a recent period of hospitalization, but said he hopes to start again soon. His work has been illustrated in exhibition catalogs, including *The Naive Approach* and *Kentucky Spirit*. You may call for information at (606) 266-4370.

FLAVIAN B. SIDIAREN-"KAYUMANGUI"-HAWAII

Sidiaren is from the Philipines and now lives in Hawaii, where he has decorated the exterior of his house and has creations around the grounds. See the index for a reference to an article from *KGAA NEWS* about his environment, where he welcomes visitors.

EARL SIMMONS

Lives in Mississippi, where he makes large colorful trucks from found wood and metal. He paints them in flat rich colors—rather the "on land" equivalent of a J.P. Scott boat. They are

available from Galleria Scola in Oakland, California.

ALVIN SIMPSON
(b. 1962)
Born and raised in Rockport, Illinois and "reportedly lives in Atlanta." He works in oil on canvas, is entirely self-taught, and "started painting by copying *Playboy* (girlie) photos." His work is available from Epstein/Powell in New York.

VOLLIS SIMPSON-WINDMILLS ENVIRONMENT-LUCAMA, NORTH CAROLINA
Simpson (b. 1919) grew up in eastern North Carolina. After serving in World War II, he returned home to design and build house-moving equipment. Around 1985 he began making giant windmills and installing them on the corner of the family farm. Some are as tall as forty feet, are brightly painted, and have reflectors attached. Do not miss an opportunity to see this environment at night. It is easy to see the windmills from the side of the road, and if he is not too busy, Simpson will show you his workshop. He makes airplane whirligigs too, which are available from Clinton Lindley in Hillsborough, North Carolina.

BERNICE SIMS
(b. 1926)
Born in the south Alabama community of Hickory Hill. She was the eldest of ten children, and grew up mostly with her grandmother. Sims herself married at sixteen and has six children. After her children were grown, Sims went back to school to get her high school diploma at age fifty-two. During class excursions to museums, she was inspired to paint, something she had not done since she was eight years old. She is a memory painter, capturing the activities and events of her life and community in Brewton, Alabama. She paints scenes of farming, church activities, cotton picking, and making cane sugar. She also paints compelling images of struggle, including the police turning dogs and hoses onto people in the streets of Birmingham and the Selma, Alabama march during civil rights struggles. Sims' memory paintings present strong color, movement, and energy; her people seem to be interacting. Her work is carried by numerous galleries.

HERBERT SINGLETON
(b. 1945)
Born in New Orleans and lives in Algiers, the part of New Orleans across the Mississippi River. He went to school through the sixth grade and has spent time in Angola Penitentiary. He started carving wood when the snakes he made from Mississippi mud "would just fall apart." He made staffs and stools carved from stumps and painted in bright enamel colors, mostly for his neighbors. He also carved beautiful canes from ax handles, until one was used to kill somebody. Now Singleton carves deeply complex narratives on flat found objects (e.g., doors), "about his perception of the self-destructive course of African-American life." His themes include the Bible, "the duplicity of the church and its ministers," and the "falseness of women." The combination of his sure hand as a carver, his symbolic vocabulary, and his brightly painted surfaces make some collectors, including the author, believe he is the best. His work is available in several galleries, including Barrister's in New Orleans which first found him.

WENDELL SINGLETON
(b. 1963)
Is in the National Institute of Art and Disabilities Program in Richmond, California. The staff say he presents an enigma: "He enjoys and is able to work in a most complex artistic manner with a great variety of shapes, colors, and images, but is unable to read or write. He cannot measure, yet creates the most complex abstract geometric shapes with great artistic sensitivity." He uses acrylics for his paintings, which include some with flowers and animals. The National Institute of Art and Disabilities Gallery shows his work.

DROSSOS P. SKYLLAS
(1912-1973)
Born in Kalymnos, Greece. As a young man, he worked for a while as an accountant for his father's tobacco business on the Aegean island of his birth. Just after World War II he immigrated to the United States and settled in Chicago where, with encouragement from his wife, Iola, and free from his father's prohibition, he began to make art. He never held a job during his years in America and his wife supported the household. At his death in 1973, Skyllas left a legacy of thirty-five highly detailed symbolic paintings. His work is available from Phyllis Kind Gallery in New York.

ERNEST ARCHER "FROG" SMITH
(b. 1896)

Smith got his nickname during the Depression when he went frog hunting to feed his family. He was born in south Georgia, and moved to the piney woods of north Florida as a boy. He has now lived in every part of the state. His memory paintings are full of action and the color is true to the place. His paintings reflect his other known talent as a storyteller and writer of anecdotes about life in Florida. He has been an invited storyteller at the Folklife Festival in Washington, D.C., and has self-published a book, *The Tramp's Heritage,* that is a semi-fact, semi-fiction adventure story of life in an early Florida town. His work is available from The Ames Gallery in Berkeley, California and at Bud's Men's Shop in North Fort Myers, Florida.

FRED SMITH- "CONCRETE PARK"- PHILLIPS, WISCONSIN

Fred Smith (1885-1976), a lumberjack, tavern owner, farmer, and dance hall musician, began building his Concrete Park in 1950, when he was sixty-five. The roadside park environment of over 200 sculptures represents history, mythology, and local lore. Built over a fourteen-year period, his statues include Ben Hur, the Lincolns, a double wedding party, an itinerant cowboy beer drinker, Sacajawea, Mabel the Milker, and Paul Bunyan. The Hemphill and Weissman book has illustrations. After Smith died in 1976, the Wisconsin Concrete Park was purchased by the Kohler Foundation in order to preserve Smith's visionary environment. Restoration was completed in 1978 (although it is in fact an unending process), and the site was turned over to Price County for use as a public art park. Wisconsin Concrete Park is located on the southern edge of Phillips, a crossroads town at the intersection of State Highway 13 and several county roads. It is fourteen miles south of the intersection of Hwys 13 and 70; phone (715) 339-4505.

ISAAC SMITH

A wood carver from Dallas, Texas. His interest in woodcarving began when he was a child. He has been carving full-time since 1978, using found wood as his medium. Isaac says his inspiration comes from God. His work is carried by galleries.

JOHNNY RAY SMITH
(b. 1943)

Born in Tylerstown, Mississippi and lives in New Orleans. He went to school through the tenth grade and works now as a carpenter and a jack-of-all-trades. He has lived in New Orleans for thirty-eight years and has been married for thirty. He started carving toys as a child, having won his first knife when he was seven or eight years old in a carnival game. He carves canes, pipes, and flat panels of oak, pecan, or maple. It usually takes him many hours a day for four to six days to make a cane. The whole length of his canes are carved with designs, while the cane head is usually a very classical-looking head and face. Barrister's Gallery in New Orleans carries his work.

K.E. SMITH
(b. 1959)

Born in Denver, Colorado. As a Colorado native, Smith and his family have always been involved in the cattle business. Smith earned a degree in business administration from the University of Denver. Through his work on the ranch, he developed his skill with steel. Over the past twelve years he has created furniture, accessories, abstracts, and most recently "southwestern" figures. He works with Corten steel. His figures include roadrunners, buffalo, coyotes, and other animals of the Southwest. His work is currently shown at American West in Chicago.

LILLIAN SMITH

Grew up in intense poverty in Brooklyn, New York. Her hard life put her "over the edge," and she spent some time in institutions. She drew obsessively, using oil sticks, and depicting images in her head. She wrote deliberately misspelled words on some paintings. She died quite recently. Sale of Hats in New York carries her work.

MARY T. SMITH
(b. 1905)

Born in Brookhaven, Mississippi and moved to Hazelhurst in the 1970s. She spent most of her adult life as a tenant farmer and a cook for other families. When she moved to Hazelhurst, she began to paint pictures and words on wood and on sheets of metal. Although she created a one-acre environment with her art, there is very little left. She is written about and exhibited frequently, and many galleries carry her work.

ROBERT EUGENE SMITH
(b. 1927)

A contemporary Missouri naive painter. He enjoyed art and singing while growing up with his alcoholic stepfather and mother. His dream was to be a recording artist. Smith joined the army in 1948, but spent less than a year in the service. He entered a mental hospital in 1950, and was not released until almost eighteen years later. He began to draw and paint in the hospital. He was discovered selling his paintings at a Missouri State Fair. Smith paints visions of his world, describing his daily life, his dreams, and his nightmares. In his paintings he shows Apollo rockets, local bars, army life, and monkeys drinking beer. He writes descriptions of each painting which, though they have no punctuation or structure, provide insight into his thoughts. Smith's abstract sense of subject, color, and composition is totally uncontrived. His work is available in various galleries.

JES SNYDER

Paints with a passion and a flair for color. She says "with the way that I paint, I feel that the term of 'modern primitive' is a way of describing my work." Snyder's subjects are often done with strokes of bold color and brilliant contrast, while backgrounds are developed with an interesting variety of patterns and shapes. She starts on a canvas with compulsive line drawings and forms, which usually resolve themselves into landscapes, animals, or human faces. Charles Locke in Duluth, Georgia carries her work.

ISADOR "GRAND PA" SOMMER
(1881-1964)

Born in Galatz, Romania. At the age of sixteen he came to America and began a number of successful business ventures, among them pocketbook manufacturing, real estate, farming, and running a country hotel in Saratoga Springs, New York. When he was sixty-four he set his hand to painting and was hailed by the director of the American-British Art Center, Ala Story, as among the finest she had ever seen. She promoted Sommer the way she helped promote Grandma Moses. She may also have given Sommer the nickname of "Grand Pa," or at least encouraged it. Sommer's earliest paintings were dated 1945 and 1946, and were signed I. Sommer or Isador Sommer. He did not sign them "Grand Pa" until later, and on some paintings that appellation was added in a different color at some time after the work was completed. An art critic of the *New York Times* described his work as "A theme of naive quaintness." He paints landscapes of scenes from an earlier era. Gregory Quevillon in Tesuque, New Mexico handles his work.

SIMON SPARROW
(b. 1925)

Born in West Africa. He went to school in North Carolina where his parents were sharecroppers. At the age of twelve he ran away to Philadelphia, where a Jewish family took him in. Eventually he moved to Madison, Wisconsin, and is a street preacher there. He does some drawings but is best known for his collages of thousands of small found objects. His work is in spired by his religious visions. Several galleries carry his work.

FANNIE LOU SPELCE
(b. 1908)

Born in Dyer, Arkansas, the oldest of five children. She left Dyer at eighteen to take nurses training, and worked for forty years, the last eleven at a school in Austin, Texas. She married and had two sons. While working in Austin, summers free from school gave her time to sign up for an art course, but she did not do well at it. When she tried an oil painting from memory, her instructor told her to drop out of the class but never stop painting. During her productive years in Austin she produced many very detailed paintings of her memories. She paints remembrances of her childhood: family activities, country fairs, farms. She has been in many solo exhibitions, and also in group shows. Her art may be seen in several publications. Her work is available from Webb & Parsons in Burlington, Vermont.

GEORGIA SPELLER
(1931-1987)

Born in Mississippi and lived in Memphis, Tennessee from the early 1940s until her death. She was married to Henry Speller. She made watercolor paintings on paper, "including quite a number of intriguing erotic pieces." Galleries carry her work.

HENRY SPELLER
(b. 1902)

Born in Rolling Fork, Mississippi and moved to Memphis in the 1940s. He was married to Georgia Speller. He started to draw regularly after moving to Memphis. Speller incorporated

his experiences into his work, and his television watching inspired many of his images. His life and work are detailed in the Rosenak encyclopedia. Galleries carry his work.

LONNIE SPENCER
(b. 1939)
Born in Menifee County, Kentucky, and now lives in Frenchburg, Kentucky. He started working at a rock quarry near Frenchburg in 1965. Disabled by an accident at the quarry in 1968, he began carving big stone heads of cowboys and Indians, which he sold at auctions and stock sales. These pieces are partially painted to bring out the details. He stopped carving for a number of years because he was afraid he would lose his disability income. He has started working again but may not be able to sell his work. The exhibition catalog *God, Man and the Devil* pictures his work.

OSCAR SPENCER
(b. 1980)
Lives in Blue Ridge, Virginia, and has been carving wood since he was twelve years old. He worked as a coal miner until he lost a leg in an accident and then became a painter of buildings. The majority of Spencer's artwork consists of snakes carved from vines, roots, or branches, which he paints with extreme care; he makes other forms too. Several galleries carry his work.

HUGO SPERGER
(b. 1922)
Born in northeastern Italy to German parents. They came to the United States in 1929. After living in upstate New York, he moved to Kentucky in 1955 and

settled in his wife's homeplace, Salyersville. He is a painter, carver, and toymaker. His subject matter varies, ranging from religious paintings to erotic carvings. He uses bright-colored acrylics. His work is available from several galleries.

M. "SPIKE" SPLICHAL
(b. 1920)
From Lincoln, Nebraska, and now lives in Portsmouth, Virginia. He spent thirty-two years in electronics, in the Navy and at the Naval Shipyard in Norfolk. When he retired he started to make hand-built sculptured clay miniatures of people and buildings. He has stopped that work and now, moving from realism to fantasy, he makes numerous three-dimensional pieces inspired by his imagination using clay, steel, and other found objects. His art was exhibited recently along with the art of Anderson Johnson and Geneva Beavers. His work may be seen or purchased by contacting Splichal or his wife Ruth at (804) 397-8636.

MARCUS J. STAPLES, JR.
(b. 1936)
Born in Reading, Pennsylvania, one of six children. His father died when he was two, and his mother died one year later. Of American Indian, black, and white lineage, he has been on his own since the age of fourteen. "When I look back," he says, "I see myself alone, drawing pictures, scenes of people where they were not—faces on rocks, in the trees, in clouds. No one else could see them there but myself." He began to paint seriously after a brush with death, when he went into a diabetic coma. He supports himself

by selling used furniture, collectibles, and his art. "His work, images of farms, slaves, religious and historical figures, seems familiar at first glance but upon closer scrutiny they come alive with spirit." His work is available from Clinton Lindley in Hillsborough, North Carolina.

MAICOL STARK
(b. 1911)
Born in Romania and now lives in Los Angeles. Retired from his job as a cook at the Budapest Restaurant on Fairfax, this self-taught artist does oil paintings of Old Testament stories—"warm, clear pictures without the booming histrionics of much religious art." He also makes many, many whimsical paintings of Elvis Presley and "high points of the King's life" in soft, flat colors and simple compositions. Stark and his wife "idolized the star." His work may be seen at Little Rickie in New York or call him at (213) 936-4160 for an appointment to see his work.

LEE and DEE STEEN-ENVIRONMENT-ROUNDUP, MONTANA
Lee and Dee Steen, twin brothers, were born in 1897 in Kentucky. They were raised in Roundup, Montana and spent all of their adult lives in the Pacific Northwest. These men lived on the edges of society and created a fantastic and elaborate environment from natural objects and discarded refuse. They also kept tamed wild animals scattered throughout the yard art. Lee Steen made wonderful human and animal figures from broken pieces of trees. The work is discussed in the catalogs *Lee Steen*, published by the Yellowstone Art Center, and *Yard*

Art, published by the Boise Art Museum. Some of Lee Steen's figures are for sale at American Primitive Gallery in New York.

ELIS STENMAN-"THE PAPER HOUSE"-PIGEON COVE, MASSACHUSETTS

Starting in 1922, Elis Stenman and his wife (whose name is never mentioned in any articles) built and furnished a house completely of used newspapers. The walls and roof are thick layers of folded and pasted paper. The furniture is made of rolled tubes. According to the article "Grassroots Artist: Elis Stenman" in *KGAA News*, "Each piano, bookcase, and floor lamp can be unfolded, perused, and reassembled. Many furnishings are thematic. The grandfather clock is veneer with rolled newspapers from the capital cities of 48 states; the fireplace is faced with rolls of the Boston Sunday Herald and the New York Herald Tribune; a desk is assembled from newspapers describing Lindbergh's flight . . ." Since Stenman's death in 1942, the house has been preserved and is open to visitors. It is located at 52 Pigeon Hill Street in Pigeon Cove, Massachusetts, north of Glouster on Route 127 near the New Hampshire border.

Q.J. STEPHENSON
(b. 1920)

Currently lives in North Carolina. He as a dragline operator for a construction company for forty years, and also a trapper. He retired in the mid-1970s, and began building an environment called Occoneechee Trapper's Lodge. His environment is made of petrified wood, fossils, Civil War relics, Indian artifacts, and other finds from his trapping days, all embedded in cement. In 1981 he began making free-standing sculptures using the same methods and materials. His work is available in several galleries.

HELEN STEWART

A woman of seventy-eight who spent many years in state institutions for mentally retarded persons. Her memory is excellent. She describes her adventures and places she has visited with clarity and understanding. She does not have any interest in painting the past, though; she prefers to paint flowers. "Her flowers are not realistic, but usually are like rays emanating from a central point and yet she catches the feeling of the flowering world." Her work is unusual and compelling. The National Institute of Art and Disabilities Gallery in Richmond, California carries her work.

WESLEY STEWART

A native of South Carolina, but has been living in Florida for many years. For the last 40 years he has been creating unusual sculpture and paintings by gluing together thousands of toothpicks and painting them. Red Piano Art Gallery in Hilton Head, South Carolina handles his work.

JOHN STOSS
(b. 1940)

Comes from central Kansas, of a family of Czech-German farmers. He attended the Catholic church near his home in Olmitz and went to school six miles away in Otis. The years spent in Kansas were a life of pigs, windmills, traveling salesmen, and long nights of cards by the stove.

"John Stoss still loves pigs, baseball, windmills, and the moon. There is, however, little lingering affection for the Church, politicians, traveling salesmen, church-sanctioned marriage, or the children such marriages produce." Much of his adult life has been spent on the road, with stays in the Arkansas Ozarks, New Orleans, North Carolina, and other places. He currently resides in his rusty automobile in and around Monterey, California. He sleeps in his car or on the ground, gathers his food from grocery store dumpsters, and paints, writes, and shares his unique vision. He paints personal themes using acrylics on paper. Tartt Gallery in Washington, D.C. has his work.

"QUEENA" STOVALL
(1887-1980)

Grew up in and around Lynchburg, Virginia. She was a southern memory painter who often portrayed her black neighbors as well as her own family. She started painting at age sixty-two, when she was already a great grandmother. She has been written about and a film has been made about her life.

VANNOY STREETER

Began working with wire to make his own toys as a child in Wartrace, Tennessee. A boyhood fascination with wagons and machinery gave rise to the creation of model vehicles, and growing up around many local stables inspired him to depict his other favorite subjects, Tennessee walking horses. His horse models replicate the conformation and spirit of particular champions and challengers in the local show ring of Shelbyville, where he still lives. Us

ing only pliers, his own imagination, and self-taught techniques, Streeter has practiced this art form all his life, and has earned himself the nickname "Wire Man." He most commonly uses coathangers, but has used about every kind of wire he has come upon. He has sculpted many objects, from trucks, fishing boats and airplanes to hunting scenes, guitars, hats, and a life-sized horse. He also does people, such as Elvis Presley and Tina Turner. Often his works have movable parts and always have whimsical details. One of Streeter's wire sculpture semi-trucks is on display at the Peterbilt Truck Company headquarters in Michigan and his horse sculptures were presented as trophies at the Dixie Jubilee Horse Show in Mississippi. He continues to work with wire and pliers. Several galleries carry his work.

DAVID STRICKLAND
(b. 1955)

Born in Dallas and now lives in Red Oak, Texas. He is an ex-welder who always wanted to make art. He creates welded metal sculptures of animals, people, and abstracted figures using found objects. His figures range from three inches to nine feet tall. His work is available in galleries.

CLARENCE STRINGFIELD
(1903-1976)

Born in Erin, Tennessee and lived in Nashville as an adult. He began to carve when he was bedridden with tuberculosis. He carved figures of "bathing beauties," country-western singers, and several other figures. He also carved wall plaques. Galleries carry his work.

JIMMY LEE SUDDUTH
(b. 1910)

Lives in Fayette, Alabama. He worked for years as a farm hand. His wife, Ethel, whom he married in the 1940s and who is the subject of some of his paintings, died during the summer of 1992. Self-taught Sudduth has been an artist for many years. He paints on plywood boards, and uses natural materials, including mud, as well as paint. His subjects include people, animals, and buildings. He is included in many publications, and browsing through the gallery listings in this book will indicate the wide availability of his work for purchase (forty-nine galleries). He also appears at the Kentuck Festival (where, in 1991, he was asked his preference for writing his name—he cannot write, and "draws" a signature on paintings as he was taught to do by a friend and supporter—he said "Jimmy with a 'y' ").

VANGIE SUINA

A Cochiti potter who makes storyteller dolls. Her clay and sand come from sites on the pueblo and her pieces are fired in the traditional manner. However, she breaks with tradition and uses an acrylic ceramic stain to paint the figures after firing. She says she can get much more detail doing the work this way. She has been making dolls since 1981. Cristof's Gallery in Santa Fe carries her work.

MAURICE SULLINS
(b. 1911)

From Joliet, Illinois. He painted over 1200 works from 1970 to 1986, but has not painted since his wife died in that year. He is a self-taught artist, who worked at the Joliet Municipal Airport waxing planes by day, and painted at night. He was the subject of an Illinois State Museum retrospective exhibition in 1988. Descriptions of his art include such comments as "unique images," "sophisticated composition," "bold use of color," "exuberance of visionary expression." Frank J. Miele Gallery in New York handles his work.

PATRICK SULLIVAN
(1894-1967)

Born in Braddock, Pennsylvania and lived in Wheeling, West Virginia. His father died when he was two, after which he lived in an orphanage until the age of fifteen, when he rejoined his mother. He held a series of low-paying jobs including being a house painter. Though his work was discovered by Sidney Janis and received critical acclaim, he never was able to support himself with the sale of his art. It is said that he made his allegorical paintings "to make people think." He work is discussed in publications and is in the permanent collections of the Museum of Modern Art, the National Museum of American Art, the Oglebay Institute's Mansion Museum, and the Sacred Heart Church in Wheeling.

REVEREND JOHNNIE SWEARINGEN
(b. 1908)

Lives in Brenham, Texas. He is a black preacher who paints religious scenes inspired by the Bible, and memory paintings inspired by his own life in rural Texas. His work has been written about and is available in several galleries.

IONEL TALPAZAN
(b. c.1956)

Escaped from Bucharest, Romania in 1987. He swam across the Danube River to Yugoslavia, where he lived and worked for several months until the American government gave him political refugee status. Talpazan now lives in New York City. Talpazan's interest in outer space began when he came to the United States. After seeing a television program on UFOs, he began making his first drawings of outer space and space ships. He currently paints on both canvas and oak tag, using acrylics, oils, pastels, glitter, and nail polish. Several galleries handle his work and he is sometimes on the street, near the Museum of Modern Art, selling his work.

LUIS TAPIA
(b. 1950)

Born and still lives in Santa Fe, New Mexico. He began carving both traditional and non-traditional *santos* in the 1970s. His style looks different than that of old traditional *santeros*. He carves wood and paints it. His work is in the permanent collections of the National Museum of American Art and the Los Angeles Craft and Folk Art Museum. Leslie Muth Gallery in Santa Fe carries his work.

WILLIE TARVER
(b. c.1950)

Lives in a small Georgia town near Augusta. He is a goat farmer and makes headstones for graves. Tarver started making art in the late 1960s. He uses concrete and paint to form and decorate animal and human figures. Most stand about two to three feet tall, but many are smaller, and a few are very large.

Tarver also makes metal cutouts which he paints. Galleries carry his work.

KEA TAWANA-"KEA'S ARK"-NEWARK, NEW JERSEY

Tawana built an ark sixty feet long from castaway materials and gutted buildings on a rubble-strewn weedy lot in central Newark, New Jersey. She worked by herself. Then of course officials noticed and eventually—in spite of many supporters from the community and the art world—they made her destroy it. There is a beautiful photograph of the ark in Time-Life's *Odd and Eccentric People*. See also Holly Metz, *Two Arks, a Palace, Some Robots and Mr. Freedom's Fabulous Fifty Acres*, for detailed information about Tawana's work.

LANELL G. TAYLOR

Born in Chicago, Illinois and grew up on its far south side. She graduated from Carver High School and was employed after graduation as a secretary. Later she studied interior decorating and custom drapery making, after which she opened her own drapery shop. While making draperies, she was introduced to and became interested in folk art. She began making miniature dolls and this led to the creation of her story boxes. The story boxes are made of brown paper, hand painted, mounted on wooden panels, which are sometimes stained, and enclosed in plexiglass. The story box figures depict different periods of the past. Taylor now lives in Hazel Crest, Illinois and sells her boxes from her house—PO Box 224, Hazel Crest, IL 60429, or call (708) 335-1673.

SARAH MARY TAYLOR
(b. 1916)

Born in Anding, Mississippi, a small rural community near Yazoo City where she still lives. She is best known for her quilts, but she also makes drawings. Galleries carry her work.

VERONICA TERRILLION-ENVIRONMENT-LEWIS COUNTY, NEW YORK

Veronica Terrillion filled her yard and a pond with life-sized figures of human and animal figures and religious scenes. Most of the groupings of figures represent either Bible stories or family-related activities. There is also a log house, a garden of natural plants, and hand-made sculpture. The pond has two stone islands occupied by cement figures. The site can be seen next to the road, Highway 12, at Indian River, Lewis County, New York.

MARY THIBODEAUX

An elderly lady from Denham Springs, Louisiana. She used to watch her father work with wood when she was a child, and drew on this experience to make her own art. Now she makes paintings of rural places and adds dimension with crushed leaves, pebbles, and rocks. Southern Tangent Gallery in Sorrento, Louisiana carries her work.

DWAYNE THOMAS

Lives in Leland, Mississippi. He is the son of James, "Son" Thomas. He makes clay heads and skulls that may resemble those of his father, but are definitely his own work. His figures are available in galleries.

JAMES "SON" THOMAS
(b. 1926)
Lives in Leland, Mississippi. He is a well-known blues musician and clay sculptor. He is especially known for his skulls and skull-like heads, which often have real teeth. He has been performing and making art full-time since 1971. He is the subject of frequent articles and films and his work is in museums. Many galleries carry his work.

PAT THOMAS
Another son of James "Son" Thomas who lives in Leland, Mississippi. He also makes clay skulls with teeth, a traditional form similar to his father's. However, Pat Thomas' skulls have a harsher, harder look. His work is available at Barrister's Gallery in New Orleans.

GARY THOMPSON
(b. 1948)
Born in Phoenix, Arizona. He came to Oregon with his family about twenty-five years ago, and now lives in Waldport, Oregon. He is married, and one of his two sons, Trevor, is also very artistic. Thompson is a chain saw carver. He uses cedar as often as possible, plus some redwood and maple. He used to draw a lot. This self-taught artist watched someone else, then decided he could do it too. His choice of subjects is most often influenced "by woods and the sea," but he "tries to do everything for the challenge of it." Some of his work is obviously influenced by the need to please tourists, but other pieces are more individualistic and reflect his skill. He sells his own work from his home on Highway 101. Write PO Box 265, Waldport, OR 97394 or call (503) 563-2821 or 563-4821.

CARTER TODD
(b. 1947)
Came from Indiana and now lives in Madison, Wisconsin. He started drawing while in a center for alcohol treatment. His formal education ended in the ninth grade, and he has worked at a variety of jobs such as short order cook and gas station attendant. He also suffers from epilepsy and other health problems. He makes drawings, always of buildings of various kinds, done with painstaking detail using colored pencil, ink, and graphite. His sister believes the subject of his art comes from the family occupation of rehabilitating buildings. Todd's work was included in the exhibition "Contemporary American Folk Art: The Balsley Collection." His work is represented by Dean Jensen Gallery in Milwaukee, Wisconsin.

ANNIE TOLLIVER
(b. 1950)
Remembers drawing in the dirt of Sternfield Alley outside the home where she was born in Montgomery, Alabama. She went to high school until the tenth grade, when she dropped out to take care of her son Leonard. She has been married and divorced twice, and has three children. She worked for a long time cleaning hospitals, hotels, and restaurants. Now she is a part-time cook. She says her father was the first to influence her art. When the family gathered to share a meal with father Mose and mother Willie Mae, they all watched Mose work. Annie started out wanting to paint like her daddy, she says, but later developed a style more her own. For about five years she worked with her father and signed his name to her work. In 1990 she started signing her work with her own name. Her work shows some definite differences from that of Mose Tolliver's. Annie's is more colorful, with brighter and more varied colors. Her shapes are her own, with more muscular bodies and many more details such as tiny white teeth, trim on the clothing, polished finger nails, and so on. Her paint has a flat, hard-edged look, and she seldom mixes her colors. She nearly always writes a little on the back of her paintings. Many galleries carry her work.

CHARLES TOLLIVER
(b. 1962)
Is the son of painter Mose Tolliver. He was born when the family lived on South Decatur Street in Patterson Court, an urban housing project in Montgomery. Charles is married and has two sons and a daughter. He works hard to support his family, six days a week for the City Sanitation Department. He does not have as much time to paint as he would like. He loves to paint. "When I start out painting," he says, "I'm not sure what it will be. The picture paints itself." He works in a space behind his house and tries to paint every day. He says he feels "driven to it." He started painting in 1983, encouraged by his father at Sunday evening family gatherings. His work is influenced in material and technique by his family, but his own unique style is developing. Black and gray dominate in his paintings; he is not a colorist like his sister Annie. He paints a variety

of images such as birds and other creatures and also African themes. He writes titles on the backs of his work. Both titles and imagery reflect influences from his personal life and from his imagination. Two galleries carry his work.

MOSE TOLLIVER
(b. 1915, or 1919)
Born to a family of tenant farmers and was one of twelve children. He had to go to work at an early age and received very little formal education. In the 1960s, while working for a furniture manufacturer, his legs were crushed in a work-related accident. Soon after the accident, Mose Tolliver taught himself to paint. He uses wall or exterior house paints rather than artists' colors. His figures are flat, only partially representational, and sometimes explicitly erotic. Details of Tolliver's life, art, and recognition are included in the Rosenak encyclopedia and in many other publications. Tolliver's work is well-represented throughout the country; forty-eight galleries listed in this book carry his work.

DONNY TOLSON
(b. 1958)
Is the fifth youngest of Edgar Tolson's eighteen children. Donny left home in his early teens and traveled around some, working for a moving company until he went back home. He now lives in Campton, Kentucky. He is "a child of the video age," in whose works elements of both folk and pop cultures as well as "many traditional folk sculpture conventions, frigid frontality, and simplification of forms, for instance, are present."

He makes walking sticks decorated with snakes, and also rock stars, hippies, women, and some religious images. His work is available in galleries.

EDGAR TOLSON
(1904-1984)
From Campton, Kentucky, is considered by some to be the most important of the Kentucky wood carvers. His sculpture is very clean, with smooth lines and finish. Sometimes it is painted, but often it is not. Edgar Tolson's work has been exhibited frequently, and is included in a number of publications. His work is available in several galleries.

PARKS L. TOWNSEND
(1909-1991)
Born near Beech Mountain in North Carolina. He was a farmer who married and raised a family of ten children. In the early 1960s he went to Alexandria, Virginia to work in construction for ten to twelve years. He then retired and returned to farming in Elizabethton, Tennessee, near Johnson City. When in his sixties he suffered a broken hip in a car accident and was not able to do much physical work thereafter. Wood carving became not only a pastime but a passion, and he created hundreds of items both functional and whimsical. Among his works are canes, walking sticks, weather vanes, pipe racks, religious symbols, farm, exotic and prehistoric animals, mythical creatures, ornaments, and his much loved "jumpin' jacks" (hand operated acrobats). Townsend's work was included in the book *By Southern Hands,* by Jan Arnow,

and is available from Blue Spiral I in Asheville, North Carolina.

PHILIP TRAVERS
(b. 1914)
Born in New York City and still lives there. He began drawing as a child. Travers tried a class at the Art Students' League but found the watercolors used "too messy." He has created hundreds of detailed drawings with dense text. Travers has a narrative he has developed in his art about King Tut chasing "Mistaire Travaire" (Travers' alter ego) through time. He is described as "possessed and obsessed" about his work [a rather simple explanation; a far better one is available from his dealer]. Travers' art, "outsider" for sure, is represented by Sale of Hats in New York.

BILL TRAYLOR
(1854-1949)
Lived the last years of his life in Montgomery, Alabama. He was born in Benton, Alabama and lived in slavery until emancipation. The first record of his residing in Montgomery is dated 1936. His famous drawings, which have been described in great detail in many sources, were discovered by artists connected with the New South School and Gallery. Frank Maresca and Roger Ricco published *Bill Traylor: His Art-His Life,* which presents many illustrations of Traylor's work. Although the date "1947" is usually given for his death, compelling information from his living family members, discovered by Miriam Fowler of the Alabama State Council on the Arts and Marcia Weber, Montgomery gallery owner, indicates that the correct date is 1949.

SANTIAGO "TAGO" TREJO
(b. 1937)

Lives in his birthplace of Socorro, Texas, and has spent most of his life around the El Paso area. He has worked as a barber, tailor, and at various odd jobs. He has eight children, thirteen grandchildren, and one great grandchild. Tago started carving as a young man. He carves found wood, not plentiful in his area. He has a very special vision, making raw dream-like carvings with a little added paint to highlight figures. One of his art works is a stool, "Pancho Villa," which consists of three figures including a lawyer with very sharp teeth. He also makes logs with carving on the inside and the outside, and carved relief on boards of horned women. His work is available at Art of the American Desert in Santa Fe.

FAYE TSO
(b. 1933)

Resides in Tuba City, Arizona on Navajo lands. She married into a long line of potters and acquired their skill, but introduced her own images into the traditional craft, turning her work into art. She makes many original shapes and designs. The Rosenak encyclopedia, which includes details of her life and art, says "Her work is a milestone in contemporary Navajo pottery, and her busts and portraits of her family and neighbors are unique in the history of Navajo culture" (pp 306-307). The Rainbow Man in Santa Fe carries her work.

CLEVELAND TURNER- "THE FLOWER MAN"- HOUSTON, TEXAS

Cleveland Turner (b. 1935) was born in Mississippi. He was raised by his aunt, who taught him to be a gardener. At the age of twenty-three Turner moved to Houston and found work at a sheet metal fabricating plant. He also found wine and drank himself out of a job and almost out of a life. After a severe bout of alcohol poisoning, Turner made a pact with God: if God would help him stay sober, Turner would use his time to make a place of beauty. After turning one place into a "magical garden," vandals set fire to his house. Turner destroyed the garden "in a powerful rage" and cried for days. Undaunted, he started over again. "The Flower Man's new garden covers every inch of land available, spilling out into the ditch in front and to the street beyond, and he has packed every conceivable flower into an incredibly small space. Pictures of personal heros, shapes and colors he likes, and mementos of his boyhood in Mississippi dot the side of the house. Cleveland Turner's house is an ever-evolving testament to the magic of the garden." Turner's house is on Sampson at Francis in the Third Ward. He enjoys seeing appreciative observers who stop to look and smile (Quotes above are from Susanne Theis of the Orange Show Foundation).

TERRY TURRELL
(b. 1946)

Born in Spokane and now lives in Seattle, Washington. He sells his own hand-painted T-shirts at the Public Market in Seattle to make a living. He creates art that is part wood sculpture, part painting. He uses paint, materials used to fill in dents in cars, bondo, metal, cheesecloth, dirt. A writer has called Turrell's work "reminiscent of prehistoric or tribal art." Two galleries carry his work.

HERMAN TYLER

A Navajo sand art painter. His work is identified as art, not sacred work. No further information was forthcoming from the gallery. Cristof's in Santa Fe carries his work.

VALTON TYLER
(b. 1944)

A self-taught artist from Texas City, Texas, who now lives in Dallas. He has been referred to as "an unconscious surrealist." However, art curator Jerry M. Davies from the Amaretto Art Center in Texas describes Tyler's work as "offering no intellectual conceptions . . . he is a man who confronts the world in entire isolation. Tyler uses objects in his immediate environment to stimulate unconscious associations . . . he constructs undefinable creatures, sinister looking mechanisms, and monumental technological structures . . . his creatures parody human emotions and act out mysterious dramas." When Eric Vogel of Valley House Gallery discovered Tyler's work and introduced him to printmaking, Tyler made about fifty, then quit and turned to painting. His paintings often contain strange creatures stalking about in very bright colors. Others are machines with no known use. Sometimes the machines have wheels and sometimes they wear hats or sprout hands. He has received much positive critical attention. Valley House Gallery in Dallas carries his work.

WILLIAM TYLER
(b. 1954)

Born in Ohio. He has worked at Creative Growth Art Center since 1978. The staff there says, "Tyler is a reflective dreamer and wonderer with a prodigious memory for significant dates, events, and symbols. He is very interested in magic and illusion as well as the uncertain boundary between make-believe and reality. Tyler's artwork has been included in many exhibitions throughout California. He works in many different media. His pieces are ordered and precise, and demonstrate his measured control over the materials. Tyler's art draws liberally on his personal experiences and his fascination with illusion. In his work Tyler creates a symbolic place where make-believe and reality are equally powerful, but order reigns over emotion." His work is available at Creative Growth Gallery in Oakland.

HORACIO VALDEZ
(1929-1992)

Born, lived, and died in Apodaca, a village just east of Dixon, New Mexico. He was a carver in the *santero* tradition, and a member of the Brotherhood of Penitentes. He made carved and painted religious figures and relief panels. He added his own style to these traditional works. Galerie Bonheur in St. Louis handles his work.

MICHAEL VAN AUKEN
(b. 1942)

Born in Dayton, Ohio. He was interested in art as a child, but as a member of a working-class family, he found "art school was just not acceptable." He had an uncle, "the black sheep of the family," who was an artist and gave Michael a carving set and paints as gifts, but these were immediately put away as too good to use. Much to his surprise, when he "turned forty," his mother gave him the still-untouched carving set. He is married to an artist, lives in the middle of sixty-four acres, and has to work full-time in a video store. From one piece of wood he carves images of women, often dancers. He has recently started making more than one figure, still from a single branch of a tree. Van Auken looks for branches from a tree that is already down, branches in which he sees something. It has to have a certain branching, shape, angle, or curve. He uses the "dynamic tension and strength that is natural to the wood, formed in its process of growth." When he starts to carve he knows exactly what the figure will look like when he has finished. He says that when the work is complete, though he paints his pieces with acrylics, the viewer will still be aware that it was a tree. Van Auken has won many prizes at sculpture exhibitions. He started carving about ten years ago. In 1991 Van Auken's sculpture won one of the three top awards from the jurors for the Huntington (West Virginia) Museum of Art's Exhibition 280: Works Off Walls, out of an original field of over 170. He is not prolific in his art work, because he must work full time to earn a living. He does want to sell his work though and may be contacted through the mail. He does not want visitors without a prior appointment. Write to Michael Van Auken, 42732 TR 227, Shade, OH 45776.

GREGORY VAN MAANEN
(b. 1947)

Experienced the horrors of war in Vietnam. He has been painting since 1972. Randall Morris says Van Maanen "is a shaman without a tribe, making charged paintings and drawings that writhe with spirit and healing energies." His large pieces, often monochromatic and dominated by skulls, are quite powerful. His small paintings, intimate in scale, are "suffused with a strength that belies their size; there are evocations of sorrow and death." Galleries carry his work.

ELSIE VAN SAVAGE

Lives in Brunswick, Maine. She began to paint as a child, but was ridiculed by her parents for her primitive style and funny paintings. Van Savage paints scenes of everyday life but with a humorous touch. Her style is childlike and naive, but her message is strong and mature. She paints on masonite with primary and bright colors. Subject matter is generally people in situations that sometimes seem normal and mundane, but she brings out the human emotion, humor, and joy possible in each, presenting her unique views of human life. "She is a delightful person whose love of life, joy, and wonderful sense of humor show through in her work. She is self-conscious about it because of the early criticism she received." Her work is available from Galerie Bonheur in St. Louis.

CARRIE VAN WIE
(b. 1880-1947)

Born and died in San Francisco. She made sketches and paintings, mostly of architectural

landmarks of San Francisco at the turn of the century. Her works have great appeal and may be seen in the book, *The Wonderful City of Carrie Van Wie,* by Edwin Grabhorn. Her art was included in the exhibition "Cat and a Ball on a Waterfall." Thirty-eight of her paintings are in the collection of the Oakland Museum.

GUEYDAN TOUSSAINT VERRETT
(b. 1959)
Born in Florida. An "Air Force brat," he grew up in England, Germany, and Italy. He started making art as a child, encouraged by his grandmother. He has done some small sculptures, but mostly he paints. He paints on boards and found objects, using bright colors and acrylics on a variety of bases. Most of his work to date shows single figures, but he is beginning to put in more background. Some think his work is "scary," or has the look of fetishes. Verrett says that he is "not very religious, but is inspired by religious imagery." His images are more intense than pretty. Epstein/Powell in New York has his work.

FRANK VIVOLO
(b. 1928)
The youngest of folk artist John Vivolo's seven children. He was born in Hartford, Connecticut, served in the Army after high school, and worked as a landscape designer until he started his own commercial real estate business. He had to retire at age 52 because of ill health, and began to carve with some regularity. He had made heads and human figures, but now makes imaginary birds painted with in-

tense bright colors. Frank Vivolo, whose first name is actually the same as his father's, will have the first public showing of his work at the Litchfield Auction House in Connecticut in November, 1992.

JOHN VIVOLO
(1886-1987)
Born in Accri, Italy. When he was fourteen his father had managed to save enough to send him to America. He did menial, backbreaking work until he saved enough to get out and return to Italy, where he was a farmer. After marrying in 1907 he and his bride moved to Connecticut. Misfortune followed until finally they moved to a suburb of Hartford. Vivolo always worked at a number of jobs in order to care for his wife and seven children. He retired in 1957 and started carving the wooden figures he called his children. He painted some figures, which progressed from dull in tone to very bright. He also made large whirligigs that were meant to be placed out of doors. He has been written about and his work illustrated in the Rosenak encyclopedia and a book by Ken Laffal.

EUGENE VON BRUENCHENHEIN
(1910-1983)
Born in Marinette, Wisconsin, but lived the greater part of his life in Milwaukee. For about forty years he worked obsessively in virtual isolation, producing thousands of artworks including paintings, sculpture, and photographs. An excellent source for information about his life and work is *Eugene Von Bruenchenhien: Obsessive Visionary,* by Joanna Cubbs. Galleries carry his

work, which may also be seen at the John Michael Kohler Arts Center in Sheboygan, Wisconsin.

REV. ALBERT WAGNER
(b. 1924)
Born in Arkansas and lives in Cleveland, Ohio, where he moved with his mother and brothers at the age of seventeen. Wagner is a black urban artist who creates paintings and sculpture. "I had always wanted to paint since I was five years old, but there was nothing, not even an old piece of cardboard, to work on . . . but I could not be bitter with anyone because what seemed to have been lost has all come to pass at its proper time." His work is carried by the J.E. Porcelli Gallery in Cleveland.

FATHER PHILIP J. WAGNER-"GROTTO AND WONDER CAVE"-RUDOLPH, WISCONSIN
Father Wagner built a Grotto Wonder Cave with a maze of walkways and a series of Biblically-inspired scenes made of sheets of tin with proverbs spelled out in pin-holes, backlit by colored lights. The "cave" is not real, but is rather a conceptual representation. After Wagner's death, his co-worker and fellow builder Edmund Rybicki continued with renovation and building until his own death in 1991. The grotto is on the parish grounds of Saint Philip the Apostle Church in Rudolph, Wisconsin, and may be visited. The site is described in *KGAA News,* and is discussed and illustrated in a periodical article by Matthew Groshek, who "attended the Catholic grade school in the shadow of the Grotto."

ARTHUR WALKER
(b. 1912)

Born and raised in Sullivan, Illinois, along with six brothers. A builder and carver, he has created over 1,000 works. Walker was an avid traveler, and many of his works are inspired by what he has seen far from home. He makes many different images including fish, horses, wagons, merry-go-rounds, pigs, owls, Indian families—all done with style and craftsmanship. He used to sell his work at stores around Sullivan, but that was last confirmed several years ago. His work may be seen in the Tarble Art Center in Charleston, Illinois.

DONALD WALKER
(b. 1953)

A thirty-nine-year-old black man from a California family. He is one of twins, the other being Ronald, with an older brother and sister and a younger sister. He is currently, and "temporarily," living in a convalescent care home, his father is dead and his mother too ill to care for him. His mother, who is sometimes difficult to understand, describes him as retarded. His sister says he is autistic. He loves to draw, seems in fact to be "driven" to draw. His walls are covered with sketches of intense color and very strong and angular pencil lines. Walker makes lines across a page and plays with shapes which eventually develop into an image. The images are people primarily, with animals and birds occasionally appearing. Sometimes all are combined in one drawing that looks rather like a totem. His human heads have shapes piled on top as if wearing a headdress or carrying a large burden. His

drawings, made with crayon or pencil, are often accompanied by unintelligible writings. Donald Walker, who is happy to present his work, is a new discovery by Bonnie Grossman and his work may be seen at her Ames Gallery in Berkeley, California.

INEZ NATHANIEL WALKER
(1911-1990)

Born into poverty in Sumpter, South Carolina, she eventually moved to New York State and spent most of her life as a migrant farm worker. Imprisoned for killing a "probably abusive" man, she began to draw while in the Bedford Hills Correctional Institution. Her drawings are in pencil, colored pencil, and felt-tip marker. The subjects are usually women. The heads are large, with bodies proportionally smaller. The hair is elaborately detailed, and the drawings include lots of patterning. Numerous detailed accounts have been written of Walker's sad life. She is included in the Rosenak encyclopedia and in *Black Folk Art in America, 1930-1980*. Her work is represented by numerous galleries, including seventeen of those listed in this book.

MILTON WALKER-"THE WALKER ROCK GARDEN"-SEATTLE, WASHINGTON

The Walker Rock Garden, at 5407 37th Avenue, S.W., Seattle, Washington, was created by Milton Walker (1905-1984) between 1959 and 1982. The Garden is a series of towers, walls, miniature mountains, lakes, paths, fountains, a patio, and fireplace, all built with semi-precious stones,

rocks, crystals, geodes, and chunks of glass. Walker worked non-stop until 1982, when Alzheimer's disease made work impossible. His wife Florence had noticed he was beginning to have problems, "but when he told me he didn't know how to make an arch, then I knew what was wrong." The garden, the artist, and the inspiration for the work are discussed in a periodical article by Peter O'Neil. There is a "Friends" group (listed in the chapter on Organizations) that arranges tours.

HERBERT WALTERS
(b. 1931)

Born in Jamaica. He immigrated to New York in 1970, and later to North Carolina, where he now lives. He was a commercial fisherman for twenty-five years and built his own boats. He was also a textile worker. Now he is in business for himself, operating a small concession. Walters sculpts people, animals, or boats, which he sometimes embellishes with found objects. He uses sheet metal, wood, and auto body filler, painted with waterproof paint. His work was included in the exhibition "Signs and Wonders" and is carried by galleries.

JUNE WALUNGA

Born in the Eskimo village of Sivuqaq (Gambell) on the western edge of St. Lawrence Island in the Bering Sea. Her father, a member of the Avatmii Clan, rode in the great skin boats between Siberia and Western Alaska just prior to the closing of the U.S. border with the U.S.S.R. Her mother's traditional design work and artistic expression have appeared for years in sewing and beading

craft, and drawings on bleached skins. Walunga was raised in traditional Siberian Yupik culture until the time she left the island for schooling. Walunga is a woman of two worlds. She mastered the traditional skills and customs of her people when she was quite young. As someone with a spirit for adventure and knowledge, she has enjoyed several years of sport parachuting, and has travelled extensively outside the United States. She has worked in many facets of Alaskan life, including staff work with the Alaska legislature, hairstyling, apprenticeship as an electrician on the pipeline as one of the first women apprentices, and, throughout her career, as an accomplished artist. Walunga's natural artistic talents, evident since childhood and self-developed, are expressed in her oil paintings and drawings that depict the marine environment in which her people have prospered for more than 10,000 years. She paints animals, sea creatures, birds, and landscapes. Interested persons may write to her at PO Box 193, Gambell, Alaska 99742.

VELOX WARD
(b. 1901)
Born on a farm in Franklin County in eastern Texas. He was named after his mother's German-made sewing machine. He began painting in 1960 at the request of his three children. Many of his canvases are based on remembrances of his early years, recollections of his childhood, and photographs. He often made paper cutouts, which he then traced on the canvas before painting "in order to obtain the perfection he sought." He is written about and

his work is in the Amon Carter Museum of Western Art. Valley House Gallery in Dallas carries his work.

WIBB WARD-
"BEAR PARK"-
SAND LAKE, OREGON
William "Wibb" Ward (1911-1984) created a five-acre environment populated by bears which he carved from pine logs using a chain saw. Many of the bears were used to illustrate his personal beliefs, especially that government should stay out of the way of private business. The bear park is maintained by Ward's family and visitors are welcome.

FLORETTA EMMA WARFEL
(b. 1916)
Born in Dushore, Pennsylvania. She began painting around 1952, at the suggestion of a neighbor. Using ballpoint, tubes of paint, and often cloth instead of canvas, she constructs vibrant colorful landscapes, which are usually quite cheerful. The Rosenak encyclopedia provides details about her personal history and her art. Several galleries carry her work.

WILLIAM WARMACK
A Chicago native. He lives in the Old Town section, with his brother and fellow-artist Mr. Imagination. He takes cast-off furniture and other items and wraps them carefully with meticulous attention to pattern and design. This is a typical prison art form, which he learned during a troubled time. He uses cigarette packages and the color sections of newspaper comic strips. If you have a chair or another piece that you want

him to work on, he will do it. Call him in Chicago at (312) 472-4523 or see his work at Metropolitan Gallery in Milwaukee.

HENRY WARREN-
"SHANGRI-LA"-
PROSPECT HILL,
WHITE ROCK,
NORTH CAROLINA
With the help of neighbor Junius Pennix, Henry Warren (1883-1978) converted a corner of his large yard into a miniature village. They built twenty-seven white quartzite buildings, and decorated the pathways from the miniature village to his house with arrowheads embedded in cement, creating a mosaic-like pattern. After Warren died, his wife and sister continued to maintain the environment in White Rock, North Carolina. The environment is easy to see from the road that passes by it.

BOBBY WASHINGTON
(b. 1946)
Born in Bastrop, Louisiana, and now lives on the south side of Chicago. He started watching snakes while fishing with his grandmother in the Louisiana bayous, and the snakes "have been in his imagination ever since." Washington is a self-taught wood carver, creating unique wooden canes with snakes carved as though wrapped around them, which sometimes also include carved faces and other motifs. He uses found wood, wood that has fallen. He says, "I don't cut down anything." Washington works for the Chicago & Northwestern Railroad. He says his sticks are "not African style." He also carves busts of African-American

heroes. Objects Gallery in Chicago carries his art.

ARLIS WATFORD

Makes wood carvings, often from cedar. He makes a variety of figures, all very precise and clean. Sometimes they are painted, but often not. He lives in Ahoskie, North Carolina, and his work appears in the catalog *Signs and Wonders*. Lynne Ingram Southern Folk Art in New Jersey carries his work.

JAMES WATKINSON
(b. 1943)

Born in Philadelphia and now lives in New Hampshire. He makes assemblages from found objects, tree branches, lead, and earth. His work is available from two galleries.

WILLARD WATSON
(b. 1905)

Born in a mountain commumity in North Carolina. He spent his work life doing many hard tasks such as coal mining, logging, stone masonry, and carpentry. He retired at age sixty and started carving wood, using curly maple, black walnut and black cherry. He makes miniatures of pre-mechanized farm implements, furniture and toys with movable parts. Watson is included in *Signs and Wonders* and Jan Arnow's *By Southern Hands*.

WILLARD "THE TEXAS KID" WATSON-ENVIRONMENT AND ART WORK-DALLAS, TEXAS

Willard Watson (b. 1921) calls himself "The Texas Kid." He dresses in cowboy hats, boots, and fancy shirts. He began decorating his Dallas yard in 1970; his front yard is a forest of found objects and sculpture. He also makes objects to sell. His initial constructions offended his wife Elnora and the neighbors, who circulated a petition to get rid of the mess. He says, "at first they wouldn't speak to me at church on Sunday, but now everybody comes by and takes pictures and appreciates the yard." Watson attributes his unique design sense to his background of Choctaw, French, and African. Elnora Watson now helps with work, saving chicken bones (an important material in his art work) and sewing clothes for some of the more risque sculpture. Watson makes a distinction between the yard decorations and his art work (with the chicken bones); he sells his art and has received some gallery attention. He likes visitors—6614 Kenwell, Dallas, Texas, near Love Field. His art work is available at Leslie Muth Gallery in Santa Fe.

LILLIAN WEBB

Lives in a suburb of Nashville, Tennessee. She is a private person, and so not much is known about her. Webb has been painting for ten to fifteen years. She works in oil and acrylics on canvas and paper. Her works cover a wide range of images, from landscapes to portraits. Several galleries handle her work.

TROY WEBB
(b. 1926)

Lives in Hamlin Town, Tennessee, just across the border from Kentucky. He started working in the coal mines when he was fourteen and did not stop until he was nineteen, when he lost his right leg in an accident. Though they told him his days in deep mines were over, eighteen months later he returned and continued to work another twelve years. He started carving during the time he was recuperating from the loss of his leg. Although he once made animal shapes, he is now known more for his human forms—"coal miners and their wives," he says. He uses buckeye mostly, and carves with a knife. The sales shop of the Appalachian Museum in Norris, Tennessee carries his work.

DEREK WEBSTER
(b. 1934)

Born in Porto Castillo, in Honduras. He came to the United States in 1964 to visit his sister, and decided to stay. He has a wife and a daughter. He started working as a maintenance man, producing no art work of any kind until 1978, when he bought his present home. This sparked an urge to decorate his house and yard with creations from his imagination. He used pieces of wood and objects thrown away by others to make elaborate constructions placed in his home and yard. Many galleries handle his work.

FRED WEBSTER
(b. 1911)

A retired high school principal who lives in Berry, Alabama. He has whittled for many years but only recently at his present volume. "People just keep hearing about me and calling up wanting things. I can't keep up." "He seems to be puzzled by but enjoying all the fuss." He especially enjoys visiting primary schools to show his work to children. Webster's sculptures are hand carved with a pocket knife and painted with ordinary

house paint. The wood is mostly southern pine drawn from scrap pieces in his shed. He constructs painted, carved wood pieces mostly assembled to tell Bible and other stories. Many galleries carry his work.

PAUL AND MATILDA WEGNER-"PEACE MONUMENT/LITTLE GLASS CHURCH"-CATARACT, WISCONSIN

The Wegners and their son, Charles, being much inspired by the Dickeyville Grotto of Father Wernerus, built over thirty free-standing sculptures, a garden for meditation, a church, and a roadside pulpit during the 1930s. Their environment was surrounded by a decorative fence. All of the constructions were made with concrete, many of them decorated with pieces of glass and crockery in interesting designs. The small church has symbols honoring all religions. After the death of Paul Wegner in 1937 and Matilda Wegner in 1942, the site was purchased and restored under the sponsorship of the Kohler Foundation. It is now open to the public. Take Hwy 27 north out of Cataract to Sparta, then west on Hwy 1 toward Melrose.

ANNIE GERALDINE SAVAGE WELLBORN
(b. 1928)

Born in Lexington, Oglethorpe County, Georgia. She has "never been out of Georgia but one time"—as a child she went with the family lumber business to the edge of North Carolina. In a vision she had twelve years ago, the Lord revealed to her that "she would paint and He would be known through her." He said she would be well-

known; when she replied that she did not want to be well-known, "He said, 'Yes, but I do.'" She feels "very humble that God gave me this talent." Wellborn had to survive surgery seven times. She lives in a small mobile home with her husband and a retarded brother-in-law. Her subjects are often family life, but she also paints the visions she has had, especially those she had in the hospital and also the angels which have flown over her bed for the last fifteen years—some of whom she recognizes as close relatives. She paints using acrylics on board, tar paper, wall paper, and canvasboard. She uses "anything I can paint on and with." Two galleries carry her work.

P.M. WENTWORTH

An artist about whom very little is known. It is believed that he died around 1960. He worked in the San Francisco Bay Area in the 1950s, but spent most of his life in Southern California. His art was based on "visions in the sky." "He reportedly worked as a night watchman at a naval facility," according to his brief biography in the catalog *Cat and a Ball on a Waterfall*. His work is available in galleries.

FATHER MATHIAS WERNERUS-"HOLY GHOST PARK"-DICKEYVILLE, WISCONSIN

This environment has been described as "perhaps the most spectacular grassroots environment in Wisconsin" in an article in *SPACES*. The park consists of two large grottos and two major shrines, as well as small niches for statues. Building materials were concrete and

rock, with colored glass and "treasures" from people in the local parish embedded to decorate the concrete surfaces. Father Wernerus and his parishioners worked on Holy Ghost Park from 1925 to 1930. Wernerus died in 1931 before he could complete the additional shrines he had planned. It is maintained by the church and may be visited. The grottos are "dedicated to the Mother of God and the Holy Eucharist; the shrines to the Sacred Heart and patriotism." Father Wernerus was born in Germany in 1873 and was ordained a priest in Milwaukee in 1907. Dickeyville is on Route 151 north of Dubuque, Iowa.

FREDERICK WEST
(b. 1941)

Born in Chester, Pennsylvania, the third of seven children, and has lived there most of his life. In 1961 he joined the Army and spent nineteen months in Germany. After discharge he returned to Chester and entered school, where he learned the trade of auto-body technician. He worked at that trade for twenty-five years, taught it at Chester High School for one year, worked as a city inspector, and is now employed as a sheet metal assembler. West took his only art lesson at the Chester YMCA when he was ten years old. Years later he set up an easel in the basement and let inspiration do the rest. He tries to express through art his feelings about the world we live in and how different societies exist. "Through art he looks at pollution, corruption, racism, politics, morality—in short, the human value system." The Tartt Gallery in Washington, D.C. carries his work.

MYRTICE WEST
(b. 1923)

Born in Cherokee County, Alabama and still lives in that state. The Bible story of "Revelations manifested itself in my life," according to West, and she devotes much of her time to telling through paintings the whole story of Revelations, as she has seen it in visions. She also makes memory paintings of when she picked cotton and was involved with river boats piled high with bales of cotton. West works with found cloth stretched around found window frames, which are then gessoed and painted with oils. She occasionally applies glitter to her work. "Many of her works are extremely detailed and she works over six months to finish one, thus her work is rare and very important" says Marcia Weber in Montgomery, Alabama who carries her work.

EARNEST WHITE
(b. 1929)

Born in Newport News, Virginia. For many years, whenever there was down time on the job or in his spare time, he would make pencil sketches. When he retired about three and a half years ago, he was very bored and a friend suggested he do more with his art. He started painting. He uses acrylics on canvas and canvasboard. His themes are memories of the past, and he also does seascapes and landscapes. However, he likes best to do "work in black art," to document the lives of black people. White has a small studio behind his home and sells his art there: 315 West Queen Street, Hampton, Virginia 23669. Call first for an appointment, (804) 723-7005.

GEORGE W. WHITE, JR.
(1903-1970)

Born in Cedar Creek, Texas, and lived in other places including Petersburg, Virginia and Washington, D.C. In 1945 he moved to Dallas and stayed there until his untimely death from a minor foot infection. He was a jack-of-all-trades—cowboy, oil field worker, veterinarian's assistant, barber, deputy sheriff, and homemade liniment hawker. He gave it all up the morning he had a dream of becoming an artist. He painted and made sculpture, some of which he mechanized. He also made wood reliefs. The subjects were scenes representing his life experiences and the southern black experience. He has been written about and his work exhibited. Leslie Muth Gallery in Santa Fe handles his work.

WILLIE WHITE
(b. c.1908)

Born in Natchez, Mississippi but has lived in New Orleans for many years. He was "inspired by God and movies of faraway places" seen on his black and white television. He began painting in the 1960s when he was a janitor at a nightclub on Canal Street and watched someone sketch. White draws with bright magic markers on poster board. He paints numerous subjects: religious images, houses, tomatoes growing, prehistoric creatures, rocket ships, watermelons, birds, crosses, donkeys, and cacti. His shapes are simple and the colors are strong and bold. Galleries carry his work.

CLYDE WHITESIDE
(b. 1917)

Lives in the mountains of western North Carolina, where he created a beautiful home environment that one may see in the pages of *O, Appalachia*. After he married, in 1936, he began converting a four-acre lot into a landscaped garden. For years he worked as a laborer, and was finally able to retire in 1980. Then he started working full-time on his house and garden, decorating it with carved animal heads, whirligigs, and cut-out tin birds and fish. A few "extras" of the work he makes are for sale at Appalachian Folk Art.

ENOCH TANNER WICKHAM-ENVIRONMENT-PALMYRA, TENNESSEE

In Buckminster Hollow, Palmyra, Tennessee, Enoch Tanner Wickham (c.1883-1971) built fifty statues made of concrete and painted with enamel. These statues were of national heroes, religious scenes, and local people and ranged in size from six to thirty feet tall. Wickham began his project in 1952, when he was sixty-nine years old. Soon after his death, vandals began to strike with some regularity and savagery. In his article, "Giants of Tennessee: The Primitive Folk Sculpture of Enoch T. Wickham," Daniel Prince speculates about the reasons for the physical abuse of these statues, describes the background of Wickham and the futile efforts to save the art. In 1991, Jonathan Williams wrote of a 1988 trip to Palmyra in which he describes the site as "ruinous, but absolutely thrilling: an arcade of sculpture lining a rural road. Daniel Boone, the Kennedy brothers, Patrick Henry, Estes Kefauver, local soldiers, local doctors . . . very moving, even with no heads and with all the

graffiti." Each of these articles is illustrated with photographs of the work, particularly the one by Prince. A few of Wickham's pieces were removed to the Austin Peay Museum. There are still a few pieces of sculpture—mostly headless—to be seen among the loblolly pines planted by Wickham to enhance a once-barren hill for his sculpture garden.

ISIDOR "POP" WIENER
(1886-1970)

Born in Russia and immigrated to the United States in 1901. He lived in the Bronx and ran his own grocery store from the 1920s to his retirement in 1950. His wife died soon after, and Wiener was encouraged by his son to paint to overcome his sorrow and loneliness. He painted his memories, Bible stories, and scenes of life in New York. He also carved and usually made animals. He is said to have painted with good humor and spirit. His work is illustrated in the Rosenak encyclopedia and is included in Fenimore House museum.

TOM WILBURN
(1925-1991)

"Carved and painted miniatures of co-workers, friends, and townspeople, occasionally grouped together in a scene. He used scrap wood and often rubbed the carvings with dirt ['so they would look like real life'] . . . often men were carved scratching their butts because it was easier than carving a loose hand." Wilburn was born in Ramage, West Virginia, the son of a coal miner. During the Depression there was no money, so he whittled his own toys. He served in the navy in World War

II, worked as a coal miner for two years, and then attended barber college. When times got too hard for people to afford a haircut, Wilburn moved north and got a job with Ford Motor Company at their foundry in Ohio. There he started carving again, mostly images of his co-workers. The Ames Gallery in Berkeley, California carries his work.

LIZZIE WILKERSON
(1901-1984)

Born the youngest of twenty-one children to a black family in rural Georgia. She moved to Atlanta after getting married, where she worked in factories and as a domestic worker. She started painting at the age of seventy-seven, while attending a senior center. Her bright, lively paintings represent rural Georgia. She is featured in several publications and a film.

KNOX WILKINSON
(b. 1954)

Lives in Rome, Georgia, and is a self-taught artist. He is developmentally disabled, but with the help of his genuinely loving and supportive family and his "God-given talent" he has managed to create his well-received art. Knox Wilkinson is best known for highly patterned, brightly colored works on paper. Among his best known images are one or a group of women, room interiors, Elvis Presley, fantasy animals, and especially country music singer Loretta Lynn. Wilkinson has had his work shown in a number of exhibitions, has been written about and is in the permanent collection of the High Museum of Art in Atlanta. Galleries carry his art.

CHARLIE WILLETO
(1905-1965)

Born on Navajo Nation land in New Mexico. He was a carver of Navajo men and women, which is definitely not traditional. Details about his life and work are included in the Rosenak encyclopedia, which also tells of the short, sad life of his carver son LEONARD (1955-1984). It also says his sons HAROLD and ROBIN "recently began to carve." Two southwestern galleries carry Charlie Willeto's work.

"CHIEF" WILLEY
(1889-1980)

Born in Falls Village, Connecticut. He worked at many jobs including in lumber camps, saw mills, farming, the automobile business, and circus work. The job he enjoyed most was driving an eight-horse team for the Barnum & Bailey circus. He served in World War I and eventually ended up as chief of security for the New Orleans Water Board. He started painting in the 1960s and sold his work along the fence at Jackson Square, a New Orleans tradition. His subject matter was the many sights and sounds of New Orleans. His work is in the permanent collections of the Museum of American Folk Art and the Museum of International Folk Art. Several galleries carry his work.

"ARTIST CHUCKIE" WILLIAMS
(b. 1957)

Lives in Shreveport, Louisiana, and started drawing when he was a child. He uses found materials such as cardboard, plastic board, and plywood. He paints mostly celebrity figures, and adds glitter to the images. Michael Jackson, Janet Jackson,

Elizabeth Taylor, and Dolly Parton are among his favorite subjects. His inspiration comes from television. He says he prefers to be called "Artist Chuckie," not Chuck or Charles. Many galleries handle his work.

BEN WILLIAMS
(b. 1928)
Lives in the same Montgomery, Alabama home his parents bought before he was born. He dropped out of school in the sixth grade because he wanted only to draw. In his teens Williams moved to Cincinnati, where he shined shoes, drawing his pictures between customers. When his father's health failed, he returned to Alabama. He married in 1947 and had six children. He and his wife separated after the children were grown,and he moved to Washington D.C. In 1985, a broken leg suffered in an automobile accident left him disabled, but with time to devote to his art. The figures in his paintings are frequently of grotesque proportions, with claw-like hands, anguished faces, and accentuation of physical flaws. The women in his paintings exhibit sexual poses, as if for sale. Williams attributes the inspiration for his images to God, pointing a finger skyward and saying "He give 'em to me. My ideas come from the Lord,"–adding "I always liked drawing the ladies." He says some of his inspiration comes from magazine advertisements. In contrast to his overtly sexual images, the other frequent subject of his work is the weeping Christ, either in crucifixion or portraiture. Artist and gallery owner Anton Haardt says "this contrast suggests the artist's

struggle, which has led him to destroy all his work until recently. It is as though creation is the sin, and salvation lies in destruction" says Anton Haardt. He works on a lap board, sometimes drawing in near darkness. "His rudimentary collages of cut-out figures drawn on brown paper bags relieve the stark white surfaces of poster board. The detailed drawings evidence the considerable time he takes with each piece, which is first sketched in pencil and then traced an retraced with ballpoint pen until the pressure carves deep furrows in the paper." His work has begun to attract an appreciative audience and Williams has begun to save his pictures. Anton Haardt Gallery in Montgomery, Alabama which supplied this information, carries some of his work.

DECELL WILLIAMS
A black man about sixty years of age, who lives in Mississippi. He works as a carpenter and a cabinet maker. He also carves canes, staffs, and small figures from cedar or walnut, and paints the finished carvings. Justin Massingale in Mississippi handles his work.

GEORGE WILLIAMS
(b. 1920)
Grew up in Clinton, Louisiana, where he was born, and now lives in Fayette, Mississippi. He is well-known for his carved male and female figures, which sometimes are dressed and sometimes are not dressed. He also does a few other images, including the Statue of Liberty. Williams' work is written about and is available in galleries.

JEFF WILLIAMS
(b. 1958)
Born in Sampson County, North Carolina, one of a family of fourteen children. He started carving when he was about eleven years old. He works as a carpenter and mechanic, and continues to carve, spending more and more time at it. He carves and paints animals, human figures, and abstracts using sweetgum wood and enamel paint. He also makes some paintings on canvas and wood. Galleries carry his work.

"INDIAN JOE" WILLIAMS
(b. 1948)
Born in Jefferson, Georgia and received his nickname from his mother. A truck driver by profession, Williams hauls fertilizer all across the Southeast. On the long hauls, he usually does not play the radio but instead passes the time trying to think about his next creations. The ideas change constantly and take shape as he assembles the work. "I just start cutting and I end up with what I end up with. Working with wood is relaxing and I get a lot of satisfaction watching it all come together." Williams makes heaven/hell devil boxes with various images. A favorite is "Hell's Alley" where "the devil is a bowler and the pins are the sinners." Timpson Green in Clayton, Georgia carries his work.

OLIVER WILLIAMS
(b. 1948)
Lives in Iowa has been painting for about the last twenty-five years. The rather eerie quality of his work is explained by the artist as an attempt to portray "man's inner fears in mundane, everyday settings." Five years ago

Williams began making terra cotta sculptures. In his "animal revenge" series, animals get even with humans. Oliver Williams' work is available from The Pardee Collection in Iowa City.

RUSSELL WILLIAMS
A retired barber from West Liberty, Kentucky. He makes whimsical simple sculptures and birds from pine knots. His work may be seen at Morehead State University Folk Art Museum.

SYLVESTER WILLIAMS-YARD ART-HOUSTON, TEXAS
Sylvester Williams moved to Houston from Wharton, Texas in 1955. He worked for a while at the Post Office. Now he is the coordinator of skycaps at Houston International Airport. Williams has been "junking" since he was a kid. "His collection includes some of everything, from pre-electric irons to pictures that remind him of his youth. Every square inch of his home is covered with things neatly displayed in endless collections..." Williams has a great interest in black history and this is evident in his yard art. Sylvester Williams and his wife Lori live in the Third Ward (Quotes from Susanne Theis of the Orange Show Foundation, where you may call for further information).

CLARA McDONALD WILLIAMSON
(1875-1976)
Born in the small Texas frontier town of Iredell and raised in a rural community "filled with hard work, family responsibilities, and simple pleasures." Her life consisted mostly of maintaining a household for her hus-

band and three children. At the age of sixty-eight she was widowed, and began painting. She was a memory painter, recording the domestic history of early Texas life. Valley House Gallery in Dallas carries her work.

LUSTER WILLIS
(1913-1990)
Born in Terry, Mississippi and died in Egypt Hill. He developed an interest in drawing at an early age. His themes were friendship, morality, and racial justice. He also drew portraits of his friends. His works were made with whatever materials were available—pencil, tempera, pen, watercolors, shoe polish, glitter. His work was interrupted for a while because of a stroke. Willis' work has been shown in many important exhibitions and several galleries handle his art.

WESLEY WILLIS
A youngish black man who lives in Chicago. He sits in public places, often in the Loop-area subway, where he talks to people and draws. He uses colored pens to make large appealing drawings of Chicago scenes, mostly buildings and trains. He "draws Chicago," but not the people. From 1983 to 1986 he lived in the Robert Taylor Homes, one of Chicago's most notorious public housing projects, with his mother and a brother or two. He was befriended by several Illinois Institute of Technology faculty, who let him "hang out" there. After several moves, Willis seems to have gotten a place of his own about two years ago. He still works on the streets and sells his art in the subway. Bruce Shelton/Folk Art in Nashville has his work.

ALLEN WILSON
(b. 1960)
Lives in Summerville, Georgia, and is the son of Howard Finster's daughter Gladys. He worked in a local cotton mill until he was 26, and began pursuing art full-time about six years ago. He does a lot of maintenance work on Paradise Garden, and a year or so ago suffered severe damage to one eye while cutting the grass, which has slowed down his ability to make art. Allen Wilson's creations are most unusual. He carves large figures such as clowns, devils, prehistoric creatures, and other figures from rings of wood, which he fits over bottles to make a torso. Then he carves and paints details and adds the head (which comes off, so the bottles are usable). His work is seen by some collectors as not at all derivative of his grandfather's work. Two galleries in addition to the one at Paradise Garden carry his work.

GENEVIEVE WILSON
Born in Casey County, Kentucky, and now lives near Russell Springs. She is a self-taught artist who does memory paintings with acrylics. She also finds wood and paints it, creating animals, birds, and fantasy creatures. Morehead State University Folk Art Sales Gallery carries her work.

CHARLES WINCE
A self-taught artist from Columbus, Ohio. He paints with oil on canvas and had three works in the exhibition "Interface" in Ohio in 1986. In the catalog essay Gary Schwindler discusses Wince's painting "The Walls Inside My Mind," which has an inscription around the edge.

Schwindler says Wince's paintings "depict situations in which various characters occupy center stage, either acting as protagonists or victims in some kind of human drama." He says the painting named above (which is illustrated in the catalog) "seems to symbolize the consequences of deprived and desperate people made irrational and fearful by the pressures of overcrowded ghetto existence." He says Wince's "quickly brushed, vivid, expressionistic style has the look of illustrated popular fantasy or science fiction."

DAVE WOODS- YARD ART ENVIRONMENT- HUMBOLDT, KANSAS

Dave Woods (1885-1975) spent nearly thirty years, beginning after he returned to Humboldt, Kansas in the 1940s, gathering discarded objects and building a massive fence and assemblages in his yard. "Over the years his home, yard, and garage became covered with a montage of color, pattern, and light. The yard became a maze of paths lined with multi-colored fences strung with hanging objects which stirred with the slightest breeze that blew across Humboldt" (*KGAA Newsletter,* Fall 1980). After his death, hundreds of the pieces were donated to the KGAA. The work was once reassembled and shown at the University of Kansas art Museum. Photographs of the work may be seen in the periodical article "The Grass-Roots Artist" by Gregg N. Blasdel.

CLARENCE WOOTEN
(b. 1904)
Born in Cutshin Creek, Ken-

tucky and grew up in Hell-For-Certain. Now he lives in Noctor. Wooten painted a lot in the 1930s and early 1940s. He worked in the WPA artist project and assisted in the work on several public murals. His first exhibition was in Long Beach, California, and he has had others all over the country, including Rockefeller Center in New York. Wooten quit painting during World War II and started painting again in 1987. He paints every day. He takes a walk with his sketch book, then comes back and paints what he has sketched. He calls himself a "regional painter," preferring to paint what he sees outside his house and in the mountains. His work was exhibited not long ago at Berea College and as part of an exhibition at Appalshop. It is a great pleasure to talk with Wooten, and he accepts visitors when they have an appointment. Call (606) 666-8322.

BEATRICE XIMENEZ- CEMENT YARD ART- FLORESVILLE, TEXAS

Religious shrines, large animals, fantasy beasts, and cement art furniture welcome all visitors to the front yard of the Ximenez home in Floresville. Fifty works in all were made by Ximenez over 30 years, before she died in 1989 at the age of 84. Her husband had learned the art of cement sculpture from his employer in San Antonio. The yard art and Mrs. Ximenez are described in detail in the exhibition catalog *Hecho Tejano.*

LULA HERBERT YAZZIE
(b. c.1954)
Born in Tez Nos Pos, Arizona, and grew up in the Navajo Nation where she lives today. With

her husband Wilfred, she makes standing cottonwood carvings of barnyard animals. Chickens, chickens with chicks, rooster, sheep, and black crows are common subjects—the crows are done only by Wilfred as it is considered bad luck or improper for a woman to do this animal. The pieces stand twelve to twenty inches high, are relatively primitive in style, and are painted with acrylics. Her work is available in several galleries.

WILFRED YAZZIE
(b. c.1950)
Born in Tez Nos Pos, Arizona, and lives there with his wife. In addition to the figures they carve together (see entry under Lula Herbert Yazzie), Wilfred makes standing pieces of the Navajo holy men, or "Yei" figures. These are rather finely done, and average 30-48 inches in height. They are generally carved from a single cottonwood log and have a white base, a blue shirt with painted jewelry, and a painted face. They are adorned with beaded earrings, white fur, and an occasional eagle feather. His work is available in galleries.

JOSEPH YOAKUM
(1886-1972)
Born on a Navajo reservation in Arizona. He began at age fifteen his career as a hired hand, hobo, stowaway, and hand with many traveling circuses. When Yoakum settled in Chicago in 1962 he began to draw, following a dream. He made carefully titled landscapes from around the world. Yoakum was a powerful influence on contemporary Chicago trained artists. At the "Altered States/Alternate Visions" symposium in Oakland, Califor-

nia in April 1992, Gladys Nilsson describes the "strength, directness, and simplicity" of Yoakum's work. From 1962 to 1972 "the length of his art life," says Nilsson, "he made from 1500-2000 drawings." There are many written references to Yoakum, and his work has been included in numerous exhibitions. Seven of the galleries listed in this book carry his work.

ANTHONY YODER

Lives in Iowa and is a Mennonite whose visionary art work is inspired by his meditations about Bible scripture. He lives with his wife and two young daughters in a rural area of the state where they are active members of their local church. Yoder makes his living as a carpenter, house painter, and part-time security guard. His art consists of drawings in notebooks. He says that the beauty of the scriptures is that "they are talking pictures; anyone who reads them long enough is going to get a mental picture." His work is filled with often-repeated symbolism, especially of people and buildings that reveal a cross-like structure within the images. His drawings are often made in the solitude of his nighttime work as a security guard. The Pardee Collection in Iowa City carries his work.

HENRY YORK
(b. 1913)

A retired farmer and has carved off and on all of his life. He makes primarily canes, animals, and articulated figures. He used to drive a station wagon topped by a large set of oxen with riders. His usual wood is cedar, found in old fence posts and rails. York carves with a pocket knife and then accents with paint, although sometimes he will paint the whole object. He shellacs his pieces when they are done. Some of his canes have handles that represent horses with riders, and snakes are a frequent subject on his canes. The articulated figures are "usually erotic," men with exaggerated penises attached with a spring. York is included in the *Sticks* catalog and the book on canes by George Meyer. His work is available in galleries.

PURVIS YOUNG
(b. 1943)

A self-taught African-American artist who lives in Miami, Florida, where he was born and has lived all his life. He does paintings, often surrounded by found wood, street murals, and mixed media works. It is said "his subjects are his life." Some people say "his work is very important." He was included in the exhibition catalog *A Separate Reality* and his work is in galleries.

LENA ZARATE
(1916-1991)

Born in Key West, Florida, of Cuban-American ancestry. Zarate is considered a "memory" artist, painting primitive historical or garden scenes on bottles and jugs. According to her grandson, Zarate's supply of bottles came from his uncle, "who drank." Since she was reluctant to throw any away, she started painting them in the mid-1980s. Her work was very popular and is still sought after. Occasionally it turns up at Lucky Street Gallery in Key West.

MALCAH ZELDIS
(b. 1931)

Born in the Bronx, New York, and now lives in Manhattan. Her paintings are an expression of her own life, her experiences, her feelings, her religion, and her environment. With her flat style and bold colors, Zeldis creates works of art which have great appeal. She does not concern herself with academic rules of painting; she follows her own rules. Zeldis is written about and her work is in the permanent collections of many museums around the world including the Museum of American Folk Art, National Museum of American Art, Jewish Museum, Milwaukee Museum of Art, Musèe d'Art Naif de l'Ile-de-France, and the International Folk Art Museum. A book of her recent paintings of animals, *A Fine Fat Pig,* was published in March 1991. Galleries carry her work.

JOSEPH ZOETTL
(1878-1961)-
"AVE MARIA GROTTO"-
CULLMAN, ALABAMA

The builder of the miniatures at the Ave Maria Grotto was a Benedictine monk, born in Bavaria. When he came to the Abbey in Cullman he was appointed to run the power plant. While there he started building his miniature shrines. He worked for over forty years on the 1725 reproductions of famous churches, shrines, and buildings from all over the world. He built his last model, of the Basilica at Lourdes, at age eighty. The site covers over three acres and is located at the St. Bernard Abbey, 1600 St. Bernard Drive, S.E., Cullman, AL 35055 (205) 734-4110.

SILVIO PETER ZORATTI
(1896-1992)

Lived with his wife in Conneaut, Ohio. He was born to a farming family in northeastern Italy. He left for Austria at the age of nine, apprenticed to a stonemason uncle. In 1916 he was drafted into the Italian army, and spent a year as a prisoner of war of the Germans. He came to the United States in 1919 and worked for a farm tool manufacturer. In 1923 he went to work for the Nickel Plate Railroad where he stayed until he retired in 1961. During his working life he had no time to work on art, with one exception—in the 1950s he made large cement animal sculptures which he placed in the yard behind his house for the amusement of his grandchildren. His daughter Alvera Terry says he went to his basement workshop the morning after his retirement and worked on art all day, every day, into the 1980s when he could no longer see. An article about Zoratti referred to his work as "bursting with energy and excitement," and continues "the bulky aspect of his figures, such an essential part of his style, serves to convey the abundant and apparent joy put into their making." His figures are people, children, politicians, animals, figures from popular culture, and American icons—the Statue of Liberty, Uncle Sam. The sculptures filled the deep yard behind his house. He received media attention in the 1960s, but was largely ignored by art collectors—perhaps, according to the gallery that represents him, because he lived far away from art centers. Silvio Zoratti and his wife Beatrice eventually moved to a nursing home near Conneaut. Zoratti's works were featured in the exhibition catalog *New World Art: Old World Survivor.* J.E. Porcelli in Cleveland carries his work.

JANKIEL "JACK" ZWIRZ
(1903-1991)

Born in Poland and immigrated to Belgium where he was a Resistance hero. He suffered in World War II at the hands of the Germans, but lived to migrate to the United States in 1950, where he settled in Memphis. He was a painter whose subject matter ranged from Jewish life in Europe and the horrors of concentration camps to futuristic visions of space ships. Two galleries carry his work.

APPENDIX:
Art Environments by State

The list that follows is arranged by the state where the art environment is located. All of those listed may be visited or may be viewed from an adjacent street or road. This is not a definitive list: there are a few well-known sites missing because it could not be confirmed, even with experts in the field, that they are currently open to visitors. Details about the site, the location and the creator are listed in the chapter on artists, alphabetically by the name of the artist who made the environment.

There are many more such environments, dozens in North Carolina for instance, but those who discover them often keep the location a secret—believing as they do that those interested in the work as art will try to take it away; these same people often think they have the right to "protect" the artist from selling his or her work, even when the artist wants to do so. There have also been, sad to say, many cases of vandalism of art environments. As often as not, these are perpetrated by neighbors, not by art collectors. Whatever the truth, it is assumed here that the people who visit these folk/grassroots environments and sites will treat the art, and the artists and their families where present, with respect.

STATE	ARTIST	ART ENVIRONMENT
ALABAMA	Joseph Zoettl	*Ave Maria Grotto*
ARIZONA	Bryce Gulley	*Mystery Castle*
CALIFORNIA	Art Beal	*Nitt Witt Ridge*
	John Ehn	*Old Trapper's Lodge*
	Romano Gabriel	*Wooden Sculpture Garden*
	Tressa Prisbrey	*Bottle Village*
	Simon Rodia	*Watts Towers*
CONNECTICUT	John Greco	*Holyland, USA*
DISTRICT OF COLUMBIA	James Hampton	*Throne*
	Donald G. Morgan	*Jamaica*
FLORIDA	Edward Leedskalnin	*Coral Castle*
GEORGIA	E.M. Bailey	*Bailey's Sculpture Garden*
	Howard Finster	*Paradise Garden*
	ST. EOM	*Pasaquan*
HAWAII	Flavian B. Sidiaren	*Kayumangui*
ILLINOIS	Bill Notzke	*Jubilee Rock Garden*
IOWA	Paul M. Dobberstein	*Grotto of the Redemption*

STATE	ARTIST	ENVIRONMENT
KANSAS	Florence Deeble	*Rock Garden and Miniatures*
	S.P. Dinsmoor	*The Garden of Eden*
MASSACHUSETTS	Elis Stenman	*The Paper House*
MICHIGAN	Mae Mast	*Yard Art*
MISSISSIPPI	Loy Bowlin	*The Rhinestone Cowboy*
	Harvey Lowe	*Yard Art*
NEVADA	Chief Rolling Mountain Thunder	*Rolling Thunder Monument*
NEW JERSEY	William Clark	*Junkyard Robots*
	Joseph Laux	*Fairy Garden*
NEW MEXICO	Pop Shaffer	*The Shaffer Hotel and Rancho Bonito*
NEW YORK	Veronica Terrillion	*Indian River Environment*
NORTH CAROLINA	Clyde Jones	*Haw River Animal Crossing*
	Vollis Simpson	*Giant Windmills and Whirligigs*
	Henry Warren	*Shangri-La*
OHIO	Ben Hartman	*Hartman Rock Garden*
OKLAHOMA	Ed Galloway	*Totem Pole Park*
OREGON	Loren Finch	*Zig Zag Zoo/El Ranch Fincho*
	Rasmus Peterson	*Peterson's Rock Garden*
	Rod Rosebrook	*Environment*
	Wibb Ward	*Bear Park*
TENNESSEE	Enoch Tanner Wickham	*Sculpture Garden*
TEXAS	Manuel Castañeda	*Whirligigs*
	Victoria Herberta	*Pigdom*
	Alva Hope	*Yard Art*
	Felix "Fox" Harris	*Forest*
	Timoteo Martinez	*Yard Art*
	Jeff McKissack	*The Orange Show*
	John Milkovisch	*Beer Can House*
	Cleveland Turner	*The Flower Man*
	Willard "The Texas Kid" Watson	*Yard Art*
	Sylvester Williams	*Yard Art*
	Beatrice Ximenez	*Yard Art*
WASHINGTON	Emil & Vera Gehrke	*Windmills*
	Milton Walker	*Walker Rock Garden*

STATE	ARTIST	ENVIRONMENT
WISCONSIN	Tom Every	*The Fancy*
	Ernest Hupenden	*Painted Forest*
	Mary Nohl	*Yard Art*
	Herman Rusch	*Prairie Moon Park*
	Fred Smith	*Concrete Park*
	Philip J. Wagner	*Rudolph Grotto*
	Paul & Matilda Wegner	*Peace Monument/ Little Glass Church*
	Mathias Wernerus	*Holy Ghost Park*

INDEX

Index entries are alphabetical and include artists, recent and/or frequently cited exhibitions, recent symposia that have attracted national attention, a few privately assembled collections, and support groups for specific art environments (e.g., "Friends of the Walker Rock Garden"). Names of art environments follow the name of their creator, in brackets, and are also cross-referenced by their own name. The entry "environments" refers to works in the bibliography containing information on more than one site. The entry for "libraries and archives" points the reader to sources for further reading and research.

Numbers in regular typeface refer to page numbers, for all but the bibliographic chapters. **Bold-face** letters and numbers refer to specific resource types and *item* numbers (*not* page numbers) in the bibliographic chapters (e.g., **B: 315** refers to item number 315 under Books; **P: 78** refers to item number 78 under Periodicals; **N: 62** refers to item number 62 under Newspapers; and **AV: 4** refers to item number 4 under Audio-Visual Materials).

Perez, Mikie, **B: 87**

Perkins, Benjamin F., 5-7, 10, 14, 16, 18, 20-23, 25, 29, 31, 33, 35, 36, 38, 39, 41, 42, 45, 47, 49, 50, 51, 53, 56, 58, 69, 81, 90, 104, 106, 108, 398; **B: 154, 161, 204, 211, 248, 307, 311, 312, 353, 413; N: 55, 76, 170, 178, 282, 337; AV: 51**

Perkins, Clarence "Cy," 398; **B: 60, 221; P: 131**

Perkins, Ruth, 398; **B: 60, 95, 221; P: 131**

Perkins-Robinson, Mary Lou, 398; **B: 60, 221; P: 131**

Perrin, Gilbert, 78

Perry, James, **B: 185**

Perry, Judy, 24, 35, 398; **B: 149**

Perry, Virgil, 6, 7, 16, 106, 399; **B: 312; P: 548**

Person, Leroy, 89, 399; **B: 264, 310, 381; P: 265**

"Personal Intensity: Artists in Spite of the Mainstream," 96, 106, 138; **B: 322**

"Personal Voice: Outsider Art and Signature Style," 105; **B: 323**

Pete sisters, **B: 354**

Peters, Richard Carl, **B: 145**

Peterson, Oscar, 399; **B: 156, 244, 343, 353**

Peterson, Rasmus [Peterson's Rock Garden], 399, 440; **B: 41; P: 202**

Peterson, Richard Carl, **B: 145**

Peterson, Thelma, **B: 16**

Phelps, Nan, 42, 89, 399; **B: 134, 266, 270; P: 415**

Philadelphia Wireman, 48, 84, 102, 114, 130, 399; **B: 24, 103, 125, 289, 343, 408; P: 96, 266, 376, 446; N: 164, 267**

Phillips, Irene, 43, 399; **B: 15, 267**

Philpot, David, 25, 108, 138, 399; **B: 62; P: 73, 93, 264; N: 58, 320**

Pickering, Audrey, 11, 400; **B: 97**

Pickett, Joseph, 41, 42, 84, 400; **B: 49, 51, 60, 65, 75, 193, 217, 221, 226, 249, 250, 288, 353; P: 55; N: 262**

Pickle, Frank, 16, 35, 50, 52, 56, 108, 400

Pickle, Helen, **B: 260; P: 239; AV: 45**

Pierce, Elijah, 8, 32, 48, 70, 81, 85, 90, 96, 102, 106, 111, 115, 400; **B: 12, 13, 22, 51, 59, 106, 117, 118, 134, 166, 173, 191, 193, 202, 203, 221, 237, 254, 288, 294, 343, 351, 353, 378, 408, 410, 419; P: 7, 39, 43, 44, 57, 83, 116, 318, 446, 525, 530, 635; N: 64, 66, 190, 284, 360; AV: 14, 61**

Pierce, Warren, 8, 400

Pinette, Betty Cole, 17, 401

"Pioneers in Paradise," **B: 324; P: 181, 336, 466, 490; N: 39, 192**

Pippin, Horace, 42, 48, 72, 74, 76, 106, 401; **B: 42, 49, 51, 60, 65, 75, 85, 106, 152, 193, 198, 199, 217, 221, 226, 249, 250, 270, 288, 347-349, 353, 405; P: 394, 395, 445**

Pittman, Rosemary, 56, 401; **B: 353**

Podhorsky, John, 44, 48, 401; **B: 24, 193, 285, 324, 424; P: 161**

Polaha, Steven, 111; **B: 58**

Polhamus, Melissa, 36, 45, 401; **B: 413**

Polinski, Joe, 41, 401; **N: 362**

Polk, Naomi, 38, 102, 111, 402; **B: 64, 353; P: 383; AV: 6**

Polo, Guido, **B: 314**

Pond, Juan, 7, 402

Ponder, Braxton, 22, 51, 52, 402

Ponders, Harry, 77; **P: 45**

Poole, Ray, **B: 275**

Pope, Laura, **P: 88, 459**

Poppin, John, 57, 402

Popso, James, 131

"Popular Images/Personal Visions," 90; **B: 325**

Porter, Cecil, **B: 17**

Porter, Howard ["OK Corral"], **P: 567**

Porter, Jane, **B: 81**

Possum Trot; *see,* Black, Calvin and Ruby

Potts, Darwood, 78

Potts, William E. "Bill," 14, 56, 108, 402; **B: 289; P: 426; N: 56**

Powers, Stephen, 56, 402

Prairie Moon Park; *see,* Rusch, Herman

Predmore, Jessie, **B: 217**

Prendergast, James, **B: 267**

Pressley, Barbara, 22, 402

Pressley, Daniel, 20, 41, 96, 403; **B: 51, 62, 191, 193, 310, 353**

Pressman, Meichel, **B: 239**

Preston, William, **B: 434**

Price, Janis, **B: 221, 294**

"Primal Portraits: Adam and Eve Imagery...," 72; **P: 453; N: 16**

Prisbrey, Tressa "Grandma" [Bottle Village], 121, 130, 403, 439; **B: 41, 45, 81, 89, 180, 246, 287, 329, 352, 353, 654, 363, 409; P: 88, 102, 121, 164, 209, 245, 255, 357, 367, 445, 518, 563, 581; N: 82, 121; AV: 24**

Prosper, Ray, **B: 419**

Provenja, Rosario, **B: 197**

Pry, Lamont "Old Ironsides," 41, 43, 54, 69, 74, 81, 90, 96, 111, 115, 403; **B: 13, 221, 353, 377; P: 9, 298**

Pugh, Dow, 8, 32, 52, 72, 92, 111, 403; **B: 202, 204, 353, 419; P: 259, 412**

Purmell, Bluma, **B: 173**

Q

Qoyawayma, Al, 70

Queen, Ruby, 403

Queor, William, **B: 151**

Quigley, E., **B: 434**

Quinlin, Bobby, 78, 95, 403

Quinn, Norman Scott "Butch," 16, 74, 81, 105, 108, 113, 114, 404; **B: 244, 314, 405, 415; P: 240, 299; N: 18**

R

Rabinov, Isaac Irwin, 9, 404; **B: 81, 324**

Radoslovich, Matteo [Whirligig Garden], 86, 404; **B: 244, 353, 409, 415**

Rae, Helen, 9

Rakes, Sarah, 6, 22, 25, 45, 49, 50, 404; **B: 164, 413**

"Rambling On My Mind," **B: 337; P: 478**

Ramirez, Martin, 26, 34, 44, 48, 73, 74, 82, 94, 96, 102, 103, 106, 111, 113, 115, 130, 404;

Betty-Carol Sellen is an independent library consultant, Professor Emerita of Brooklyn College, and author of numerous professional and reference books. She is a member of the American Library Association, The Folk Art Society of America, Intuit, the North Carolina Folk Art Society and many other regional associations for those interested in folk, self-taught, and outsider art.

Cynthia J. Johanson is Assistant Chief in the Regional Cooperative Cataloging Division of the Library of Congress in Washington, D.C. She is an active member of the American Library Association as well as the Folk Art Society of America and Intuit and is an enthusiastic collector of folk, self-taught, and outsider art.

Book design: Gloria Brown, Aurora, Colorado
Cover design/photo layouts: Apicella Design, Montclair, New Jersey
Typography: The Type Set, New York City